LIVING OUR CULTURES

SHARING OUR HERITAGE

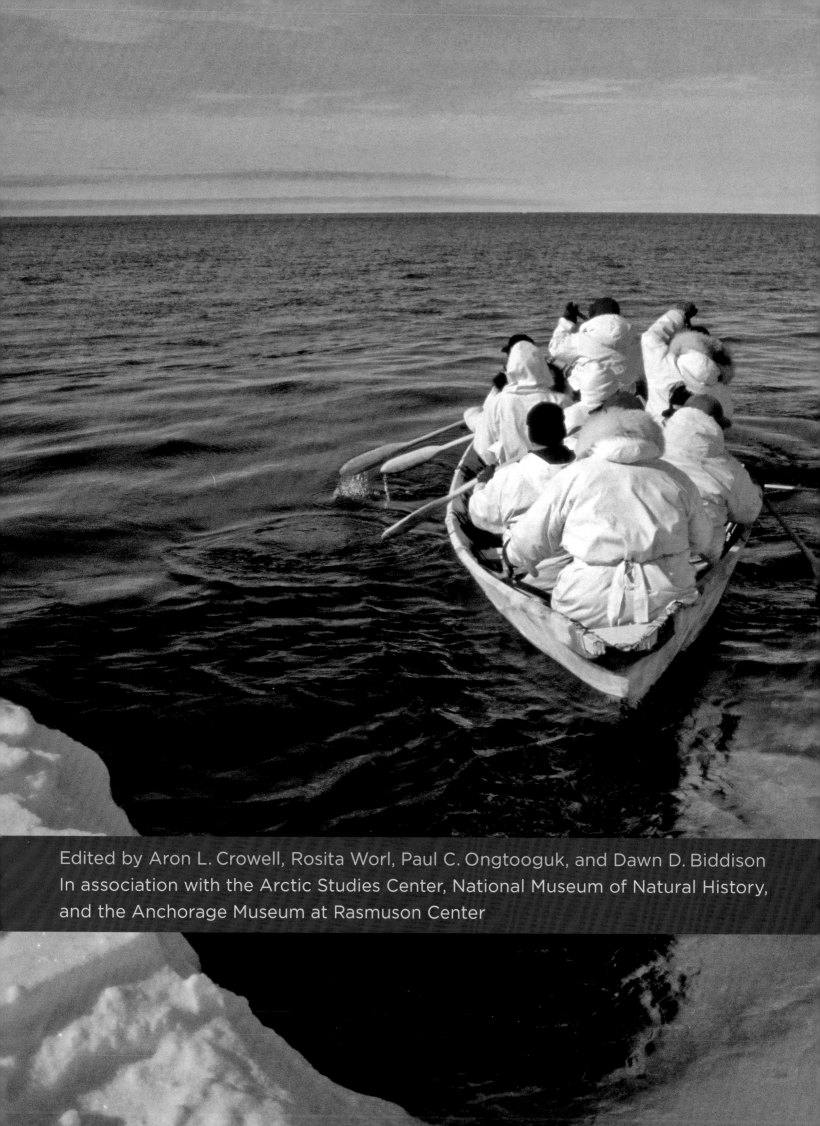

Edited by Aron L. Crowell, Rosita Worl, Paul C. Ongtooguk, and Dawn D. Biddison
In association with the Arctic Studies Center, National Museum of Natural History,
and the Anchorage Museum at Rasmuson Center

LIVING OUR CULTURES

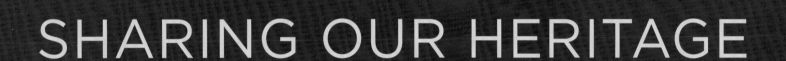

SHARING OUR HERITAGE

THE FIRST PEOPLES OF ALASKA

SMITHSONIAN BOOKS
WASHINGTON, DC

Living Our Cultures, Sharing Our Heritage: The First Peoples of Alaska is the companion volume to the exhibition of the same name opening at the Anchorage Museum at Rasmuson Center, May 2010.

This publication has been prepared by Smithsonian Books in association with the Arctic Studies Center, National Museum of Natural History, and the Anchorage Museum at Rasmuson Center.

For information please write:
Special Markets Department
Smithsonian Books
P.O. Box 37012, MRC 513
Washington, DC 20013

SMITHSONIAN BOOKS
Director: Carolyn Gleason
Executive Editor: Caroline Newman
Project Editor: Christina Wiginton
Design Consultant: Kate McConnell
Editorial Assistants: Kathryn Murphy and Michelle Lecuyer
Object Text: Aron L. Crowell
Linguisitic and Photo Research: Dawn D. Biddison
Smithsonian Object Photographers: Donald Hurlbert, Carl Hansen, Ernest Amoroso, and Walter Larrimore

Book Design: Service Station | Bill Anton
Editor: Robin Whitaker
Proofreader: Lise Sajewski

Printed in China through Oceanic Graphic Printing, Inc.

Library of Congress Cataloging-in-Publication Data
Living our cultures, sharing our heritage:the first peoples of Alaska/edited by Aron L. Crowell…[et al.].
 p. cm.
"In association with the Arctic Studies Center, National Museum of Natural History and the Anchorage Museum."
"Companion volume to the exhibition of the same name opening at the Anchorage Museum, May 2010"—T.p. verso.
Includes bibliographical references and index.
ISBN 978-1-58834-270-6 (hardcover)
1. Alaska Native art—Exhibitions. 2. Art and design—Alaska—Exhibitions. 3. Alaska Natives—Material culture—Exhibitions. 4. Alaska Natives—Social life and customs—Exhibitions. 5. Alaska Natives—Alaska—Intellectual life—Exhibitions. 6. Art and society—Alaska—Exhibitions. 7. Community life—Alaska—Exhibitions. I. Crowell, Aron L. II. Arctic Studies Center (National Museum of Natural History) III. Anchorage Museum at Rasmuson Center.

E78.A3L58 2010
979.8'01—dc22 2009048682

15 14 13 12 11 10 5 4 3 2 1

FRONT COVER:
Page numbers in brackets if image appears elsewhere in book.

TOP ROW, LEFT TO RIGHT
Haida lineage poles at Hydaburg Totem Park [p. 234]
Sugpiaq elder Senafont Zeedar, Sr. [p. 148]
Fishermen at Klawock [p. 202]
Tsimshian dancer in Killer Whale mask[p. 250]
Unangax̂ kayak, St. Paul Island [p. 123]
Sadie Neakok splitting a bearded seal hide, Barrow

SECOND ROW FROM TOP, LEFT TO RIGHT
Iñupiaq ceremonial pail [p. 51]
Iñupiaq bolas [p. 53]
Yup'ik snuff box [p. 113]
St. Lawrence Island Yupik doll [p. 88]
Athabascan mittens [p. 179]
Haida ladle [p. 246]

THIRD ROW FROM TOP, LEFT TO RIGHT
Iñupiaq woman's parka [p. 61]
Tlingit crest hat [p. 219]
Tsimshian headdress frontlet [p. 270]
Yup'ik mask [p. 120]
Unangax̂ hat [p. 127]
Sugpiaq child's boots [p. 163]

BOTTOM ROW, LEFT TO RIGHT
Tlingit weaver Teri Rofkar
Yupik walrus hunters, St. Lawrence Island [p.72]
The 4th Generation Tsimshian Dancers [p. 268]
George Attla training a dog team, Huslia
Mary Ann Arnaucuaq Sundown with basket [p. 10]
Flensing a whale, St. Lawrence Island [p. 21]

TITLE PAGE:
Iñupiaq whalers (the Little Kuupaq crew) launch from shorefast ice at Barrow

TABLE OF CONTENTS:
Interior of a Yup'ik kayak built by Phillip Moses of Toksook Bay

BACK COVER:
Cutting and tying the skin cover on a Yup'ik kayak

Elders, Advisers, and Contributors

Jacob Ahwinona
Martha Aiken
Ludmila Ainana
Anatolii Alekseev
Rebecca Amarok
Angela Arnold
Phillip Arrow
Paul Asicksik
Sylvester Ayek
Andrew Balluta
LaRue Barnes
Linda Belarde
George Bennett
James Bennett
Phillip Blanchett
Karla Booth
Mary N. Bourdukofsky
David Boxley
Jeane Breinig
Ron Brower Sr.
Jane Brower
Frances Charles
Malinda Chase
Vernon Chimegalrea
Delores Churchill
Joe Cook
April Laktonen Counceller
Lucille Antowock Davis
Martha Demientieff
Ruth Demmert
Daria Dirks
Moses Dirks
Barbara Donatelli
Crystal Dushkin
Anna Etageak
Oleg Ettylin
Nikolai Ettyne
Vladimir Etylin
Trimble Gilbert
Ed Gregorieff
Donald Gregory
Mary Haakanson
Sven Haakanson Jr.
Sven Haakanson Sr.
Christopher Hadden
Eleanor Hadden
Joan Hamilton
Jana Harcharek
Shirley Holmberg
Beverly Faye Hugo
Gennady Inenkuyas
George Inga Sr.
Art Ivanoff
Peter Jack Sr.
Clarence Jackson Sr.
Shirley Jimmerson
John F. C. Johnson
Eliza Jones
Mary Jones

Bernice Joseph
Tommy Joseph
Veronica Kaganak
Vera Kaneshiro
Anna Katzeek
David Katzeek
Shirley Kendall
Elaine Kingeekuk
Merlin Koonooka
Ignatius Kosbruk
Oscar Koutchak
Jordan Lachler
Angela Larson
Aaron Leggett
Beth Leonard
Enid Lincoln
Larry Matfay
Chuna McIntyre
Marie Meade
Vera Metcalf
Virginia Minock
Theresa Nanouk
Paul C. Ongtooguk
Estelle Oozevaseuk
Beauford "Charlie" Pardue
Florence Pestrikoff
Rena Peterson
Alice Petrivelli
Patricia Petrivelli
Ilidor Philemonof
John Phillip Sr.
Cass Pook
Gordon L. Pullar
George Ramos
Alice Aluskak Rearden
Karen Rifredi
Neva Rivers
Tony Roberts
Teri Rofkar
Jonathon Ross
Marie Saclamana
Olga Sam
Vlass Shabolin
Hishinlai' (Kathy) Sikorski
Doreen Simmonds
Karen Stickman
Donna May Sumner-Roberts
Clare Swan
Tasian Tein
Kenneth Toovak
Branson Tungiyan
Maria Turnpaugh
Fred White
Jonella Larson White
Judy Woods
Ricardo Worl
Rosita Worl
Miranda Wright
Edvard Zdor

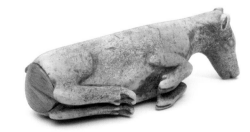

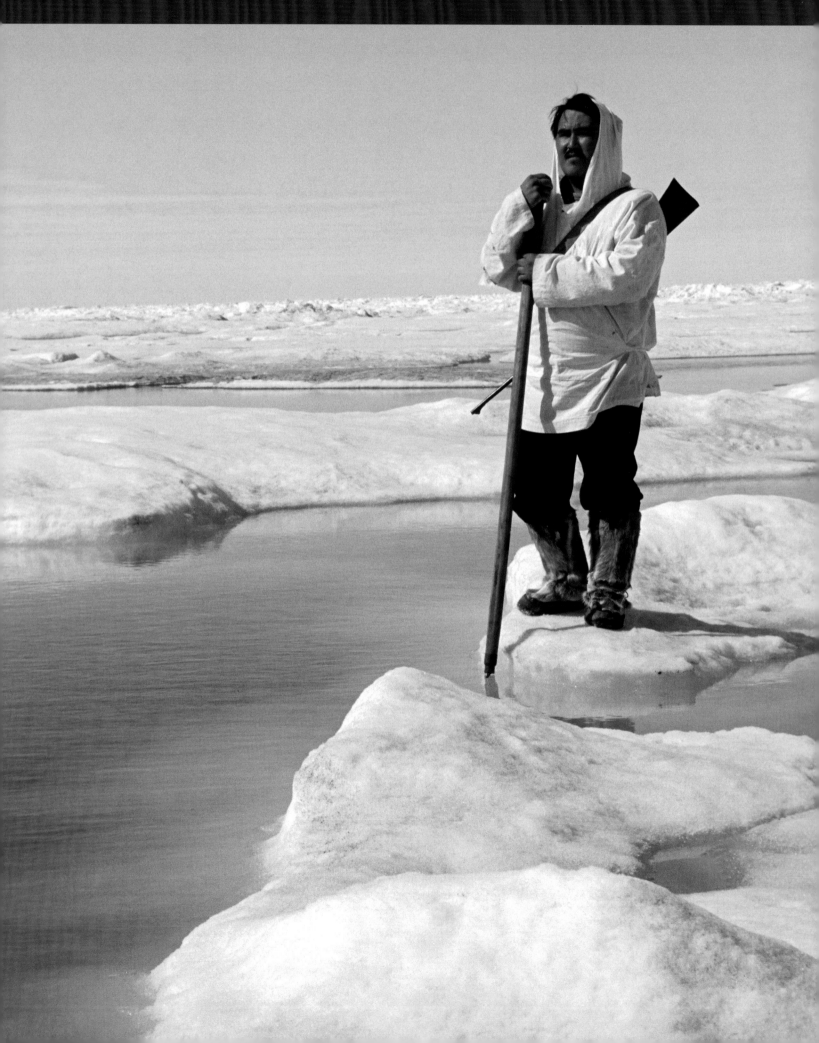

FOREWORD

Cristián Samper Director of the National Museum of Natural History

THE SMITHSONIAN INSTITUTION'S CONNECTION WITH ALASKA through research and collections dates back more than 150 years. The early scientific explorations in the 1850s–1880s focused largely on collecting traditional objects that were brought to museums like the National Museum of Natural History in Washington, D.C. More than a century later, these masterworks provide us with a window into the past, reflecting the cultures of the First Peoples and their close interdependence with this extraordinary land.

Our work in Alaska continues today, but the approach has changed significantly. Native elders and scholars from throughout Alaska come to Washington to use the collections made more than a century ago, learn about their ancestors, and share their oral histories. They also help us to interpret these objects and design exhibitions about the Arctic, to share their cultures and heritage with visitors from around the world. Smithsonian anthropologists are working with Native communities to document the impacts of climate change on the Arctic and the livelihoods of people. It has become a dynamic exchange of knowledge between scientists and Native communities, providing new insights into the past, present, and future of Alaska.

At a time when the Arctic region is undergoing rapid and profound changes, it is crucial to understand the diversity and complexity of Alaska. Our commitment to the study and under-standing of this region was reinforced and expanded with the establishment of the Arctic Studies Center (ASC) in 1988. Under the capable leadership of Dr. William Fitzhugh, the ASC explores cultures, history, and environments of the northern part of the globe and conducts research throughout the circumpolar region. In 1994 the ASC, in partnership with the Anchorage Museum, opened its Alaska regional program under the direction of Dr. Aron Crowell. This

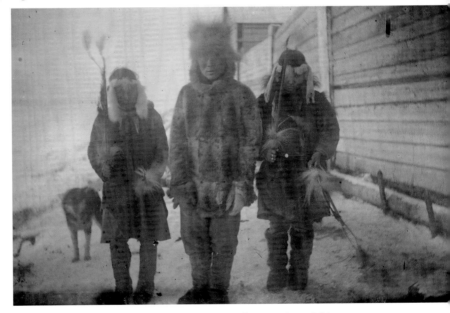

program has led to a new under-standing of the remarkable lives of the First Peoples from Alaska and their adaptations to this environment over many generations. It has also reinforced the importance of engag-ing Native scholars in our work.

This book and the exhibition Living Our Cultures, Sharing Our Heritage: The First Peoples of Alaska repre-sents this new approach and marks a new chapter in our history. The exhibition represents the first time the Smithsonian has entered into a long-term agreement to display a large collection outside of Washington. More than 600 masterworks from the National Museum of Natural History and the National Museum of the American Indian will be on display in the recently expanded Anchorage Museum, available to the people of Alaska. This beautiful book offers an overview of this remarkable collection and exhibition, thanks to the work of Aron Crowell and his collaborators. You will discover that every object tells a unique story and offers a glimpse into the lives of the First Peoples and their fascinating relationship with their environment.

ABOVE: Yup'ik dancers at the old lower Yukon River village of Andreafsky, photographed by Smithsonian naturalist and collector Edward W. Nelson in 1877. The two women wear ermine fur headdresses and carry dance wands made from eagle feathers.

OPPOSITE: Fred Brower hunting on the ice-covered Chukchi Sea near the Iñupiaq community of Barrow, 1992.

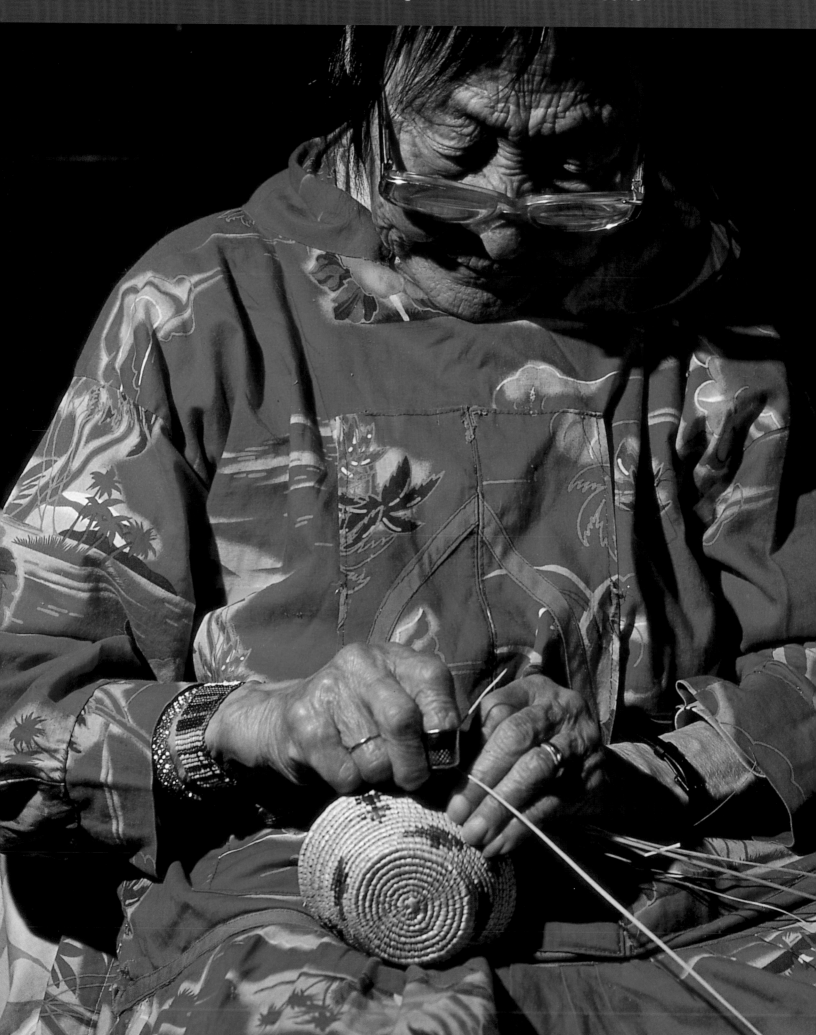

FOREWORD

James Pepper Henry Director of the Anchorage Museum at Rasmuson Center

IT HAS BEEN THE PRACTICE OF MANY MUSEUMS with indigenous material culture collections to display these items for their aesthetic or historical value, without thought or regard to their original contexts and the people who created them. Museums have been very successful in dismantling these cultural contexts, segregating the tangible from the intangible. From a Native perspective, the process of creating an object can be more important than the object itself; the true significance derives from such qualities as the traditions, songs, beliefs, and rituals that are associated with its manufacture and use.

Unprecedented in its scope, scale, and complexity, the exhibition Living Our Cultures, Sharing Our Heritage: The First Peoples of Alaska breaks many conventional museum barriers and establishes new methodologies for community collaboration to reestablish cultural contexts. The exhibition features nearly six hundred Alaska Native objects from the collections of the National Museum of Natural History (NMNH) and the National Museum of the American Indian (NMAI), all on exhibition in Anchorage until at least 2017. These cultural materials represent all of the major Native groups in Alaska, and many have never been witnessed by the descendants of their makers.

From concept to installation, Native community elders and representatives were intimately involved in the development and facilitation of the exhibition. Serving as co-curators, community members selected the objects from Smithsonian repositories for exhibition that best represent their heritages. They provided oral and written content from their unique perspectives. The actual display of objects evolves beyond a visual storage concept, allowing for direct access to the objects by Alaska Natives for special up-close and tactile viewing. The knowledge gained from this close interaction between object and person will be shared with the community and become a significant resource for future generations.

Living Our Cultures is the result of a long and creative partnership between the Anchorage Museum at Rasmuson Center and the Smithsonian Institution. In 1994, the Anchorage Museum joined with the Smithsonian's National Museum of Natural History to establish the Alaska office of the Arctic Studies Center. Since that time, the two organizations have worked together to develop and deliver a wide variety of exhibitions, research projects, and educational programs focusing on and involving Alaska's First Peoples. In 2007, the National Museum of the American Indian entered into a parallel cooperative agreement with Anchorage, and joined in loaning its materials for Living Our Cultures.

The Anchorage Museum and both Smithsonian museums are deeply committed to utilizing their resources—artifacts, archives, and photographs—to expand awareness and appreciation of Alaska's indigenous citizens and their cultures, languages, and history. A recent expansion of the Anchorage Museum, including 12,000 square feet dedicated to the Arctic Studies Center and the Living Our Cultures exhibition now offers an unprecedented opportunity to share these invaluable resources in a much more comprehensive and intimate way with the Alaska Native community, Alaska citizens, and visitors to the 49th State. This book, *Living Our Cultures, Sharing Our Heritage: The First Peoples of Alaska*, gives us a glimpse of the objects and photographs on display in the exhibition, enriched by Alaska Native authors whose essays describe the land they live on, the communities they build, and the ceremonies and traditions they celebrate.

Many generous donors have made all of this possible—foundations; Alaska Native corporations; local, state, and federal agencies; private corporations; and scores of individuals. The Anchorage Museum at Rasmuson Center thanks all who have supported the project and all who have contributed their knowledge and insight. We look forward to a long and mutually beneficial relationship with the Arctic Studies Center and with the First Peoples of Alaska.

Mary Ann Arnaucuaq Sundown of Scammon Bay is among the elders who are teaching their knowledge and skills to younger generations.

INTRODUCTION

Aron L. Crowell

MASTERWORKS OF ALASKA NATIVE ART AND DESIGN in the Smithsonian Institution's collections, many produced more than a century ago, still breathe the lives of their people. Despite the North's transformation through globalizing change, ancestral objects in the National Museum of Natural History and National Museum of the American Indian evoke contemporary meaning as well as history for the residents of indigenous communities. Alaska Native elders, artists, and scholars of several generations interpret these objects in the light of their own experience, cultural knowledge, and spiritual outlook. The story of the past is enriched by oral tradition and anthropological scholarship, including Smithsonian research in Alaska that began in the mid-nineteenth century.

The dialogue across time conveyed through these collections, along with new initiatives for community access to them and for collaborative exchanges of knowledge, is the foundation for Living Our Cultures, Sharing Our Heritage: The First Peoples of Alaska. The long-term exhibition at the Anchorage Museum represents the "coming home" of Smithsonian collections to their place of origin and to the diverse cultures in which they were created.

The traditional material culture represented by these objects was the product of an intensely observed universe. Fish nets inspired by the spider's web; snowshoes that imitated the broad feet of ptarmigan floating on soft powder; varied and intricate tools for hunting and fishing; artful skin boats, canoes, and sleds; tree roots and grass transformed into watertight basketry; clothing engineered from hide, furs, fish skin, feathers, sinew, and gut to provide comfort and protection in all extremes—these cultural products derived from intimate knowledge of the northern world and perpetual observation of its life and natural processes. Hundreds of generations of innovation refined Alaska Natives' equipment for survival in demanding boreal and Arctic regions.

In their creation, traditional forms were linked to natural ones by the principles of transposition and spiritual sympathy. Hunting boats replicated the streamlined bodies of sea mammals, supported by wood and sinew likenesses of their skeletons and covered with their skins. In traditional belief the boats themselves were living ocean creatures and received the same respectful offerings of food and water.[1] Images of the polar bear were carved on the socket ends of harpoons and hunting darts, and the sharp points inserted there were barbed like the animal's teeth; in both design and function the weapon conjured the predator.[2] Ptarmigan feet were fastened to snowshoes—their human-crafted counterparts—as charms for speed across the frozen land.[3] The tough skin of caribou legs was transformed into the boots of hunters who, with that animal's endurance, traveled challenging routes across tundra and mountain passes.[4]

LEFT: An Iñupiaq harpoon from Sledge Island in the Bering Sea, made for hunting walrus and large seals. The socket piece represents a polar bear, the ultimate predator on ocean ice (NMNH E045145).

LOWER RIGHT: A wolf is carved on the socket piece of a Yup'ik seal dart, which held the weapon's barbed tip. In myth, wolves become seal-hunting killer whales when they walk into the sea (NMNH E038442).

Traditional art reflects a universe in which all things have spirit. It expresses its creators' spiritual sympathy with other natural beings and a belief that animals comprehend human intention and are sensitive to rituals of respect, purification, and supplication. Natural beings—plants, wind, mountains, and celestial bodies as well as birds, fish, and mammals—are thought to have

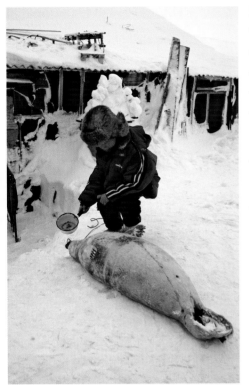

personhood and the capacity to appear in human form. Animals cooperate with humans, offering themselves rather than being subdued; they are eternal, perpetually reborn, and clothed in new flesh after death at the hand of the hunter. In oral tradition, animals live parallel lives in salmon, seal, and whale villages under the sea and in bird villages in the sky, reachable through ceremony and shamanism. Their lives are the gifts from which all human culture is created.[5]

These core beliefs—universal in outline but with variation in different Alaska Native traditions—were overlain in the nineteenth century by a Christian worldview introduced through Russian Orthodox, Catholic, and Protestant missions. Yet an indigenous spiritual consciousness rooted in the lived experience of ancestral generations remains strong. In this book the St. Lawrence Island whaling captain Merlin Koonooka writes, "They know we are there even if there is no sound. That is why we say that a whale decides to let itself be taken, not the other way around." In the chapter "Athabascan," Koyukon scholar Eliza Jones explains, "In Athabascan belief, everything around us has life. The land and trees have spirits, and we treat them with respect. If we need to cut a tamarack, which gives the best wood for making fish traps, it is Koyukon courtesy to explain our need to the tree and to leave an offering of a bead or ribbon behind." These are eloquent reminders that the objects of previous generations, now stored in museum collections, reflect spiritual dimensions that remain active and familiar.

In equal measure to their spiritual meaning, traditional objects conveyed social meaning. Items worn on the body—parkas, tunics, boots, hats, headdresses, bags, and jewelry—expressed identity through design. Their beaded, painted, stitched, and quilled patterns variously referred to age, gender, clan, and place of origin. Diverse items belonging to particular families or lineages were embellished with similar iconography that identified them with their owners. Circulation through social networks added to their significance; an object now exhibited in a museum might have been made for a child by a relative, exchanged between trading partners, distributed to guests at a Yup'ik or Iñupiaq Messenger Feast, or bestowed to clan opposites at a Haida, Tsimshian, or Tlingit memorial ceremony. Behind every object is a story about people and relationships.

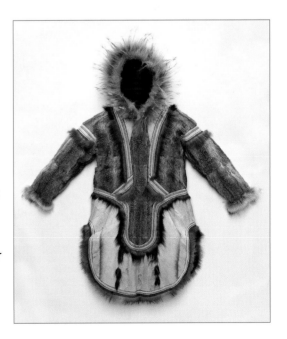

UPPER LEFT: Out of respect for the spirit of a seal, a Chukchi boy pours fresh water into its mouth. The offering is a tradition on both sides of Bering Strait. Photographed at Uelen, northeastern Siberia, 2002.

LOWER RIGHT: An Iñupiaq woman's parka made of Arctic ground squirrel, caribou or reindeer, wolf, wolverine, and mink. Details of a parka's design were particular to the individual artist, her family, and village (NMNH E176105).

From another perspective, heritage pieces symbolize the struggle for survival that all Native peoples have endured during two and a half centuries of interaction with the West. As Paul Ongtooguk and Rosita Worl describe, Western contact has been an assault on indigenous cultures, languages, and freedoms. Native peoples were devastated by smallpox and other introduced diseases to which they had no immunity and by the loss of land and other resources through commercial and governmental appropriation. Milestones in the hard-fought struggle for renewal included rights to citizenship and voting, legal protection against racial discrimination, recognition of tribal governments, access to local schools, and secure hunting and fishing rights. The Alaska Native Claims Settlement Act of 1971 recognized indigenous title to Alaskan lands and created Alaska Native regional and village corporations. In the contemporary evolution of this long struggle, the perpetuation and strengthening of Alaska Native languages, arts, and knowledge of ancestral cultures have come to be some of the highest priorities.

Most Alaska Native objects at the Smithsonian Institution and in other museums were purchased by scientific expeditions, museum collectors, and traders in the nineteenth and early twentieth centuries, a time of vulnerability and loss for many indigenous communities. In museums today, pieces that left the hands of individuals and families long ago are national exemplars of traditional craftsmanship and design, inspiring to all visitors but especially to the descendants of those who made them. They are "objects of bright pride," in Haida artist Bill Reid's phrase, signifying the complexity and achievements of traditional societies.[6] The desire for their return to their places of origin is strong. About his visit to the Northwest Coast hall at the American Museum of Natural History in New York, Tsimshian carver David Boxley said, "Our culture was there in that place, so far from home. That made me both really sad and excited at the same time. It inspired me to work, as an artist and organizer, for the restoration of Tsimshian heritage to my community."

Under the Native American Graves Protection and Repatriation Act (NAGPRA) and the National Museum of the American Indian Act (NMAIA), human remains taken from indigenous sites and cemeteries are being returned to their communities along with objects that were improperly acquired by collectors. As defined by the acts, these include sacred items, burial goods, and objects of cultural patrimony not sold legally according to traditional law. Repatriation is an ongoing process in which the Smithsonian has taken a proactive role, although most of the thirty thousand Alaskan objects in the collections of the National Museum of Natural History (NMNH) and the National Museum of the American Indian (NMAI) probably do not fall into repatriable categories and have not been requested for return by tribes.[7]

To make this priceless heritage more accessible in Alaska, the Smithsonian's Arctic Studies Center developed Living Our Cultures, Sharing Our Heritage in partnership with the Anchorage Museum and Alaska Native cultural organizations. Nearly six hundred objects will come on extended loan to the Anchorage Museum, where they will be exhibited and available to Native communities for close-up study. Exhibit case design will allow them to be removed from display for examination and handling in a dedicated consultation studio. Working with museum staff, visitors will make use of the collection for research, teaching, and inspiration. They will share their discoveries and expertise through Alaska Native Collections: Sharing Knowledge, a Web site developed by ASC–Alaska to offer community information, historical background, photography, and educational resources for the entire Anchorage loan.[8] Through these innovations, the Living Our Cultures project represents a new open-source extension for cultural learning from museum resources.

This catalog combines the perspectives and knowledge of many individuals. Between 2001 and 2009, almost fifty Alaska Native cultural advisers traveled to Washington, D.C., to view and discuss a wide range of objects in the Smithsonian collections. The consultations at NMNH and NMAI were integral to research, planning, and preparation for the Anchorage exhibition. The contributions of this distinguished group are heard throughout these pages, and transcripts of the Washington discussions can be accessed on the Alaska Native Collections Web site. In this book their commentaries, augmented by oral tradition and information from the archives of anthropology and history, provide cultural context for over two hundred objects from the Living Our Cultures, Sharing Our Heritage exhibition. Indigenous scholars, leaders, and educators, many who served as advisers during exhibit development, add their voices to the book in essays about Alaska Native cultures and communities today.

PEOPLES AND LANDSCAPES

Alaska is home to over one hundred thousand indigenous residents, about 15 percent of the state's present population. They live in almost three hundred villages, towns, and cities across the state and are heirs to twenty different Native languages and a highly diverse cultural heritage.

In part this cultural variety reflects the process of adapting to a vast and varied environment. Mainland Alaska extends 850 miles south from the Arctic Ocean to the Gulf of Alaska and 1,200 miles east to west across the arc of the southern coast. The Aleutian Island chain projects another 1,200 miles westward across the North Pacific, following the southern edge of the Bering Sea. Across Bering Strait from Alaska's Seward Peninsula is northeastern Siberia, and to the east lie Canada's Arctic and subarctic provinces, home to northern Athabascan and Inuit First Nations.

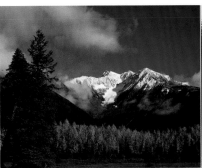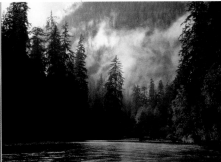

Alaska encompasses treeless tundra, boreal and coastal forests, large river systems, mountain ranges, glaciers, and some of the world's most biologically productive marine ecoregions. Great mountain belts divide its main geographic zones. The Brooks Range separates the Arctic coastal plain in the north from the immense forested basin of the Yukon River, which has its headwaters in Canada and flows west to the lake-dotted Yukon-Kuskokwim Delta, on the Bering Sea coast. South of the Yukon and Kuskokwim rivers is the towering Alaska Range, including Denali, North America's highest summit. Cook Inlet interrupts a third mountain belt, the spectacular chain of volcanoes and glacier-capped peaks of the Aleutian, Kenai, Chugach, St. Elias, and Coast ranges along the southern coast.

A panorama of Alaska's interior and coast. From left to right, a fall landscape with Crow Peak in the Chugach Mountains near Cook Inlet; spruce forest along the Wilson River in southeastern Alaska's Misty Fiords National Monument; dividing channels of the Yukon River near the town of Circle in the eastern interior

ARCTIC

CHUKCHI

CHUKCHI SEA

Barrow

Pevek

Mys Shmidta

Wainwright

Atqasuk

TESHEKPUK LAKE

Nuiqsut

Point Lay

IÑUPIAQ

COLVILLE RIVER

Vankarem

Amguema

Egvekinot

Kanchalan

Konergino

Neshkan

Enurmino

Point Hope

Kivalina

NOATAK RIVER

Uel'kal'

Anadyr

Inchoun

Uelen

Kotzebue

Kiana

KOBUK RIVER

Noatak

KOTZEBUE SOUND

Ambler

Shungnak

Kobuk

Alatna

Allakaket

Enmelen

BIG DIOMEDE ISLAND

Diomede

Shishmaref

Noorvik

Selawik

KOYUKUK RIVER

Hughes

CHUKCHI PENINSULA

Lorino

Lavrentiya

LITTLE DIOMEDE ISLAND

Wales

SELAWIK LAKE

Deering

Huslia

Nunligran

Yanrakynnot

Providenya

STRAIT

SEWARD PENINSULA

Candle

Buckland

KOYUKON

GULF of ANADYR

Sirenik

BERING

Brevig Mission

Teller

Koyuk

Koyukuk

Nulato

Galena

Ruby

Tanana

New Chaplino

KEREK

KING ISLAND

Council

White Mountain

Kaltag

Elim

Shaktoolik

ALASKA

SIBERIAN YUPIK

Gambell

SLEDGE ISLAND

Nome

Solomon

Golovin

Savoonga

ST. LAWRENCE ISLAND

NORTON SOUND

Unalakleet

YUKON

ST. LAWRENCE ISLAND YUPIK

St. Michael

Stebbins

HOLIKACHUK

Telida

Kotlik

Emmonak

Alakanuk

Grayling

Anvik

McGrath

Nikolai

ATHAB

BERING ISLAND

COMMANDER ISLANDS

Sheldon Point

Mountain Village

St. Marys

Shageluk

Holy Cross

UPPER KUSKOKWIM

MEDNY ISLAND

Scammon Bay

Pitkas Point

Pilot Station

Marshall

Russian Mission

Crooked Creek

Red Devil

Stony River

UNANGAX̂ (ALEUT)

Hooper Bay

Chevak

Kalskag

Chuathbaluk

Sleetmute

Lime Village

Newtok

Nunapitchuk

Lower Kalskag

Aniak

KUSKOKWIM RIVER

DEG HIT'AN

Mekoryuk

Tununak

NELSON ISLAND

Kasigluk

Akiachak

Tuluksak

DENA'INA

Toksook Bay

Nightmute

Atmautluak

Oscarville

Akiak

Bethel

Attu

NUNIVAK ISLAND

Chefornak

Napakiak

Kwethluk

Napaskiak

YUP'IK

NUSHAGAK RIVER

LAKE CLARK

Tuntutuliak

Eek

Nondalton

Iliamna

Pedro Bay

Kiphuk

Kongiganak

Kwigillingok

Koliganek

Newhalen

ILIAMNA LAKE

Kokhanok

Nanwal

Quinhagak

Ekwok

New Stuyahok

Igiugig

Goodnews Bay

Aleknagik

Levelock

Twin Hills

Togiak

Manokotak

Dillingham

Platinum

Clark's Point

Portage Creek

Naknek

Ekuk

South Naknek

SUGPIAC

BERING

Egegik

Port Lions

SEA

BRISTOL BAY

Pilot Point

Ugashik

Karluk

KODIAK ISLAND

Larsen Bay

Old Harbor

Port Heiden

Akhiok

Kaguyak

Nelson Lagoon

Chignik Lagoon

Chignik

Chignik Lake

Ivanof Bay

Perryville

UNANGAX̂ (ALEUT)

Cold Bay

Belkofski

Sand Point

ALEUTIAN ISLANDS

False Pass

King Cove

Squaw Harbor

Atka

Unalaska

Akutan

SHUMAGIN ISLANDS

Nikolski

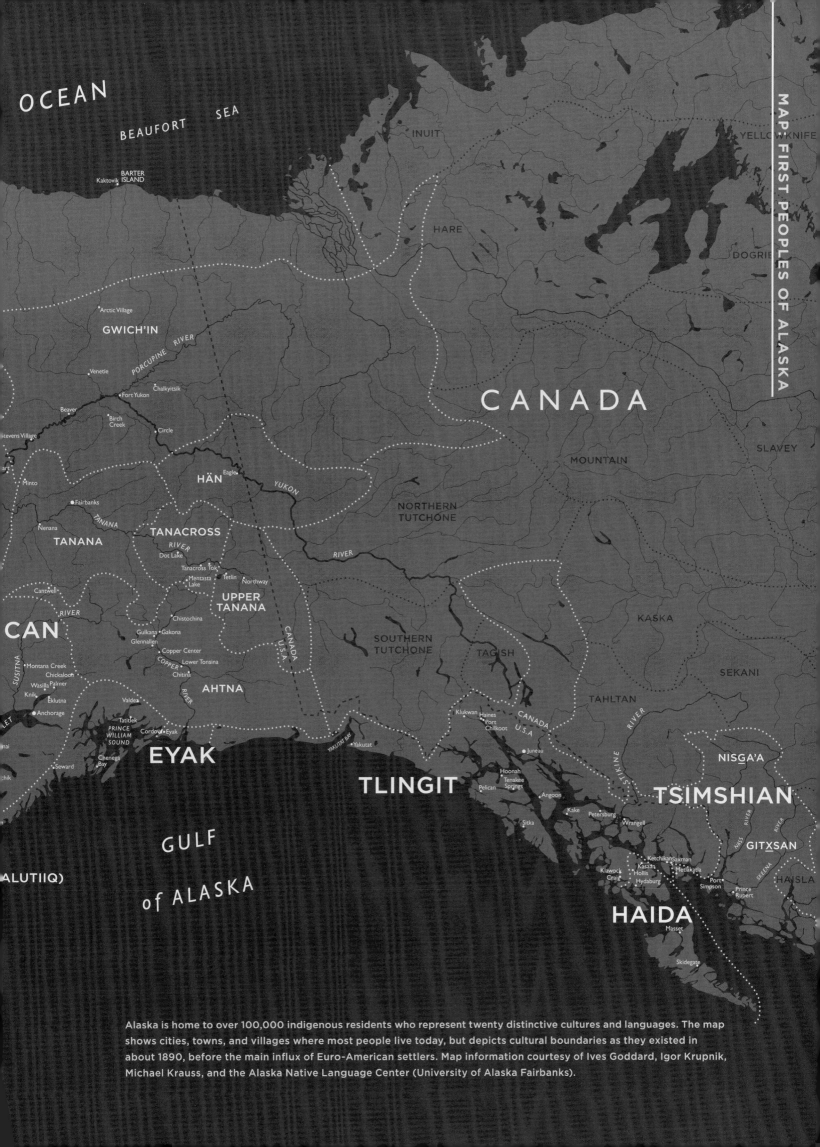

OCEAN

BEAUFORT SEA

INUIT

YELLOWKNIFE

Kaktovik
BARTER
ISLAND

DOGRIE

HARE

Arctic Village

GWICH'IN

CANADA

Venetie

PORCUPINE RIVER

Chalkyitsik

Fort Yukon

Beaver

Birch
Creek

Stevens Village

Circle

MOUNTAIN

SLAVEY

HÄN

Eagle

YUKON

NORTHERN
TUTCHONE

Minto

Fairbanks

TANANA

TANACROSS

RIVER

Dot Lake

Nenana

TANANA

Tanacross Tok

KASKA

Mentasta Tetlin
Lake Northway

Cantwell

UPPER
TANANA

RIVER

Chistochina

CAN

Gulkana Gakona
Glennallen

Copper Center

COPPER

Lower Tonsina

Chitina

SOUTHERN
TUTCHONE

TAGISH

SEKANI

Montana Creek

Chickaloon

SUSITNA

Wasilla Palmer

AHTNA

TAHLTAN

Knik

Eklutna

RIVER

Valdez

Anchorage

Tatitlek

PRINCE
WILLIAM
SOUND

Cordova Eyak

Klukwan Haines
Port
Chilkoot

CANADA
U.S.A

STIKINE RIVER

NISGA'A

Seward

Chenega
Bay

EYAK

YAKUTAT BAY Yakutat

Juneau

TSIMSHIAN

Hoonah
Tenakee
Springs

TLINGIT

Pelican

NASS RIVER

GITXSAN

Angoon

ALUTIIQ)

GULF

Kake

Petersburg

Wrangell

SKEENA RIVER

HAISLA

Sitka

of ALASKA

Ketchikan Saxman
Kasaan
Klawock Hollis Metlakatla
Craig Hydaburg

Port
Simpson

Prince
Rupert

HAIDA

Masset

Skidegate

Alaska is home to over 100,000 indigenous residents who represent twenty distinctive cultures and languages. The map shows cities, towns, and villages where most people live today, but depicts cultural boundaries as they existed in about 1890, before the main influx of Euro-American settlers. Map information courtesy of Ives Goddard, Igor Krupnik, Michael Krauss, and the Alaska Native Language Center (University of Alaska Fairbanks).

These regions hold stark contrasts in climate and light. People living north of the Arctic Circle experience many weeks of ongoing daylight in summer and continuous darkness in winter, along with extreme storms and cold weather in the latter season. The subarctic interior is dry with intense cold in winter and high heat in summer. The southern coastal regions have mild temperatures year-round with nearly constant precipitation, especially in the southeast.

The diverse peoples of Alaska represent three large cultural families, each associated with a different part of its geography. The territories of the Alaskan Inuit peoples are located along the northern, western, and southern coasts, extending well inland in some areas.[9] The Alaskan Inuit are the Iñupiat in northern Alaska; the Yupiget of St. Lawrence Island; the Yupiit of southwestern Alaska; and the Sugpiat, or Alutiit, of the Gulf of Alaska region.[10] The Unangax̂ of the Aleutian Islands—called Aleuts by Russian fur traders who arrived in the eighteenth century—are closely affiliated with the Inuit through culture and history, and linguists place all the languages of this family in a single "Eskimo-Aleut" group.[11] Inuit and Unangax̂ peoples harvest resources from the sea, land, and rivers to sustain their communities with marine mammals, fish, birds, and wild plants. Caribou and other inland game are available to some communities. In the past, coastal and interior villages traded extensively with one another to obtain resources unavailable in their home areas.

The Athabascans of Alaska are part of the larger Northern Athabascan family that extends into western Canada. They constitute eleven cultural groups, each speaking a different language—the Koyukon, the Gwich'in, the Hän, the Holikachuk, the Deg Hit'an, the Upper Kuskokwim, the Tanana, the Tanacross, the Upper Tanana, the Dena'ina, and the Ahtna.[12] Their lifeways were historically based on mobile hunting, trapping, and fishing in the boreal forests of the continental interior, although the Dena'ina around Cook Inlet adopted aspects of coastal Inuit life, including kayaks and sea mammal hunting. The Eyak at the mouth of the Copper River are also culturally linked to the Athabascans, although they, like the Dena'ina, are not an interior but a coastal people. Linguists include them with the Athabascans in the Na-Dene language group.[13]

The Tlingit, Haida, and Tsimshian of southeast Alaska constitute the third family of Alaskan cultures. They are the northernmost peoples of the Northwest Coast culture area, which extends south through British Columbia to Oregon. Northwest Coast languages are highly diverse. While linguists categorize Tlingit with Eyak and Athabascan as Na-Dene, they consider both Haida and Tsimshian to be unique with no present-day relatives.[14] Living on islands and along shores backed by coastal mountains and thick rain forests, indigenous residents of southeast Alaska depend on maritime resources. In the past they traded extensively with adjacent Athabascan groups for caribou skins, copper, berries, and other interior products.

Traditional material cultures and historical descriptions of ceremony and daily life illustrate extensive interaction and cross-influences among Alaskan Inuit, Athabascan, and Northwest Coast peoples. Yup'ik hunting ceremonies and regalia may have spread up the Yukon River to the Deg Hit'an, their Athabascan trading partners.[15] The Gwich'in, Koyukon, and other Yukon Basin peoples adopted dog sledding, snow goggles, and parkas from Iñupiaq neighbors, who in turn learned the Athabascan art of snowshoe making.[16] Sugpiaq spruce-root basketry, carved bowls, horn spoons, and other objects reflect artistic influence from the neighboring Tlingit, who in turn adopted Sugpiaq sea otter arrows, slate tools, and other Alaskan Inuit technologies.[17] The Northwest Coast and Athabascan peoples also have analogous clan systems, which provided a structure for cross-cultural trade and social interaction.

ORIGINS OF THE FIRST PEOPLES

In oral tradition, Raven is the creator of the universe. Through his energetic and sometimes mischievous acts, the world is shaped: men and women are born, animals come into being, and the sun and moon are liberated from hidden places to enlighten human life.[18] This tradition is widespread, extending across northeast Siberia, all of Alaska, western Canada, and as far south as Oregon. In addition to telling about the beginning of the world, Raven stories are also evidence of an ancient connection between the peoples of northeast Asia and North America, suggesting migration between the two continents.

Like Raven, Thunderbird is a universal figure in Alaskan tradition and may have come from Siberia with the ancestors of Alaska's First Peoples. She is a giant eagle that nests on mountaintops and in volcanoes; her voice is the thunder, and the blinking of her eyes is the lightning; the box drum imitates the booming sound of her heart. Thunderbird preys on whales and sometimes people but is also the mythic founder and crest of southeast Alaskan lineages and, as the Eagle Mother, taught Iñupiaq men and women how to perform the Messenger Feast.[19]

Confirming the suggestions of oral tradition, archaeology has documented a series of geographically overlapping migrations from Siberia that appear to correlate with the modern distribution of cultures and languages in Alaska and elsewhere in North America.[20] More than fifteen thousand years ago, a Siberian vanguard crossed to North America at Bering Strait, at that time a wide land bridge connecting the two continents.[21] Called Paleo-Indians by archaeologists, these pioneers were ancestral to the well-known Clovis culture of North America. Paleo-Indian projectile points and other stone tools were typically bifacial, a trait that assists scientists in tracking their dispersal and development on both American continents. In Alaska, Paleo-Indian sites have been found along the Nenana and Tanana rivers, in the Brooks Range, and elsewhere in the interior, with the oldest dates so far approaching twelve thousand years.[22] On the southern Alaskan coast and in British Columbia, known sites are as old as ten thousand years. These maritime Paleo-Indians may have been ancestral to the Haida, Tsimshian, and other contemporary peoples of the Northwest Coast culture.[23] Other Paleo-Indian groups diversified into the hundreds of indigenous cultural-linguistic groups present on both American continents.

"Paleo-Arctic" peoples, of the second wave of migration, came from Siberia about twelve thousand years ago bearing a different stone tool technology. Their signature artifacts were tiny microblades struck from stone cores and set in rows to make sharp edges on bone weapons. They eventually settled in mainland Alaska, the eastern Aleutian Islands, Kodiak Island, the Yukon Territory, and British Columbia as far south as Vancouver Island. With the exception of coastal portions later taken over by the Alaskan Inuit,

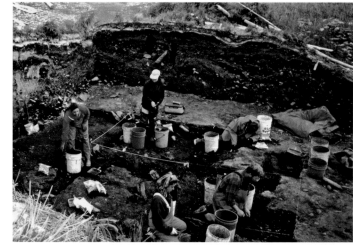

UPPER LEFT: An ivory harpoon rest from the village of Wales on Bering Strait depicts *tiŋmiaqpat* (thunderbirds) catching whales (NMNH E048169).

LOWER RIGHT: Archaeologists at the Malina Creek village site on Afognak Island in southern Alaskan. Layers of shell and bone—the remains of meals consumed by the inhabitants—are visible. The 5,000-year-old site contains microblade tools.

this territory coincides with areas occupied by contemporary Na-Dene speakers, so it is likely that the Athabascans, Eyak, and Tlingit are Paleo-Arctic descendants.[24] Na-Dene peoples expanded again between seven hundred and eight hundred years ago, creating distant branches along the California coast and in the American Southwest. Athabascan oral traditions suggest that this second migration included refugees who were fleeing a catastrophic eruption of the White River volcano near the Alaska-Canada border, radiocarbon-dated to about A.D. 720.[25]

A third period of migration and interaction across Bering Strait began about forty-five hundred years ago, when people possessing a new and varied technology known as "Arctic Small Tool" arrived in northwest Alaska, rapidly spreading across Canada to Greenland to occupy previously uninhabited areas of the high Arctic. The series of cultures—called Choris, Norton, Ipiutak, Old Bering Sea, Okvik, and Birnirk—that then emerged on both sides of Bering Strait were ancestral to modern Alaskan Inuit peoples of the region, with southern counterparts developing in the Unangax̂ and Sugpiaq areas.[26] Their languages were early forms of Eskimo-Aleut, and they developed material cultures and artistic styles that carried forward into historic times.

Finally, about one thousand years ago, Inuit living around Bering Strait, referred to as the Thule or Punuk, began hunting bowhead and gray whales. In addition to this new economic base, they adopted Siberian armor and the sinew-backed bow, a powerful new implement of war. Expanding across Arctic Canada, the Thule displaced descendants of the earlier Arctic Small Tool migration, and in Alaska they took over Yup'ik-speaking areas to occupy the region that is now Iñupiaq.[27] Yup'ik speakers pushed south into the Sugpiaq region, and the Dena'ina moved from their interior homeland to the coasts of Cook Inlet. All across Alaska an era of competition and militancy arose, recalled in Yup'ik oral tradition as the "bow and arrow wars" and called "the first war in the world" in one Tlingit story.[28] Archaeological evidence for warfare in this period includes fortified settlements built across southern Alaska on high rocks and islands for defense against attacks.[29]

More than twelve thousand years of history have been enacted on Alaska's huge stage. Archaeology, linguistics, and oral tradition help in understanding how ancestral peoples met the challenges of their environment and succeeded in developing societies, knowledge systems, and technologies that were inspired by and finely attuned to living in a far northern world.

CULTURAL THEMES

Three main themes organize the chapters that follow. The sections titled "Sea, Land, Rivers" center on the complex relationship of culture and environment. The discussion in "Community and Family" sections takes in the social diversity of Native communities, family life, cultural identity, and the meaning of place. Under "Ceremony and Celebration" the focus turns to communal spiritual expressions, including ceremonies in supplication of abundance, festivals of social connection, and memorials for the dead.

Sea, Land, Rivers

Today, as in the past, Alaska Natives harvest wild foods to sustain themselves and their communities. Surveys indicate that across rural Alaska subsistence use of fish, sea mammals, caribou, birds, shellfish, and plants averages about 375 pounds per person per year. In some places consumption is twice that high.[30] As authors of this catalog describe, the seasonal rhythms

of contemporary hunting, fishing, and gathering follow old patterns now modified by commitments to jobs and school and by access to modern equipment such as firearms, radios, and store-bought nets. Engine-powered boats and snow machines increase the range and distance that a hunter can travel in a given day. The costs of equipment, ammunition, and fuel mean that family networks usually consist of people fully dedicated to subsistence as well as wage earners who fund their efforts.

The cultural and social dimensions of subsistence are no less important today than historically. Speaking of his home at Unalakleet, on Norton Sound, Iñupiaq elder Oscar Koutchak said,

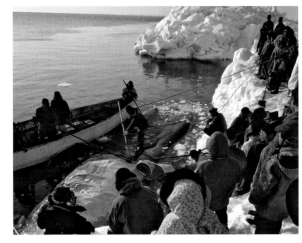

"We're living a subsistence way of life; it's been that way ever since day one."[31] Long-held traditions celebrate the fundamental connections among place, family, and community. As described by Paul Asicksik Jr. (in "First Seal Hunt"), sharing is a pervasive ethic, and the fruits of the harvest go first to elders, kin, and people in need. Subsistence forges bonds between generations, as illustrated by Jeane Breinig's memories of Kasaan (in "Haida").

Differences in lifeways arise naturally from the contrasts between inland and coast. As Eliza Jones describes for the Alaska interior (see the chapter "Athabascan"), the pursuit of caribou, moose, mountain sheep, waterfowl, fish, and small game traditionally required a mobile, small-scale way of life. Birch-bark canoes and baskets, sleds and toboggans, snowshoes, the bow and arrow, fish traps, and game snares were essential tools for a people who moved from camp to camp throughout the year. Settlement on the lower Yukon and Kuskokwim rivers contrasts with this pattern. There, resources from the rich surrounding delta and great harvests of migrating salmon that ascend the rivers each summer supported numerous permanent villages in the past, as they do today (see Alice Aluskak Rearden, "Yup'ik").

Along the sea coasts, especially where upwelling currents enrich the food chain, concentrated resources support larger and more settled populations. In winter, pack ice extends from the Arctic Ocean to the southern Bering Sea; in summer it retreats north of Bering Strait. Bearded seals, ringed seals, walrus, and polar bears are found on or near the ice throughout the year, and in spring beluga and bowhead whales follow its receding edge north. Coastal Iñupiaq, St. Lawrence Island Yupik, and western Yup'ik communities are located where the movements of these animals bring them close to shore. *Paapi* Merlin Koonooka (in "St. Lawrence Island Yupik") and Beverly Faye Hugo (in "Iñupiaq") talk about the seasons of subsistence in two such communities, Gambell and Barrow, respectively, both anciently established at prime hunting locations. Their descriptions animate a world of beauty, which is honored and sustainably used. The equipment of their ancestors—skin boats, fur and waterproof gut clothing, hunting hats, snow goggles, ice cleats, hunting charms, harpoons and darts, ice scratchers for attracting seals, seal nets, bolas, and bird nets—provide a window on traditional knowledge and subsistence practices. Current changes in ice extent and distribution due to global warming are direct threats to this way of life.

OPPOSITE: An Old Bering Sea harpoon head carved from walrus ivory, about 1,500 years old. Smithsonian archaeologist Henry B. Collins collected the artifact on Little Diomede Island in Bering Strait in 1929 (NMNH A347940).

ABOVE: St. Lawrence Island Yupik whalers flense blubber from a 65-foot bowhead whale taken by John Apangalook's crew at Gambell, 1970s. Whales are hunted from ten coastal Iñupiaq and Yupik communities.

South of winter ice, the Aleutian Islands, Gulf of Alaska, and southeast Alaska provide an even richer and more diverse mix of marine resources. Alice Petrivelli (in "Unangax̂"), Gordon L. Pullar (in "Sugpiaq"), Rosita Worl (in "Tlingit"), David Boxley (in "Tsimshian"), and Jeane Breinig (in "Haida") each describe seasonal patterns in their regions. As Pullar notes, "If you spend any time at all in a Sugpiaq village you will be aware that someone is always out getting something to eat." Fur and harbor seals, sea lions, sea otters, fin and humpback whales (species no longer hunted), many kinds of sea birds, abundant salmon, halibut, herring, and eulachon are all found in southern Alaska. Productive intertidal zones, not scoured by ice in winter, offer edible seaweeds, clams, chitons, octopi, and other "beach foods." When Western contact began, villages south of the ice were generally larger, and the number of persons per square kilometer along the coast was five to thirty times higher than in the Chukchi and northern Bering seas.[32] The complex social arrangements of the south—ranked lineages, distinct social classes, powerful and wealthy leaders—may have arisen from this combination of plentiful resources and dense settlement.

Traditional subsistence equipment in this region overlapped with that of the North but also possessed distinct characteristics. Toggle-headed harpoons, designed to stay embedded beneath a sea mammal's skin even when the wound is scrubbed against ice, were not needed in the open waters of the south. Instead most weapons there were fitted with barbed points. Sugpiaq and Unangax̂ whalers hunted in kayaks and killed with poisoned darts, whereas northern whalers hunted from large umiaks with toggling harpoons. Watercraft were more varied in the south and included both Inuit-tradition skin boats and Northwest Coast wooden canoes. Also unique to southern waters were halibut hooks and harpoon-arrows used for hunting sea otters.

Everywhere, the spiritual aspects of hunting, fishing, and gathering were expressed in traditional ritual and art. Hunting hats, boats, weapons, and charms—such as the ivory whale figures carried even today by some Iñupiaq captains—influenced the animals to give themselves over to human hunters. In some areas it is a continuing practice each spring to make new clothes, equipment, and boat covers to show respect to the animals. Yupik elder Estelle Oozevaseuk, of St. Lawrence Island, talked about how whales see skin-covered hunting boats from below: "Some of them have very light shadows, and look clean. Some of them are very dark, with black all the way down to the bottom of the sea, their shadows showing." The whales rise up to the clean boats whose crews have properly prepared for the hunt. The bodies of seals, whales, polar bears, and other animals taken by hunters are welcomed to the village as guests, and as Beverly Faye Hugo explains, Barrow's meat cellars are still cleaned and lined with fresh snow to make an attractive place for a whale's body to rest. Hospitality also includes the symbolic offer of food or fresh water. Yup'ik elder Neva Rivers of Hooper Bay explained that an animal "tells its relatives that our water tastes good—it tells its relatives to come to us."[33] On St. Lawrence Island, polar bears killed by hunters were traditionally welcomed, "fed," and given tobacco or beads, almost like human guests.

Family and Community

The late Sugpiaq elder Martha Demientieff said, "We know the place we belong by where our family is buried, by where we were born."[34] Generations spanning hundreds if not thousands of years have lived and passed in the oldest Alaska Native settlements, giving rise to a profound connection between identity and place.

Native-language names describe the natural, cultural, and historical landscapes in which communities are embedded. Names for places near the Iñupiaq village of Kaktovik include Sirraq (meaning "place where polar bears come to cover themselves with snow to have their cubs"), Uqpiuruuraq (place of willows), Nullaaġavik (place to camp), and Igluġruatchiat (place of sod houses).[35] Chookaneidi and T'akdeintaan clans fled from frigid winds and surging ice that filled Glacier Bay in the eighteenth century, taking shelter at Xuniyaa (meaning "lee of the north wind"); the name of the village connects Tlingit history to dramatic environmental change during the Little Ice Age.[36] Aaron Leggett describes historical Dena'ina place-names that preserve the legacy of his people amid the urban sprawl of Alaska's largest city (in "Dena'ina Anchorage").

In large part, the social basis of Alaska Native communities is kinship. Descent and marriage create bonds of cooperation and obligation that are woven into daily and ceremonial life. Among Athabascan and southeast Alaskan peoples descent is matrilineal, and the same was probably true of the Unangax̂ and Sugpiaq before Western contact. That is, children belong to the same clan and clan group as their mothers. The Tlingit and Haida have two clan groups: the Eagles and the Ravens. The Koyukon, Dena'ina, and other Athabascans have three such groups, variously named, and the Tsimshian have four: the Eagles, the Ravens, the Wolves, and the Killer Whales.

Members of these social divisions marry outside their own groups and assist their "opposites," or in-laws, in many ways, especially when a death or some other crisis occurs. Each side honors the other in ritual and ceremony, reinforcing the attachments of community. In her chapter "Tlingit," Rosita Worl emphasizes, "One of our strongest values is that social and spiritual balance must be maintained between Eagle and Raven clans to ensure the well-being of society."

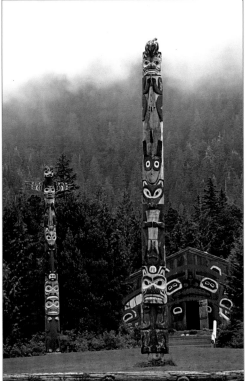

In the past, Northwest Coast families of up to fifty people lived together in large plank-walled houses, each headed by a senior member of the lineage. Crest images symbolizing the group adorned the house and its lineage pole, interior screens, and posts. Sugpiaq and Unangax̂ households were also lineage based, but their dwellings were large sod-covered domes and longhouses. In these southern Alaskan societies certain clans possessed high status and wealth, although the majority of people had no claim to nobility. Slaves—captured in war or purchased—were the lowest members of society and were not recognized as members of any clan.[37]

On St. Lawrence Island, patrilineal clans play an important role in marriage, residence, and the organization of whaling crews, but in the Yup'ik and Iñupiaq traditions descent is equal through both parents. Kin connections are numerous and flexible, and cooperation extends through bilateral families rather than between clans.

UPPER RIGHT: Laverne Edenshaw and her son, Michael, at Sukkwan Strait near Hydaburg. Clan membership is passed from mother to child in matrilineal Haida society.

LOWER LEFT: Tlingit crest poles stand in front of a lineage house at Saxman Totem Park near Ketchikan, 2001.

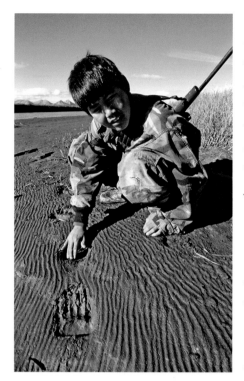

In traditional Alaskan societies, boys trained to hunt, fish, handle boats, and craft a wide range of material culture, including tools, containers, and boats. Girls learned to sew, prepare skins, weave, care for children, fish, snare game, and gather plants. Childhood toys reflected adult roles, such as a girl's dolls, which in Sugpiaq and Yup'ik society were spiritually charged symbols of her future motherhood. Children grew up immersed in the languages and stories of their people, absorbing the knowledge, customs, and graces of social life that would serve them as adults.

Yup'ik elder John Phillip Sr. described how children learned by being involved in the activities of adults, listening and observing, then trying it themselves. He said, "In our tradition there is a saying. If a person is able to do things, let him start."[38] He regretted the closing of traditional Yup'ik men's houses, where boys were taught this way, and the replacement of this institution by Western schools and teaching methods. Beverly Faye Hugo, Alice Rearden, Eliza Jones, Merlin Koonooka, Rosita Worl, and other authors in this book relate their experiences of learning from parents and elders and of teaching their own children in turn.

Shamans, midwives, artists, warriors, and whalers possessed personal talents or underwent special training for their roles in traditional societies. Shamans were spiritual and medicinal specialists who sought to heal the sick, foretell the future, discern distant events, and mediate the community's relations with the spirit world, often dramatizing their abilities through performances of magic.[39] Shamans' art—the decorative aspect of their amulets, rattles, head-dresses, masks—depicts birds, land otters, and other spirit beings said to assist them in their practice.[40] Some of these objects are considered to be sacred or to retain spiritual power and have been included in the exhibition by permission of the Sealaska Heritage Institute's Council of Traditional Scholars.

The external relationships of traditional Alaska Native communities included widespread trade, and the objects illustrated in this catalog give a sense of the busy interchange between the Asian and North American continents, up and down the region's river systems, and between its interior and its coasts. Koryak and Chukchi herders traded reindeer hides across Bering Strait and to St. Lawrence Island, along with tobacco, pipes, beads, iron, and armor from Russian and Chinese sources. Iñupiaq men gathered at Hotham Inlet, on Kotzebue Sound, to exchange caribou and other interior furs for sea mammal oil and skins.[41] Tlingit and Tsimshian traders acquired cedar canoes, abalone shells, snail opercula, and dentalium shells from the Haida and more southerly Northwest Coast peoples. Hundreds of varieties of food, clothing, hides, pigments, and precious materials were circulated before Western contact and new goods from Russia, Britain, and the United States were incorporated into existing trade networks.

War, like trade, was an avenue to wealth and political success. Attacks on enemy settlements avenged transgressions against persons and territory, settled debts of honor, and seized valu-ables, including weapons and crest objects. Often nearly all the residents were killed; the few taken captive were brought home as slaves.[42] The culture and equipment of traditional warfare, such as bows, spears, daggers, helmets, and armor, are discussed in subsequent chapters.

On his first moose hunt with the men of his family, Jerrald John discovers bear tracks along the Chandalar River north of the Gwich'in Athabascan community of Arctic Village, 1998.

Ceremony and Celebration

The traditional ceremonies of Alaska Native cultures were highly diverse, varying within and among regions and over time. As expressions of non-Christian beliefs—and of the power and wealth of Native leaders and clans who hosted the ceremonies—they were considered a threat by Russian and American missionaries and civil authorities. Although systematically suppressed, some survived or reemerged in modern form to regain their place as essential expressions of culture and identity.

Yup'ik, Sugpiaq, Unangax̂, St. Lawrence Island Yupik, and Iñupiaq communities held hunting ceremonies from late fall through early spring to honor the animal spirits, ask for their cooperation, and ritually assist in their regeneration.[43] In the Yup'ik Bladder Festival, or Nakaciuryaraq, celebrants placed the bladders of seals killed by hunters back in the sea through a hole in the ice. Return of these organs, which in traditional Yup'ik belief contain the animals' souls, ensured that the seals would reappear in spring clothed in new bodies.[44] Several communities along the coast of the Yukon-Kuskokwim Delta still conduct the festival.[45] Kelek, a major ceremony also known as Agayuliyaraq or the Inviting-In Feast, took place later in the winter. Songs and masked

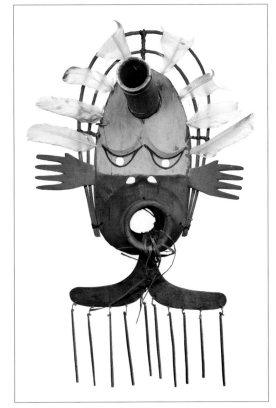

dances, composed and directed by shamans, were performed in the qasgiq (men's ceremonial house) to honor and supplicate the animal spirits and sky deities for their aid in future hunts.[46] Elder Paul John views this old ceremony as a kind of prayer: "Our ancestors used masks, calling it Agayuliyaraq ('way of making prayer'), as resolutions to petition God for the things they needed."[47]

Unangax̂ and Sugpiaq communities held similar winter hunting ceremonies until the late nineteenth century, and traces of these festivals survive in the "masking" now associated with Russian Orthodox Christmas and New Year's Day.[48] Iñupiaq villages celebrated winter hunting festivals with masks and dancing until about 1910, when the last of the ceremonial houses (qargich) was closed down under missionary pressure.[49] At Point Hope, carved figures of whales, seals, polar bears, caribou, walrus, and birds were hung in the qargich and symbolically fed.[50] Although the old Iñupiaq winter festivals have been suspended for a century, the summer whaling celebrations called Nalukataq still thrives, as Beverly Hugo describes.

Diverse hunting ceremonies on St. Lawrence Island once included Kamegtaaq, in which a whale figure was swung over an oil lamp and caught by the participants to reenact the hunt.[51]

The Messenger Feast represents a second important category of Inuit ceremony. It is a late winter or spring dance and gift-giving festival, originally widespread among Iñupiaq villages of northwest Alaska and the Yup'ik communities of Norton Sound, Nunivak Island, and the Yukon-Kuskokwim Delta.[52] The Messenger Feast is called Kivgiq in Iñupiaq and Kevgiq in Yup'ik. The ceremony was historically conducted in several Deg Hit'an and Koyukon villages along the lower Yukon River.[53] Once suppressed, the event has been revived in some communities.

A Yup'ik mask representing Tomanik, the Wind Maker. Winter winds blow from the white tube and summer winds from the black tube; goggles on the eyes represent spiritual transformation (NMAI 093429.000).

Traditionally before a Messenger Feast, leaders of the host village sent two men as messengers to invite another community and to make specific requests for what the guests should bring, including furs, food, weapons, kayaks, and other valuables. The messengers returned home with similar requests from the invitees.[54] Both communities worked for months to acquire the goods they needed to make a good showing at the feast. At the five-day event they performed a gift exchange accompanied by oratory, songs, and dances. Parts of the Messenger Feast reflected historical patterns of warfare and competition, such as athletic contests, teasing, and the mocking "songs of indigestion" that Yup'ik hosts sang to their guests as they ate.[55] The dramatic Wolf Dance was performed in some Iñupiaq communities as part of Kivgiq.

A third major Alaska Native ceremony is the memorial feast, or potlatch, an ancient and continuing institution of Athabascan and Northwest Coast cultures.[56] At least one year after a person's death, clan relatives and descendants host a potlatch to thank and repay the guests, members of opposite clans, who assisted around the time of the funeral. These in-laws sat with the deceased, prepared the grave, provided food, and shared in grief. Through speeches, songs, and dances, the hosts honor those in attendance, the individual who has passed, and ancestors.

During a Tlingit, Haida, or Tsimshian potlatch, the hosts display crest objects and the regalia of the clan to publicly validate their ownership of these symbols. The hats, helmets, chests, bowls, knives, blankets, drums, and other objects bear the clan's crest emblems. When a chief or other

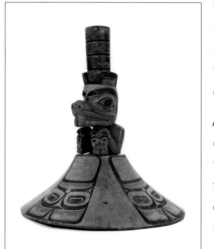

titled individual has died, the ceremony also marks the ascension of his heir. Large memorial potlatches of the past often dedicated a new lineage house built in the successor's honor and repaid clan opposites who provided labor for that task. Hosting a memorial potlatch socially elevated the clan, and wealthy leaders gave as many as they could in a lifetime.

All of these purposes of the potlatch are part of an overall concept of honoring the dead and carrying on the traditions that they established. Athabascan potlatch traditions, described by Eliza Jones, have many social and spiritual similarities to the Northwest Coast traditions. The most important are held in memory of the dead, but contemporary celebration potlatches also mark such events as Christmas, marriage, recovery from illness, or an individual's return to the community after a long absence.[57]

AIMING FUTURE'S ARROW

Gwich'in elder Trimble Gilbert, summing up a week spent in Washington, D.C., with other Athabascan elders to document the Smithsonian collections, said, "We can shoot this arrow up in the air. I wonder, how far will it go? That's the future. That's what we were here for: future generations need to know our cultures." All who joined together to create Living Our Cultures, Sharing Our Heritage share this commitment to celebrating, teaching, and carrying forward the cultures and languages of Alaska Native peoples. As Jeane Breinig ends her chapter, "What does it mean to be Haida? The answer now is different from that of the past, obviously. We need to know our history and learn from it; we need to know our culture and draw strength from it. We need to make it work for us today." We are very pleased to offer this book as an expression of the rich heritage of Alaska's First Peoples.

On this wooden Haida crest hat (see p. 244) an ancestral beaver holds two eagles in its paws; cylinders on top signify that the hat's owner had hosted four memorial feasts (NMNH E089036).

1. Curtis, *The North American Indian*, 152; Fienup-Riordan, *Yuung-naqpiallerput*, 87, 110; Rainey, *The Whale Hunters of Tigara*, 257. At Point Hope, whaling boats were given fresh water to drink, the same offering provided to whales and other sea mammals. Yup'ik kayaks were "fed" with *akutaq*, seal oil or caribou fat mixed with various ingredients, often berries, fish, and greens.
2. Arutiunov, "The Eskimo Harpoon"; Crowell, "Sea Mammals in Art, Ceremony, and Belief."
3. Osgood, *Ingalik Material Culture*, 349.
4. Oakes and Riewe, *Our Boots*, 62–63; Oakes and Riewe, *Alaska Eskimo Footwear*, 32–33, 47–48, 56–57, 94–96.
5. Crowell, Steffian, and Pullar, eds., *Looking Both Ways*; De Laguna, "Under Mount Saint Elias"; Fienup-Riordan, *Boundaries and Passages*; Fienup-Riordan, *The Living Tradition of Yup'ik Masks*; Fienup-Riordan, *Agayuliyararput*; Nelson, *The Athabaskans*; Nelson, *The Eskimo about Bering Strait*; Osgood, *Ingalik Mental Culture*; Rainey, *The Whale Hunters of Tigara*; Spencer, "The North Alaskan Eskimo."
6. Reid, "Out of the Silence," 71.
7. Information about Smithsonian repatriation for the National Museum of Natural History is at http://anthropology.si.edu/repatriation; for the National Museum of the American Indian, please see http://www.nmai.si.edu/subpage.cfm?subpage=collaboration&second=repatriation.
8. See Alaska Native Collections: Sharing Knowledge, Smithsonian Institution, at http://alaska.si.edu.
9. "Inuit" is used here as the preferred general name. "Eskimo," common in popular English, was probably derived from an eastern Canadian Algonquian word in the sixteenth century. It has been almost entirely replaced by "Inuit" in Canada. See Damas, introduction to *Arctic*, 5–7.
10. The spelling "Yup'ik" is used for the language and culture of the people of the southwestern Alaskan mainland; "Yupik" pertains to the people and language of St. Lawrence Island and northeastern Siberia.
11. Woodbury, "Eskimo and Aleut Languages."
12. Krauss and Golla, "Northern Athapaskan Languages."
13. Thompson and Kinkade, "Languages."
14. Goddard, comp., "Native Languages and Language Families of North America."
15. Osgood, *Ingalik Social Culture*; Snow, "Ingalik."
16. De Laguna and McClellan, "Ahtna," 649; Hadleigh West, "The Netsi Kutchin," 231, 242; McKennan, *The Upper Tanana Indians*, 91; McKennan, *The Chandalar Kutchin*, 42; Nelson, *Hunters of the Northern Forest* 170–71, 314; Osgood, *Contributions to the Ethnography of the Kutchin*, 64.
17. Holm, "Art and Culture Change at the Tlingit-Eskimo Border."
18. Boas, "Tsimshian Mythology," 567–881; Bogoras, *Chukchee Mythology*, 151–58; Golder, "Tales from Kodiak Island," part 1; Jochelson, "The Koryak"; McKennan, *The Upper Tanana*, 189–95; Nelson, *The Eskimo about Bering Strait*, 452–67; Swanton, *Tlingit Myths and Texts*, 3–21, 80–154.
19. Black, *Glory Remembered*, 36–41; Bogoras, "The Chukchee," 328; Curtis, *The North American Indian*, 168–77; Fienup-Riordan, *Boundaries and Passages*, 85, 124–25; Golder, "Tales from Kodiak Island," 90–95; Holmberg, *Holmberg's Ethnographic Sketches*, 31; Ivanov, "Aleut Hunting Headgear and Its Ornamentation," 501–2; Jacobsen, *Alaskan Voyage*, 110; Jochelson, *The Koryak*, 661; Kingston, "Returning"; McKennan, *The Chandalar Kutchin*, 74; Nelson, *The Eskimo about Bering Strait*, 445–46, 486–87; Oquilluk, *People of Kauwerak*, 149–66; Veniaminov, *Notes on the Islands of the Unalashka District*, 411–12.
20. Dumond, *Late Prehistoric Development of Alaska's Native People*; Greenburg, "The Linguistic Evidence"; Greenberg, Turner, and Zegura, "The Settlement of the Americas"; Hadleigh West, ed., *American Beginnings*.
21. Barton et al., eds., *The Settlement of the American Continents*; Dillehay, *The Settlement of the Americas*; Stanford, "Introduction to Paleo-Indian."
22. Dixon, "Paleo-Indian,"; Hoffecker, Powers, and Bigelow, "Dry Creek"; Hoffecker, "Late Pleistocene and Early Holocene Sites in the Nenana River Valley"; Holmes, "Broken Mammoth"; Kunz, Beaver, and Adkins, *The Mesa Site: Paleoindians above the Arctic Circle*.
23. Carlson, "Cultural Antecedents"; Matson and Coupland, *The Prehistory of the Northwest Coast*, 49–96.
24. Carlson, "Cultural Antecedents"; Dixon, "Paleo-Indian"; Greenberg, Turner, and Zegura, "The Settlement of the Americas"; Hadleigh West, ed., *American Beginnings*; Holmes, VanderHoek, and Dilley, "Swan Point"; Matson and Coupland, *The Prehistory of the Northwest Coast*, 49–96. Remains of a man who lived about 9,150 years ago were found at On Your Knees Cave, on Prince of Wales Island, in present-day Tlingit territory, associated with microblades and other Paleo-Arctic tools (Dixon, "Paleo-Indian," 144). Carbon isotopes from the bones indicate a diet of almost entirely marine foods. DNA extracted from the teeth match modern indigenous populations in California, Ecuador, and Peru, suggesting that Paleo-Arctic descendants traveled south along a coastal migration route (Kemp et al., "Genetic Analysis of Early Holocene Skeletal Remains from Alaska.")
25. Moodie, Catchpole, and Abel, "Northern Athapaskan Oral Traditions and the White River Volcano."
26. Ackerman, "Prehistory of the Asian Eskimo Zone"; Collins, *Archaeology of St. Lawrence Island, Alaska*; Dumond, *The Eskimos and Aleuts*; Dumond and Bland, "Holocene Prehistory of the Northernmost North Pacific"; Larsen and Rainey, *Ipiutak and the Arctic Whaling Culture*.
27. Woodbury, "Eskimo and Aleut Languages."
28. Fienup-Riordan, "Yup'ik Warfare"; Swanton, *Tlingit Myths and Texts*, 72–78.
29. Moss and Erlandson, "Forts, Refuge Rocks, and Defensive Sites."
30. Wolfe and Utermohle, *Wild Food Consumption Rate Estimates for Rural Alaska Populations*."
31. Project consultation, Alaska Native Collections: Sharing Knowledge, 2001.
32. Kroeber, *Cultural and Natural Areas of Native North America*, table 7; Oswalt, *Eskimos and Explorers*, 311–14.
33. Neva Rivers, project consultation, Alaska Native Collections: Sharing Knowledge, 2002. See also Brower, *Fifty Years below Zero*, 16; Rainey, *The Whale Hunters of Tigara*, 267; Spencer, "The North Alaskan Eskimo," 272; Stefánsson, *The Stefánsson-Anderson Arctic Expedition of the American Museum*, 389; Van Valin, *Eskimoland Speaks*, 199.
34. Martha Demientieff, interview at 1997 elders' conference in Kodiak for organizing the exhibition Looking Both Ways: Heritage and Identity of the Alutiiq People.
35. Pedersen, Coffing, and Thompson, *Subsistence Land Use and Place Names Maps for Kaktovik, Alaska*.
36. Hoonah Indian Association, *Tlingit Placenames of the Xunaa Káawu*.
37. De Laguna, "Under Mount Saint Elias," 461–75; Emmons, *The Tlingit Indians*, 37–42.
38. John Phillip Sr., project consultation, Alaska Native Collections: Sharing Knowledge, 2002.
39. See, for example: De Laguna, "Under Mount Saint Elias," 670–725; Fienup-Riordan, *Boundaries and Passages*, 203–10; Hughes, *An Eskimo Village in the Modern World*, 89–92; McKennan, *The Upper Tanana Indians*, 149–58; McKennan, *The Chandalar Kutchin*, 78–83; Osgood, *Contributions to the Ethnography of the Kutchin*, 156–59; Rainey, *The Whale Hunters of Tigara*, 274–79; Silook, *Seevookuk*, 7–10; Spencer, "The North Alaskan Eskimo," 299–331; and Veniaminov, *Notes on the Islands of the Unalashka District*, 219–20, 365–69.
40. Jonaitis, *Art of the Northern Tlingit*.
41. Rainey, *The Whale Hunters of Tigara*, 240.
42. Burch, "War and Trade"; De Laguna, "Under Mount Saint Elias," 580–85; Fienup-Riordan, "Yup'ik Warfare"; Nelson, *The Eskimo about Bering Strait*, 327–30; Venianminov, *Notes on the Islands of the Unalashka District*, 203–10.
43. Lantis, *Alaskan Eskimo Ceremonialism*.
44. Fienup-Riordan, *Boundaries and Passages*, 266–98; Himmelheber, *Eskimo Artists*, 15–16; Jacobsen, *Alaskan Voyage*, 149–50.
45. Fienup-Riordan, *Agayuliyararput*, 15–19.
46. Fienup-Riordan, *Boundaries and Passages*, 304–23; Fienup-Riordan, *The Living Tradition of Yup'ik Masks*, 40–41; Michael, ed., *Lieutenant Zagoskin's Travels* 228; Morrow, "It Is Time for Drumming," 136–39; Nelson, *The Eskimo about Bering Strait*, 358–59.
47. Fienup-Riordan, *Ciuliamta Akliut*, 275.
48. Crowell, Steffian, and Pullar, eds., *Looking Both Ways*, 188–221; Desson, "Masked Rituals of the Kodiak Archipelago"; Koniag, Inc., Alutiiq Museum, and the Château-Musée, *Giinaquq*; Lantis, "Aleut"; Merck, *Siberia and Northwestern America*, 69–71; Sarychev, *Account of a Voyage of Discovery*, 61–63.
49. Spencer, "The North Alaskan Eskimo," 348.
50. Rainey, *The Whale Hunters of Tigara*.
51. Krupnik, Walunga, and Metcalf, eds., *Akuzilleput Igaqullghet*, 319–21; Hughes, "Eskimo Ceremonies," 84–86; Rookok, "Memories of My Girlhood," 143–45.
52. Curtis, *The North American Indian*, 67–73; Fienup-Riordan, *Boundaries and Passages*, 324–47; Lantis, "The Social Culture of the Nunivak Eskimo," 188–92; Lantis, *Alaskan Eskimo Ceremonialism*, 67–72; Morrow, "It Is Time for Drumming," 131–35; Nelson, *The Eskimo about Bering Strait*, 361–63; Ostermann and Holtved, eds., *The Alaskan Eskimos*, 267–75; Bodfish, *Kusiq*, 23–24; Curtis, *The North American Indian*, 146–47, 168–77, 213–14; Ellanna, "How the Wolf Dance First Came to King Island"; Giddings, *Kobuk River People*, 52–60; Kingston, "Returning"; Koranda, "Some Traditional Songs of the Alaskan Eskimos," 18–19; Lantis, *Alaskan Eskimo Ceremonialism*, 67–73; Oquilluk, *People of Kauwerak*, 149–66; Ostermann and Holtved, eds., *The Alaskan Eskimos*, 103–12; Ray, "Ethnographic Sketch of the Natives," 41–42; Spencer, "The North Alaskan Eskimo," 210–28; Van Valin, *Eskimoland Speaks*, 53–56.
53. Carlo, *Nulato*, 56–59; Clark, "Koyukuk River Culture," 237–47; Madison and Yarber, *Madeline Solomon*, 49–52; VanStone, *E. W. Nelson's Notes*, 17–18.
54. Fienup-Riordan, *Boundaries and Passages*, 332–33; Lantis, "The Social Culture of the Nunivak Eskimo," 191.
55. Fienup-Riordan, *Boundaries and Passages*, 325–26, Fienup-Riordan, *The Living Tradition of Yup'ik Masks*, 99; Fienup-Riordan, *Ciuliamta Akliut*, 353–57.
56. De Laguna, "Under Mount Saint Elias," 606–51; Emmons, *The Tlingit Indians*, 303–24.
57. Clark, "Koyukuk River Culture," 43–45; De Laguna and McClellan, *Ahtna*, 659–60; Huntington, *Shadows on the Koyukuk*, 73–74; McKennan, *The Upper Tanana Indians*, 134–39; Osgood, *Contributions to the Ethnography of the Kutchin*, 125–39; Schmitter, *Upper Yukon Native Customs and Folk-Lore*, 15–16; Simeone, *Rifles, Blankets, and Beads*.

NATIVE PERSPECTIVES ON

Paul C. Ongtooguk and Claudia S. Dybdahl

NATIVE PEOPLES HAVE ALWAYS BEEN AN INTEGRAL PART of the American imagination, and there is a profound national curiosity about the thousands of years of indigenous civilizations that preceded the formation of this country. Museums display the art and artifacts of Alaska Native and Native American peoples, and writers, artists, and film makers reimagine the past. These snapshots of history can be fascinating but also distorted and antiquarian, failing to capture the complex dynamics of cultural progression. The way we live our lives today as "modern" Natives, whose dress and diet and education no longer match the lifeways of the eighteenth and nineteenth centuries, can be profoundly confusing to some, both outside and even within our communities. If we have changed so much, then who are we now? And we may ask ourselves, what choices and challenges confronted our forebears? How have contemporary Native lives and identities been shaped by what came before?

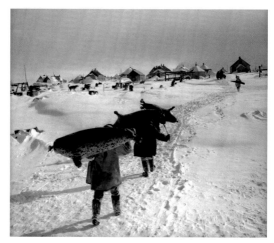

The concluding words of Thomas Berger's *Village Journey: Report of the Alaska Native Review Commission* capture the sense of a story that is still unfolding, as well as the importance of understanding it: "Here in these villages the encounter that began in 1492 continues. The encounter will not end in Alaska, but the choices that Americans confront there may, in the long sweep of history, provide a unique opportunity to do justice to the Native peoples. It is an opportunity they must not reject."[1]

STRANGERS IN TALL SHIPS

The hundreds of centuries that Alaska's First Peoples inhabited the land before the arrival of Europeans—more than 99 percent of its history—were filled with change. Generation after generation created new knowledge and responded to transforming natural and social worlds. Climate and animal migration patterns shifted, new technologies arose and spread, religious and spiritual concepts flowered, and wars and alliances emerged from intertribal relations.

An antithetical image of Native cultures as fixed and frozen in time came out of the Euro-American literature of contact, written during the late eighteenth to the early twentieth century. Traders, missionaries, whalers, and government officials most often viewed the peoples they encountered as primitive, basing their own sense of superiority on narrow but important technological and scientific innovations that had provided the means to dominate the planet. These strangers to Alaska's shores were filled with the confidence of conquest and saw its peoples as stuck in the past, lingering at the dawn of history.

John A. Marquis expressed this sentiment in his introduction to the autobiography of missionary S. Hall Young: "The fifty years Hall Young spent in Alaska witnessed the transition of an aboriginal race from savagery to civilization, from primitive tribal confusion and anarchy to orderly government, and most of all from a dense and cruel paganism to the Christian faith and the Christian view of life."[2] Almost entirely missing from this view was an understanding of the complex social,

St. Lawrence Island Yupik hunters return home to Gambell carrying sealskin floats, part of their equipment for hunting at sea, about 1958.

philosophical, and economic systems that Alaska Native peoples had developed. Many early accounts demonstrated a kind of cultural blindness to this complexity, perhaps in part because they were written on the basis of brief encounters, generally limited to coastal areas. The misperceptions and stereotypes that arose were recorded and perpetuated, remaining influential even to the present day.

Alaska Native experiences of contact were dramatically varied. The Unangax̂ of the Aleutian Islands first encountered Russian sea otter traders in the 1740s and were rapidly swept up in a tsunami of disease, destruction, and warfare, out of which perhaps 10 percent survived. The

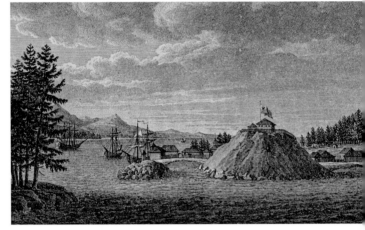

Sugpiaq experience a few decades later was similar. In contrast, Native peoples in the Alaskan interior passed through an extended period during which knowledge about Europeans was largely secondhand. The Russian fur trade did not extend very far inland, and not until 1847, when Britain's Hudson's Bay Company founded Fort Yukon, near the Alaska-Canada border, did many Gwich'in or Koyukon ever interact directly with Westerners. For Iñupiaq communities on the north Alaskan coast, intensive contact began when American commercial whaling fleets started plying the Arctic Ocean in the 1850s.

For some Alaska Native peoples the first real encounter with the West took the form of lethal new diseases that swept through their communities even beyond the leading edge of contact. As one example, smallpox raged across the Northwest Coast in the early 1770s with no European witnesses; Nathaniel Portlock and other British traders who came in the next decade, as well as the French and Spanish, saw only abandoned settlements and scarred survivors.[3] European populations had been winnowed by plagues and infections for thousands of years, and the surviving generations had built up significant resistance, but in Alaska a terrifying host of new diseases all hit virgin territory within a century. They included smallpox, the deadliest of all, as well as

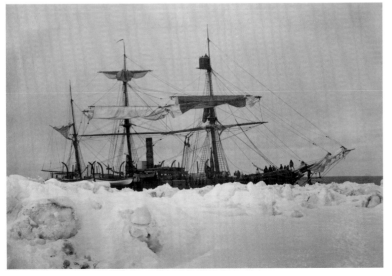

diphtheria, scarlet fever, malaria, measles, influenza, whooping cough, typhoid fever, typhus, pneumonia, and tuberculosis.[4] Today's estimates are that from one-half to three-fourths of Alaska Natives fell to these diseases. The loss of life had enormous consequences, bringing fundamental alterations to indigenous cultures, societies, and beliefs.

UPPER RIGHT: The newly founded Russian-American Company capital at Novo-Arkhangel'sk (Sitka) in 1805. The first Russian fort at Sitka was burned by the Tlingit in 1802.

LEFT: The American whaling ship *Alexander* at Cape Prince of Wales in 1903. Commercial whaling vessels began hunting in the Bering Sea in 1848 and in Arctic waters beginning in the 1850s.

The European development of "tall ships"—wooden-hulled sailing vessels often equipped with a complement of muzzle-loading cannons—is one key to understanding this transitional period of Alaska Native history. As a result of advances in boat building, navigation, and mapping, tall ships were able to traverse the oceans. Desire on the part of European nations to establish trade routes to Asia spurred development of the shipping industry and brought financing for transoceanic voyages. Alaska was one piece of the "new world" encountered via tall ship exploration, and it was targeted for trade, resource exploitation, colonial settlement, and political control.

For Alaska Natives the newcomers were strange and foreign indeed. Natives found it remarkable to encounter people who spoke no known languages, not even those of neighboring tribes or those heard along the ancient trade routes. The aliens possessed fabulous tools, resources, and skills—metals in abundance, powerful firearms, medicines that protected them from disease. At the same time they lacked the most basic knowledge of northern survival. When it came to predicting the weather or the timing of "freeze-up" in the fall, making warm and waterproof clothing, finding and subsisting on fish and animals, or harvesting plants for food and medicine, they were hopelessly ignorant. Worst of all, their use of resources was devastatingly nonsustainable, resulting in the mass slaughter of sea otters, fur seals, whales, walrus, and salmon, all of whom Native peoples had relied upon for millennia.

Faced with these new realities, Alaska Native peoples at various times cooperated, resisted, or withdrew from contact with the Euro-Americans. Ultimately, wherever the tall ships prevailed, Alaska Natives were forced to reexamine and change their cultural practices to reflect the new circumstances of Western influence.

The Russian period in Alaska (1740s–1867) illustrates these forces at work. Russian merchant companies, in search of valuable furs, came armed with weapons and seagoing capabilities that allowed them to conquer the Aleutian Islands, the Kodiak archipelago, and the southern mainland coast by the 1780s. The new regime was brutal in overcoming resistance, asserting control, and maximizing profits. Its practices in the early years included forced labor, kidnapping, torture, and murder. Russian dominance was far less complete in southeast Alaska, in part because the Tlingit and Haida residents of that region had armed themselves with muskets and even cannons acquired from rival British and American trading vessels.[5] The Tlingit burned early Russian outposts in Yakutat and Sitka, resisted Russian control, and eventually settled into a standoff that allowed mutual trade. Overall, Russian settlement in America was a prosperous enterprise that lasted for over a century. The actual number of Russians in Alaska, which never exceeded more than about one thousand, is therefore striking, underlining the military and commercial advantages of ship-based colonialism.

MANIILAQ: PREPARING FOR CHANGE

The written record of contact is valuable but one-sided, biased by Western ideologies, agendas, and misunderstandings. Alaska Native oral tradition, even if now fragmented and incomplete, is an important alternative source.

Stories about Maniilaq, an Iñupiaq man born in the Kobuk River basin of northwest Alaska in the early 1800s, have persisted for over two hundred years. Elders shared knowledge about his life at a 1978 conference and in a subsequent book.[6] Maniilaq is widely viewed as an important historical figure. Whether one believes that his visionary power came from God and that he was a prophet in the biblical sense or that he was simply a person with remarkable insight and

ability, he was, without question. a powerful leader and a keen interpreter of the tumultuous times that were precipitated by contact between Alaska Native and European societies.

Maniilaq was a trader who traveled long-established routes from northwestern Iñupiaq country to Unalakleet and other Yup'ik villages in Norton Sound. He would have known about the newly established Russian forts at Golovin and St. Michael and the spread of Russian-American Company goods and influence. Returning home from a trip to Unalakleet in the mid-1830s, he found that villages in his region had been devastated by the great smallpox epidemic then burning across the state. The healing powers of shamans were proving to be useless against the

new diseases, shaking Native spiritual beliefs to the core. He would have heard about the struggles of other Alaska Native peoples and been aware that the Russian Orthodox Church was offering an alternative spiritual path and attempting to relieve their suffering, even helping to provide the lifesaving smallpox vaccine to Native communities.[7]

Maniilaq understood that the world of northwest Alaska Native peoples was about to change radically, and he tried to prepare them for what was to come. He is said to have predicted that huge boats with white tops, larger than anything the Native peoples had ever seen, would ascend the Kobuk River and that other "boats" would one day fly through the sky. He challenged the shamans, saying that their powers would be overturned and that people would someday communicate over great distances without their assistance. He said that people should accept Christian beliefs, warning that the social order of Native societies would be different but that the traditional values of sharing and balance could and should be preserved. People listened, remembered, and accepted his words.

Maniilaq was an extraordinary person whose story illustrates how Alaska Native peoples met the challenges of contact by taking active roles in defining and controlling their futures. As William Hensley says in the introduction to his memoir, "It amazes me: most of the books written about Alaska have been by people aiming to glorify their personal brush with Alaska's magnetism. Most knew nothing about Alaska Natives, even after spending a lifetime among us as teachers, missionaries, or bureaucrats. Many saw only the surface of our lives and never understood our inner world."[8]

ALASKA NATIVES FIGHT FOR LAND AND CIVIL RIGHTS

The 1867 Treaty of Cession, which effected Alaska's transfer to the United States from Russia, contains language that reveals the social and racial hierarchy prevailing at the time. It refers to Russian and American citizens but also to "Creoles, or mixed breeds," "civilized or conquered native peoples," and "uncivilized native peoples."[9] As an occupying power, the United States tended first to the interests of industry, from the fur trade (taken over by the Alaska Commercial Company and other American firms) to mining, whaling, and commercial salmon canning.

Iñupiaq artist James Kivetoruk Moses's painting depicts Seward Peninsula Iñupiat dancing to celebrate the U.S. victory in World War II. The dancers are husband and wife, dressed in hand-sewn fur parkas and boots, and the man wears a loon-skin headdress. The drums are covered with dried walrus stomach.

It imposed systems of governance and law that did little to recognize the rights and needs of the new Alaska Territory's indigenous residents. Native peoples were not granted U.S. citizenship or voting rights, and although tribal land ownership was officially recognized by the 1884 Organic Act, the related rights were often ignored.

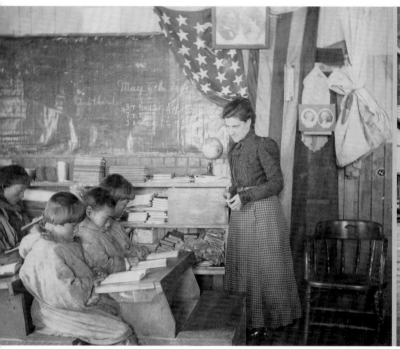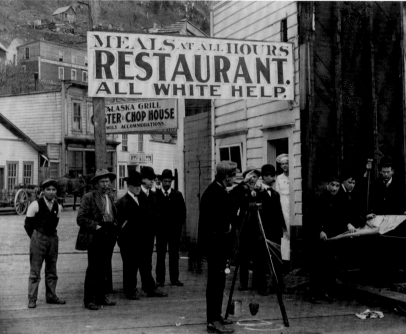

The U.S. government defined its mission as providing assistance to "civilize" Alaska Natives, and, in fact, U.S. policies in the nineteenth century and well into the twentieth were shaped by this view. In 1887, the commissioner of Indian affairs for the United States banned Native-language instruction in the schools and declared an English-only policy.[10] Wages were discriminatory, and white-hire preferences for business, government, and community jobs were standard practice. Natives were not allowed to testify in civil courts against whites, and Native children were barred from attending white schools. Society was segregated with "Whites Only" signs, and some communities were entirely off-limits to Native people.[11]

During the late nineteenth-century gold rush era, outsiders were free to seek their fortunes, but Alaska Natives were denied access. The Mining Act of 1874 allowed only two groups to stake mining claims: citizens of the United States and immigrants of good standing; Alaska Natives met neither of these criteria. In Circle City, Rampart, Crooked Creek, and other places, Alaska Natives filed legitimate mining claims only to have them taken away.[12] Tlingit clans that controlled access to Chilkoot Pass and the Yukon gold fields attempted to tax miners for using the trail, just as they had traditionally collected passage fees from Native traders, but the U.S. Navy stepped in forcefully on the side of the miners.[13]

Faced with the reality of their marginal status, Native peoples responded in a number of ways. Scattered incidents of armed conflict arose in southeast Alaska but were met with aggressive responses from the U.S. Army and Navy, including bombardment of the Tlingit villages of Kake

UPPER LEFT: Iñupiaq children in class at the U. S. government school in Wales, 1902. Sheldon Jackson, placed in charge of Alaska's first American schools, wrote that their purpose was Native assimilation into white society.

UPPER RIGHT: A restaurant sign proclaiming "All White Help" reflects racial discrimination against Alaska Natives. Front Street, Juneau, about 1908.

and Wrangell in 1869 and of Angoon in 1882.[14] Nonviolent confrontations occurred as well. After the army pulled its troops out of Sitka in 1877, Alaska Natives asserted their rights to be involved in the governance of the town. White Sitka residents panicked and pleaded for protection from the government, which arranged for the appearance of a British ship, the H.M.S. *Osprey*, as a show of force.[15]

Many Native communities allied with the new Christian missions, turning to them for education and cultural access in the new colonial regime. Starting in the 1890s, Presbyterian, Catholic, Moravian, Episcopalian, Baptist, Quaker, and other denominations established missions and schools throughout the territory with the support and cooperation of the Bureau of Education. The outcome of Native participation was not always what the church or civil authorities had predicted, however. Presbyterian-affiliated Tlingit, Tsimshian, and Haida founded the Alaska Native Brotherhood (ANB) in 1912 and the Alaska Native Sisterhood (ANS) in 1923. These organizations accepted the logic of cultural assimilation and prohibited their members' participation in potlatches, their speaking of Native languages, and their practice of Native religions. But they also took up the cause of civil rights, including a successful fight for the Native vote, awarded by the Alaska Territorial Legislature in 1922.

In interior Alaska in 1915, the Tanana chiefs protested against the appropriation of their traditional lands with neither their consent nor their compensation for construction of the Alaska Railroad.[16] The federal government ignored these protests, but that confrontation led to the formation of the Tanana Chiefs Conference to promote the social, civic, and educational advancement of Alaska Natives.

By the 1920s some Native leaders were trying to move their land rights issues into the court system. A generation of attorneys, including Tlingit lawyer William Paul, entered the fight, and the ANB and ANS made the pursuit of land claims a major part of their agenda. In 1935, the U.S. Court of Claims allowed the Tlingit and Haida to bring suit for millions of acres of land taken by the federal government to create the Tongass National Forest and Glacier Bay National Park.[17] The Native claims were based on traditional use and occupation, a contention that required the support and presentation of evidence in court. An extraordinary effort went into gathering the necessary data by explaining the case to communities and interviewing elders about how specific areas had always been utilized for subsistence hunting and gathering. The operation of a whole cultural system had to be documented and translated into the terms of Western law. The complex case suffered many reversals and wound on until 1968, when financial compensation in the amount of $7.5 million was awarded to the Central Council of Tlingit and Haida. No land was regained, however, and the results were a disappointment to many.

Land rights continued to be a main issue for all Alaska Natives. The Alaska Statehood Act of 1959 specified that the state government could select 104 million acres of land for its own use, setting off well-justified fears that large amounts of Native property would be appropriated. In northern Alaska the Rampart Dam Project, on the Yukon River, and Project Chariot, a plan to create an Arctic harbor at Cape Thompson using atomic explosions, would have destroyed Native lands but were defeated by the opposition of organizations such as the Fairbanks Native Association and the Tanana Chiefs Conference.[18] In response to Project Chariot, the first Native newspaper, the *Tundra Times*, was launched and edited by Howard Rock, an Iñupiaq artist from Point Hope. In 1966, the Alaska Federation of Natives was launched to block the land takeover by the State of Alaska, with the federation submitting its own claims for 370 million acres out of the state's total of 375 million.[19]

THE IMAGINATION TO RESOLVE

In the midst of this tempestuous time came the discovery of major oil reserves on the North Slope. The need to construct an eight-hundred-mile pipeline from the production fields in the north to a shipping terminal in Prince William Sound made essential the long-overdue resolution of conflicting tribal, state, and federal land claims.

The result of intensive negotiations between the Alaska Federation of Natives and the U.S. government is known as the Alaska Native Claims Settlement Act (ANCSA), signed into law by President Richard Nixon in 1971. By the terms of ANCSA, Alaska Natives were enrolled in thirteen state-chartered regional corporations and over two hundred village corporations; the corporations were granted clear title to approximately forty-four million acres and received a financial settlement of $962.5 million to manage on behalf of their Native shareholders. In return, all other Native land claims were dissolved. Although several tribal reserves and reservations were established, the vast majority of tribal governments were left without any ownership of land.

In the chapter that follows, Rosita Worl discusses some of the far-reaching effects that this legislation has had on Alaska Native communities and institutions. Although some corporations have far outperformed others, Native peoples have profited as shareholders, and Anchorage is dotted with multistoried glass buildings that are visible signs of the substantial role that Native corporations now play in the state's economy.

An important issue that the ANCSA legislation did not address was shareholder status for children born after 1971. While some corporations have taken steps to allow younger people— the "after-borns"—to acquire shares, most have not. This disenfranchisement of the post-1971 generation has created an enormous divide within the Native community and a sense of alienation among those who are excluded. With the Alaska Native population growing steadily younger (the majority is now under twenty years old), the demographic group that holds the future in its hands has no direct stake in some of our most important institutions.

The relationship between Alaska Native regional corporations and tribal governments is another complex matter. Exclusion of tribal governments from ANCSA was deliberate, in part the result of political backlash against the success of tribes in the lower forty-eight states in winning legal battles for land, water, subsistence, and treaty rights.[20] By the late 1960s, the authority of Alaska's tribal governments appeared to be generally increasing. Vesting corporations, rather than tribes, with land and money avoided an expansion of the latter's authority.

Subsistence issues also divide the state. Communities in rural Alaska must be able to participate in subsistence hunting and fishing to sustain their lives and cultures, especially given the rising costs of electricity, heating oil, food, and supplies in the "off-road" villages. In 1980, the federal government's Alaska National Interest Lands Conservation Act affirmed the right of Alaska's rural residents to continue their customary and traditional subsistence practices. However, the State of Alaska has held that its constitution does not allow for a distinction between urban and rural residents and that regulations concerning fish and game and hunting and gathering will be the same for all Alaskans. Failure to reconcile these opposing positions led the federal government to take control of the management of fish and game on federal lands and waters in Alaska in 1990. Today, Alaska has two sets of fish and game regulations: one for state lands and waters and another (with rural subsistence preferences) for federal lands and waters. The eventual resolution of the subsistence issues will depend, in great part, on the degree to which Alaskans value the continuation of the distinct cultural heritage of the state.

The arrival of the West in the eighteenth and nineteenth centuries was cataclysmic for Alaska's First Peoples. By the time of Alaska's transfer to the United States in 1867, few would have predicted that Alaska Natives would survive at all, much less achieve the kind of economic, political, and social success that is evident today. Nonetheless, our cultural and social continuity as distinct peoples is not to be taken for granted. All across our region we see the decline of Native languages, and with few exceptions fluent speakers are confined to a dwindling generation of elders. The Eyak language, whose last fluent speaker, Marie Smith-Jones, recently passed away, has become virtually extinct. The perpetuation of indigenous languages is essential, for they are the fundamental medium of Alaska Native cultural and intellectual heritage. All aspects of that heritage must be actively supported and taught, for it has proven to be capable of sustaining our peoples through the vicissitudes of a long and difficult history.

An understanding of that history—fairly represented, understood, debated, and shared with others—is fundamental to finding a sure sense of direction. That accounting should include the struggles, the limitations and frailties of the people involved, and descriptions of the circumstances that existed at the time. William Oquilluk, one of the many great Alaska Native leaders of the twentieth century, spoke eloquently about the need for Alaska Native peoples to summon the "Power of Imagination," which is required to resolve fundamental issues that threaten Native societies.[21] Such imagination, as well as a sure sense of direction that comes from knowledge of the past, will help those of each generation respond to the same question that has been considered by their parents, their grandparents, and their great grandparents: How will Alaska Natives continue as distinct cultures and peoples, carrying on the proud heritage that has been ours for thousands of years?

Honorary chief Marie Smith-Jones was the last fluent Native speaker of the Eyak language; she died in 2008. Photographed at her home in Anchorage, 2002.

1 Berger, *Village Journey*, 187.
2 Young, *Hall Young of Alaska*, 5.
3 Boyd, "Demographic History, 1771–1874," 137; Portlock, *Voyage around the World*, 271, 276.
4 Fortuine, *Chills and Fever*.
5 Black, *Russians in Alaska*.
6 Ramoth-Sampson and Newlin (comps.), Pulu and Ramoth-Sampson, eds., *Maniilaq*.
7 Ivanov, *The Russian Orthodox Church of Alaska*; Kan, *Memory Eternal*; Oleksa, *Orthodox Alaska*.
8 Hensley, *Fifty Miles from Tomorrow*, 8.
9 Johnson, Treaty concerning the Cession of the Russian Possessions in North America.
10 Prucha, ed., *Documents of United States Indian Policy*, 174–76.

11 Alaskool, Jim Crow in Alaska.
12 Mitchell, *Sold American*, 125–26, 152–55, 193–94.
13 Arnold, *Alaska Native Land Claims*, 68.
14 Secretary of the Treasury, Letter from the Secretary of the Treasury, in relation to the Shelling of an Indian Village; Worl, "History of Southeastern Alaska since 1867," 149.
15 Haycox, *Alaska*, 184.
16 Arnold, *Alaska Native Land Claims*, 81–82.
17 Goldschmidt and Haas, *Haa Aani*.
18 O'Neill, *The Firecracker Boys*.
19 Mitchell, *Take My Land, Take My Life*, 11–195.
20 Wilkinson, *Blood Struggle*.
21 Oquilluk, *People of Kauwerak*, 23–24.

NEWLY ARRIVED EIGHTEENTH- AND NINETEENTH-CENTURY Europeans and Americans denominated Alaska's diverse Native peoples with several preconceived terms—Indian, Eskimo, and Aleut. Indigenous peoples rejected these foreign names except when speaking to a *kass'aq*, *qavlunaaq, naluaġmiu, or dleit ḵáa* (meaning "white person"), knowing that few of the newcomers knew or could pronounce the real tribal names. Nonetheless, elders in southeast Alaska admonished the youth not to forget that they were Tlingit, not Indian, a name that represents no more than Columbus's mistaken notion of where he landed in 1492. "Tlingit," like the names of many other aboriginal nations, means the "Real People."

Indigenous interest groups such as the Alaska Native Brotherhood and Sisterhood, the Tanana Chiefs Conference, and eventually the statewide Alaska Federation of Natives (AFN, founded in 1966) were steps toward a new, collective identity—that of "Alaska Native." Iñupiaq, Yupik, Yup'ik, Unangax̂, Sugpiaq, Athabascan, Tlingit, Haida, and Tsimshian representatives to the AFN strove to overcome the cultural differences and enmities that had historically divided their peoples. They built a unified movement for settling land claims issues that arose out of Alaska statehood and the North Slope oil discoveries, as Paul Ongtooguk has described in "Native Perspectives on Alaska's History." The resulting Alaska Native Claims Settlement Act of 1971 (ANCSA) gave legal standing to "Alaska Native" as an ethnic identity, basing it primarily on biological heritage consisting of "one-fourth degree or more Alaska Indian (including Tsimshian Indians not enrolled in the Metlakatla Indian Community), Eskimo, or Aleut blood, or combination thereof."

Alaska Native peoples have never abandoned their ancient and unique cultural identities, but through their long encounter with the West they have gradually come to recognize what they have in common. As Alaska Natives they have worked together toward political, economic, and cultural sovereignty, pioneering a path toward economic development that incorporates tribal values. These goals, taken together, define indigenous self-determination.

POLITICAL SOVEREIGNTY

When the United States took jurisdiction over Alaska in 1867, the territorial and U.S. federal governments assumed total authority over indigenous lands, resources, and lives. New policies and laws dictated when and where indigenous peoples could hunt and fish, prohibited them from using their own languages, and required them to abandon their traditional customs and beliefs. Formerly self-reliant Native societies that had been effectively governed by their own leaders and tribal councils were gradually transformed into depressed communities under external control.

The Russian-American Company had characterized as "civilized" those indigenous groups whom it had subdued and who had adopted a Russian way of life. So-called uncivilized tribes were those who had resisted Russian domination and had maintained their traditional ways. The

A Koyukon leader, Chief William, at Tanana in 1916. The chief's clothing, including a beaded leather coat (see p. 196), knife sheath, and dentalium shell bandolier, is emblematic of his high position.

A Path to Self-Determination

uncivilized tribes were not granted Russian citizenship, land, or religious rights.[1] The U.S. federal and Alaska territorial governments adopted and applied similar policies well into the twentieth century. For example, the federal Nelson Act (1905) established two school systems in Alaska, one for whites and "children of mixed blood who lead a civilized life," and the other for Natives. In 1908 a Tlingit man petitioned the Sitka School Board for admission of his mixed-blood stepchildren to the white school; he was literate in English, owned a house and store, paid taxes, belonged to the Presbyterian Church, and was recognized in the community as an industrious, law-abiding, and intelligent man. However, a judge denied the petition on the basis that the family had failed to sever all relationships with tribe and kin and did not associate exclusively with whites.[2]

In 1915 the Alaska Territorial Legislature applied a similar standard to Native voting rights. Any Native person seeking suffrage had to be endorsed by five white citizens and demonstrate, first to federal government teachers and then to a district judge, his total abandonment of tribal customs and adoption of a "civilized" life. [3]

Through the Alaska Native Brotherhood and under the leadership of a brilliant Tlingit, William Paul Sr., Alaska Native peoples were successful in obtaining full and universal citizenship in 1922, two years before this right was extended to other Native Americans. The turning point came when a Tlingit clan leader was found "not guilty" of illegal voting.[4] With the right to vote, the Native community began to elect its own representatives to the Territorial Legislature and later to the Alaska State Legislature.

By means of the 1934 Indian Reorganization Act (IRA), amended in 1936 to include Alaska, the federal government established tribal governments throughout Alaska. However, Native communities tended to rely on their traditional political councils and social organizations, so many of the IRA governments remained dormant.

Activation of the IRA governments in the 1980s was spurred by concerns that Alaska Natives might lose their ANCSA lands after 1991, the year when restrictions against the sale of Native corporation stock were to be lifted. It seemed likely that a significant portion of the land held by the regional and village corporations would be lost through sale to outsiders, bankruptcy, tax liabilities, corporate failures, and takeovers. One proposed solution was for ANCSA lands to be transferred to the IRA tribal governments. However, the U.S. Congress signaled that this action would be accompanied by restrictions significantly undermining tribal sovereignty, and in the end Alaska Natives rejected "retribalization" of their land. Instead, they obtained an amendment to ANCSA, creating a land bank for protection of their assets against loss by taxation or other legal means. In addition, many of the corporations adopted policies and bylaws to make the

Alaska Native civil rights activists Elizabeth Peratrovich (second from left) and Roy Peratrovich (far right) led the fight to bring about passage of Alaska's Anti-Discrimination Act of 1945. They witnessed the signing of the bill by Governor Ernest Gruening (seated).

sale of corporate land nearly impossible.[5] They also successfully promoted an amendment that allows corporations to adopt a policy to include children born after 1971 as shareholders, assuring that Native children would have the same ownership rights as their parents.

The tribal movement continued, with its leaders advocating for full recognition of tribal status and sovereignty. The federal government ultimately complied and in 1993, through the *Federal Register*, issued a listing titled "Indian Entities Recognized and Eligible to Receive Services from United States Bureau of Indian Affairs." The State of Alaska, however, refused to recognize tribes as legal, sovereign entities and rejected their authority to act in a government-to-government capacity. Tribal governments continue to face difficulty in developing their institutional capacities, because they are hampered by the absence of both funding and any land base.

Alaska Native regional nonprofit corporations were originally established prior to the ANCSA legislation, to pursue and oversee the land claims effort. After ANCSA's passage land management became the responsibility of the profit-making corporations, and the nonprofits assumed new roles. They took advantage of the Indian Self-Determination and Education Assistance Act of 1975 to contract with the federal government for provision of governmental services in the areas of health, housing, and rural electric power supply.

As the result of the 1960s land claims movement, an unusually complex institutional environment emerged in Alaska's rural Native communities. It includes tribal, city, state, and federal governments, each with specific and sometimes conflicting domains; village and regional ANCSA for-profit corporations; and ANCSA nonprofits and affiliated organizations that administer service programs. For the most part, Native communities have been successful in resolving the fractionated political authority and control that are apportioned among these entities. In fact, through these new institutions Alaska Native people have clearly assumed greater control over their lives, gained substantial influence over the laws and policies that impact their communities, and realized a degree of political sovereignty that is enjoyed by few other indigenous societies throughout the world.

ECONOMIC SELF-DETERMINATION

Alaska Native societies sustained themselves for thousands years by means of their traditional hunting, fishing, and gathering economies. These subsistence economies were based on socially organized harvesting, cooperation within and among clans and families, and cultural values that emphasized the sharing of resources with the elderly and dependent.

Alaska Natives first entered the capitalist economy through trade, exchanging furs and other products of their subsistence economies for Western goods. During this early phase, Western imports such as iron, beads, cloth, tobacco, china, and guns were incorporated without bringing significant changes to traditional lifestyles. Exceptions occurred in areas under complete Russian control, where the colonial relationship was one of servitude rather than voluntary trade.

One of the first wage-paying industries in Alaska was commercial salmon fishing. Canneries were built all along the southern coast from southeast Alaska to Bristol Bay starting in the 1880s, and Native men became commercial fishermen while women worked in the packing plants. Native communities continued their annual rounds of subsistence hunting, fishing, and gathering, however, and this was the beginning of the dual cash and subsistence economy that has characterized rural Alaska to the present day. Until the institution of ANCSA in the 1970s and Native

peoples' subsequent economic advancement through their regional and village corporations, Alaska Natives were largely wage earners in their participation in the cash economy, with few opportunities to be business owners or managers.

Although Congress viewed ANCSA, with its corporate structure, landownership, and monetary assets, as a means to assimilate Alaska Natives into the capitalist economy, Alaska Natives saw corporations as a way to maintain full ownership and control of their land rather than to have it held in trust and managed for them by the Department of the Interior, the arrangement that applies to federal Indian reservations. They also viewed corporations as the means to achieve economic security and self-determination.

Under ANCSA, Alaska Natives retained approximately 10 percent of their original land base, divided among the village and regional corporations. In addition, they were compensated nearly one billion dollars for lands to which they surrendered aboriginal claims. ANCSA also included unusual provisions requiring the regional corporations to share 70 percent of their profits from mining, oil, and timber harvesting with all other regions and to share 50 percent of their revenues with the village corporations within their regions. These provisions ensured that all Alaska Natives would benefit, even those living in regions with few developable resources.[6]

The financial success of individual Alaska Native corporations has been varied. Some regional corporations have almost gone bankrupt while others, including the Arctic Slope Regional Corporation and the Sealaska Corporation, have made the Forbes 500 list of the most successful companies in the United States. The village corporations have had diverse histories as well. Several were threatened with dissolution because they were inactive or failed to file corporate reports required by the State of Alaska; others have been extraordinarily financially successful, with revenues matching those of the larger regional corporations.

Overall, Alaska Native corporations make an extraordinary contribution to the economy of the state. The *Alaska Business Monthly* included nineteen Native regional and village corporations in its 2007 annual list of the state's top forty-nine businesses.[7] This group of corporations ac-

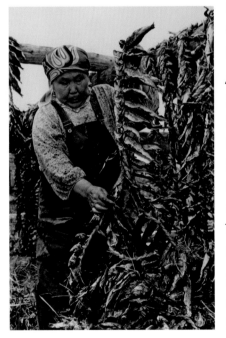

counted for 63 percent of the total revenue earned in the state and 52 percent of all Alaskan jobs. In addition, Native employees constitute more than 20 percent of the Alaskan workforce.

Although Native corporations compose a major sector of the state's economy, they have not eliminated poverty in the state's two hundred predominantly Native rural communities. These villages are mostly small (numbering from four hundred to eight hundred residents) and located in remote locations with high transportation costs. Many lack the basic infrastructure, energy sources, and conditions that would attract year-round economic investment. Although economists have periodically predicted the demise of rural villages, they persevere. Their survival has been attributed to the Native peoples' strong attachment to their land and subsistence way of life.

Because of their economic strength, Alaska Native corporations are able to advance the social and cultural welfare of their members. They invest in future Native leadership by providing annual educational scholarships, which in 2006

Ella Tulik at Umkumiut fish camp on Nelson Island in 1976. She is taking down herring that have been strung together with grass and hung up to dry.

totaled $21.1 million.[8] They support the Alaska Federation of Natives through annual dues and special assessments, enabling the AFN to be a major political force that advocates for Native interests on a wide range of issues, including education and subsistence. A number of regional and village corporations have established affiliated nonprofit organizations dedicated to the preservation and enhancement of Native culture and languages.

ANCSA has been heralded as the largest aboriginal land claims settlement in the United States' history, but the act has not been a panacea for Alaska Natives. While the congressional framers of ANCSA and public policy observers viewed the act as social engineering for the assimilation of Alaska Native peoples, and Native leaders who contributed to its design saw corporations as the road to economic sovereignty and control of the land, Alaska Natives' reality lies somewhere in between. Carl Marrs, a former chief operating officer for one of the most successful ANCSA corporations, acknowledges that ANCSA has not solved the social problems of Native peoples. He adds, however, that as he reflects on the sweeping changes that have been made in Alaska's political, economic, and social landscape as a result of ANCSA, he believes that Alaska Native peoples can celebrate their tremendous progress toward self-determination.[9]

SUBSISTENCE RIGHTS AND PRACTICE

Subsistence cultures are often perceived to be manifestations of economic underdevelopment. Native peoples, however, view subsistence as a way of life that embodies cultural values and a spiritual relationship with the land and animals. It unifies them as tribal groups through the harvesting and sharing of wild foods.

Subsistence economies were formerly constrained solely by environmental conditions, indigenous technological capabilities, and cultural ideologies. This changed under American jurisdiction as new laws and regulations were imposed to favor the interests of commercial and sport hunting and fishing. Almost immediately, confrontations emerged over the allocation of resources. Alaska Natives were compelled to mount a political battle to protect their subsistence cultures.

ANCSA extinguished aboriginal hunting and fishing rights, but Congress clearly intended for the secretary of the interior and the State of Alaska to initiate "any action necessary to protect the subsistence needs of the Natives."[10] A watered-down version of this promise was included in the Alaska National Interest Lands Conservation Act of 1980 (ANILCA), which mandated a subsistence preference for "rural residents" in general rather than for Alaska Natives specifically.

Thomas Thornton described the rural preference as "a political compromise designed to protect Native subsistence in keeping with Congress' intent in ANCSA, while not discriminating on the basis of ethnicity—something powerful non-Native interests in the state vigorously opposed."[11] I noted elsewhere, in writing about the political confrontations to resolve fish and wildlife competition among subsistence, commercial, and sports hunting and fishing interests, that "Alaska

Community members gather to enjoy Native foods at Kivgiq (Messenger Feast) at Barrow in 2003. The traditional winter festival is held today in both Iñupiaq and Yup'ik villages.

Natives have learned that compromise translates into Native people giving up something they possess while non-Native people give up something they want."[12] This form of compromise has resulted in the continual erosion of Native political rights, has severely reduced subsistence allocations of hunting and fishing resources, and has granted nonsubsistence users more than 95 percent of all fish and wildlife harvests.

As a result of its "rural preference," the state's subsistence law was ruled unconstitutional by the Alaska Supreme Court, because this preference constituted a "special privilege." With the state thus out of compliance with ANILCA, in 1990 the federal government assumed management of fish and wildlife on Alaska's federal lands. The state retained its authority over state and private lands, which ironically include the forty-four million acres owned by the ANCSA corporations.

Dual management by the state and federal governments has intensified confrontations between Natives and the state. The state government has advanced amendments to adopt a more restricted meaning of "rural preference," whereas Natives have supported an amendment to recognize a Native subsistence priority. The Alaska Federation of Natives held two statewide subsistence summits in 1992 and 1997, resulting in the adoption of guiding principles and policy recommendations that were viewed as necessary to protect Alaska Native subsistence economies and cultures.

ANILCA remains in place today in its original form, but Natives are learning that its rural preference does not offer adequate protection against the process of urbanization, which has engulfed several formerly rural indigenous communities and disqualified them from the law's provisions. Quiet battles are also being waged over federal and state regulations. Among the more recent threats are changes in hunting and fishing permits that to Alaska Native critics represent an effort to individualize and break up the communal practice of subsistence. Today Alaska Natives remain vigilant in their efforts to protect their subsistence cultures.

NATIVE CORPORATIONS AND TRIBAL VALUES

The Native leaders who were instrumental in crafting ANCSA did not have the luxury of time to assess the long-term cultural consequences of the legislation. Their major objective was to secure full ownership and control over the maximum acreage of land. By the 1980s, however, the Native community began to focus on the linkages between land and culture. Amendments to prevent the sale or seizure of corporate land and to allow corporate enrollment by Alaska Natives born after 1971 must be understood as expressions of persistent Native communal values; holding land as a group, including all generations, is essential to cultural unity and survival.

The integration of traditional values is demonstrated as well by changes to ANCSA—changes sought and implemented by a number of the Native corporations—that allow special benefits and dividends to elders. Banking and security laws require corporations to provide equal distributions to all shareholders, but elders hold a privileged place in Alaska Native societies. They are culture-bearers who possess and teach the knowledge, wisdom, and languages of their ancient traditions. Elders are held in the highest regard and are provided with subsistence foods, including the most highly prized parts of fish and other animals. Supplemental monetary benefits from the Native corporations are simply an extension of this regard.

The Sealaska Corporation is an example of how tribal values can transform a purely capitalistic institution. The corporation has been a leader in implementing the ANCSA policy changes

discussed above and in addition has made enrollment perpetual, which replicates the system of perpetual membership in traditional clans. Through a separate nonprofit affiliate, the Sealaska Heritage Institute, the corporation has also invested substantially in the promotion and perpetuation of southeast Alaska Native cultures. SHI encourages and supports traditional dance and music, preserves traditional knowledge and oral history through scholarly publications, promotes Native language learning and restoration, and develops culturally based curricula and materials for schools.

The Sealaska Board of Directors, together with the SHI Board of Trustees and Council of Traditional Scholars, has identified three core values to guide its policies.[13] *"Haa aaní"* translates simply as "our land" but encompasses both physical and spiritual relationships that Native peoples hold with the earth. In 2007, the Sealaska Corporation initiated the First Tree Ceremony, in which the spirits of trees were thanked for allowing themselves to be harvested as timber and advised that proceeds from the harvest would be expended to employ tribal shareholders, provide dividends, support scholarships, and fund cultural programs. Sealaska recently introduced legislation in Congress to amend the corporation's land selection rights under ANCSA to include sacred sites. Although profit-making corporations generally do not select unproductive lands to own, the Natives of southeast Alaska are committed to protecting their sacred sites, such as the burial grounds of their shamans, under Sealaska ownership.

Haa shagoon expresses the unbreakable bond among ancestors, those alive today, and future generations. The enrollment of young people in the Sealaska Corporation, supported by an affirmative vote of the shareholders, was an endorsement of this value. Caring for culture and future generations *(haa shagoon)* is intimately linked to caring for the land *(haa aani)*, and both are demonstrated by Sealaska's initiative to set aside tracts of forest for use by totem pole carvers, canoe makers, and other artists. The corporation is assessing green practices for its timber businesses, including forest certification and carbon sequestration.[14]

Haa latseen (meaning "our strength") encompasses physical, mental, and spiritual strength. In terms of corporate policy, *haa latseen* mandates college scholarships and internships to educate youth for the leadership challenges of the future. It links to *haa shagoon* through the concept that traditional knowledge and values can be the real source of Native strength in contemporary society. It requires forceful advocacy in the political arena to advance and protect the interests of southeast Alaska Natives.

The corporate integration of these values is in its infancy but demonstrates the will to implement true cultural sovereignty. Sealaska, along with other ANCSA corporations, continues to evolve. Carl Marrs said, "We can look to our cultural traditional values and our elders for guidance. The leadership who crafted ANCSA wisely developed an evolving agreement, which has been amended many times and likely will be amended many more times. Those who will make changes in the future will be Native people themselves—in the act of self determination."[15]

RESTORING NATIVE CULTURE

In the 1960s, Alaska Native peoples unified politically and began reasserting themselves and their claims to aboriginal lands. In the decades that followed they secured the largest land settlement in U.S. history, developed Native corporations, built a secure and diverse economic base, created nonprofit organizations to administer health, housing, and energy programs, and fought for state and federal recognition of their tribal governments. Alaska Natives went through a period, sometimes characterized by conflict, when the separate powers, responsibilities, and interrelationships of these institutions were being determined.

With the institutional framework established and their political and economic sovereignty recognized, Alaska Natives refocused their efforts on cultural survival. Throughout the 1980s and 1990s they were compelled to protect their subsistence economy, which many see as the basis and essence of indigenous values and spirituality. Corporations and nonprofit organizations devoted increasing attention and resources to the perpetuation of Alaska's rich and diverse Native cultures, arts, and languages.

At base, sovereignty may be defined as a people's right to govern its membership and its territory. From a Native perspective, however, sovereignty must include spiritual and cultural dimensions. Vine Deloria wrote that sovereignty "can be said to consist more of continued cultural integrity than of political powers and to the degree that a nation loses its sense of cultural identity, to that degree it suffers a loss of sovereignty."[16]

Over the last decades, the indigenous peoples of Alaska have been reconstructing sovereignty through multiple and interrelated institutions, in which over one hundred thousand Natives, their cultures, and their general welfare are common denominators.

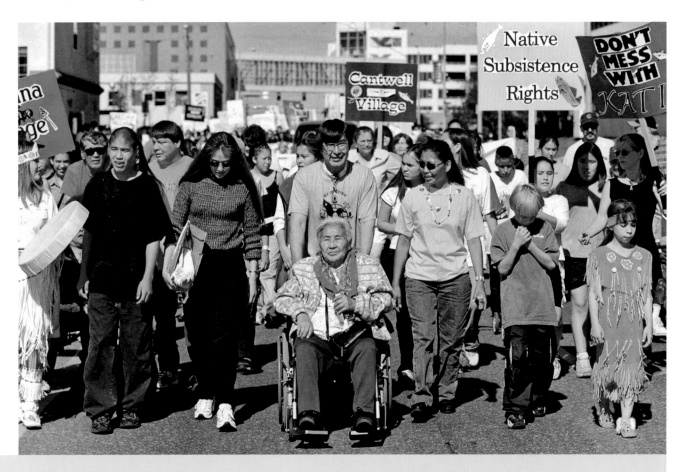

1　Case and Voluck, *Alaska Natives and American Laws*, 46.
2　Wickersham, ed., *Alaska Reports*. Two other families, whose children included John and Lottie Littlefield and Lizzie Allard, were also plaintiffs in this case.
3　Certificate of John M. Tlunaut, 1919.
4　Drucker, *The Native Brotherhoods*, 46.
5　Worl, "Models of Sovereignty and Survival in Alaska."
6　Notti, "AFN Position with Respect to the Native Land Claims Issue."
7　*Alaska Business Monthly*, "Top 49ers."
8　*ANCSA Regional Association Report*, 37.
9　Marrs, "ANCSA."
10　U.S. Congress, Senate, *Alaska Native Claims Settlement Act*, 37.
11　Thornton, "Alaska Native Subsistence," 30.

12　Worl, "Competition, Confrontation, and Compromise," 77.
13　The terms used in the text are Tlingit. The Haida terms are as follows: our land, *íitl' tlagáa*; our ancestors, *íitl' kuníisii*; our strength, *íitl' dagwiigáay*.
14　Forest certification is a process whereby third party auditors certify that the forest is being managed in accordance with specific standards. Sequestration is the biological process that captures carbon dioxide from the atmosphere and stores it permanently or over an extended period of time. Since trees are long-lived and consist of approximately 50 percent carbon they are a good sequesters of carbon.
15　Marrs, "ANCSA," 30.
16　Deloria, "Self-Determination and the Concept of Sovereignty," 26.

Athabascan elder and Native subsistence activist Katie John (center in wheelchair) leads the fourth annual We the People march in Anchorage, 2001.

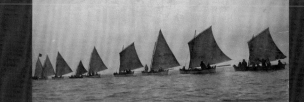

IÑUPIAQ

Beverly Faye Hugo

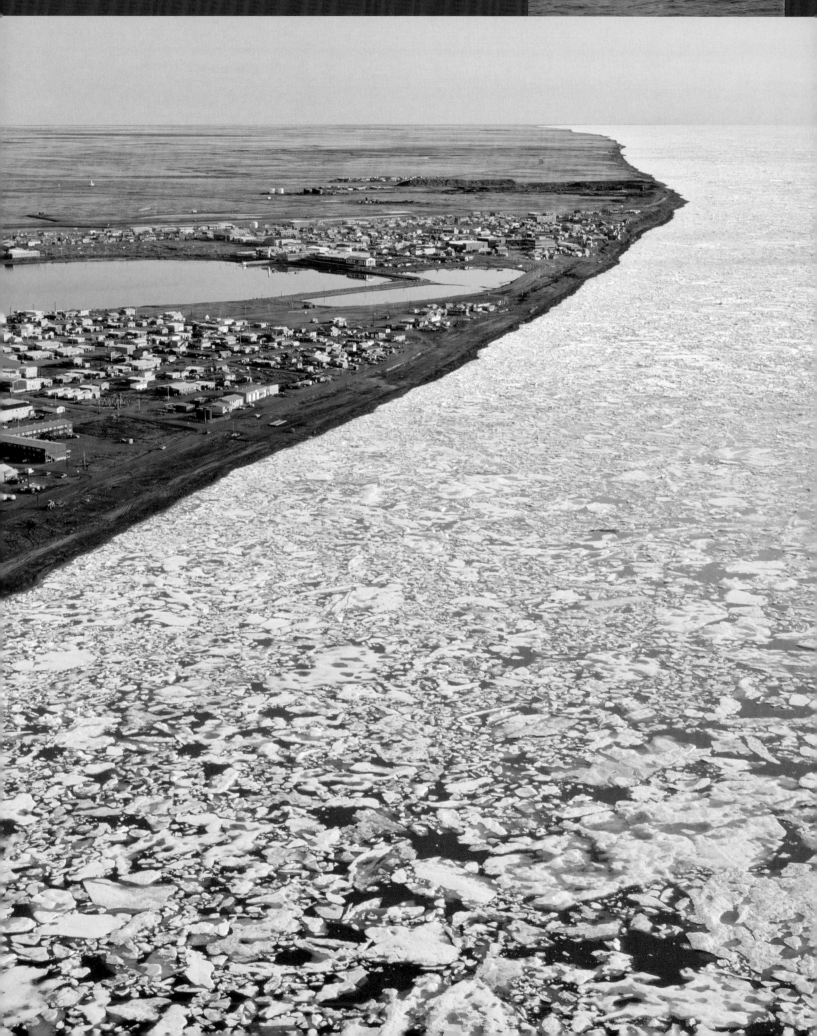

THERE'S ICE AND SNOW, the ocean and darkness. That's all I've known—darkness in the winter and twenty-four hours of daylight in the summer.

Barrow was originally called Utqiaġvik (meaning, "the place where *ukpik*, the snowy owl, nests"). It's a good place, and I always long for my home when I've been gone. That's where my people, the Iñupiat, have survived and lived, and I am doing as they have done.

On the Arctic coast you can see vast distances in all directions, out over the ocean and across the land. The country is very flat, with thousands of ponds and lakes, stretching all the way to the Brooks Range in the south. It is often windy, and there are no natural windbreaks, no trees, only shrubs. Beautiful flowers grow during the brief summer season, and I do paintings of favorites, like the woolly lousewort and Arctic poppy.

The ocean is our garden, where we hunt the sea mammals that sustain us. It's so full of life! Throughout the year some seasonal activity is going on. We are whaling in the spring and fall, when the bowheads migrate past Barrow, going out for seals and walrus, fishing, or hunting on the land for caribou, geese, and ducks.

Whaling crews are made up of family members and relatives, and everyone takes part. The spring is an exciting time when the whole community is focused on the whales, hoping to catch one. And people who are persistent and patient are often successful. The number we are permitted to take each year is set by the Alaska Eskimo Whaling Commission and the International Whaling Commission.

Whaling is not for the faint of heart. It can be dangerous and takes an incredible amount of effort—getting ready, waiting for the whales, striking and pulling and towing them. But the men go out and do it because they want to feed the community.

Everyone has to work hard throughout the whaling season. People who aren't able to go out on the ice help in other ways, such as buying supplies and gas or preparing food. When I was a girl my mother would tell us to get

OPPOSITE TOP: *Umiat*—skin-covered boats used for whaling—under sail off Point Barrow in 1921.

OPPOSITE: An aerial view of Barrow, bordered by the Chukchi Sea; the view is to the west. The sea ice is fragmented by late spring warming but the tundra is not yet green. Bowhead whales pass close inshore along this northern-most part of the Alaskan coast as they migrate east to their summer feeding grounds in the Beaufort Sea. Other local and migrating species—polar bear, walrus, bearded seals, ringed seals, beluga whales—are abundant. Archaeological sites in and around Barrow show that the area has been occupied by Arctic hunting peoples for well over two thousand years.

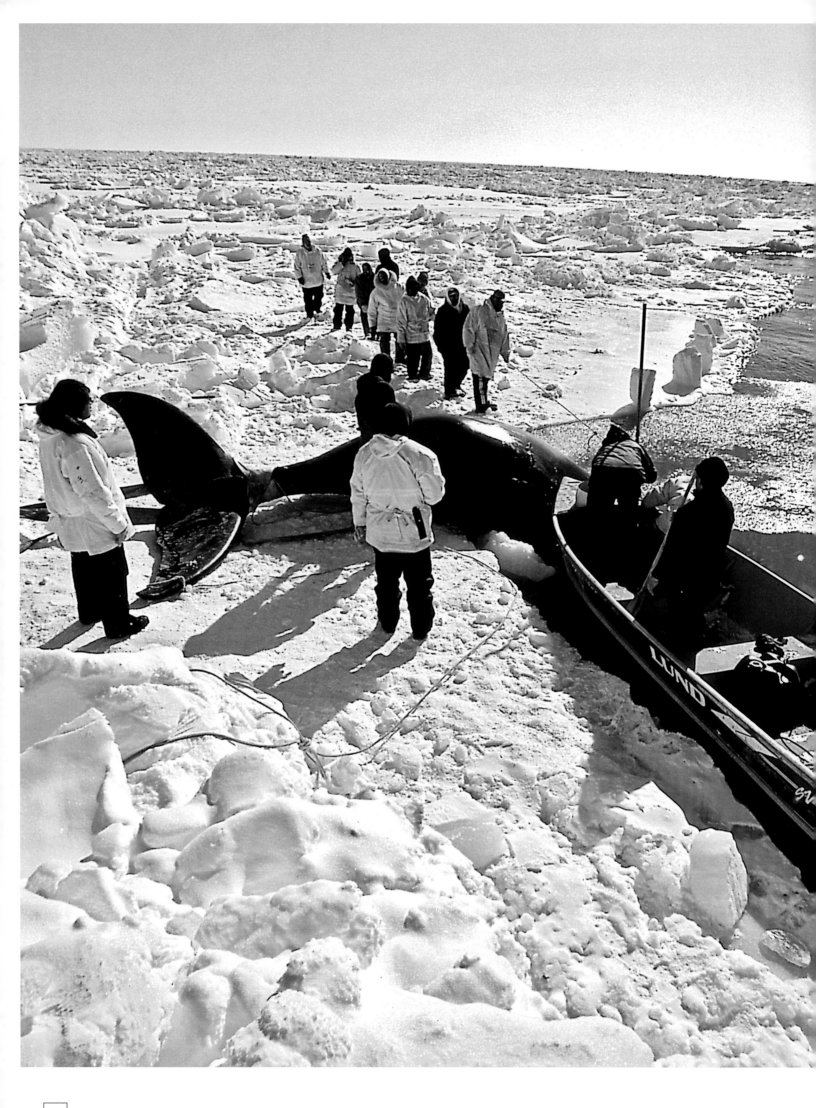

something for our crew, and she'd want it done immediately. Even today, whenever I get a call I *run* to do it; I'll say, "Gotta go; my crew is depending on me!"

You have to make clothing for them; they need warm parkas, boots, and snow pants. They have to have white snow shirts for camouflage. Whales are bothered by dark things, but if you are wearing white, they think it is ice.

We believe that a whale gives itself to a captain and crew who are worthy people, who have integrity—that is the gift of the whale. Caring for whales, even after you've caught them, is important. They love to be in clean ice cellars. Every January before the whaling season we haul out any leftover food stored there, such as walrus or seal, and we give it away. Then we reline the ice cellar with fresh powder snow. That's the kind of place where a whale wants to rest and where it will feel welcome. Cleaning the cellar is one of the traditions.

After a whale is caught and divided up, everyone can glean meat from the bones. Each gets his share, even those who don't belong to a crew. During spring whaling, elderly women wait alongside the trail that leads across the ice back to the village. If they want some part of the whale, they ask for it and will receive it. Elderly or disabled people always receive foods like fresh fish, *tuttu* (caribou), ducks, geese, and even whale. No one is left out.

We are really noticing the effects of global warming. The shorefast ice is much thinner in spring than it used to be, and in a strong wind it will sometimes break away. If you are out on the ice, you have to be extremely conscious of changes in the wind and current so that you will not be carried off on a broken floe. Someone has to be watching on twenty-four-hour alert during whaling season. We are concerned as well about the effects of offshore drilling and seismic testing by the oil companies. They try to work with the community to avoid problems, but those activities could frighten the whales and be detrimental to hunting.

OPPOSITE: Using a block and tackle, an Iñupiaq crew hauls a spring bowhead whale up on to the ice edge near Barrow in 2001. The whale will be butchered and the meat divided. Contemporary whaling is the continuation of a millennium-long tradition.

LEFT: Ice fishing for tomcod at Kivalina beside a pile of the frozen catch, 2007. Jigging for the fish with a short wooden rod is an important subsistence activity during winter and spring.

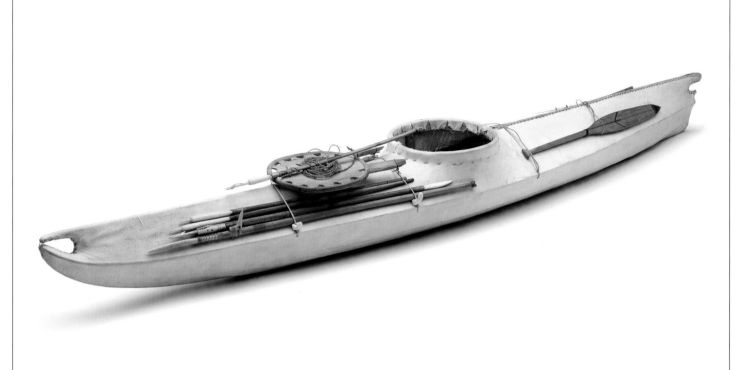

Qayaq
KAYAK (MODEL)

Norton Sound
Collected by J. Henry Turner, accessioned 1892
National Museum Natural History E153656
Length 80.6 cm (31.7 in)

This Iñupiaq-made model depicts a traditional Norton Sound *qayaq*. Weapons and hunting equipment are held securely on deck by sealskin cords. A seal dart rests on top of a float board, attached by a coiled line; the board was designed to drag behind a wounded seal, hindering its escape. A gaff hook and several throwing and thrusting harpoons are shown within reach of the boat's cockpit, and a spare paddle is carried on the back.

The frame of a full-sized *qayaq* was constructed from more than eighty carved and fitted parts. Seal-thong lashings gave the boat great flexibility and strength in rough seas. At the same time, *qayat* were light enough to be carried easily and were fast in the water. Men built the frames, and women sewed the bearded seal skin covers using sinew as thread to create waterproof stitches. Finished boats were coated with seal oil.[1]

Margaret Seeganna of King Island said that a man's "height, weight, the length of each arm, the distance from elbow to fingertips, and the distance from fingertip to fingertip with arms out-stretched" were applied in measuring the frame, so that the boat would fit his body exactly.[2]

"I went out with my grandpa when I was a young man. Nice spring weather, not a breath of wind. He had a *qayaq*, and we were pulling it over the ice to the edge of the water. The sea was like a mirror, but he took one look and said, 'A storm is going to hit.' Before we got back to the beach, that storm came. Those old-timers—they look at the water or the sky, and it's 'Uh-uh, we're not going anywhere today.'"

—Jacob Ahwinona, 2001

Men in kayaks. Noatak, ca. 1929.

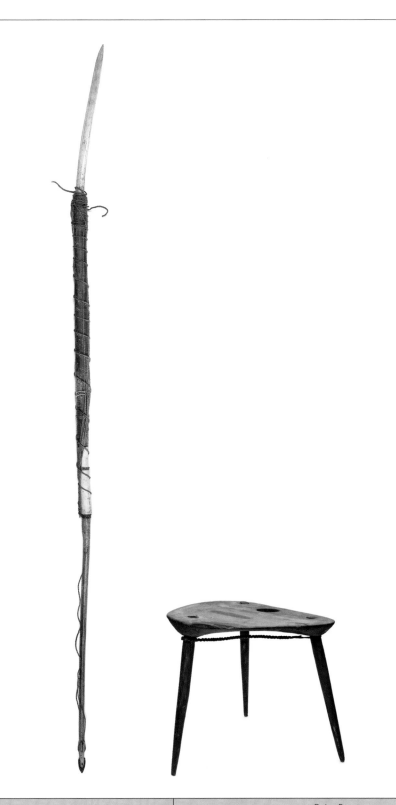

Nauliġaq
HARPOON

Point Barrow
Collected by Lt. Patrick. H. Ray, accessioned 1883
National Museum Natural History E089910
Length 157 cm (61.8 in)

Nukirvautaq
SEALING STOOL

Point Barrow
Collected by Lt. Patrick. H. Ray, accessioned 1883
National Museum Natural History E089887
Height 25.5 cm (10 in)

Ringed seals swim under the sea ice and come up for air at breathing holes. In the past, hunters with harpoons waited at the holes, standing silently and motionlessly on small stools, which elevated their feet, protecting them from the frozen surface.[3] A feather mounted on a T-shaped ivory pin that was placed in the hole revealed the seal's first exhalation, which was the signal to strike.[4]

This harpoon has a "toggling" head made of caribou antler embedded with a copper blade. The wedge-shaped head was designed to slip off the harpoon's long ivory foreshaft and turn sideways inside the seal. It is attached to a line that the hunter used for pulling the seal out of the water, after he first enlarged its hole with a pick on the harpoon's upper end. A tern's bill is tucked into the lashings for luck.[5]

This spruce wood stool is thin and light, with leather thongs to brace the legs. The hole in the top is for carrying and hanging.[6]

"This is a sealing harpoon. Once you harpoon the seal, you can pull it up. This braided sinew line is pretty strong. And the harpoon point, that's for catching seals. This end is for chopping the ice around the seal hole. This would also have the little stool that goes with it."

—Ronald Brower Sr., 2002

Harpooning a seal at its breathing hole. Northwest Alaska, 1890s.

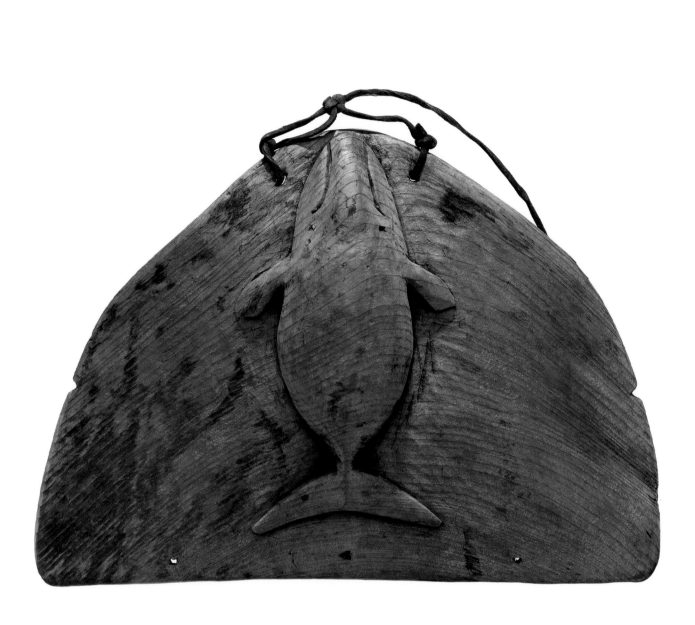

Iktuġaq
WHALE PLAQUE OR BOAT STEERSMAN'S SEAT

Wales
Collected by Clark M. Garber ca. 1928, purchased 1958
National Museum of the American Indian 226908.000
Width 42.5 cm (16.7 in)

Wooden plaques with images of the bowhead whale are traditional hunting charms, still used today by some Iñupiaq whaling captains.[7]

At Point Hope in the 1940s, whale plaques were wedged inside the bow of the *umiaq*, making a small deck just in front of the harpooner. The carved bowhead image was on the bottom side and thus invisible. The harpooner tapped the plaque as he sang a song to summon whales to the surface.[8]

Talking about this plaque from Wales, Barrow elders Kenneth Toovak and Ronald Brower Sr. said that it was placed either in the bow of a boat, as at Point Hope, or in the stern as a seat for the steersman. When used as a bow platform, the plaque provided a resting place for the coiled sealskin harpoon line.[9] Sylvester Ayek suggested that the plaque might also have served as an ornament hung from the front of a whale boat, adding that this kind of charm was customarily placed on the captain's grave.[10]

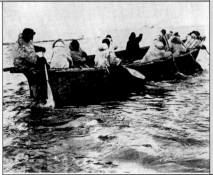

A whaling crew sets out. Wales, 1906.

"Uvvakii aġviqsiuqtinmakua umiaġiratiŋ piqpagipiaġataġuugait qutchiksuaġisuugait. Tavra tainna umialguruam marra suġauttaŋi."

"And so it is, whalers really do have respect for their boats and have high regard. These are a boat captain's items."

—Kenneth Toovak, 2002

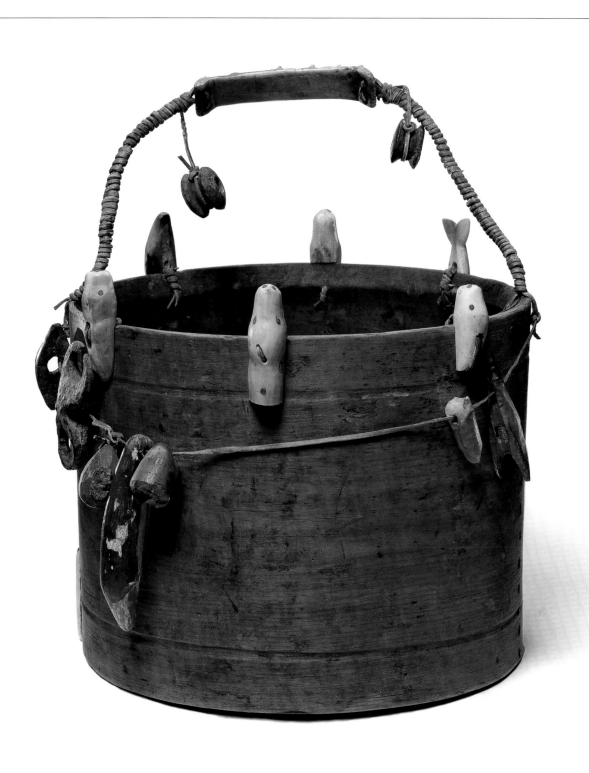

Qatauġaq
CEREMONIAL PAIL

Wales
Collected by Samuel P. Fay ca. 1913, purchased 1952
National Museum of the American Indian 218952.000
Width 23 cm (9.1 in)

The wife of an *umialiq* (boat captain) is believed to have great influence over the whales. In earlier times, she abstained from using a knife during the hunt in the belief that it might cause the harpoon line to break and avoided sewing because that might cause the line to tangle.[11] Even today, a captain's wife is expected to remain tranquil so that a whale will calmly give itself to the hunters.[12]

In the old custom, a captain's wife greeted his catch at the edge of the ice. Singing her welcome to the spirit of the whale, she poured fresh water onto its snout from a ceremonial pail. In Iñupiaq belief this quenched the great sea mammal's thirst for fresh water.[13] The ceremonial pail seen here is made of steam-bent wood and is ornamented with polar bear teeth carved in the shapes of polar bear heads and a whale tail.

Ceremonial water containers were used in other rituals as well. An *umialiq*'s wife poured a drink for the whale boat when it was launched, because the sealskin-covered *umiaq* was viewed as a living sea mammal.[14] Seeking the success of their husbands in the spring hunt, Point Hope women raised their buckets to Alignuk, the Moon Man, who controlled game.[15]

*"Taimani aġvaŋman—
umiaqtuqtuaq aġvaŋman—
aġnaq tuvaaqataa
aġvaktuam saavitchuuruq.
Aasii tavra aġviq imiqtiłługu
fresh water."*

"Traditionally when a crew captain catches a whale, the woman goes out to where the whale is caught. And the whale is given fresh water to drink."

—Ronald Brower Sr., 2002

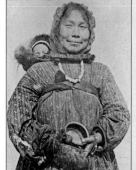
A whaling captain's wife. Nome, ca. 1901.

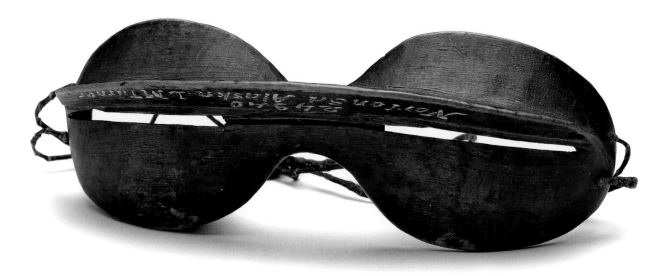

Yukłuktaak
SNOW GOGGLES

Norton Sound
Collected by Lucien M. Turner, accessioned 1876
National Museum Natural History E024340
Length 13.5 cm (5.3 in)

Ultraviolet light reflected from snow and ice can burn the retinas of the eyes, causing severe pain and temporary blindness. Snow blindness is a threat particularly during the late northern spring, when the sun's rays grow stronger and more direct. Goggles with narrow slits reduce incoming light but still provide a wide range of vision.[16]

Iñupiaq eyeshades were made in several shapes and styles. This pair from Norton Sound has long, narrow eye slits, a visorlike ridge for additional shade, a notch for the nose, and a leather strap.

"Yukłuktaak [snow goggles]… I got snow blind once, and I had to stay in the house for three days…. If you get snow blind, you're worthless. It's painful."

—Oscar Koutchak, 2001

Wearing snow goggles. Barrow, ca. 1925.

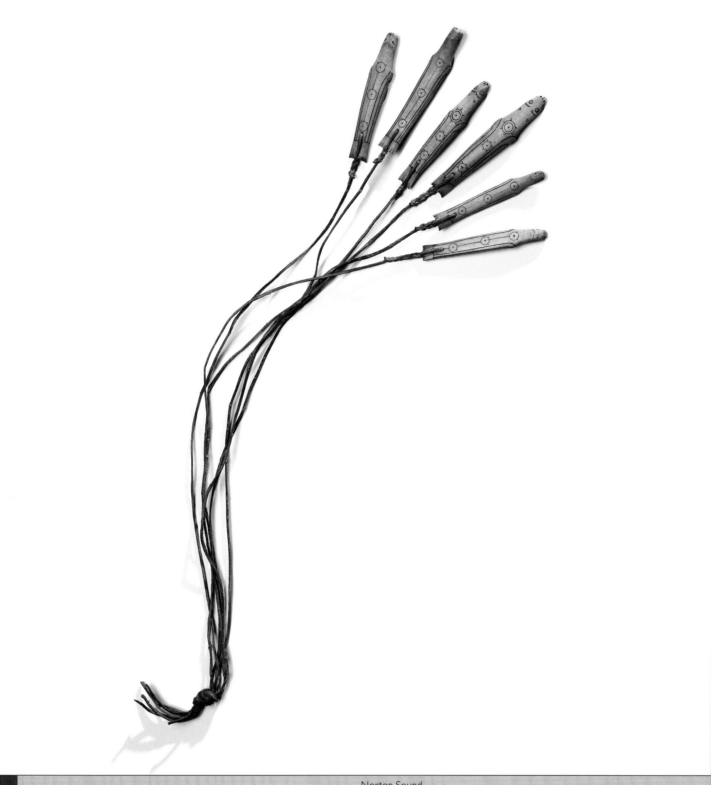

Tiŋmiagniasutit
BOLAS

Norton Sound
Bequeathed by Mrs. Sarah Imhof, accessioned 1966
National Museum of the American Indian 238986.000
Length 61 cm (24 in)

The bola is a throwing weapon used to bring down flying ducks and geese. It consists of weighted strings that fan out in flight.[17] The bone weights of this set are in the form of seals and are adorned with circle and dot designs.

Paul Ongtooguk described the use of bolas: "My experience with them was primarily in the early spring out on the sea ice, when it's warm with high humidity and fog. There are certain points where the birds pass over, and in the fog they stay down low and fly slowly. The fog also makes it hard for them to see and track you.… If one of the bola ends connects with a bird, the others will wrap around it like a spider web. The birds lose wing control and fall to the ground. You have to be ready to whack them. You have a walking stick for checking the ice, and you hit them with that." He added, "The bola is better than a shotgun, because it is reusable, home-made, and most of all silent. Birds in the area don't know that you are there."[18]

Throwing bolas. Wales, ca. 1910.

"The throwing isn't twirling around; it's more like a fastball for a baseball pitcher. You throw it off your heel, twist your torso, and put your arm into it. And you have to lead the bird—that takes practice."

—Paul Ongtooguk, 2009

IÑUPIAQ

Puktaġun
NET FLOAT

Point Hope
Purchased 1936
National Museum of the American Indian,
191315.000; Length 13 cm (5.1 in)

A dark night in early winter is the time to net seals under the sea ice. The leather nets, which have weights along the bottom and a wooden float at one end, are strung beside an open-water lead or around an area where a seal has its breathing hole. Hunters make tapping or scratching noises to lure the animals into the net, which is invisible in the pitch-black sea.[19]

Sylvester Ayek observed that this wooden net float represents a woman, with female chin tattoos.[20] Her eyes are old Venetian glass trade beads, a type common in Alaska before 1840. The clicking of the float's ivory rattles, carved with seal images, probably helped to attract the animals.

The ivory gauge shown here was a tool for net making, used to measure the distance between knots so that the mesh would be just large enough for a seal's head. Numerous seals are etched on the tool, indicating how productive netting can be; dozens of seals may be caught on a good night.[21]

Nigaqtutilaaġun
NET GAUGE

Alaska
Donated by Mrs. Thea Page 1915
National Museum of the American Indian,
045319.000; Length 28 cm (11 in)

"You have to set a seal net down in a lead, below the ice. Then you have to wait for the daylight to stop. You have something to make noise, and the seal's swimming by in the open lead, and he hears the sound. And then he'll come over and listen to what's going on…. Then he's tangled up in the net."

—Kenneth Toovak, 2002

A hunter returns home under the northern lights. Nome, ca. 1960.

Uluuraqpak
WOMAN'S KNIFE

Point Hope
Purchased 1936
National Museum of the American Indian 191319.000
Length 25.5 cm (10 in)

Historically the *ulu* or *uluuraq* (woman's knife) was nearly universal among Arctic peoples and is still common today. The addition of the *-pak* suffix to the name for this knife signifies a large size. *Uluuraq* blades are often semicircular but can be other shapes as well. They were originally made of ground slate or chipped stone, later replaced with steel.[22] This knife has a steel blade, wooden handle, and ivory retainers.

According to Sylvester Ayek, this *ulu* would be used for flensing whale blubber or cutting up large mammals.[23] The maker would have soaked the handle in water, inserted the blade, and then let the wood dry around it for a shrink-tight fit.

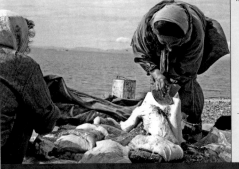

Bonnie Thomas using an *ulu*. Kotzebue, 1962.

"This can be used for many things. It can be used for flensing fat off seals. It can be used for skinning a variety of animals. It can be used for cutting a whale. It's a multipurpose heavy tool with all-around practical uses."

—Ronald Brower Sr., 2002

ABOVE: Migrating caribou, some of more than 100,000 animals that make up the Porcupine Herd, cross the Niguanak River in the Arctic National Wildlife Refuge near Kaktovik, July 1992. The group includes calves that were born on the tundra just two months earlier.

OPPOSITE: Thomas and Ruth Rulland of Anaktuvuk Pass head out with snowmobile and sled to hunt for caribou, 2003.

IÑUPIAQ RESIDENTS OF BARROW, Wales, Point Hope, Wainwright, and other coastal communities, are the Taġiuqmiut, "people of the salt." People who live in the interior are the Nunamiut, "people of the land." The Nunamiut used to be nomadic, moving from camp to camp with their dog teams, hunting and fishing to take care of their families. They packed light and lived in skin tents, tracking the caribou and mountain sheep.

My husband, Patrick Hugo, was one of them. For the first six years of his life his family traveled like that, but when the government built a school at Anaktuvuk Pass in 1959 they settled there. I was twenty when we married, and I moved to my husband's tiny village from the "big city" of Barrow (population, forty-five hundred). Unlike Barrow, there was no natural gas or electricity, and we had to use Coleman lanterns or hurricane lamps or sometimes candles. Only one small plane came each week. Many times I wondered, "What did I get myself into?" But that community was kind to me and embraced me as its own.

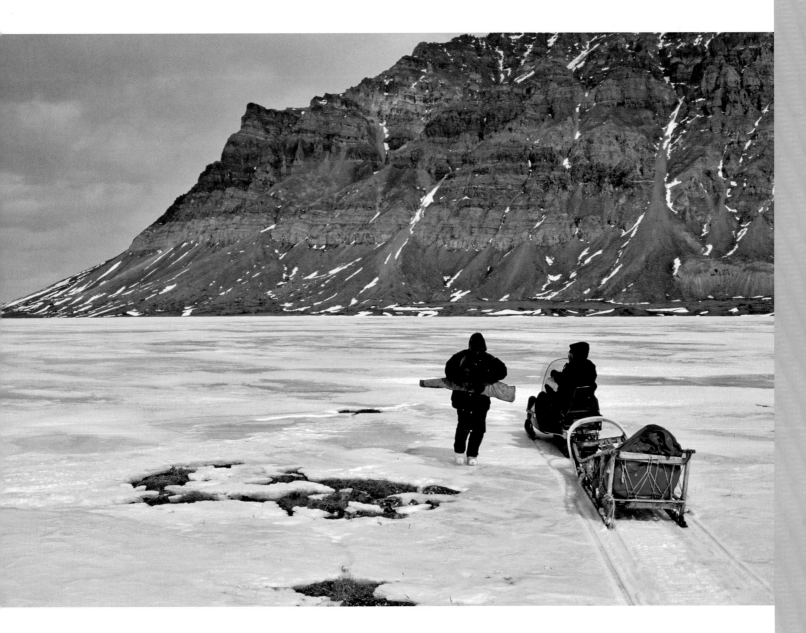

When my oldest son was about eighteen months old he became sick, and I didn't know what to do. There was no hospital or way to communicate with the outside world. I just had to pray and do the best I could, remembering the things that my mother did for us. He recovered, but I decided that as a good mother I would have to be able to really take care of my children. More than that, I should step up and become a health aide to help others. Eventually I trained as a physician's assistant at the University of Washington and followed that career for twenty-one years.

My parents, Charlie and Mary Edwardsen, were my foremost educators. They taught me my life skills and language. When I came to awareness as a young child, all the people who took care of me spoke Iñupiaq, so that was my first language. I had thirteen siblings, and we were a very close-knit family. We all worked and played together, and I was really fortunate to have such wonderful parents. Our father would trap and hunt. We never went hungry and had the best furs for our parkas. Our mother was a fine seamstress, and we learned to sew by helping her. My mother and grandmother taught us to how to care for a family and to do things in a spirit of cooperation and harmony.

I was a child during the Bureau of Indian Affairs era, when we were punished for speaking Iñupiaq in school. My first day in class was the saddest one of my young life. I *had* to learn English, and that was important, but my own language is something that I value dearly and have always guarded. It is a gift from my parents and ancestors, and I want to pass it on to my children and grandchildren and anyone who wants to learn. I took a degree in Iñupiaq from the Alaska Native Language Center, at the University of Alaska Fairbanks, and now I teach an intensive language program at Hopson Middle School in Barrow. We found that a lot of children at that age already knew how to read and write some Iñupiaq but could not speak or comprehend it well. We focus on that; the class is very interactive and fast-paced, and only Iñupiaq is spoken. We start by getting them to use basic nouns like *aġnaq* (woman), *niviaqsiaġruk* (girl), *nukatpiaġruk* (boy), and *nanuq* (polar bear). We go on from there until the kids are speaking confidently in whole sentences.

OPPOSITE: **Women of Barrow's Edwardsen Crew sew a new *umiaq* cover out of bearded seal skins, in preparation for the 2003 whaling season. The work took place inside the community's Iñupiat Heritage Center.**

LEFT: **Jonas Aakataq Ramoth, originally from Selawik, teaches Iñupiaq words to preschoolers at the Nikaitchuat Ilisagviat language immersion school in Kotzebue, 2005.**

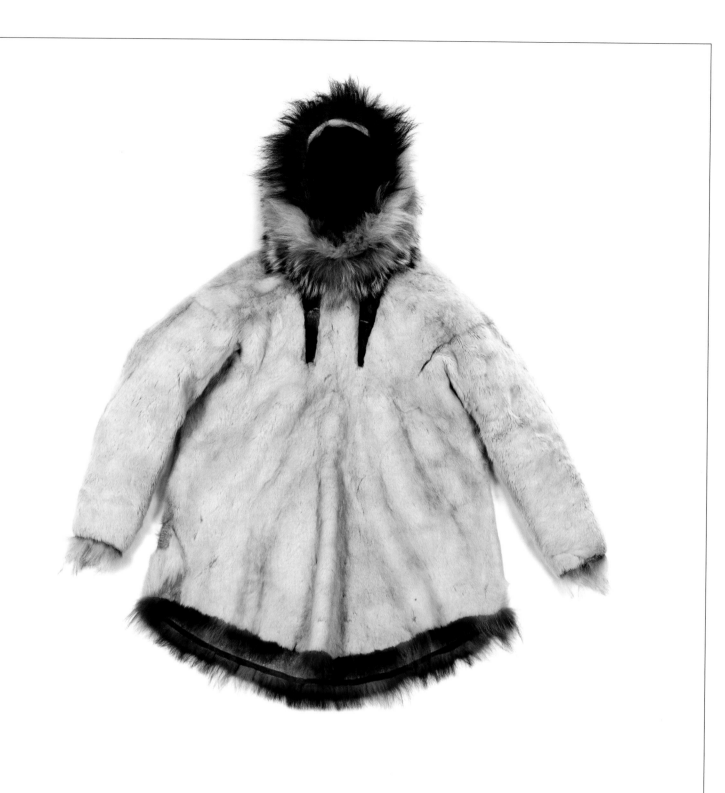

Qusuŋŋaq

MAN'S PARKA

Alaska
Collected by J. Henry Turner, accessioned 1892
National Museum Natural History E153734
Length 129.5 cm (51 in)

Iñupiat who lived on the coast traded sea mammal hides and blubber to interior villages in exchange for the pelts of caribou, wolves, wolverines, foxes, and mountain sheep.[24] The sheepskins used for this Arctic coast parka probably came from the Brooks Range. Men's parkas extended to the thigh and were cut straight across on the bottom, whereas women's parkas were longer (see opposite), with U-shaped edges across the front and back on the bottom.[25]

Martha Aiken, Jane Brower, Ronald Brower Sr., and Kenneth Toovak discussed this parka and said that mountain sheep needed for winter clothing were hunted in late summer, when their fur is thickest. Skin from the head of a sheep was used for the hood, which has a ruff with three layers of fur consisting of wolverine, wolf belly, and wolf back, from the inner layer to the outer, respectively. The dark-colored *manusiñiq* (tusk-shaped gores on the chest) are made of caribou fur, with a straight design for a man; for a woman these would be wider and slightly curved. The bottom of the coat is trimmed with wolverine. The parka could be worn for spring whaling or any kind of winter hunting. Underneath, a person wore an *atigi*, or inner parka, made of caribou or caribou fawn skin.[26]

Nungoktok. Noatak, 1927.

"In August, *annuġaaksrat annuġarriaksrat turġutilaaŋat naammaguuruq* [fur gathered for winter parkas is just right, the thickness of fur is just right]. August-*mi* [in August], last part of July."

—Jane Brower, 2002

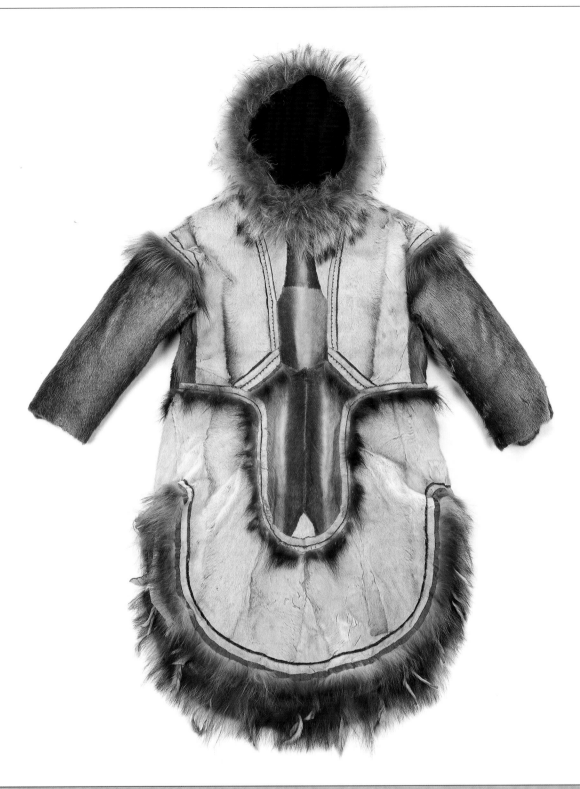

Qusuŋŋaq
WOMAN'S PARKA

Point Barrow
Collected by Lt. Patrick H. Ray, accessioned 1883
National Museum Natural History E074041
Length 132 cm (52 in)

This is a young woman's fancy parka for festivals and ceremonies, made of reindeer skin. The U-shaped bottom edge is a traditional feminine style that is no longer made.[27]

Reindeer are semidomesticated caribou and were historically acquired in trade from Chukchi herders on the Siberian side of Bering Strait. Starting in 1892, the U.S. government established reindeer herds in northwest Alaska. Their light-colored fur is highly valued.[28]

The term *qusuŋŋaq* is used for a parka worn with the fur facing out. According to Martha Aiken, Ronald Brower Sr., Jane Brower, Doreen Simmonds, and Kenneth Toovak, the white fur on this parka is from the belly of the reindeer, and the brown fur is from its other parts, including leg skins used to make the vertical panels. The seams and bottom are trimmed with wolverine fur. Along the lower edge are a strip of alder-dyed skin, and decorative lines of brown fur and red yarn.

Elders added that the fine work shows the young woman's skill as a seamstress. When people gathered at festivals they were looking for marriage partners, and if a woman could sew clothing like this she would be highly prized.

Norwadluk and Nora. Wales, ca. 1905

"There were diseases that wiped out many of the people who had the skills to make clothing like this in the early days. First there was starvation followed by introduced diseases, until right up to the 1930s. And people began changing their style of clothing, probably as a result of that."

—Ronald Brower Sr., 2002

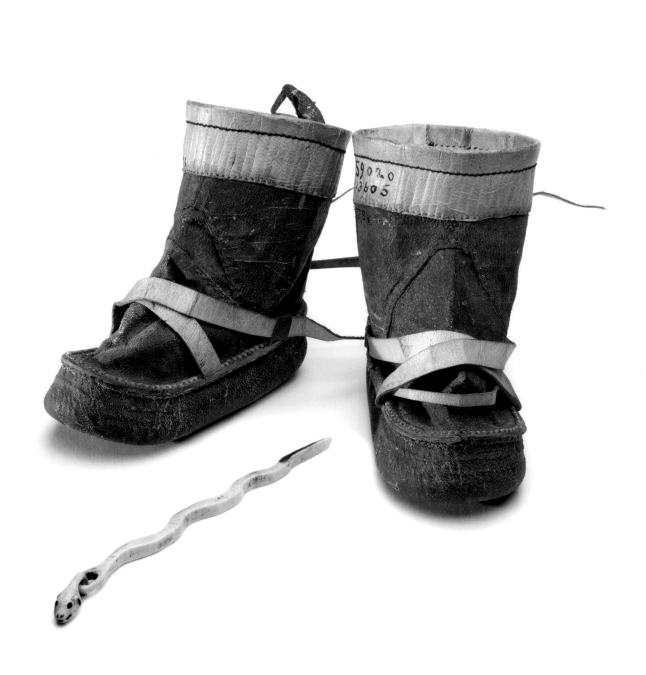

Piñiqqak	Northwest Alaska	**Kuuŋnaqsuun**	Northwest Alaska
CHILD'S BOOTS	Bequeathed by Victor J. Evans, accessioned 1931	**BOOT CREASER**	Collected by Edward W. Nelson, accessioned 1882
	National Museum Natural History E359020		National Museum Natural History E063806
	Length 16 cm (6.3 in)		Length 20.3 cm (8 in)

IÑUPIAQ

According to Barrow elders, these short summer boots for a child have uppers made of seal-skin dyed with alder bark; tops and straps made of winter-bleached seal; and soles made from young bearded seal hide. The soles were chewed to soften the leather.

Kenneth Toovak said that children wore this type of boot for the Nalukataq, or whaling festival.[29]

Iñupiaq women in some areas used a special bone or ivory tool to crease neat pleats into the toes and heels of skin boots.[30] The sinuous boot-creasing tool seen here is decorated with the carved image of the head of a polar bear. At Barrow and other locations along the north Alaska coast, women used only their teeth for crimping.[31]

Girls wearing boots. Nome, ca. 1915.

"In the old days all the men, women and children dressed in their finest clothes after the feast, when they were beginning to do the celebrations and dances.

Ronald Brower Sr., 2002

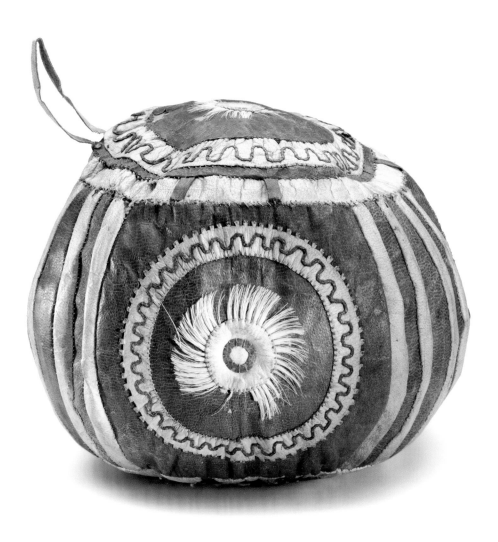

Wales
William M. Fitzhugh Collection, accessioned 1936
National Museum of the American Indian 193368.000
Diameter 19.4 cm (7.6 in)

IÑUPIAQ

Aqsruq
HIGH-KICK BALL

High kick is a traditional test of agility in which both feet are used simultaneously. Early Western visitors to Iñupiaq communities saw children and adults kicking balls that were suspended at head level or higher; with each successful attempt the ball was raised.[32] This fancy ball is stitched from dyed and bleached pieces of leather and stuffed with reindeer hair, with a loop for hanging.

Jacob Ahwinona said his father taught him the proper technique. The jump and landing have to be perfectly silent. The competitor thrusts from the knees, legs together and eyes up, then kicks straight out.[33]

High-kick competitions were once part of Kivgiq.[34] As each man entered the qargi, he tried to kick an inflated animal bladder suspended from the ceiling.[35]

An Iñupiaq story tells of a young woman who owned two balls; the larger was the sun, and the smaller the moon. The sun ball fell (or in one version was dropped by Raven) and burst open, bringing light to the world.[36] The circular designs seen on this kick ball represent the sun and commemorate this ancient story (also seen on Yupik ball, p. 95).

High-kick competition. Nome, July 1914.

"The high-kick games, when they played in the qargi—they usually do that when the different tribes get together [Messenger Feast]. Each tribe tries to beat the other's kick. When I was young, I used to kick that high [above the head]."

—Jacob Ahwinona, 2001

NALUKATAQ (BLANKET TOSS) IS A TIME of celebration when spring whaling has been successful. It is a kind of all-day picnic. People visit with friends and family at the windbreaks that the crews set up by tipping the whale boats onto their sides. At noon they serve *niġliq* (goose) soup, dinner rolls, and tea. At around 3:00 P.M. we have *mikigaq*, made of fermented whale meat, tongue, and skin. At 5:00 they serve frozen *maktak* (whale skin and blubber) and *quaq* (raw frozen fish). It's wonderful to enjoy these foods, to talk, and catch up with everyone at the end of the busy whaling season.

The kids play at *nalukataq* all day, but in the evening it is for adults. The "blanket" is made of bearded seal skins stitched together. Men and women hold handles that are sewn around the edge, pulling the skin tight to send a person high into the air. Some of the jumpers can't even stand up, or they get terrified and fall down. Some are so good at it that they can go until everyone's arms are tired. They are acrobats, even using a sealskin jump rope while in the air.

Another game is *agsraatchiaq*, or high kick, where the challenge is to leap off the floor and kick a ball that is suspended six or seven feet in the air. It was traditionally played in winter, when people were often confined indoors because of the extreme cold, darkness, and blizzards. The high kick,

seal hop (jumping forward on your knuckles and toes), and other competitions were ways for hunters to keep up their skills and stay agile. Today these games are featured in the World Eskimo-Indian Olympics.

Kivgiq, the Messenger Feast, was held in the *qargi* (ceremonial house). The *umialgich* (whaling captains) in one community sent messengers to the leaders of another, inviting them and their families to come for days of feasting, dances, and gift giving. They exchanged great quantities of valuable things—piles of furs, sealskins filled with oil, weapons, boats, and sleds. That took place until the early years of the twentieth century, when Presbyterian missionaries suppressed our traditional ceremonies, and many of the communal *qargich* in the villages were closed down.

OPPOSITE: A Nalukataq jumper at Barrow in 1992, backlit by late-night summer sun

ABOVE LEFT: A contestant in the One Foot High Kick event at the World Eskimo and Indian Olympics in Anchorage, 2007

RIGHT: The Barrow Dancers performing at Kivgiq in 2005. The annual celebration in February attracts performers from Alaska, Russia, Canada, and Greenland.

In 1988, Mayor George Ahmaogak Sr. thought it was important to revitalize some of the traditions from before the Christian era, and Kivgik was started again. Today it is held in the high school gymnasium. People come to Barrow from many different communities to take part in the dancing and *maġgalak*, the exchange of gifts. You give presents to people who may have helped you or to those whom you want to honor. When you receive a gift you must dance with that person. People bring different foods and furs and barter for what they want. Barrow has few berries, so people who live there look for "berry buddies" from Point Hope and other places where *aqpik* (salmon berries) grow. Visitors from Anaktuvuk Pass bring sheep meat and dried caribou to trade. Kivgiq brings us together as one people, just as it did in the time of our ancestors.

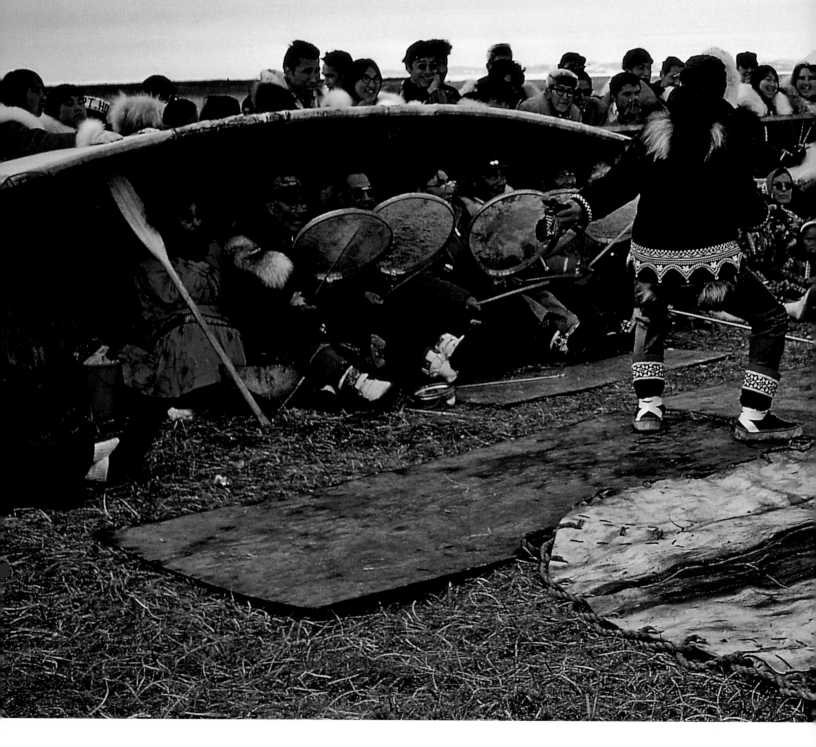

FIRST SEAL HUNT

Paul Asicksik Jr.

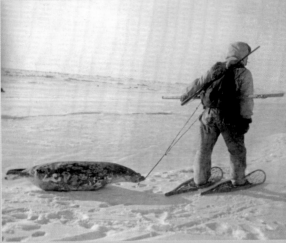

A seal hunter returns to Nome from off the sea ice, 1930s.

MY FATHER TOLD ME, "When you catch your first seal, you can't keep it." That's the Iñupiaq way of looking at it—your first catch goes to an elder or someone else in the village who needs it. A portion of every animal after that is also for others. That teaches us not to be stingy and to think about our community. It teaches us to respect the land and the animals, to use them carefully.

My first seal hunt was at Shaktoolik, where I grew up. Hunting is different today from in the past; a rifle is the main weapon instead of a harpoon, and we travel in an outboard-powered skiff rather than a *qayaq* or an *umiaq*. The modern boats are faster, but we've lost the element of stealth. A *qayaq* has a driftwood frame and a seal-skin cover, so it sounds just like an animal in the water, perhaps a seal that's bouncing up against a piece of ice. But the animals know a metal-hulled boat is something foreign.

On that first hunt I was with my dad and cousin, out in Norton Sound. When a seal popped its head out of the water, I saw it first and raised my rifle. I looked at the animal, and our eyes locked. We are taught not to let this happen, because it makes you pause, and the seal has a chance to dive down. But I was only a young boy and let it look me right in the eyes. A thought arose in my mind, and I realized it came from the seal; it asked, "Will you waste?" I replied without words, "I will give you as a gift, and everything will be put to good use." The seal knew what we were from the sound of the boat, and he saw me with the gun. But he turned his head and gave me the shot I needed.

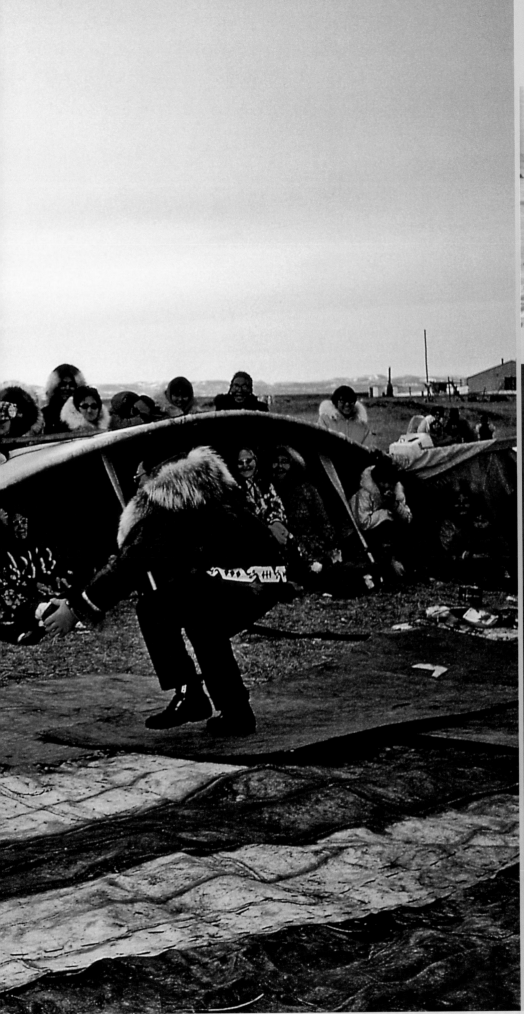

Nalukataq dancers at Point Hope, probably in the early 1970s. Drummers and singers are seated inside tipped whaling boats. A bearded seal skin tossing blanket is spread out on the ground behind the dancers.

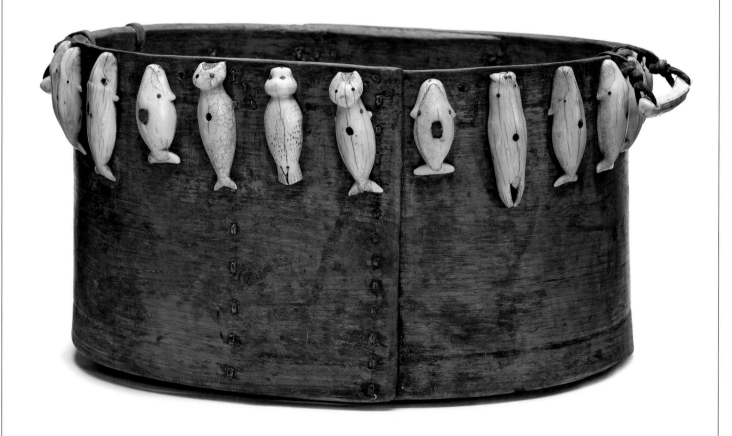

Kayukaq
CEREMONIAL BOWL

Wales
Purchased 1935
National Museum of the American Indian 188306.000
Diameter 47.8 cm (18.8 in)

Wooden bowls and trays with carved bottoms and sides made of steam-bent wood were used for serving food.[37] Large decorated vessels like this one from the Bering Strait village of Wales were employed in festivals and feasts.[38] The interior is stained black from oil.

Elders Jacob Ahwinona, Marie Saclamana, Branson Tungiyan, and Estelle Oozevaseuk said that the ivory carvings represent adult bowhead whales, yearling bowheads, a beluga, seals, and possibly gray whales. Two of the bowheads have blue beads on their backs, and nearly all the figures now have holes where beads or stones were once present. Ronald Brower Sr. said that blue beads are placed on whale figures to mark the location of the animal's life force and that this is where the harpooner aims.

Elders observed that several of the whale figures have walrus or seal heads and that very good hunters sometimes glimpse such magically transformed creatures. The carvings affixed to the bowl may represent one man's lifetime of hunting and visionary encounters at sea.

"The person who made this has seen animals change into something else.... It could be years since they've seen it, but they can carve ivory to make the image of what they have seen.... Those aren't just imaginary things."

—Jacob Ahwinona, 2001

Frank Ellanna serves *akutuq*. King Island, 1938.

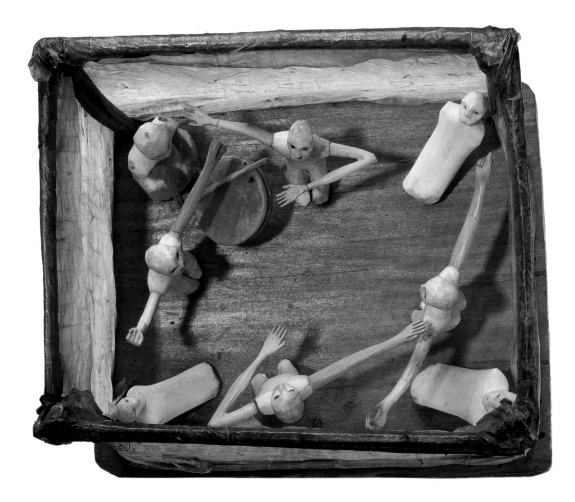

Qargi
DANCE HOUSE AND SHAMAN'S RITUAL (MODEL)

IÑUPIAQ

Kotzebue Sound region
Collected by J. E. Standley, accessioned 1916
National Museum of the American Indian 056064.000
Width 13.5 cm (5.3 in)

The Iñupiaq shaman *(aŋatkuq)* was powerful and sometimes feared. In addition to healing the sick, summoning game, and foretelling the future, shamans—both men and women— were called upon to control the weather, find the lost, and perform other feats of magic and prophecy. They were assisted by supernatural animals, birds, and deceased people, called *tuuŋat* (helping spirits). Some shamans were malevolent and were believed to bring death, sickness, or famine.[39]

This Kotzebue Sound model of a shaman's ceremony includes a drummer (who is possibly the shaman), several dancers, and spectators. Drumming and song summoned the helping spirits and induced a trance, during which the shaman's soul left his body to fly to other worlds.

A shaman from Kotzebue Sound said, "In the moon live all kinds of animals that are on the earth, and when any animal becomes scarce here the shamans go up to the chief in the moon and, if he is pleased with the offerings that have been made to him, he gives them one of the animals that they wish for, and they bring it down to earth and turn it loose, after which its kind becomes numerous again."[40]

Inside a *qargi*. Wales, 1906.

"When I was describing those things that were used by shamans, we are reminded by our elders that that kind of life has passed…. The traditional lifestyle before Christianity is gone. And so are the powers associated with that. Because today our people have accepted a new faith and live a different lifestyle, which does not require the old way of life in order to be successful."

—Ronald Brower Sr., 2002

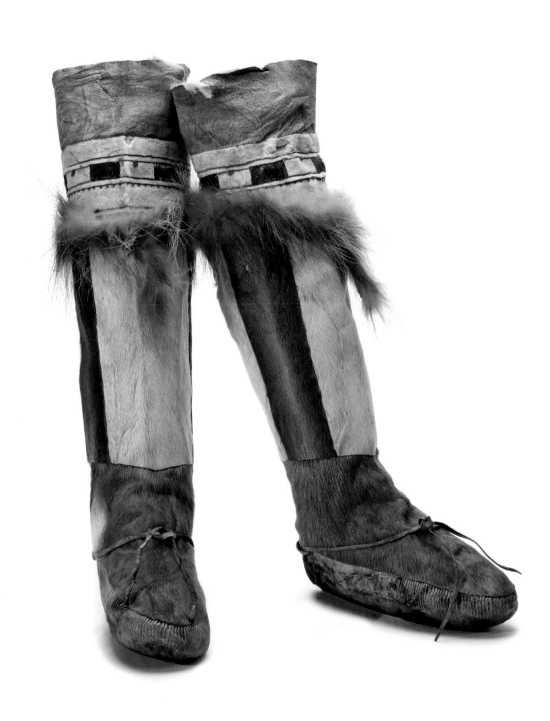

Point Barrow
Collected by John Murdock, accessioned 1892
National Museum Natural History E153892
Height 50 cm (19.7 in)

Atikullak
DANCE BOOTS

Ronald Brower Sr., Jane Brower, and Kenneth Toovak identified these as a man's caribou skin dress boots for winter ceremonies and dancing. A man would tuck the undecorated tops inside his short dance pants.[41]

The upper parts of the boots are alternating vertical strips of white caribou belly and brown caribou leg skin. Geometric bands around the top include reindeer fur, caribou fur, and red yarn. The ruffs are wolverine, and the straps are sealskin. The soles are made of bearded seal hide, heavily scraped to make it soft and light in color. Lightly scraped bearded seal is black and waterproof and was used for soling summer boots.[42]

Insulating layers worn inside boots included grass socks, caribou skin socks, sealskin slippers, grass footpads and stuffing, or shavings of whale baleen.[43]

Drumming and dancing. Wainwright, 1920.

"Iñilgaan nauŋ qaa tarrani qargimi."

"Long ago they danced right there at the community house."

—Oscar Koutchak, 2001

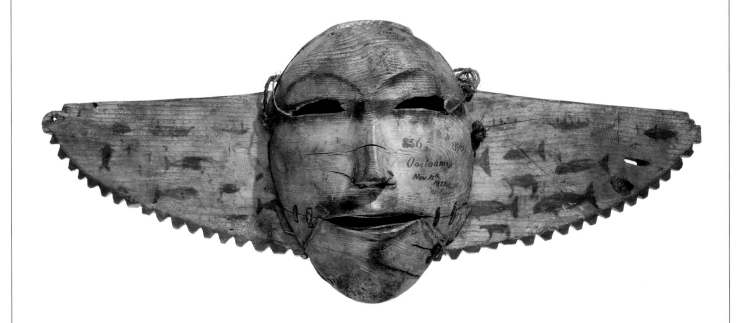

Kiiñaġuq
WHALING FESTIVAL MASK WITH PLAQUE

Point Barrow
Collected by Lt. Patrick H. Ray, accessioned 1883
National Museum Natural History E089817
Length 47.5 cm (19 in)

At the end of spring whaling in Barrow, men who had served on successful crews danced first in the ceremonial house and then at each home in the village, wearing wooden masks on their faces and wooden plaques around their necks.[44] Mask and plaque are tied together in this set. Painted images include whales, whaling boats, and polar bears. Underneath the mask, painted on the plaque is the image of a standing man; he grasps a whale in each hand and stands on top of an *umiaq*. John Murdoch recorded that this was Kikamigo, a deity believed to control the supply of whales and other sea mammals.[45] White feathers were formerly inserted along the top edge of the plaque, enhancing its resemblance to a pair of wings.

Black paint around the eyes and mouth of the mask may represent smudges of soot that whalers wore on their faces. The mask is encircled by a groove in which the wearer secured the edge of his parka hood.

Masked whaling ceremonies ended in the late nineteenth or early twentieth century under pressure from Christian missionaries, and today's elders remember little about them.

Ready to strike a whale, ca. 1960.

"Whaling is a *very* important part of our life. In many ways it's part of our sacred beliefs. Everything that we're doing during a year is dealing with whaling— some form of preparation, celebration, rites, and rituals of whaling."

—Ronald Brower Sr., 2002

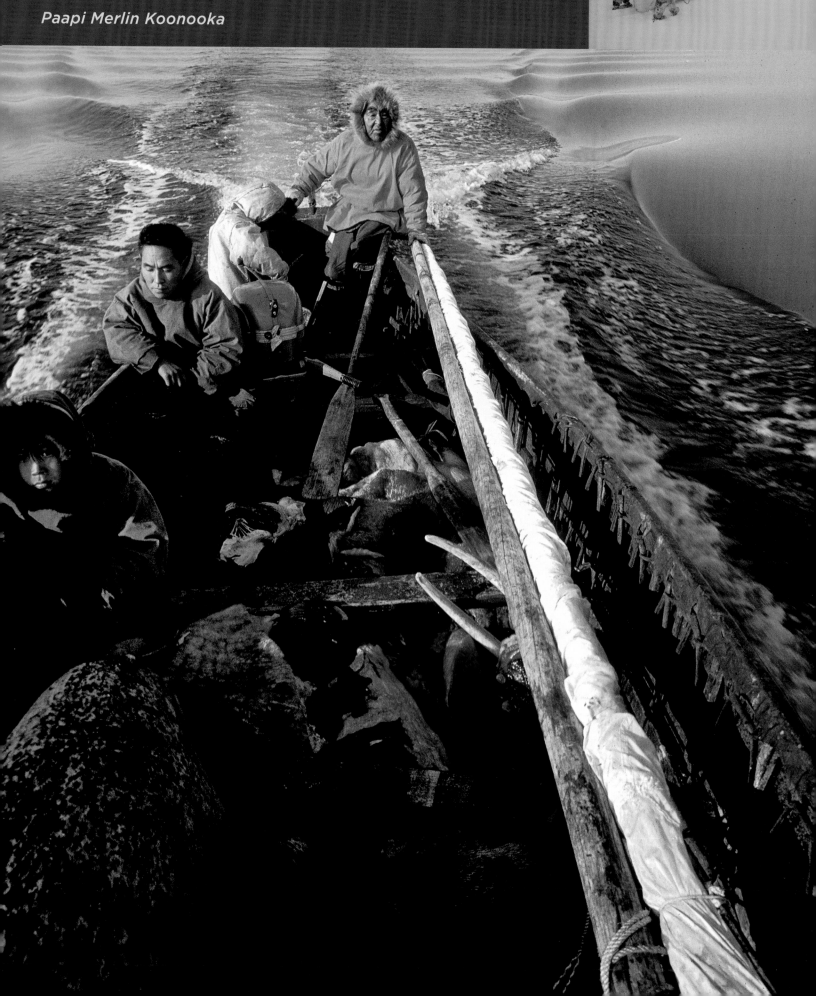

ST. LAWRENCE ISLAND YUPIK

Paapi Merlin Koonooka

SIVUQAQ, THE YUPIK NAME FOR St. Lawrence Island, means "to be wrung out." According to tradition, when the Creator finished the mainland of Alaska and Siberia, he felt that a part in the middle was still missing. He took a great handful of earth from the bottom of the ocean, squeezed it dry, and placed it between the two continents. Then he said, "There, it is complete."

Sivuqaq rises out of the Bering Sea in the heart of a vast and bountiful marine ecosystem. All around us, depending on the time of year, we have walrus, whales, and seals. Standing on the point at Gambell, you can watch ducks and seabirds flying by in endless motion over the sea.

Our island lies just below the Arctic Circle, so we are surrounded by sea ice for much of the year. The winters are long and often extreme. The wind gusts at fifty miles per hour, and the wind chill can get to minus fifty degrees Fahrenheit or lower. When spring and summer bring longer daylight and new life, people travel out from the villages of Gambell and Savoonga to their hunting and fishing camps around the island. Many of those places are ancient settlements where our ancestors lived up to two thousand years ago.

I was born and raised in Gambell and have been a subsistence hunter there for my entire life, going back to when we traveled with dog teams instead of on snow machines and all-terrain vehicles. I am a whaling captain like my grandfather, granduncles, and father before me, and I serve on the Alaska Eskimo Whaling Commission.

Marine mammals, birds, reindeer, and wild plants are important in the island diet throughout the year, far more so than store-bought foods. Late spring is the season for fishing, hunting birds and young seals, and gathering eggs. In summer, young birds that hatched in the spring start flying, and they are fat, tender, and delicious. We take seagulls, cormorants, eider ducks, geese, puffins, auklets, sandhill cranes, and many others. On the tundra and mountainsides people gather *ququngaq* (willow leaf), *nunivak* (roseroot), *angukaq* (dwarf fireweed), and various edible roots. In late summer the *aqavzik* (cloudberry) and *pagunghaq* (crowberry) ripen, and to us these are great delicacies, like apples, oranges, and grapes.

OPPOSITE TOP: Hunters launch a skin-covered *angyaq* hunting boat at Gambell, 1958.

OPPOSITE: Philipon Campbell (at stern) and family return home under power after a successful walrus hunt. The boat's furled sail and paddles are for silent travel while hunting.

RIGHT: Anders Apassingok of Gambell selects roseroot greens to be eaten later with whale or walrus meat, 2001.

Late summer and fall are prime seasons to hunt spotted hair seal, *nazighaq*, and bearded seal, *maklak*. Hunters hide in blinds up and down the coast and wait for seals to come by, positioning themselves downwind so that when they shoot one it will drift toward shore to be snagged with a throwing hook.

As fall freeze-up begins the walrus migrate south past the island. They have always been essential to our way of life. We hunt them in open water and later on the frozen ocean, making use of nearly everything as either food or material. The meat and fat are bundled into large *tuugtuq* (meatballs) to store in underground food cellars, and in the past that meat sustained our dog teams as well. Good-quality hides of female walrus are stretched, split, cured, and stitched to cover the *angyapik* (hunting boat). Walrus stomachs become heads for drums, and their intestines, ivory, and whiskers are transformed into adornment and art. Our predecessors used the skins to make tough rope and covers for the *nenglu* (traditional house) and interior *aargha* (sleeping room). They spun walrus sinew into thread and carved the tusks into tools and sled runners.

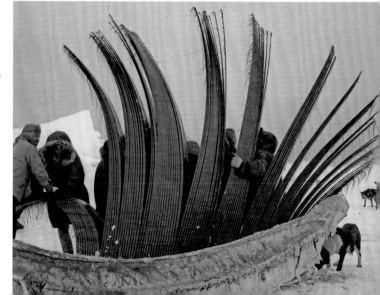

In winter, people fish through the ice for sculpins, tomcod, and crabs. It takes a lot of effort to chop a fishing hole when the ice is four to five feet thick. Later in the season we rake the ocean bottom for *uupa* (sea peach, a marine invertebrate), using poles through a large ice opening.

In spring the southern edge of the Bering Sea ice retreats northward past the island, bringing an abundance of seals and other sea mammals, including walrus cows with their calves, into our vicinity. In April or May the bowhead whaling begins. Captains and their crews really look forward to this time. Traditionally, the captain prepared for whaling in a religious way, using charms, special songs, and rituals that showed the great respect we feel for this animal. While these rituals are no longer practiced, strict hunting protocols and the responsibility of the captain remain unchanged.

A bowhead whale is so immense and powerful that hunters, even though armed with modern weapons, are really at its mercy. We use skin-covered boats and sails rather than motors during the approach, keeping absolute silence, because whales have a very sharp sense of hearing. But they know we are there even if there is no sound. That is why we say that a whale decides to let itself be taken, not the other way around. Some who have chosen to escape in the past are now very, very old, as shown by century-old bone or ivory harpoon heads that we find in their flesh. One whale provides an abundance of food that is shared with families on the island and across Alaska.

Our hunting lifestyle has never been harmful to the animal species. Nature has her own way of opening up the ice and sea for us or withholding access. During storms we have to stay at home and wait for a change. When the weather is nice, the conditions may still not be right for going out, even if walrus are floating by on top of the ice floes. Sometimes we will be punished this way if we've failed in our respect. Even the best hunter can try day after day and come home empty-handed. That is Nature's way of conservation, more effective than game laws or the U.S. Fish and Wildlife Service. But as long as the creatures make themselves available to us, we will gather them for food and traditional needs.

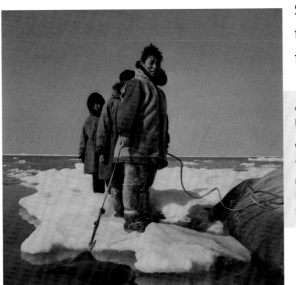

OPPOSITE TOP: **Forty-five-knot storm winds kick up snow at Gambell village on St. Lawrence Island in the spring of 2009.**

OPPOSITE BOTTOM: **Men removing baleen from the jaw of a whale killed at Gambell in April 1966**

LEFT: **Victor Campbell on an ice floe with two walrus, near Gambell in 1959. His clothing includes sealskin pants and boots. Standing behind him are his brother Wilmer and nephew Iver Campbell (facing camera).**

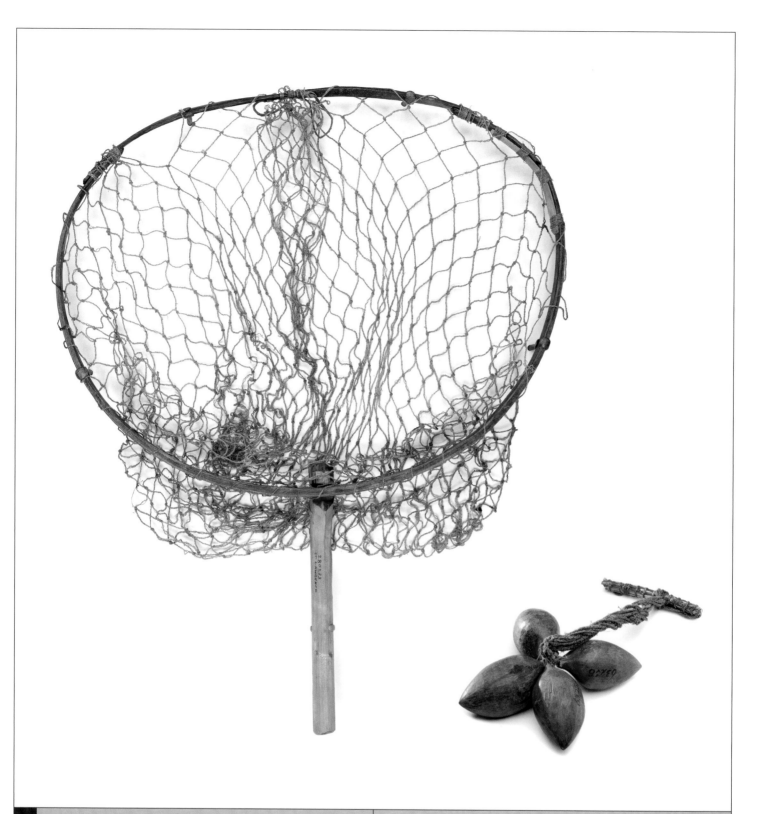

ST. LAWRENCE ISLAND YUPIK

Anaavaataq
BIRD NET

St. Lawrence Island
Collected by Riley D. Moore, accessioned 1913
National Museum Natural History E280233
Length 75 cm (29.5 in)

Avleqaghtat
BOLAS

St. Lawrence Island
Collected by Edward W. Nelson, accessioned 1882
National Museum Natural History E063258
Length 22 cm (8.7 in)

Hunters used short-handled nets to catch crested auklets at their nests and long-handled nets to take them on the wing.[1] Men and boys waited for the birds in hunting blinds at the rookery. Conrad Oozeva wrote that the birds fly upwind as they approach, so "different blinds were used depending on the wind direction.... It took a lot of practice to learn how to use those pole nets."[2] Strings of live birds served as decoys.

Bolas were thrown into flying flocks of ducks and geese. The weights spread out, wheeled through the air, and with the slightest touch wrapped themselves around a bird. Hunters sometimes kept bolas coiled on their heads when in search of game.[3] Roger Silook recalled hunting old squaw ducks, saying, "These birds fly real low, and when the moon is shining bright the men use their bolas to catch them. It is the best exercise I know."[4] Bola strings were made of sinew, and the weights were walrus ivory, bone, or wood. Wooden balls were used over water.[5] Estelle Oozevaseuk said that old women twisted some of their hair into the bola strings "so they can better entangle the birds."[6]

"So thick, going around [were] the auklets; on a sunshiny day they come just like a shadow, covering the sun."

James Aningayou, 1940[7]

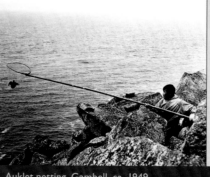

Auklet netting. Gambell, ca. 1949.

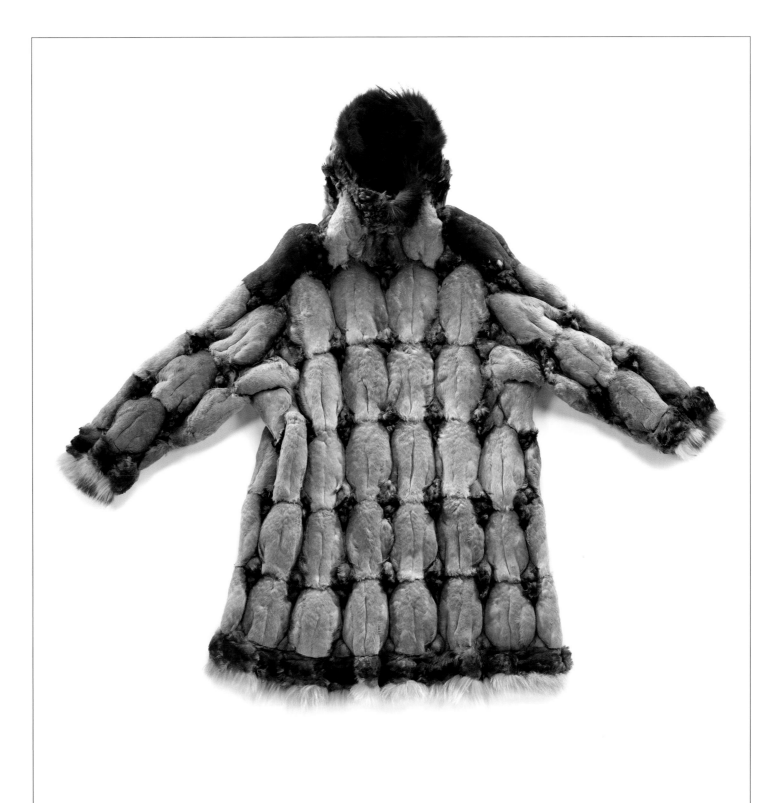

Sukilpaq atkuk
BIRD-SKIN PARKA (CRESTED AUKLETS)

Bering Sea region
Donated by Mrs. Thea Heye, accessioned 1923
National Museum of the American Indian 118010.000
Length 127 cm (50 in)

St. Lawrence Island women made light, warm parkas from the skins of ducks, cormorants, murres, loons, auklets, and puffins. Other Bering Sea cultures had similar garments, which were worn in both winter and summer.[8] Hilda Aningayou said, "Bird skins make very good and warm parkas. With a bird-skin parka, one will never freeze to death."[9]

This parka is made from crested auklets with a dark-colored guillemot skin at each shoulder. The hood ruff, cuffs, and bottom trim are dog fur.

Hunters today use shotguns to harvest auklets. Although no longer needed for parkas, the birds are an important subsistence food.[10] Estelle Oozevaseuk said other species that few people hunt anymore are dying off because animals need human attention: "If you don't hunt them, they will just go down, but if we can hunt them, they'll multiply."[11]

Men's and women's bird parkas were similar in design. A coat required about eighty-five crested auklets, thirty-five murres or puffins, or twenty-five cormorant skins, all stitched together with whale or reindeer sinew.[12]

"My grandma used to spend the whole summer cleaning auklets. Keep them in a wooden barrel, soak them in there, and then use a scraper to clean, clean, clean. The back of the skin would be white."

—Elaine Kingeekuk, 2007

Akulki (right) and his grandson Uusiiq wear bird-skin parkas. Gambell, 1912.

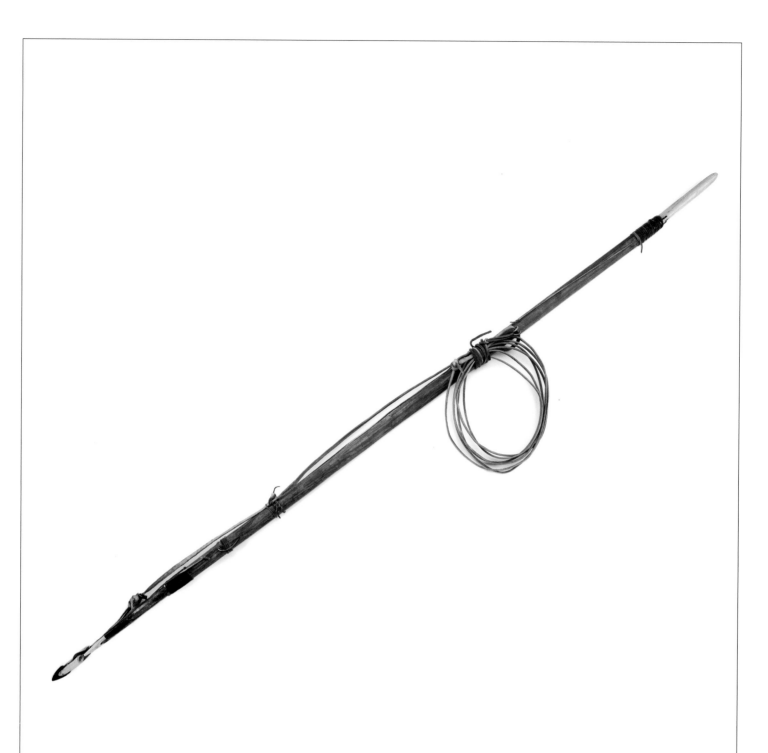

Uunghaq
WALRUS HARPOON

St. Lawrence Island
Collected by A. E. Thompson, accessioned 1924
National Museum of the American Indian 133745.000
Length 214 cm (84.3 in)

The walrus harpoon was one of a man's most important weapons, used by some until the mid-twentieth century, when hunting switched entirely to rifles.[13] The parts of an *uunghaq* include its toggling harpoon head, stout shaft, coil of thick hide line, and ice pick.

In winter, hunters would trek miles on the sea ice in search of an active walrus breathing hole, spotting it from afar by spray sent up as the animal exhaled. They stalked from downwind, moving only when any sound they made would be covered by the walrus's noisy breathing. They harpooned the walrus in its snout as it came up for air, dug in the pick end of the weapon, and braced as the animal dove and ran out a 60–150-foot-long line attached to the harpoon head. More than one man was pulled underwater to his death as the line snaked around his feet. When the walrus surfaced again, they lanced it through the heart or shot it.[14] Harpoon heads were coated with ice so they would slip smoothly through a walrus's thick hide.[15] St. Lawrence Island Yupik men used harpoons with attached sealskin floats to hunt walrus from skin boats in open water or among floating ice.

Lloyd Oovi attaches a harpoon head. Gambell, 1959.

"In the 1940s I remember seeing Samuel Irigoo and Lincoln Blassi, who would go hunting with coils of rope around their necks, and that harpoon that they'd carry along. That's how they'd get the walrus."

—Leonard Apangalook Sr., 2009

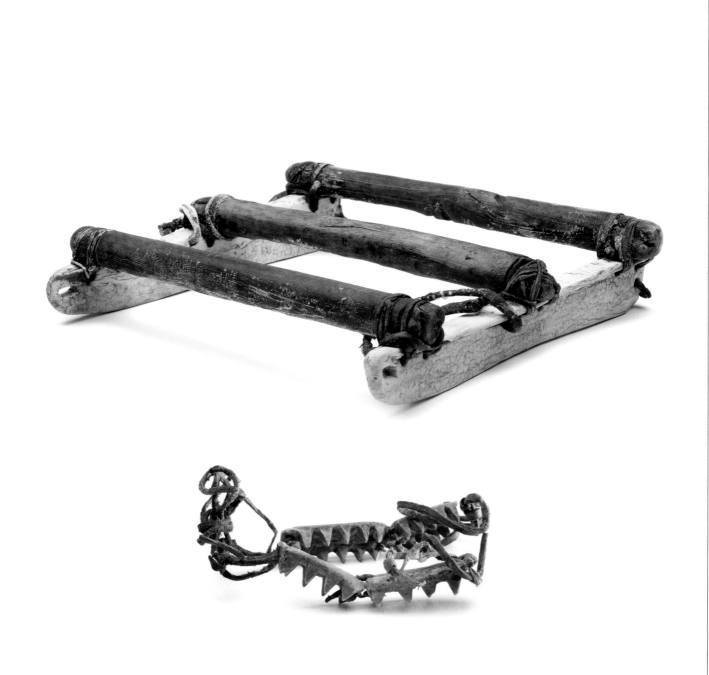

Qaanrak
BOAT SLED

St. Lawrence Island
Collected by Edward W. Nelson, accessioned 1882
National Museum Natural History E063587
Length 46 cm (18.1 in)

St. Lawrence Island Yupiget still use large skin boats *(angyapiget)* covered with split walrus hides for hunting walrus and whales among the floating sea ice. Hauling the boats to open water is a strenuous job, especially when broken ice piles up into high pressure ridges. Crews clear a pathway for the boats and pull them on top of small sleds like this example, which has runners made from walrus tusks.[16] The holes at the front are for attaching a pull rope. In the past such sleds were sometimes also used to haul meat, although baleen toboggans were more common for that purpose.[17]

Cleats for skin boots were made of walrus ivory with leather fastening straps.[18] Today, metal cleats are used when working on the slick ramps where boats are launched. Branson Tungiyan said, "We sometimes have to cut ice about ten, fifteen feet wide towards the edge of the water, and we chip it away to make a *kenileq* (ice ramp) to launch our boats. When the sun gets warm in late spring it gets very slippery, so we use those [metal cleats] under our boots."[19] Ivory cleats were invented at least two thousand years ago and have been found in sites of the Old Bering Sea and Punuk cultures on St. Lawrence Island.[20]

Kiksak
ICE GRIPPERS

St. Lawrence Island
Collected by Riley D. Moore, accessioned 1913
National Museum Natural History E280385
Length 19 cm (7.5 in)

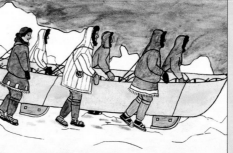

"They use two small sleds under the boat, one at each end. The little sleds were only about a foot-and-a-half long and about the same width. They used ivory for runners, which was very slick on ice."

—Roger Silook, 1976[21]

Using boat sleds to haul an *angyaq* (skin boat). Gambell, 1928.

THE PEOPLE OF THE ISLAND, have close ties to the Yupik communities of Ungaziq and Sireniki on the Siberian coast, and we speak dialects of the same language. Before the cold war began in the late 1940s, our families traveled back and forth to visit, trade, and seek marriage partners. The forty-mile trip took a full day in a skin boat using sail and paddles. Visits resumed in the 1980s after *glasnost* took hold in Russia, and now with a fast powerboat and calm seas, the crossing takes only two or three hours. In a plane the trip is only fifteen minutes.

In former times when people from the island and Siberian coast got together, they would *aqellqaghniiq*—challenge guests to contests such as wrestling and foot races. And sometimes there was war when Siberian Yupik or Chukchi raiders arrived on our shores. Even when I was a child, my parents warned us to be on the lookout for attackers who might throw us into a bag and take us away.

A terrible epidemic and famine swept St. Lawrence Island in 1878–80, killing two-thirds of the population and destroying whole villages. Yankee whaling ships that had come to the Bering Sea several decades earlier slaughtered thousands of the whales and walrus that we needed for food, and the sailors exposed us to virulent new diseases. Bad weather and the trade of alcohol may also have played a part in the disaster. Some of the clans that now live at Gambell descend from the last survivors of villages lost at that time or come from Siberian families that immigrated here in the aftermath.

Savoonga started out as a reindeer herders' camp in 1912, part of a U.S. government project to introduce these animals and rebuild our food supply. Families from Savoonga are still active in managing and harvesting the herds.

Some of my best memories from childhood are of traveling with my dad. He had a wonderful dog team, and in the wintertime we would go on the sled to trap white fox. Even in the summer we'd take it across the gravel and tundra. When I started raising a family I did the same thing. We would hitch up a team of twelve dogs to pull our heavy sled, which was nine

feet long with steel runners. As a child you really look forward to going out with your parents and elders for food gathering and hunting, because you want to learn.

I sometimes think of early days when everyone was living in *nenglut*. They would go seal hunting on the ice, pulling whale baleen toboggans behind them to bring back the meat. You had a backpack and a rifle slung over your shoulders and an ice tester to see where it was safe to walk. You had to observe the ice and the direction it was moving, making sure not to get caught on an outgoing current. Boys were doing all that by the age of ten or twelve, and by fifteen you had to know everything. Your parents and elders made sure you were ready, or you weren't allowed to go alone.

Our culture is changing rapidly in some ways, more slowly in others. Fluency in the Yupik language is declining in the younger generations, although among the older people our daily conversation continues to be in Yupik. We maintain marriage customs such as *nengaawaq*, which means that a husband works for his wife's parents' family and clan for about a year after the marriage. And mainlanders are sometimes surprised to see the way we eat. The lady of the house will use an *ulaaq* knife to cut up the meat and then throw it onto a platter for everyone to share.

There is less respect among some young people now for their parents and elders, too much television and video gaming, problems with drugs and alcohol. We need to find a balance between traditional and modern ways, and I believe the best way to do that is through education. If you can be successful in your formal education, you will be in a strong position to help preserve your Yupik heritage. I'm glad to see so many young people still going out with their families to the places where we have always hunted and fished, even if now they travel on machines instead of on foot or by dog sled. They are still eating the same foods that we have always gathered and staying connected to our land and way of life.

OPPOSITE: **Wrestlers at Ungaziq (also called Indian Point or Chaplino) on Russia's Chukotka Peninsula in 1901. Athletic contests, feasts, and trade traditionally took place whenever visitors arrived from St. Lawrence Island or from other Yupik villages on the Siberian mainland.**

ABOVE: **A family heads home after shopping at the Savoonga Native Store, 2001. Snow machines replaced dog sleds in the 1970s.**

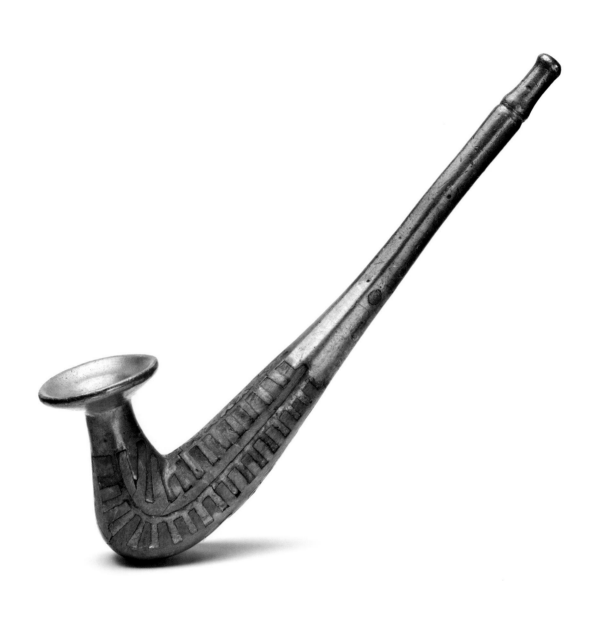

Kuynga
PIPE

St. Lawrence Island
Collected by Rev. Sheldon Jackson, accessioned 1921
National Museum Natural History E316796
Length 19 cm (7.5 in)

Russian fur traders brought tobacco to Siberia, and peoples in northwest Alaska obtained it through exchange networks and trade fairs.[22] Tobacco came to St. Lawrence Island through trade with Siberian Yupik villages, the nearest located forty miles west of the island by skin boat. Traditional St. Lawrence Island pipes, like those made in many other parts of Alaska, had wide, flaring bowls, a design that originated in China or Japan.[23]

This pipe has a lead mouthpiece and bowl and lead-filled inlays. Albert Kulowiyi of Savoonga, St. Lawrence Island, still made pipes of this kind in the 1970s.[24] He first carved the wooden part of the pipe, often selecting walnut from an old gunstock. He used a two-piece wooden mold for the stem and a three-piece mold for the bowl, pouring in a mixture of melted lead and tin. A greased wire formed the stem hole.

Roger Silook wrote, "The old people smoked by swallowing smoke until they blacked out.... The pipes were made of hardwood and inlaid with lead and with a lead bowl. They held a very tiny bit of tobacco which was filtered through reindeer hair."[25]

Smoking a pipe. Gambell, 1928.

"Some of the Siberians and their relatives came. Right after a big dinner, they started to smoke. Always passing the pipe clockwise, taking two puffs, one puff."

—Estelle Oozevaseuk, 2001

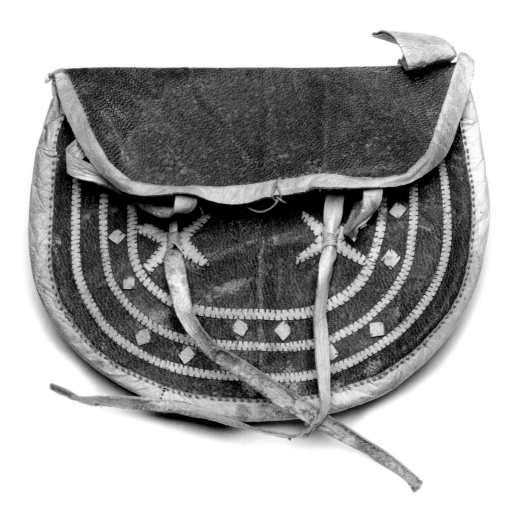

Qantaqusiq

MAN'S TOBACCO BAG

St. Lawrence Island
Collected by Riley D. Moore, accessioned 1913
National Museum Natural History E280164
Width 19 cm (7.5 in)

On St. Lawrence Island and around Bering Strait, women and men carried small decorated bags to hold a personal supply of chewing tobacco, snuff, or smoking tobacco.[26] Hilda Ainingayou, of St. Lawrence Island, said, "My mother's tobacco bag was made of a hair-seal poke cut in half. It was filled with that leaf tobacco which was very strong. When people ran out of tobacco, they would cut a piece from the tobacco-permeated bag and chew on it."[27] Siberian and St. Lawrence Island Yupik tobacco bags were decorated with geometric designs made from strips and patches of bleached, alder-dyed, and black skin.[28] A similar type of bag was used to hold gun cartridges for hunting.

Estelle Oozevaseuk said, "That is shaven skin. They tried to use a thin hair seal, shaved it, and made it into these. Again there are those stitches. We called them *siklapegtaq* [stitching in a toothlike pattern]."[29]

"That is a man's tobacco pouch.... They carried it on their belt like that all the time. And later on, we used to make similar bags for the men to hold shells for their guns, called *uunghun.*

—Estelle Oozevaseuk, 2001

Tobacco or cartridge bag worn on the belt. Gambell, 1929.

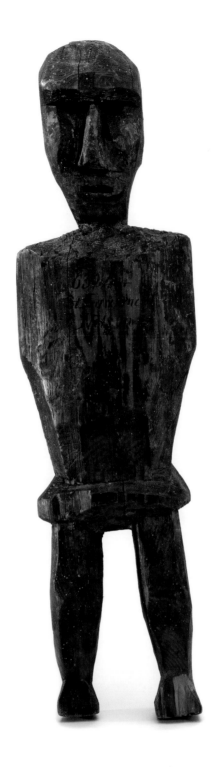

Alingtiiritaq
HOUSE GUARDIAN

St. Lawrence Island
Collected by Edward W. Nelson, accessioned 1882
National Museum Natural History E063244
Height 43 cm (17 in)

Wooden figures once served many religious purposes on St. Lawrence Island. Some were household guardians that protected families from harmful spirits, and others were used in hunting, whaling, and weather rituals.[30] After successful hunts men fed or rubbed certain wooden figures with blubber from whales, walrus, and seals.[31]

According to Vera Kaneshiro, a wooden figure like this one, which is larger than an ordinary doll and carved in a different style, would be called an *alingtiiritaq* (amulet, charm, household guardian). An *alingtiiritaq* was placed at the entrance of a home for protection against bad spirits and to scare away enemies.[32] Elaine Kingeekuk recalled that her grandmother had a guardian figure, smaller than this one, that stood in a corner; its duty was to protect the children of the house. The effigy was cared for like a child itself and was always "fed" before the family began its own meal.

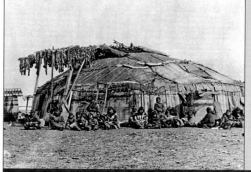

A *mangteghapik* house with walrus-skin roof. St. Lawrence Island, ca. 1897.

"They have a hole just like a mouth…. They feed it with a little seal blubber, grease, sour grease; they put it in the mouth just like a human."

—Nelson Alowa[33]

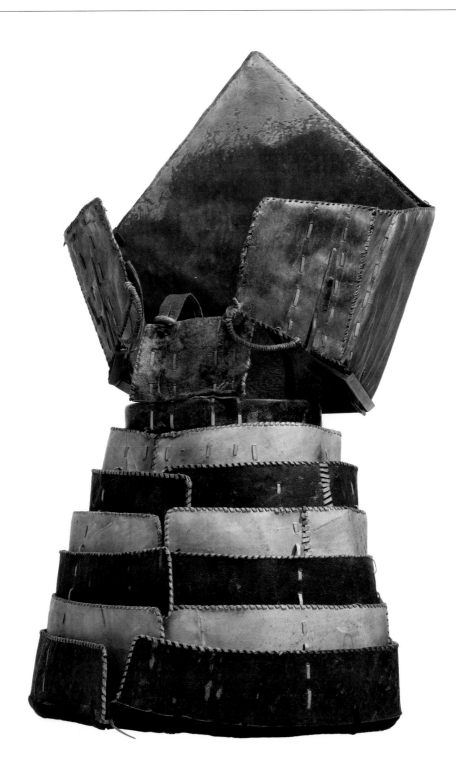

Akulghaaghet
ARMOR SHIELD

Reported as Kotzebue Sound; probably St. Lawrence Island
Donated by U.S. Department of Interior, accessioned 1910
National Museum Natural History E260564
Height 78.5 cm (31 in)

Akulghaaghet
ARMOR SKIRT

St. Lawrence Island
Collected by Riley D. Moore, accessioned 1913
National Museum Natural History E280200
Height 85 cm (33.5 in)

Warriors in northern Bering Sea societies historically wore several types of protection: bone- and ivory-plated armor and vests; metal plate armor produced by the Koryak and traded north from Japan; and hoop armor made of heavy hide, seen here with a winged shield that protected the upper body.[34] They fought with powerful sinew-backed bows, spears, and knives. Chukchi and Siberian Yupik raiders attacked St. Lawrence Island in spring and summer, trying to take valuables as well as prisoners.[35] Roger Silook wrote that when enemy boats appeared, defenders "would make it rain with arrows" to repel them.[36]

The shield was worn on a warrior's back, and its wings protected his sides and arms. This example is made of seal hide sewn over wooden slats, with a medallion embroidered on the back as a talisman. A fighter could fire his bow, then crouch and turn to block incoming arrows with the shield.

The lower part of the armor is made of six telescoping hoops of doubled bearded seal hide, alternating between dark (scraped) and light (aged) skin. The hoops were lifted and secured at the waist to enable the fighter to run or walk more freely. On top is a hide chest protector with shoulder straps.

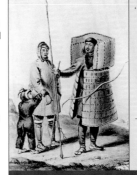

A Chukchi man wearing armor. Plover Bay, Siberia, ca. 1816.

"They have a special kind of uniform when they fight these wars. These uniforms are made out of shaved *ugruk* [bearded seal] skin. They are made by overlapping the pieces of skin…. Only the strong man's arrow goes through."

—Roger Silook, 1976[37]

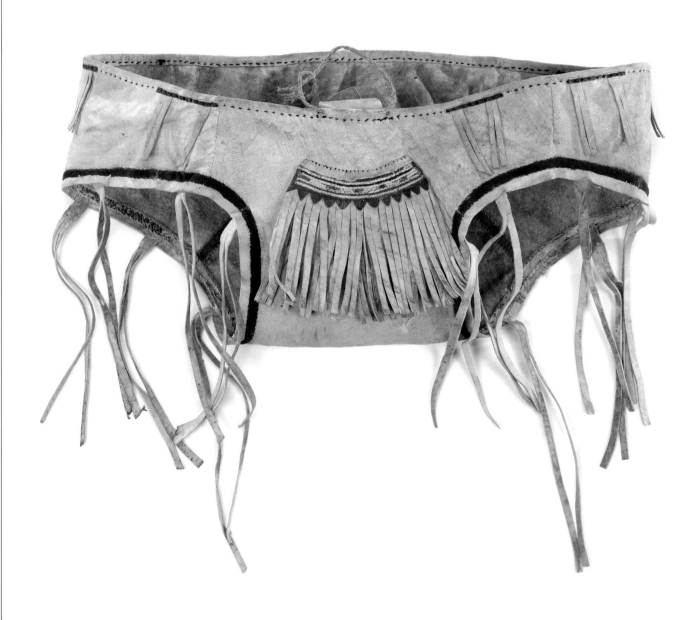

Kakak
WOMAN'S HOUSE PANTS

St. Lawrence Island
Collected by Riley D. Moore, accessioned 1913
National Museum Natural History E280117
Width 37 cm (14.6 in)

The inner chamber of a traditional walrus-hide-covered Yupik home was heated with oil lamps, which kept it warm enough for the family to wear very minimal clothing. Women often wore these fringed trunklike garments called *kakak*.[38]

The tasseled pants are made of tanned, scraped reindeer hide with borders of bleached and alder-dyed skin. The embroidery on the front panel is *segeni*, stitched designs made with long reindeer hair.[39] Short pants of this kind were customary on St. Lawrence Island, in the Yupik communities of Siberia, and among the Chukchi.[40]

Drawings by St. Lawrence Island artist Florence Napaaq Malewotkuk show Yupik women wearing the *kakak*, their bodies often adorned with bracelets, arm and leg bands, belly strings, and beaded body harnesses.[41] Some have their hair fashioned in two looped braids, an indication that they were pregnant.[42] Fancy *kakak* were worn by women up through the early part of the twentieth century but were eventually replaced with breechcloths made of blue denim.[43]

St. Lawrence Island dance. 1927.

"These house pants are for women. Women would dance in these pants, with beads around their necks.... A cover goes over the pants, and women would wear white and black panels that would hang down in the front and back.... Dyed reindeer hair was used for the stitching in the past, and then they switched to embroidery thread."

—Elaine Kingeekuk, 2007

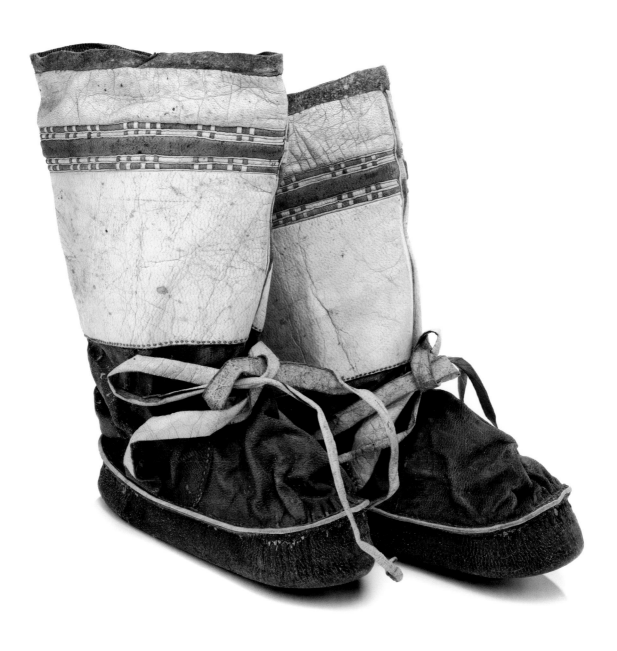

Payaaqek
BOOTS

St. Lawrence Island
William M. Fitzhugh Collection, accessioned 1936
National Museum of the American Indian 193374.000
Height 21 cm (8.3 in)

Many traditional styles of reindeer and sealskin boots have been created, some still made by Yupik skin sewers from St. Lawrence Island and Chukotka.[44] These have included winter boots for hunting on the ice, waterproof summer waders, and fancy dress boots for dances and ceremonies.

The tops of this girl's pair of dress boots are bleached sealskin, whitened by exposure to freezing cold and wind. The bottoms are seal hide that has been shaved down to reveal its inner dark brown color. Intricate designs in white and red-dyed seal leather make a band around the top of each boot. This style of decoration—called *takaghaghquq*—is a signature of St. Lawrence Island boot makers.[45] Vera Kaneshiro said that the thin red strip down the front of each boot is called *atngaghun*, a name that also refers to lines traditionally tattooed from a woman's forehead down to the end of her nose.[46] Soles are sewn to the vamp and leg with thread made from whale sinew that goes through a welt of white leather and makes a strong, decorative seam in a running stitch.[47]

"Oftentimes we'd put beads on the side for the little girls. And where the squares are up here, we strip the skin and put *takaghaghquq* [designs made with strips of sealskin, first bleached, then dyed red] just to make it fancy."

—Estelle Oozevaseuk, 2001

Wearing a *sanightaaq* (gut parka) and *payaaqek* (bleached sealskin boots). Gambell, 1929.

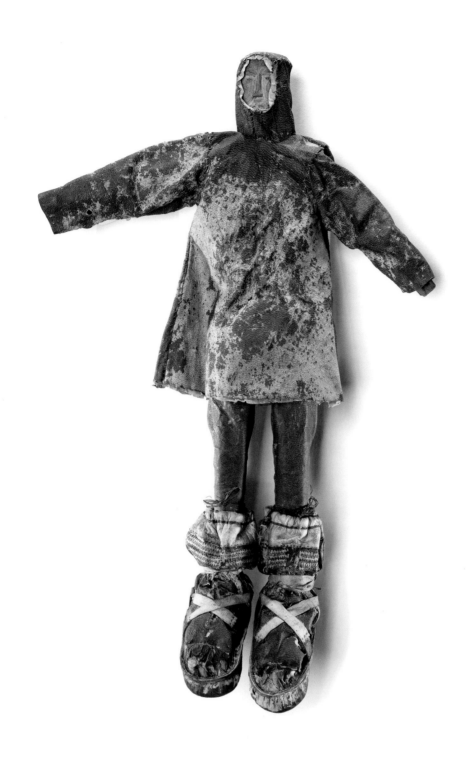

Taghnughhaghwaaq
DOLL

St. Lawrence Island
Donated by the U.S. Department of Interior, accessioned 1910
National Museum Natural History E260554
Length 44 cm (17.3 in)

Traditional play dolls from St. Lawrence Island, like those of other Bering Sea regions, were dressed in skin clothing that reflected local styles.[48] This doll has a hooded parka, pants, and boots, all sewn from shaved seal skin. The oversized boots are embellished at the top with red thread to represent the *takaghaghquq* designs (patchworks of red and white skin strips) that were applied to Yupik footwear (see p. 87). Artist Elaine Kingeekuk explained that the doll's boots needed to be extra large in order to show details of the *takaghaghquq*, which signify age, gender, and clan.[49]

The interior wooden armature of this toy was jointed to allow a child to make it walk and to bend at the waist and arms. Scraps of an 1897 newspaper were used as stuffing in the boots.

In recent years the St. Lawrence Island Yupik communities of Gambell and Savoonga have become doll-making centers. Characteristics of modern dolls include red-and-white clothing, beads used as earrings and to decorate braids, and extra large feet to show boot designs, as on this older example.[50]

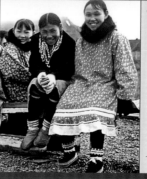

Girls at Gambell. ca. 1945.

"This embroidered work is called *takaghaghquq* This is one of the ways a man's formal boot would be made. These soles are old; *nateghqaq* we call them. Somebody, a little girl, let this little doll walk and walk. He's like a real person, and he wore out the soles. The body is made out of driftwood and the head is bark."

—Elaine Kingeekuk, 2007

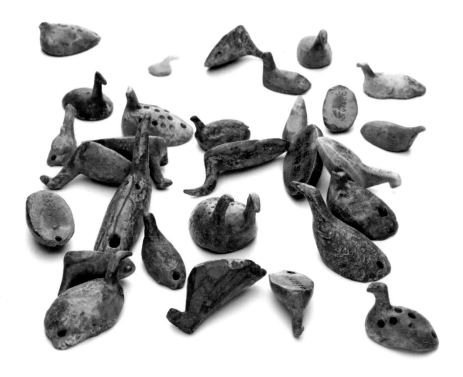

Meteghlluwaaghet

TOY BIRDS

St. Lawrence Island
Collected by Aleš Hrdlička, accessioned 1926
National Museum Natural History E333175
Length (largest) 3 cm (1.2 in)

These ivory bird carvings are pieces for a game that was played all across the Arctic. Bird figures found in archaeological sites show that the game spread across northern Alaska, Canada, and Greenland about a thousand years ago, carried by migrating Thule ancestors of the modern Inuit.[51]

Some birds land upright when tossed onto the ground, while others tip over onto their sides. Different species of ducks or geese are represented by the shapes of the birds' heads and the markings on their backs. Holes through the tails are for tying the pieces together on a string.

Estelle Oozevaseuk explained that the first round of the game was to divide the birds among the players. Each person cupped the pieces in his hands, shook them, and spilled them onto the floor, keeping only the figures that landed in an upright position. Each then "wrestled" his birds against an opponent's. He held two of the bird figures between thumb and forefinger, rubbed their heads together, and flipped them down. Birds that tipped onto their sides were "killed." The winner added the dead bird to his pile, and play continued until one person had won all of the pieces.[52]

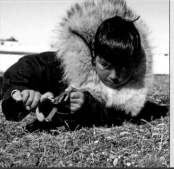

Practice bird hunting with a slingshot. Gambell, 1940s.

"That's for the bird game. It's fun. I used to make some for my children when they were small, just to keep them in one place when they were bothering me too much, asking me what to do."

—Estelle Oozevaseuk, 2001

SLEEPING MEMORIES

Jonella Larson White

Nita Tokoyu of Gambell sews strips of sea mammal intestine to make a waterproof gut parka.

MY FIRST ENCOUNTER with St. Lawrence Island historical material was in 1996, during an undergraduate internship at the University of Alaska Museum in Fairbanks. There in the storage rooms were thousands of archaeological and ethnographic pieces that university research expeditions had taken from the island in the 1930s. It was a bit of reverse culture shock to see and handle these beautiful and interesting objects that came out of my own heritage but that I had known about only from books and family stories. To see them firsthand validated our history, and I knew that other Yupiget would have the same reaction I did.

I learned that there is a lot of sleeping information within each material piece—language, memories, and cultural meanings. When elder tribal members visited the collection, long dormant words and recollections came to them almost like dreams. It is contact with the actual objects and discussion among community members that will awaken the information inside. The more that we can facilitate this process, the better off our communities will be.

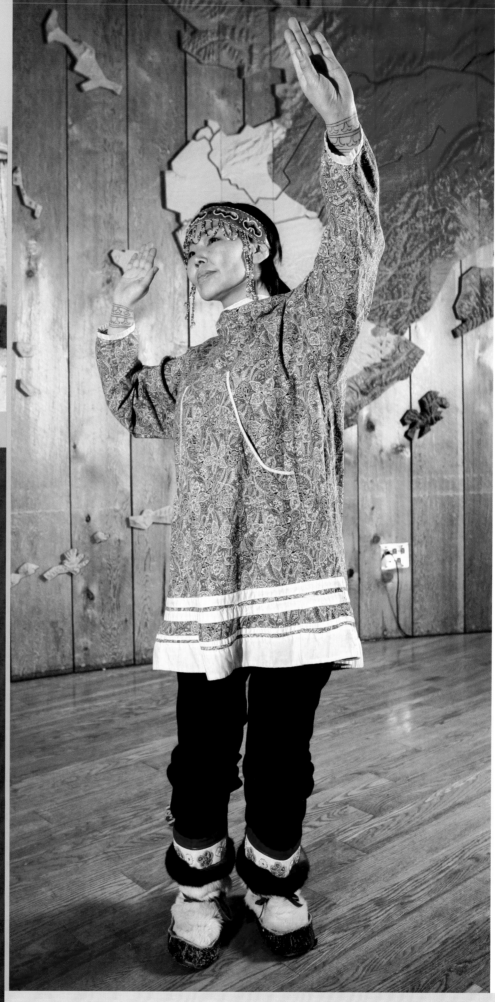

Yaari Kingeekuk, leader of the Sivuqaq Dancers and Cultural Programs Coordinator for the Alaska Native Heritage Center. Anchorage, 2009

THE REMOTENESS OF THE ISLAND has helped to sustain some of the ways of our forebears. The practices of *atuq* and *aghula* (Yupik drumming, singing, and dancing) were never interrupted, despite the introduction of Christianity, and people continue to compose new songs and motions. Both communities on the island hold dance celebrations where we welcome visitors and performers from mainland Alaska, Russia, and beyond. Other ceremonies are more family-oriented, marking life events, such as marriage and the birth and naming of a child. When a young person catches his first seal, a special small celebration is held to share the catch with relatives, making sure that everyone gets a taste. The same thing happens with your first bird.

Many of the former ceremonial practices pertained to hunting, especially whaling. To prepare for the season, a captain would use certain songs and sacrifices that were specific to each clan. The purpose was to please the whale spirits. When the hunters captured a whale, the boats would come back in a line with the successful captain and crew in front. The captain's wife would wait to greet them, and when they reached the shore, the striker (as we call the harpooner) or the captain himself would throw the harpoon between her legs. They believed that the wife's spirit was connected to that of the whale. Everyone was deeply thankful, and they celebrated by feasting, singing, and dancing. That feeling of appreciation and gratitude for the food that has been provided is just as strong today, even though our beliefs and customs have been modified.

The Yupik culture has a very long, rich history, and at the Smithsonian you will see artifacts that our ancestors created hundreds or even thousands of years ago. I can only imagine those old-timers, sitting next to the seal oil lamp during the wintertime and etching walrus ivory with such skill. Today many of the island's residents are world-renowned Native artists whose work is shown in national and international museums and art galleries. Some of the ivory they use comes from archaeological sites, and this material, crucial to sustaining life generations ago, is equally important today because of the income generated by art sales. But much more than that, their work is a celebration of our culture, heritage, and continuing way of life.

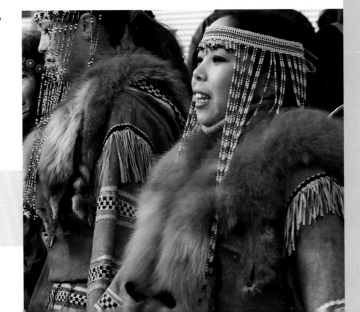

Chukchi dancers perform during the 2005 Beringia Days conference in Anadyr, Russia. Chukchi and Yupik arts reflect a long history of interaction along the northeastern Siberian coast.

Sanightaaq

CEREMONIAL GUT PARKA

St. Lawrence Island
Collected by Arnold Liebes, accessioned 1923
National Museum of the American Indian 123404.000
Length 124 cm (48.8 in)

This ceremonial parka is made of winter-bleached intestines from a bearded seal or walrus. It is decorated in a man's style, using plumes and beak parts from crested auklets. Baby walrus fur was applied along the bottom edge, dyed seal fur on the shoulders, and strips of seal skin around the hood.[53] Women's parkas were ornamented with tassels of fur from unborn seals, dyed reddish-brown with larch or alder bark.[54]

People dressed in this style of parka for religious ceremonies, such as Ateghaq, a spring ritual to ask God (Kiyaghneq) for good hunting, and Kamegtaaq, a thanksgiving that followed the hunting season. The wife of a whaling captain put one on to greet her husband's boat when he returned to the village with a bowhead whale.[55] Maritime Chukchi people of Siberia wore decorated gut parkas in ceremonies honoring the sea spirit Kere'tkun.[56]

To make a *sanightaaq*, a woman first cleaned intestines and hung them outside to whiten in the cold and wind. Then she split them and sewed the strips together with thread made of whale or reindeer sinew. She stitched the seams on the outside for a man's parka and on the inside for a woman's.

Two girls wearing ceremonial gut parkas. St. Lawrence Island, ca. 1900.

"This kind of clothing is not for hunting…. They just wear it in a ceremonial or whenever there is a dress-up…. It seems to me that we just owe everything to the ancient times, to our ancestors. They had beautiful clothes."

—Estelle Oozevaseuk, 2001

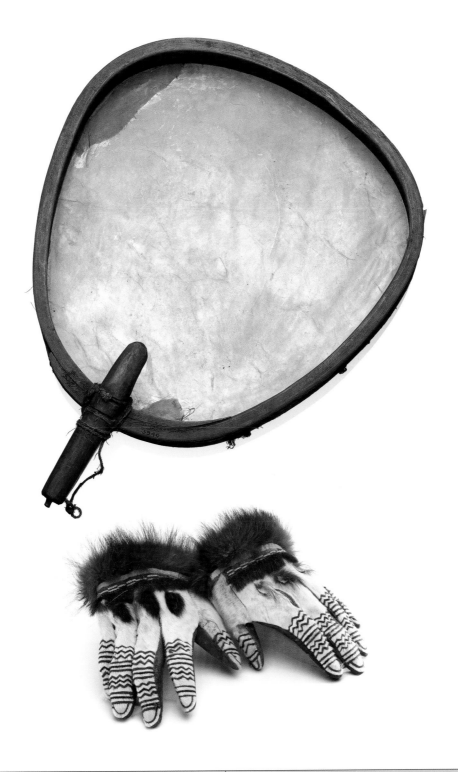

Saguyaq
DRUM

St. Lawrence Island
Collected by Arnold Liebes, accessioned 1923
National Museum of the American Indian 123940.000
Length 52 cm (20.5 in)

Aghulasit iiggat
DANCE GLOVES

St. Lawrence Island
Collected by Riley D. Moore, accessioned 1913
National Museum Natural History E280162
Length 23 cm (9.1 in)

Men play walrus-stomach drums to provide the rhythm for St. Lawrence Island dance and singing today, and in the past they were used during feasts and religious ceremonies.[57] Fast drumming in a darkened house accompanied shamans' healing and magical performances.[58] The head of this drum is the lining of a walrus stomach, inflated, dried, and stretched; the frame is driftwood, whittled down and softened in hot water to allow it to be bent into shape.

Collector Riley Moore recorded that Yupik men always danced wearing gloves, even if they were bare to the waist.[59] These fancy reindeer skin gloves were made in a traditional Siberian Yupik pattern, with gores of colored skin between the fingers.[60] The cuffs are trimmed with brown fur, probably wolverine, and embroidered with dyed reindeer hair stitching. Straight and zigzag lines of red and blue thread accent the finger joints, and fingernails are outlined in red.

Men dancing. Gambell, 1928.

"They had Eskimo dances in the largest igloo [*nenglu*] in the middle of the village. There is about five to a dozen singers, each with an Eskimo drum.... The movement of the bodies fits to the words of the song."

—Roger Silook, 1976[61]

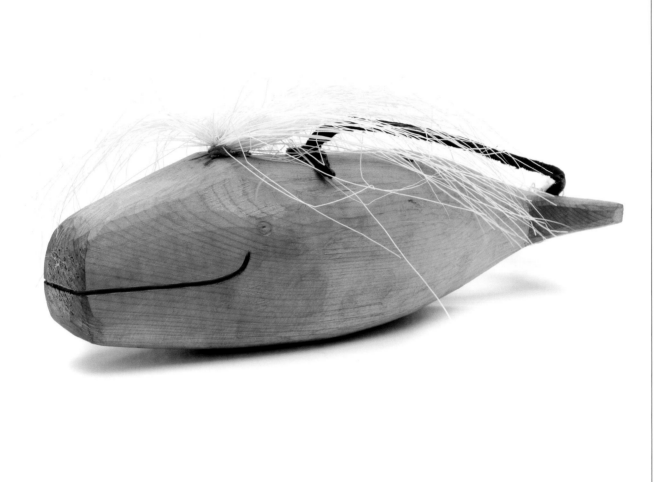

Kamegtaaq
FIGURE FOR WHALING RITUAL

St. Lawrence Island
Collected by Riley D. Moore, accessioned 1913
National Museum Natural History E280155
Length 24 cm (9.5 in)

Wooden models of bowhead whales were used in the St. Lawrence Island whaling ceremony called Kamegtaaq.[62] The tuft of reindeer hair represents the whale's spout.

Kamegtaaq (from the word *kamek*, "boots") was a thanksgiving ritual that took place after the whaling season. The whale figure hung by a cord above the seal oil lamp in a whaling captain's house. Beginning with the captain, each man and a female partner swung the whale back and forth to each other across the burning lamp. Catching the whale carving may have been a way of reenacting the real whale hunt, which also requires the cooperation of women and men. Afterward each woman gave her partner a pair of new skin boots.

Ruby Rookok remembered, "We would hold back the dangling whale and release it to our partners across the room. When the whale got there, they would catch it. If the whale veered off course between them, someone had questionable health or life in the future. When the whale would swing toward our grandfather, Aghilluk, the whale would veer off course and he got frightened. He lived a year and died the following fall."[63]

Cutting up a whale. Gambell, 1966.

"In the center of the *mangteghapik* [traditional house] there's a pole—people call it *aghveghaqetaq* or *tiiwri*. A rope was tied from it to here, on top of the carving. You take hold of this and try to get it straight over for the one who is standing opposite you to catch."

—Estelle Oozevaseuk, 2001

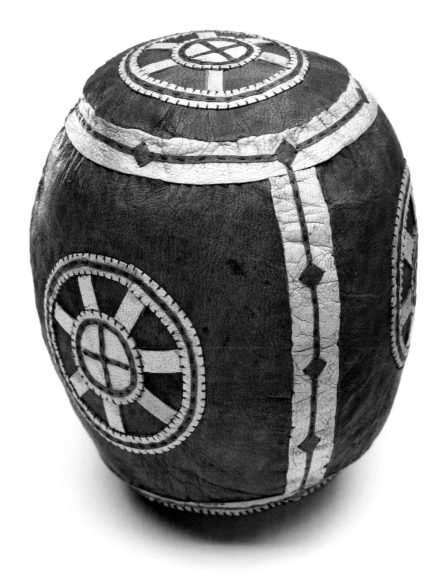

Aangqaq

BALL

St. Lawrence Island
Collected by Riley D. Moore, accessioned 1913
National Museum Natural History E280256
Length 14 cm (5.5 in)

This hand ball, which is decorated with patches of bleached sealskin and stuffed with reindeer hair, was used for a traditional game of keep-away between men and women.[64] It was played to celebrate the first whale of the season. Lloyd Oovi remembered that elders urged the young men to paddle faster on the way back from whaling so that they would not miss the game.[65]

Branson Tungiyan said, "This is used for what we call men-against-women catch ball. Men would try to take it away when women had the ball, and women would throw it to just the women. And then the men would do the same thing and women would try to take it away."

Flirtation added to the excitement of the occasion. Estelle Oozevaseuk laughed and said, "Qetngwaaghutaqut [boys and girls hug each other]!"[66]

Playing ball at Gambell, ca. 1961.

"Kalleghtekayuguniiqegkangit aghvengenghata."

"They say that this ball game is played when a whale is caught."

—Branson Tungiyan, 2001

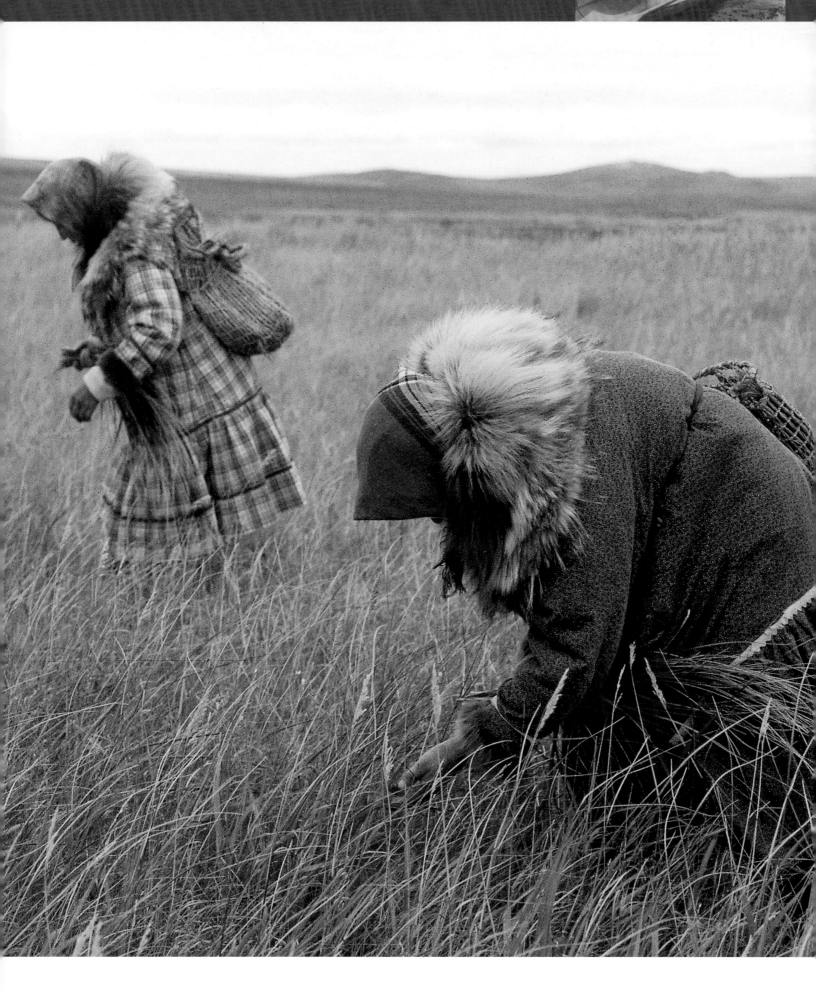

YUP'IK

Alice Aluskak Rearden

THE YUP'IK HOMELAND in southwest Alaska extends from Bristol Bay to Norton Sound and centers on the great delta where the Yukon and Kuskokwim rivers reach the sea. It is a country of treeless tundra, countless lakes, and low mountain ranges. Almost seventy Yup'ik communities are situated along the Bering Sea coast and lower courses of the two rivers, including the Kuskokwim village of Napakiak, where I grew up.

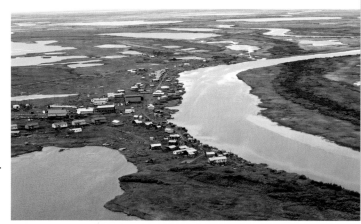

Whenever I ask elders about the traditional way of life on this land, they always say, "*Caperrnarqellruuq*— how difficult, how daunting it was back then." Previous generations had to master a wide range of specific knowledge that was critical to their survival. You can see the meticulous care they took in making their tools; with a harpoon, you had to know the right wood to use, where to attach the lines, and how to balance it perfectly so that it would be effective. The values they lived by—cooperation, generosity, diligence, humility, and respect for others—were just as important as skill and knowledge in sustaining their communities.

The contemporary Yup'ik lifestyle is easier than the traditional one, although people still work incredibly hard to provide for their families. We have Western schooling and such amenities as store-bought goods and clothing, although the cost of those things is high in rural Alaska. The environment around us remains the primary source of what we need, but it takes less effort to subsist by hunting and fishing with the guns, snow machines, and other equipment that we depend on today than it took with the equipment of the past.

My mom was young when I was born, so my grandparents helped care for me during childhood. They were hard-working people who taught us how to honor Yup'ik values and utilize the resources of the land. In summer we moved from Napakiak to our fish camp across the Napakiak slough, to be closer to the Kuskokwim. When the king salmon came in my grandmother

OPPOSITE TOP: A man in a bentwood hunting hat with kayak and harpoon, Nunivak Island, 1929

OPPOSITE: Mrs. Kanrilak (left) and a friend gather fall *taperrnaq* beach grass for making baskets, near Tununak on Nelson Island. On their backs they carry open-weave gathering baskets.

ABOVE: Aerial view of Kwethluk, 2002. The Yup'ik village of about 700 people is on the Kwethluk River near its confluence with the Kuskokwim.

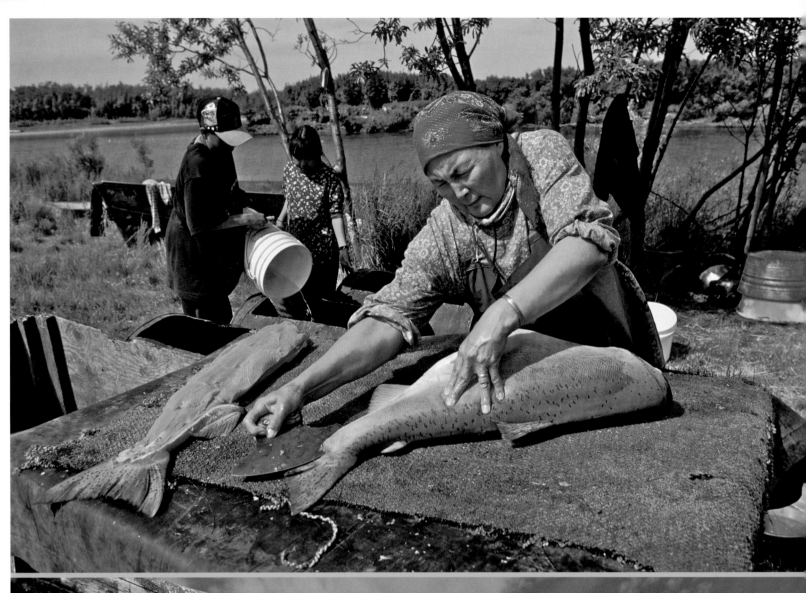

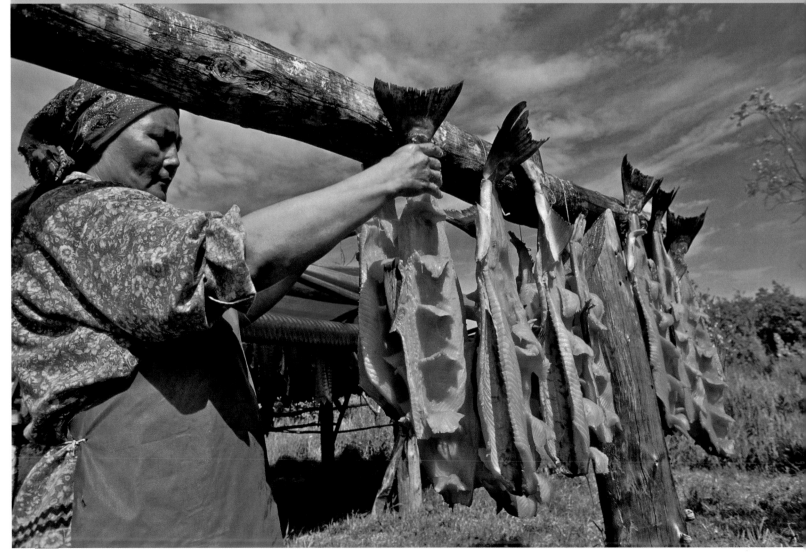

was constantly busy, splitting and hanging fish until the drying racks were full from end to end. Kings are huge and hard to lift, and there is a special way to cut the thick flesh so they will dry properly.

After the kings, the chums and then the red salmon migrate up the river. My grandmother worked the whole season from late May until mid-July or even August. When fish were finished drying they went into the smokehouse, where she tended them carefully to prevent mold from growing in wet weather. At home in Napakiak she had many other things to do, from caring for children to cooking and sewing for everyone. I remember her preparing and preserving the food that my grandfather brought home from the wilderness in different seasons—blackfish, whitefish, migratory birds, caribou, and moose. He had a full-time job with the Bureau of Indian Affairs but was an active subsistence hunter as well, and he had his hands full in supporting our large family.

My grandmother was very concerned that we never waste food, and we would always lick the last of the soup or *akutaq* (berries mixed with sugar, seal oil, shortening, or fish) from our bowls. She disliked seeing fish bones or food scraps left on the floor or outside on the ground, and that was never allowed. Although she did not explain it directly, I came to understand that she was concerned that such negligence would show disrespect to the animals and diminish my grandfather's success as a hunter.

She was also very strict about traditional rules of abstinence. When I had my first menstruation I had to keep fully covered, including a hood over my head, for an entire year. I could not run around outside or look out the windows and was not allowed to eat anything fresh, only preserved foods from the year before. Most important, I was forbidden to wade or swim in the river. If I did, my grandmother said, no more fish would come, or the ice would break up sooner than normal, or the weather would be bad. I was especially admonished not to travel to the ocean or to the mountains; if I did not follow the rules, she said, I would end up with chronic arthritis when I got older.

OPPOSITE, TOP AND BOTTOM: Vera Spein cuts king salmon and hangs them up to for dry at a fish camp near Kwethluk in 1999. She uses a large knife with a rounded blade (in Yup'ik, *uluaq*), a universal tool of Inuit tradition peoples (see Iñupiaq example, p. 55), and Unangax̂, p. 138).

LEFT: Darlene Ulak makes *akutaq* at Scammon Bay in 1999. The name means "mixture" and ingredients vary but always include oil or fat.

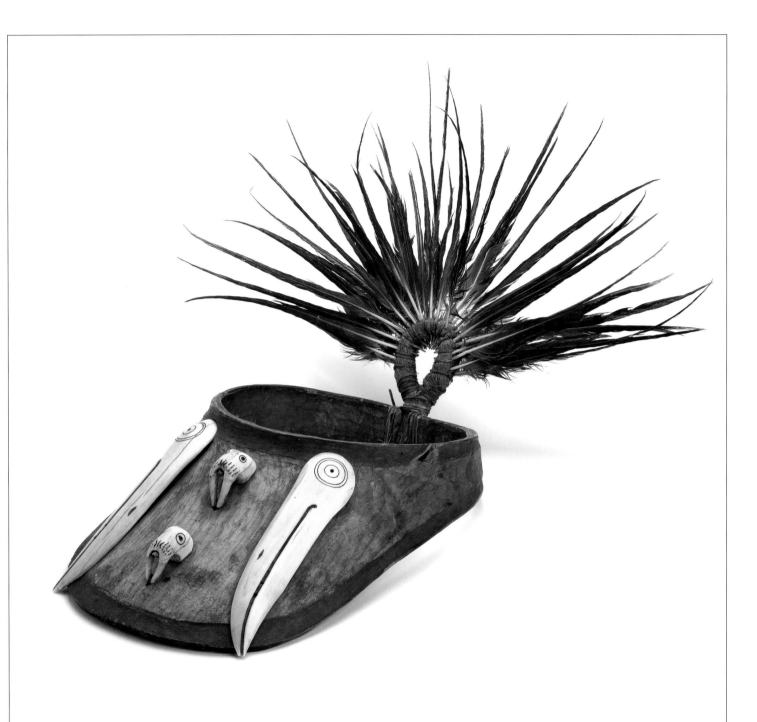

Pastolik
Collected by Edward W. Nelson, accessioned 1879
National Museum of Natural History E176207
Length 51 cm (20.1 in)

YUP'IK

Elqiaq
HUNTING VISOR

Yup'ik hunters of the Bering Sea coast wore wooden visors to protect their eyes from glare,[1] and artist Chuna McIntyre said that the visors were "beautified to attract and honor the animals."[2]

The craftsman used steam or hot water to soften the wood for a visor, then bent it around in a circle. He stitched the ends together with sinew, baleen, or split root and blackened the underside with soot to minimize reflections. Animal carvings were added as hunting charms, like the walrus and seagull heads on this visor.[3]

Speaking of a bentwood hunting hat at the Ethnologisches Museum in Berlin, elder Wassilie Berlin said, "Obviously this was owned by a man from the coast since it is deco-rated with walrus designs. When shamans performed rituals wearing these helmets, they did it to help hunters who would be going out on the ocean in the coming season. These carved walrus on it were what they wanted the hunters to get while hunting on the ocean."[4] Bird carvings and feathers—like the fan of oldsquaw plumes on this visor—may have been added to assist the transformation of hunters into birds as described in traditional tales.[5]

Hunting for seals. St. Michael, ca. 1880.

"I never saw a decorated one, only plain wood. This wood is from the stump of a tree; they bent it…. They used to color the wood underneath with charcoal, to lessen the glare from snow. They decorated this one with the tail feathers of oldsquaw ducks."

—John Phillip Sr., 2002

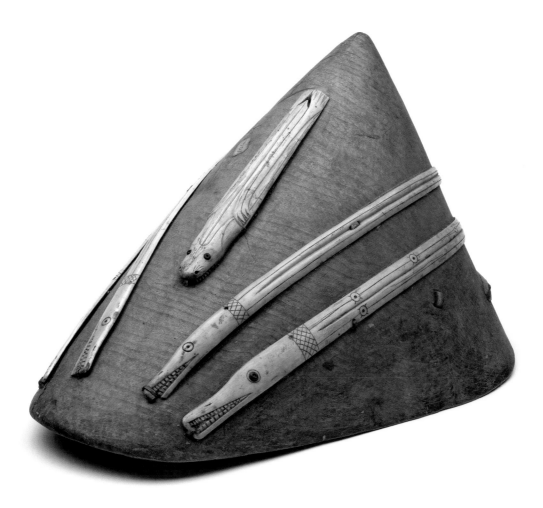

Ugtarcuun
HUNTING HAT

Nushagak River area
Donated by the U.S. Department of Interior, accessioned 1910
National Museum of Natural History E260555
Length 37.7 cm (14.8 in)

Men wore conical bentwood hats for hunting seals amid floating sea ice.[6] According to John Phillip Sr., the pointed shape was to make the hats "look like ice,"[7] disguising the hunter. They were decorated with feathers, paint, or ivory carvings, which here include a seal and several long, toothy fish.[8] The fish are marked with nucleated circles, a symbol of enhanced spiritual vision and of the movement of people and animals between levels of the cosmos.[9]

Nunivak Island kayak hunters sought to have "all gear clean and freshly painted blue, white, and light ocher; they wore a clean gut parka, fish skin mittens, and wooden hunting hat painted white and blue. Although all this was done principally to please the seals…it also provided an effective disguise in the midst of blue sea and white ice floes."[10] In addition, the hats provided protection for the head against breaking waves and collected sound from the watery environment, improving the hunter's hearing.[11]

In a traditional story told by Paul John, a hunter's bentwood hat makes him look like a small seabird to the seals he is pursuing.[12] As the bird/hunter approaches, he breathes out a fog that puts the seals to sleep so that they can be harpooned.[13]

"Makucit pissurcuutekait makut imarpigmi qayanun. Una-ni wani cikut waten ayuqngata ayuqelingnaqluki."

"These are all used for hunting in the ocean on the kayak. Since the ice looks the way it does, they tried to make them look like ice."

—John Phillip Sr., 2002

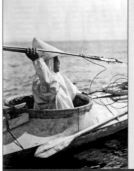

Hunting by kayak. Nunivak Island, 1929.

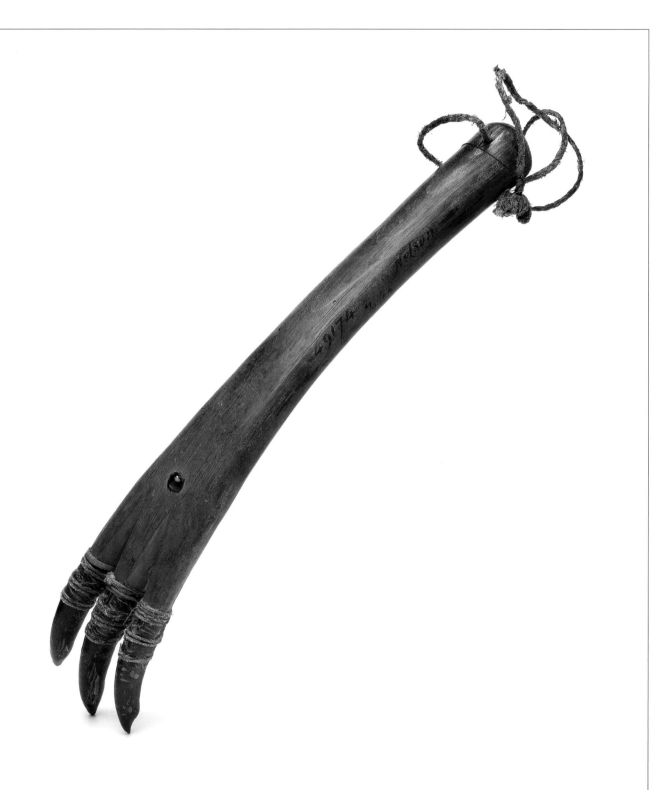

Aiggatet
ICE SCRATCHER

Yukon River area
Collected by Edward W. Nelson, accessioned ca. 1879
National Museum of Natural History E049174
Length 28 cm (11.2 in)

In late winter and early spring, hunters stalked seals as they slept or sunned themselves on the sea ice. First walking, then crawling, a hunter made his approach, concealing himself behind a white fur-trimmed parka hood and a large white mitten made from dog or polar bear skin. If the seal sensed danger and raised its head, the hunter raked the ice or snow with a scratching tool made of seal claws. The familiar sound, which imitated a seal digging its hole, reassured the animal until it fell back asleep.[14] The device could also be used to attract a swimming seal to within harpoon range.

This scratcher is made of bearded seal claws lashed to a short wooden handle. An inset blue bead recalls the pierced hand motif seen on Yup'ik masks and other objects, representing passageways between worlds traveled by animals on their way to hunters.[15] Beings that are half seal and half human *(qunuit)* are said to have holes in the middle of their palms, and this is where a hunter was told to aim his harpoon.[16] Chuna McIntyre linked the bead's color to "the blue of summer sky" and indirectly to *ella*, meaning "sky" or "awareness."

"Cikuq mana citugmirtur-cilluku nayit-llu tamana ullagyugngaciqngaku."

"They keep scratching the snow, because the hair seal will come to it."

—Neva Rivers, 2002

A hunter using an ice scratcher, ca. 1960.

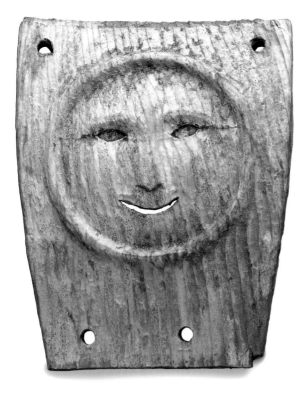

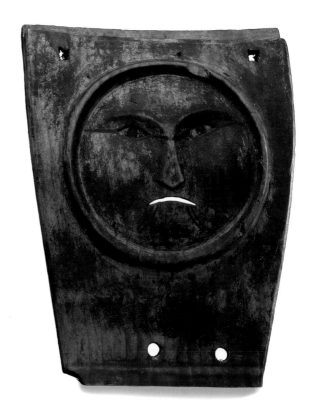

Ayaperviik
KAYAK COCKPIT STANCHIONS

Nunivak Island
Collected by Henry B. Collins Jr. & Thomas D. Stewart, accessioned 1927
National Museum of Natural History E340373
Length 17.6 cm (6.9 in)

The smiling face of a man and the frowning face of a woman grace these pieces from a Nunivak Island kayak frame.

A kayak's cockpit was encircled by a wooden hoop, which was supported from below by two stanchions, one fastened to the frame on each side of the boat. When getting in or out of the kayak, a paddler balanced his weight over these supports, leading to their Yup'ik name ayaperviik from *ayaper-* (meaning "to lay hands on").[17]

Stanchions were carved or painted in paired designs—two eyes, breasts, faces, animals, or birds—that acted in spiritual concert to keep the boat in equilibrium.[18] Male and female faces may also have represented the numinous connection between a man and his wife; her actions on land influenced her husband's success on the water, and she abstained from practices that might "cut" the seals' pathway to him.[19]

"They prevented the person from falling while getting in and out of the kayak. All kayaks had *ayaperviik* on them. This one has a woman's face with a down-turned mouth carved on it. Perhaps the other side would have a man's face carved on it."

—Wassilie Berlin, 1997[20]

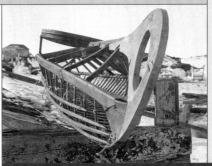

One stanchion can be seen on this *qayaq*, under the cockpit hoop. Western Alaska, 1930s.

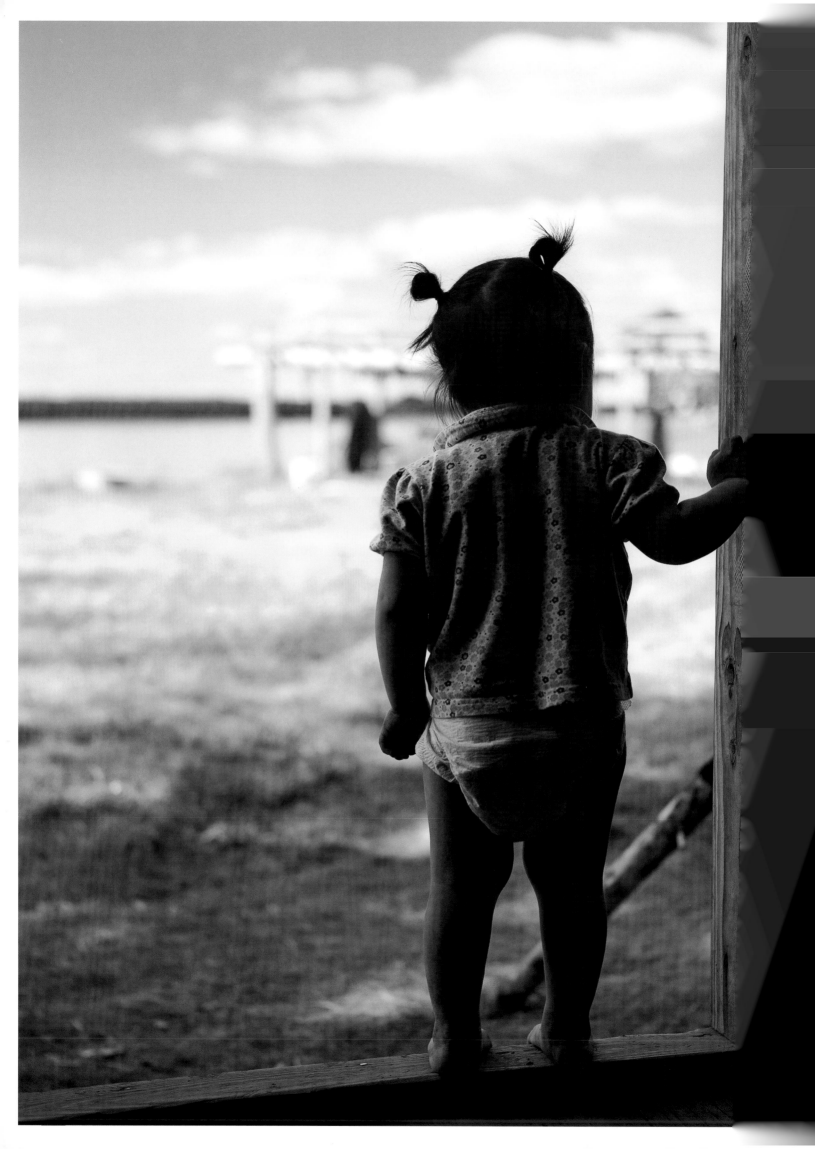

AT A CERTAIN TIME a child becomes aware of life. A baby will be sitting and looking around when an expression of surprise and delight comes to her face. My mom will say "*Ellangartuq*—she has just become aware." The child will never forget that moment or her surroundings when it happened. When people tell stories, they often begin by saying, "This is what I saw when I became aware of the world."

Ella is the word for awareness, but it also means weather, the world, the universe; as human beings we gradually wake up to a consciousness of all that exists. Different stages of awareness occur during a child's growth. For that reason it is important to be extremely careful around babies; their early perceptions will shape the rest of their lives. They will be stronger people later on if they have a quiet environment where they are never startled, or scared, or exposed to inappropriate behavior. My mom never raised her voice or spanked me when I was growing up, because that only makes a child unhappy and withdrawn rather than obedient. Elders say that a woman should keep her infant at home, rather than taking it visiting from house to house, so that later in life the child will be cautious and not too ready to stray everywhere.

Before there was a television in our home I remember spending hours and hours watching my grandmother sew. Those were long evenings, but I was never bored. She would sit on the floor in our back room with her legs extended, her sewing kit lying next to her. Sometimes when I would get too close she would say, "Watch out, I'm about to poke your eye!" Those are wonderful memories, of a quiet house and her busy hands. Later when I started sewing myself, I was surprised to discover how much I already knew just from observing her.

I grew up speaking Yup'ik as my first language and was also one of the first children to benefit from the bilingual education program that was started in the Napakiak schools. From kindergarten through elementary school I took classes that were taught in Yup'ik, and during those years I learned to read and write the language. Later on I took a Yup'ik course at the University of Alaska Fairbanks and after graduation used my training to work for the Calista Elders Council (CEC) as a Yup'ik transcriber and translator. I had kids then, and it was something I could do at home.

OPPOSITE: Tia Skye Kup'aq Frederick watches from a cabin doorway as her family fishes on the Kuskokwim River, 2005.

LEFT: Elizabeth Lake teaches sewing to Juanita Jackson and Gloria Williams at Akiak High School, 2005.

ELLAM YUA— PERSON OF THE UNIVERSE

Marie Meade

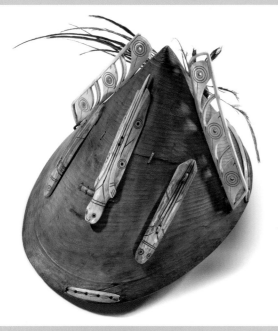

Ivory ornaments on this hunting hat are adorned with circular designs representing Ellam Yua (NMAI 062364).

THE CIRCLE WITHIN A CIRCLE, with the dot in the middle and four lines, is what I call the Yup'ik emblem. It represents Ellam Yua, the Person of the Universe. It shows who we are and how we see our connection to the cosmos. There are circles within circles, just as there are levels of life and being.

Our elders talk about *ircenrrat*, spirit beings. Some animals, like killer whales and wolves, are believed to be *ircenrrat*. They can transform into humans and back into animals. We have stories about how they can bring us into their world in time of need or, if we're in trouble, out on the land to help us to survive.

They're helpers. If they bring you into their world, they can also bring you home. Our elders say that there are three days, or three levels, or three holes, and if they decide to bring you back, it will be through the middle door.

The first, or inner, level is within our mother's womb, where we were formed. The middle level is where we are now. And once we die, there's another level— where we go from here.

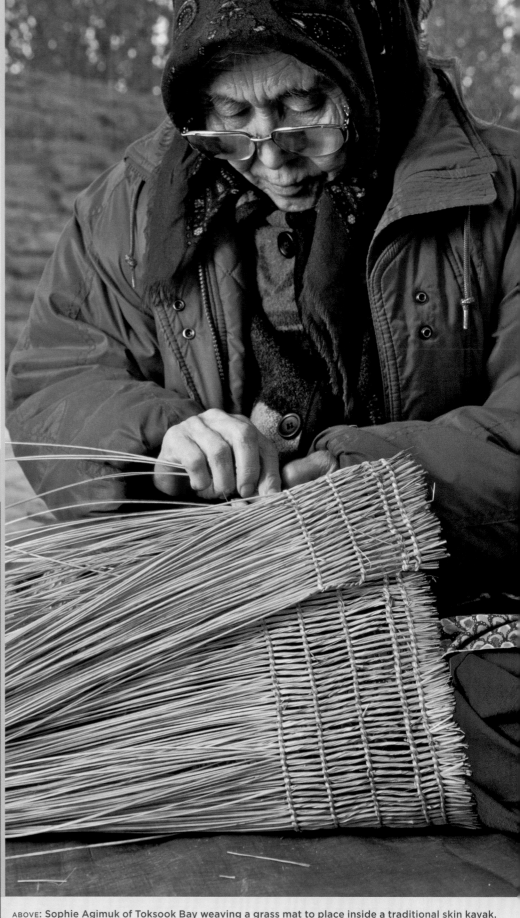

ABOVE: Sophie Agimuk of Toksook Bay weaving a grass mat to place inside a traditional skin kayak. Photographed at the Alaska Native Heritage Center in Anchorage, 2000.

OPPOSITE: The late Lucy Napoka (1926–2009) ice fishing on the Kuskokwim River near Tuluksak, 2005. The river, surrounding delta, and coast are rich in fish resources including salmon, herring, blackfish, whitefish, tomcod, burbot, smelt, and lamprey.

My first project was to transcribe and translate audiotapes of elders speaking at a CEC convention in Kasigluk. The work was extremely difficult at first! I was not an expert in the subtleties of grammar and structure, and the speakers used terminology that was new to me. I had to ask many people about some of the words and to check that I fully understood their meanings. I was excited by what I was doing and found it rewarding to learn new aspects of Yup'ik culture and history. I've continued this work and most recently helped to translate for an exhibition that the CEC organized, called Yuungnaqpiallerput, the Way We Genuinely Live: Masterworks of Yup'ik Science and Survival, in cooperation with the Anchorage Museum.

In listening to elders' words, I have been impressed by the passion they feel about young people learning to appreciate the traditional values so that they can lead better lives and contribute to the health of their communities. Elders see how much has been lost as a result of cultural and material change and the shift away from Yup'ik ways of learning, being, and speaking. Alcoholism, loss of respect for others, broken families, and hopelessness come from losing that vital connection to cultural knowledge and identity.

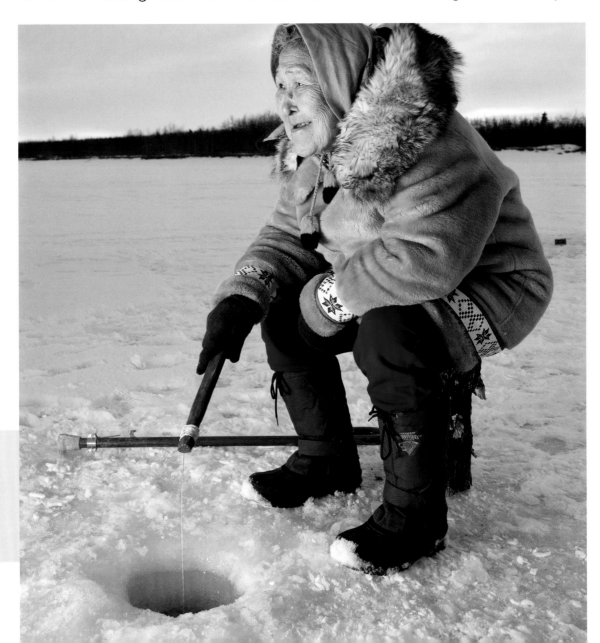

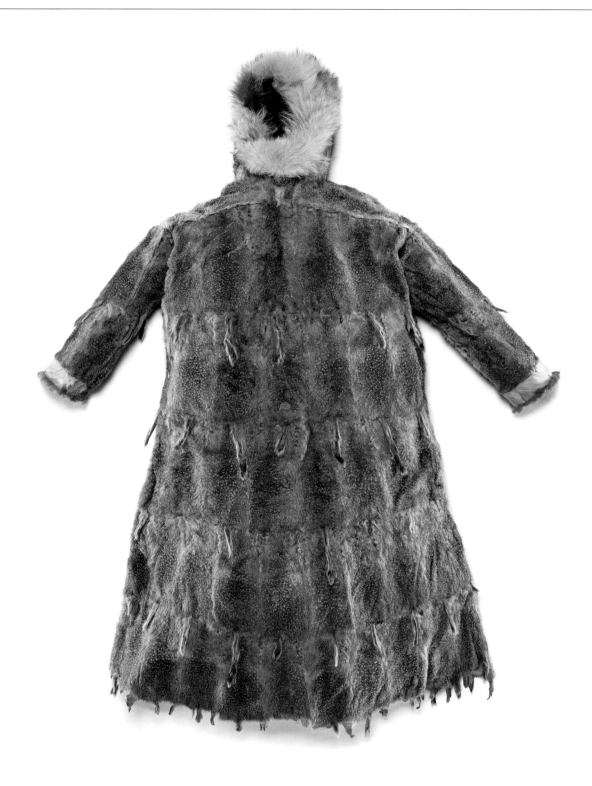

Atkuk
MAN'S PARKA

Nushugak
Collected by Edward W. Nelson, accessioned 1880
National Museum of Natural History E043282
Length 160 cm (63 in)

This warm, lightweight winter parka for a man was sewn from ninety-three Arctic ground squirrel skins, complete with the animals' dangling tails. The maker used whole pelts, turning the bellies toward the inside of the garment. Ground squirrels were snared in the spring and fall and traded between inland and coastal peoples; one pack of squirrel pelts (about forty skins) was worth one seal bag of oil.[21] The hood ruff is wolf, and the cuffs have bands of white caribou and brown wolverine fur.

A woman's role as clothing maker had social and spiritual meanings. The designs she sewed expressed personal and family identity, and well-made, beautiful clothing helped her husband as a hunter because it pleased the animals.[22] A fine parka demonstrated her sewing skills as well as her husband's success as a provider.[23] Clothing enveloped the wearer with the spirits of animals, which still resided in their skins.[24] Girls learned to sew by watching their mothers and other older women.[25]

A Yup'ik family. Togiak, 1927.

"When they just bring in an animal and it's not cut up yet, the spirit is still there.... Before it's cut up or while it's drying, the spirit is still there, and it's going to go out and tell the rest of them: 'This family took good care of me; this family is a good place to stay.'"

—Virginia Minock, 2002

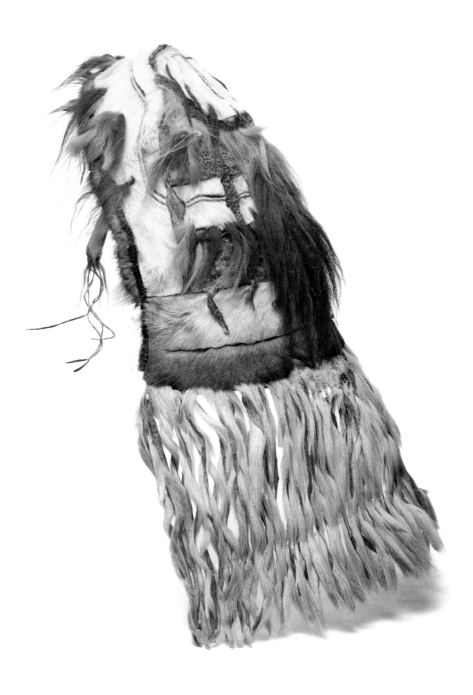

Nunivak Island
Collected by William H. Dall, accessioned 1874
National Museum of Natural History E016344
Length 81 cm (31.9 in)

Yuraryaraq

HOOD

South of the Yukon River, parkas seldom had built-in hoods. Instead, people wore separate head coverings made of ground squirrel, caribou, fox, and furs of other animals.[26] Styles varied considerably among villages, from simple circular caps to heavy hoods hung with tails and tassels, allowing a person's place of origin to be easily determined.[27]

The most highly decorated Kuskokwim River hats were worn for ceremonial occasions,[28] and on Nunivak Island, where this hood was made, men and boys wore fancy caps during the Messenger Feast and Bladder Festival.[29] Chuna McIntyre said that Nunivak dancers turned their backs to onlookers so that the details of their hoods could be seen.[30]

Neva Rivers, Joan Hamilton, and John Phillip Sr. identified the furs sewn into this hood.[31] They include the white belly and brown leg fur of caribou, long fringes of caribou or reindeer fur at the bottom, spotted pieces of Arctic ground squirrel, a whole wolverine tail and small wolverine tassels.

Nunivak drummer wearing a hood. Nunivak Island, 1929.

"Kina tua ilumun tua, kina tua uumeng, makucimeng aturluni tekiskan una tangerrluku camiungullra nallunricaran."

"It is true that if someone came wearing certain clothing, you would recognize where he is from by the type of clothing he wore."

—Joan Hamilton, 2002

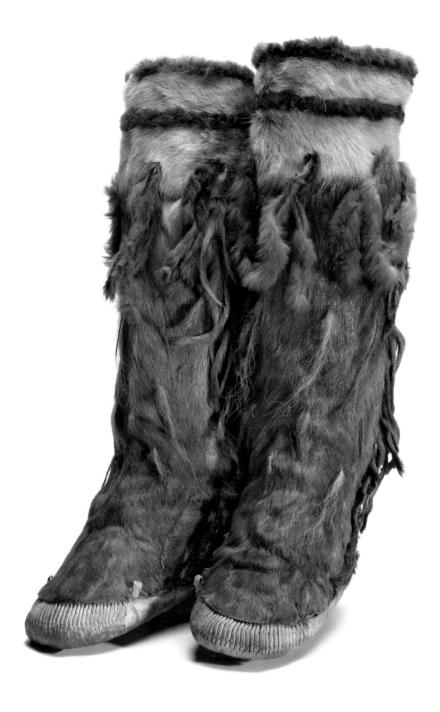

Piluguuk

BOOTS

Nushugak
Collected by Edward W. Nelson, accessioned 1879
National Museum of Natural History E038871
Length 51 cm (21.0 in)

For winter travel and work outdoors, Yup'ik residents of southwestern Alaska wore warm, knee-high boots made of caribou or moose fur or sealskin.[32] In summer, they wore short fur boots or waterproof sealskin ones.

Caribou boots like these were made from caribou leg skins, a correspondence that is common in traditional Arctic clothing, emphasizing shared identity between human and animal beings.[33] One pair of caribou boots required all four of the animal's limbs. Skins from the backs of its legs were used for the fronts of the boots, and skins from the fronts of its legs, which are usually in poorer condition, were used in back.

Bands of reindeer or white caribou belly also encircle the uppers of these boots, along with narrow stripes of brown beaver or bear fur and tassels of the same material. Caribou tassels and tufts of red yarn and white hair decorate the legs.[34] John Phillip Sr. said that ornaments of this type were used only on women's boots, whereas men's were plain. The soles of these boots were constructed of bearded sealskin.

"We wore these all the time, year-round.... except in the summertime, when we usually went barefoot or used short little boots. Mostly we used these caribou boots for warmth."

—Neva Rivers, 2002

Men wearing winter boots. Nushugak, 1885.

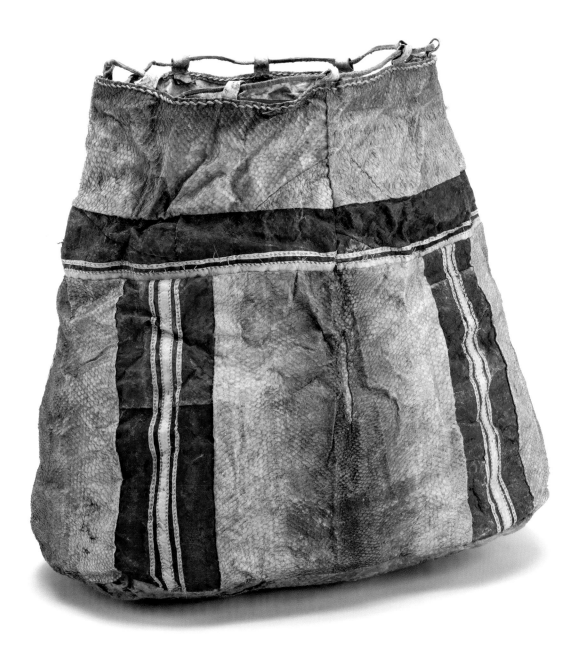

Kellarvik

YUP'IK

BAG

Nushugak
Collected by Edward W. Nelson, accessioned 1879
National Museum of Natural History E037401
Length 40 cm (15.8 in)

Salmon skins were used to make boots, mittens, and bags, especially along the lower Yukon and Kuskokwim rivers, where these fish are abundant.[35] When properly prepared the skins were strong, durable, and waterproof. Fish-skin bags, used for storing clothing, dried fish, and other essentials, were among the gifts traditionally offered to the spirits of the dead through their namesakes during Elriq, the Great Feast of the Dead.[36]

According to elders Neva Rivers and Virginia Minock, the skins used for this bag are silver salmon and king salmon. The bag is stitched with sinew and ornamented with bands of red-dyed fish skin, and white strips of bleached seal esophagus. A rawhide drawstring encircles the top.[37]

Elder Annie Blue said that a similar salmon-skin sack in the collection of the Ethnologisches Museum in Berlin was used to hold sewing materials. She said "As women, we always had materials like these for sewing back in those days. And we always owned bags like these. If someone asked and said, 'Do you have something?' I'd reply, 'Aren [Oh my], I do have some. It's in my *kellarvik*.'"[38]

"Qemagvissugmek wani-wa. Una tua wani-wa wiinga makuc-ingqellruama. Mecungyuglalriit yukutarcessqumanrilrenka wavet eklaranka. Espickangger-quma wavet eksugngaluku. Imat imkut puyurkat."

"This is a storage bag. This one right here, I had this kind. When I didn't want something to get damp, I would put it in this. If I had matches, I would put them in here, also bullets or gunpowder."

—John Phillip Sr., 2002

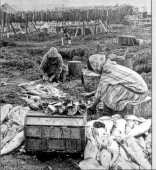

Processing fish. ca. 1933.

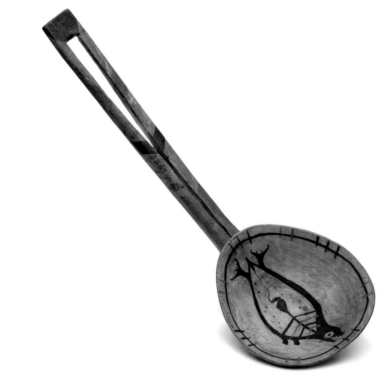

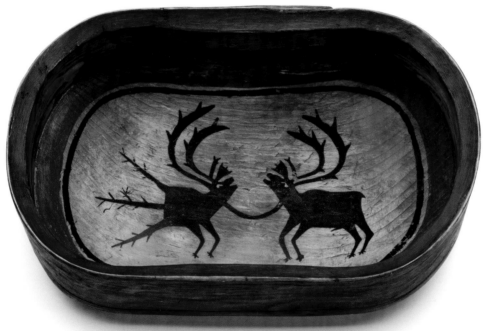

Ipuun	Sfaganuk	**Qantaq**	Nuloktolok
LADLE	Collected by Edward W. Nelson, accessioned 1879	BOWL	Collected by Edward W. Nelson, accessioned 1879
	National Museum of Natural History E038634		National Museum of Natural History E038644
	Length 27.9 cm (11 in)		Length 24.4 cm (9.5 in)

This wooden food dish has a carved bottom and a bentwood rim; the image inside may represent a caribou linked to its inner spirit.[39] Bentwood dishes for serving, storing, eating, and cooking food were everyday items in Yup'ik communities, and everyone had a personal eating bowl.[40] They were painted with inherited family designs.[41]

A woman served her family's food in their dwelling house, but only the women, girls, and youngest boys ate there. Men and older boys ate in the *qasgiq*, receiving meals brought in by their wives, daughters, or sisters. The women waited until the men had finished and then took the eating dishes home.[42] In the *qasgiq*, men made bowls from driftwood pieces they collected during summer.[43] Making new dishes was part of preparing for Nakaciuryaraq, when seals were honored and their souls returned to the sea.[44]

The painting of a seal on the serving ladle recalls a traditional ritual practice. Women greeted seals that their husbands had killed, using a ladle to offer the animal fresh snow or drinking water and to sprinkle moisture on its flipper joints. This completed the seal's journey from water to land and satisfied its thirst.[45]

"When I became aware of life, we already had wooden bowls like this, just our size. Our dad had a large bowl, our mom had a smaller one, and beginning with our oldest brother we all had bowls.... When I walked into the middle of the men's house, I used to see bowls being made by elderly men."

—John Phillip Sr., 2002

Vasil paints the bottom of a bowl. Jetland's Post, 1936–37.

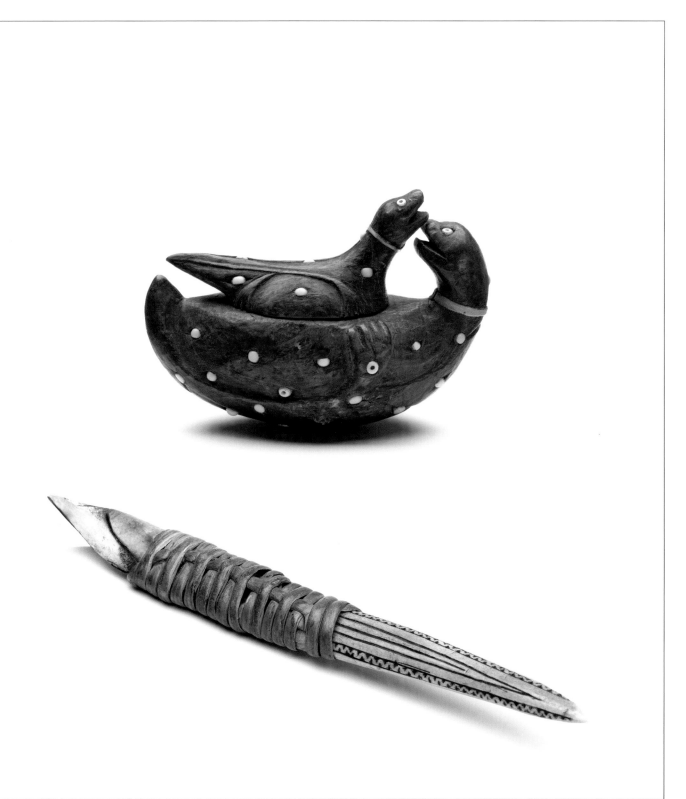

| **YUP'IK** | **Meluskarvik**
SNUFF BOX | Mission, Lower Yukon River
Collected by Edward W. Nelson, accessioned 1882
National Museum of Natural History E048839
Length 11 cm (4.3 in) | **Mellgar**
CURVED KNIFE | Unalakleet
Collected by Edward W. Nelson, accessioned 1879
National Museum of Natural History E176120
Length 26 cm (10.2 in) |

The curved, or "crooked," knife is an old tool still used by contemporary carvers. Yup'ik men in the past employed them to shape masks, boxes, trays, tubs, harpoon shafts, bows, arrows, boat frames, and many other items.[46]

With its curved edge, a *mellgar* can sculpt grooves and concave interiors as well as flat or convex surfaces, and the sharp tip lends itself to carving fine details. The blade is made from scrap metal or a piece of steel knife or file, bent to form a curve. It is lashed to a handle of wood, bone, or antler.[47]

Small boxes for storing chewing tobacco or snuff mixed with ash provide some of the finest examples of traditional Yup'ik carving.[48] Paul John said, "Back in those days, people really cherished tobacco. They finely crafted their tobacco boxes."[49] This box depicts a seal on its back with a smaller seal on top, to form the cover. The surface is decorated with white beads and small ivory pegs, and the seals have collars made of bird quill.[50]

Ivan uses a curved knife. Jetland's Post, 1936–37.

"Cavilqaat. Tau taumeng wii atutullrat tangtullruamki qaygimi uitatullruama arnaungerma tang wii qanerrcigatellruunga."

"They carved with it. I used to see them use it when they stayed in the men's house, even though I was a girl. I was a mischievous girl."

—Neva Rivers, 2002

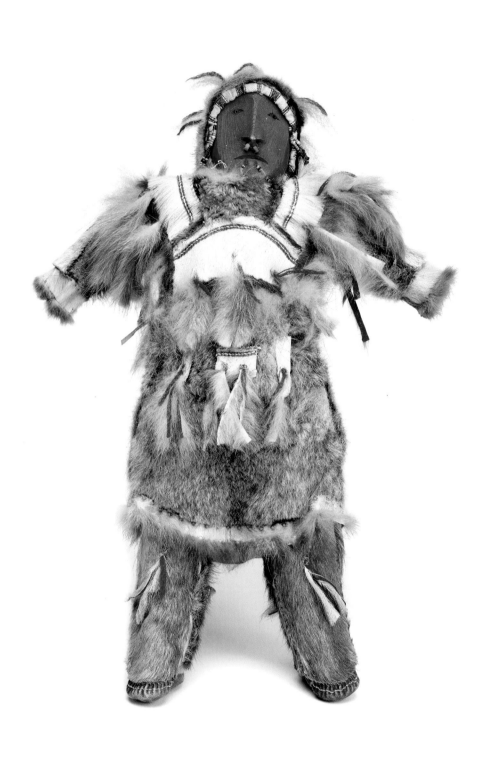

Inuguaq
DOLL

Bristol Bay area
Collected by Charles L. McKay, accessioned 1882
National Museum of Natural History E055904
Length 43 cm (16.9 in)

A Yup'ik girl's dolls were toys as well as symbols of her future life as an adult.[51] As a young girl, she owned dolls of different sizes and played house with them, using miniature dishes and tools; her doll blankets were made of mouse skins.[52]

There was a strict rule against taking dolls outside during winter, and breaking it was thought to bring endless cold and storms. Girls took their dolls out only after certain birds—on Nelson Island, the red-throated loon—appeared on their spring annual migrations.[53] Bringing *irniaruaq* (meaning "pretend child," another word for doll) out of the house at that time of year, when new life was beginning all around, has been interpreted as a ritual of symbolic birth.[54]

When a girl experienced her first menstruation, she went through a long period of restriction from the normal life of the village. A feast called Putting Away the Doll marked her maturation as a woman. She unwrapped the dolls from her *kakivik* (sewing kit) and gave them away to her younger companions, a ceremony that marked her new social role and ability to give birth to real children.[55]

A girl and her doll. Chevak, 1963.

"Tua-i-llu nutaan ilii tauna waten inuguallermini ellami makuciq waten ellamun anullu"

"One of them played with a doll like this and brought it outside, and no one knew about it. Soon the weather became stormy and stayed bad all winter without ceasing in their village."

—John Phillip Sr., 2002

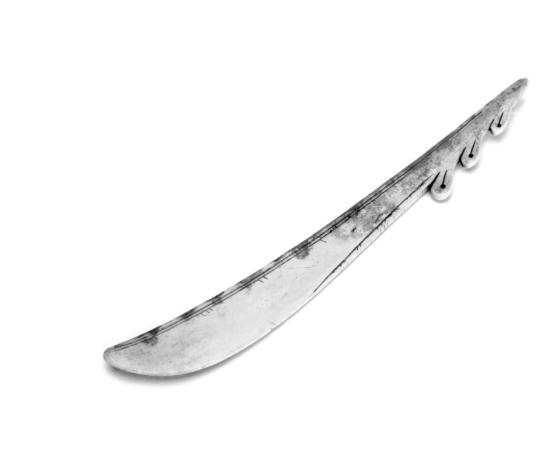

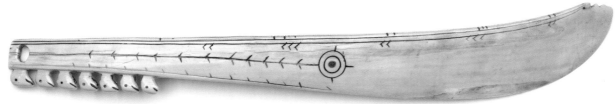

YUP'IK

Yaaruin (above)
STORY KNIFE

Togiak River area; Collected by Samuel Applegate and John W. Clark, accessioned 1886
National Museum of Natural History E127393
Length 25.5 cm (10 in)

Yaaruin (below)
STORY KNIFE

Kongiganak
Collected by Edward W. Nelson, accessioned 1879
National Museum of Natural History E036576
Length 36.6 cm (14.3 in)

The story knife is a traditional girl's toy used for drawing pictures on the ground or in the snow. The pictures show clothing, people, houses, animals, and events, often to illustrate a story or sometimes as a game in which others try to guess the artist's subject. Snow knife stories are accompanied by songs.[56]

Neva Rivers said, "We use this for drawing the house—[saying,] 'make a bed in here,' 'this side is my house,' 'when I woke up, my mama was here, my dad was here,' 'there's a stove, and here's my auntie, there's my uncle.' We just use it to tell stories.... And we erase it again."[57] Girls still play this game using metal butter knives instead of the traditional wood, bone, or ivory *yaaruin*.

The story knives shown here are made of carved, polished, and engraved walrus tusk. Old story knives were often ornamented with carvings of salmon, gulls, seals, and other animals, but others were simple and plain.[58] A girl's father or grandfather made her knife, and they were given as gifts during Elriq.[59] After a girl experienced her first menstrual period, she gave away her story knife along with her dolls.[60]

"We used it to try to copy our older sisters when they played using the *yaaruin* [story knife]. We'd just scratch it out, just like we're using a short little pencil. *Tamaa-i tamakut yaaruitni pencil-aqelqaput wangkuta* [the story knives were our pencils]."

—Neva Rivers, 2002

Using a story knife. Bethel, 1936.

OUR TRADITIONAL SPIRITUAL LIFE was based on the recognition that all things have *ella,* awareness. Elders were taught that if you are out walking and see a piece of driftwood sticking out of the mud, you should pull it out and turn it over so that the muddy part can dry. That piece of wood is alive and aware, and it will feel gratitude for your kindness.

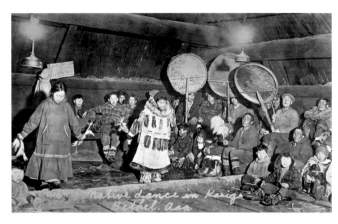

Elders have told us about the masked dance ceremonies of the past. The winter celebrations honored the *yuit,* or inner persons, of the animals, and the dances were a kind of prayer that asked for these spirits to give their physical bodies to meet the needs of the community. Shamans made carvings or masks representing animals—walrus, caribou, seals, and others.

When the masks were danced in the *qasgiq* (men's community house), it was a petition for those animals to return in the spring. During Nakaciuryaraq, the Bladder Festival, the bladders of seals that had been taken by hunters during the year were returned to the sea through a hole in the ice, allowing those seals to be reborn in new bodies.

Kevgiq, the Messenger Feast, was a spring festival for sharing and bringing communities together. People worked hard throughout the year, gathering plants, hunting furs, and harvesting food, and Kevgiq was a time to distribute some of what they had earned to others. Parents were especially proud if one of their children had contributed to the family's effort for the first time—a son who brought home his first game or a daughter who picked her first berries or caught a pike through the ice. Those events were

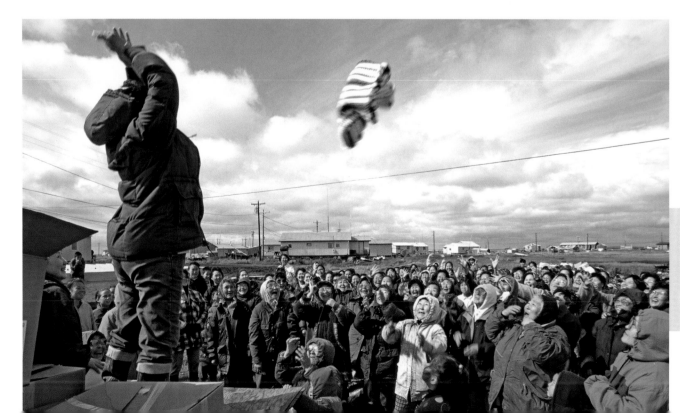

recognized as rites of passage that meant the child was beginning a lifetime of providing for kin and community. By giving away food, skins, tools, and other goods at Kevgiq, a family ensured the future success of its children and the prosperity of the whole group; the principle is that if you give, you will get back. Kevgiq involved formal protocols of invitation between one village and another and during the gift exchange itself. There was a rich feast with dancing, and a newly composed song preceded the awarding of each gift.

Toksook Bay, Chefornak, and several other coastal and Yukon River villages still carry out the Messenger Feast tradition of inviting guests from other places and distributing presents to them. The dancing and gift giving represent the same values as in the past, even if some of the items are store-bought goods from Wal-Mart. It is about giving generously to others and celebrating the success of the subsistence harvest.

Napakiak was not a "traditional" village when I was growing up, and I never saw Yup'ik dancing there until a group from Kwethluk performed at our high school. They were boys and girls who danced whenever they traveled to play basketball in intervillage tournaments. The beat of the drum was so powerful that I instantly felt it all through my body, with the same thrill that you experience when you are very, very proud of something. I was amazed but looked around to see how other members of the community were reacting. I wondered if perhaps they might be a little bit ashamed of the past or disapprove of seeing something that was connected so strongly to our old religious practices. But they accepted the dancing, and over time it has regained tremendous popularity in the Yup'ik region. The biggest annual event is the Cam'ai Dance Festival in Bethel, where dozens of groups from around the region perform onstage over a three-day period.

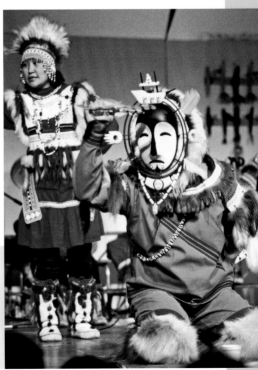

Some elders feel that the new dancing is disrespectful or immodest or that it is just for entertainment rather than a true celebration of community. But for my generation, the energy of contemporary dance expresses cultural identity and pride; we hear and see a message about who we are today.

OPPOSITE TOP: Dancers and drummers in a Bethel *qasgiq* in the 1930s

OPPOSITE BOTTOM: A woman tosses a bolt of cloth during a spring Seal Party at Kipnuk. Parties are given by the wives and mothers of hunters to celebrate the first bearded seals of the year.

RIGHT: John McIntyre performing at the 1992 Cam'ai Dance Festival in Bethel. His *issiisaayuq* mask illustrates a shaman's prediction of the coming of Europeans.

Nasqurrun
HEADDRESS

Togiak
Collected by Samuel Applegate and John W. Clark, accessioned 1886
National Museum of Natural History E127329
Height 23 cm (9.1 in)

In coastal villages of the Yukon-Kuskokwim Delta, men who led ceremonial "asking songs" during Kevgiq, wore caribou-hair headdresses like this one. They directed the drumming and singing with feathered *enirarautet* (pointing sticks or dance sticks).[61] Women wore similar headdresses, which remain a part of modern Yup'ik dance regalia for both sexes.[62] Some villages carry on the tradition of Kevgiq today, although the details have changed.[63]

Traditionally, Kevgiq was a competitive feast in which the leading families of host and guest villages asked each other for large quantities of gifts and goods and then tried to exceed their rivals in generosity.[64] The name comes from *kevgak* (messengers), two young men who were sent from the host community to the guest village in early autumn with a long list of requests. They carried sticks with painted markings to help them remember what to ask of each family, including such things as furs, foods, weapons, kayaks, and other valuables.[65] The messengers returned home with a list of similar requests from the intended guests. Both communities labored to acquire the goods they needed to make a good showing at Kevgiq, then came together for the feast in March or thereabouts.

"So in the fall they sent two messengers to other villages. They told what the family wanted at that dance…. They would all gather when the time came. They invited them and had a real dance…. They used a dance stick, and there was a song leader in the middle of the men's house."

—John Phillip Sr., 2002

Woman dancing. Kepnek [Kipnuk], 1933.

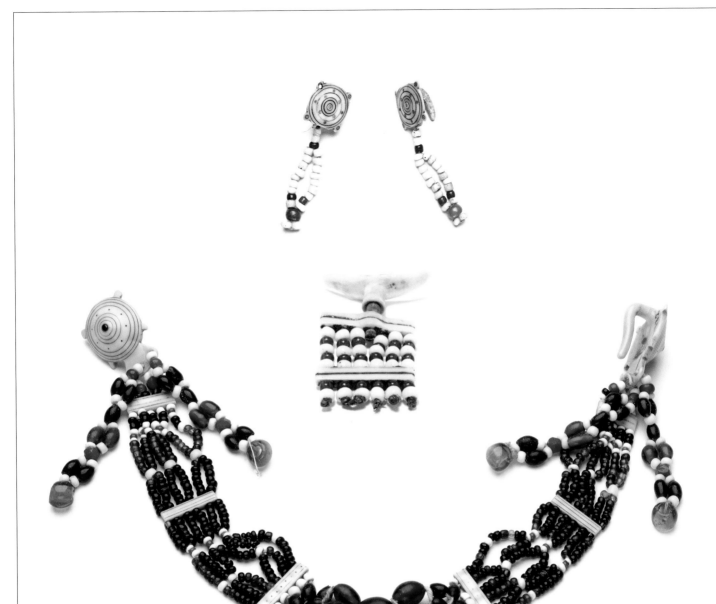

Yup'ik women, especially those living in villages south of the lower Yukon River, wore earrings, necklaces, and labrets (lip ornaments) in designs that combined glass trade beads with walrus ivory hooks and fasteners.[66] Men also wore labrets and earrings.[67] Jewelry was part of the regalia that people wore during ceremonies and dances.[68]

Nunivak Island women pierced young girls' ears and inserted braided caribou hair or an ivory pin to keep the holes from closing. Men pierced boys' ears using the stone tip of a bow drill.[69]

The correspondence between the pierced holes and the child's vision, expressed in Neva Rivers's quote, is echoed in the concentric circle designs seen here on the earrings and the earrings with necklace. These represent Ellam Yua, the "Person of the Universe," and signify existential levels of the universe, passage between levels, and supernatural vision.[70]

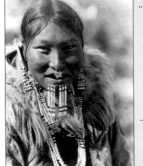

"Kenowun" wearing jewelry. Nunivak, 1929.

"When babies are first born [women] cut their cord, and at the same time they pierce their ears…. *Mamevkayunakek roll-arturluku. likegcinaluni-gguq.* [Never let it close, keep it open with a roll (of grass). To have good eyesight, they said.]"

—Neva Rivers, 2002

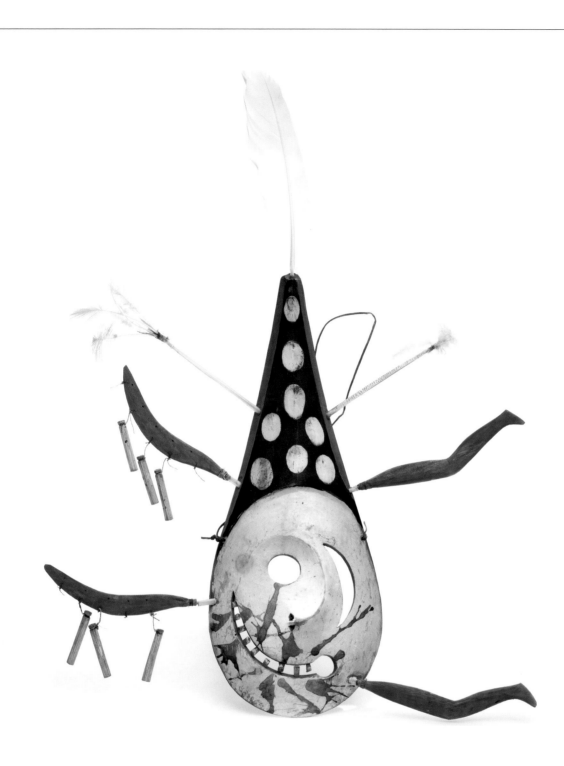

Kegginaquq
MASK

Pastolik
Collected by Edward W. Nelson, accessioned 1878
National Museum of Natural History E033105
Length 49 cm (19.3 in)

Yup'ik shamans directed the making of masks and composed the dances and music for Kelek and other winter ceremonies. Each mask represented a shamanic vision or experience. Some of the stories behind them have survived in Yup'ik oral tradition, and others were recorded in the past.[71]

Collector Edward W. Nelson reported that this Yukon River mask represented a *tuunraq*, or shaman's helping spirit.[72] It has a semihuman face, wooden peg teeth, a blood-splattered mouth, and red-painted attachments, including two human legs. Other masks show *tuunrat* with blood-splattered mouths, including one who chased and ate people in the mountains.[73] A wolf *tuunraq* was said to attack the source of disease inside a shaman's patients, emerging with its mouth dripping in blood.[74]

This mask also possibly represents an *ircenrraq*, described in traditional stories as a powerful, humanlike being that could appear as a wolf, a fox, or a killer whale.[75] These beings are described as having long pointed heads, distorted mouths, and half human–half animal faces, all aspects seen in this mask. The white spots variously represent snowflakes, stars, or eyes, depending on the story that was being told.[76]

"These are the workings of the *angalkuq* [shaman], and they're to be respected and revered and treated very carefully."

—Joan Hamilton, 2002

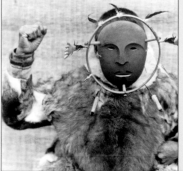

Demonstrating a mask. Nunivak, 1929.

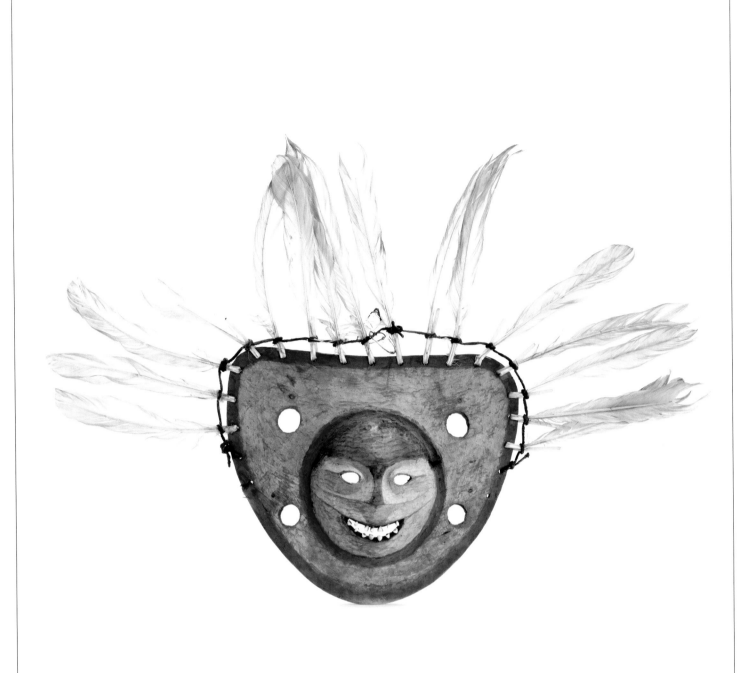

Nepcetaq

YUP'IK

MASK

Kuigpalleq ("Starikwikhpak")
Collected by Edward W. Nelson, accessioned 1879
National Museum of Natural History E038812
Width 62 cm (24.4 in)

Elders from the lower Yukon River remember that this type of a mask was called *nepcetaq* and that it was used only by an *angalkuk*, or shaman. If a shaman bent down over a *nepcetaq*, it was said, the mask would rise from the floor and stick to his face.[77]

Nepcetat and ordinary dancing masks were used during the winter festival of Kelek.[78] The purpose was to ask the spirits to return in spring and to give their bodies to the hunters.[79] Elder Paul John views the old ceremony as a kind of prayer: "Our ancestors used masks, calling it Agayuliyaraq [way of making prayer], as resolutions to petition God for the things they needed."[80]

Masks portrayed animals, animal spirits (*yuit*, or "inner persons") or *tuunrat* (helping spirits) that assisted the shaman in his communications with other worlds.[81] Some *tuunrat*, it was believed, held animal *yuit* in the sky world until the shaman flew to the moon to release them.[82] *Nepcetaq* masks may represent the *tuunraq* moon spirit, and the holes that surround the face are openings through which the *yuit* pass on their journey to earth.[83]

"Angalkurtauniluku qanrutektullrukait makut."

"They would say that these were from a shaman."

—Virginia Minock, 2002

Edgar Frances displays a mask. Pilot Station, 1956.

UNANGAX̂

Alice Petrivelli

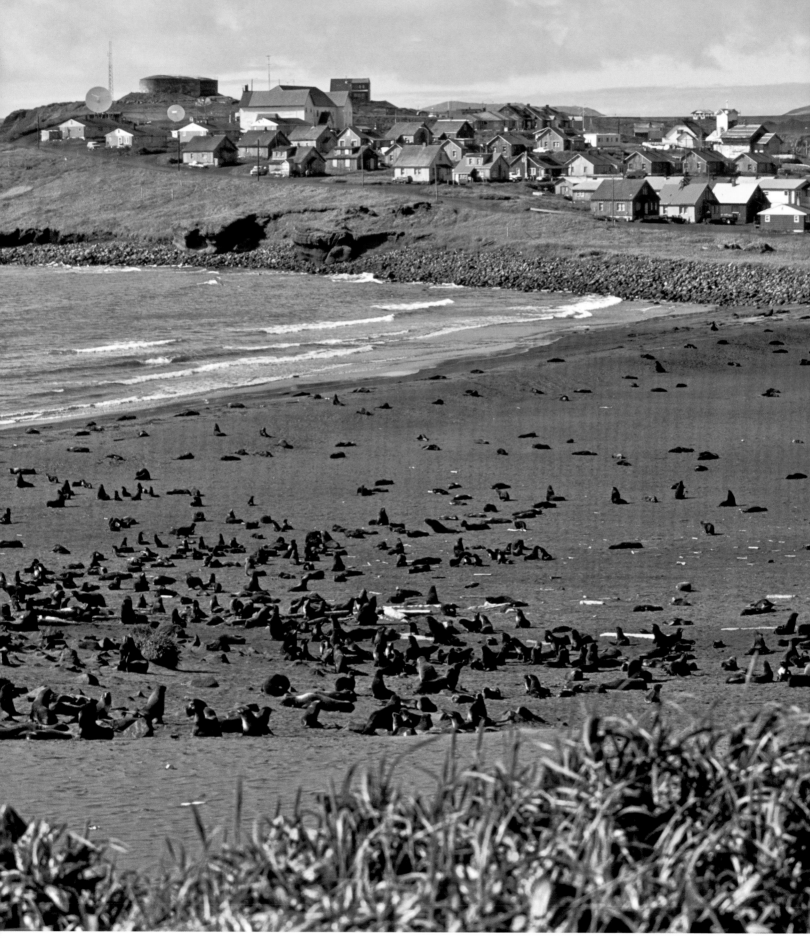

ALL OF THE ALEUTIAN ISLANDS are beautiful to me, because they are my home. In summertime they are just gorgeous. The mountains are snow-capped, with green grass and tundra plants spreading up their sides. Even out on the water you can smell the flowers. In fall the vegetation turns shades of red and brown, and in winter there is a clear, blue, endless sky between periods of storm. The islands have no trees, but driftwood from around the whole North Pacific washes up on our beaches.

More than three hundred Aleutian Islands stretch westward across the Pacific from the tip of the Alaska Peninsula. Many of them are active or extinct volcanoes up to eight thousand feet in elevation. The islands cluster in groups, including the Shumagins, the Pribilofs, the Fox Islands, the Islands of the Four Mountains, the Andreanof Islands, the Rat Islands, and the Near Islands. Farther west near Russia are the Commander Islands, named after explorer Vitus Bering, who shipwrecked and died there in 1741.

People of the Aleutians call themselves Unangax̂, meaning "sea-sider." In the Niiĝux̂ dialect of the western islands the plural form is "Unangas"; in the Qawalangin dialect of the east it is "Unangan." We are also called Aleuts, a name first used by Russian fur traders in the eighteenth century.

Its meaning and origin are unclear, but the name became part of our own heritage, along with the Russian Orthodox Church. Our language is Aleut, or Unangam Tunuu.

To our south is the open Pacific Ocean, to our north the Bering Sea. Everything our ancestors did was connected to the marine world around us. They built beautiful kayaks with split bow tips to cut swiftly through the waves. They navigated through storms, fog, and the fast currents that run between the islands. Their clothing was made of sea mammal hides and intestines and the feathered skins of ocean birds.

OPPOSITE TOP: Men in hunting hats paddle a double kayak near the historic Russian settlement of Iliuliuk on Unalaska Island. Illustrated by Louis Choris in 1825.

OPPOSITE: Several hundred thousand northern fur seals come ashore each summer to breed on the Pribilof Islands in the Bering Sea. This rookery is near the Unangax̂ village of St. Paul, 2000.

ABOVE: Mike Livingston, wearing a traditional wooden visor and seal intestine parka (see p. 128), paddles a kayak in the waters off St. Paul Island in 2000.

The sea provided nearly all of our ancestors' food—seals, sea lions, ducks, salmon, all kinds of fish and shellfish—and that's still true today. From the time we're little we're taught to respect the water and to keep it clean, because that's where our living comes from. On Umnak, Atka, and the Pribilof Islands are reindeer herds that were established by the government in the early 1900s, and those people who live nearest the Alaska mainland can hunt caribou and other land animals.

I was born in 1929 on the far western island of Atka and grew up speaking the Niiĝux̂ dialect. My father was Cedar Snigaroff, and my mother was Agnes Zaochney. I had four brothers and one sister; my mother passed when I was five, and three of my brothers also died. I was the youngest in the family to survive.

Until 1942 we used to go camping all summer. With the first warm days of spring we would travel by boat to Amlia Island, where we planted potatoes and other vegetables. Gardening was impossible on Atka, because rats had invaded from a shipwreck sometime in the past and ate the plants and killed off nesting birds. Amlia was fortunately rat free. We stayed on the south side of the island from May to June, tending our vegetables and fishing for cod and halibut. Later in the summer we'd go to the north shore for red, pink, and dog salmon. We preserved fish by salting, drying, and smoking.

We lived mostly on subsistence resources, because the supply ship came to Atka only twice a year, bringing in the staples we needed. My father would get a hundred-pound barrel of butter, two hundred pounds of flour, and one hundred pounds of sugar, and that had to last until the next ship. Growing up I learned to fillet fish, hunt birds, harvest grass for weaving baskets, and gather roots, plants, and shellfish.

The men went out fox trapping in September or October on Amchitka and other islands. It was a community effort; everyone trapped for the whole village, and when they sold their furs to the store at the end of the season in March the money was divided into shares. If you had ten children you got ten shares. My father had his own fox farm on a small island that he leased from the government, so we had extra income from that. When the men were gone the women took care of the village and were in charge of everything.

OPPOSITE: **King, tanner, and Dungeness crabs are fished both commercially and for subsistence use in the Aleutian Islands. Here a crab is measured for legal keeping size, Unalaska Island, 2001.**

ABOVE: **The village of Atka, population about 70, amid the treeless hills of Atka Island. The Russian Orthodox church was burned in World War II and rebuilt twice, most recently in 1996.**

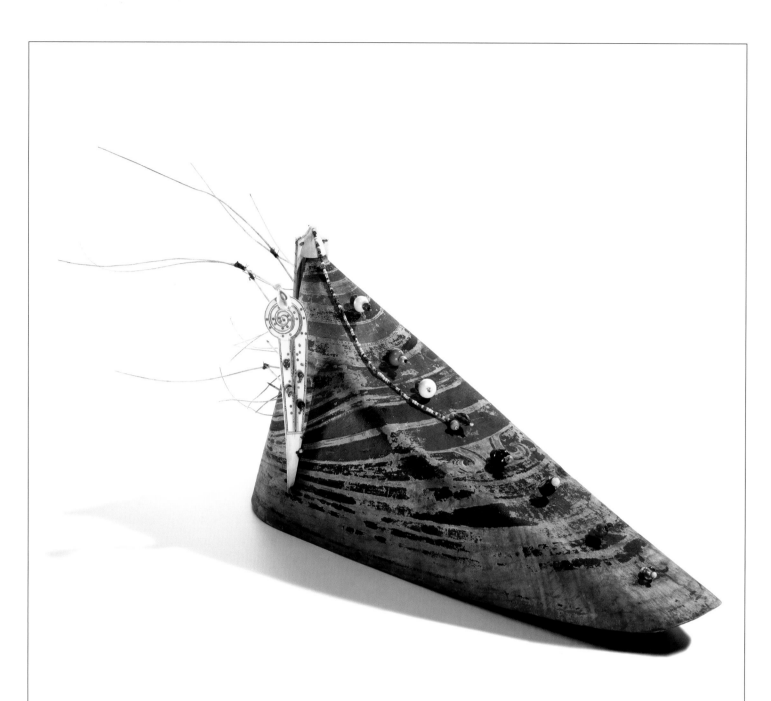

Angnakĝum saleeĝuu
HUNTING HAT

Aleutian Islands
Donated by Mrs. Thea Heye, accessioned 1925
National Museum of the American Indian 144870.000
Length (including sea lion whiskers) 106.3 cm (41.9 in)

Whalers and headmen of the central and eastern Aleutian Islands wore bentwood hats that marked their elevated positions in Unangax̂ society.[1] This hat has a walrus ivory side piece topped with a spiral eye; a small bird carving perches on top. Wings, eyes, and other masklike features of Unangax̂ hats are thought to have represented thunderbirds or killer whales, which transferred spirit power to the hunter.[2]

Sea lion whiskers are attached to an ivory plate on the back of the hat; Vlass Shabolin called these "hatch marks," a tally of animals the owner had killed. Large Russian trade beads decorate the bill, and a string of small beads dangles from the crown. Faded red and black bands, probably painted with traditional mineral pigments, encircle the hat.

Whalers hunted humpback and fin whales from kayaks using darts with poison-coated tips.[3] The active ingredient of the poison was aconite, extracted from the roots of the monkshood flower and mixed with oil from human corpses stored in caves. The potency of the whalers' poisons was said to cause their own deaths eventually.[4]

Man wearing hunting hat with dart and throwing board. Aleutian Islands, 1909–10.

"What if this belongs to a whaling captain, because they used kayaks to hunt for whales? That's why they represented the tail of a whale here [referring to spiral designs on front of hat]."

—Mary Bourdukofsky, 2003

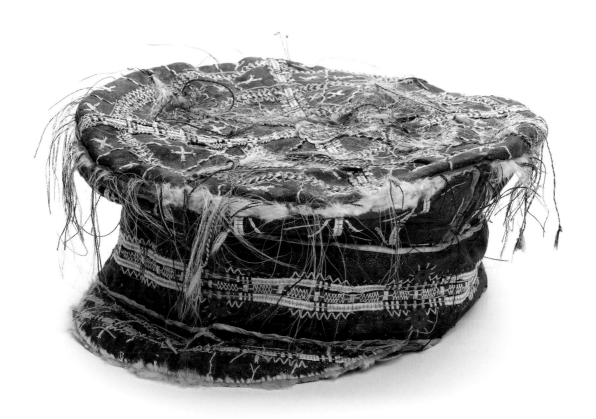

Tayuĝa saleeĝuu

MAN'S HAT

Fox Islands
Collected by F. Bischoff, accessioned 1868
National Museum of Natural History E006555
Length 28 cm (11 in)

Before contact with the Russians, the Unangax̂ went bareheaded except for wooden hunting hats and visors that men wore at sea and skin caps that both women and men put on for dances and celebrations. In later years, homemade Russian-style caps with visors, made of cloth or sealskin, became popular among Unangax̂ men.[5]

This beautifully decorated cap from Unalaska Island dates to 1868, only a year after Alaska passed out of Russian control and became a territory of the United States. While its shape is Russian, the ornamentation is purely Unangax̂. It is embroidered with caribou hair, cotton thread, dyed yarn, fox fur, and strips of colored seal esophagus.[6] The hat itself is made of stiff skin and painted with a black sparkling pigment. This is possibly a traditional paint made from volcanic scoria (sngaax̂) and octopus bile.[7] Stepan Glotov, who was on Umnak and Unalaska islands during 1759–62, noted that people there painted their faces with "silvery glitter."[8]

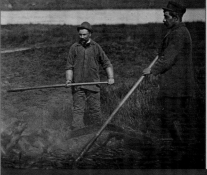

Wearing a Russian-style cap. St. Paul, ca. 1899.

"Consequently when the Aleuts saw the first Russians, who covered their heads, they called them, before any other name, *saligungin*, that is one having caps or hats."

—Ivan Veniaminov, Russian priest, 1823–34[9]

Chaĝtalisax̂
GUT PARKA

Aleutian Islands
Collected by the Army Medical Museum, accessioned 1869
National Museum of Natural History E383185
Length 110.0 cm (43.3 in)

The *chaĝtalisax̂*, also known by the Russian name *kamleika*, was a lightweight waterproof garment that Unangax̂ women created from the intestines of sea lions, harbor seals, fur seals, whales, or grizzly bears. Other tough membranes, such as the skin of a whale's tongue, were sometimes used.[10] The gut taken from one sea lion was enough to make two coats, according to elder John Gordieff. The intestines were cleaned and dried, split open to make strips about 1¼ inches wide, then sewn together with sinew.[11] The hood, which has a drawstring for the face, was sewn separately and attached.[12]

Women made watertight seams by sewing a double fold with thread made from fox or whale sinew in a combination of running and overcast stitches.[13] On this garment, red, blue, and black yarn was worked into the seams for color. Women used bird- or fish-bone needles that held the thread with notches instead of eyes, but these were replaced by iron needles, which the Russians brought in the eighteenth century.[14]

The *chaĝtalisax̂* was essential dress for kayak hunting. When it was used in combination with a spray skirt, which fastened snugly around the rider's waist, a man and his boat were completely sealed off from the waves.

Kayaker wearing gut parka. Cold Bay, 1909.

"The intestines were cleaned and blown up, then dried in the air, in the sun. They didn't cut them until they dried, and then they split them open. It could be sea lion or bearded seal or any big sea animal."

—Maria Turnpaugh, 2003

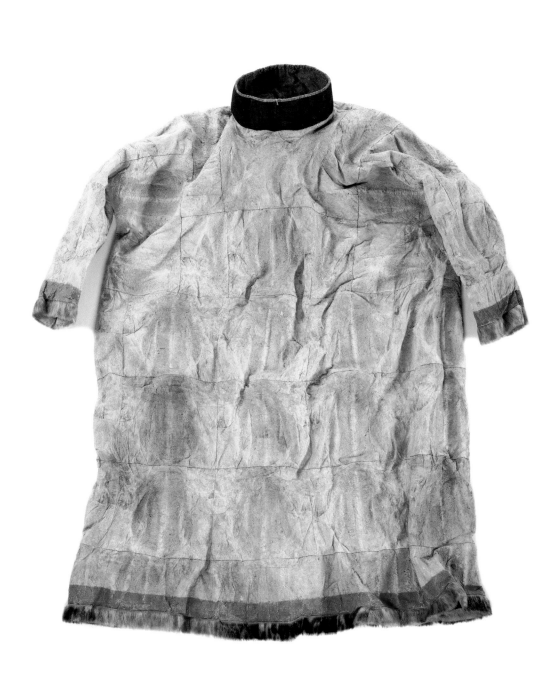

Sax

BIRD-SKIN PARKA

Commander Islands
Collected by Leonhard H. Stejneger, accessioned 1883
National Museum of Natural History E073030
Length 126 cm (49.6 in)

This eider duck parka has a standing collar of black wool cloth, red painted bands and trimmings of seal fur at the hem and cuffs. Parkas are reversible, and this one is shown with its feathers turned to the inside for warmth. Parkas made for dancing and ceremonies reached to the ankles and were decorated with puffin beaks, beads, tassels of fur and painted leather, feathers, and ornate hair embroidery.[15]

The first foreign explorers and fur traders in the Aleutians observed that Unangax̂ men wore bird parkas on land and sea, often beneath a waterproof intestine *kamleika*. Women's garments were made of fur seal or sea otter, but under Russian rule the use of these commercially valuable furs for ordinary clothing was banned, and women adopted bird and sealskin parkas like the men's.[16]

Eider ducks, old squaw ducks, cormorants, ravens, and puffins were used for parkas, the puffins snared in large numbers at the entrances to their underground burrows.[17] Twenty-five to forty birds were needed, depending on the species, and skins were stitched together with the birds' necks facing upward so that the feathers would shed water.[18]

"The parka for Aleuts in the local climate is an indispensable article. On the road, it constitutes their bed and blanket and, one might say, home. With it they are not afraid either of wind or cold."

—Ivan Veniaminov, Russian priest, 1823–34[19]

Decorated bird-skin parka with feathers turned to the outside. Unalaska, 1790.

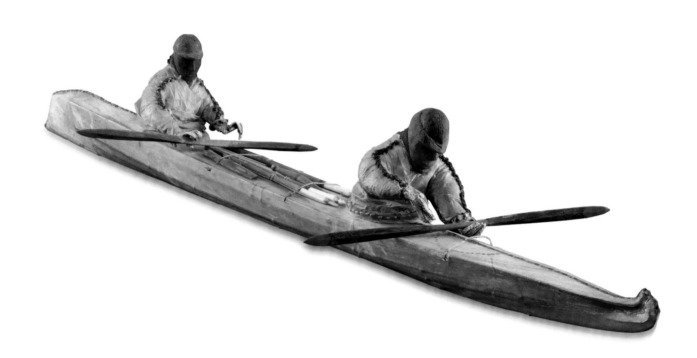

Ulux̂taĝ
KAYAK (MODEL)

Unalaska
W. G. Ross Collection, accessioned 1916
National Museum of the American Indian 052909.000
Length 33.7 cm (13.3 in)

The Unangax̂ kayak—built for survival on the stormy, tide-ripped seas of the Aleutian Island chain—has been praised for its sophisticated design, speed, beauty, and skill of construction.[20] The boats varied in length from about thirteen to twenty-one feet, depending on whether they were made for one, two, or three paddlers. The finest old kayaks were so narrow and sharp-keeled for speed that they would not float upright without a rider.[21] Unangax̂ names are *iqyax̂* (single-hatch kayak), *ulux̂taĝ* (double-hatch kayak), and *iiqyaada-x̂* (three-hatch kayak). The Russian name *baidarka* is commonly used in the islands today.

The split, upturned bow is said to represent a sea otter lying on its back with arms upraised;[22] the stern contracts to a narrow, rudderlike tail. The figures on this model hold double-bladed paddles, standard equipment in the Aleutian Islands.[23] The paddles have sharp points and, when tipped with ivory, could be employed as weapons.[24]

Spray skirts worn around the waist kept water from coming inside the boat. Kayaks and hunting weapons were beautifully made and decorated to attract the sea otters and other game.[25]

Kayakers wearing gut parkas. St. Paul Island, ca. 1904.

"If perfect symmetry, smoothness, and proportion constitute beauty, they are beautiful; to me they appeared so beyond anything that I ever beheld. I have seen some of them as transparent as oiled paper, through which you could trace every formation of the inside."

—Martin Sauer, Billings Expedition, 1802[26]

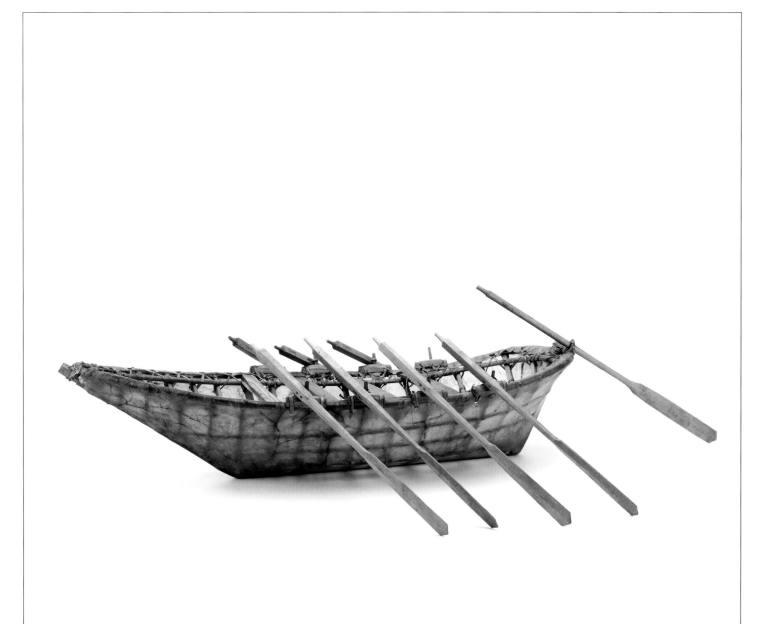

Niĝaalaĝ
BOAT (MODEL)

Aleutian Islands
Collected by Leonhard H. Stejneger, accessioned 1883
National Museum of Natural History E073019
Length 61 cm (24 in)

In addition to kayaks, the seafaring Unangax̂ needed large skin boats for carrying people, food, and cargo between islands or on long-distance expeditions for trade and war.[27] The *niĝaalaĝ*, made with a driftwood frame and covered with sea lion skins, could hold up to twenty passengers and crew. The original design had a rounded bow and was propelled with paddles. It lacked seats, requiring the crew to sit on the gunnels. The *niĝaalaĝ* was light but easily overturned if not skillfully handled.[28]

Russian fur trade companies imported a Siberian design that was more suited to their purposes.[29] These boats, which resembled the model shown here, were wider, more stable, and had wooden seats. The bow was slanted and sharply pointed, and oars were used. These working boats, called *baidary* in Russian, were owned by the Russian-American Company and manned by Unangax̂ crews. They were used to haul furs, driftwood, and food; to tow whales and ships into harbor; and to bring cargo ashore from ships.[30] Canvas-covered *baidary* were used until very recently, and Vlass Shabolin remembered crewing on them in the 1960s, the steersman shouting "*Noĝathatha!*" (row) and "*Tabanetha!*" (turn) as they landed in heavy surf.

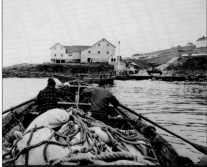

Transporting cargo by *niĝaalaĝ*. St. George, 1948.

"In early years, this was used for halibut fishing and sea lion hunting.... When the men used to go fur seal hunting, they'd come in on the beach in the rocks there, and then they'd put all the skins inside the *baidar*.... These *baidary* were seaworthy, and even if you got them full of water, they'd float."

—Vlass Shabolin, 2003

WE HAVE ALWAYS HAD STRONG LEADERS in our communities. Traditionally a chief would inherit his position, but for his authority to be recognized he had to excel as a hunter and be spiritual, generous, fair, and kind in his dealings with the people. There were no elections until the U.S. government started them in the 1930s.

The shamans, or medicine men, took care of the people's medical needs. They possessed detailed knowledge of the human body and had names for every part of it, both inside and out. They used plants to heal infections, burns, and internal ailments and healed the sick with the touch of their hands and by manipulating organs. Letting blood through a cut in the ankle was another method, used for rheumatism and tuberculosis. They prepared the bodies of the dead to be preserved as mummies in burial caves. Some shamans used their powers for evil and to cause sickness and were feared.

Russian fur traders came to the islands in the mid-eighteenth century following Bering's discovery that sea otters were abundant there. The Russians set up a colony that lasted until 1867, and they were cruel, especially in the early years. They enslaved the people, forcing the men to hunt sea otters and fur seals and the women to serve the traders, sew their clothing, and produce food. The Aleuts declined as a result of this mistreatment and disease until the majority of our people and over two-thirds of the original villages were lost.

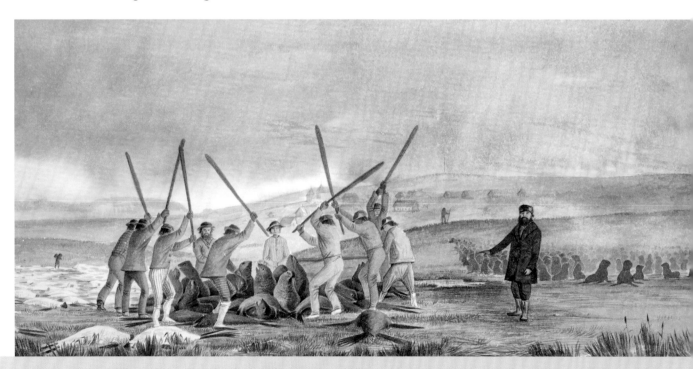

ABOVE: Henry Wood Elliot's 1872 watercolor depicts the commercial killing of fur seals near the village of St. Paul. Potential profits from sealing helped spur the U.S. government to purchase Alaska from Russia in 1867.

OPPOSITE: Agnes and Anna Lekanoff were among the Unangax̂ residents of the Pribilof Islands forced to evacuate their homes during World War II. They were photographed on the return voyage to St. George in 1946.

The Orthodox Church urged the Russian government to treat the people more kindly, and the situation improved. Ivan Veniaminov, an Orthodox missionary who came to Unalaska Island in 1824, was later canonized for his religious and humanitarian work. Our ancestors accepted the new faith, and through everything that we have faced since then it has held the Aleut people together. The Russians built schools to educate the Aleuts, and when the United States came in they reeducated us in the American way. So we've been "civilized" twice, first by the Russians and then by the Americans!

In December 1941, I was a twelve-year-old school girl. Our teacher, Mrs. McGee, told us one morning that the Japanese had bombed Pearl Harbor, and she made us put up blackout blankets. In April we learned that an invasion of the Aleutian Islands was feared and that the United States wanted to get us out of the way of the war. Only a few weeks later the Japanese bombed Dutch Harbor and invaded Attu and Kiska islands, at the west end of the chain. In June a U.S. Navy ship, the *Hulbert*, came to Atka to evacuate everyone.

Before leaving, the navy burned our village to the ground, even the church. Only three houses were left standing, including ours and the home of Mr. William Dirks, the chief. It was devastating to the whole community. No one was allowed to get anything from the houses before they were destroyed, and we left with only the clothes on our backs. No one told us our destination.

All of the Aleut refugees were taken to internment camps in southeast Alaska. My family was at Killisnoo until 1945. It was very poorly set up, and we had little food and no medicine or appropriate housing. In that two and a half-year period we lost almost all of our elders and newborns, a total of seventeen deaths out of eighty-five who had left Atka together. We almost lost our culture entirely because of that, and the way I grew up no longer exists.

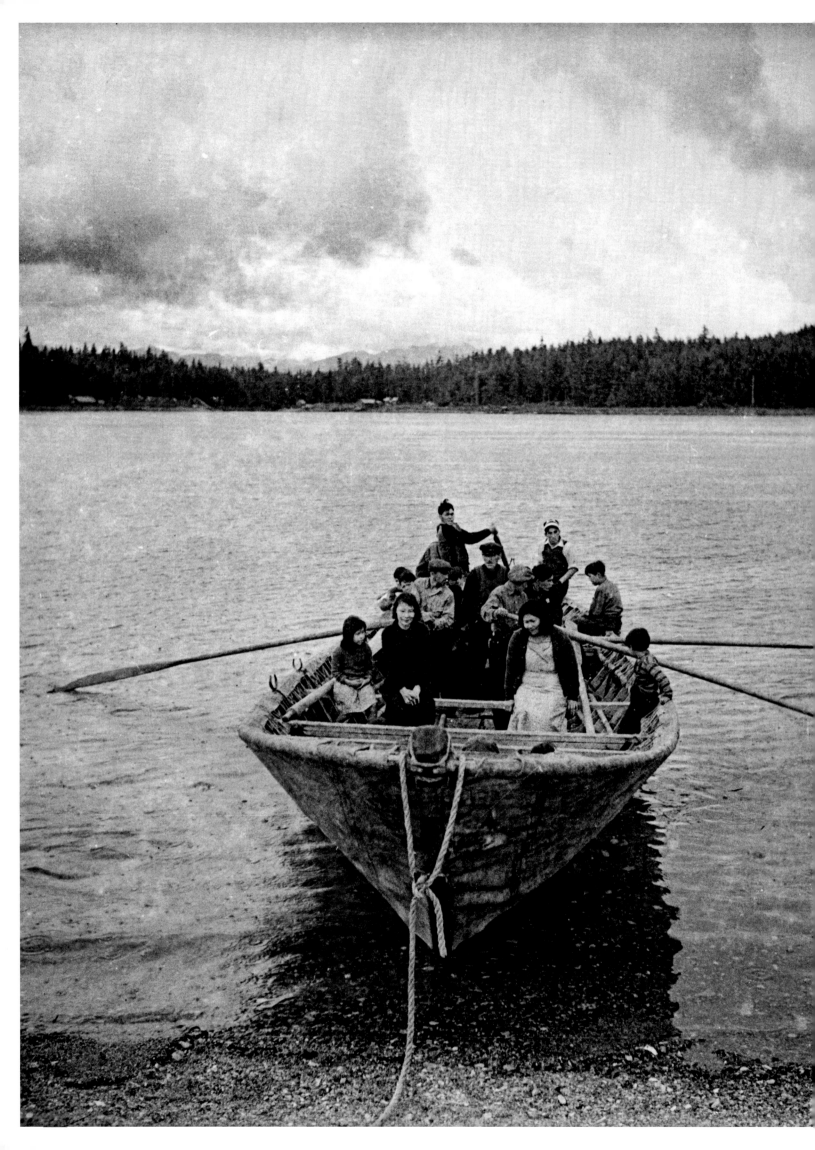

After Killisnoo I stayed in southeast Alaska to continue my education at the Wrangel Institute. Many of the students there were from St. Paul, St. George, and Unalaska, and I picked up their eastern dialect. When I went home to Atka I would talk to my father in Aleut. I'd always start out in Niiĝux̂, then switch to the Qawalangin, and he'd tell me, "Stop doing that. Speak your own dialect." English was my second language, and sometimes it still is, but when I'm under pressure I think in Aleut.

My daughter Pat and I visited Bering Island in the Commanders; it has a population of Niiĝux̂ speakers, whose ancestors were settled there by the Russians. It was so good to hear that pure, pure language like my father spoke; it was beautiful. What people learn now they call contemporary Aleut. I'm so glad they are teaching it but hope they will preserve the original pronunciations and sounds.

Before the Alaska Native Claims Settlement Act of 1971 everyone had summer camps. When we got food, we shared it, and you could use another person's camp as long as you kept it clean and replenished what you used. Land claims introduced the word *mine*, as in, "That's mine. You can't use it." After that, people didn't share as much and started expecting to be paid to do things instead of just helping, as in building a house. And the Native corporation leaders didn't want to involve elders in the new enterprises, thinking they were too old and not ready to do things in the Western way.

Those were the negative effects of land claims, but things have improved over the years, and ANCSA has brought us many benefits. I first went to work for the Aleut Corporation as a receptionist in 1972 and was eventually employed in each of the departments. I wrote up land selections, helped with the accounting, and ended up getting elected to the board in 1976. I served until 2008, including a long term as president. It was a challenging and terrifying ride, because we were a "have not" corporation with no forests, oil, or minerals on our lands to generate profits. Yet we needed to do the best we could to support our communities and shareholders. Your heart really has to be in it, because it takes a lot of personal sacrifice. When I was the president I had a beautiful team. Some other regional corporations gave me advice, which helped to make my tenure as president successful.

Unangax̂ refugees aboard a *niĝaalaĝ* skin boat (see p. 131) in southeast Alaska, 1942. Almost 900 residents of Akutan, Atka, Umnak, St. George, and St. Paul islands were removed to Funter Bay, Killisnoo, and other internment camps in the southern Alaskan panhandle, where about 10 percent died.

Alitxudanam Saluu
WARRIOR'S SHIELD

UNANGAX̂

Kagamil Island
Collected by Aleš Hrdlička, accessioned 1937
National Museum of Natural History E389861
Length 69.5 cm (27.4 in)

Unangax̂ chiefs led war parties against neighboring islands and foreign enemies[31] and fought Russian fur traders as they sought to subdue and exploit the Native population.[32] The goals of traditional warfare were to capture valuables such as amber, dentalium shells, and obsidian, retaliate for attacks by the other side, and take captives for use as slaves.[33]

Warriors traveled long distances to carry out surprise attacks, sometimes fighting at sea if enemy boats were encountered.[34] Raiders dropped fireballs made of burning grass and blubber through the rooftop entrances of enemy dwellings, incinerating the people inside or forcing them out into the open to be speared.[35] For defense, villages were built near steep-sided rocks or on islands, where residents could retreat and try to hold off the enemy.[36]

Weapons included lances, bows, daggers, and darts.[37] War darts, armed with barbed bone and obsidian-tipped heads, could penetrate a man's chest from front to back and were sometimes coated with poison.[38] For protection against these deadly weapons, Unangax̂ fighters used wooden shields and armor made of wooden rods lashed together side by side. This shield, taken from a burial cave on Kagamil Island,[39] is made of split wooden planks held together with leather cords. The spirals were repainted in an old museum restoration.

An Unangax̂ man with his tools. Unalaska, 1768.

"Their weapons consist of bows, arrows, and darts: they throw the latter very dexterously, and to a great distance, from a hand-board. For defense they use wooden shields, called *kuyakin*."

—Ivan Solov'ev, Russian fur trader, 1765[40]

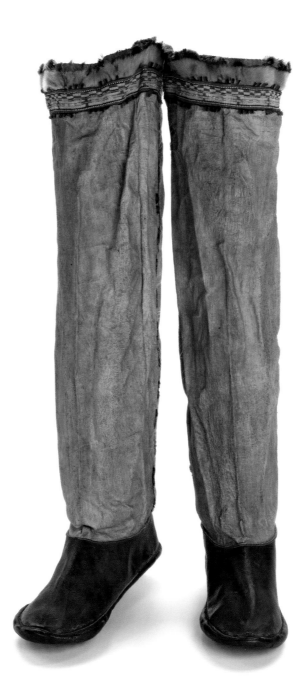

Aleutian Islands
Collected by James G. Swan, accessioned 1876
National Museum of Natural History E020921
Length 63 cm (24.8 in)

UNANGAX̂

Sapuugam anuĝnaseĝa

MAN'S BOOTS

Everyday undecorated Unangax̂ boots usually had seal or sea lion soles and upper parts made of seal or sea lion esophagus or caribou skin.[41] Boots were sewn with whale or caribou sinew, which swelled when wet to make the seams completely watertight.[42]

This tall pair of esophageal boots, identified in museum records as "boots from an Aleutian chief," is finely made and ornamented along the seams with colored embroidery thread and around the tops with dyed-membrane appliqué and bands of fur seal. The interiors are lined with red cloth. The most beautifully decorated clothing often denoted status in Aleutian society and was worn for ceremonies. Elders Vlass Shabolin and Maria Turnpaugh joked that the chief who wore these must have been exceptionally tall, because on most short-legged Unangax̂ people they would be hip boots.

Man wearing boots. St. Paul, ca. 1880.

"The chief of Aglagax took the woman home and had her sew boots of some very dry sea lion gullet [esophagus]. She sewed the dry gullet and finished a pair of boots. Her husband put them on and waded in a lake and his boots didn't leak."

—Ivan Suvarov, 1910[43]

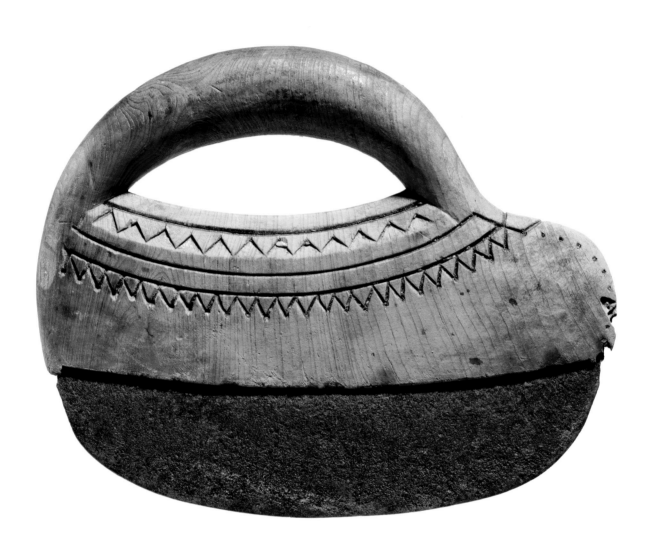

Nuusix̂
WOMAN'S KNIFE

Aleutian Islands
Collected by D. F. Tozier ca. 1900, purchased 1917
National Museum of the American Indian 069166.000
Length 14.2 cm (5.6 in)

This knife is similar to the *ulu* used even today all across the Arctic. Among its many uses is in cutting hides to make clothing and boots.[44] Russian priest Ivan Veniaminov wrote in the 1820s that the curved knife with wooden handle (*pekulka*, Russian for "knife") was one of a woman's basic tools, which she used "very skillfully as a knife or scissors." It was also employed in cutting whale meat. Older knives had blades made of ground and polished stone, but iron took its place.[45] From his observations at Unalaska in 1790, Carl Heinrich Merck noted, "There is a broad knife made of iron. They use it to eat with. They bite into whale blubber, for instance, and with the knife they cut off a good size piece in front of the mouth."[46] He also saw women using their knives to split seagull bones into fine slivers for making needles.

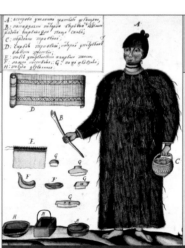

"Oh, I use it [a woman's knife] all the time. I just love it; it's nice and big."

—Maria Turnpaugh, 2004

An Unangax̂ woman with tools she used. Unalaska, 1768.

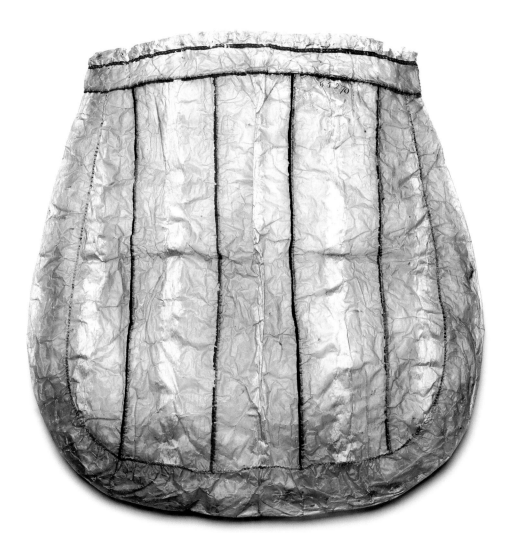

Atka Island
Collected by Lucien M. Turner, accessioned 1882
National Museum of Natural History E065270
Length 29.8 cm (11.7 in)

Imguĝdax̂

BAG

Unangax̂ women sewed strong waterproof bags from the intestines of sea lions and the gullets of seals. David Samwell, who visited Unalaska Island in 1778 with Captain James Cook, noticed small bags that "they ornament very pretty with their needles."[47] Elders Mary Bourdukofsky and Maria Turnpaugh said that this 1880s Atka Island bag is made from sea lion intestine sewn together with sinew thread and that it was probably used to hold sewing materials. The decorative stitching was done with embroidery thread. Older bags were decorated with caribou or mountain goat hair, seal fur, bird feathers, and strips of black or brightly colored esophagus.[48]

Intestine bags had many uses and often held small tools or sewing materials. Bags filled with pieces of fur, feathers, and other sewing supplies were among the household goods that were placed in burial caves on Kagamil Island.[49]

Preparing sea lion intestines. St. Paul Island, ca. 1899.

"And after we had supper, sometimes it was very nice out, so she let us play for a while, and then around seven we all had to come in, my sisters and I.... And there was a certain day we'd do sewing by hand, do certain kind of stitches by hand.... That's when we learned how to do things as a woman's supposed to do."

—Mary Bourdukofsky, 2004

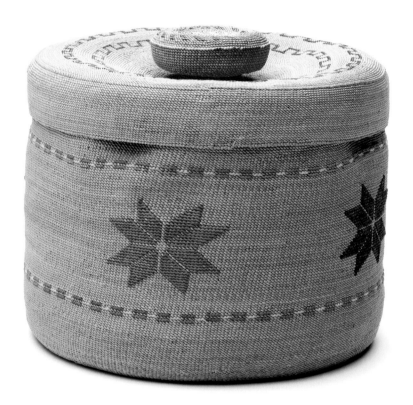

| UNANGAX̂ | # Chivtux̂
 BASKET | Attu Island
 Collected by Howard B. Hutchinson, accessioned 1976
 National Museum of Natural History E417767
 Height 10.5 cm (4.1 in) |

The grass baskets of the Aleutian Islands, so tightly woven that some were capable of holding water, greatly impressed early visitors.[50] The best weavers were on Attu Island, which may have been the starting point for a tradition that spread across the Aleutian chain.[51] After a decline in basket weaving, Unangax̂ artists are revitalizing the tradition.[52]

Grass storage baskets traditionally held dried fish, roots, and meat; other types were used for gathering beach foods and plants.[53] Small round baskets with lids, like this example, were invented in the nineteenth century and made primarily for sale.[54] Decorative designs were added using dyed grass, spruce root, silk embroidery thread, and yarn.[55] Older baskets were decorated with bird feathers.[56]

Rye or beach grass *(Elymus mollis)* for baskets is gathered in the summer on coastal hillsides well above the beach, because grass exposed to salt spray is too coarse and thick.[57] The weaver picks, bundles, ages, sorts, dries, and then splits the grass stems with her fingernail into strands that are suitable for use as "weavers" (vertical strands, or warp) and "weaves" (horizontal strands, or weft).[58] At least eight weaving patterns are historically known.[59]

"When you pick it you say a little prayer thanking the grass for letting us have some of it, and that we won't abuse it…. It's easier to weave if it is moist. If it's not so moist it breaks all the time. You have to do that as you go along. We usually keep a little glass of water to dip our fingers in."

—Maria Turnpaugh, 2004

Weaving a basket. Attu, ca. 1923.

Chiqiliitix̂
GRASS MAT

Attu Island
Collected by J. M. Moore, accessioned 1933
National Museum of Natural History E365225
Length 137 cm (53.9 in)

Weaving mats from wild rye grass was one of a woman's constant tasks.[60] Ivan Korovin wrote of the Unalaska people during 1763–65 that "they sleep upon thick mats, which they twist out of a kind of soft grass that grows upon the shore."[61] Finely woven mats made of split grass were used as kayak seats, sleeping blankets, and floor coverings. They were hung up as screens to demarcate separate family areas inside the large communal houses in which up to 150 people lived.[62] Mourners wrapped the dead in embroidered mats before placing them in the ground, tomb, or cave.[63] Later in time women wove grass prayer mats and rugs to cover the floors of Russian Orthodox churches.[64]

The activities of harvesting, processing, and weaving the grass for mats were much the same as for baskets, although long, tough grass harvested in late summer or even early winter was preferred for its durability.[65] A large fine mat could take months or an entire year to complete, a task that sometimes fell to female slaves in precontact society.[66] Embroidery techniques, such as the geometric designs worked with colored thread in this fine mat, were similar to those used on baskets.

Mats used at home. Unalaska, ca. 1778.

"Some used them as room dividers, also as burial mats.... If somebody died they say they wrapped them up like a mummy, but they took all the insides out and studied them to figure out the cause of the death. Before they buried them they stuffed them with grass and moss and then wrapped them all up. Before they had cloth they used grass mats."

—Maria Turnpaugh, 2004

RETURN OF THE DANCE

Crystal Dushkin

The Unangax̂ Dancers performing at the Festival of Native Arts in Fairbanks, 2006

IN UNANGAX̂ my name is Kdam Idigaa. Every October when I was growing up in Atka Village, in the western Aleutians, I would watch the Alaska Federation of Natives convention on Rural Alaska Television (RATNET). They would broadcast Quyana Night with drumming and dancing from around the state. I asked my parents, "Who are those people? Where are they from?" They told me, "Those are the Chukchas [Eskimos] and Kalushkas [Indians]." I asked, "Where are the Aleuts?" "Our people do not dance," they said. That part of Unangax̂ culture had been asleep for many years.

The Netsvetov School in Atka, led by my father, who was president of the board, helped to bring dancing back. Our teacher Ethan Petticrew was Unangax̂, and his family comes from Nikolski. In class we watched a silent 1934 black-and-white film that showed an elderly couple, with the man drumming and the woman demonstrating dance motions. We read Russian accounts of our ceremonies and looked through books that showed the people's clothing. A Koryak dance teacher from Russia taught us basic movements and how to make our own regalia, which is styled after the bird-skin parkas called *sax* (bird), which our ancestors wore. We listened to tapes of our ancestors' songs and drum beats, recorded on wax cylinders by anthropologist Waldemar Jochelson in 1909–10. There were even old ivory carvings that showed men drumming and women dancing, their knees bent and seal stomach rattles held at their sides. We put all of this together, like pieces of a puzzle, to learn what our dancing was like and how to do it ourselves. The Atka Dancers were born.

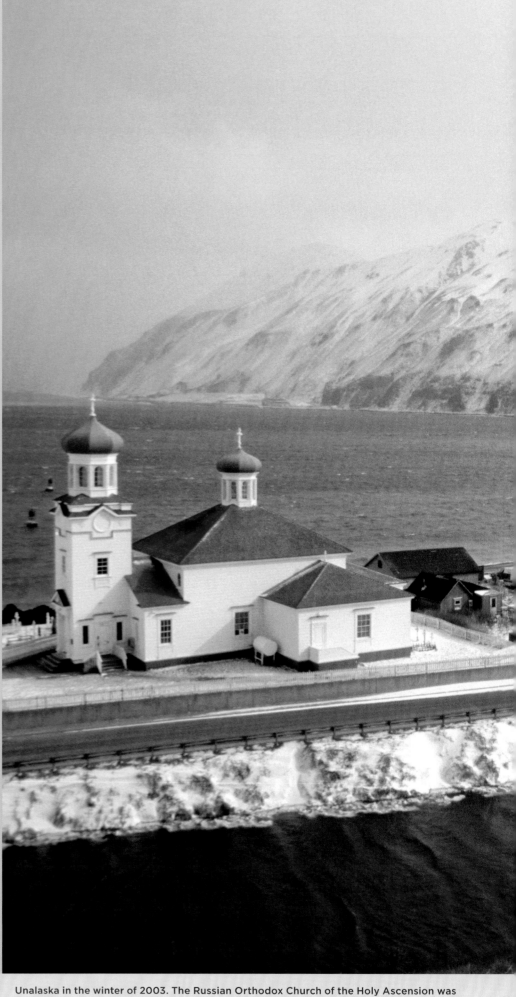

Unalaska in the winter of 2003. The Russian Orthodox Church of the Holy Ascension was completed in 1826 during the tenure of priest Ivan Veniaminov. Unalaska, originally called Iliuliuk, was the first permanent Russian colonial settlement in Alaska.

FATHER YAKOV NETSVETOV (later St. Yakov), whose mother came from our island, was the first resident priest. He consecrated the church on Atka in 1830, and ever since then Russian Orthodoxy has been a foundation of community life. Christmas, New Year's Day, Easter, and other feast days mark our calendar of worship and celebration. Starring and masking—still practiced in some villages during the midwinter holidays—are similar to rituals carried out before the Russians came.

The original Unangax̂ festivals were held in the fall and winter, when people celebrated successful hunting and food gathering and asked for the animals to return. Those ceremonies survived Russian rule but were banned after the United States took over in 1867. In the decades that followed, the Aleuts adopted new music and dances for fun and entertainment, such as polkas, two-steps, and waltzes. When our men traveled to the far western islands to trap foxes before World War II, they brought their fiddles, guitars, and other instruments along to hold dances in villages along the way. Since 1992, groups of young people have formed to restore and perform some of the original Unangax̂ dances.

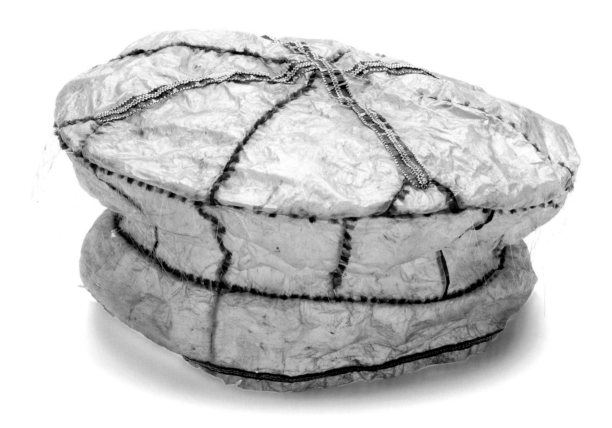

Saleeĝuu
WOMAN'S HAT

Unalaska Island
Collected by Thomas T. Minor, accessioned 1869
National Museum of Natural History E007957
Diameter 23 cm (9.1 in)

Elders Mary Bourdukofsky, Vlass Shabolin, and Maria Turnpaugh identified this as a woman's ceremonial hat worn for dancing during celebrations at the end of the fur seal harvest and on other special occasions, such as weddings. Round embroidered caps made of sea mammal intestine first became popular in the early nineteenth century and were based on the shape of a Russian sailor's hat.[67] The caps were sometimes worn as waterproof covers for cloth caps underneath. In the original pre-Russian winter hunting ceremonies, Unangax̂ dancers dressed in embroidered, fringed, and feathered hats made of bird or seal skins, some tall and peaked, others flat or shaped like birds with bobbing heads and tails.[68]

The decorative strips on the top of this cap are seal esophagus painted red and black. The white stitching may be caribou hair, although mountain goat, sheep, and human hair were also used. In the twentieth century, colored ribbon was often substituted for the colored strips of esophagus.

"The men always had their hunting hats all decorated when they did their ceremonies, and the women wore something on their heads like this. They danced wearing these."

—Mary Bourdukofsky, 2004

Wearing ceremonial attire. Aleutian Islands, ca. 1862.

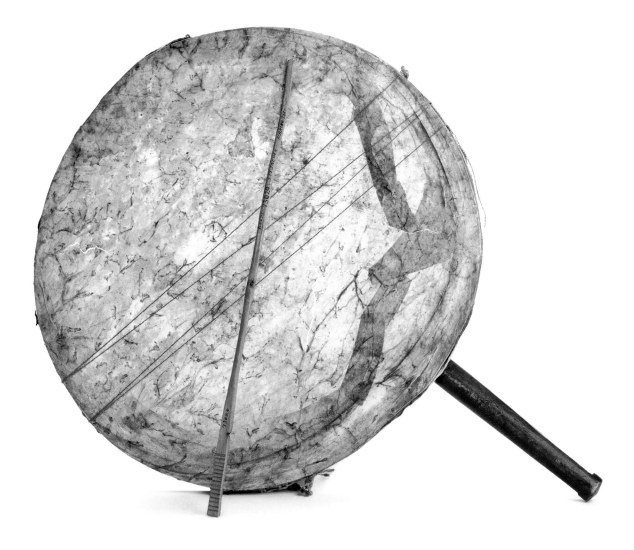

Chaayax

DRUM

Commander Islands
Collected by Leonhard H. Stejneger, accessioned 1883
National Museum of Natural History E073020
Length 65 cm (25.6 in)

Drumming accompanied dance and song during the traditional ceremonial season from December through April.[69] Young men struck their instruments with wooden sticks while the women and older men danced.[70] Drums with handles were most common, although in the 1760s Andrean Tolstykh saw another type that was held by cross-cords.[71] Dancers dressed in festival hats and clothing, wore masks, and carried rattles made from inflated seal stomachs. Drums, like masks, were broken after the ceremonial season or placed in caves, never to be used again.[72] As told in the story of Uĝdigdang, drums were given as offerings to the mummified bodies of chiefs for use in the afterlife.[73] Shamans beat them during séances, and raiders pounded war drums during attacks.[74]

Elder Bill Tcheripanoff demonstrated how to make drums with fox- or caribou-skin covers and told how men used to compose songs when they were hunting and trapping.[75] Drums could also be covered with sealskin or sea mammal gut, such as this example, which was constructed with a fur seal bladder.[76] Wrappings of sinew cord secure the cover to the frame.

"There was a man called Uĝdigdang who always had celebrations…. He used to say to his people, 'Even when I am dead I shall have celebrations. So when I die, you shall lay me in the cave of my observation hill, putting with me my drum and paints.'"

—Ivan Suvorov, 1910[77]

Detail from illustration on manuscript map. Atka, 1756–62.

UNANGAX̂

Ayagam ax̂am chugaayuu
DANCE CAPE OR BLANKET

Commander Islands
Collected by Leonhard H. Stejneger, accessioned 1883
National Museum of Natural History E073028
Width 151 cm (59.5 in)

This dance cape, made of sea mammal intestines, was acquired from the residents of Bering Island in the Commander Island group. The Commanders, originally uninhabited and located at the far western end of the Aleutian chain, were settled by Atka Island Unangax̂ who were taken there for sea otter hunting by the Russians.

Carl Heinrich Merck witnessed the use of a dance cape in 1790: "A man holds a mask in front of his face, and his jumps and turns stay exactly in time with the beats of the hand drum. In each hand he holds two blown-up stomachs of sea animals. He swings them about to the same beat. Sometimes he throws these away and instead picks up a red-and-white-striped blanket made of gutskin."[78]

According to Gavriil Sarychev, who witnessed the same dance, it ridiculed a vain hunter who boasted about the many animals that he had caught, which were represented by the bladders and blanket.[79]

Masks used at dances. Unalaska, ca. 1790.

"It'd be Russian Christmas. And they'd have dancing, oh, they'd have drums. There'd be old Jenny Galuktinoff, John Goldovoff, Walter Gardayoff, and they'd dance. Aleut dances and old songs."

—Maria Turnpaugh, 2004

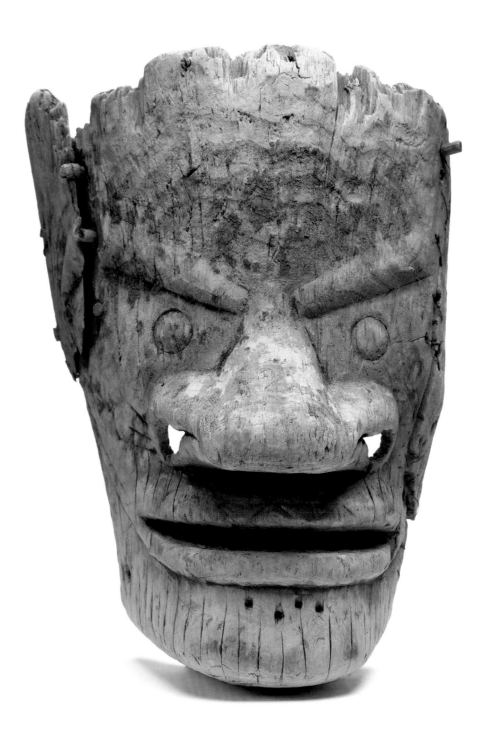

Maskx̂a

MASK

Unga Island
Collected by William H. Dall, accessioned 1869
National Museum of Natural History E007604
Length 32 cm (12.6 in)

Masks were originally worn during elaborate "plays" *(ukamax̂)* that Aleutian Islands villages presented to guests from other settlements, accompanied by feasts and gift giving that could leave the hosts in a state of proud poverty.[80] In the chief's communal house, masked performers enacted hunts, battles, and ancestral legends. During other winter festivals masked men and women danced to the beat of drums and carried seal-stomach rattles.[81] Ivan Solov'evwrote that in celebrating the capture of a whale, "some of them dance naked in wooden masks, which reach down to their shoulders, and represent various sorts of sea-animals."[82]

Conversion to Russian Orthodoxy brought about the decline of the original ceremonies by the early 1800s.[83] A modern masking tradition continues, however, in the form of Mascarrata, a religious play in which devils or evil spirits are represented by masked members of the community.[84]

This large mask from a burial cave on Unga Island bears traces of red and green paint and has holes around the edges that once held painted wooden ornaments. Attached to the back is a wooden grip for holding the mask with the teeth. The mask may have been supplied to the dead for use in ceremonies during the afterlife.[85]

"We call it Mascarrata.... Three days after our Orthodox Christmas, it was a custom then that the masking begins."

—Mary Bourdukofsky, 2004

A mask and mask attachments from Aknañh Cave. Unga Island, 1871.

SUGPIAQ

Gordon L. Pullar

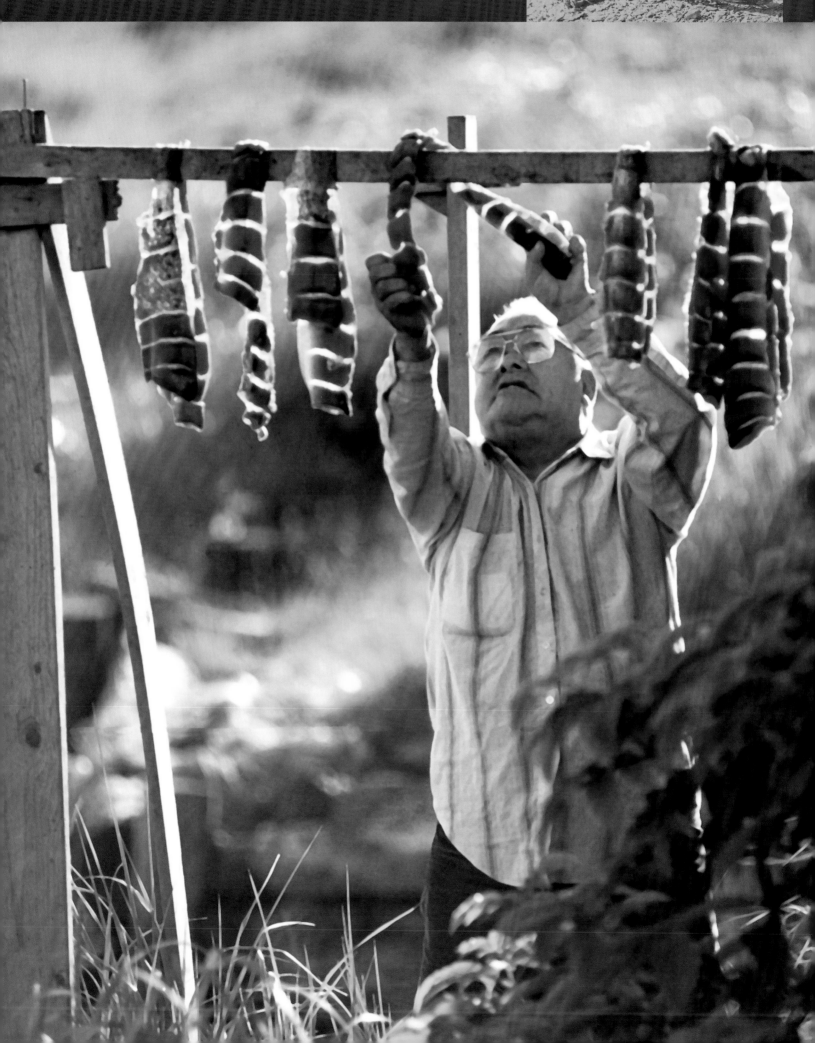

IF YOU SPEND ANY TIME at all in a Sugpiaq village, you will be aware that someone is always out getting something to eat. Along our coasts you can fish for salmon, halibut, and crabs, hunt seals or sea lions, and walk the shore at low tide to collect shellfish and seaweed. Depending on the season you might search out an octopus under beach rocks, gather eggs on a seabird island, pick berries, or go hunting in the hills for bears, caribou, or deer.

The Sugpiaq homeland is large, spanning Prince William Sound, the Kenai Peninsula, Kodiak Island, and the Alaska Peninsula. Our climate is wet and stormy but mild. Massive glaciers flow from the high coastal mountains, but the sea remains unfrozen. Spruce forests cover the eastern areas but dwindle in the west, so that much of Kodiak Island and the Alaska Peninsula are treeless, windswept tundra.

The Gulf of Alaska once supported ten thousand or more Sugpiaq people, who lived in scores of villages along its coasts and large rivers. Those from the far ends of the region interacted little with one another, except in war, but residents of nearby settlements traded, intermarried, and joined together for winter ceremonies.

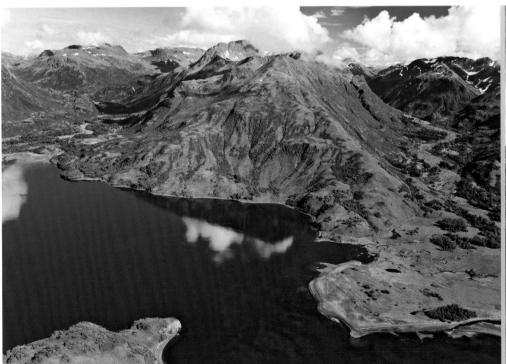

OPPOSITE TOP: **Boys with three-hole kayaks at Kiniklik village, Prince William Sound, 1925**

OPPOSITE: **The late Senafont Zeedar Sr., a Sugpiaq elder and chief who grew up at Kaguyak on Kodiak Island, hanging filleted salmon at Akhiok in 1998.**

ABOVE LEFT: **Aerial view at the head of Ugak Bay on Kodiak Island, 2007**

ABOVE RIGHT: **Stella Zeedar harvesting sea urchins during low tide at Akhiok, 1998**

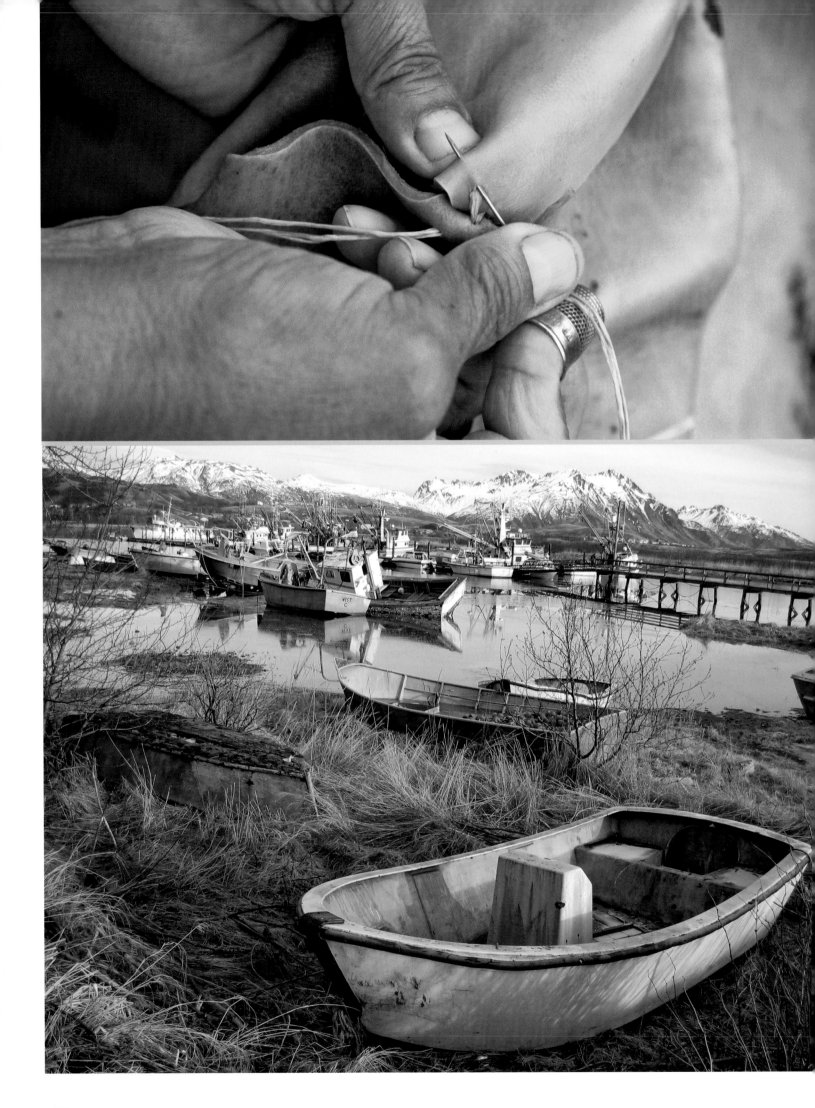

Today about thirty-one hundred Sugpiat make their homes in our communities, and more than two thousand have moved outside. Although reduced in numbers, our people occupy the same lands that our ancestors first settled ten thousand years ago.

Traditional Sugpiaq hunting depended on the *qayaq* (kayak) and *angyaq* (large open boat), both covered with seal or sea lion skins. Ancestral weapons included throwing boards, harpoons, and arrows. Sugpiaq whalers who hunted from kayaks using poisoned darts were known as *ahhuhsulet*, "shamans who hunt whales," because of their magical practices.

Many communities today depend on commercial fishing for cash income, but in recent years that industry has faltered, no longer offering the same promise of prosperity that it once did. Even so, there are Sugpiaq fishermen who have been successful at it their entire lives. Part of the problem today is the high cost of fuel for boats and home heating. An increasing number of people can no longer afford to stay in the villages and are migrating to cities such as Kodiak and Anchorage.

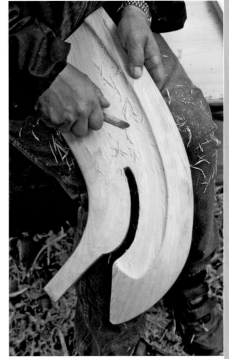

When the *Exxon Valdez* oil spill occurred in 1989 people were deeply shocked and depressed. They did not know if their lives would ever be the same. Eleven million gallons of oil poured into Prince William Sound and then drifted west on the wind and currents, polluting fifteen hundred miles of shoreline. The huge spill coincided roughly with the geographic boundaries of the Sugpiaq culture area. We were told by some that the oil would wipe out all food sources from the sea and were reassured by others that it would do little damage and be quickly cleaned up. Neither prediction was entirely correct. Most sea life eventually recovered, but the communities that relied most heavily on fishing and coastal subsistence were disrupted for years and suffered deep economic losses. Today oil can still be found on the beaches, weathered and buried by storms but lying just below the rocks and sand. Its pollution still leaches slowly into the sea.

OPPOSITE TOP: **The blind stitch used to sew waterproof kayak covers, demonstrated at the Alaska Native Heritage Center in Anchorage, 2000**

OPPOSITE BOTTOM: **Skiffs and fishing boats at the village of Old Harbor, Kodiak Island in 2002**

ABOVE: **Nick Tanape Sr. carves the bifurcated bow piece of a Sugpiaq kayak frame for the Traditional Native Boat Project, Alaska Native Heritage Center, 2000.**

Caguyaq

HUNTING HAT

Katmai
Collected by William J. Fisher, accessioned 1884
National Museum of Natural History E090444
Length 51 cm (20.1 in)

Sugpiaq bentwood hats, described by eighteenth- and early nineteenth-century Russian fur traders and voyagers,[1] have been compared to masks that magically invoked the hunting assistance of the Killer Whale/Wolf, the Raven, and the giant Eagle of Sugpiaq oral tradition.[2] The painting on this hat depicts a wolf face with down-turned mouth, long snout and nostrils, and crescent-shaped eyes with dangling ornaments of colored yarn and thread. Jutting out from the back are the animal's pointed ivory ears. The ivory side panels are simple in shape on this hat but carved on others to represent beaks or wings, often topped with bird "eyes" or small bird figures.[3] Sea lion whiskers adorn the back of the hat, which also has a braided sinew chin strap.

Open-topped hats like this one were typical of the Alaska Peninsula–Bristol Bay area and are intermediate in shape between hunting visors and closed-crown hats produced in other Sugpiaq, Unangax̂, Yup'ik, and Iñupiaq regions. Bentwood hats were said to bring luck in hunting sea otters[4] but may have earlier been associated with whaling. Sven Haakanson Sr. said that marks were added to a whaler's hat to show how many whales he had killed.[5]

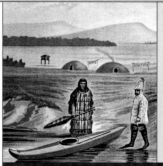

Man wearing a hunting hat. Lower Kuskokwin River region, ca. 1880.

"Before dawn next morning the raven flew away over the sea.... About midday they espied him flying toward the shore, carrying a whale."

—anonymous, from "The Raven and His Grandmother," 1903[6]

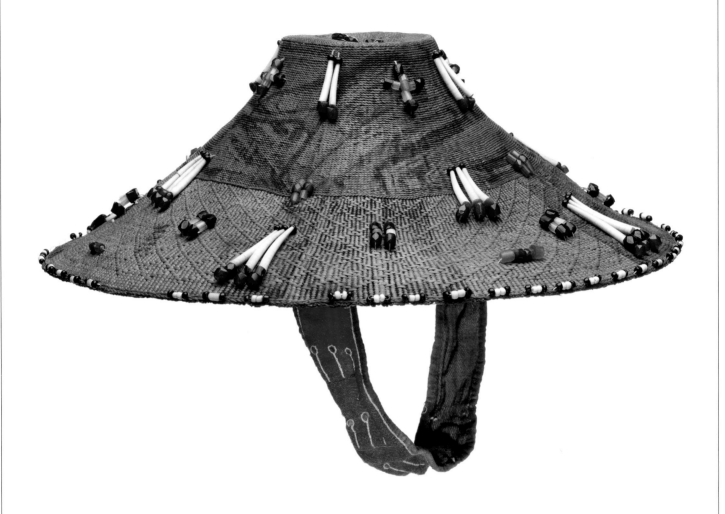

Awirnaq

SPRUCE-ROOT HUNTING HAT

Karluk
Collected by Vincent Colyer, accessioned 1872
National Museum of Natural History E011378
Diameter 40 cm (15.8 in)

Basketry hats plaited from split spruce roots were traditional dress for Sugpiaq men.[7] They were similar to hats worn by the Tlingit (see p. 218) but more ornately decorated with glass trade beads, dentalium shells, and sometimes sea lion whiskers. Sugpiaq "men of the first consequence" and "young gallants" wore hats topped with stacks of basketry cylinders.[8] Weaving on the brim was patterned to make radiating diagonals, zigzags, or diamonds, and the crown was twined to a smooth finish.

The image painted on the crown of this hat represents an animal, possibly a hunter's helping spirit, with face forward and teeth displayed; its body wraps around the back. Sugpiaq hat paintings resemble Tlingit crest designs but have a graphic style that subtly departs from Northwest Coast artistic conventions.[9] The hats were worn by hunters at sea, as seen on kayak models (see p. 154), and, like bentwood hunting hats, were ascribed with the power to attract sea otters.[10] Women wove and sometimes wore them, at least on Kodiak Island.[11] Dancers added feathers to the hats to perform in the winter ceremonies.[12]

"Their hats are woven very skillfully and stoutly from fir [spruce]-roots, with wide brims and a low crown slightly pointed at the top, and they are decorated with various designs."

—Gavriil Davydov, Russian naval officer, 1802[13]

Man wearing spruce-root hunting hat. Kodiak Island, 1790.

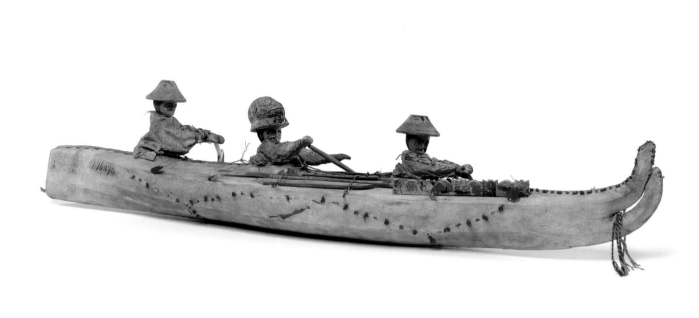

Paitaalek
THREE-HATCH KAYAK (MODEL)

Kodiak Island
Collected by William H. Dall, accessioned 1874
National Museum of Natural History E016275
Length 52.5 cm (20.7 in)

The Sugpiaq *qayaq* (or *baidarka*, in Russian) was made in one-, two-, and three-hatch designs.[14] Single-hatch boats were for fast pursuit with a double-bladed paddle; double-hatch kayaks allowed the man in front to wield a harpoon, dart, or gun while the stern paddler steadied the boat. Three-hatch kayaks, invented after Russian contact, were used for hunting but also to convey fur traders or Sugpiaq village chiefs as passengers in the middle seat.[15] Fore and aft paddlers in this model have spruce-root hats (see p. 153), whereas the central figure wears a hunting helmet shaped like a seal's head.[16]

Sugpiaq paddlers knelt in their boats on pads of grass or animal fur. Darts, throwing boards, harpoons, bows, arrows, and extra paddles were kept on deck.[17] A wooden siphon or hollow kelp stem was used to suck out any water that leaked inside.[18] Kayakers wore waterproof intestine parkas, tying the bottom over the cockpit rim to keep the boat dry.[19]

Sugpiaq kayaks are designed with a split prow, a feature shared by Unangax̂ boats. Men built the frames by bending carved pieces of hemlock or driftwood and lashing them together with rawhide or sinew. Women sewed the seal or sea lion covers with whale sinew, using watertight stitches.[20] The wavy line of blue and red yarn on the sides of many kayak models may indicate the seam pattern where the individual skins were stitched together.

"I watched Alex Anahonak build a *bidarki* kayak for the last time.... First, we put some [hot] rocks into a container of water and made the water boil so when he was ready to bend the frames, he just had to put them in the water. That made them bend easier. Then he put the ribs and frames together with sinew."

—Joe Tanape, 1980[21]

Men traveling by three-hatch kayak. Valdez, ca. 1905.

GUNNEL BOARD

Eagle Harbor
Collected by William J. Fisher, accessioned 1884
National Museum of Natural History E090420
Length 101 cm (39.8 in)

The decorated gunnel boards were placed on the front deck of a Sugpiaq *qayaq*, as can be seen on the three-hatch kayak model illustrated opposite. Skin cords passed through slots in the boards to secure harpoons and other equipment that were arrayed in front of the forward paddler.[22]

This board is painted with images of sea otters, which the hunters hoped to catch, and with killer whales, which could be summoned to assist in the hunt. Killer whales, or orcas *(arllut)*, were believed to be deceased people from the community who had changed into animal form; hunters spoke to them through a paddle held upright with its blade in the water.[23] On land a killer whale could assume the shape of a wolf; conversely, orcas were the pack-hunting wolves of the sea.[24] The head of a cormorant, possibly another helping spirit, is carved at the end of the board.

"People respected the killer whales and didn't bother them. They would ask the whales for anything to help their hunting. Sometimes the whales used to get the people some seal by scaring the seals over to the hunter. The people would talk to the whales through an oar (on their boats out in the ocean)."

—Herman Moonin, 1980[25]

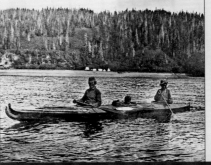

Tools on the front deck of a kayak. Iniskin Bay, ca. 1913.

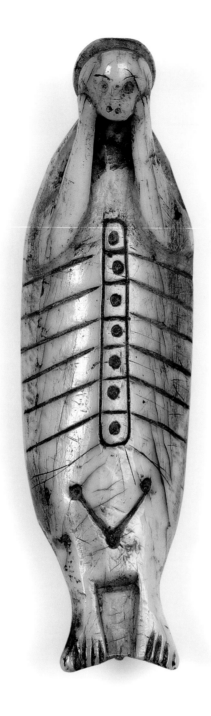

Samanaq

SEA OTTER CHARM

Napartalek
Collected by William J. Fisher, accessioned 1894
National Museum of Natural History E168626A
Length 7.2 cm (2.8 in)

According to oral tradition, a man who was collecting shellfish along a beach in Prince William Sound was surprised by the in-rushing tide; to save himself he cried out, "I wish I might turn into a sea otter!" His wish was granted, and evidence for the kinship of humans and otters is seen in their internal organs, which are said to look the same.[26] Hunters used charms, songs, and beautifully decorated clothing and hunting gear to attract these animal beings. Sugpiat offered newly killed otters fresh water to drink, a ritual gesture of respect that echoes Yup'ik, St. Lawrence Island Yupik, and Iñupiaq practices.[27]

The ivory hunting charm seen here was made to be fastened inside the cockpit of a kayak. It was collected in Bristol Bay, but similar figures were used throughout the Sugpiaq and Unangax̂ regions.[28] Engraved designs depict the animal's ribs and spine and likely refer to the belief that a sea otter's soul resides in its skeleton; to ensure that otters would be reborn, hunters returned their bones to the sea.[29] Skeletal elements of the charm resemble corresponding human parts, as well as the keel and ribs of a kayak, which was itself viewed as a kind of living sea mammal.[30]

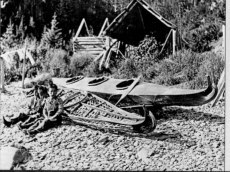

Boys with three-hatch kayaks on the beach. Kiniklik, 1925.

"They had good luck charms…. There was a little sea otter in there. Baby sea otter [a dried embryo]. And the guy told me, 'That's for our good luck. We put that up on a kayak, and pretty soon we find a sea otter.'"

—Larry Matfay (Old Harbor), 1986[31]

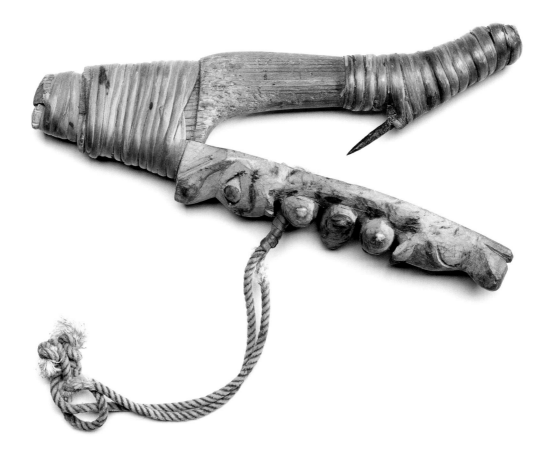

Iqsak
HALIBUT HOOK

Probably Kodiak Island
Collected by Emile Granier, accessioned 1898
National Museum of Natural History E200831
Length 25.5 cm (10 in)

Halibut was a staple food, eaten fresh, dried, or smoked. The fish, which can grow to well over two hundred pounds, were taken using V-shaped wooden hooks that floated a short distance above the sea floor, held down by a stone sinker.[32] This hook is carved with animal faces in the Tlingit style, and when it was in use these images faced downward so that bottom-dwelling halibut could see and be attracted to them. The point in this example is iron, but those of an earlier date were made of sharpened bone. Elder Bobby Stamp said that blubber, flounder, sculpin fish, or pork chops were good as bait, and octopus was another traditional favorite for this use.[33]

A strong line made of twisted kelp, sinew, or baleen ran to the surface and was attached to an inflated stomach buoy. The line could be tended from shore or from a kayak, but pulling up a large halibut at sea held the risk of capsize unless two boats were braced together. Halibut were once more abundant than today and reportedly shoaled in great numbers along the shores of Kodiak Island in early spring, when they were killed with spears.[34]

Men fishing by kayak for halibut. Unalaska, 1872.

"When an American hooks a big halibut he never gives the line a sudden jerk in case the wood splits or the *baidarka* is capsized, so he draws it in and lets it out again until the halibut is exhausted; after this the fish can be killed with a blow on the head from a stick."

—Gavriil Davydov,
Russian naval officer, 1802[35]

HISTORY HAS PROVEN the Sugpiaq people to be highly resilient. Despite the traumatic events of conquest and oppression, the culture did not die. Its candle has burned dimly at times, but the light has never gone out. Now it's becoming bright again.

Sugpiaq, meaning "genuine human being," is our original name. Russian invaders in the late eighteenth century called us Aleuts, a foreign term they applied to Native peoples all across southern Alaska. "Aleut" was indigenized to "Alutiiq" in our Sugcestun language. All three names—Sugpiaq, Aleut, and Alutiiq—are used today, although preferences have changed over time. All are equally valid and authentic in terms of our history, and which term one chooses is a matter of personal choice.

Russian traders in search of sea otter furs first conquered and then enslaved the Native population of southern Alaska. In 1784 a force led by Grigorii Shelikhov used guns and cannons to slaughter hundreds of Sugpiaq men, women, and children on Kodiak Island. The victims had gathered on top of

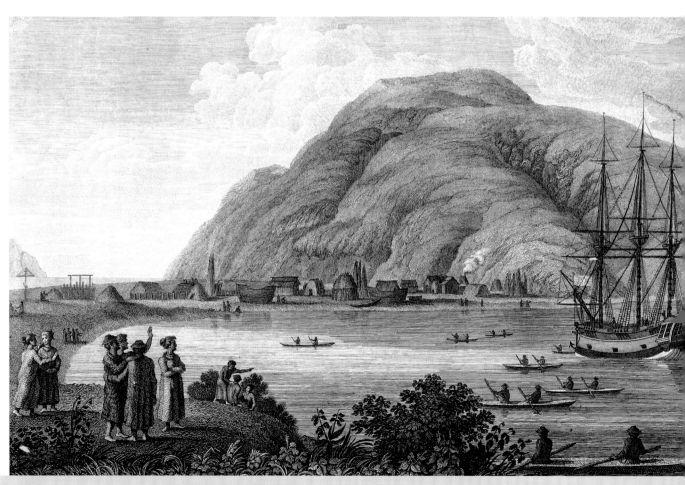

ABOVE: The Russian fur trade post at Three Saints Harbor, Kodiak Island, built by Grigorii Shelikhov in 1784. This romanticized engraving, based on a 1790 sketch by Luka Voronin, shows Sugpiaq residents gladly greeting a Russian ship. In reality, Native residents at Three Saints were hostages or involuntary workers.

OPPOSITE: Elizabeth Agizza (left) and an unidentified companion at the Kodiak Baptist Mission, Woody Island, in about 1918. Many mission children were orphans of the 1917–19 influenza pandemic.

a steep-sided refuge rock off the east coast of the island, a place afterward known to us as Awa'uq, "to become numb." The name signifies the grief people felt at the loss of both lives and freedom.

Shelikhov built forts on Kodiak Island and the mainland, holding the children of high-ranking Sugpiaq leaders as hostages and brutally suppressing any attempt at rebellion. Men were forced to hunt otters in fleets of kayaks, sometimes paddling hundreds of miles and being gone from their homes for months at a time. Others had to provision the Russians with whales, fish, and game. Women prepared plant foods, dried fish, and clothing for the traders. During these years people suffered from disease and malnutrition. It was a dark, traumatic period when many thousands died.

After 1818 reform in the management of the Russian-American Company brought some relief; Alaska Natives officially became employees instead of slaves. Atrocities ended, and a health care system was put in place. In Kodiak there was a hospital to treat the sick and injured, and schools were built to teach children to be literate in both Russian and Sugcestun. Missionaries of the Russian Orthodox Church were influential in seeking better conditions.

A new category emerged in colonial society—the Creoles. They were originally the offspring of Russian fur traders and Native women, but "Creole" was a social class rather than a racial designation. Being Creole meant that you were educated, had been baptized into the Russian Orthodox faith, and were recognized as a Russian citizen. Creoles trained as craftsmen, priests, and navigators. Some were appointed as village chiefs who were in charge of hunting and other work for the Russian company and were also responsible for the welfare of their communities. Creoles adopted Russian foods, clothing, and customs to a greater extent than other Native peoples and came to identify themselves as Russian rather than Sugpiaq.

The U.S. government, which took over Alaska in 1867, did not recognized Creoles as having any special rights or status. The change caused misunderstanding, anger, and embarrassment. In the new government and mission schools, children were beaten for speaking either Sugcestun or Russian. Educational policies were aimed at bringing about the assimilation of all to American speech, values, and beliefs.

This history created complex feelings about identity. My mother, Olga Rossing, was born in 1916 and grew up at Woody Island, near the town of Kodiak. She was biologically Sugpiaq but considered herself to be Russian. She was not alone; during two hundred years of Western contact and cultural change, first under Russian then U.S. rule, indigenous identity had been devalued and even shamed.

The Alaska Native Claims Settlement Act in 1971 put a new twist on the situation. Anyone who had one-quarter Native blood was eligible to enroll, meaning that he or she would receive shares in the village and regional Native corporations. This was the first time for many that being Native had any positive benefits. The new opportunity generated tension when people redefined themselves and heard comments such as "He was never a Native before land claims!"

ABOVE: The Afognak Native Corporation's headquarters in Anchorage opened in 2006. The corporation was established under the Alaska Native Claims Settlement Act.

OPPOSITE: Sugpiaq model kayak-building class with artist and instructor Alfred Naumoff (bottom left), 2009. Alutiiq Museum director Sven Haakanson Jr. is second from right, middle row.

There was much turmoil, infighting, and litigation during the early days of ANCSA. Families and lifelong friends were split apart. The new institutions that had been established under the act began to crumble, including Koniag, Inc., the regional corporation for Kodiak Island. The Kodiak Area Native Association (KANA), a nonprofit originally established to pursue land claims and later reorganized to run programs in Native health and education, also came under fire.

When I became president of KANA in 1983, I was asked to rebuild the organization and find out how we could sustain better relationships. Elders advised that the biggest reason for our problems was that people had lost touch with who they were. They didn't know their history, and the traditional values of sharing and cooperation had been lost. We turned our efforts to cultural rebuilding through dance, traditional arts, kayak building, language renewal, archaeology, oral history, youth-elder programs, and more. The idea was to build knowledge, pride, visibility, and self-esteem as a pathway for healing.

From the beginning we wanted to have a museum and cultural center that people would feel belonged to them and where they could celebrate their culture. It was, ironically, a settlement from the *Exxon Valdez* oil spill that provided the core funding for that effort. The Alutiiq Museum and Archaeological Repository opened its doors in 1995 and has realized the vision we held, receiving national awards and widespread recognition for its exhibits, educational projects, language programs, and cultural research. Led by Dr. Sven Haakanson Jr., a Harvard-educated archaeologist from the village of Old Harbor, the museum conducts cultural programs in all of the island's communities.

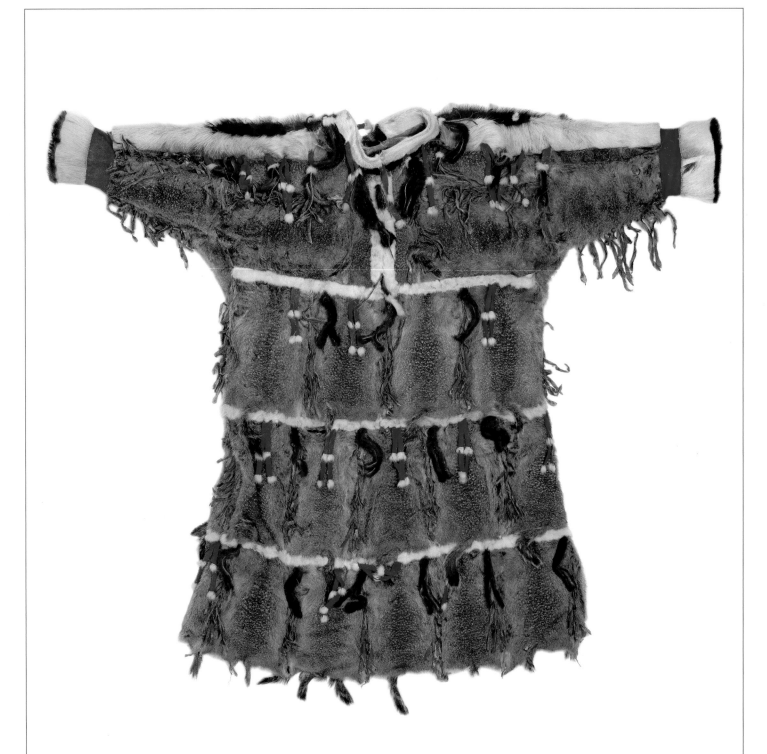

Qanganaq
PARKA

Ugashik
Collected by William J. Fisher, accessioned 1884
National Museum of Natural History E090469
Length 126 cm (49.6 in)

Traditional parka materials reflect Sugpiaq access to both coastal and interior animals. Caribou, bears, foxes, lynx, wolverines, marmot, ground squirrels, ermine, mink, seals, sea otters, river otters, and various sea birds were used, and whale, seal, sea lion, and bear intestines were employed for waterproof coats (in Sugcestun, *kanagllut*).[36] After contact, Russian rulers forbade Alaska Native use of sea otter and fox furs because of their commercial value; Hieromonk Gideon said that such clothing would be "torn off the person's back." Other furs were restricted as well, and nearly everyone was forced to wear bird-skin parkas, formerly the dress of poor people and slaves.[37]

This man's parka, probably intended for ceremonial use, suggests relative wealth and status. It was sewn from forty-eight split ground squirrel pelts with the tails left on. Tassels of sea otter fur and strips of red wool cloth and white ermine fur dangle from the horizontal seams, which are also accented with ermine piping; fringes of red-dyed squirrel skin ornament the vertical joins. White caribou fur appears on the collar, cuffs, shoulders, sleeves, and chest, and strips of mink adorn the tops of the shoulders. Decorative tabs made of red cloth, caribou hide, and dyed seal esophagus attach to the back of the collar.[38]

"The woman who sewed this parka used a lot of small pieces and obviously didn't throw things away. I'm sure she didn't, because these are very tiny pieces of sea otter, which she would have saved. It just appears that she didn't waste anything; she even left the feet on some of the squirrels!"

—Susan Malutin, 1996[39]

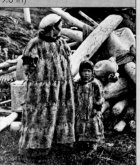

A Sugpiaq woman and child wear squirrel-skin parkas. Portage Bay, 1909.

SUGPIAQ

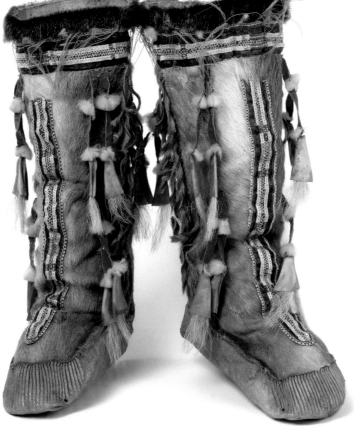

Kulusuk
CHILD'S BOOTS

Probably Alaska Peninsula
Collected by Lt. Wilkes, accessioned 1858
National Museum of Natural History E002129
Height 15 cm (6 in)

These delicate child-sized boots have uppers made of caribou leg skin, encircled on top with seal fur. The neatly creased soles may be sea lion. Embroidered bands at the cuffs and on the front of each boot are composed of narrow strips of sea lion esophagus, both natural color and dyed, which has been cross-stitched with caribou hair, a decorative technique employed by both Sugpiaq and Unangax̂ skin sewers. Tassels of red-dyed skin and white fur terminate in puffin beaks filled with caribou hair. All stitching was done with sinew thread.

Potap Zaikov noted in 1778 that residents of the western Alaska Peninsula used caribou for their boots.[40] Elsewhere the tanned hides and esophagi of seals and sea lions were commonly employed, along with whale, bear, and salmon skin.[41] On Kodiak Island in the winter of 1802–03, Gavriil Davydov observed, "The rich, especially women, have warm shoes made from squirrel or marmot skin," while the poor went barefoot.[42] That Sugpiaq people frequently chose to go without shoes, even in winter, astonished historical observers.[43] When boots were worn, grass, moss, or fur stockings could be added inside.[44]

"My dad had skin boots…made out of sealskin, I believe it was, with sea lion skin on the bottom. And they put the grass inside of them. They don't leak. But no heels— that's why they're slippery."

—Larry Matfay, 1992[45]

Chief Alexi and his sons. Chignik, ca. 1934.

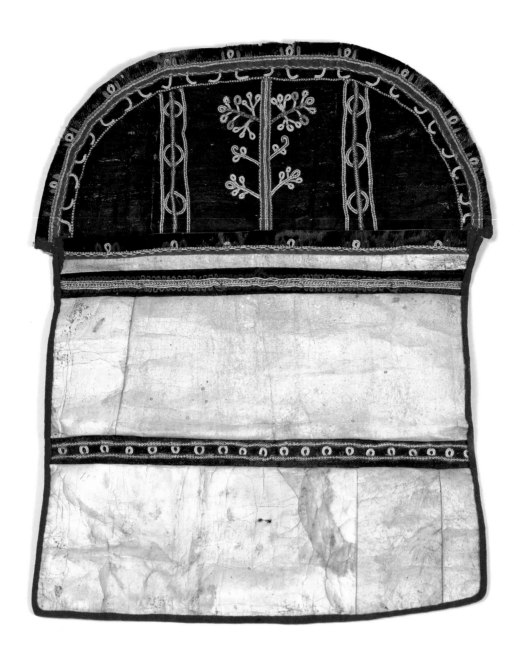

Katmai
Collected by William J. Fisher, accessioned 1882
National Museum of Natural History E072497
Length 39 cm (15.4 in)

SUGPIAQ

Kakiwik
SEWING BAG

Sewing was an essential skill and one of a woman's most important assets for marriage.[46] Growing up, girls learned to stitch fine clothing, bags, hats, and boat covers using skin and gut; make sinew thread; wrap the bindings on arrows and darts; tie fishing nets; and weave baskets and hats from spruce roots.[47]

Women carried fancy roll-up pouches to hold sewing supplies, and a nicely made *kakiwik* demonstrated the owner's talent and artistry. This example from Katmai, on the Alaska Peninsula, has a black-painted flap, sealskin trim, dyed-esophagus strip appliqué, delicate caribou hair embroidery, and rows of tiny yarn loops. A sinew cord, not shown, wraps around the bag when rolled.[48] The pouch would have held needles—traditionally made of split bird bone, ivory, or native copper—as well as thread made from whale or caribou sinew and other supplies.[49]

"It was a sewing kit. They had little pockets to put their sinew in. You had your ivory needles, and then your thread, whale sinew…. The ladies, they would take it along just like a handbag so they would always have their sewing with them…. My mother and my god-mother, they used to carry them."

—Lucille Antowock Davis, 1997[50]

A finely stitched gut parka. Kodiak, 1919.

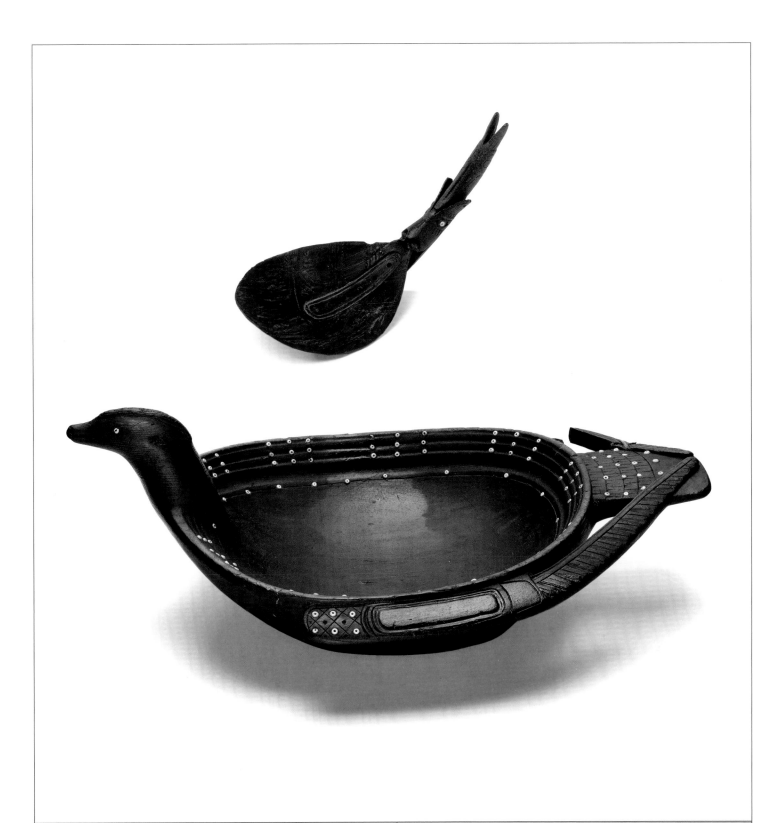

| SUGPIAQ | **Luuskaaq** SPOON | Eagle Harbor Collected by William J. Fisher, accessioned 1884 National Museum of Natural History E090429 Length 15.2 cm (6 in) | **Ciquq** BOWL | Chenega Collected by William J. Fisher, accessioned 1894 National Museum of Natural History E168623 Length 38 cm (15 in) |

Decorated spoons and serving bowls were used for everyday meals and winter feasts, their beauty celebrating the harvest of land and sea. This spoon was cut and molded from the steam-softened horn of a mountain goat. The carved handle depicts two animals with large ears, the lower one with white beads for eyes.[51] The Tlingit made similar spoons but with recurved handles, a less angular carving style, and specific totemic designs; inset beads were used only rarely.[52] This spoon came from Kodiak Island, where mountain goats are absent, but horns of the animals were acquired in trade from Prince William Sound and the Kenai Peninsula.[53]

The large bird-shaped dish, probably representing a merganser duck, is saturated with fish or sea mammal oil from use as a serving bowl. The naturalistic carving is Sugpiaq in style, while ovoid "joint marks" on the wings reflect Tlingit influence. Sugpiaq artists typically used white beads for decorative inlays, whereas the Tlingit preferred the opercula of red turban snail shells.[54] Other materials could also be selected; on Kodiak Island in 1790 Carl Heinrich Merck noted, "Of dishes they have wooden platters and plates, carved from flat pieces of wood and decorated with bones, crystals, beads, and the teeth of various animals."[55]

"When I'm out there berry-picking, I have a picture in my mind of my ancestors.... I see their clothing and I see them picking the same kind of berries I'm picking, with the same feeling that this is for my children, this is going to be so good. This is food for our body and for our soul. It's something that our grandmothers have done forever."

—Martha Demientieff, 1997[56]

In this reconstruction, a Sugpiaq elder eats from a bird-shaped bowl at a midwinter ceremony in the early nineteenth century.

SUGPIAQ MASKS

Sven Haakanson Jr.

Sugpiaq artist Perry Eaton with masks at the Château Musée, Boulogne-sur-Mer, France, 2006

SUGPIAQ MASKS are a tradition that is finally coming back, along with a new understanding of the value they hold for the people. For years I was told by elders, "You can't talk about them. They are bad. They are evil." That perspective derives from organized religion. The masks, once revered and respected, came to be despised and feared. It has been a challenge for us to raise awareness of what they meant in the past and what they mean today.

About fifteen years ago we learned of seventy Sugpiaq masks that had been acquired by ethnologist Alphonse Pinart in 1872–73 and are now housed at the Château Musée, in Boulogne-sur-Mer, France. In 2008 the Alutiiq Museum, on Kodiak Island, of which I am the director, opened an exhibition of this collection called Giinaquq: Like a Face. We brought the masks back home and, on the basis of Pinart's field notes, explained the stories, songs, and dances that were presented with them during the traditional winter ceremonies. A group of our artists traveled to France to study the masks, and elders became involved in their cultural interpretation.

We learned that the masks convey moral and social principles, history, even comedy. One is Payulik, "the bringer of food." The person who wore it would come in at the beginning of a celebration carrying a bowl. He would go to the elders and give them all food, working down from the highest in rank. It was a way of honoring them for their lives and of expressing the health and values of the community. Another mask is Nakllegnaq, which means "poor you." We don't have the exact story behind it, but the idea is one of teasing somebody a little, as if saying, "Quit feeling sorry for yourself—life isn't that bad!"

ABOVE: Holy Resurrection Cathedral in Kodiak, founded in 1794 by the first Russian Orthodox missionaries to Alaska. The church has been rebuilt four times, most recently after a fire in the 1940s.

OPPOSITE: Sugpiaq dance performers Sophie Chyda and Serenity Schmidt with beaded headdresses and painted facial designs, Alaska State Fair, 2005

MOST SUQPIAQ HAVE a firm belief that if not for the Russian Orthodox Church, the people would have been lost entirely. The population was in serious decline when Orthodox monks traveled to Kodiak in the 1790s. They were shocked at the conditions they saw, and the Church exerted its influence with the czar to ameliorate illegal practices of the Russian-American Company. That is why the Orthodox faith was embraced and why it has persisted so strongly to the present day.

Sugpiaq people recognized connections and similarities between their own spiritual concepts and those of the new religion. They believed in Lam Sua, the "person of the universe," who as a supreme and all-knowing deity became equated with God. Their *kassat*, or wise men, consulted with deities subordinate to Lam Sua and directed the performance of religious ceremonies. In these functions they were similar to priests who conducted Orthodox worship.

Traditional hunting ceremonies, held in October through March, were a means of communicating with sky gods and the spirits of animals. Performances and rituals wove together the arts of song, narrative, masking, and dance. Visitors were invited from neighboring villages to share in rich feasts, gift giving, and trade. These rituals continued in some communities until the late 1800s, coexisting with widespread Orthodox conversion.

Over time, the Native practice of Russian Orthodoxy has absorbed certain aspects of the older winter ceremonies. On Russian Christmas (January 7) and for two days following, worshippers walk through their communities holding a spinning wooden star and singing hymns and carols in Sugcestun and Russian. The practice is called starring (*sláwiq*). In some communities, *sláwiq* is followed by a masking ceremony (Maskalataq), in which masked men dance and impersonate "devils" who bear resemblance to the animal spirits of old. Russian New Year (January 14) is celebrated with a costume pageant that mixes Russian folk tradition with echoes of the winter festivals.

Cultural revitalization has taken hold in the Sugpiaq/Alutiiq region since the 1980s, bringing new confidence and visibility to our people and culture. We have come a long way since the days when many suffered embarrassment and even shame to see the dance, regalia, and cultural vibrancy of other Alaska Native peoples while not having our own to share publicly. We've listened to elders, encouraged Native language and arts, and reconsidered the meaning of events, some terrible and traumatic, that shaped who we are today. Sugpiaq young people have gained an appreciation for their rightful place in the world.

Nacaq
BEADED HEADDRESS

Ugashik
Collected by William J. Fisher, accessioned 1884
National Museum of Natural History E090453
Length 54 cm (21.3 in)

Beaded headdresses were "worn by Koniag [Sugpiaq] girls in the big ceremonies" of the Kodiak Island archipelago in the 1870s, according to linguist Alphonse Pinart.[57] Smithsonian collector William Fisher acquired this headdress about a decade later, when the major Sugpiaq ceremonies were in decline.[58]

Use of these spectacular garments was widespread; Sugpiaq, Yup'ik, Deg Hit'an, Dena'ina, Eyak, Ahtna, and Tlingit women and girls wore regionally varied styles for winter hunting festivals, feasts, dance performances, weddings, and other ceremonial events.[59] Possession of large numbers of beads and their lavish display in the form of headdresses, necklaces, labrets, and other jewelry was an indication of high status in Sugpiaq society,[60] and in Prince William Sound the bead and dentalium-shell headdresses worn by chiefs' daughters were said to reach all the way to their ankles.[61]

This headdress has a cap of small to medium-sized beads and a long tail of heavier beads that widens at the bottom, an Alaska Peninsula style.[62]

In this reconstruction, Sugpiaq women dance at a midwinter ceremony in the early nineteenth century.

"Women and young girls dance by themselves, without men.... During the women's dance, old men who are enjoying themselves make every possible effort to make some of them [the dancers] laugh, as according to their custom the father or husband of the woman who succumbs to teasing and laughs must pay a fine."

—Hieromonk Gideon,
Russian priest, 1804–07[63]

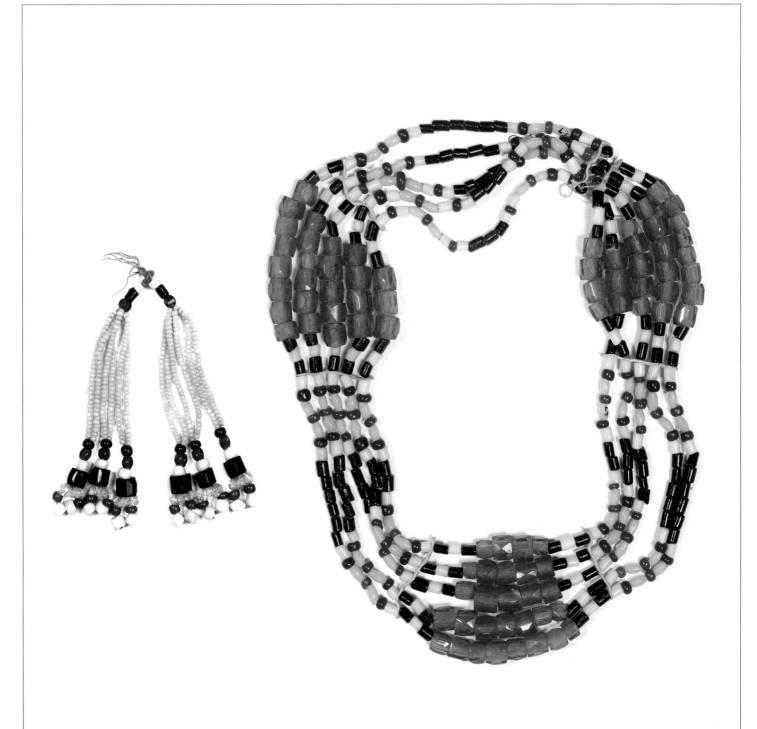

Kulunguak
EARRINGS

Ugashik
Collected by William J. Fisher, accessioned 1882
National Museum of Natural History E072465
Length 14 cm (5.5 in)

Sugpiaq women adorned themselves with beaded jewelry, nose pins, labrets, body paints, and tattoos of the face and body.[64] According to an account from 1851, "At the turn of this century, the lips and ear jewelry of a rich Koniag [Kodiak Island Sugpiaq] woman or an adorned dandy might have weighed a whole pound."[65] Up to six or eight earrings were worn in piercings around each ear. Fur trader George Dixon (in 1786) recorded that, in Prince William Sound, "their noses and ears are ornamented with beads, or teeth…. this I could observe was always in proportion to the person's wealth."[66]

Smithsonian collector William Fisher acquired these earrings and this necklace along with additional earrings, a beaded headdress, collar, bracelets, anklets, and belt, together described as "a full set of bead ornaments worn by the Ugashik belles."[67] Contemporary Sugpiaq artists re-create many forms of traditional jewelry and dance regalia.

Uyamillquaq
NECKLACE

Ugashik
Collected by William J. Fisher, accessioned 1882
National Museum of Natural History E072467
Length 28 cm (11 in)

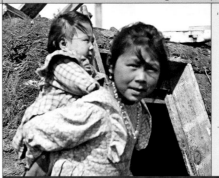

"I'm making a headdress of white fur, blue felt, and black, white and blue beads to wear when I am Alutiiq dancing. I like this headdress because it is beautiful and useful and makes me feel connected to my culture."

—Geri Pestrikoff, 2001[68]

A Sugpiaq girl wears beaded earrings and necklace. Egegik, 1917.

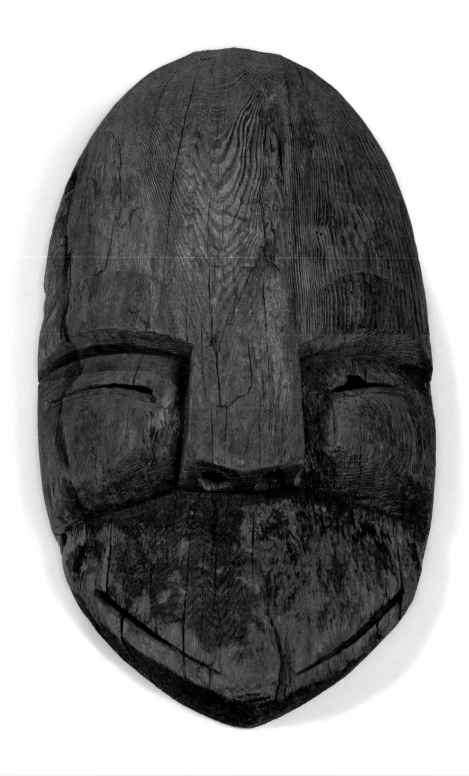

Ggiinaquq

MASK

Douglas
Collected by William J. Fisher, accessioned 1884
National Museum of Natural History E074694
Length 51.8 cm (20.4 in)

Sugpiaq masks represented ancestors, helpful and harmful supernatural beings, and the personified spirits of game animals (sing., *suk*, "its person"); all were magically summoned to the *qasgiq* (ceremonial house) during winter festivals.[69] The visitations of mask spirits were dramatized by dance, drumming, song, oratory, and ritual enactments of hunting, witnessed by the whole community.[70] The ceremonies were an appeal to the animals for their return to hunters in the coming spring; to Imam Sua, the undersea woman who controlled all sea mammals; and to Nunam Sua, who dwelled in the forest and was the mistress of all land creatures.[71] *Kassat* composed the dances and songs and led the ceremonies.[72]

This large mask, in appearance part human and part bird, may have been suspended from the ceiling of the *qasgiq* with a rope so that performers could dance behind it or send it flying across the room. Holes around the edges of the mask probably once held feathers, wooden ornaments, or concentric hoops representing the multilevel Sugpiaq cosmos. The weathered appearance and loss of paint and appendages suggest it was found in a cave or crevice, where masks were sometimes stored.[73]

"During the night he saw in a dream masks that the Koniags afterwards used as if they were alive, and heard songs sung by some unknown voice. As soon as he awoke he began to sing these songs and went hunting and killed a great many animals."

—oral tradition recorded by Alphonse Pinart, 1871–72[74]

Sugpiaq dancer with mask and puffin-beak rattles at a hunting ceremony. Representing Kodiak Island, nineteenth century.

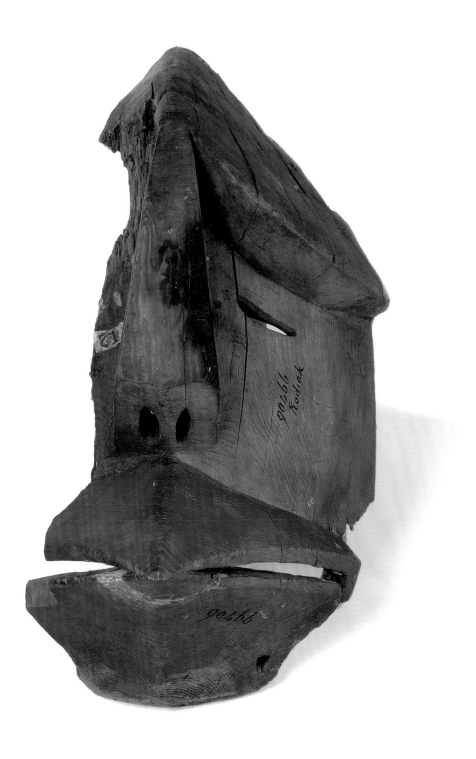

Agayulgútaq

MASK

Sitkinak Island
Collected by William J. Fisher, accessioned 1884
National Museum of Natural History E090466
Length 32 cm (12.6 in)

This mask has a birdlike mouth and the pointed head of a dangerous being called an *íyaq* on Kodiak Island and a *kaláaq* in Prince William Sound; today's elders translate these words as "devil." An *íyaq* was the soul of an evil or insane person who had died five times and was said to be hungry for meat or human flesh.[75] An *íyaq* could be used by a *kaláalek* (shaman) as his helping spirit to spy on distant events, to carry messages, or to carry him to other worlds.[76] Owls, cranes, and other birds also served as shaman's assistants, which may explain this mixed being's pointed beak. The mask has been partly burned, perhaps to destroy it after a shaman's ritual or hunting ceremony.

Kodiak Island traditions recorded by Alphonse Pinart in the 1870s tell of mask spirits that were so terrifying that the stone lamp and grass on the floor of the ceremonial house would retreat from them in fear.[77]

Although traditional masked rituals ended by the turn of the twentieth century, they were replaced by new Maskalataq practices associated with the Russian Orthodox New Year.[78] Today, Sugpiaq artists are involved in the revitalization of mask carving.[79]

Sugpiaq New Year's Pageant at the Baptist Mission orphanage. Woody Island, 1899.

"But then they said they [the shamans] had messengers, to go from here to Old Harbor, or Karluk, or Larsen Bay. And they travel as a ball of fire. They call them *keneq íyaq* [fire devil]."

—Ephraim Agnot, 1986[80]

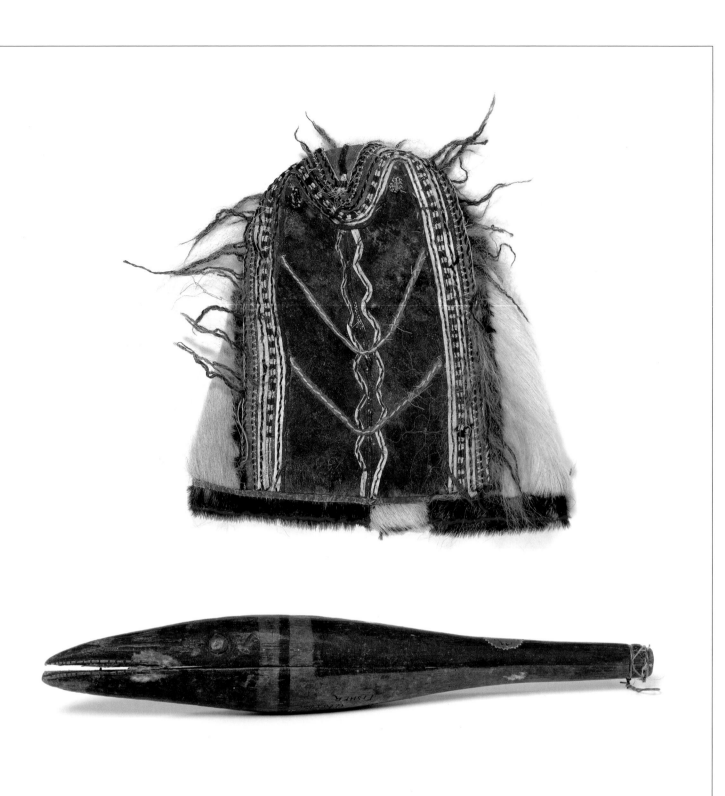

All'ugaq

SHAMAN'S HAT

Ugashik
Collected by William J. Fisher, accessioned 1887
National Museum of Natural History E127804
Length 25 cm (9.8 in)

SHAMAN'S RATTLE

Ugashik
Collected by William J. Fisher, accessioned 1887
National Museum of Natural History E127805
Length 25.5 cm (10 in)

This hat and rattle were part of an Alaska Peninsula shaman's outfit that included a charm belt with grizzly bear claws, a whistle, and bracelets made from river otter snouts. The hat is black-painted skin stitched with caribou hair and colored thread. The side panels are caribou, and the bottom trim is sealskin with a white patch of caribou. Tall pointed hats of this type were worn for rituals and ceremonies in both the Sugpiaq and Unangax̂ regions.[81] The rattle represents a toothed bird; its eye is copper. Inside is a sinew-wrapped charm bundle consisting of a quartz crystal, a mica flake, a sliver of wood, and clippings of hair.

Sugpiaq shamans claimed powers that could be used for both good and evil purposes.[82] A shaman's helping spirits—variously birds, animals, and human souls—informed him about events in distant places, transported him on his spiritual journeys, and helped or harmed people according to his wishes.[83] The rattle and other charms may have been used to summon these spirits.

"A girl was out hunting seagull eggs, and she fell off the bluff and was all smashed up. They brought her home; she was just screaming and crying. The shaman...boiled some roots and let her drink the water. She calmed right down, and she was even laughing while they were straightening her out so she could heal."

—Sven Haakanson Sr., 1997[84]

Detail from illustration on manuscript map. Atka, 1756–62.

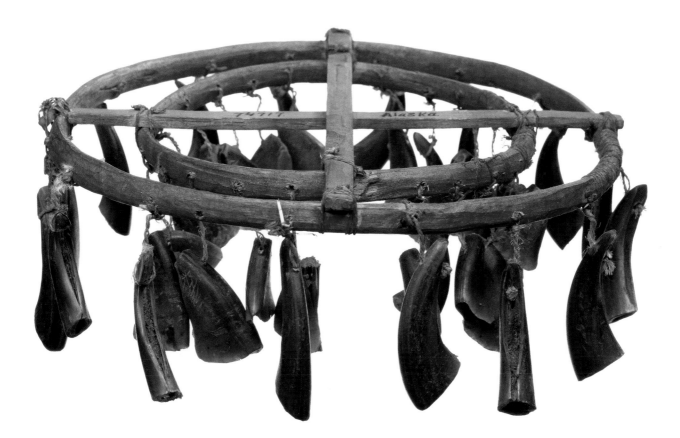

Uulegsuuteq
HOOP RATTLE

Uganik
Collected by William J. Fisher, accessioned 1884
National Museum of Natural History E074717
Length 22 cm (8.7 in)

Dancers and shamans of southern Alaska performed to the accompaniment of hoop rattles hung with hooves, claws, shells, and puffin beaks.[85] This Alaska Peninsula rattle consists of thirty-six bear claws tied with sinew strings to a red-painted circular frame.[86]

Rattles were used in preparation for war, among other occasions. Before departing, a Kodiak Island war party assembled in the ceremonial house, equipped for battle with wooden shields and rod armor, bows, spears, and helmets. After feasting, "the war leader and he alone, their foremost *angayuqaq* [headman], rose and took up the rattles, i.e., small hoops to which are attached the red beaks of the sea bird called puffin, and began to dance. At this very moment his kinsmen commenced to beat the drums.... They sang about the deeds of their ancestors and fathers, who warred with fame and honor."[87]

"The dancers wear...masks ornamented with paints, and in their hands they carry rattles, made of two or three hoops of various widths, reinforced with crosspieces of stick, decorated with feathers, which serve in place of a handle. To the hoops are tied many sea parrot [puffin] beaks. Thus, as they shake them in time to the tambourine beat, much noise is created."

—Carl Heinrich Merck, naturalist, 1790[88]

Sugpiaq dancer with mask and puffin-beak rattles at a hunting ceremony. Representing Kodiak Island, nineteenth century.

ATHABASCAN

Eliza Jones

WHEN I WAS GROWING UP, our family moved in every season—to spring camp for ducks and muskrats; to fish camp in summer; and to hunting and fur-trapping sites during fall and winter. That was my Koyukon Athabascan childhood in the 1940s and '50s. We came back to the old village of Cutoff, on the Koyukuk River, for Christmas and again in April, to sell beaver pelts at the trading post and to join in the celebration of Spring Carnival.

That kind of traveling life was once universal in Athabascan country, from the Arctic Circle to Cook Inlet in Alaska and across the western interior of Canada. It's a vast territory, hundreds of thousands of square miles covered by boreal spruce and birch forest. The rivers that cross it—the Yukon, Tanana, Koyukuk, Kuskokwim, Nenana, Porcupine, Mackenzie, Copper, Susitna, Innoko, and others—were highways for dog sledding in winter and canoe voyages in summer. Today the rivers, along with air and snow machine travel, still link our scattered communities, but roads reach only a few.

Denali, the highest mountain in North America (from the Koyukon Deen-aalee, "the great tall one"), is located in the southern part of our homeland,

rising far above other peaks of the Alaska Range. The mountain's name is the answer to an old Koyukon riddle, "the stars are rotting on me." Ducks and other migratory birds are the "stars" that fly into the top of the mountain as they head south during the dark nights of September. Nearby is Mt. Foraker, called Deenaalee Be'et, "Deen-aalee's wife."

Athabascan peoples are an ancient family that spread out across the land and gradually grew apart. Koyukon, Gwich'in, Hän, Holikachuk, Deg Hit'an, Upper Kuskokwim, Tanana, Tanacross, Upper Tanana, Dena'ina, and Ahtna communities occupy different areas of interior and southern coastal Alaska. Their languages share the same complex grammar yet

OPPOSITE TOP: **Two Gwich'in men from the Fort Yukon area with rifles and beaded garments. Photographed by Edward W. Nelson at St. Michael in 1877.**

OPPOSITE: **Spring sun streams through an aspen forest in the Tanana River Valley near Fairbanks, 1998.**

ABOVE: **Sunrise on Mount Hayes and the Alaska Range. Below is the Tanana River near Delta Junction, 2007.**

have developed different vocabularies. The people have varying subsistence practices, customs, ceremonies, and clan structures. The Eyak, who live on the southern Alaskan coast around the mouth of the Copper River, are more distant relatives.

Our knowledge of the land comes from experience and close observation. The quality of birch bark, for example, is revealed by the dark horizontal lines that in Koyukon we call *benoghe'*, "its eyes." If they are short, the bark will be limber and peel easily from the tree for use in making baskets or, in the past, covering canoes. A birch that stands alone, not crowded by other trees, will be healthy and strong and have straight-grained wood for sleds and snowshoes.

In Athabascan belief, everything around us has life. The land and trees have spirits, and we treat them with respect. If we need to cut a tamarack, which has the best wood for making fish traps, it is Koyukon courtesy to explain our need to the tree and to leave an offering of a bead or ribbon behind. Animals and fish are given the same kind of care. Before bringing a mink carcass into our cabin, my mother or stepfather would rub its nose with grease so that its spirit would not be offended by the human scent inside. If they trapped a fox, they put a bone in its mouth, because the animal was seeking food when it met its death.

We always left our camping places clean out of respect for the land, but the modern lifestyle generates so much trash—packaging, plastics, and worn-out junk—that it is hard to maintain that standard in the places where we live today. Over the last decade, the Yukon River Inter-Tribal Watershed Council has had success in cleaning up waste, old cars, and fuel drums that have been dumped along the river's banks by military bases and towns and in removing sources of water contamination. The council provides a way for our communities to work together to honor traditional protections for the environment.

When I was young we traveled to spring camp in April, the whole family riding in one big dog sleigh. We lived in canvas tents and set traps for muskrats at their push-up ice houses on the frozen lakes. As the lake ice melted and migratory birds returned to the north, the woods filled with beautiful music. Waking up in the morning, you could hear birds' singing through the thin tent walls and the sounds of cranes, ducks, geese, and

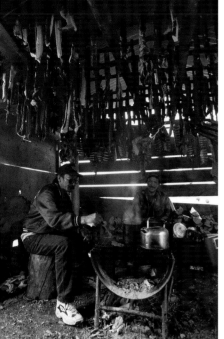

grebes calling to one another on the water. It made you feel eager to be up and starting the day.

The men made canoes, covered the frames with painted canvas, and went out hunting for ducks, geese, muskrats, and beavers. We dried the meat to preserve it, including some for the dogs. We netted pike when they started running in the streams and mixed their eggs with sugar and wintered-over cranberries to make *kk'oondzaah* for dessert.

At summer camp on the Koyukuk River we caught and dried whitefish, sheefish, and salmon, and in fall time we got ready for winter by hunting caribou and moose, snaring small game, and hauling firewood. As it got colder we froze fresh-caught pike or whitefish on beds of willow instead of drying them.

In the early part of winter—October through December—the men trapped mink, otters, weasels, foxes, and wolves so we could sell the furs to buy necessities at the store. Women snared rabbits, ptarmigan, and grouse, and as a girl I had my own snare line to check every day. We did a lot of skin tanning and sewing at that time of the year to make clothes for the whole family.

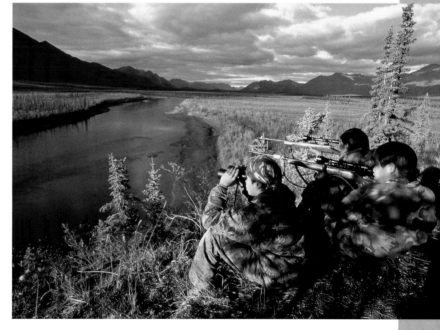

After spending Christmas in the village, we moved back out to winter camp in February for beaver trapping. It's amazing to remember that now—the whole family, including toddlers bundled up in fur parkas, living in a frame tent when the temperature outside was 30 or 40 degrees below zero. People wouldn't think of doing that today!

OPPOSITE: Debbie and Cindy Charlie harvesting birch bark near Fairbanks, 2000. The bark was used to cover a traditional canoe built by Moses Paul at the Alaska Native Heritage Center in Anchorage.

UPPER LEFT: Koyukon men tending the fire in a smokehouse at the village of Hughes on the Koyukuk River, 1998.

LOWER RIGHT: Young Gwich'in hunters using binoculars and rifle scopes to scan the valley of the Chandalar River for moose, 1998.

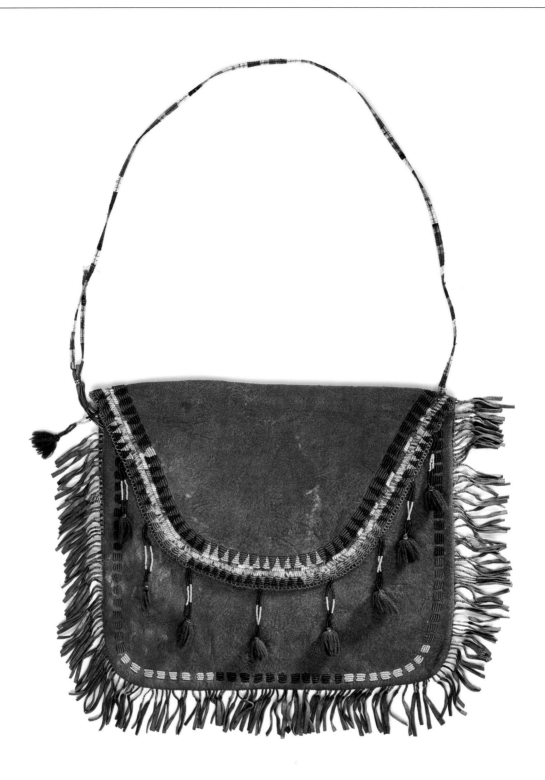

Khał ǫhtsuu

TOBOGGAN BAG

Upper Yukon River region
Purchased from W. O. Oldman, accessioned 1914
National Museum of the American Indian 036396.000
Width 47 cm (18.5 in)

This tanned moose-hide pouch was made to hang from the handlebars of a traditional Gwich'in toboggan or "big sleigh," where it could be easily reached by the driver.[1] Toboggans were pulled by dog teams and used to carry meat, wood, water, gear, and passengers; they had curved wooden runners, spruce frames lashed with *babiche* (rawhide strips), and high sides of stretched moose hide.[2]

A row of red, pink, and black beads forms a decorative band along the edge of the bag. Around the flap are two rows of interlocking beaded triangles, separated by porcupine quill stitching; the tassels on the flap are made from beads and wool yarn. Narrow strips of caribou hide wrapped in quills make up the outer fringe. The shoulder strap is woven from dyed quills.

Making a bag began with scraping moose or caribou skin and softening it with a mixture made from the animal's brains.[3] Beadwork was started with a sketched outline of floral or geometric designs, and beads were stitched on with strands of animal sinew.[4] Toboggan bags were versatile and could hold clothes or a woman's things, and churchgoers used them to carry their Bibles.[5]

"They used it behind the sled, and they keep their valuable things in there while traveling— whatever they need, maybe lunch is in there, or dry fish and dry meat."

—Trimble Gilbert, 2004

Flattening quills for sewing. Fort Yukon, 1940.

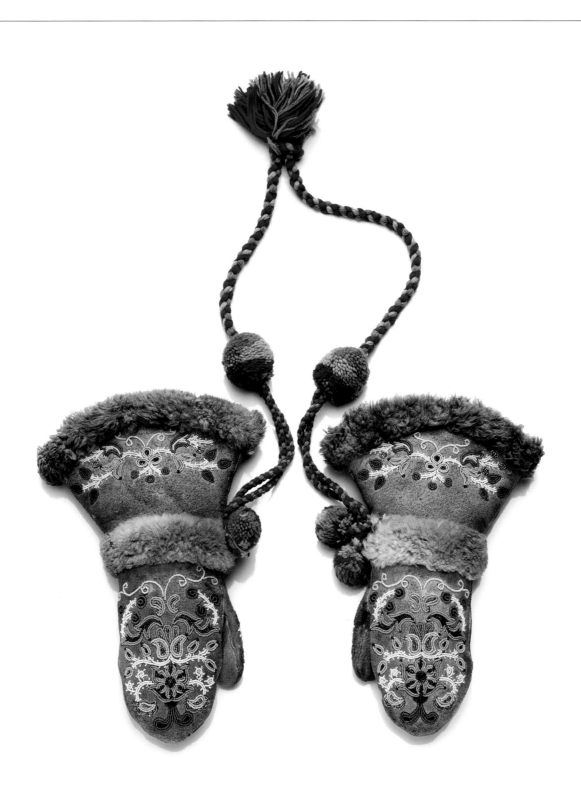

Dinjik dhah dzirh

MITTENS

Upper Yukon River region
Collected by Micajah W. Pope ca. 1910, accessioned 1928
National Museum of the American Indian 161647.000
Length 37 cm (14.6 in)

Moose-skin mittens, often beaded with leaf and flower designs, are designed for the deep cold of northern Athabascan country.[6] These long, gauntlet-style Gwich'in mittens have wide tops to accommodate the sleeves of a parka. Bands of beaver fur encircle the cuff and wrist, and the braided yarn neck string is decorated with pompoms. Eliza Jones said, "When it's windy, this beaver fur right here is good to hold against your face to warm it up." Small glass and metal beads were used to work the intricate floral patterns.

Inside, the mittens have a thick lining of blanket wool. Phillip Arrow and Trimble Gilbert said that rabbit-fur liners or caribou-hair stuffing can be added for extra insulation during extreme weather. Hunters typically wear cloth gloves inside their moose-skin mittens so that they can take their hands out and shoot without exposing their skin to frigid air or gun metal.[7]

"*Dinjik dhah dzirh* [moose-skin mittens]. *Dzirh tl'yàa* [mitten strings]. Sometimes you put rabbit skin inside. But when there are no rabbit skins they use caribou hair; they cut it and put it inside. When they travel, they don't get cold."

—Trimble Gilbert, 2004

Woman wearing parka and mittens. Fort Yukon, ca. 1915.

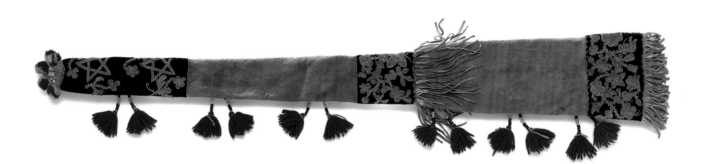

Dink'ee dhah

GUN CASE

Upper Yukon River region
Collected by Micajah W. Pope ca. 1910, accessioned 1928
National Museum of the American Indian 161632.000
Length 119 cm (46.9 in)

Guns, including muzzle-loading muskets and later rifles and shotguns, were among the most valued items obtained through trade with the Hudson's Bay Company, which built its first Alaskan post at the junction of the Yukon and Porcupine rivers in 1847. Within a few years interior Athabascan hunters were using firearms instead of bows and arrows to hunt large game.[8] Men took great pride in their weapons and carried them in custom-made cases even when out on the trail.[9]

Trimble Gilbert and Eliza Jones thought that this fancy Gwich'in fringed and beaded moose-hide case was made as a potlatch gift rather than for everyday use. The flower, leaf, and star designs are worked entirely in expensive brass and steel beads ("steelies"). The artist pretraced the outlines of her designs in flour and water paste, traces of which are still visible. She added tassels of red yarn, strung with blue glass beads. Mr. Gilbert thought that the proportions of the case, especially its long, narrow stock, indicate that it was made with a muzzle-loading musket in mind rather than for a modern gun.

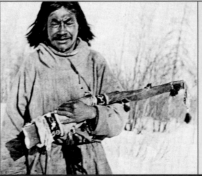

Man carrying gun case. Alaska, ca. 1911.

"Wow, how beautiful!… Sometimes they make a really fancy gun case and give it as a gift at a potlatch. Then you would use it like a wall hanging; it's not for practical use. It's treasured the way you would treasure a picture."

—Eliza Jones, 2004

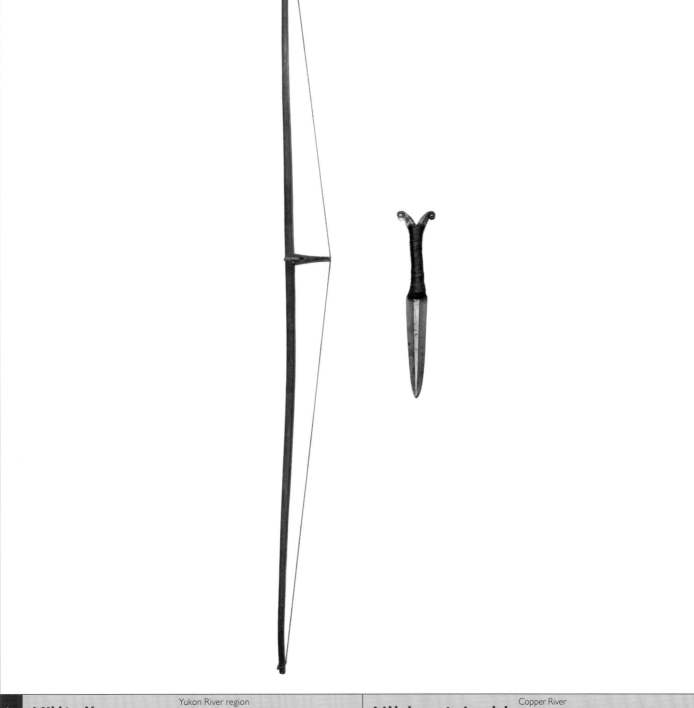

K'iłtąį'
BOW

Yukon River region
Collected by Edward W. Nelson,
no date of accession
National Museum of Natural History E049140
Length 169.5 cm (66.7 in)

Niłdzaats'aghi
KNIFE

Copper River
Collected by Israel C. Russell ca. 1890,
accessioned 1908
National Museum of the American Indian 020429.000
Length 26.5 cm (10.4 in)

Athabascan longbows were made from birch, willow, or spruce wood;[10] the string was twisted sinew from the spinal tendons of a caribou.[11] The wooden projection caught the string and prevented it from lashing the bowman's wrist.[12] Before guns, bows and arrows were used to kill large animals such as caribou, bears, moose, and mountain sheep and to hunt small furbearers, including rabbits, lynx, foxes, wolverines, and muskrat.[13] In the fall, migrating caribou were driven into corrals at the end of converging brush fences, where the animals were snared or shot with arrows.[14] Hunters in canoes used bows and arrows that had large blunt tips to kill ducks on the lakes; the special arrows avoided damage to the birds' skins. This method was commonly used in late summer and early fall, when the ducks were molting and flightless.[15]

Athabascan hunting and fighting knives were originally made of bone or from native copper nuggets from the Copper River valley; later knives like this one were shaped from iron obtained in trade.[16] Every man carried a knife at his side in a beaded or quill-embroidered sheath. The blades were fluted and had single or double spirals on the hilt. The handle was wrapped in tanned skin.

"Young people today can't… but the old people a long time ago, they were strong, and they pulled the bowstring just like that. They killed grizzly bear, moose, and caribou. They used it inside the caribou corral too."

—Trimble Gilbert, 2004

Man with bow. Mouth of the Yukon River, ca. 1879.

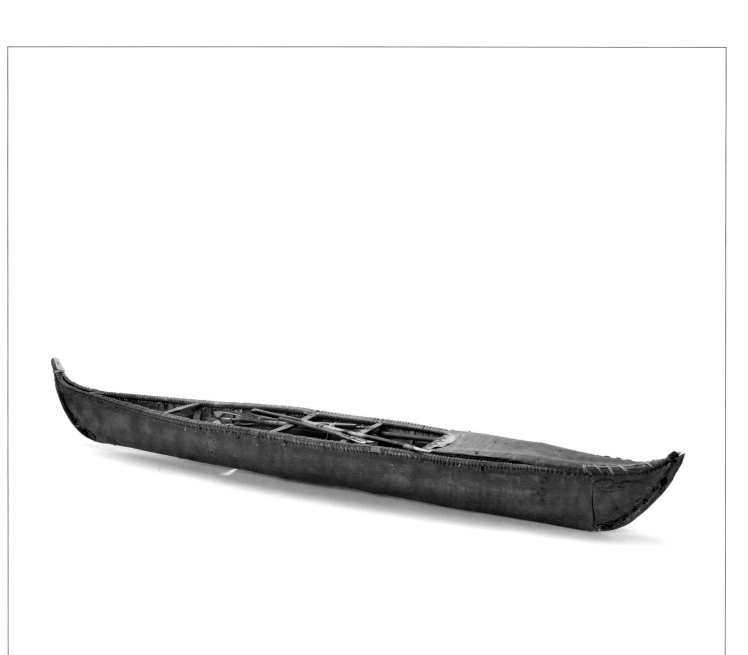

Tr'eyh
CANOE (MODEL)

Lower Yukon River region
Collected by J. Henry Turner, accessioned 1892
National Museum of Natural History E153659
Length 107 cm (42.1 in)

Canoes covered with birch bark and later canvas were used from spring breakup until the rivers and lakes refroze in the fall. Elders Eliza Jones, Judy Woods, Trimble Gilbert, and Phillip Arrow remembered moving with their families from camp to camp by canoe; dog teams were used to pull the boats upriver, the dogs trotting on the bank or swimming ahead of the boat.[17] Canoes were also paddled, poled, and sometimes sailed.[18]

This Deg Hit'an model shows a fore-decked Yukon River canoe equipped with a bone-pronged fishing spear and a long-handled net hook. Bows, arrows, and other gear could be stored under the deck.[19] Big traveling canoes were twenty or even thirty feet long, whereas hunting boats were much smaller.[20] Athabascan bark canoes were light, fast, and notoriously tippy.[21]

Canoe makers first stitched the bark hull together inside a boat-shaped outline of stakes driven into the ground. The birch or willow frame of the boat was then constructed inside the bark, a sequence opposite that of building a kayak frame and then covering it with animal skins.[22] Bark pieces were sewn together with finely split spruce roots and seam-sealed with hot spruce sap, or pitch. Canvas-covered "ratting canoes," for hunting muskrats, became popular in the early twentieth century.[23]

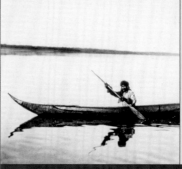

Traveling in a birch-bark canoe. Lower Yukon River, ca. 1899.

"She used human anatomy to describe it—they cut down the belly of the birch tree and then peeled it off real slow. When they got enough for the canoe, they rolled it up and kept it in a cool place. Then they spent a day walking around in the woods, picking spruce sap. And they took spruce roots and got them ready."

—Eliza Jones, 2004

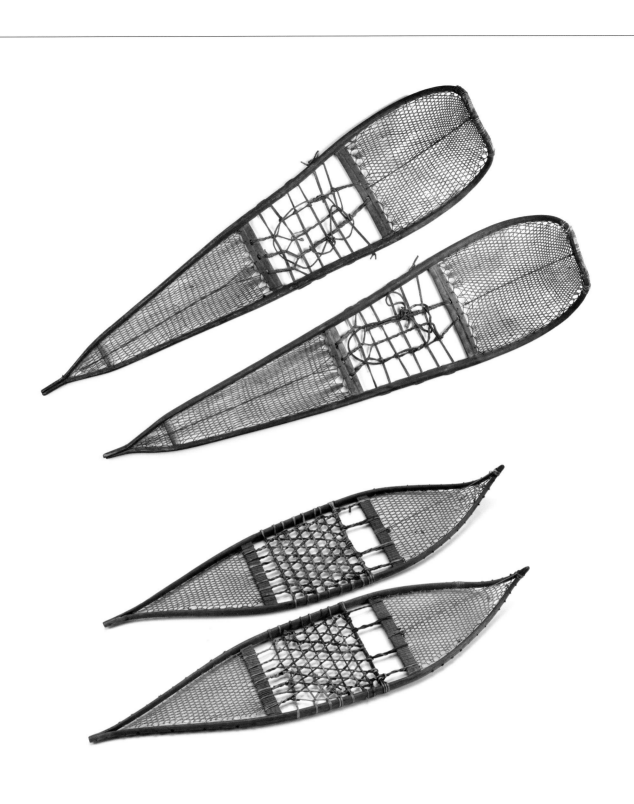

Ush (above)
SNOWSHOES

Iliamna Lake region
Collected by Edward W. Nelson,
accessioned 1879
National Museum of Natural History E038874
Length 132 cm (52 in)

Łinitsyaatł'įį aih (below)
TRAIL SNOWSHOES

Probably upper Yukon River region
William M. Fitzhugh collection,
accessioned 1936
National Museum of the American Indian 193336.000
Length 114.3 cm (45 in)

Upper Tanana people ascribed the invention of snowshoes to the far-traveling ancient hero Tsa-o-sha.[24] Large, round-toed traveling shoes with tailed heels *(top)* may be as long as a man is tall and provide maximum flotation in deep snow. Trimble Gilbert called this type *łąįį vik'ii itree* (meaning "a dog cries after someone") in Gwich'in, because dogs sink in soft snow and can't keep up with a man who is wearing them. Short shoes with pointed toes and heels *(bottom)*— called "Raven's snowshoes" by the Deg Hit'an—are faster on packed trails and are commonly used for racing and dog sledding.[25]

On crusted snow a hunter on snowshoes and his dogs could easily run down a moose, which breaks through to its belly with every step.[26] Hunters traditionally wore snowshoes to stalk caribou, clicking the shoes together to mimic the sound of the animals' hooves.[27]

Fine snowshoes are still made. Men craft the frames from straight-grained, flexible birch; women sew the mesh in complex traditional patterns using moose *babiche* for the center and caribou *babiche* for the toe and heel.[28] Ptarmigan feet are sometimes tied onto snowshoes as charms for added speed, and new shoes are walked downriver first, according to Eliza Jones, so that "you will always move with the flow of things."

"Another thing people used to do is have races, like running in snowshoes. Whenever they could come up for a potlatch, those boys used to run behind the team all the way. See who could come into town first. That kind of race might be thirty or forty miles."

—Madeline Solomon, 1981[29]

Man making traveling snowshoes. Stevens Village, 1939.

WESTERN CULTURAL INFLUENCE came to Athabascan country in the late eighteenth and early nineteenth centuries when Russian fur traders set up forts in southern Alaska and the Hudson's Bay Company built a post at Fort Yukon; later in the century, the U.S. government and the Alaska Commercial Company took over from the Russians. The gold rushes of the 1880s and 1890s brought a flood of miners, settlers, and traders into the region. Our communities became less nomadic, more tied to trapping and a cash economy, and increasingly dependent on clothing, guns, food, and tools from the company stores. Through the efforts of missionaries most Athabascans adopted Christianity by the early 1900s. The twentieth century brought the airplane, the snow machine, and many other new technologies; mass media and communications; and Western schools where the teaching was in English only.

One of the biggest changes in my lifetime has been in the way that our children learn. I grew up in an oral tradition in which all our teachers were family and kin. Story telling time, as we called it, began in October after

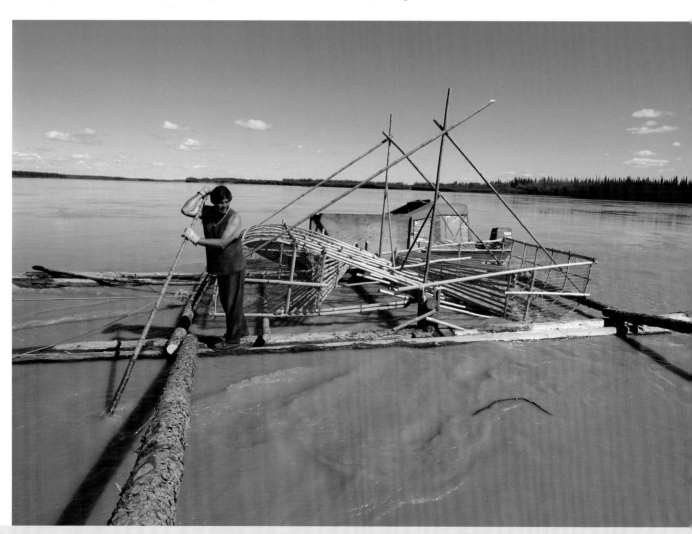

John Eric of Venetie positioning a fish wheel in the turbid Yukon River near Beaver, 2002. When in operation the two large baskets revolve in the current, dipping out salmon that drop into a collection box. Hundreds of fish may be harvested in a single day.

freeze-up. We would be home in our small cabin, chores finished for the day, our mother sewing by the light of a coal oil lamp. My stepfather would tell a *kk'edon ts'ednee*, a story in our language about ancient times when animals were human beings. It would include a lot of repetition to make it easier to learn and remember and a lesson about living in harmony with nature and people.

We would listen as hard as we could, going "Hmm, hmm, hmm" in the pauses to show we were paying attention. When my stepfather didn't hear that anymore, he knew everyone was asleep and stopped. Before he continued the next night, we had to repeat the story back to him, line by line, and if we tried to rush through it he'd say, *"Onts'aa ggɨh deten nogheltleł!"* (Slow down, you're telling it like a rabbit hopping along its path!). At other times we listened while adults talked and reminisced but were not allowed to interrupt. If we had a question we asked our grandmother or someone else about it later.

I was taught to read and write in English by my mother, Josie Peter Olin, who received her education as a child in the Episcopal mission school in Allakaket. I was about fourteen years old when the first one-room government school was built in our own village, which by then had moved a few miles and been renamed to Huslia. Because I was older than most before I started school, I attended it for only three years before graduating, but in that time I finished the work of all twelve grades.

When I married my husband, Benedict Jones, I moved to Koyukuk, and that's where we raised our children. I worked as a volunteer health aide, and he was village chief. In 1970 we moved to Fairbanks, where he had a job with the Alaska Department of Transportation. I began working with the Alaska Native Language Center at the University of Alaska Fairbanks, editing the manuscript for a Koyukon Athabascan dictionary that had been compiled by Jules Jetté, a Jesuit priest who came to the Koyukon region in 1898 and learned to speak our language fluently. That dictionary turned into my life's work; I thought it would take three years to finish and instead it took twenty-five, as I added and corrected and consulted with elders. It contains detailed information about Koyukon culture as well as language, including knowledge that Jetté recorded but that no longer exists in our communities.

After we retired and came back to Koyukuk, I began teaching the language in the public school in the hope that a new generation would know and continue our culture despite the huge changes and challenges that affect their young lives.

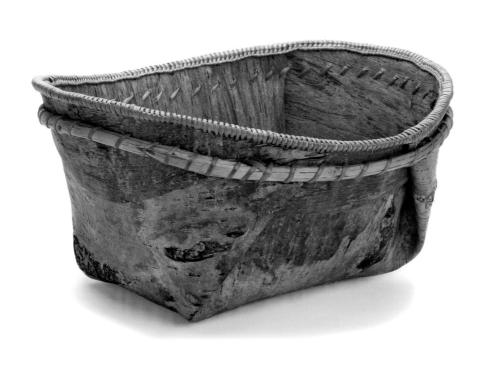

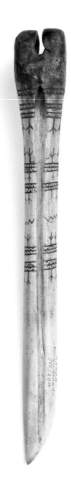

	Anvik		Nulato
Q'iyh tth'ok	Collected by John W. Chapman, accessioned 1927	**Bet'o k'eetlooge'**	Collected by Edward W. Nelson, accessioned 1878
BASKET	National Museum of Natural History E339747 Length 31 cm (12.2 in)	BARK-STRIPPING TOOL	National Museum of Natural History E033026 Length 31 cm (12.2 in)

This Deg Hit'an basket is made of folded birch bark with a double rim of bentwood hoops; it is stitched with split red willow roots. A traditional tool for peeling birch bark from the trees *(above right)* is a sharpened caribou leg bone decorated with raven-foot designs.

In the past, birch baskets large and small were made to hold water and store foods such as berries, roots, fish, meat, oil, and bear grease.[30] Soups and stews were cooked in them by adding hot stones or, if they were made of thick bark, by hanging the basket directly over a fire.[31]

Although no longer everyday necessities, beautiful baskets are still created by Athabascan artists.[32] Bark is peeled in the spring or early summer, taking only the outer layer so that the tree will survive. The bark is cut, warmed to make it flexible, folded into shape, and stitched with spruce or willow root, with the use of an awl to make the holes. To add color the roots are dyed with blueberries (for gray-blue), rhubarb (for green), and alder (for red). Rims and reinforcing strips are made of red willow or cranberry wood. Other decorative materials, such as porcupine quills, may be worked into the design as well.

"It's good to sew birch bark when the sun is shining. Good to dig roots when it's raining. The roots slide right out then."

—Sarah Malcolm, 1984[33]

Hän women with birch-bark baskets. Moosehide, ca. 1900.

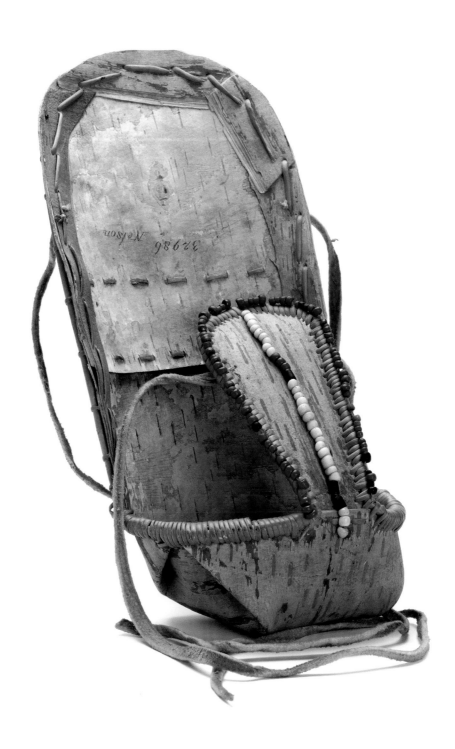

Tl'ołeł
BABY CARRIER

Nulato
Collected by Edward W. Nelson, accessioned 1878
National Museum of Natural History E032986
Length 32 cm (12.6 in)

The carrying cradle was important in mobile cultures, in which families traveled by foot, snowshoe, dogsled, toboggan, and canoe throughout much of the year. A very young child would ride on her mother's back supported by a baby strap, but older infants rode seated in birch-bark carriers.[34]

This small Koyukon baby carrier, probably a model, shows the construction: a straight back, leather tie straps, a basket-shaped seat to hold diaper materials, and a vertical pommel that went between the child's legs. The baby was dressed in fur pants that were cut away in the back, and dry moss or caribou hair was placed between its bottom and a layer of absorbent stove ash.[35] Eliza Jones and Judy Woods said that parents would run out of "baby moss" when traveling in the winter and have to search for it in the woods, causing delays.

It was considered bad luck to make a cradle or other things for a child before it was born, for fear that this would cause its death.[36]

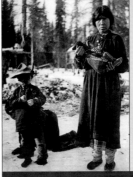

"In the morning it's quite a process to get the baby carrier ready when they're traveling. And there was a saying that you've got to just be quick and get ready to go. Anytime someone was slow they used to tease him, 'Tl'ołeł yee nohutaatltaan ło nughunee?' (Is he putting his baby in its carrier?)"

—Eliza Jones, 2004

Child in baby carrier. Copper River region, 1909.

ATHABASCAN

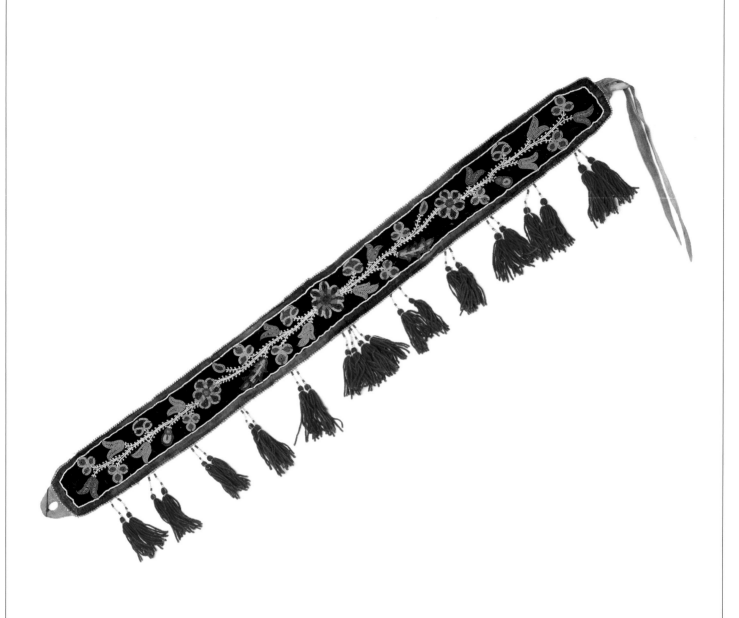

Tł'ôot'aii
BABY BELT

Fort McPherson, Inuvik Province, Canada
Collected by Edward A. Preble, accessioned 1906
National Museum of Natural History E238534
Length 112 cm (44.1 in)

Beaded baby belts are an important traditional form in Athabascan art.[37] Gwich'in straps like this one have square ends and short ties. The beading is an "old style" open floral pattern on black velveteen.[38] The beads are strung on sinew and tied down with thread. Beaded red wool tassels hang from the belt, which is backed with smoked moose hide.

A young baby rides on her mother's or sister's back, supported from underneath by the strap. For warmth the child is carried under the wearer's parka or wrapped in a blanket or shawl. Beaded straps are made and used across western Canada and eastern Alaska, including the Gwich'in, Ahtna, and Tanana regions.[39]

Gwich'in artist Dixie Hutchinson wrote, "When a baby is born, friends of the family would do beadwork for the baby like baby boots, slippers, hats, and mittens. Beaded baby straps were made mostly by the grandmothers. It was like saying, 'Welcome into our rich culture,' to give a baby beadwork."[40]

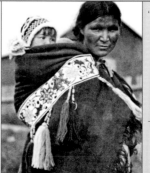

"In Canada a lot of them are still using it. I've seen them over at Fort McPherson when people gather on the mountain. A lot of people still use this baby strap. Some wider ones too, they're beautiful."

—Trimble Gilbert, 2004

Carrying a child with a baby belt. Fort Yukon, date unknown.

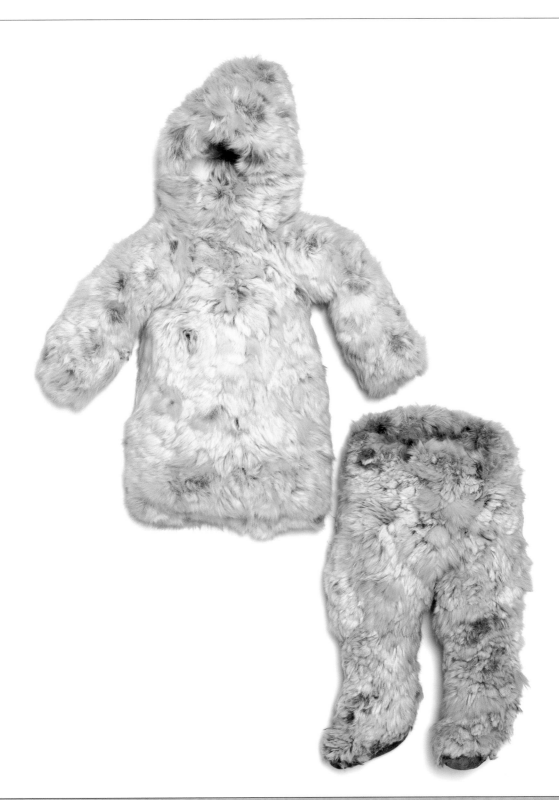

Geh dhah ik, Geh dhah thał
CHILD'S PARKA AND PANTS

Collected by Donald A. Cadzow, accessioned 1917
Peel River / Porcupine River region, Yukon Territory, Canada
National Museum of the American Indian 071053.000 and 071054.000
Length of parka 87.5 cm (34.5 in); pants 68 cm (26.8 in)

ATHABASCAN

This Gwich'in parka and trouser set for a child is made from a double layer of Arctic hare skins sewn back to back. Rabbit skins are light and extremely warm, although not very durable, and were used for blankets and all kinds of clothing.[41] Because the animals are common and easily captured, parkas made from their skins were considered to be undistinguished; the well-off preferred marten, wolf, wolverine, and caribou garments.[42] Nonetheless, hare parkas and pants were so useful that people wore them long after giving up other types of traditional clothing.[43]

Whole pelts can be used, as in this set, or skins can be spiral-cut into long strips ("rabbit yarn") and crocheted together.[44] Judy Woods remembered making a hooded sleeping bag out of rabbit yarn for her son's use during winter nights when the family bedded down on spruce bows in a canvas tent.

Arctic hares go through dramatic population cycles. Koyukon author Sydney Huntington wrote, "When hares suddenly erupted in great numbers, Koyukon elders explained that the winter-white animals had 'fallen from the sky with the snow.'"[45] Traditionally they were taken singly using snares or arrows and in large numbers by communal drives.[46]

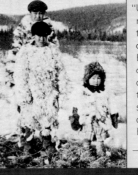

"Up in the Allakaket area it gets really, really cold, especially a long time ago. These women who were older than me said they remembered playing outdoors in really cold weather, and you know it was cold because they used to go like this [exhales] and their breath just sizzled. They had rabbit-skin clothes like this, and the cold didn't bother them."

—Eliza Jones, 2004

Stephan John, Stanley David, and Rachel David. Tetlin, ca. 1936.

DENA'INA ANCHORAGE

Aaron Leggett

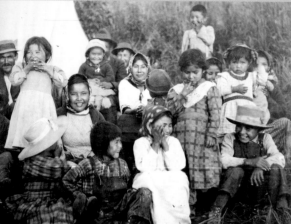

Dena'ina chief Nikolai of Knik village and his family, at Eklutna in 1918

MY DENA'INA NAME is Chada, "Old Man," although I am in my late twenties. I belong to the Nulchina (Clan of the Sky People) and the K'enaht'ana (Knik River band of Dena'ina). I live in the city of Anchorage but my home village is Idlughet (Eklutna).

Anchorage, which now has almost three hundred thousand people, was founded in 1914. It was only a workers' tent camp at first, located near our fishing camps on Dgheyaytnu (Stickleback Creek). But as the city grew and spread, it covered more and more Dena'ina land. Our people were forced out, moving our fish camps to Nutuł'iy (Fire Island), near the city, and to Eklutna and other more distant settlements in the winter. Today even Eklutna is within city limits, served by its own highway exit.

Because of this I live in one place but two worlds. I didn't grow up in a rural Alaska Native village, and I can't walk out my door and shoot a moose, although I can run down the street and go to a Target store. But the land underneath this urban sprawl is still my ancestors', and my home and our history are under my feet. All over the city are the places our elders remember like Ggeh Betnu (Rabbit Creek), Chan-shtnu (Chester Creek), and Qin Cheghitnu (Campbell Creek).

The funny thing is that when people ask me where I'm from I say, "From here." They try again, "Well, where's your family from?" "We're from here." "Well, no, where are your Native relatives?" I say, "We're really from here. This is our place!" Being the original inhabitants—I'm proud of that. My kids, grandkids, and whoever comes after me will know that this is Dena'ina Ełnena, this is our Dena'ina land.

ABOVE: Renae Egrass from McGrath beads floral patterns on a skin garment at the Alaska Native Heritage Center, 2002. Designs are first sketched on the leather.

OPPOSITE: Nulato fiddle master Berchman Esmailka at the Athabascan Fiddlers Festival in Fairbanks, 2004

OUR MIDWINTER CELEBRATIONS take place between Christmas and New Year's. During that week there are church gatherings, children's programs, snowshoe and dogsled races, and dances. On New Year's Day we finish with a celebratory potlatch. In some villages it used to be a custom, called *k'ekkaał det'aanh*, to gather what was needed for the festivities by going from house to house singing for tea, sugar, tobacco, or food. Everything that they collected was put on a blanket or piled onto a sleigh, and if someone didn't contribute they threw him onto a piece of canvas and tossed him up and down. My uncle, Chief Henry, talked about doing that at Stevens Village when he was young. People save and prepare special foods for Christmas week and make new clothing and beaded moccasins to wear for the dances.

Spring Carnival takes place in early April at the end of beaver trapping season. We do a lot of traveling to other villages to share in their celebrations. It's a wonderful and exciting time, with high-stakes dogsled races, snowshoe competitions, ice-picking contests, Athabascan fiddling, and dancing every night.

I remember stories I heard about the spring gathering in my grandmother's time. The families that were spring-camped along the Koyukuk River would leave and go downriver, joining with other families along the way and stopping to wait for stragglers.

Finally they would all be together in one big caravan of canoes and rafts, floating down toward the village of Koyukuk, just below the confluence with the Yukon River. The people up along the Yukon would do the same thing. As the boats drew near the village, everyone began shooting guns and singing, and the people on shore danced to greet them. When the boats landed the men and women danced their way up the bank, dressed in their most beautiful clothing. It was the beginning of a big celebration.

Today, Athabascan communities hold potlatches, or "give-away" ceremonies, on various occasions. Some are informal festivities to celebrate holidays; others are formal and spiritual occasions to recognize turning points in the lives of community members. Potlatches can mark a first successful hunt, a homecoming, recovery from an illness, or settlement of a grievance.

The most important and universal events are memorial potlatches held a year or more after a death to honor the memory of the deceased and to repay those who assisted the family during their time of grief. These are the helpers who built the casket, dug the grave, provided food for the vigil,

or sewed traditional clothing to dress the body. In some Athabascan regions, this assistance is given by members of the "opposite" moiety or sib (groups of related clans), and the memorial potlatch is just one of the ways that sibs support one another. In other areas, clan membership does not play an important role.

To prepare for a memorial potlatch, the hosts make, buy, and gather large quantities of gifts and food. A mistaken conception in the Western point of view is that the hosts are trying to show off their wealth, but it is nothing like that; it is simply our way of thanking those who generously gave service. Often several families join together to share the financial burden.

In Koyukuk a memorial potlatch takes place over a three-day period. Residents and guests from other villages arrive with food for a gathering in the community hall. Friends and relatives sing songs that they have composed for the deceased to commemorate his or her unique accomplishments,

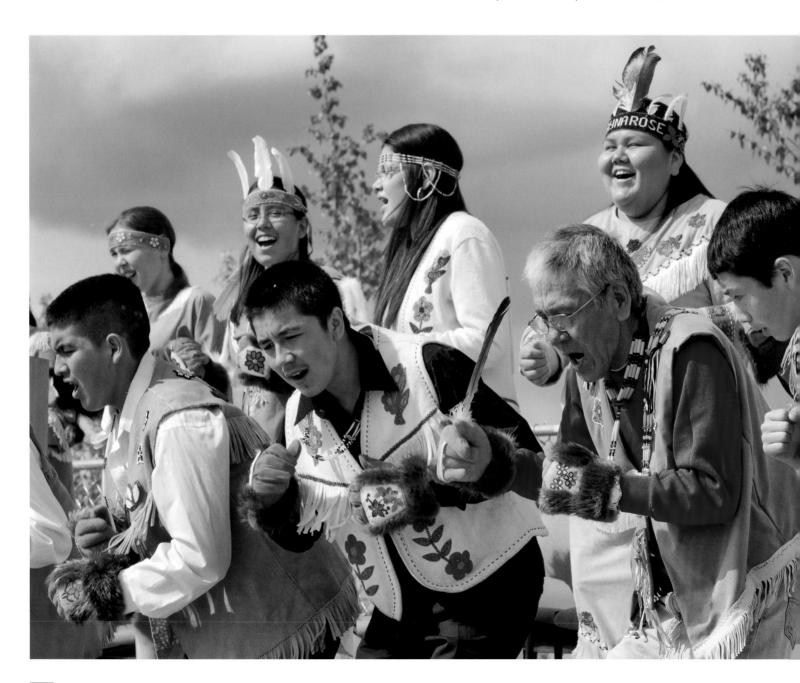

personality, and service to others. With the songs there is dancing. The dancers carry yards and yards of calico cloth decorated with wolf and wolverine pelts, and when the singing is finished they hang the cloth and furs on the wall. It is an emotional and difficult time for the family. To lift their spirits everyone joins afterward in singing old familiar songs and dancing to fiddle music or rock and roll. On the last day all of the guests sit down for a feast of special foods, including dishes that the deceased person most enjoyed. After the meal the hosts distribute gifts to everyone in attendance, with the finest presents reserved for the funeral helpers and composers of memorial songs.

The protocols, songs, and dances for memorial potlatches vary greatly among the different Athabascan peoples, yet the fundamental idea of the whole community marking the passage of a human soul to the world beyond is the same for all.

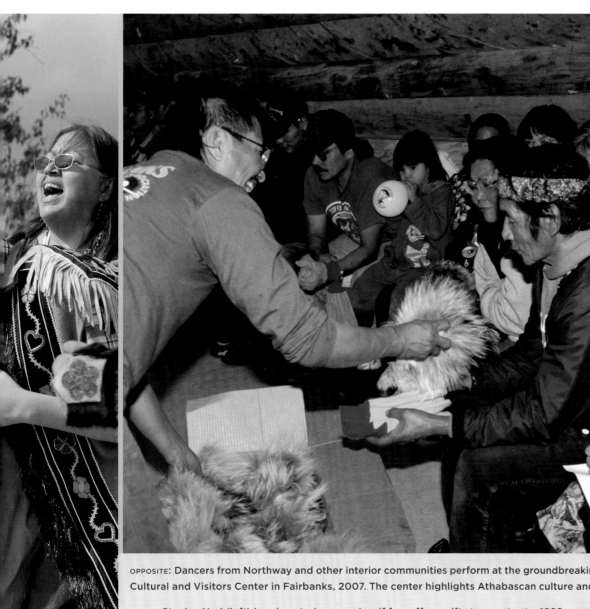

OPPOSITE: Dancers from Northway and other interior communities perform at the groundbreaking for the Morris Thompson Cultural and Visitors Center in Fairbanks, 2007. The center highlights Athabascan culture and opened in 2009.

ABOVE: Stanley Ned (left) hands out gloves and wolf fur ruffs as gifts to guests at a 1998 memorial potlatch in Allakaket.

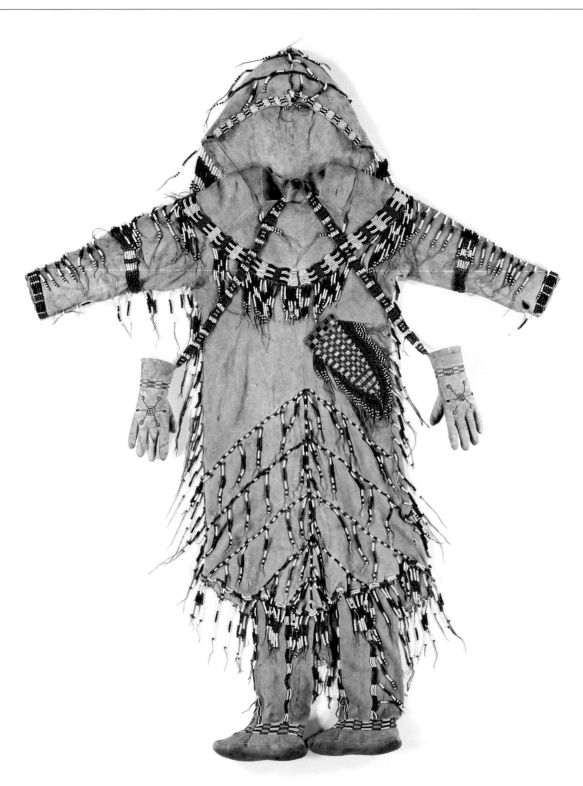

Ukaych'uk'a, Chik'ish, Seł, Lugech', K'iyagi yes

TUNIC, HOOD, BOOTS, GLOVES, AND KNIFE SHEATH

Probably southern Alaska
Purchased 1926
National Museum of the American Indian 151481.000
Length of tunic 141 cm (55.5 in)

This complete set of beaded summer ceremonial clothing, stylistically Dena'ina,[47] is made of supple, brain-tanned caribou hide and includes a hood, tunic, moccasin boots, gloves, and knife sheath. Clothing of similar design was worn in all Athabascan regions of Alaska and adorned with long fringes, red ocher paint, and colorful beadwork or in earlier times porcupine-quill embroidery.[48] Noting the beauty of such clothing, Russian explorer Lavrentiy Zagoskin wrote in 1842 that Athabascan peoples were "passionately fond of finery and bright colors."[49] Winter garments were similar, but caribou hair was left on the skins and turned to the inside for warmth.

A man's tunic usually came down to about the knee and was pointed on the bottom in both front and back; a woman's tunic extended to the ankles with a long point in back and a relatively straight hem in front, as on this example.[50] Athabascan advisers Shirley Holmberg, Karen Rifredi, Shirley Jimersen, and Karen Stickman suggested that this heavily beaded tunic and associated garments might have been worn by a young woman during her puberty seclusion.[51] Men and women carried face paints, fire-making equipment, charms, and small personal belongings in pouches that they hung around their necks or tucked into their belts. Knives were worn in the belt or carried in a hanging sheath.[52] The boots seen here were a late nineteenth- or early twentieth-century style, replacing the one-piece "moccasin trousers," which came to the waist, covering both feet and legs, and were originally worn by Alaskan Athabascan peoples.[53]

Gwich'in men, ca. 1851.

"Shahnyaati', he's a big chief. He'd bring in people from different areas in Yukon Flats. Everybody was coming from Northway, Eagle, Tanana, and everywhere.... That's the time they have celebrations, and they all wore fancy clothes. Big time, and competition too, wrestling and everything. So this is just for the special time."

—Trimble Gilbert, 2004

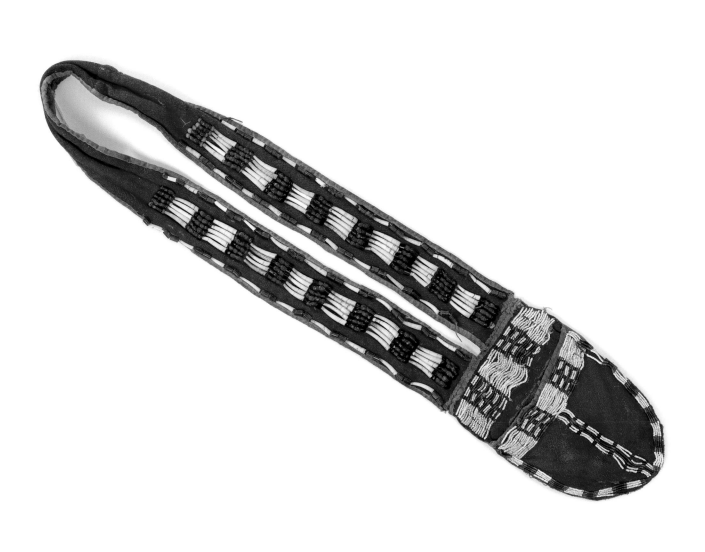

Viqizdluyi
FIRE BAG

Alaska
Collected by Charles L. McKay, accessioned 1883
National Museum of Natural History E073048
Length 67 cm (26.4 in)

ATHABASCAN

A man's essentials included a small "fire bag" to hold chert and steel for striking sparks and tinder such as wood shavings or powdered birch fungus.[54] When guns became available, hunters began using fire bags to carry ammunition as well. George Emmons wrote in 1911, "In every household these were found in great abundance, as many as ten or twelve in the possession of an individual. Indeed these bags…seem to mark the measure of the wife's affection for her husband, for in no other product of the Tahltan (save the knife case, which forms a companion piece) is so fully expressed a sense of the aesthetic both in elegance of design and harmony in color."[55] Among the Upper Tanana a deceased man was cremated in his best clothes, wearing his knife sheath and fire bag.[56]

This fire bag is of tanned leather with a red wool strap, richly ornamented with white dentalium shells and red and blue faceted glass beads. Dentalium shells from the Northwest Coast were a highly prized trade item among Athabascan peoples, and their use on this bag indicates wealth and status.[57] It would have been worn on important occasions, such as a potlatch.[58]

Gwich'in man wearing a fire bag. Mouth of Yukon River, ca. 1879.

"So they kept sharing fire with each other, and this was the way they kept the fire going for thousands of years. They built fires too, but it took a long time."

—Trimble Gilbert, 2004

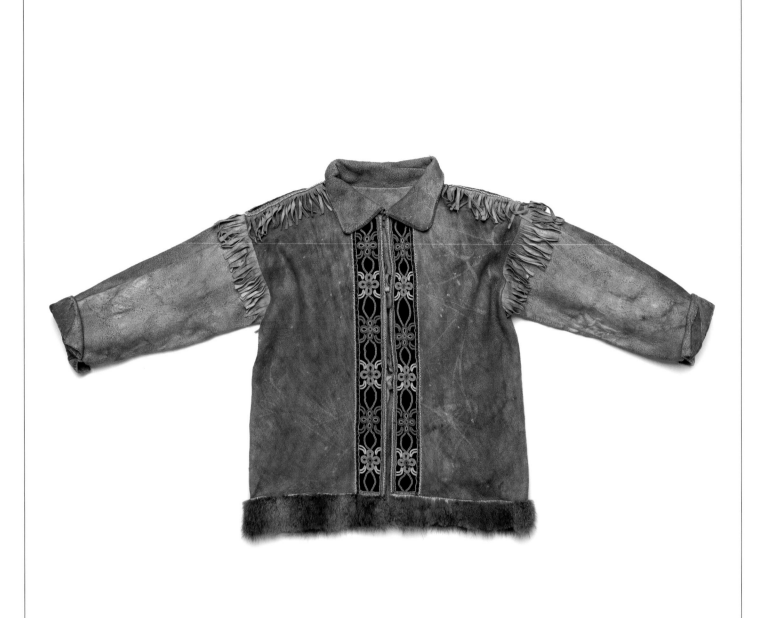

Deniigi zes dghaec

CHIEF'S COAT

Copper River region
Purchased 1949
National Museum of the American Indian 214801.000
Length 82 cm (32.3 in)

At Athabascan potlatches and other special occasions, men of influence, wealth, and oratorical skill—"big, strong people," in one elder's phrase—wear dentalium-shell necklaces and beaded moose-hide jackets known as chiefs' coats.[59] The coats, usually trimmed with beaver or otter fur, are symbols of personal prestige and connection to ancestors.[60] Trimble Gilbert said that when a young man is about to assume leadership in his community his grandmother will make him a jacket like this to put on in front of a gathering of the people, "so everybody will know he will be the chief."

Chiefs' coats, which open down the front, are adapted from an earlier Yukon fashion, the closed-front "English hunting shirt," made of red wool with beaded and fringed epaulets, beaded yoke, and pearl buttons. English shirts were awarded by Hudson's Bay Company traders to prominent local leaders. Reproduced in skin, they were worn by men of the Gwich'in, Koyukon, Tutchone, Tanana, and other groups during the latter part of the nineteenth century.[61] This coat from the Copper River region is probably Ahtna.

"On the Koyukuk River the men who have inherited coats like this, they wear them on special days like holidays, during New Year's."

—Eliza Jones, 2004

Albert Maggie wearing a chief's coat. Nenana, ca. 1918.

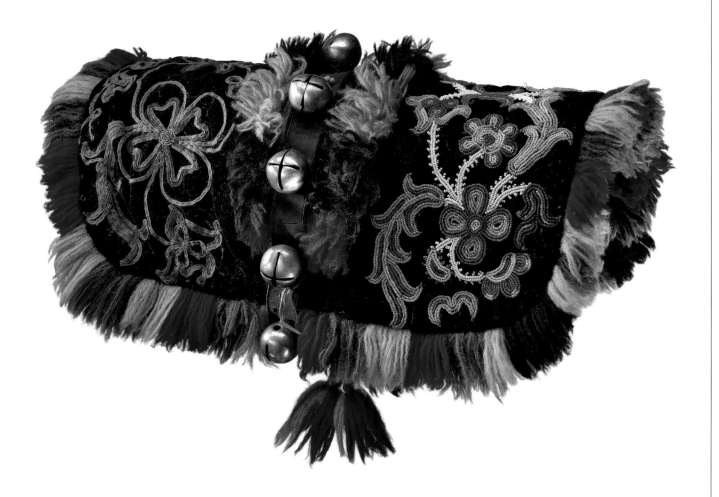

Łąįį ts'at
DOG BLANKET

Upper Yukon River region
Collected by Micajah W. Pope ca. 1910, accessioned 1928
National Museum of the American Indian 161665.000
Length 66.5 cm (26.2 in)

For special occasions, Gwich'in chiefs and wealthy men dressed their sled dog teams in beaded velvet blankets with sleigh bells and long yarn fringes.[62] Blankets were usually made in sets of four or six to outfit the whole team. The right half of this blanket is decorated with small seed beads, and the left half with appliquéd cotton braid. In addition, the dogs wore tall *łąįį ji'* (dog's antlers) on their harnesses. The *łąįį ji'* were hung with ribbons, bells, and fox tails.

The colors and jingling sounds of dog blankets and antlers made for a proud and prominent entrance into a trading post or village for New Year's, a wedding, a feast, or another big event. The garments were not worn on the trail; drivers stopped to dress their dogs when they came within hearing distance of a settlement.[63]

Dog blankets developed as an art form in the nineteenth century after trade beads became available in abundance. They were made not only by the eastern Gwich'in but also by Canadian Athabascan groups all the way to Hudson Bay.[64] The floral designs that Athabascan beaders apply to dog blankets, moccasins, jackets, and other garments were originally inspired by European embroidery patterns taught by Roman Catholic missionaries in Canada.[65]

"At New Year's time Rampart was a very popular place. Canada and American side, they all came to celebrate, because Dan Cadzow had a store there. So they came in with furs, and everybody started shooting up in the air, to celebrate.... And at the same time they rang the church bell, and all the dogs just ran away."

—Trimble Gilbert, 2004

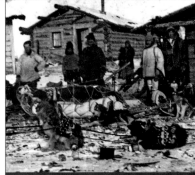

Dog team. Rampart, Yukon Territory, Canada, ca. 1910.

| **Ghinoy yeg**
CEREMONIAL BATON | Anvik
Collected by Herbert W. Krieger,
accessioned 1928
National Museum of Natural History E339811
Length 52 cm (20.5 in) | **Nik'aghun yeg**
CEREMONIAL BATON | Anvik
Collected by Herbert W. Krieger,
accessioned 1928
National Museum of Natural History E339812
Length 37.5 cm (14.8 in) |

ATHABASCAN

These batons were used to direct singers during preparations for the Deg Hit'an Partner's
Potlatch, which resembled the Messenger Feast of neighboring Yup'ik and Iñupiaq peoples.[66]
The upper carving portrays a caribou with white caribou hair to represent the animal's long
chin ruff. The lower figure is a wolf; the feathers may be owl or winter ptarmigan.[67]

Men of one village hosted the potlatch for "parka partners" from another settlement, but
nearly everyone from both communities participated.[68] Messengers carrying "memory sticks"
traveled between the host and guest villages requesting gifts such as food, snowshoes, and
clothing, which would be exchanged by the partners. The potlatch was a spiritual occasion for
sacred songs, dances, gift giving, feasting, and ceremonies to honor the dead.

Before the messengers were sent, men of the host village divided into two groups to practice
"asking songs" that would be directed to their guests. A man holding the caribou baton led one
group (the "askers"), and a man holding the wolf baton led another (the "chorus"). A different
style of wooden potlatch baton (gunho), similar to the Tlingit type, is used by people at Tanacross
and historically at other villages in the Upper Tanana region.[69]

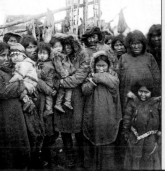

"In my young time,
I saw them use this
too.... And they sing
thirty-some songs,
different songs, all
night."

—Phillip Arrow, 2004

Deg Hit'an residents of Anvik, ca. 1879.

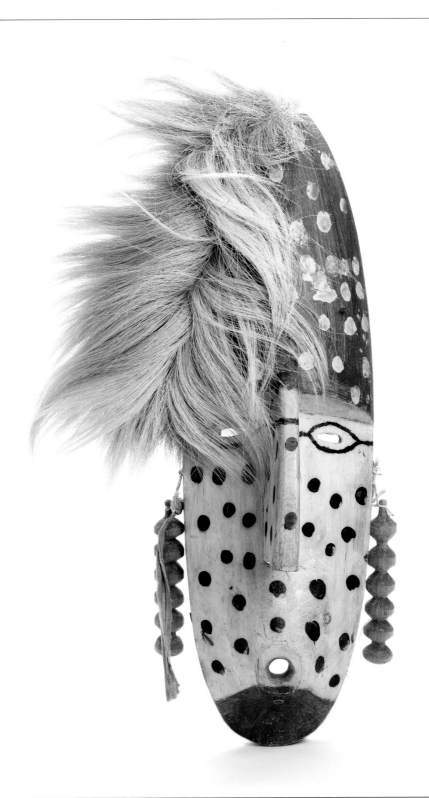

Giyema
MASK

ATHABASCAN

Anvik
Collected by Herbert W. Krieger, accessioned 1928
National Museum of Natural History E339831
Length 67 cm (26.4 in)

Phillip Arrow identified this as a Wild Man mask, still used in the Deg Hit'an region. It has a spotted face, goggled eyes, rounded mouth, earrings, and a straight nose; its hair is caribou. Arrow said that an ornament representing snot, now missing, would dangle from the nose.

Anvik residents in the 1930s also made this type but called it the Cry Baby.[70] The Cry Baby appeared in the annual Giyema and was said to live inside a mountain.[71] The being was male but wore earrings and other feminine ornaments, and the blue-painted chin on the mask shown here may indicate a woman's facial tattoos.[72]

Arrow said that at Shageluk the Wild Man mask is used for Giyema and formerly for the Stick Dance or Animals' Ceremony.[73] At the end of the Stick Dance, carved sticks representing the souls of killed animals were placed in the river to release the souls back into the wild, ensuring the animals' return to be hunted again. A very different performance also called the Stick Dance takes place at Koyukon memorial potlatches.[74]

Deg Hit'an masks used in the Feast of Masks. Anvik, ca. 1900.

"From what I hear there used to be lots of songs around those masks.... Those have strong songs, they say, medicine.... In the Stick Dance, they use all those masks around the *kashim*. They made animals, all kinds of animals, out of sticks."

—Phillip Arrow, 2004

TLINGIT

Rosita Worl

LINGÍT HAA SATEEYÍ!, We are "the People," and we have owned and occupied southeast Alaska since time immemorial.

When we say *haa aaní*, "our land," we are speaking from the heart. Those words mean ownership, which we have had to defend through history. They mean identity, because this is our homeland. They mean the nourishment of body and spirit provided by bountiful rain forests, coasts, and rivers. This land and its gifts have sustained us for hundreds of generations.

We believe that animals are our ancestors. Each matrilineal clan has its ancient progenitors. I am an Eagle from the Thunderbird clan, of the House Lowered from the Sun in Klukwan. I am proud to be a child of the Lukaax̱.ádi, or Sockeye, my father's clan.

The history of our lineages is portrayed by images of ancestral animals and by origin stories, ceremonial regalia, dances, songs, and names. These things represent *at.óow*, or "crest" beings, to which each clan has exclusive rights. Mountains, glaciers, and other places on the land are also *at.óow*,

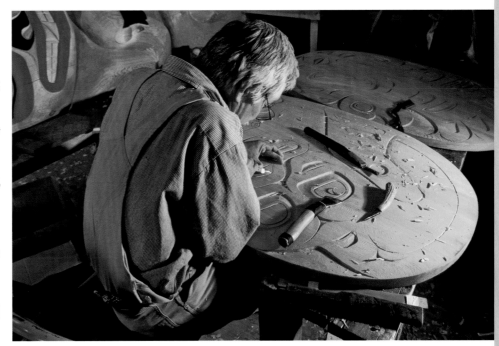

because they are linked to incidents in the birth of our people. The concept is profound; for a Tlingit person *at.óow* embody history, ancestry, geography, social being, and sacred connection. They symbolize who we are.

The Tlingit homeland extends from Icy Bay in the north to Prince of Wales Island in the south, some four hundred miles along Alaska's panhandle. The population is about ten thousand, distributed among a dozen villages, cities, and towns. The ocean spreads

OPPOSITE TOP: Tlingit chief Kaa dik nei in full ceremonial regalia including a crown of carved mountain goat horns and bear claw necklace, 1906. He is holding a song leader's staff.

OPPOSITE: Traditional cedar canoes on the Inside Passage near Petersburg, Alaska, in 1998. Haida and Tlingit carvers built the boats at Masset, British Columbia, and paddled them north to Juneau for Celebration, a biennial cultural festival sponsored by the Sealaska Heritage Institute.

ABOVE: Master artist Nathan P. Jackson carves panels commissioned by Gold Belt Corporation at the Edwin D. DeWitt Carving Center, Saxman, Alaska, 2002.

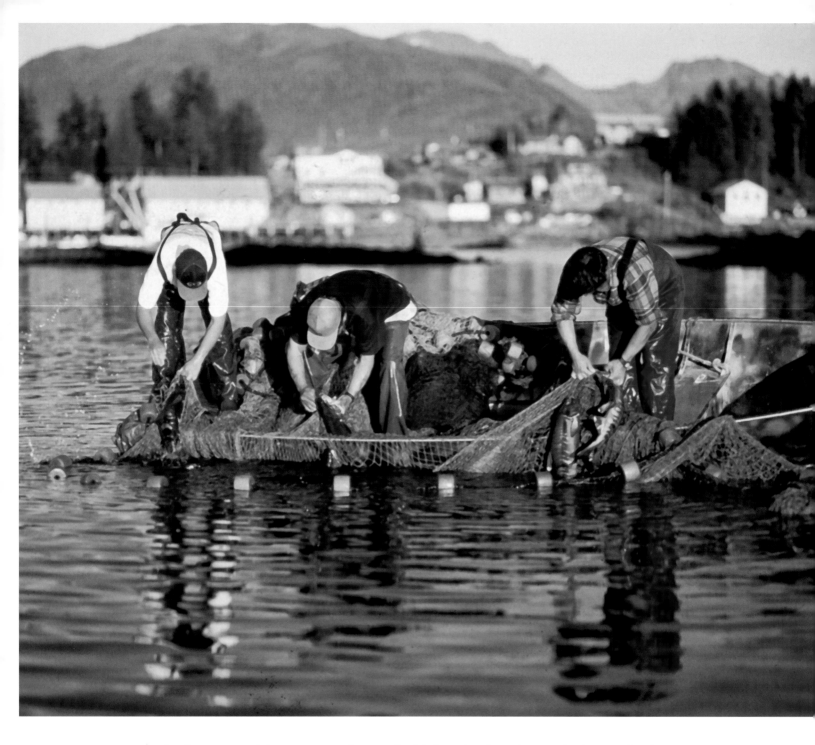

out before us, with a maze of wooded islands, fjords, and channels that Tlingit seafarers historically traveled in cedar-trunk canoes. Behind us are high glaciated mountain ranges that extend inland from the coast.

Elder Tlingit scholars tell of an ice age that forced our ancestors south and of their return migration when the climate warmed. Scientific research supported by our communities offers new evidence of this epic journey. An ancestor found on Prince of Wales Island was radiocarbon-dated to over ten thousand years, a time when massive Pleistocene ice had only recently withdrawn from southeast Alaska. Isotopic markers in his bones show that he subsisted on marine mammals and fish, and the obsidian he used for tools came from a mainland volcanic source. The evidence points to an early maritime lifestyle and the capability of long-distance voyaging. Moreover, our ancestor's DNA matched that of modern indigenous peoples

living down the west coast of the Americas in California, Mexico, Ecuador, Chile, and Argentina. Recently we reinterred his remains with new knowledge and respect for those early generations who traveled so far.

Fish, especially salmon, is the most important and bountiful resource in the Tlingit region. Harvested in summer and fall and preserved by smoking and drying, it allowed the historical population to grow large, to live in permanent winter villages, and to produce surpluses for trade. It is still the year-round staple of our diet.

The winter is long, and we look forward to spring and to herring eggs. The fish deposit their sticky roe on seaweed in the intertidal zone. Excitement spreads quickly at the first signs of the spawn. People rush to prime harvesting locations around Sitka and on Prince of Wales Island; in the past good areas were much more extensive.

We pick spring greens as they come up and gather spruce roots for basket making. Through the mid- to late summer people gather berries and put them away. Summer is the season for hunting seals, which are important both for meat and for their fat, which everyone especially loves. We use rendered seal grease for dipping dried fish and eat it with other foods at almost every meal.

Nutritionists note the exceptional quality of our traditional diet, which includes omega-3 fatty acids found in salmon, cancer-preventing antioxidants in blueberries, and the rich vitamins and proteins of wild meats and fish. We've always enjoyed the health benefits and superb tastes of those foods.

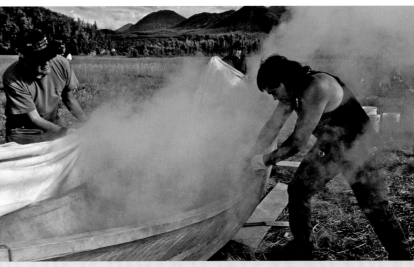

OPPOSITE: Beach seining for salmon at Klawock in southeast Alaska, 2001

LEFT AND ABOVE: Tlingit boat builder Wayne Price of Haines shapes a red cedar dugout canoe, then heats and steams the hull so that the sides can be spread apart. The hull is filled with salt water and hot rocks are added. Anchorage, 2000.

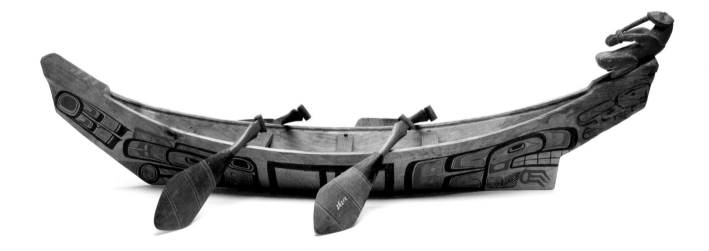

Yaakw kayáa
CANOE (MODEL)

Sitka
Collected by John B. White, accessioned 1876
National Museum of Natural History E021595
Length 78 cm (30.7 in)

Large "war canoes" with projecting bow, straight cutwater, and high stern were up to sixty feet long, with room for many passengers and thousands of pounds of gear and supplies. They served for coastal travel of all kinds, including trade, war, and relocation to seasonal camps.[1]

Haida men carved the canoes from tall red cedar trees that grow in the Queen Charlotte Islands and traded them to northern neighbors; the Tlingit made their own smaller boats from spruce. Elder Clarence Jackson said, "It was a sign of wealth when you had a Haida canoe," and such boats were always the property of a Tlingit *hít s'aatí*, or house chief.[2] They were painted with clan crests—on this model, a bear on the bow and a bird figure on the stern.[3] Boats had names such as *Hootz York* (meaning "Brown Bear Canoe," belonging to Chief Shakes at Stikine) and *Qaxyí'xdoxoa* (meaning, "Canoe That Travels through the Air"), the swift "arrow canoe" of Tlingit legend.[4] When guests arrived by canoe, the hosts carried both boat and passengers ashore.[5] Canoes were shaped with adzes, hollowed with fire, and steamed so that the sides could be spread apart and seats inserted (see p. 203).[6]

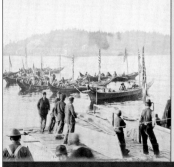

Canoes arriving at Sitka for a potlatch. 1904.

"They say that when one of these canoes came to your village to pick up a young lady, and the person who was going to marry her was in that boat, all the young men had to come down and put a pole underneath the bow, all the way out in the deep water. They picked up the canoe and packed it up the beach just so this man would not get his feet wet."

—George Ramos, 2005

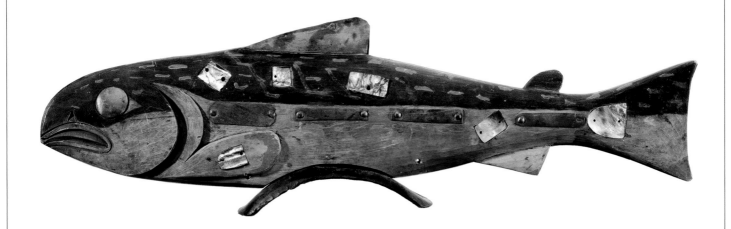

Xáat s'aaxwu

SALMON HEADDRESS

Ketchikan
Collected by George T. Emmons ca. 1890, purchased 1927
National Museum of the American Indian 154416.000
Length 90.8 cm (35.8 in)

This ceremonial headdress represents a sockeye, or red salmon, the principal crest of the Lukaax̲.ádi clan of the Raven moiety.[7] The fish has a copper eye, copper plates along its sides, and abalone shell inlays.

Five species of salmon return from the sea to their natal rivers each year, and whether eaten fresh, dried, or smoked they are the most important Tlingit food. They were traditionally harvested using weirs that funneled them into wooden traps; fences that trapped them in tidal pools; barbed harpoons; gaff hooks; and sharpened stakes that impaled leaping fish.[8] Fishing spots owned by each lineage were its most valuable property.

In traditional belief salmon are a numerous and powerful tribe, organized into five clans; they travel in invisible canoes, directed by their chiefs.[9] To them, traps in the rivers look like forts to be stormed.[10] If the fish failed to arrive, shamans were sent to conduct them to the coast,[11] and in the story of Salmon Boy, a drowned child learns from the fish how humans should treat them to ensure their return.[12] Salmon must never be wasted; their bones must be burned; and they have to be cut and hung to dry with their heads pointed upstream.[13]

"During the migration some of them separated and ended up at Ltu.aa [Lituya Bay]. From among them, young men went searching. When they returned they reported they had found a beautiful land. The fur animals were good and the salmon were plentiful, and they asked if it was possible to buy this land."

—George Ramos, 2005

Tlingit man spearing salmon from Ketchikan Creek, 1904.

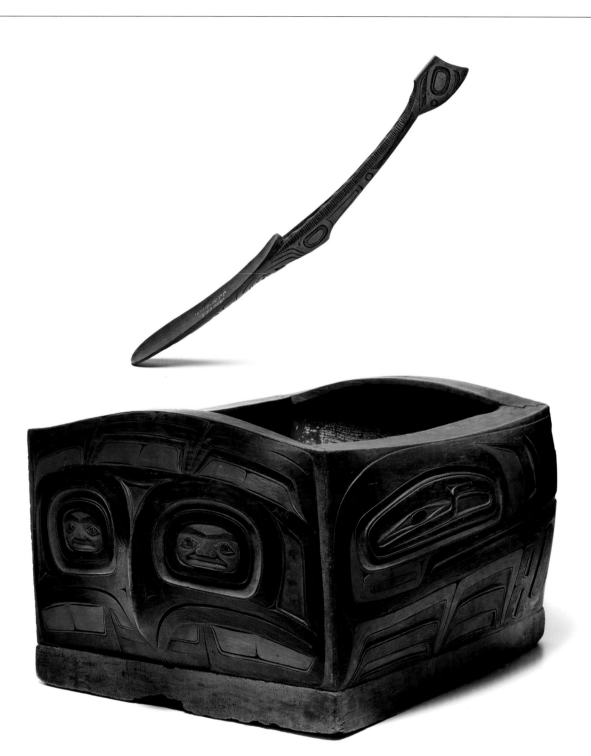

TLINGIT

Xakwl'l shál
SOAPBERRY SPOON

Kootznahoo (Letushkwin)
Collected by John J. McLean,
accessioned 1882
National Museum of Natural History E060147
Length 38.3 cm (15.1 in)

Laakt s'íx'i
BENTWOOD BOWL

Southeast Alaska
Purchased 1920
National Museum of the American Indian
099857.000
Length 53.6 cm (21.1 in)

Bentwood bowls were used for storing and serving water, berries, seal grease, and other foods, often becoming darkly stained with fish and sea mammal oils. Liquid contents of bowls and baskets could be boiled by adding hot stones.[14] To make a bowl, the artist shaped and kerfed a hardwood plank, softened it with hot water, bent the corners, and pegged or stitched the ends together. He added a separate bottom piece and sealed the seams with a compound of clamshells, salmon eggs, seal brains, and blood. The sides were shaped to bulge gently outward, and crest designs were applied with knife and paintbrush.[15] On this bowl is a sculpted face, possibly Raven, at one end; an owl-like spirit face with tailfeathers on the other (not shown); and wing designs that extend along both sides.[16]

Soapberries are a prized feast food, traditionally acquired from Athabascan trading partners. Dried berries are whipped with water to make pretty red foam and eaten with carved hardwood spoons.[17] This spoon has a spinelike design along the handle, along with a bird's head pointing toward the end, and a spirit face on the back of the bowl. Clarence Jackson said that fine soapberry spoons are given as special gifts between friends.

"Yóo lákdi tóox' Daakw aasá cháatl wanee…áyú dustéix atsú. A áyú lákt shadulhíkt. Té ataadé yéi daadunéinuch."

"In these bentwood boxes, halibut, whichever part,…is boiled. With that, bentwood bowls would be filled. Hot stones would be put into the basket to cook the food."

—George Ramos, 2005

Display of regalia and crest objects, including the Beaver Feast Dish. Angoon Raven House, ca. 1900.

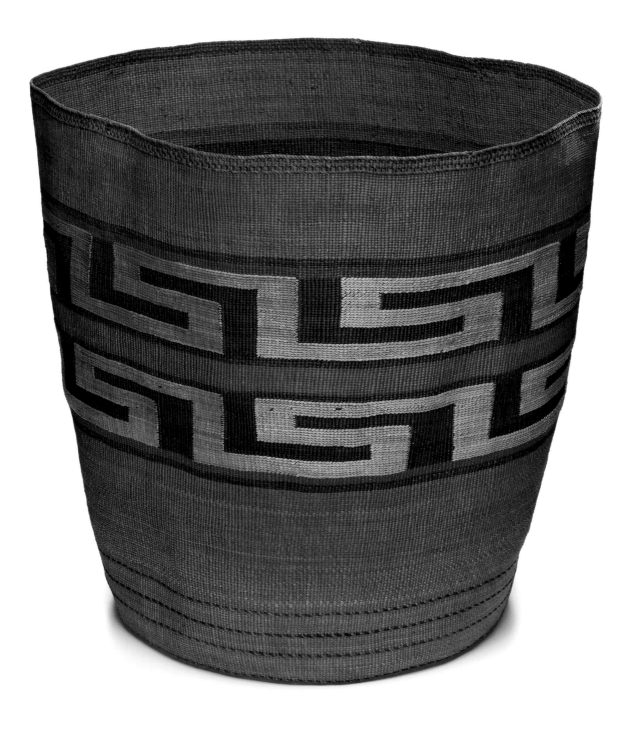

Southeast Alaska
Frederick W. Skiff Collection, purchased 1927
National Museum of the American Indian 156615.000
Height 41.5 cm (16.3 in)

TLINGIT

Shéiyi x̱aat ḵákgu
SPRUCE-ROOT BASKET

The mother of the Children of the Sun is said to have woven the first spruce-root basket, in which she and her offspring were lowered to Earth.[18] The northern Tlingit, especially the women of Yakutat, were renowned for tightly woven baskets that were "just like wood" in their rigidity and strength. South of Frederick Sound baskets were made of soft cedar bark.[19] Spruce baskets were used for gathering berries, plants, and shellfish; storing water, food, and household goods; and hot-rock boiling of soups and stews. Cooking baskets were lined with kelp to prevent scorching.[20]

Spruce roots are harvested in spring, roasted and stripped of their bark, soaked, and cut into fine splits.[21] Delores Churchill said, "For every hour you harvest you have one hour to cook it and eight hours to split it…. When you start weaving you always have to be happy; you can't think bad thoughts."[22] Tlingit baskets are woven upright with weft strands twined around the warp in a clockwise direction.[23] Weavers insert dyed grasses, maidenhair fern, and other plant materials into the weft to make decorative patterns.

This basket has a classic watertight weave with three-strand twining added around the rim for strength.[24] The "blanket-border" pattern copies early Hudson's Bay Company trade blankets.[25]

"When you're dealing with spruce root you really show respect not just to the trees but to the ground around them…. When you're getting your roots the first thing you say is, 'My ancestors were here, and my great-grandchildren will be here, so we're going to be real careful how we get our roots. And we're only going to take a little bit.'"

—Delores Churchill, 2005

A Tlingit woman weaves a basket. Hoonah, ca. 1905.

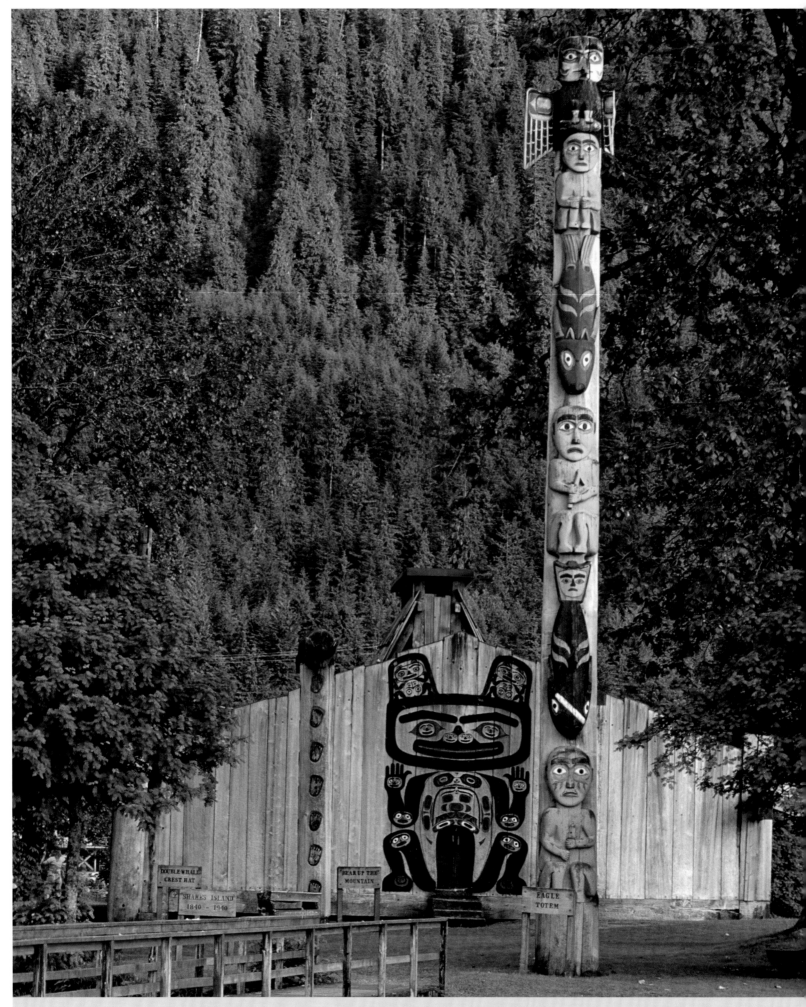

Replica of the Bear House of Wrangell's Chief Sheiyksh (or Shakes) VI, who died in 1916. The current house and crest pole were built in 1939 through a Native artists program of the Civilian Conservation Corps.

TLINGIT ARE DIVIDED INTO into opposing and complementary halves, Eagle and Raven, which are called moieties. Each moiety is composed of large extended families that we identify as clans. The clans, in turn, are divided into tribal houses. In the past, fifty or more members of a tribal house lived together in a large, elegant dwelling built from spruce or cedar planks.

Proper marriages among the Tlingit are between individuals from opposite moieties. Their children are recognized as members of the mother's moiety and clan, and they are given names owned by those clans. In the past, children lived in the house of their father. But when a boy reached the age of ten, he went to live with his mother's brother, who assumed responsibility for the schooling of his young nephew. A girl remained in her father's clan house until she married.

In the present day, many Tlingit people introduce themselves to others first by personal name and moiety—Eagle or Raven—and then by clan name and house. We inherit clan membership from our mothers but call ourselves the "children" of our father's clan.

The complexity of classic Tlingit society had other dimensions. Chiefs and their relatives enjoyed high rank, wealth, and privilege compared with the common people. Some clans and houses held greater status than others, and the humblest and poorest people were captured slaves and their descendants. In our large and stable communities some individuals held special positions based on talent and calling, such as shamans, master carvers, weavers, and canoe builders.

Although locally organized by village and clan, our region was never politically unified until coming into conflict with the West. Russian settlers tried to expropriate Tlingit land and resources, causing alarm among our clan leaders. Joined by Haida from southern Prince of Wales Island, Tlingit chiefs combined forces in 1802 to drive the Russians from their capital at Novo Arkhangelsk (Sitka). The Russians reestablished themselves by military force in 1804 but never gained control of significant Tlingit territory beyond small colonial garrisons.

When the Treaty of Cession was signed in 1867 our great-grandparents were astonished to learn that Russia had purported to sell Alaska, including our aboriginal lands, to the United States. War against the United States was deemed impractical, since American traders were our only source of guns and ammunition. Instead, tribal leaders sent a lawyer to Washington to tell the government, "If you want to buy Alaska, then buy it from us, its

rightful owners." It was an unusual step for an indigenous people—to adopt the legal institutions of the larger society to try to protect its own rights.

The struggle for our land continued for more than a century. The Central Council of Tlingit and Haida Tribes, established during World War II, litigated for thirty years to reach a financial settlement over tribal property taken by the U.S. federal government to create the Tongass National Forest. In 1968, the Tlingit and other groups unified under the Alaska Federation of Natives to pursue both state and federal claims.

Discovery of oil in Alaska's far north and the need for a pipeline across the state built political momentum for a comprehensive settlement. In 1971, Congress enacted the Alaska Native Claims Settlement Act, which compensated Alaska Natives $962.5 million for ceded lands and awarded clear title to the forty-four million acres of land they kept. Twelve Alaska Native regional corporations and scores of village corporations were formed to own and manage the land and its resources.

I don't think that we truly understood what Native corporations would be or how they would work. At first we could comprehend only that full rights to our land and resources, for which we had fought so long, had finally been regained. Our Native regional corporation, called the Sealaska Corporation, gradually realized that its mission was quite complex. It needed to balance two equally essential goals: supporting the perpetuation of Tingit, Haida, and Tsimshian cultures while responsibly managing its resources to benefit Native shareholders.

The Tlingit people, like all Alaska Natives, endured a long, hard fight for their civil rights. We were denied U.S. citizenship until 1922 and experienced decades of overt discrimination and segregation. Alaska's own "Jim Crow" laws excluded us from stores, jobs, schools, and public buildings. In 1945, the Alaska Native Brotherhood and Alaska Native Sisterhood, based in southeast Alaska, finally won the repeal of discriminatory laws by the state legislature.

LEFT: Three generations of Teiḵweidí (Brown Bear) women: Emma Williams, her daughter Frances Hamilton, and granddaugher Harriet Fenerty, Ketchikan, 1950. Tlingit clan membership is passed from mother to child.

OPPOSITE: The Sealaska Heritage Institute's Celebration, held every other year in Juneau, draws dance groups from Tlingit, Haida, and Tsimshian communities as well as thousands of U.S. and international guests and visitors. Here participants gather in full regalia gather around the main stage in Centennial Hall for the grand exit in 2004.

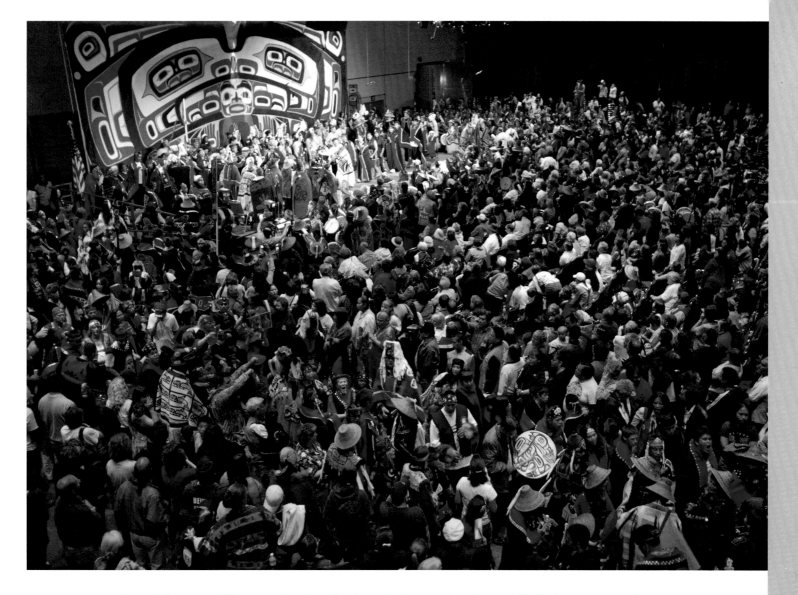

Outside my office at the Sealaska Heritage Institute (SHI), in Juneau, is my grandfather's framed Certificate of Citizenship. To earn it, he had to pass an English-language and civics test administered by white schoolteachers and then have his application approved by a judge. To practice his rights as a citizen, including the right to vote, he was forced to show that he had given up his Native language and culture to lead a "civilized" life.

When he was dying my grandfather called me to his bedside. I was fourteen years old. He said, "I want you to go back home. I want you to go back to Haines, and I want you to build a fire in the clan house." What he was saying is that my generation had to rekindle the fire of our culture and language. That became our responsibility. Through SHI and other regional and community organizations we have worked hard to help restore cultural knowledge, practice, pride, and fluency among our people. We have had substantial success, as witnessed by the huge public expression of our cultures that takes place every other year during the regional Celebration gathering. Progress has been made with the Tlingit language as well, although I don't know that we'll ever speak it the way our ancestors did.

I will tell you, though, that the voices of our ancestors will always be heard in our land. And our core cultural values will be maintained.

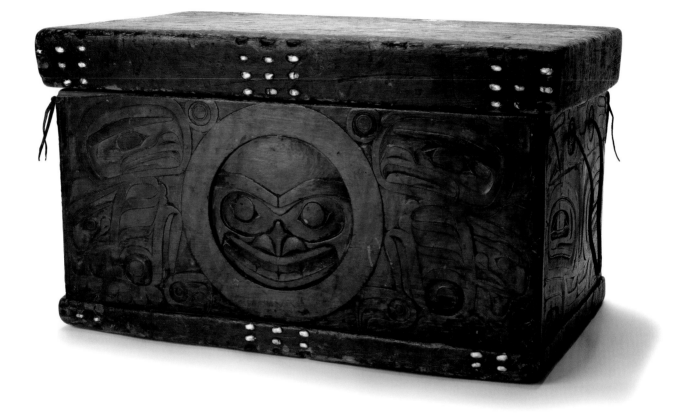

At.óowu dáakeit

Southeast Alaska
Collected by John J. McLean, accessioned 1882
National Museum of Natural History E060176
Length 65 cm (25.6 in)

TLINGIT

CHEST

This masterfully carved Hoonah chief's chest—a large bentwood box to hold clan regalia and crest objects—is decorated with white opercula on the lid and base. Opercula are the "trap-doors" of red turban snails, harvested by the Haida in deep waters off Vancouver Island and widely traded in the past on the Northwest Coast.[26] Red paint used on the chest was probably hematite, ocher, or cinnabar mixed with grease or salmon eggs or both.[27]

Elder Clarence Jackson and artist Donald Gregory identified the central carving as a brown bear peering out of the entrance to its cave in spring; the large teeth and nostrils are distinguishing marks of this animal. Bas-relief carvings of eagles flank the bear on each side, recognizable by their hooked beaks, wings, tails, and curved talons. A similar composition is carved on the back of the chest, and bears appear on the end panels. Eagle and Brown Bear are both Eagle moiety crests.

Chests were among the lineage property displayed by the host of a memorial *ku.éex'* and placed with a deceased leader as he lay in state before cremation. Tsimshian carvers produced some of the finest chests and traded them north to the Tlingit.[28]

"Here's the bear looking through his hole. In the fall time they close up their dens with a bunch of sticks and branches. Before he comes out, he looks out that opening, and that's what this represents."

—Donald Gregory, 2005

Tlingit chest inside the Whale House. Klukwan, ca. 1895.

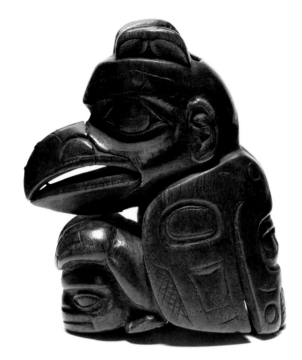

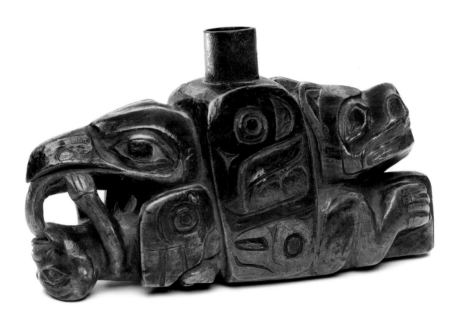

TLINGIT

Seiḵ dáakeit
PIPE BOWL

Southeast Alaska
Collected by Thomas S. Forsyth,
accessioned 1927
National Museum of Natural History E337354
Height 8.2 cm (3.2 in)

Seiḵ dáakeit
PIPE

Sitka
Mrs. Helen R. Strong Collection,
donated 1972
National Museum of the American Indian 247215.000
Length 10.9 cm (4.3 in)

From ancient times the Tlingit cultivated indigenous tobacco. They ground it in stone mortars, mixed it with wood ash and lime, and worked it into spruce gum pellets to place between gum and cheek.[29] Raven taught its use, and it was purported to be "so good that it is surprising they gave it up."[30] In the centuries-old "Story of the Kaagwaantaan," the Eagle hosts provide gum tobacco to the Raven builders of Wolf House at Kax'noowú.[31]

After Western contact Tlingit carvers made crest pipes for smoking imported tobacco. The pipe bowl (above top) represents Raven grasping a human head; a hollow twig would have been used for the pipe stem.[32] A complete pipe (above bottom) depicts a bear on one end and on the other an eagle transferring spiritual power to a person through its tongue; both animals are symbols of the Kaagwaantaan, an Eagle clan. The bowl is a section of a gun barrel.

Smoking was part of many feasts and ceremonies.[33] During the Smoking Feast on the first night of a memorial ku.éex', guests smoked pipes and placed tobacco in the fire as an offering to ancestors. For the hosts the feast marked the end of mourning; their tears were "wiped away" by the visitors, and they took off the black face paint that symbolized their sorrow.[34]

"Yes, my grandfathers, we remember you are mourning. We are not smoking this tobacco for which you have invited us. These long dead uncles of ours and our mothers are the ones who smoke it.... Our dead chief has come back because he has seen you mourning. Now, however, he has wiped away your tears."

—Katishan, 1904[35]

Exterior of a Tlingit lineage house. Cape Fox Village, 1899.

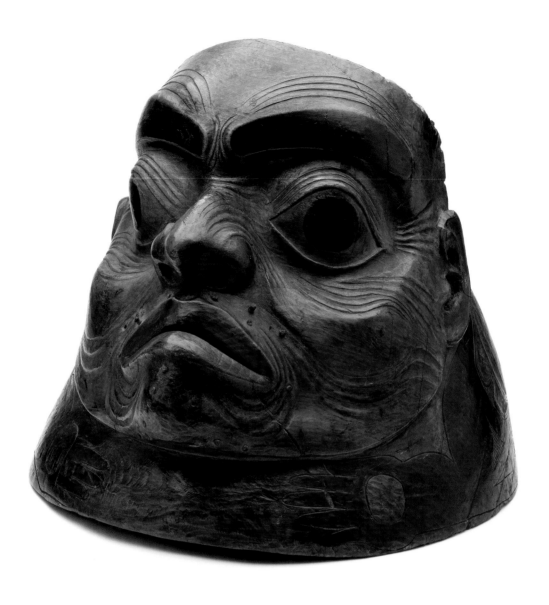

Upper Taku River region
Collected by Herbert G. Ogden, accessioned 1893
National Museum of Natural History E168157
Height 29 cm (11.4 in)

Xáa s'aaxwú
WARRIOR'S HELMET

Tlingit warriors wore battle helmets depicting crest animals or ancestors, along with wooden visors, thick leather tunics, and body armor made of wooden rods or slats. They armed themselves with bows and arrows, spears, clubs, and daggers.[36]

This helmet depicts a wrinkled human face once embellished with bear fur whiskers and shocks of human hair.[37] Pierced hands stretch across the front, joined to a stylized body in the back. Helmets were carved from hard, dense spruce burls, so that *"sha wduxeeji tlel kuwal'x"* (when the head is clubbed, it doesn't break), according to elder Peter Jack.

Europeans described Tlingit helmets as images of ferocious or monstrous beings.[38] Tomas Suria, who was at Yakutat in 1791, wrote, "They construct the helmet of various shapes; usually it is a piece of wood, very solid and thick, so much so that when I put one on it weighed the same as if it had been made of iron."[39] Urey Lisiansky, who fought the Tlingit at Sitka in 1804, observed that their helmets "are so thick, that a musket-ball, fired at a moderate distance, can hardly penetrate them."[40] Nonetheless, Tlingit armor went out of use as firearms became more common. Helmets remained in use by clans as *at.óow*.[41]

A Tlingit man wearing a battle helmet inside the Whale House. Klukwan, 1895.

"No one comes into your land until they've got an agreement to come there or have been invited. If you go into anybody else's land it's a battle. That's one of the strongest laws of the Tlingit."

—George Ramos, 2005

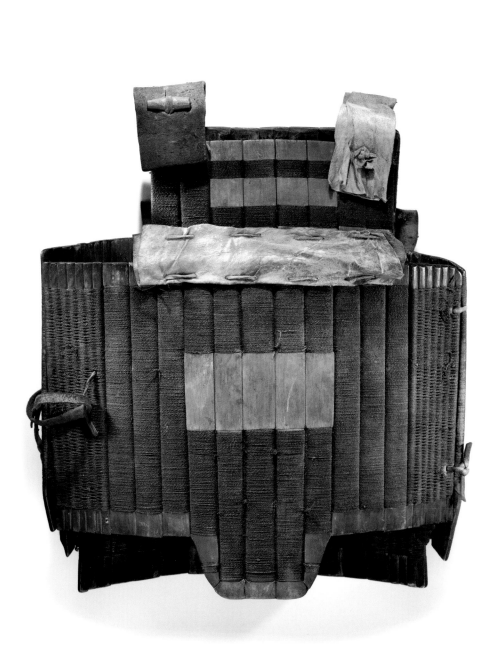

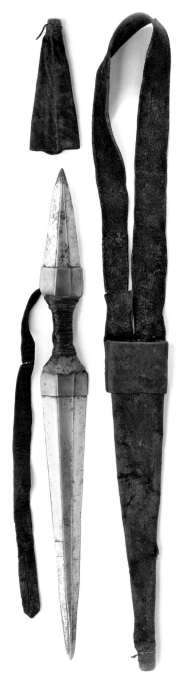

X̱áa daaka.ádi **WARRIOR'S** **BODY ARMOR**	Sitka Collected by Edward G. Fast ca. 1868, accessioned 1908 National Museum of the American Indian 018735.000; Length 55 cm (21.7 in)	**Shak'áts̱, Litaa daakeit** **DAGGER AND SHEATH**

Southeast Alaska
Collected by A. H. Hoff, accessioned 1870
National Museum of Natural History E009288
Length of dagger 60.7 cm (23.9 in)

In oral tradition, war began when Raven directed the people to "go there and kill them all, and you will have all the things in that town."[42] Raids against rival clans, villages, and foreign Native nations were launched to capture treasure and slaves, settle insults and unpaid debts, and retaliate for territorial trespass.[43] Intensive warfare may have begun about one thousand years ago, when fortified villages were first built in Tlingit country and across southern Alaska.[44]

Tlingit warriors possessed iron-bladed knives long before Western contact, crafted from metal found on Asian ships that drifted across the Pacific.[45] Sophisticated indigenous iron-working techniques produced honed and tempered blades, often with ground-on flutes.[46] The double-ended war dagger was worn around the neck in a leather sheath and used in hand-to-hand combat.[47] George Ramos said that a warrior tied his knife to his wrist before going into battle so that it would not be lost.[48]

The Tlingit fighter wore body armor made of wooden slats or rods, over a sleeveless coat of thick moose, elk, or sea lion hide.[49] This hardwood armor shown here is bound together with nettle fiber.

Tlingit warrior wearing helmet, neck and body armor, and dagger. Port Mulgrave, 1791.

"After you become a warrior, the knife is always on you. It's the first thing that you put on in the morning, the last thing that you take off at night. It's called *jaxán át*, 'something close at hand'; it is there to protect your people at all times."

—George Ramos, 2005

CLAN KNOWLEDGE

Ricardo Worl

MY TLINGIT NAME is Gaachxweinaa, and I am a member of the Shangukeidí, or Thunderbird clan, from the village of Klukwan. I am a program manager for the Tlingit Haida Regional Housing Authority and have worked for the National Bank of Alaska, the Alaska Legislature, and Sealaska Corporation.

David Katzeek, my maternal uncle and chief of the Shangukeidí, has been training me in the knowledge that a young, traditional-minded Tlingit male should have in order to conduct himself properly within our tradition and at our ceremonies. He is teaching me about our cultural protocols, clan histories, stories, songs, and names. This role, he said, requires strong commitments to our culture and clan. I have a great deal to learn.

I recall how Native Americans were portrayed in school—as simplistic and even primitive. In my lifetime I've learned quite the contrary. My own Tlingit culture is highly complex. We must understand the intricate social relationships among clans and the reciprocity between Eagles and Ravens. We must know the proper ways to acknowledge and respond to our clan opposites, our in-laws, so as not to offend them. Speaking publicly at a gathering of our people demands that we weigh our words with care or the consequences can be severe.

We learn this by training and observation, but the opportunities for learning Tlingit leadership are more constrained today. Long ago someone being groomed for this role would stand by his clan elders at ceremonies as they explained each person's heritage and descent and how each must be treated. But I work a full day and travel for my job; time with my uncle David is limited. Sharing his knowledge of the Shangukeidí will have to take place in concentrated moments, part of the modern balance of work, family, and culture.

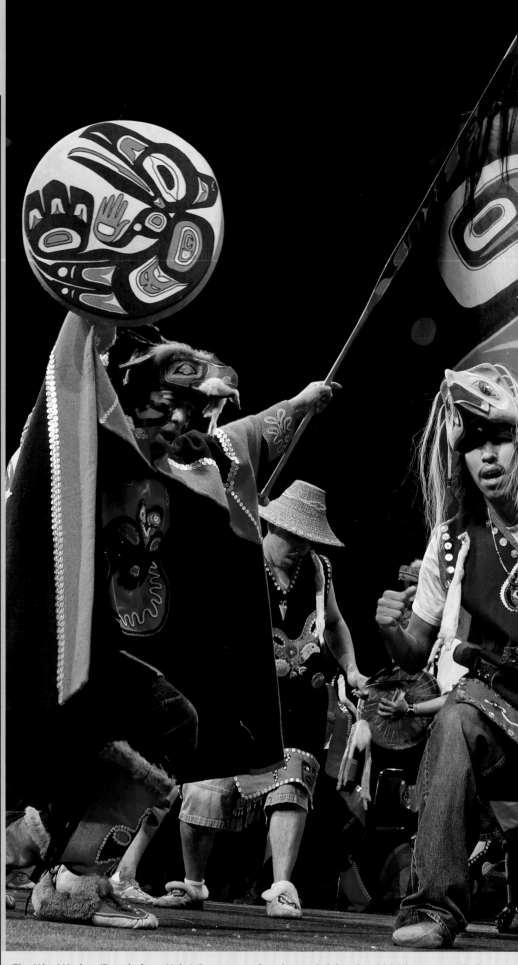

The Ḵéex' Ḵwáan (People from Kake) Dancers performing at Celebration 2006 in Juneau. Their traditional instruments and regalia include painted skin drums (see p. 224), button robes (see Haida robe p. 245), woven spruce root hats (see pp. 218, 219), and headdresses (see Haida headdress p. 248).

ONE OF OUR STRONGEST values is the maintenance of social and spiritual balance between Eagle and Raven clans to ensure the well-being of society. In addition, we have spiritual obligations to ancestors and future generations, a concept of cultural perpetuation called *haa shagoon*. These traditional beliefs form the basis of ceremonies called *ku.éex'* in Tlingit and potlatch in English.

The most significant *ku.éex'* ceremonies are memorials to those who have passed away. When someone of an Eagle clan dies, members of Raven clans come to assist the grieving relatives. They bring food, contribute to the funeral expenses, and sit with the body through the night.

A year after the death the Eagle clan hosts a *ku.éex'* for the Ravens, who come as guests. The hosts display their clan treasures, or *at.óow*, some of which have been handed down through many generations. In this context, the word *at.óow* refers to works of traditional art that bear the images of crest beings. They include Chilkat blankets woven from dyed mountain sheep wool, button blankets, headdresses, carved and painted bowls and boxes, masks, war helmets, and drums. Clan ownership of these crest objects is revalidated by their presentation in the memorial ceremony, accompanied by a recounting of their histories and the origin stories of the crests themselves.

Balance is maintained through the response of the Raven clans by present-ing their own clan regalia and ceremonial objects. The Eagle clan repays the Ravens, who came to the Eagles' assistance, by distributing gifts and acknowledging them in oratory and song.

If the person who died was a clan leader, his successor is named and assumes office at the time of the memorial ceremony. Therefore, a *ku.éex'* has multiple functions: repaying the opposite moiety and reuniting with them, fulfilling spiritual obligations, and conducting legal and political affairs. This institution, which remains so vital and important in our contemporary lives, is far more complex than a stereotypical understanding of the word *potlatch* might imply.

I would like for museum visitors to appreciate the spiritual life of the Tlingit objects they see. One of our young men recently visited a museum on the East Coast, and staff members there, two young women, offered to let him wear one of the *at.óow* of his clan. It was a very powerful, moving event for him, because he felt an immediate connection to his ancestors. He was a Raven, so he designated the women as Eagles. He said, "You will become Eagles so that we may have balance." The women were overcome with emotion. Although they couldn't explain the source of it, it came from being touched by the real meaning of *at.óow*.

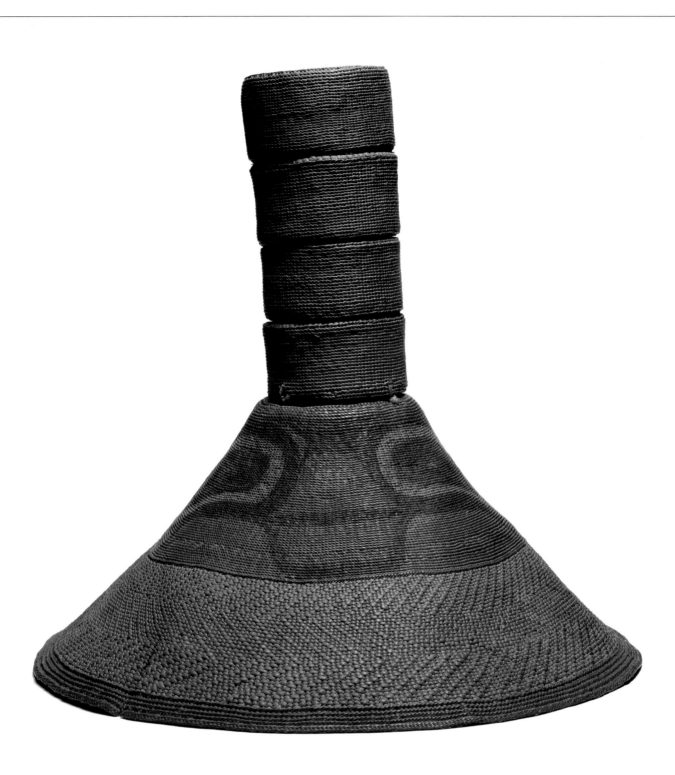

Shadakóox'
CREST HAT

Sitka
Collected by George T. Emmons ca. 1890, purchased 1920
National Museum of the American Indian 098087.000
Height 25.5 cm (10 in)

Woven spruce-root hats painted with crest designs are among the most sacred *at.óow* of Tlingit lineages and clans. A headman wears one as the crowning piece of his regalia at a *ku.éex'*. The hat, along with others owned by the group, is displayed at his wake and passed on to his successor.[50]

The hat also symbolizes exchange between the two halves of Tlingit society. Each time it is worn or displayed, the owners must make a payment to their "opposites" who are guests at the ceremony, compensating them for their witness and validation of the crest. These opposites—whether Raven or Eagle—were the original makers of the hat and, after each *ku.éex'*, will add a new woven cylinder (bob or potlatch ring) to the top for its owners.

The cylinders on this hat represent four major potlatch events, perhaps the lifetime accomplishment of one leader and his people. The painted crest design on this hat could not be identified.[51] The weave is a simple twined pattern on the painted crown and a patterned skip-stitch on the brim.[52] An opening on top of the cylinders is for the insertion of a white ermine pelt.

"The rule of making a hat is still the same today as it was one hundred or two hundred years ago. The opposite clan made the hat. When the hat got through at a party [after each potlatch], then the people who owned the hat hired the opposite clan to weave those bobs on it. And it just keeps going. The rule is still in place."

—Clarence Jackson, 2005

A Tlingit man in regalia, including a spruce-root hat with potlatch rings. Sitka, 1904.

TLINGIT

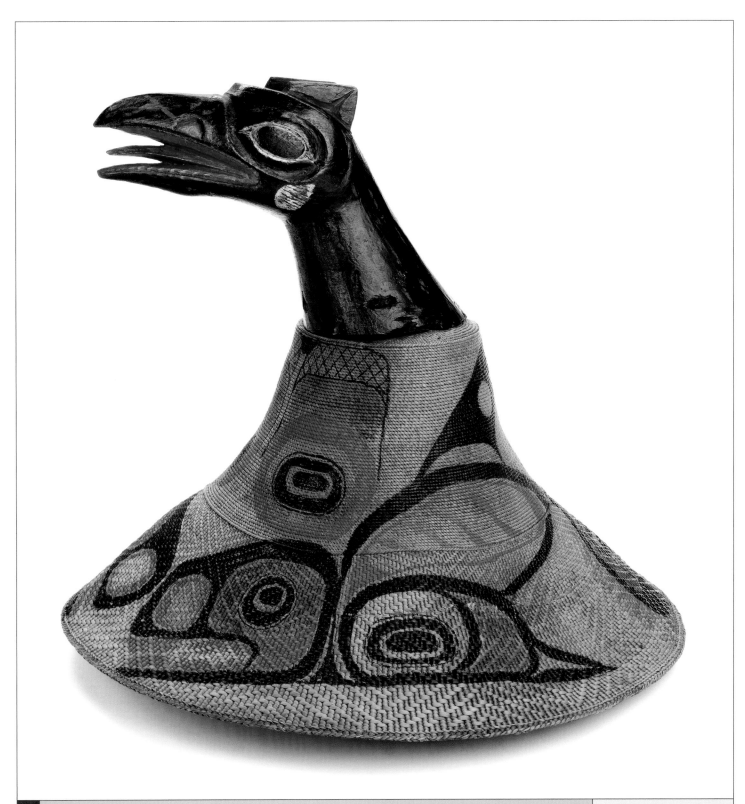

TLINGIT

Yéil s'áaxwu
RAVEN CREST HAT

Southeast Alaska
Collected by George T. Emmons, accessioned 1903
National Museum of Natural History E221177
Height 36 cm (14.2 in)

This woven spruce-root crest hat is topped with an expressive head of Raven in full voice with open beak and tongue. Yet the design painted on the crown is the Killer Whale, a crest belonging to the Eagle moiety. The combination of symbols from opposing moieties on a single hat is confounding and rare. "Even the Raven is a puzzle. He has brown bear ears," said Clarence Jackson, noting that Brown Bear is another Eagle crest.

Tlingit and Haida experts offered several possible explanations.[53] The clockwise weaving pattern of the spruce-root strands indicates Tlingit manufacture, but the painting style may be Haida, and the crest combination of Raven and Killer Whale is normal in the Haida clan system. Thus, the hat might represent trade or a gift exchange between the two peoples, or it might portray an unpaid Raven debt to their social opposites, as on "shame poles," on which a debtor's image or clan symbol is carved to mock him publicly. Even more rarely a child may be given permission to use a crest of his grandfather's clan, always of the opposite moiety, creating a mix of designs. The discussion emphasizes the complex social language embodied by crest symbols.

"There are three possibilities with this hat. First, it might have been a gift to the Haida people who put their designs on there, including the Raven…. The second is that a Raven didn't pay a debt, so they put him on top…. And the third is that a grandchild can use a grandfather's regalia, but I only saw that once in my life."

—Clarence Jackson, 2005

Tlingit man wearing a Raven crest hat. Sitka, 1904.

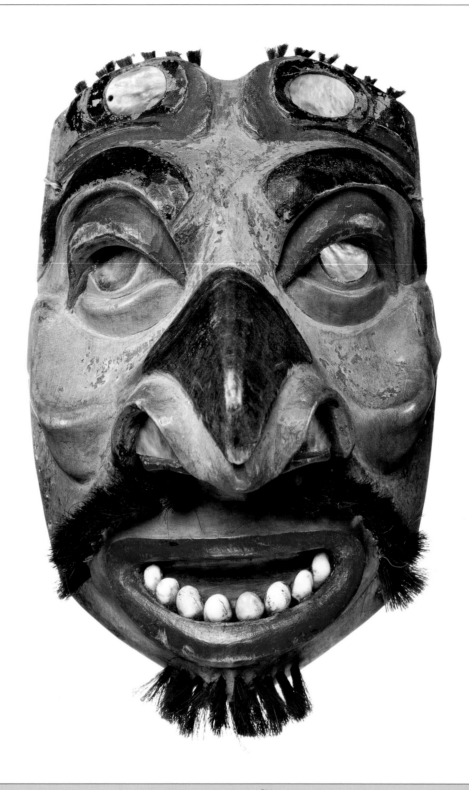

Sitka
Collected by George T. Emmons ca. 1890, purchased 1920
National Museum of the American Indian 097891.000
Length 15.5 cm (6.1 in)

L'a<u>x</u>keit

MASK

On Tlingit masks, animals usually appear in human guise, but their identities are revealed by characteristic features.[54] The curved beak of this hollow-cheeked miniature mask may represent Hawk, a crest of the Raven moiety; on its forehead two Raven crests are seen in profile. The mouth, inset with opercula teeth, is open in song or speech. Pieces of abalone shell fill its eyes and nostrils.

The mask might have been an item of ceremonial regalia but could also have belonged to an *ixt'*, or shaman; the two types are not easily distinguished.[55] An *ixt'* owned up to eight masks that portrayed his or her supernatural assistants, or *yek*—various animals, birds, nature spirits, and human beings. These spirits, invisible to all but the shaman, could spy on distant places, foretell the future, reveal witches, and rescue drowned or lost people from the dreaded Land Otter Men. During a trance performance the *ixt'* put on one mask after another, summoning and being possessed by each spirit in turn.[56]

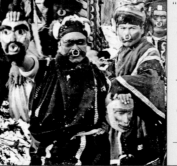

Tlingit men with regalia and masks. Chilkat, ca. 1895.

"In this dance, people sing funeral songs. Eight songs, or one song with eight verses…and if one that does not know the song starts it and begins with the wrong verse, it is looked on as a disgrace to his people. The guests danced, wearing their masks, hats, emblem coats, and other festal paraphernalia. After that, he distributed his property."

—Katishan, 1904[57]

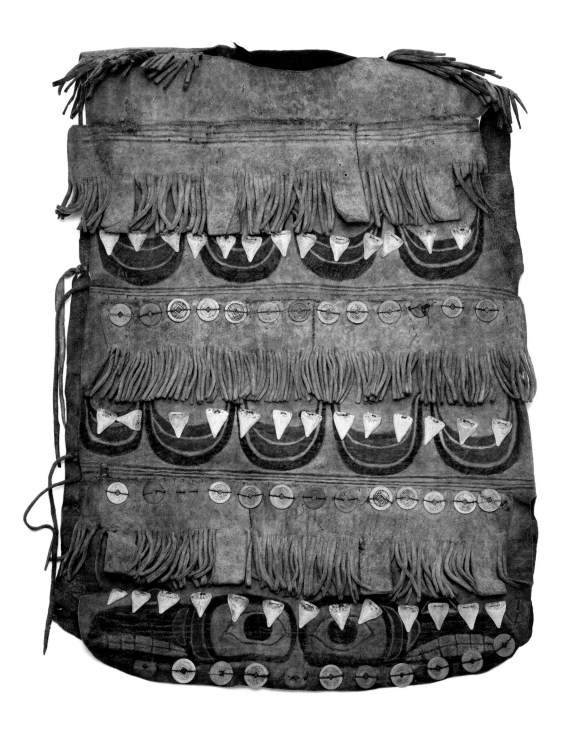

K̲'oodás'
DANCE TUNIC

Southeast Alaska
Collected by John J. McLean, accessioned 1882
National Museum of Natural History E060241
Length 79 cm (31.1 in)

This fringed moose-hide tunic resembles leather armor but is thinner and more artistically embellished than typical fighters' garb.[58] A warrior's tunic would also be open on one side, typically the right, to allow free movement of his weapon arm. As a dance garment this leather doublet might have been worn for the ceremonial reenactment of war. Similarly, shamans dressed themselves in armor to portray *yek* who were "spirits of above," that is, warriors who had been killed in battle.[59]

The tunic is decorated with fossil sharks' teeth, both real and imitated in carved bone, and with Chinese coins that were imported by Russian, British, and American traders. It is painted with U-shaped red and black designs and, along the bottom, a pair of Raven crest figures. On the back, not seen here, is a moonlike "spirit face" or "ghost face," often placed on dance shirts and tunics.

"For a while I thought that it was an armor vest, but it wouldn't be made like that with all the fringe and ornaments. It must be for dancing.... The only other thing it could be is *x'áan koonáayee*, a commander's leather armor."

—George Ramos, 2005

Tlingit men in dance clothing, including a painted hide tunic. Sitka, 1904.

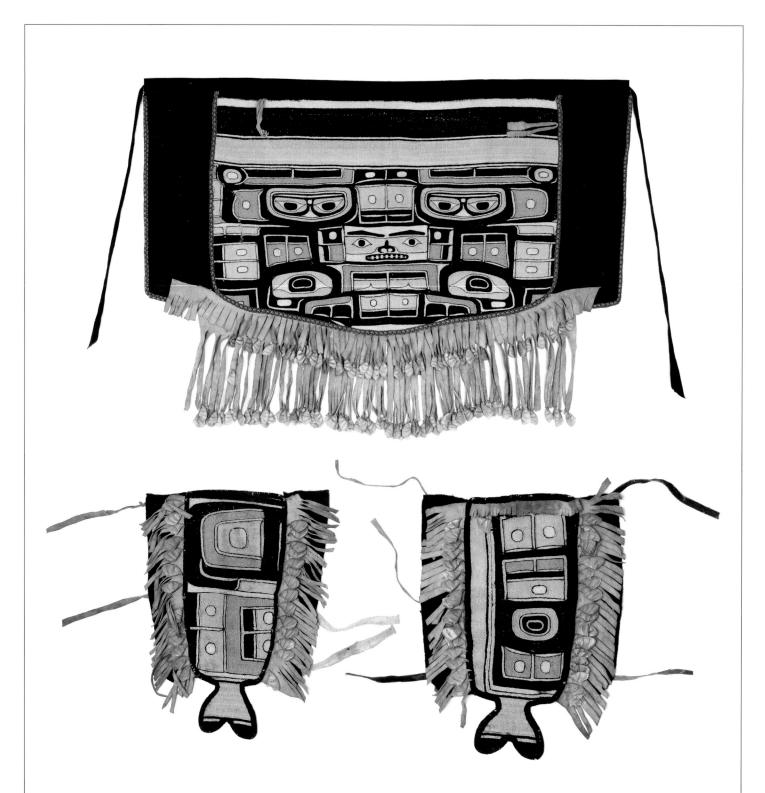

TLINGIT

Sankeit
DANCE APRON

Southeast Alaska
Collected by C. H. Popenoe, accessioned 1928
National Museum of Natural History E341202A
Length 90 cm (35.4 in)

X̱'uskeit
DANCE LEGGINGS

Southeast Alaska
Collected by C. H. Popenoe, accessioned 1928
National Museum of Natural History E341202B
Length 39.5 cm (15.6 in)

This apron and these leggings, made of mountain goat wool, display the densely packed abstract designs of Chilkat-style weaving. The style and technique were originally perfected by the Tsimshian, but by the nineteenth century the art was centered at the Tlingit village of Chilkat. Women dyed the goat wool using copper and hemlock bark boiled in urine to produce black; "wolf moss" from the interior for yellow; and boiled trade blankets or U.S. Navy uniforms for blue.[60] They wove large fringed robes on looms, using twisted cedar bark and plain wool strands for the warp and dyed yarn for the weft. The intricate process could take a year or more. Weavers followed pattern boards painted by male artists.[61]

The apron and leggings are made from pieces of a full-sized Chilkat robe, cut up and sewn onto trade wool. Tufted puffin beaks and leather fringes were added for sound and motion during the dance. The apron design represents a diving Killer Whale, according to Tlingit and Haida advisers.[62] The head, including eyes, nostrils, and mouth, forms the two lowest tiers of the design. The central "spirit face" is the whale's body, and its flukes and dorsal fin are represented by the double eyes and other elements at the top of the weaving.

"A kayéik kwshé ax̱jéen aduleix̱éen akwshá?"

"Its spirit was heard when someone is dancing with this, right?"

"Aaa, hé gúl yéi."

"Probably so, yes."

—Clarence Jackson and Peter Jack, 2005

Tlingit man wearing Chilkat robe and leggings. Southeast Alaska, date unknown.

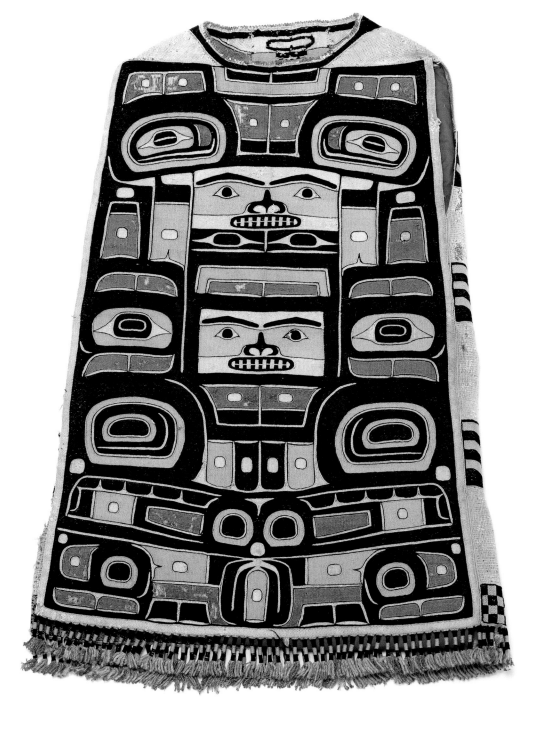

TLINGIT

Southeast Alaska
Collected by George T. Emmons, accessioned 1904
National Museum of Natural History E229789
Length 103 cm (40.6 in)

K̲'oodás'
DANCE TUNIC

The complex form-line designs on the front of this Chilkat dance tunic depict the Killer Whale. Its head takes up most of the lower half of the garment, including large rounded eyes above a wide mouth with a row of teeth. Two round nostrils appear in the center of the mouth. At the bottom, below the whale's mouth, are the profiles of two hawks. The whale's blowhole is indicated by the spirit face at the center of the shirt; and its body, by the larger face directly above that. Small yellow and black elements on either side of the body-face represent the dorsal fin, split into two parts. On either side of the blowhole-face are the upward spreading pectoral fins, with eyes to represent their basal joints. The flukes, also with eye-shaped joint marks, occupy the top part of the shirt.[63]

Wave designs on the back refer to the ancient migration of the Dakl'aweidee, owners of the Killer Whale crest, according to Anna Katzeek. A small "ghost face" is also woven there, she said, "so it can protect the person who is wearing it.... *Du ká̲x át yá.aa yá̲x áwé yatee, át daat yawsitú̲k.* [It is protecting the person; it is watching over things.]"

"*Keet áyá yáat.* [This is the Killer Whale.] *Yaa haa Lingídee, kéi haa nasdagee.* [Representing Tlingits, when we were migrating.] On the back, there are waves to remind them of when we were migrating from down south."

—Ann Katzeek, 2005

A woman weaving a Chilkat robe from a design painted on a pattern board. Klukwan, ca. 1909.

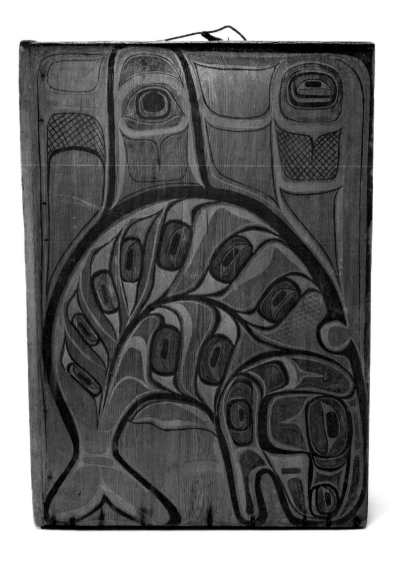

Ḵóok gaaw	Southeast Alaska	Gaaw	Southeast Alaska
BOX DRUM	Collected by John R. Swanton, accessioned 1905 National Museum of Natural History E233491 Height 100 cm (39.4 in)	DRUM	Collected by Edwin B. Webster, accessioned 1886 National Museum of Natural History E127613 Diameter 54.9 cm (21.6 in)

Drums sound out the heartbeat of grief; Clarence Jackson compared the box drum cadence of the Killer Whale mourning song to the solemn snare drum tattoo of the Kennedy funeral march. Box and skin drums accompany singing during funerals (formerly, cremation rites) and at the memorial ḵu.éex' ceremonies that follow in due course.[64]

The box drum above is a wide plank of red cedar, steamed and bent at the corners, with a separate top piece attached by nails. The painted design represents the Killer Whale. Box drums were traditionally suspended from the ceiling of a lineage house and played by young men; the technique is to hit it on the inside with fist or fingers, varying the volume and tone.[65] The skin head of the tambourine drum above is probably mountain goat hide, considered the best for this purpose.[66] Elders identified the bird figure as the Thunderbird; it is combined with the Brown Bear head at the bottom, both crests of the Eagle moiety.[67] A skin drum is played with a stick, padded and cloth-covered at one end.

Drumming also accompanied the traditional spiritual practice of shamans, whose fellow clan members sang and played during performances of healing, spirit sending, and telepathy.[68] The shaman's yek appeared to him in the air, floating over the drum.[69]

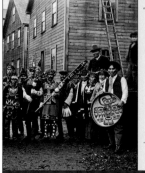

Yakutat Natives at a Sitka potlatch. December 9, 1904.

"*Eeshaan du keedí* [Our poor Killer Whale.] I'm just going to say the words to you. *Goosú du aaní?* [Where is its land?] *Gaashú ch'á l aaneex̱'yéi eetí?* [Why didn't you stay at home?] *Eeshaan du keetí.* [Our poor Killer Whale.]…And the old ladies began to cry, and they said, 'Our poor Killer Whale. Where is your home?'"

—Clarence Jackson, 2005

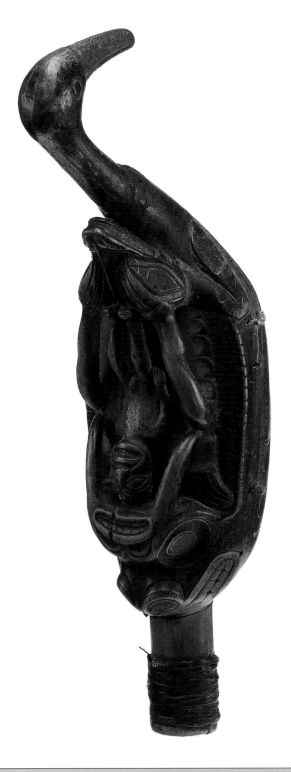

Sheishóo<u>x</u>

RATTLE

Southeast Alaska
Collected by Bernard A. Whalen 1879, purchased 1905
National Museum of the American Indian 002875.000
Length 31 cm (12.2 in)

The role of the *ixt'*—as healer, prognosticator, adviser to clan leaders, and protector of the community against dark spiritual forces—was respected in traditional communities. With Christian conversion, this role disappeared, and the practices of shamans, including the exposure and forced confession of witches, fell into disrepute.[70] Traditional proscriptions against handling a shaman's objects, especially those belonging to other clans, still apply.

The *ixt'* is said to have acquired his supernatural helpers on a series of wilderness spirit quests, each time subduing and taking the tongues of new beings that appeared to him in animal form.[71] Images inscribed on a shaman's rattle and other equipment represent these creatures and others he might have seen in dreams or trances; they are not clan crests.[72] The complex iconography of this shaman's rattle combines a number of different spirits. As interpreted by Tlingit and Haida advisers, the overall shape is that of an oyster catcher, a long-beaked shorebird that gives its name to rattles of this type. A human figure, probably that of the shaman himself, rides on the bird's back. At least two different animal beings lie beneath him: a forward-facing frog and a rear-facing creature with horns, probably a mountain goat. Red claws on each side of the shaman's head belong to a third animal, not identified.[73]

"People have different feelings about the shaman materials. Some of our communities and some of our clans have decided that they're not going to seek repatriation of these items; others want these things to come back home.... We do know that we're not allowed to touch these things unless we know they are from our own clan; we have to be absolutely certain of that."

—Rosita Worl, 2005

Shaman with a patient (reenacted). Sitka, 1889.

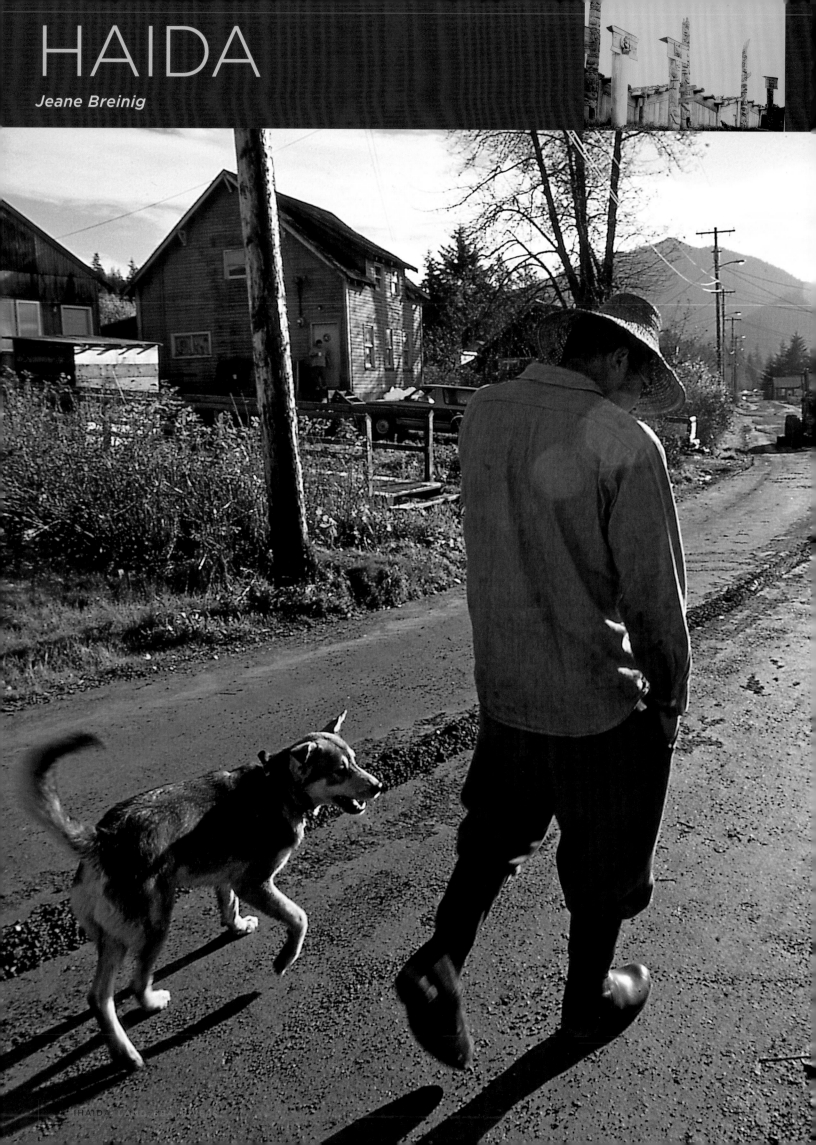

HAIDA

Jeane Breinig

My mother, moving across the slippery

low tide cliffs, hunting for black seaweed,

a certain length in May.

Her dark eyes rimmed with gray,

blend in with craggy boulders.

Her brown fingers twist and pull

a sun-dried winter treat.

—from "Mood Music" (Jeane Breinig, published in *Alaska Native Writers, Storytellers & Orators: The Expanded Edition*, 1999)

IT'S AN ENDLESS CYCLE— gathering food, putting it up, sharing it among the people. Subsistence is fundamental to our being, even for city dwellers. Every summer since the kids were little, we would return to Kasaan to join in harvesting activities with family and friends. Our traditions pass on through the foods, the seasons, and the generations.

My Haida name since childhood is K'aes, for which the meaning has been lost. Recently, my mother ceremonially bestowed upon me my grand-mother's name, T'áaw x̲íwaa, meaning "copper ribs." Her spirit is reborn in me, another cycle in our way of being.

I am Haida Yáahl-Xúuts (Raven–Brown Bear), of the Taslaanas clan (the "sandy beach people") at Kasaan, Alaska. By the custom of our matrilineal society, I trace my descent and clan affiliation through my mother, her mother, and a long line of Raven women going back through the centuries. I grew up in Kasaan and Ketchikan and now live in Anchorage, where I teach in the English Department at the University of Alaska Anchorage.

Haida identities are linked to the history of our people. Alaskan Haida look south to Haida Gwaii—otherwise known as the Queen Charlotte Islands, of British Columbia, Canada—as their ancestral homeland. The present British Columbia villages of Masset and Skidegate were the only settlements that remained after a smallpox epidemic ravaged Haida Gwaii in 1862; survivors from at least seventeen other communities found refuge there.

OPPOSITE TOP: Houses and carved crest poles at Skedans village in the Queen Charlotte Islands, British Columbia in 1878. The village was abandoned after the smallpox epidemic of 1862.

OPPOSITE: Mickey Calhoun Jr. wears a spruce root hat for a walk in Hydaburg, 2001. The village of about 400, located on Alaska's Prince of Wales Island, was founded in 1911 when residents of Sukkwan, Howkan, and Klinkwan consolidated into one village to allow their children to attend school.

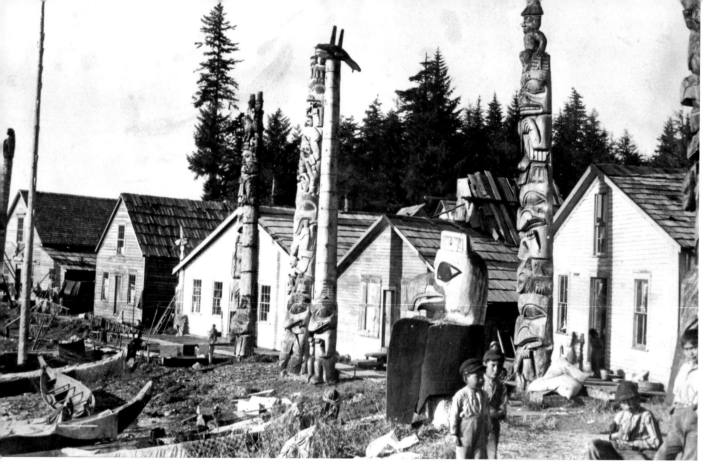

Alaskan Haida are the descendants of emigrants who left Haida Gwaii some-time before European contact. Historical scholarship suggests that this northward migration took place only a few years before Spanish explorer Juan Pérez encountered our people in 1774, although oral traditions place it in an earlier indeterminate time. Residents of Old Kasaan, one of the original Alaskan villages, moved to (New) Kasaan in 1902, and people from Howkan, Klinkwan, and other early Alaskan Haida settlements consolidated at Hydaburg in 1911.

The distance from northern Haida Gwaii to Prince of Wales Island is not great, only about thirty-five miles. On a clear day you can stand on the point at Masset and see the Alaskan coast. It is easy to imagine our forebears going across in their canoes, but the modern international border and lack of direct plane flights limit contact between Alaskan and Canadian Haida. I was thrilled by my first opportunity to go to Masset, a place I thought of as the "real" Haida country, where my ancestors originated. It was fulfilling to connect with the people there, but the flat, sandy landscape only made me yearn for the craggy peaks, thick forests, and rocky coast around Kasaan. I realized then that southeast Alaska is my true home.

When the salmon start jumping in Kasaan Bay, it's time to begin gathering the foods of our land. We pick *sghiw* (black seaweed) during the minus tides of May, when you can get out to the rocks where it grows. The fronds have to be just the right length, about five to six inches. People traditionally camped on Grindall Island, near Kasaan, to harvest *sghiw*. They spread it out on flat rocks to dry in the sun, took it home in gunnysacks, ground it up,

and stored it as a savory food for winter. We love to eat it by the handful or sprinkle it on fish soup.

As the summer goes on we fish for halibut and the different species of salmon that arrive in our waters (sockeye, king, and coho). Sockeye from the Karta River, a staple of the diet in Kasaan, are smoked and preserved using an endless variety of family recipes. But fish are just the beginning. Clams, abalone, "gumboots" (chitons), crabs, and shrimp are also harvested, and salmonberries, blueberries, and huckleberries are picked as they ripen in succession. The men go deer hunting in the fall.

Another staple is hooligan (eulachon) oil or "grease," called *satáw* in the Haida language. Haida traditionally bartered for fish grease and soapberries from the Tsimshian in exchange for our dried seaweed and halibut. That kind of trading still goes on at the annual Alaska Federation of Natives convention every October, when everyone brings specialties from home to exchange for favorite foods from other places.

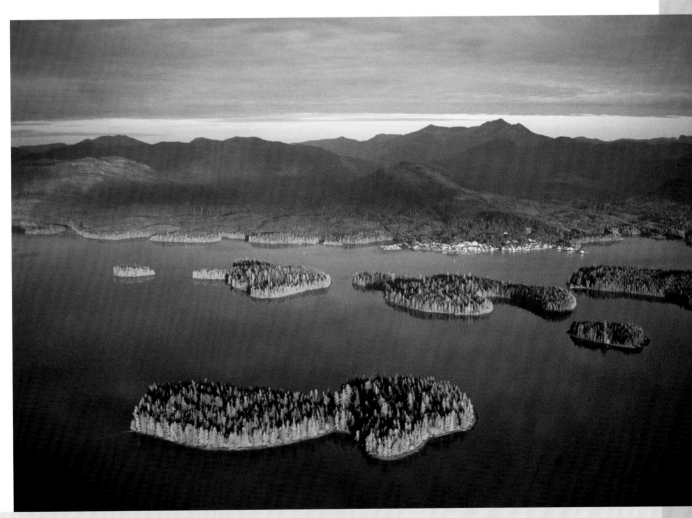

OPPOSITE: View of the Alaskan Haida village of Howkan in about 1897. Crest poles in front of each house represent the founding and history of the lineage whose members live inside.

ABOVE: Aerial view of Hydaburg and the forested shores and islands of Sukkwan Strait, 1997

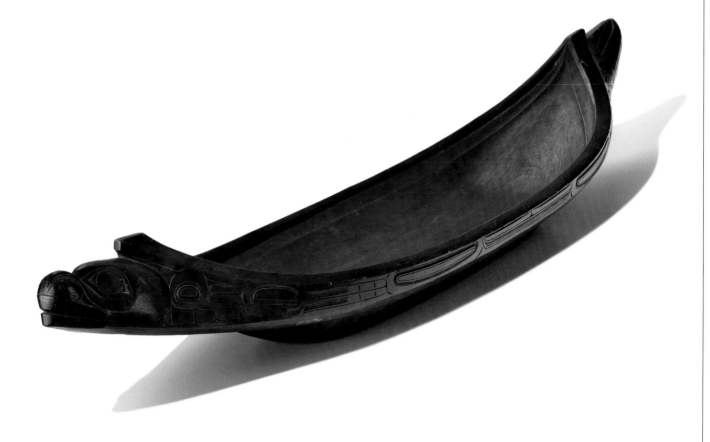

K'áagaan

FEAST DISH

Howkan
Collected by George T. Emmons 1881–89, purchased 1905
National Museum of the American Indian 004316.000
Length 94 cm (37 in)

This large feast bowl for serving seal oil is sculpted in the animal's own form with the joints and appendages outlined along the sides.[1] Haida men hunted harbor and fur seals in the Queen Charlotte Islands and along the Alaska coast, seeking their meat, rich fat, and valuable pelts.[2] Hunters fasted and purified themselves before sealing and made offerings to the Ocean People, or killer whales, who are the masters of all other sea creatures.[3]

Seal oil was a prized condiment for dipping dried fish and is still served at Haida gatherings. During a traditional house-building potlatch, or waɬəɬ, guests of the male host's clan ate from decorated dishes filled with oil, berries, and fish, while the sponsors of the feast—members of the female host's clan and others of her moiety—used plain bowls.[4] Men carved and owned feast utensils.[5]

"That same evening before it got dark, they would sing to the seal because he'd been sacrificed. And they would cut it up and hang it in the smoke house."

—Delores Churchill, 2005

Hunting canoes on the shore at Masset, 1890.

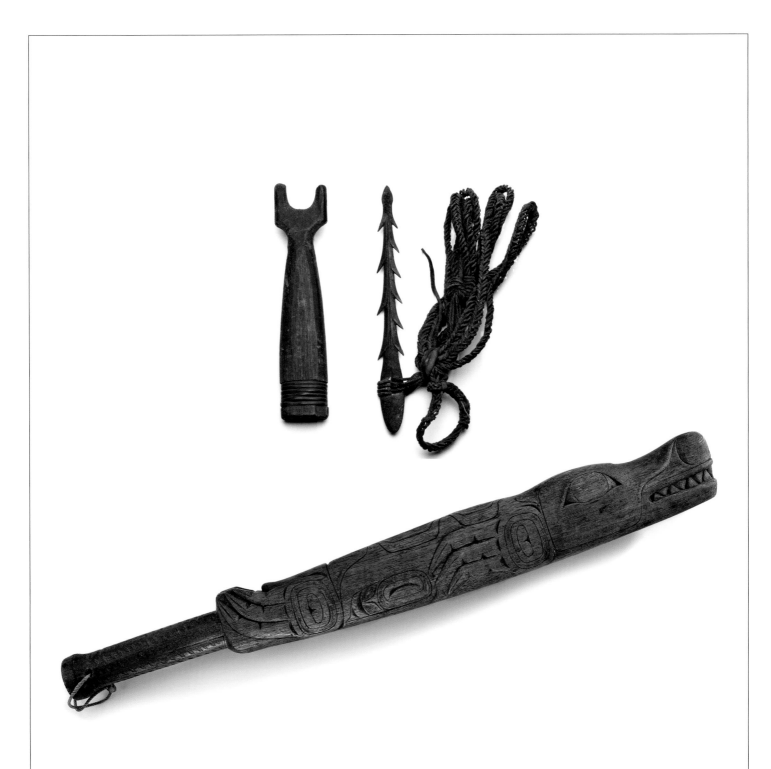

HAIDA

Kijigid juugi, <u>K</u>'áal
HARPOON HEAD AND SHEATH

Masset, Queen Charlotte Islands, British Columbia, Canada
Collected by James G. Swan, accessioned 1883
National Museum of Natural History E088927
Length of harpoon head 23 cm (9.1 in);
sheath 21.5 cm (8.5 in)

Saj
SEAL CLUB

Queen Charlotte Islands, British Columbia, Canada
Collected by C. F. Newcombe,
exchanged 1908
National Museum of the American Indian 019369.000
Length 63 cm (24.8 in)

Before firearms Haida men hunted seals using harpoons and clubs.[6] Their main weapon was a light cedar harpoon about ten feet long, tipped with a detachable point made of bone or iron. A plaited seaweed cord linked the point to the shaft so that a harpooned seal had to drag it behind.[7] A wooden sheath with a seal-like "tail" (pictured to the left of the barbed point) encased the barbed tip when not in use. Heavy hardwood clubs like the one above, carved in a sea lion design, were used to kill seals at their rookeries or to strike them in the water after they had been speared.[8]

Legendary seal hunters from Gitadjŭ' became lost in fog and arrived at the undersea house of the Ocean People. There a supernatural being dressed in rings of woven cedar bark taught them spirit dances to perform during potlatch ceremonies. On the way back home the men capsized their canoe but managed to reach shore, and when one blew on his wet harpoon sheath it made a whistling sound like the voice of the dancing spirit.[9] Haida and Tsimshian celebrants used wooden whistles to re-create this sound and dressed in bark rings as their ancestors had been shown (see p. 275).

"[Wolf Rock] is a seal rookery.... It is on the edge of the outlet where the rocks are flat that the stragglers would be speared and clubbed to death by the hunters. No guns were used in the old days."

—Robert Cogo, 1983[10]

A Tlingit seal hunter readies to throw a harpoon. 1896.

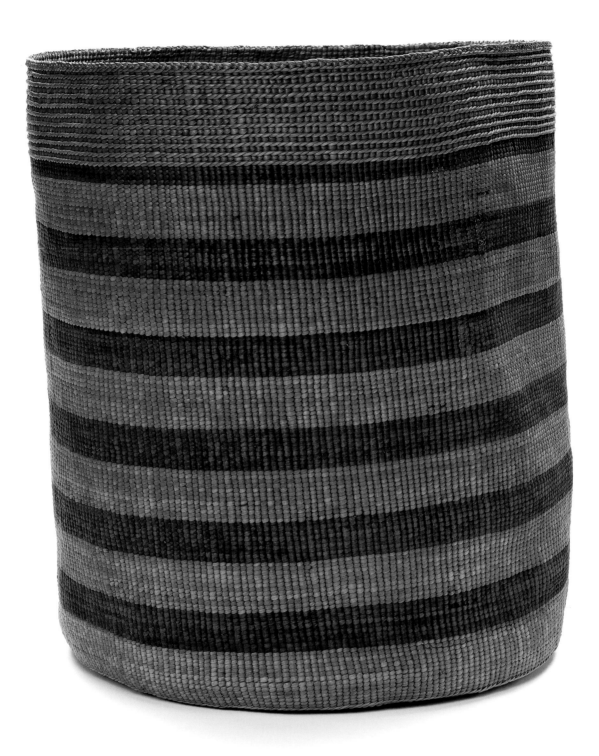

Masset, Queen Charlotte Islands, British Columbia, Canada
Collected by James G. Swan, accessioned 1883
National Museum of Natural History E088965
Height 39 cm (15.4 in)

<u>K</u>igw
BASKET

Raspberries, salmonberries, currants, blueberries, huckleberries, and salalberries ripen during summer in southeast Alaska and Haida Gwaii. Elder weaver Delores Churchill identified this large spruce-root basket as a collection vessel into which berry pickers emptied their loads. The dark bands are a traditional Haida design, woven from roots dyed with hemlock and iron soaked in urine.[11]

Elder Florence Davidson remembered helping her mother to collect and prepare spruce roots for basket making. The work took place in May, a season when they also gathered foods such as wild rhubarb, seaweed, and hemlock cambium.[12] Delores Churchill recalled that by the end of a long day of digging roots, the women of her village would be scattered through the forest. One of them would begin a song, and the others would take it up, all singing as they converged on the beach. They built a fire, roasted the roots so that the bark could be stripped off, and split the roots into strands for weaving. Haida women weave in a clockwise direction with their work "upside down" on a pole so that the weft of a finished, upright basket rises in a counterclockwise spiral. Various styles of Haida baskets were made for gathering, cooking, and household storage.[13]

"When we collected berries we put skunk cabbage leaves in the bottom of the basket, because they acted like wax paper to catch the juice. We didn't want the juice to drip down our backs, and we saved it to use when putting the berries away."

—Delores Churchill, 2005

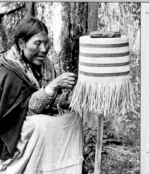

Weaving a basket. Masset, 1897.

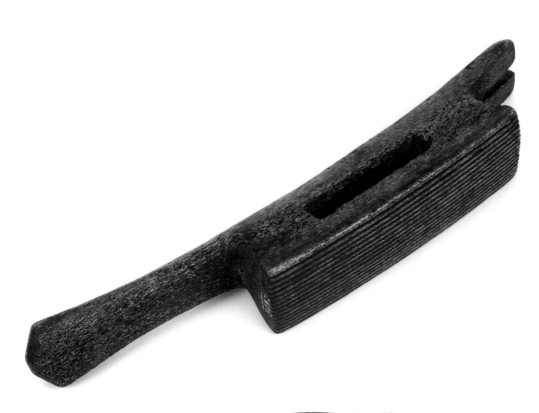

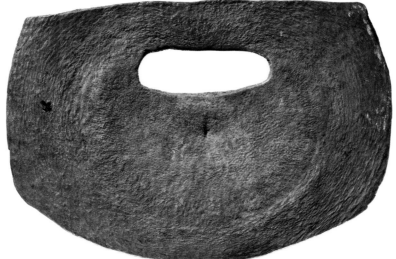

HAIDA

(above)
BARK BEATER

Queen Charlotte Islands, British Columbia, Canada
Collected by Thomas Crosby,
purchased 1908
National Museum of the American Indian 018092.000
Length 34 cm (13.4 in)

Hltánhlk' sgidáangwaay
(below)
BARK-WORKING TOOL

Southeast Alaska
Purchased 1949
National Museum of
the American Indian 213494.000
Width 22 cm (8.7 in)

In the traditional Haida view, red and yellow cedar trees were the highest-ranking plants.[14] Their wood went into houses, canoes, crest poles, containers, and implements of all kinds. The bark was woven or twisted into baskets, mats, rope, rain cloaks, hats, and ceremonial rings and was used to form the strong inner core of crest blankets woven with mountain goat wool.[15] Cedar tree people appear in Haida oral tradition, and cedar bark, so present in daily life, was known as "every woman's elder sister."[16]

Men stripped the trees in June, and women used a flat bone scraper to split the material into layers. The bright-colored innermost sheath of yellow cedar was the best for making twined baskets and mats. After soaking in water, the tough bark was beaten and softened with the bark working tool *(bottom)* to make it flexible. Further pounding with the ridged beater *(top)* produced fine threads that could be combined with goat hair for weaving.

Preparing cedar bark. Howkan, ca. 1897.

"Oh, the cedar tree! / If mankind in his infancy / had prayed for the perfect substance / for all material and aesthetic needs, / an indulgent god could have provided / nothing better.... / When steamed / it will bend without breaking / it will make houses and boats / and boxes and cooking pots. / Its bark will make mats, / even clothing."

—Bill Reid,
from "Out of the Silence," 1971[17]

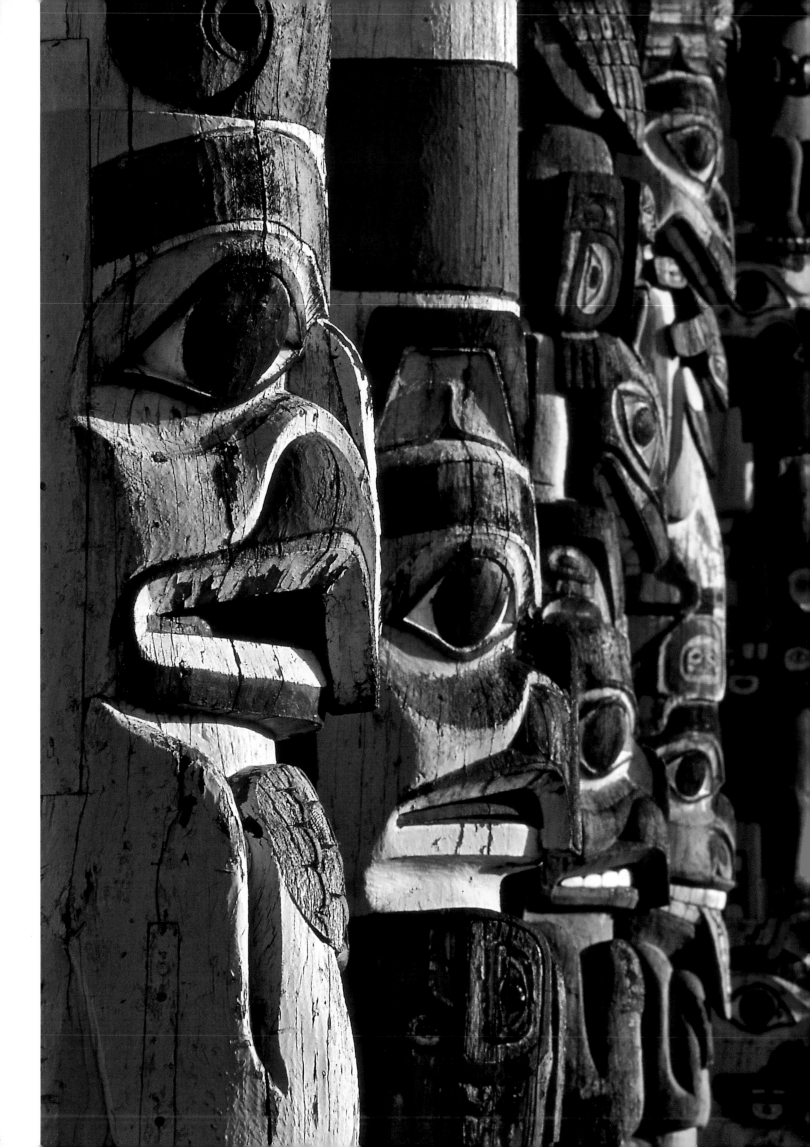

THE HAIDA ARE JUSTLY FAMOUS as seafarers and boat builders. Our red-cedar canoes, some large enough to carry forty passengers, traveled up and down the coasts of Alaska and British Columbia and were sought in trade by Tlingit, Tsimshian, and other peoples. Haida canoe builders were skilled craftsmen who trained under recognized masters.

My grandfather, Louis Jones, was born into a traditional longhouse at Old Kasaan in 1880. It was an era of cultural change and disintegration, so instead of being raised at home he was sent to live with his aunt in Juneau and then to the Sheldon Jackson School, in Sitka, to live as a boarding student. He learned carpentry and music, playing the cornet in Native marching bands, 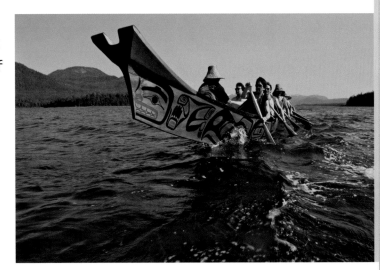 which were popular in southeast Alaska. When he became a father he decided to build boats for his sons—not traditional canoes (their time was past), but rather wood-planked power seiners for salmon fishing. He ordered blueprints, mastered a do-it-yourself course, and over the years built seven vessels with his own hands, the largest one measured over fifty feet long. He and his sons piloted them for many years. It was a remarkable achievement and a continuation of our seafaring heritage, transformed by historical circumstance.

The worst horrors of Haida contact with the West were waves of epidemic disease—smallpox, influenza, tuberculosis, whooping cough, and others— that consumed the aboriginal population, unchecked by natural immunity. Perhaps fourteen thousand Haida in the 1780s had withered to six hundred by 1915. It is hard to imagine loss on that scale, not only of life, but also of culture and heritage. Most of the clan leadership was gone, and consolidation of the widespread population into just a few villages almost destroyed the complex social system as it had functioned until then.

In a traditional Haida village, cedar-plank longhouses stood side by side, each paired with a tall pole displaying the crest animals of the clan members

OPPOSITE: A line of poles at Hydaburg Totem Park in 1999. During the 1930s and 1940s, crest poles were gathered from older villages in the region and restored or replicated by Haida artists.

ABOVE: A cedar canoe carved at Masset, British Columbia in 1998, at sea near Petersburg, Alaska. Ancestral Haida boats were prized by other Northwest Coast peoples and widely traded.

who resided there. An opening through base of the pole, representing the mouth or stomach of the lowest crest figure, served as the doorway to some houses (see p. 238).

Like other southeast Alaskan peoples, the Haida are socially divided between Ravens and Eagles, each half (moiety) composed of numerous matrilineal clans. Traditional marriages were always between a member of a Raven clan and a member of an Eagle clan. The residents of a longhouse included multiple generations of male clan members and women of other clans who came there to live with their husbands.

Much of a child's education was the responsibility of clan mentors outside the nuclear family; for a boy, this was his maternal uncle, and for a girl, her maternal aunt. On their pathways to adulthood, children received the names of ancestors, as well as piercings and tattoos that signified their clan and rank. Girls of high status wore labrets from a young age, and all girls went through ritual seclusion at the time of their first menstruation.

Children still learn through watching and participating in the activities of the community. Our oral tradition is another participatory way of learning. Elders teach through stories, although the message may be indirect. If you seek an elder's counsel, you might hear a tale about another place and time. It is up to you to think about the meaning and apply it to your own life.

Haida oral literature is renowned for its epic tales of battles and migrations, transformations from animals to human beings and vice versa, and journeys to spirit worlds in the sky and underwater. Skaay, a blind Haida Gwaii poet born in 1827, is recognized as one of the greatest Native American storytellers. Skaay's narratives, transcribed at Skidegate by linguist John Swanton in 1900, are challenging. We have to recognize that reading them in translation is far from the original experience of hearing them told in Haida with all the verbal artistry of a master epic poet. But even on the page the stories are compelling, if difficult sometimes to understand. You have to sink into them and appreciate the flow of the story, without worrying too much about all of the elusive meanings.

Other Haida tales, especially Raven stories, are simply fun with a touch of mystery. Raven, the comical trickster is always in trouble. Elders say that he turned black by getting stuck in the smoke hole of a house and being too fat and lazy to escape.

Today there are fewer than a dozen fluent Alaskan Haida speakers. I am fortunate that my mother, Julie Coburn, is one of them. Her Haida name is

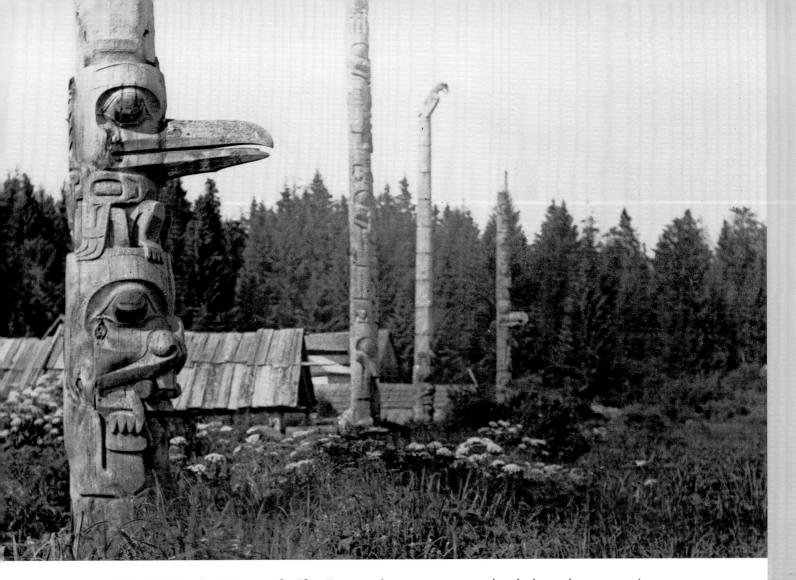

Wahlgidouk, "giver of gifts," meaning a person who brings in presents to be distributed at a ceremonial giveaway, or potlatch. She is eighty-eight years old and has been giving the gifts of language and literature throughout her life.

Keeping her language was a kind of heroism under all the pressures for acculturation. Her parents, concerned about their children's survival in Western culture, spoke Haida to them at home but asked them to answer in English. At her boarding school in Sitka, speaking Haida was harshly punished. But as an adult in her fifties, she recognized that the language was fading away, so she relearned it and now has had the good fortune also to teach others. She participated in the Haida Society for the Preservation of Haida Language and Literature and contributed to work accomplished at the Alaska Native Language Center when Haida elders developed a standardized writing system. Today Haida people are helping the Sealaska Heritage Institute to develop language-teaching materials and also a master-apprentice program.

In the foreground of this view of Skidegate in 1897 is a pole said to have been carved by Gyaawhllns (John Robson) to honor his wife Q'àaw quunaa. The bottom figure is a beaver, a crest of Q'àaw quunaa's Eagle moiety and above is a raven, a crest of Robson's Raven moiety.

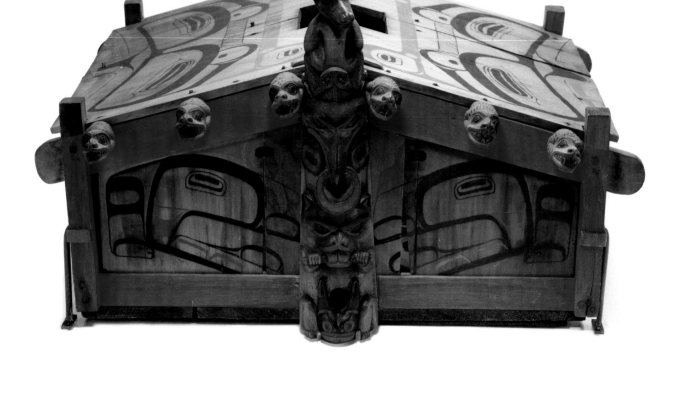

<u>X</u>aadas náay
TRADITIONAL HOUSE (MODEL)

Skidegate, Queen Charlotte Islands, British Columbia, Canada
Collected by James Deans, accessioned 1883
National Museum of Natural History E089184
Width 59.8 cm (23.5 in)

Haida houses were monumental constructions—massive posts and mortised beams, walls planked with cedar, roofs made of bark slabs, and sleeping platforms that ranged in tiers around a deeply sunken central hearth.[18] A smoke hole in the roof gave ventilation and light. Most houses were thirty to forty feet wide, but the largest known—Chief Wiah's Monster House at Masset—was twice that size.[19] Inside lived members of a single matrilineal clan along with spouses and children. The house chief and others of high rank occupied the far end of the dwelling, whereas commoners and slaves slept closer to the door.

On many houses the entryway passed through the base of a pole that displayed clan crests, and additional poles and mortuary columns stood in front of the dwelling. Crests shown on the model pole include, from top to bottom, Grizzly Bear, Raven stealing the moon, Beaver, and Mountain Goat; all but the beaver are Raven moiety crests. Haida artists made miniatures of actual houses for museum collectors, and this one may somewhat fancifully represent Grizzly Bear House at Skidegate, which had unusual bear-headed roof beams, as seen on the model. Several houses in that village also had painted fronts.[20]

Chief "Highest Peak in Mountain Range" in front of "House Where People Always Want to Go." Haina, 1888.

"He [Raven] put on his two yellow-cedar blankets and walked among them. And they did not see him. Then he went into the chief's house and to the right. It had ten tiers of retaining planks. On the upper one, in the middle of the sides, one sat weaving a chief's dancing-blanket."

—from "A Slender One Who Was Given Away," told by Skaay, 1900–1901 [21]

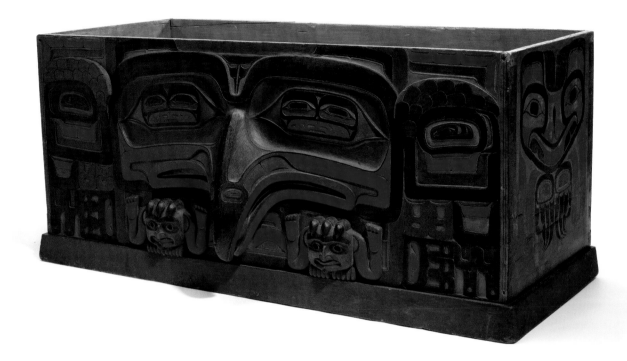

Skedans, Queen Charlotte Islands, British Columbia, Canada
Collected by James G. Swan, accessioned 1883
National Museum of Natural History E089034
Length 134 cm (52.8 in)

HAIDA

<u>G</u>ud sgúnulaas
CHEST

This chest belonged to the great "Chief Skedans," whose real name was Gida'nsta, meaning "from his daughter," a term of respect.[22] The front panel shows Raven—the chief's moiety symbol, also used as a personal crest—grasping two human figures dressed in rod armor. The image on the side panel is probably Xyuu, Southeast Wind, whose ten brothers were clouds. One of them, Cirrus Clouds, was a crest of Gida'nsta's clan and may be represented here by eyes and feathers on either side of Raven.[23] Gida'nsta's house at the village of Skedans was called House Clouds Sound against as They Roll upon It.[24]

In Haida myth cirrus clouds were the potlatch attire of Tangghwan Llaana (Sea Dweller), the supreme ocean spirit, who belonged to the Raven moiety.[25] Cirrus clouds were also thought to represent bird-skin clothing that Shining Heavens, a sky deity, put on to bring fair weather.[26] The imagery of the chest, although not completely understood, richly portrays the cosmological and social dimensions of Gida'nsta's heritage.

Chests with crest art were used to store ceremonial regalia and potlatch goods such as masks, bark rings, and blankets.[27] When a chief died, a chest became the coffin box in which his body lay in view before its placement first in the clan grave house and later atop a mortuary pole.[28]

Chest and interior house post. Prince of Wales Island, ca.1922.

"[Master Carpenter] got up and said to him, 'Come, chief, my child, let me dress you up.' Then he went to him and he put fair-weather clouds upon his face. 'Now, chief, my son, come and sit idle seaward.' As soon as he did so, the weather was good."

—from "How Shining-Heavens Caused Himself to Be Born," told by Walter McGregor, 1900–1901 [29]

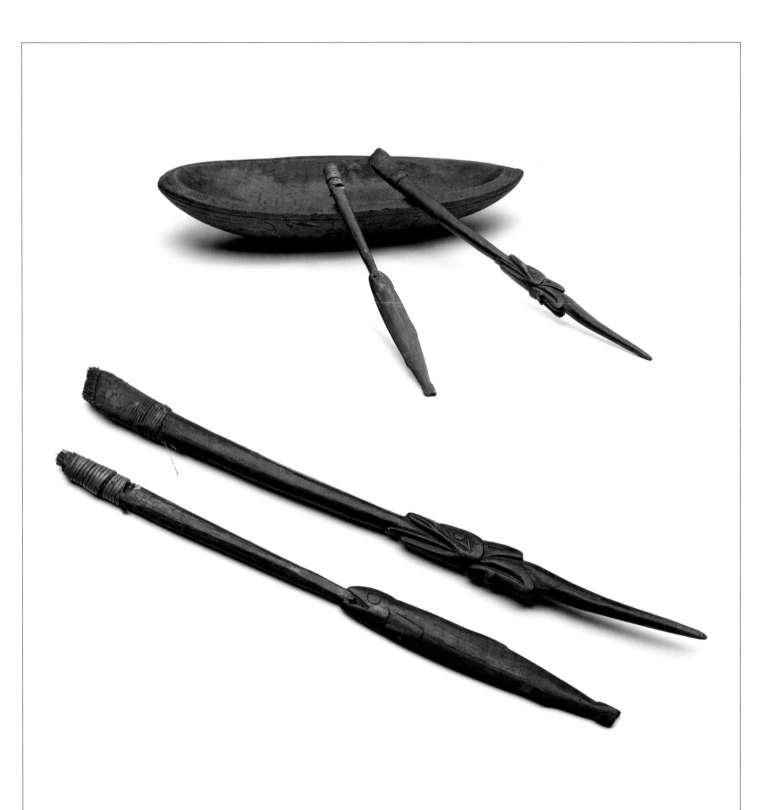

HAIDA

Gwáag
PAINT DISH

Skidegate, Queen Charlotte Islands, British Columbia, Canada
Collected by James G. Swan,
accessioned 1883
National Museum of Natural History E089022
Length 23.8 cm (9.4 in)

K̲'áalaangw
PAINT BRUSHES

Masset, Queen Charlotte Islands, British Columbia, Canada
Collected by James G. Swan, accessioned 1883
National Museum of Natural History
E088905B and E088905C
Length (upper) 24.5 cm (9.7 in) and (lower) 22.2 cm (8.7 in)

When the tip of a traditional brush wore down, the artist restored it by pulling the bristles farther out of the handle. One brush handle shown here takes the form of a salmon; another, a land otter. The otter's tongue, emphasized by the carver, was the seat of its powerful spirit.[30]

Two images intertwine on the bottom of the stone paint dish: a sea bear, according to Delores Churchill, and a killer whale, which has a human face marking the joint at the base of its dorsal fin. Both are Haida Raven crests. The dish was used for blending oil-based colors to apply to the body and face or for mixing permanent paints to use on hats, masks, boxes, and other work. For the latter purpose, crushed salmon eggs were added as a fixative. Charcoal, roasted tree fungus, ocher, cinnabar, and berry juices were among the common coloring materials.[31]

The brushes seen here were part of a set that included tattoo needles, suggesting they may have been owned by an artist who specialized in body decoration. Clan designs were painted on the face for dances, ceremonies, girls' initiation, and death; tattoos were an important symbol of high rank, applied by paid artists of the opposite moiety during potlatches.[32]

"To make a paint brush they would take a small piece of wood and tie it about four inches from the end, then split it down to where the tie stopped it…. They placed the hair inside the split…. They used guard hairs from the porcupine because they are hollow and take up the paint."

—Donald Gregory, 2005

Man with crest tattoos. Masset, 1881.

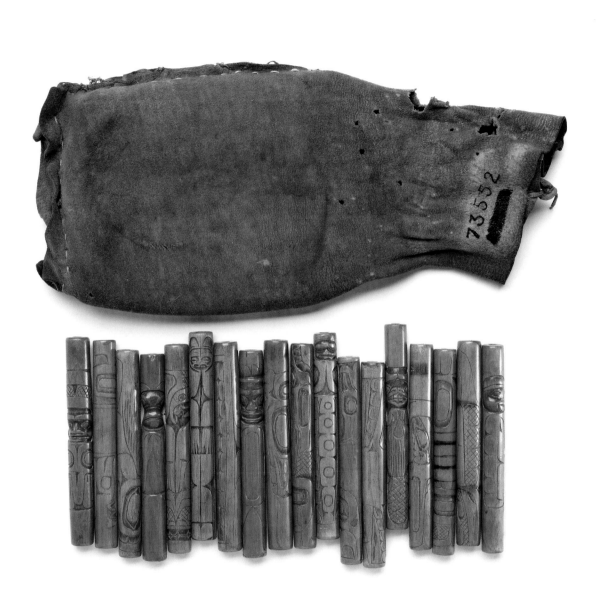

Howkan
Collected by Rev. J. Loomis Gould, accessioned 1884
National Museum of Natural History E073552
Length, bag 32 cm (12.6 in); sticks 12.4 cm (4.9 in)

Sgáal cháay

GAMBLING STICKS

Stick gambling, often for very high stakes, was a fast-paced contest between two men or as many as a dozen players on each side. Haida, Tsimshian, and Tlingit communities all played various versions of the game.

Each man owned multiple sets of thirty to seventy polished sticks and switched them during play to better his luck. Most pieces had carved or painted designs, but several called *jïl* (bait) were plain.[33] The rules varied, but in basic play the dealer shuffled two or three handfuls of the sticks, including one *jïl*, beneath a mound of shredded bark; his opponent then guessed which pile held the bait. Speed, flair, and verbal repartee were part of play. The deal went back and forth, with the winners taking sticks from their opponents until one team had them all and claimed the stake.[34] Rosita Worl described the atmosphere: "There's singing and drumming going on continuously the whole time they're playing…. It goes on for hours. It's really hypnotic; you wouldn't even be able to take your eyes away."

In Haida oral tradition, Sounding Gambling Sticks loses his father's entire town while gambling with the son of Great Moving Cloud, finally winning it back when he carves a new set of sticks from Raven's-berry wood.[35]

"We have a story about two Haida chiefs who were gambling. One of them won everything; all the other one had left was an abalone shell around his neck…. The one who lost found out that the opposite chief was making gambling sticks with pictures of him on them, upside down."

—Delores Churchill, 2005

Members of a Tsimshian trading party gambling in front of the town chief's house. Tanu, 1878.

HAIDA HISTORY AND ART

Delores Churchill

TWO CHIEFLY VOICES describe the artistic pride and historical suffering of the Haida people. Chief Wiah, the hereditary chief of Massett village, wrote, "From time immemorial my people have inhabited the Queen Charlotte Islands. From these shores has sprung a race the achievements of which fill every Haida with pride and every student of culture with amazement. But perhaps people in far away lands have come to know us best through our art and totems."

In 1913, Alfred Adams, chief councillor in Massett, testified before the Royal Commission on Indian Affairs for the Province of British Columbia and the Canadian federal government: "The missionaries came among us and the government took charge of us. We were asked to centralize, to be Christianized and educated, and we came here, to Massett, to build our homes, returning, now and then, to our old homes, where we fished and where the bodies of our forefathers laid. At the mouth of every river and stream, you will find our old camping grounds. All along the coast are our former hunting grounds and the places where we fished, hunted and made our boats and canoes. Year by year, the limits have been drawn, and we are now restricted to a small piece of land." Mr. Adams died in 1946. Haidas did not receive Canadian citizenship until the 1960s, and the land claims issue is still not settled.

The Haida were famous for their gigantic totem poles, red-cedar houses, canoes, woven spruce-root hats, and carvings in wood, argillite, and ivory. The late nineteenth century was a golden age of Haida art, when Albert Edward Edenshaw, John Robson, and Charles Edenshaw were prominent. Many others continued the traditions. My mother, Selina Adams Peratrovich, made baskets of yellow cedar and traditional spruce-root hats and taught all around the state. The next generation will continue to use the skills that have been passed on from their ancestors but will adapt to their modern culture. Chief Wiah wrote, "I am confident that in the hands of our young artists we shall continue giving the world our unique form of art."

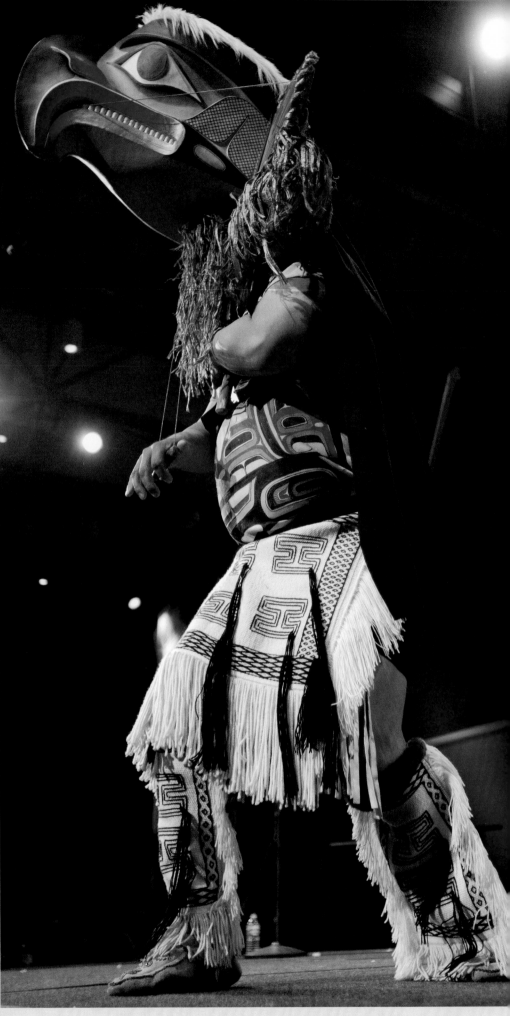

Dancer with Tuul Gundlaas Xyaal Xaade, the Rainbow Creek Dancers, performing in an Eagle headdress at Juneau's Celebration 2006

IN 1880, CHIEF SON-I-HAT BUILT NEYÚWENS (meaning "great house"), near Kasaan Bay, a mile from the location where New Kasaan was later founded. That structure, today called the Whale House, was restored in 1938 by Haida craftsmen working for the Civilian Conservation Corps. The restoration included the house's crest pole and carved interior posts, which portray Coon-Ahts, a legendary figure who captured the monster Gonaqadate and put on his skin to hunt whales. Surrounding the house are additional totem poles brought over from Old Kasaan and restored, along with copies of several more.

When the people moved to New Kasaan in 1902, they built Western-style houses, and that is what you will see today. The Whale House, once again badly in need of repairs, is the only surviving traditional Haida clan house in Alaska. The Kasaan community, the Organized Village of Kasaan, Kasaan Village Corporation, and the Kasaan Haida Heritage Foundation are working to raise funds to restore and preserve this priceless part of our heritage.

The English word *potlatch* (from Chinook jargon meaning "gift" or "giving") has been used for traditional Haida ceremonies that centered on feasting, dancing, and the distribution of property by chiefs and other leaders. The Haida word is *'wáahlahl*. The largest potlatches marked the completion of a new clan house or the death of a chief and succession of his heir. Chief Son-I-Hat, one of the wealthiest Haida leaders, hosted numerous potlatches before his death in 1912, including one said to have cost more than twenty thousand dollars in food and gifts. Potlatches were outlawed by the Canadian government in 1884, and they were discouraged by Christian missionaries who came to the Haida region in the 1870s and 1880s.

Despite attempts to suppress of our traditional ceremonies, we still hold feasts and memorial potlatches, but now in transformed ways. Traditionally, potlatches represented a time for the deceased person's clan to repay those from other clans who had helped them at the time of the death. In many respects, a potlatch can be viewed as a social occasion but with very formal aspects, acknowledging the sadness of the loss but also marking the end of mourning. Potlatches are also the time to repay those who have served as witnesses for naming ceremonies; by accepting a gift, recipients acknowledge that the name is legally granted within the traditional Haida system.

What does it mean to be Haida? The answer now is different from that of the past, obviously. We need to know our history and learn from it; we need to know our culture and draw strength from it. We need to make it work for us today.

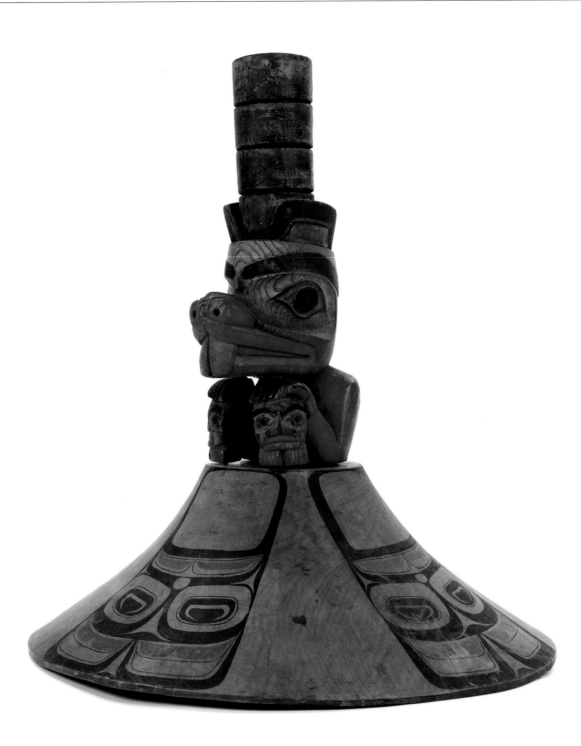

Gwáayk'aang dajangáay

CREST HAT

Port Simpson, British Columbia
Collected by James G. Swan, accessioned 1883
National Museum of Natural History E089036
Height 52.0 cm (20.5 in)

On this wooden ceremonial hat a beaver with long incisors clutches two eagles in its paws.[36] Haida clans of the Eagle moiety own both of these crests. Cylinders stacked on the beaver's head signify that the owner of the hat had hosted four major potlatches, an accomplishment possible only for a wealthy chief.

Decorated shields of beaten native copper (called "coppers") were a symbol of wealth and are represented here by painted motifs on the hat's brim. Haida acquired coppers from the Tlingit and Tsimshian, paying in slaves or sea otter furs and later with piles of Hudson's Bay Company blankets.[37] By giving valuable coppers away to guests at a potlatch, the host compensated them for his right to display clan crests on hats, robes, and other ceremonial regalia and elevated his own prestige. Haida leaders sometimes destroyed coppers or threw them into the sea to demonstrate their disregard for rivals.

The base of this hat was carved from alder and the upper portions from cedar. Elders noted that the blue color of the potlatch rings is unusual for a Haida hat and thought the pigment might have come from the Tlingit or Kaigani (Alaska) Haida.

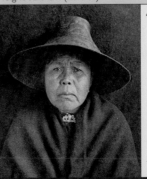

"Hahlkaiyans" wearing a crest hat. Masset, 1915.

"Copper shields were important not just to the Tlingit but also to the Haida and Tsimshian; they had great value. I wonder if someone had to give four coppers for this hat. It's like when people got married; sometimes the man threw coppers down to show how rich he was, and the bride would dance around them."

—Delores Churchill, 2005

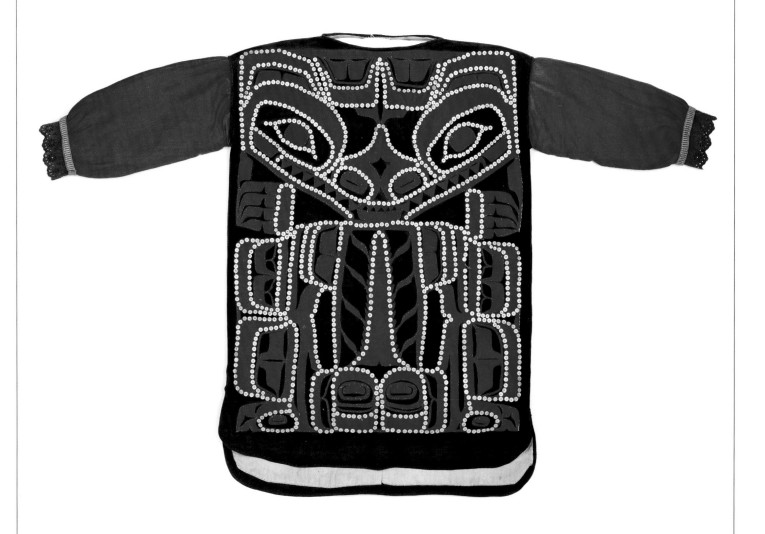

K'uudáats' k̲áahlii

TUNIC

Queen Charlotte Islands, British Columbia, Canada
Collected by James G. Swan, accessioned 1888
National Museum of Natural History E129984
Length 104 cm (41 in)

This late nineteenth-century dance tunic is made of red wool appliqué on black wool cloth and shows a bear crest design outlined in small shell buttons. The sleeves are red cotton with lace ruffles at the cuffs. Collector James Swan purchased it from Bear Skin, a Skidegate chief.

Haida artists invented appliqué dance blankets and tunics around 1850, ornamenting them with dentalium shells, mother of pearl buttons, and squares of abalone shell.[38] Florence Davidson said that they were first made in Masset after a missionary forbade the raising of totem poles; the blankets and tunics were an alternative way for people to show their clan crests.[39] As traditional feasting and ceremonies declined, the blankets were disdained. Davidson and other Haida artists brought them back to become a thriving modern form. Men customarily draw the designs, and women sew them.

"I was the first person in Masset to make button blankets in recent years.... My husband drew a grizzly bear design for it. I kept it secret because I thought someone might laugh at me for doing such an old-fashioned thing."

—Florence Davidson, 1982[40]

Robert Edenshaw wearing regalia with a shell button design. Klinkwan, ca. 1900.

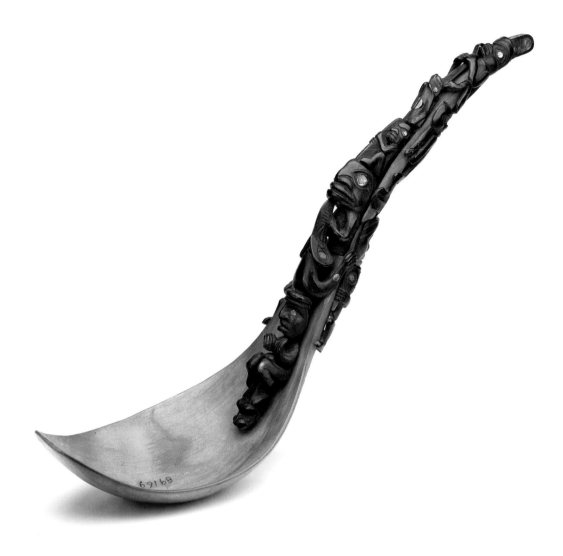

Sdláagwaal ganéelw

LADLE

Skidegate, Queen Charlotte Islands, British Columbia, Canada
Collected by James G. Swan, accessioned 1883
National Museum of Natural History E089169
Length 38 cm (15 in)

Open-work figures carved from pieces of black mountain goat horn and inlaid with abalone shell cover the handle of this elaborate ceremonial ladle. The bowl was carved, steamed, and molded from a single mountain sheep horn. Haida artists excelled in this style, even though the raw materials had to be obtained from the Tsimshian, who could hunt sheep and goats in their mainland territories.[41] Large horn ladles were used at feasts and passed to guests at waɬəɬ, for eating preserved berries from wooden bowls.[42] Feast spoons were owned by clans rather than individuals.

Designs on spoon handles illustrated stories from oral tradition, showed clan crests, or were sometimes purely ornamental.[43] No record exists of the artist's intentions for this ladle, although human, killer whale, and bear figures can be identified.

A potlatch marking the move from Klinkwan to Hydaburg. Klinkwan, ca. 1900.

"Amongst the Haida, certain shapes were for certain foods, even our horn spoons. The little black horn spoons were used for eating seaweed, but the white ones were for halibut…. When a chief came to our meal, my mother took out a fancy spoon with carving, and he used it. We were never allowed to touch it, just him."

—Delores Churchill, 2005

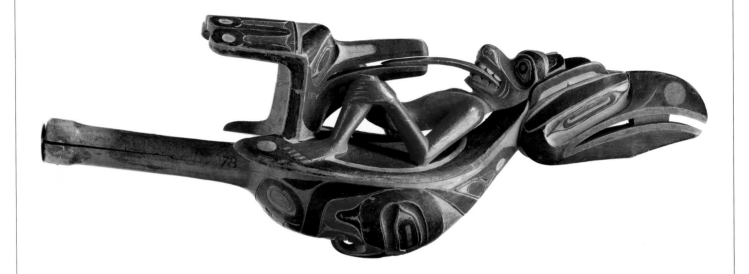

Skidgate, Queen Charlotte Islands, British Columbia, Canada
Collected by James G. Swan, accessioned 1883
National Museum of Natural History E089078
Length 35 cm (13.8 in)

Sasáa

RATTLE

Wearing ermine tail headdresses and carrying bird rattles, Haida chiefs, noble women, and youth took part in dramatic spirit possession plays. During these ceremonies, which the Haida adopted from the Bella Bella and Tsimshian in the early eighteenth century, initiates experienced capture by Walala, the Cannibal Spirit, and by other supernatural beings. Walala dancers bit onlookers, pretending to eat human flesh, and those taken by Bear, Wild Man, Beggar, and other spirits reenacted the behaviors of those beings. The ceremonies were followed by feasting and the distribution of property to witnesses.[44]

This rattle shows Raven carrying the sun in his beak.[45] On Raven's back, a supine human-Walala figure extends his tongue into the beak of a crested bird, symbolizing the exchange of spiritual power between the two beings. A sparrow hawk design covers Raven's belly.[46] Shamans, who used these rattles in healing ceremonies, believed that healing and clairvoyant powers came from birds and animals.[47]

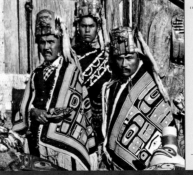

"The humanoid is being transformed when its tongue goes into the frog or bird; the rattle is showing a transformation that is used for healing. This type of rattle was not used for evil; it was used for good. I think we have to really emphasize that this is a healing rattle."

—Delores Churchill, 2005

Edwin Scott (left) holding a Raven rattle. Klinkwan, ca. 1900.

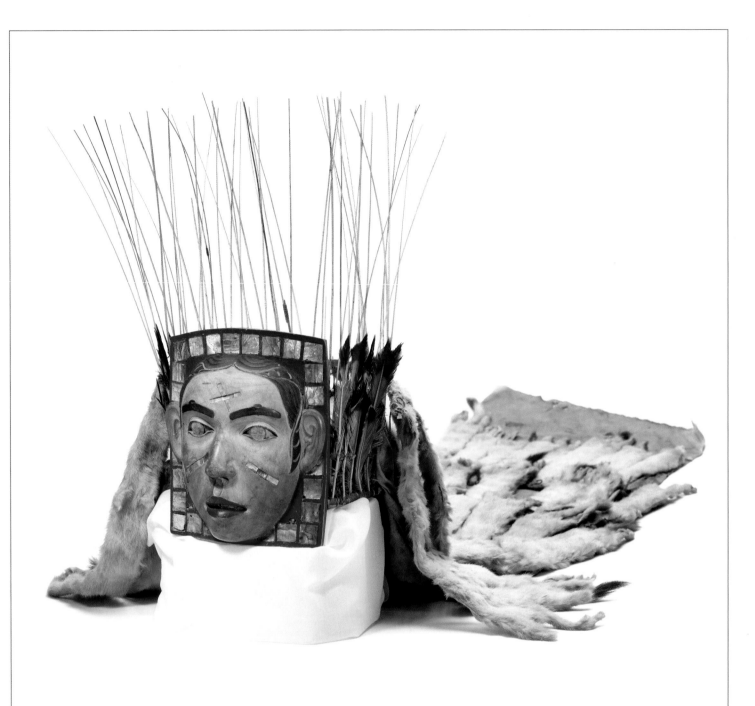

Skidegate, Queen Charlotte Islands, British Columbia, Canada
Collected by James G. Swan, accessioned 1883
National Museum of Natural History E089186
Length (frontlet to end of ermine trail) 143 cm (56.3 in)

Sakíid
HEADDRESS

During potlatch and spirit-possession ceremonies, a high-ranking Haida woman or man would wear a magnificent headdress with a carved wooden frontlet, a crown of sea lion whiskers, and a floor-length train of white ermine pelts. The frontlets resembled masks but stood above the forehead rather than covering the face; they were inlaid with abalone shell or copper and ornamented with flicker feathers. Some depicted crest beings, and others were portraits of individual persons. Before a dance the whisker crown was filled with swan or eagle down, which drifted out during the performance and fell onto the spectators like snow.[48]

Smithsonian collector James G. Swan recorded that this headdress was a portrait of Soodatl, the twelve-year-old daughter of a Chief "Ellswarsh." Her father was probably Daniel Eldjiwus, chief and builder of the House of Contentment at Skidegate.[49] A line of inlaid abalone around the girl's forehead and cheeks represents the custom of sticking pieces of the shell to the face with spruce pitch.

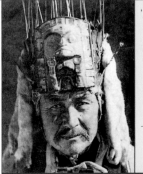

"Hayas of Kayung." Queen Charlotte Islands, 1915.

"They used it at potlatches, and they put feathers in the top of it. And when they shook the head around at a certain time, the feathers would start going up in the air and settling among the people."

—Clarence Jackson, 2005

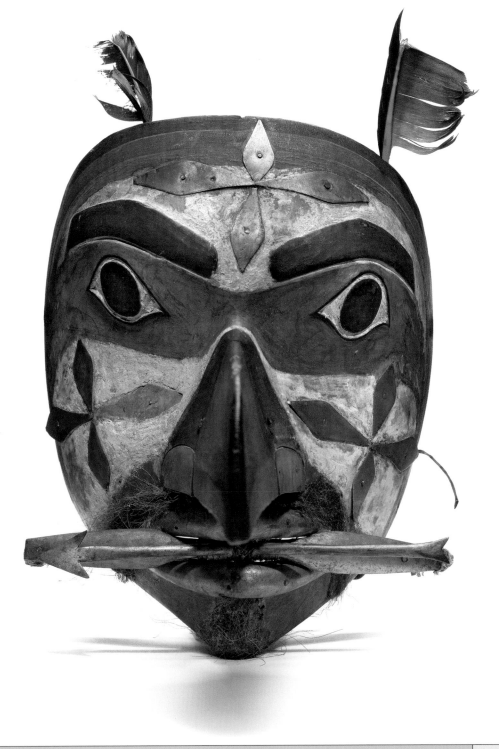

Níijaangwaay
MASK

Skidegate, Queen Charlotte Islands, British Columbia, Canada
Collected by James G. Swan, accessioned 1883
National Museum of Natural History E089043
Height 33.5 cm (13.2 in)

This mask of a bird with copper bow and arrows in its beak may represent a well-known story from Haida oral tradition. As told at Skidegate, the sky god, Shining Heavens, is raised by the daughter of a chief; when she makes him a bow and arrows from her copper bracelets, he shoots a wren, a cormorant, and a blue jay, putting on the skins to become different kinds of clouds in the sky.[50] In a Masset version the son of Sea Otter makes a bow and arrows with copper from a stick used by his mother to kill a copper bird; he shoots flickers and turns them into blankets for women, who become fair-weather clouds, seen in the red light of morning.[51] The mask bears copper ornaments that may be stars.

Dancers wore masks to depict both supernatural beings and crest animals.[52] Florence Davidson witnessed some of the last traditional dances in her childhood at Masset before 1910: "Wintertime when I was small they used to dance so much.... They did them for fun so they don't forget them. Some used to wear masks but after white people came around here they cleaned out all the masks. Too bad I didn't learn the songs."[53] Contemporary artists and dance performers are restoring the mask traditions.

Man wearing mask. Masset, 1881.

"The mother, while out of doors, heard a buzzing sound, and striking with a stick at the object that made it, found it was a copper bird. Half of her stick was changed into copper. From this her boy made a copper bow and arrows, with which he shot a great many flickers, and they made blankets for each out of them."

—told by Abraham, from "The Flood at T!ē," 1900–1901[54]

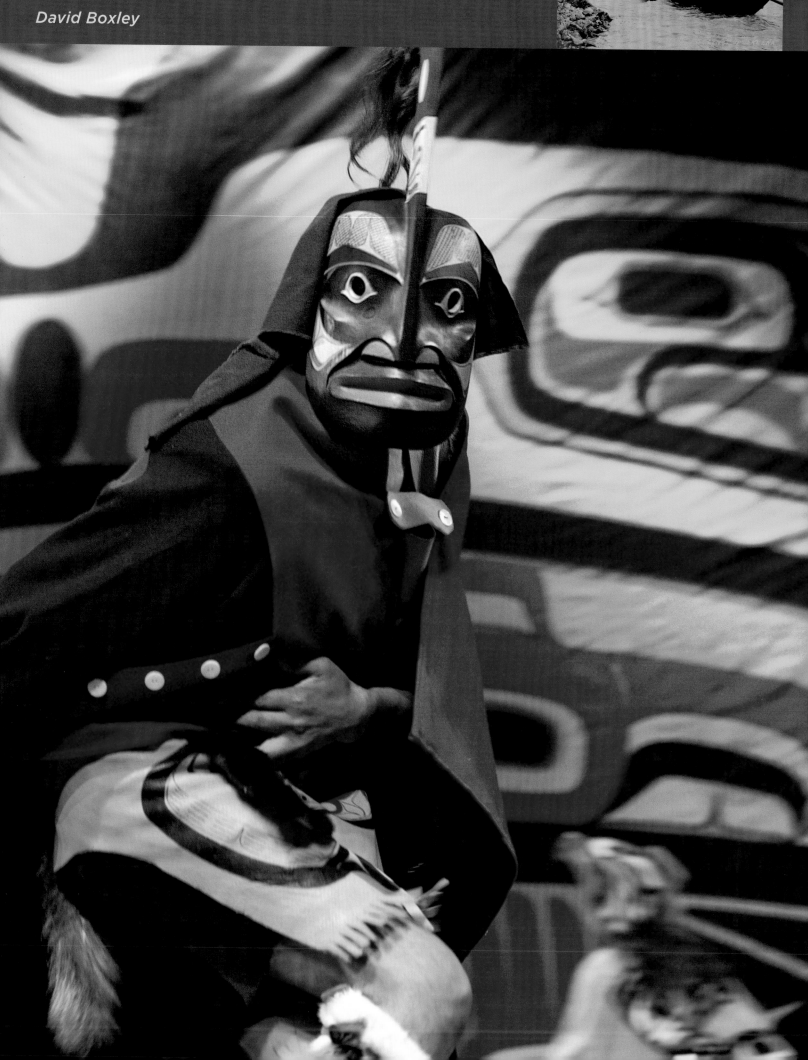

TSIMSHIAN

David Boxley

THE FIRST TIME I SAW the Northwest Coast hall at the American Museum of Natural History in New York, almost thirty years ago, I was stunned. The air seemed thick, and I felt the weight of representing my people settle over me. So many of them had never seen these objects with their own eyes—little everyday things like fish hooks, baskets, paddles, and strainers for dipping eulachon bones from the oil pot, alongside massive totem poles and beautifully carved masks and rattles.

Our culture was there in that place, so far from home. That made me both really sad and excited at the same time. It inspired me to work, as an artist and organizer, for the restoration of Tsimshian heritage to my community.

Most Tsimshian live along the coast of northern British Columbia between the Nass River and Queen Charlotte Sound. The shores and islands are covered by northern rain forests of hemlock, spruce, fir, red cedar, and yellow cedar, woods that were the basic raw materials of our culture. Tsimshian territory extends into the mountainous interior as well, following the valley of the Skeena River.

At one time at least eight thousand Tsimshian lived there, located in twenty winter villages and many seasonal camps. Today about thirty-five hundred live in seven Canadian towns. The largest is Port (formerly Fort) Simpson, followed in population by Kitkatla and Hartley Bay. The Nisga'a people along the Nass River and the Gitxsan on the upper Skeena are close neighbors and culturally akin, but they speak separate languages.

In 1862, a Tsimshian group led by an Anglican missionary, William Duncan, broke away from Fort Simpson to found a religious colony at Old Metlakatla. Twenty-five years later they moved again, building New Metlakatla on Annette Island, in southeast Alaska. Generations have lived there since, and that is the community in which I was born and grew up.

OPPOSITE TOP: Tsimshian canoe on the Skeena River in about 1915. The river leads to Gitxsan territory in the interior.

OPPOSITE: Wayne Hewson of the Git-Hoan (People of the Salmon) Dancers wearing a Killer Whale mask by David Boxley, on stage at Celebration 2006 in Juneau. The whale's dorsal fin, ornamented with human hair to represent water streaming behind it, rises from the top of the mask.

ABOVE: The coast of Annette Island in the Alexander Archipelago, 2001

I was very fortunate to be raised by my grandfather and grandmother, Albert and Dora Bolton, who gave me a strong foundation in our culture. My grandfather's ancestors were Gitwilgyots, "people of the kelp," from the British Columbia coast south of the Nass River. My grandmother's family were Gitlaan, "people of the plateau," from inland on the Skeena. Both were born in New Metlakatla after the migration.

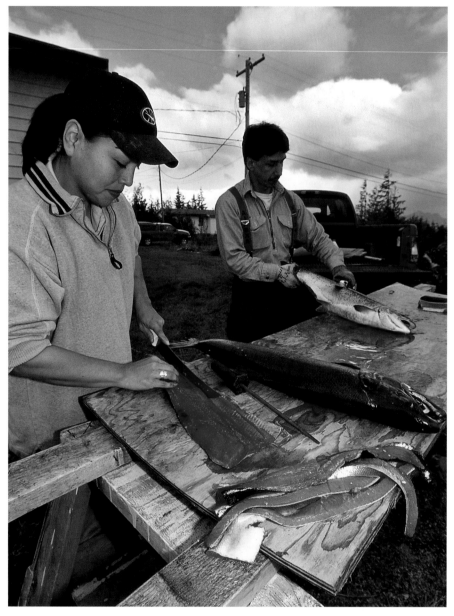

When I was young they took me with them to their fish camps and on trips all over our island for subsistence activities. Most people still rely a great deal on fish, seals, berries, and other traditional foods, supplemented by commercial fishing and other sources of cash income.

In historical times, the year's food gathering began in spring when the ice broke up on the Nass River and the eulachon began running there. People traveled to the Nass from their winter villages to harvest the fish in nets, drying some and fermenting and boiling the rest to extract the oil. Trade in eulachon grease, which no other people could produce in such quantity, was one of the sources of Tsimshian wealth and prosperity.

In spring they also gathered seaweed and herring eggs, fished for halibut, and collected bird eggs and abalone. During summer and fall they relocated to fishing sites on the rivers to catch salmon with weirs and traps, drying and smoking them for winter. At the winter villages they gathered clams, cockles, and mussels, and if you visit those old settlements today you can still see the mounds of discarded shells. At different times of the year they hunted seals, sea lions, deer, elk, mountain goats, and mountain sheep.

Archaeological sites in Prince Rupert Harbour demonstrate that this way of life goes back at least five thousand years. Artifacts from Prince Rupert show the early development of our art and culture, which influenced other tribes up and down the coast.

Crest objects such as chiefs' headdresses and masks are connected to origin stories and to the succession of clan leaders who have owned and passed them down to their descendants, along with name titles and titles to land. This is important in British Columbia where the Tsimshian Nation is attempting to reclaim territories that were taken by the Canadian government in the 1870s. Crest objects and the histories attached to them validate those aboriginal claims and link the people to specific places on the land where they lived and harvested food in the old days.

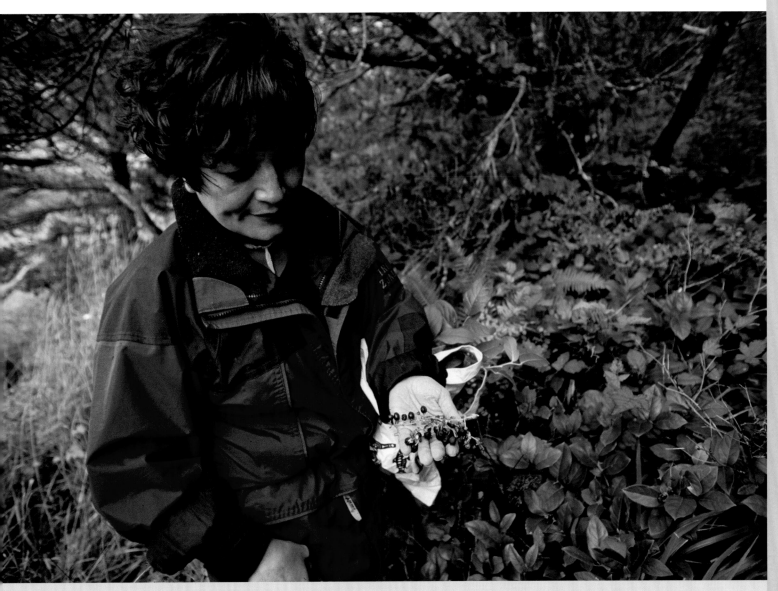

OPPOSITE: **Iris and Jack Huckleberry cutting salmon into fillets and strips, Metlakatla, 2001. Every household in the community uses wild foods, especially salmon, herring, halibut, and shellfish. Many also fish commercially.**

ABOVE: **Melody Leask picking black currants near Metlakatla, 2001**

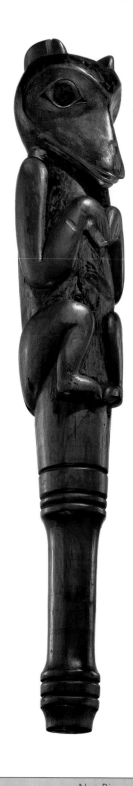

Hak'alaaxw
FISH CLUB

Nass River region, British Columbia, Canada
Collected by George T. Emmons, purchased 1917
National Museum of the American Indian 082608.000
Length 45 cm (17.7 in)

The old coastal Tsimshian villages were often situated near deep-water banks where halibut were abundant in spring. Fishermen caught them with hook and line and killed them with yew-wood clubs. The fish were too strong, vigorous, and large—up to three hundred pounds—to bring into a canoe safely while still alive.[1] Artist David Boxley identified the figure carved on this fish club as a wolf.

Clubs were also used to kill salmon as they swam in shallow streams, and it was said that Raven learned this method from Salmon Woman (Bright Cloud).[2] Later in mythical time, Spider taught the art of net making to a starving widow and her daughter. The net he wove them was like his own web but made of nettle fibers and suspended from red-cedar floats.[3] Tsimshian people traditionally harvested all five species of Pacific salmon using nets, spears, weirs, and traps.[4] Their shamans performed First Salmon ceremonies to honor the fish and ensure that they would return each year to spawn in the rivers.[5]

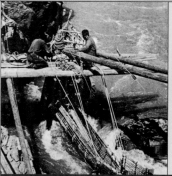

"As soon as they came to the fishing ground, they baited their hooks and threw the lines into the water. When the fishing lines touched bottom, Chief Cormorant had a bite from a halibut at once, and hauled up his line with a halibut at each end. He clubbed them and took them into the canoe."

—From "Txä'msem and Cormorant," told by Henry W. Tate, 1903–14[6]

Fishing platform and salmon trap. Bulkley River, British Columbia, ca. 1920.

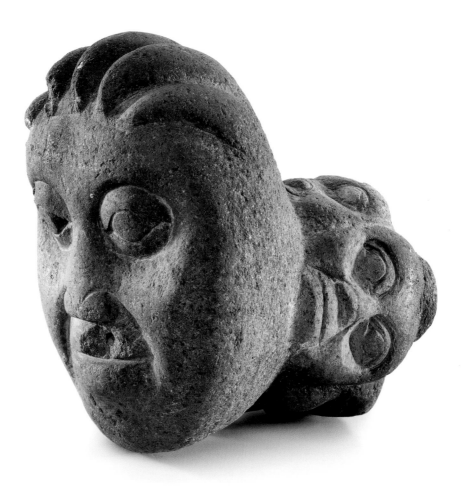

Sgan
HALIBUT SINKER

Nass River region, British Columbia, Canada
Collected by George T. Emmons, purchased 1919
National Museum of the American Indian 096731.000
Length 14.5 cm (5.7 in)

The traditional rig for halibut fishing consisted of a heavy stone weight; a long line of twisted red-cedar bark or dried kelp; a pair of barbed wooden hooks made from crooks of red or yellow cedar or else a single two-piece hook; and a wooden surface float shaped like a bird.[7]

This unusual sinker is shaped like a human head clutched in the claws of a bear; four smaller faces (two visible in the photograph) encircle the line hole through the back of the sinker. The object was likely made for shamanic ritual, its images representing helping spirits (naxnox) that brought fish to the people. Bear spirits were claimed by many shamans and symbolized by the crowns of claws and bearskin cloaks they wore. The carving was reportedly found in a deserted house by the Nass River.

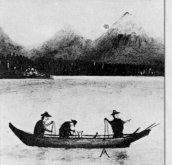

"Then the shaman said again, 'Every living fish, every living fish' and his people had to repeat what he said. . . . Then he said, 'Go a little farther to the open sea, and you will find them.'. . .Then he said, 'Pull up your fishing lines!' They hauled up their lines, and all the hooks were full of halibut."

—from "The Deluge," told by Henry W. Tate, 1903–14[8]

Drawing of men fishing from canoe. Metlakatla, Alaska, ca. 1896.

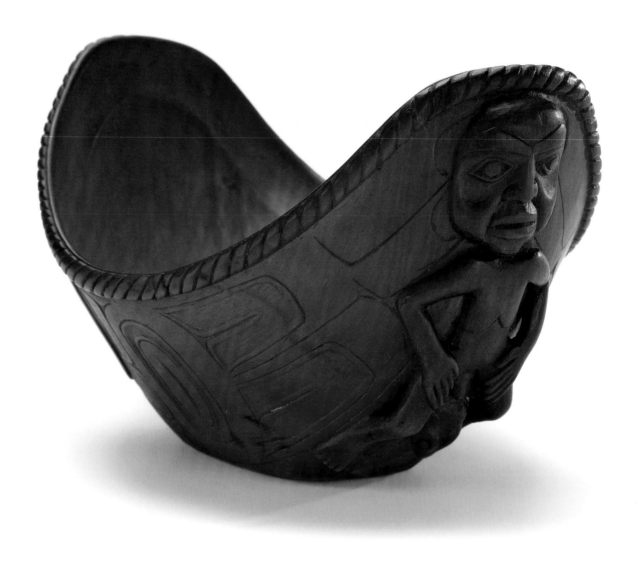

Port Simpson, British Columbia, Canada
Collected by James G. Swan, accessioned 1876
National Museum of Natural History E020613
Length 21.9 cm (8.6 in)

Ggiehl
BOWL

A naked man with a small frog between his feet appears at one end of this high-end feast bowl, which was molded and carved from the horn of a mountain sheep. The face of a crest animal was rendered on the other end, along with a second frog. David Boxley noted that wing designs extend along the sides of the vessel and suggested that the unknown crest may be a bird. Frog and Raven are both symbols of Tsimshian Raven clans along the Skeena River, suggesting a possible interpretation of the bowl's origin and design.

Hunting wild sheep and goats in the high coastal mountains was a dangerous and noble pursuit, ideally undertaken by chiefs.[9] Hunters ascended steep slopes and glaciers in spiked snowshoes, using dogs to drive the animals into bow and arrow range. The products of the hunt were highly valued—goat wool for weaving blankets and the horns of both sheep and goats for carving festal spoons and bowls. These materials as well as the finished products were traded to the Haida and Tlingit.[10]

"This is a very well done bowl, but it is from Port Simpson, where Tsimshian, Haida, and Tlingit people were all living. We may never know exactly which tribe the carver came from. The Haida had to trade with our people to get weaving materials and the horns for making bowls and spoons."

—David Boxley, 2009

Norman Tait, a Tsimshian artist from Kincolith, British Columbia, carving a bowl. Vancouver, 1979.

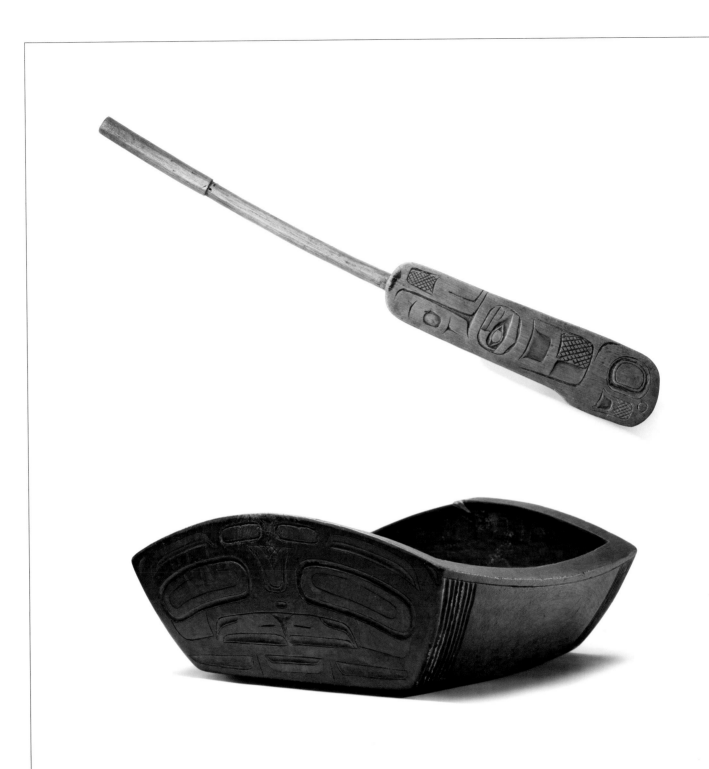

Hapshgoulgm ggan
SOAPBERRY SPOON

Southeast Alaska
Donated by William H. Dall,
accessioned 1874; National Museum
of Natural History E016255
Length 38.7 cm (15.2 in)

Ggiehl
BERRY DISH

Southeast Alaska
Collected by Rev. Sheldon Jackson,
transferred from Bureau of American Ethnology 1921
National Museum of Natural History E316903
Length 32.6 cm (12.8 in)

Wooden bowls held the fruits of the land—crabapples, cranberries, blueberries, and other foods, dried and mixed with seal or fish oil to preserve them for the winter ceremonial season. Potlatch hosts served berries to their guests in carved wooden bowls, large trays, and even empty canoes.[11] Grooves carved at the corners of this bowl mimic the bent edges of birch-bark baskets that Skeena River people used before making their legendary migration to the coast, led by the great shaman Devoured by Martens.[12]

Historically, soapberries were especially prized. They are plentiful in the dry upriver territories of the Nisga'a and Gitxsan, who traditionally traded them to people on the coast.[13] The berries were dried, whipped with water into foam, sweetened, and served with flat, beautifully carved hardwood spoons.[14] David Boxley said, "The Tsimshian word for soapberry is *as*. You whip it up, add a little sugar, maybe some salmonberries or blueberries." During an 1858 feast that marked a high-ranking girl's initiation into the Destroyer secret society, her father ordered two large canoes to be carried into the house and filled with soapberries, frothed with black molasses. The guests were unable to finish the huge serving.[15]

"This is a very simple feast bowl, also called a square or high-end bowl. It is made of alder. Carved 'wrinkles' at the corners represent the folds on birch-bark baskets that people used in the interior before they moved to the coast."

—David Boxley, 2009

Berry pickers. Hazelton, British Columbia, date unknown.

MY PEOPLE ARE DIVIDED INTO four equal groups. Each is a *pteex* (clan) with its own principal crest: Eagle (Laxsgiik), Raven (Ganhada), Wolf (Laxgibuu), and Killer Whale (Gisbutwada). Crests are symbols of matrilineal connection; whatever *pteex* your mother comes from, you will be the same. Because clans marry out, your father will be from a different one of the four. Within each *pteex* are multiple lineages, like branches on a family tree.

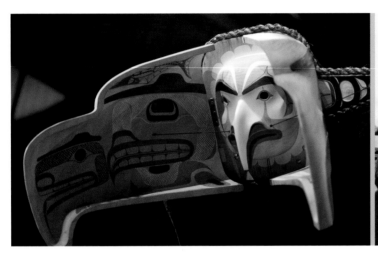

Eagle, Raven, Wolf, and Killer Whale each have as many as twenty-five subcrests, a few available that are to everyone in the clan and the rest limited to certain branches. As a Laxsgiik, I may use the Eagle, Beaver, and Halibut crests; I inherited other, more restricted crests from my close maternal ancestors.

Crests represent social identity and its corresponding rights and privileges. Crest images appear on robes, button blankets, headdresses, and other regalia that people wear at potlatches to show their ancestry. They are shown on ceremonial drums, staffs, and rattles; on dishes and ladles used for serving food at potlatch feasts; and on the totem poles, house fronts, posts, and screens of traditional lineage houses.

If you could go back in time to visit a coastal Tsimshian village of two centuries ago, you would see our social system at work. The community is built along the shore, with palisades around back to guard against possible attack from land. You arrive by canoe and announce your person and business while still afloat, waiting for permission to land. Jumping ashore without proper protocol would have been life threatening in those days.

UPPER LEFT: An Eagle transformation mask by artist David Boxley opens during a performance by the Git-Hoan (People of the Salmon) Dancers, revealing a supernatural eagle inside. Juneau, 2006.

UPPER RIGHT: Iris, Jacklynn, and Jack Huckleberry of Metlakatla wear Eagle headdresses and Eagle tunics with abalone buttons, 2001.

OPPOSITE: The Four Clans totem pole, carved by David Boxley in 1987, stood in front of the longhouse at Metlakatla until felled by a storm. It represented all four Tsimshian *pteex* (clans)–Wolf, Raven, Killer Whale, and Eagle (bottom to top).

Coming up from the beach in the company of your hosts, you see the big red-cedar longhouses, lined up in a row with their doorways facing the water. Each is home to thirty or forty people, most of them matrilineal relatives but including wives and children of other clans.

The village chief's house is the largest and is located in a central position. Its painted front panels show his crests. The other dwellings are positioned in relation to the chief's house according to the social ranking of their household heads. In front of prestigious homes are totem poles, carved with crest emblems and figures. Poles are sculptural narratives, telling who lives in a house, the ancient origin and recent history of their lineage, and the achievements of their deceased chiefs and nobles.

Entering one of the longhouses requires that you stoop down to pass through a low door, a vulnerable position for any would-be attacker. Depending on the status of the house, the interior is lined with one or more levels of wood-planked sleeping platforms, like wide bleachers that step down to the central fire pit. An important chief's house would be deeply excavated with multiple levels, requiring the labor of hundreds of people to dig out and construct. The platforms are divided into family living areas, cordoned

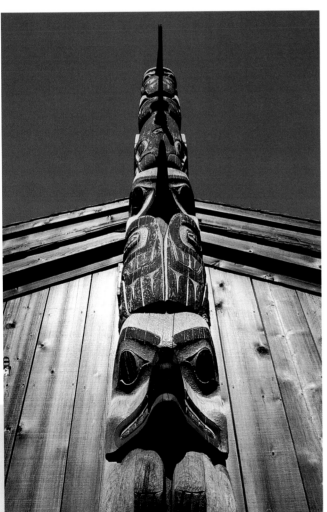

off with mats or boards. The house chief and his family have a private apartment at the far end of the house, behind a carved and painted wooden screen. Where other people sleep depends on their social status; the highest ranking are closest to the leader and higher up where it is warm, while those of lowest rank, including slaves, are positioned closest to the door.

Inside the house you see lots of preserved food—dried salmon and halibut, bentwood boxes filled with fish oil, seal grease, and berries; containers of dried meat. All of this came from hunting and fishing territories owned by the house members.

The original Tsimshian way of life began to change when British, Spanish, and American fur traders arrived in the late

1700s. The Hudson's Bay Company built Fort Simpson at the mouth of the Nass River in 1831, and missionaries of several Christian denominations came to work among the Tsimshian, Haida, and Tlingit people who had gathered near the fort for trade. The missionaries were successful at converting a large part of the population, which was in rapid decline as a result of smallpox and other new diseases. The people gave up their traditional beliefs, ended their ceremonies, and even cut down many of the totem poles.

The converts who followed William Duncan from Fort Simpson to Old Metlakatla and then to Alaska were making a new start, trying to survive in a world that was rapidly changing. New Metlakatla had a good harbor and a waterfall that provided power for the industries that the pioneers built, including a sawmill and cannery. They adopted Western clothing, houses, and forms of government.

Now, more than one hundred years later, Metlakatla is a pretty distinctive place. Our heritage connects us to the ancient traditional life on the Nass and the Skeena, but the modern community is a kind of hybrid; it has an American flavor to it. Little about its everyday appearance would remind a visitor of the lifeways of the past, but we are still proudly Tsimshian, with a strong sense of our unique identity.

Our language, Sm'Algyax, has changed from the way it is spoken in Canada, and unfortunately Metlakatla has only a few fluent speakers left, all elders. That frightens me, and I've been trying very hard to hold on to what I know and to learn more. We are who we are, but we are what our language makes us, too. If I were to sing a Tsimshian song in English, it would just not have the same impact, because we need to hear our own voices in the sounds of our Native tongue. Besides, I pay respect to my grandfather and grandmother every time I speak our language.

Houses at Metlakatla, Alaska in 1912. The community was founded in 1887 by Tsimshian migrants from Canada under the leadership of Anglican missionary William Duncan.

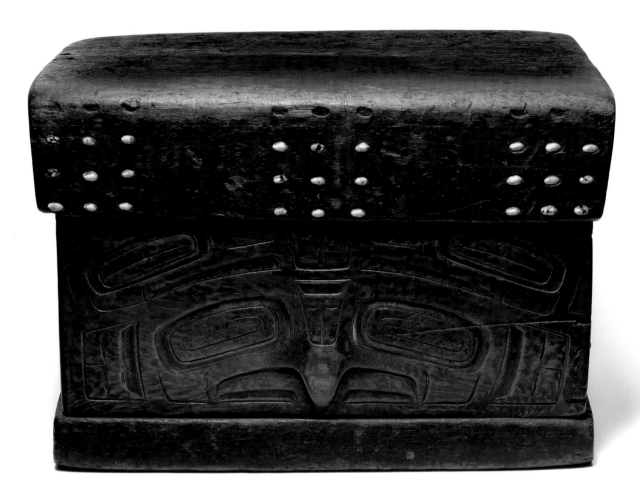

Gal ink
BOX

Kispiox, Skeena River, British Columbia, Canada
Collected by George T. Emmons, purchased 1917
National Museum of the American Indian 066324.000
Length 50 cm (19.7 in)

Decorated chests to hold blankets, provisions, and ceremonial regalia lined the walls inside traditional Tsimshian houses. Smaller telescoping boxes like this one have lids that fit snugly over an inner lip and were used to protect the most valuable or spiritually powerful treasures.[16] They were tied with rope and sometimes covered with cedar-bark matting. In oral tradition the Chief of Heaven kept the sun in just such a box until Raven stole it and smashed it open at the mouth of the Nass River, bringing daylight to the world.[17]

The panels on this treasure box depict Eagle (shown) and Beaver crests of the Eagle clan (Laxsgiik). George T. Emmons collected it at a Gitxsan village near the headwaters of the Skeena, but the carving style indicates possible Tlingit origin. The lid is decorated with white opercula (cover plates) of marine turban snails. The black patina on the polished wood is probably from the smoky cooking fires that burned in the old houses.

"It could have been a chief's treasure box, but probably belonged to a shaman and held all of his belongings. This is the size he could have afforded. It must have been old even when it was collected, and was heavily used."

—David Boxley, 2009

Display of clan regalia. Kitladamixs, British Columbia, 1903.

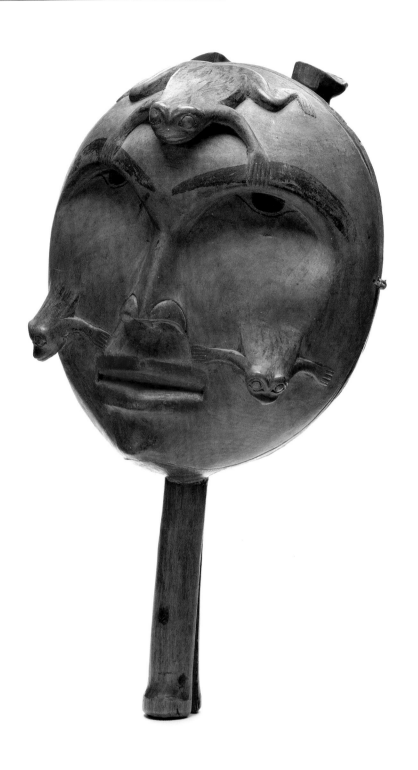

Shoa shoa

SHAMAN'S RATTLE

Port Simpson, British Columbia, Canada
Collected by James G. Swan, accessioned by 1876
National Museum of Natural History E020583
Length 30.5 cm (12 in)

Entranced by drumming, rhythm, dance, and song, shamans were possessed by their guiding spirits. With the power of these beings, they sought to heal the sick, see into the future, and travel to other worlds. Shamans shook large, globe-shaped rattles that both induced and portrayed the experience.[18]

Frogs appear often on shamanic art, because they were imagined as primordial, partly human creatures that retained supernatural power from early times. They lived in the dark before Raven brought the sun, and they made fun of the great trickster; in anger he caused the North Wind to blow the frogs away and freeze them onto rocks.[19] Tsimshian elder Henry W. Tate told anthropologist Franz Boas, "Frogs are not eaten, for they were people before the daylight was liberated."[20] Collector James Swan recorded that this rattle shows frogs that appear with the rain, springing from the eyes of a wind spirit.[21] This was the warm South Wind, who brings rain and desires the world to be green, as in spring, and perhaps (in this artist's conception) brings the frogs back to life.[22] The back of the rattle shows the Wind's arms, legs, and body. It was carved in two parts from maple wood and has round beach pebbles inside for sound.

"He is showing this look, like a trance; the eyes are underneath the lids, rolled back. Having these frogs come out, too—frogs were the shaman's messengers."

—David Boxley, 2009

Johnny Lagaxnitz holding rattle. Kitwanga, British Columbia, ca. 1924.

'Noahl

DRUM

Port Simpson, British Columbia, Canada
Collected by James G. Swan, accessioned 1876
National Museum of Natural History E020611
Length 63 cm (24.8 in)

Shamans played skin drums during healing rituals, whereas performers at potlatches and secret society ceremonies more often used wooden box drums (see p. 224).[23] This instrument is a bent wooden hoop covered by thin deer hide, with crossed rawhide holding-straps in back. The drum stick depicts a killer whale in human form, a tall dorsal fin projecting from its head.

In the "Great Shaman," Henry W. Tate told of a man with such strong supernatural power that his rhythm instruments came alive: "A young shaman came in with his crown of grizzly-bear claws on his head, his apron tied around his waist and a rattle in his right hand, an eagle tail in his left. Then the boards for beating time ran in through the door like serpents, and each laid itself on one side of the large fire. Then weasel batons ran along behind the boards. The young shaman began to sing his own song; and as he shook his rattle, the weasel batons began to beat of themselves, and a skin drum ran ahead and beat of itself."[24]

"You could still play this drum; it's tight and in good shape…. You know, it's very dry in Anchorage. When my dance group performs there, the drums sound different than in Metlakatla. They tighten up and make a higher sound, like 'dink, dink, dink' instead of a deep 'boom, boom.'"

—David Boxley, 2009

Prelude to a shaman's healing ceremony. Near Hazelton, British Columbia, 1927.

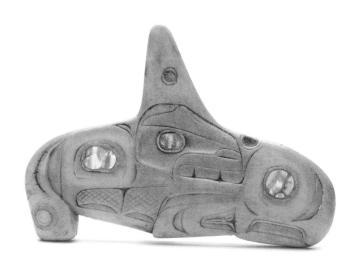

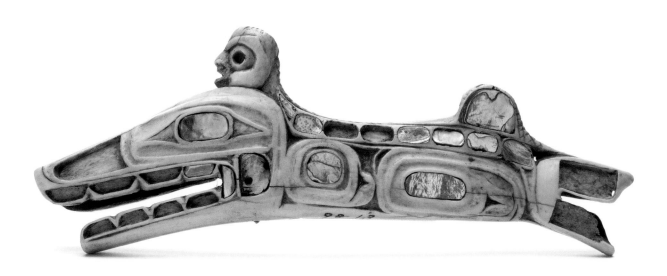

TSIMSHIAN

Ha'dsanaash (above)

AMULET

Port Simpson, British Columbia, Canada
Collected by F. W. Ring,
accessioned 1870
National Museum of Natural History E009813B
Length 9.5 cm (3.7 in)

Ha'dsanaash (below)

AMULET

Port Simpson, British Columbia, Canada
Collected by F. W. Ring,
accessioned 1870
National Museum of Natural History E009813A
Length 19.5 cm (7.7 in)

These amulets, representing guardian spirits, are the "small figures of bone and stone" that Henry W. Tate said a shaman carried in his bag, along with rattles, a crown of bear claws, a dancing apron, and red ocher face paint.[25] The upper amulet is a killer whale made of walrus ivory, its tail transformed into a long-beaked bird.

The lower amulet is fashioned from deer antler and portrays the story of Gunarhnesemgyet, whose wife is abducted by a white blackfish (killer whale). As the whale speeds away from her village with her, she shouts, "My people, come for me!" Gunarhnesemgyet follows in his canoe and eventually rescues her from the whale with the help of cormorants and the whale's servant, Gitsaedzan.[26] The theme is a common one for Tsimshian and Haida charms.

Shamans used hollow-bone tube charms to blow away illness, suck disease-causing objects from their patients' bodies, and capture wandering souls whose departure prefigured a person's death.[27]

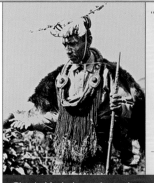

Claude Mark dressed as a shaman, ca. 1923.

"A chief was very sick and his subchiefs called in shamans from all over, but no one could help him. Finally a great shaman arrived; he looked around the longhouse where everyone was waiting and assessed the situation. He knew that if he was not successful they might kill him and find somebody else. So the first thing he said was, "You called me too late—but I'll do my best!"

—David Boxley, 2009

HERRING EGGS

Karla Booth

MY GRANDMOTHER gave me the name Gatgyetm Hana'ax, Strong Woman, but in English I am Karla Booth. I belong to the Raven clan, and my family is from Metlakatla, Alaska. Currently I work for the University of Alaska Anchorage, where I support Alaska Native and rural students in their transition to city and campus life.

It is exciting for me to go back to Metlakatla in the summers, and my days there are filled with visits to aunts, uncles, and cousins. When I'm there I get to eat the foods I grew up with, like fresh salmon and salmon eggs and seaweed. My best memory from the past summer is sitting down with my Uncle Tom and Auntie Sarah at their kitchen table, and my uncle serving up a big bowl of herring eggs and eulachon grease. Wow! I've had it plenty of times in the past but never quite that good. It was so special to be eating with family in their kitchen and home, which is filled with love for anybody who comes through the door. Besides, it is much more fun to eat that kind of food in a group. The eggs crunch between your teeth, and you hear everyone chewing. We're all talking and smacking our lips and licking our greasy fingers, and someone will say, *luk'wil ts'maatk*, "very tasty!"

I always find time to stop at the graveyard, too, to be with our ancestors. That is an important and beautiful place to me. Someone unfamiliar might see our cemetery as overgrown and rickety, little white crosses mixed with fancy headstones, not all level and manicured like a cemetery in the city. But it's just like the living people in Metlakatla—there aren't any strangers there. Everyone is buried with family all around.

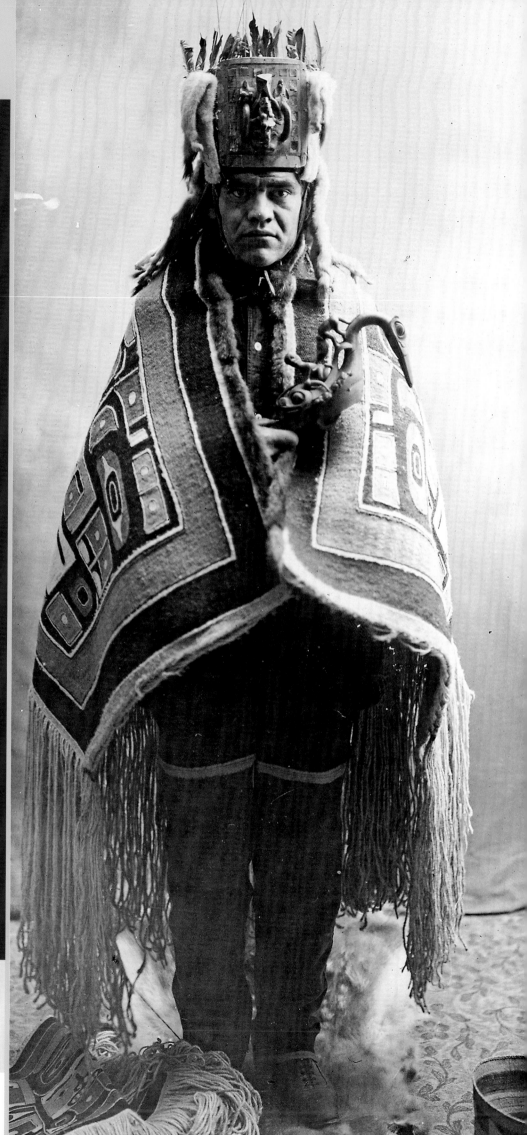

Man identified as a Tsimshian shaman, 1896. He is wearing a woven Chilkat robe and a headdress (see Haida example p. 248) with carved frontlet, a crown of flicker feathers, and a long ermine train. He carries an oystercatcher rattle (see Tlingit rattle p. 225).

HALAAYT IS SPIRIT POWER, which comes from above. It gave chiefs and high-ranking people the knowledge and strength they needed to be leaders and to make good decisions. *Halaayt* enabled them to be the link between their people and the next world, where our ancestors dwell, and to communicate with the spirits of animals.

The frontlet of a chief's ceremonial headdress was a symbol of his *halaayt*. The face in the center was a crest, surrounded by abalone, sea lion whiskers, feathers, and ermine fur. The chief's headdress, woven robe, and Raven rattle all represented his leadership and spiritual power. For secret society rituals, he danced to the music of whistles and drums, wearing a cedar-bark neck ring. At other ceremonies he wore masks that represented his ancestors and the story of their origin.

Historically, potlatch feasts celebrated events and transitions in the community—death, marriage, the completion of a new house, the raising of a totem pole, or the settlement of a dispute between clans. The largest and most important of these feasts were memorial potlatches, when new chiefs were installed and took the names of their predecessors.

Potlatches have always been based on a whole system of reciprocity. During the feast, hosts of one clan recognize and repay debts that they have incurred through services given to them by people of other clans, who come as guests.

Three things are essential to a potlatch. First, it has to be done publicly. The guests are there to serve as witnesses to what is taking place, and that is what makes it legal; a potlatch is our form of notary public. Second, the hosts have to gift every guest in payment for his or her witness. Finally, everyone must be fed, and fed very well. More than they need! The food they take home with them is another gift.

In 1982, I set out to organize Metlakatla's first potlatch. The purpose was to honor my grandfather while he was still alive and to memorialize my grandmother, who had recently passed away. For our community it would be the revival of a tradition that we had left behind over a century before in the historical move to Alaska. A few people from Metlakatla had been to potlatches in British Columbia, but most had never seen one. I researched the customs and protocols and organized a small planning committee, but the level of interest in the village seemed to be low.

A half hour before the potlatch was set to begin in the community hall, most of the tables and seats were still empty. The high school band played "The Star Spangled Banner" and several more songs as I tried to stretch

out the preliminaries, starting to lose hope that anyone would come. As the band played on, a few more people arrived. Then suddenly they were pouring through the door, carrying pans of salmon and big pots of other food. Before long we had five hundred people in there. It was something we were ready for, after all.

Many potlatches have been held in Metlakatla since then, and one of the largest was in 1994. It was originally planned as a celebration of my grandfather's hundredth birthday, but it became his memorial after he passed away at age ninety-eight. I realized that in order for the potlatch to happen on the scale that I had hoped, it would have to include all four clans. Their involvement not only ensured the amazing success of the event but also paved the way for the future, because so many participated and learned so much.

ABOVE: **The 4th Generation Tsimshian Traditional Dancers: Jennifer McCarty, Glenn Guthrie, and Vincent Dundas Sr. at Celebration 2006 in Juneau**

OPPOSITE: **Tsimshian dancers from Metlakatla at Celebration 2006 in Juneau**

The four groups held secret planning meetings, each assuming responsibility for one full day of the potlatch and vying to be the best-prepared hosts. They made piles of gifts, formed dance groups, composed new songs, and prepared large quantities of food. When the potlatch came, it was amazing. We fed a thousand people every evening, three totem poles were raised, and over fifty-five button robes were dedicated on the first night alone.

A lot of those folks are gone now, but that was one of the best things that ever happened to our community. Potlatches have continued ever since. I feel lucky to have come along when I did, at a time when it was right for these changes to take place. The way I grew up, and the gifts of language and culture that my grandparents gave me, prepared me for the journey.

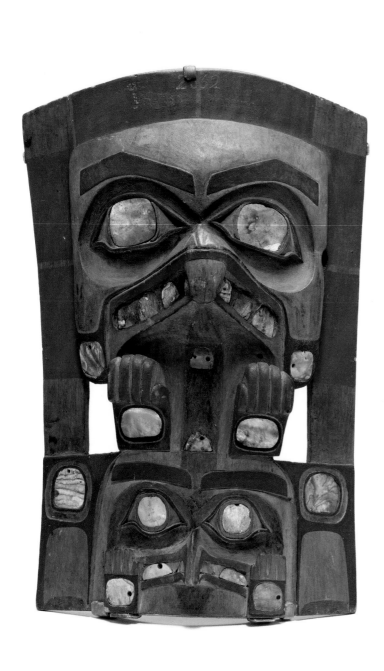

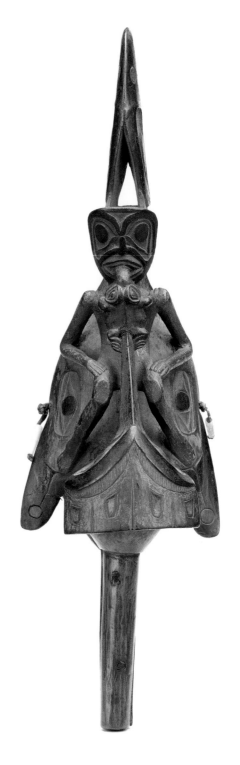

TSIMSHIAN

Aamhalaayt
FRONTLET
(DANCE HEADDRESS)

British Columbia, Canada
Collected by Edward Verry (Wilkes Expedition)
1838–42, accessioned 1858
National Museum of Natural History E002662
Height 28 cm (11 in)

Shoa shoa
RAVEN RATTLE

Nass River region, British Columbia, Canada
Collected by Lloyd W. Curtis 1882,
donated by William C. Sturtevant 1990
National Museum of Natural History E424992
Length 33 cm (13 in)

A Tsimshian chief's headdress—with its forehead mask (frontlet), crown of sea lion whiskers and flicker feathers, and long train of ermine pelts—signified his clan, rank, and spiritual powers (halaayt). He wore it as the host of naming and memorial ceremonies and other potlatches and during initiation ceremonies for the Dancer, Dog Eater, Cannibal, and Destroyer secret societies, so named because of the mythical beings portrayed by the dancers. At these performances he dramatically caught power spirits from the air and "threw" them into the young initiates, who lay hidden beneath cedar-bark blankets.[28]

The faces on Tsimshian frontlet masks are crests, in this case Beaver (above) and Eagle (below), both representing the Eagle clan. The crown of the headdress (now missing) was filled with eagle down, a symbol of peace that drifted over the crowd as the chief danced.[29]

During secret society performances chiefs carried raven-shaped rattles that portrayed the transfer of spiritual power from animals to people. On Raven's back a crested bird holds a frog in its extended beak, and through its tongue the halaayt of the frog enters and transforms a person or humanoid being.[30] Raven rattles, used by the Tsimshian, Haida, and Tlingit, are thought to have been first made by a Nisga'a artist.[31]

"Our people believe that this chief's rattle and the frontlet originated with the Tsimshian peoples, perhaps the Nisga'a, and spread to other tribes."

—David Boxley, 2009

Chief Lelt wearing a frontlet headdress. Hazleton, British Columbia, 1923.

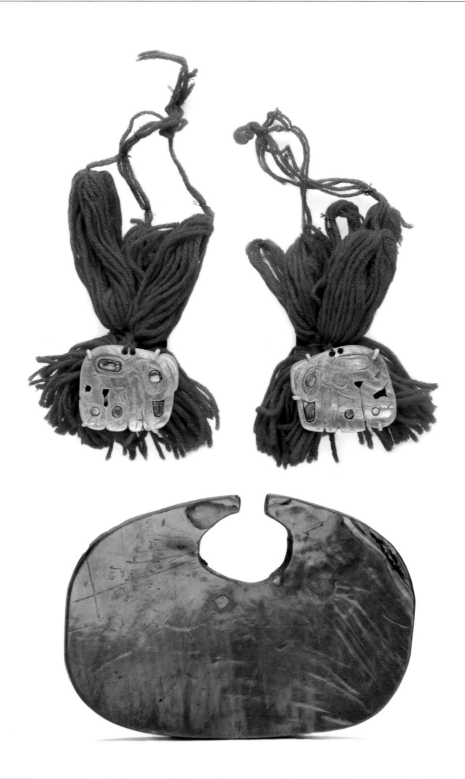

Ggamuu
EAR ORNAMENTS

Port Simpson, British Columbia, Canada
Collected by James G. Swan,
accessioned by 1876
National Museum of Natural History E020674
Length 5.5 cm (2.2 in)

Ggalkshihlooshk
NOSE ORNAMENT

Port Simpson, British Columbia, Canada
Collected by James G. Swan,
accessioned by 1876
National Museum of Natural History E020633
Length 4.3 cm (1.7 in)

Ear ornaments made of goat wool or red trade yarn and carved abalone shell were a symbol of Tsimshian nobility. Fathers or uncles hosted perforation potlatches to pierce the ears of their high-born children, nephews, and nieces, and the full measure of prestige was to reach adulthood with four holes on each side. Substantial food and property were distributed to potlatch guests for bearing witness at these ceremonies, and only wealthy families could afford the full sequence. Commoners who had no perforations were taunted with the name *wah'tsmuu*, "no ears."[32] Boys were given nasal perforations to hold bone pins or abalone pendants like the one above, and girls had their lower lips pierced for labrets.

The wise, elderly figure of Mouse Woman appears in Tsimshian sacred histories to offer warnings and advice to people in their dealings with supernatural beings. In payment she always asks for the person's wool earrings, which she burns and eats or takes away for lining her nest. Symbolically, multiple ear perforations were connected with hearing, understanding, and wisdom of the kind that Mouse Woman offered.[33]

"Do you know that a great chief is walking along the beach in front of your town, great tribe? He wears a costly pair of abalone ear ornaments."

—From "Txä'msem Kills His Slave," told by Henry W. Tate, 1903–14[34]

Mrs. Adam Gordon wearing a nose ring and ear ornaments at a wedding. Metlakatla, ca. 1896.

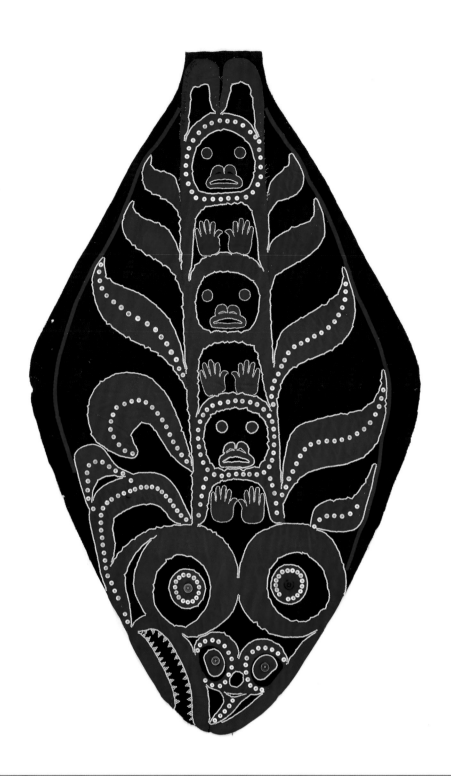

Gwish'na'ba'la

BUTTON ROBE

Port Simpson, British Columbia, Canada
Collected by James G. Swan, accessioned by 1876
National Museum of Natural History E020679
Length 124 cm (48.8 in)

In the traditional history "Explanation of the Beaver Hat," a group of Eagles flees the Copper River region after a war with the Ravens. During the voyage south to Tsimshian territory, three young people and their canoe are swallowed by a giant halibut. When the monster is killed and cut open, the bodies are found inside, as shown by this button robe design. Subsequently one of the surviving men kills a beaver with copper eyes, claws, ears, and teeth. The story explains how both Beaver and Halibut came to be crests of the Eagles, often displayed on their ceremonial regalia.[35] As Henry W. Tate said, "Whatever the clans saw on their early migrations, when they escaped from their enemies and endured the great hardships—the strange animals they saw, the birds, heavenly bodies, monsters, supernatural beings of the mountains and of the sea, anything that seemed important and unusual—they took for their crests."[36]

This halibut design may have been cut from a larger button robe. Collector James G. Swan wrote that it was worn on the back as a ceremonial vestment. The piece consists of red trade cloth appliquéd to a blue Hudson's Bay Company blanket, and the design is outlined with white beads and accented with shell buttons.[37]

"The Eagle clan came from Alaska down to British Columbia, and one of their canoes was upended by a monster halibut. This design shows the halibut and the people that it took. One guy at Metlakatla carved a panel showing this story, and I put it on a totem pole."

—David Boxley, 2009

Henrietta Dundas wears a button robe at a wedding. Metlakatla, Alaska, ca. 1896.

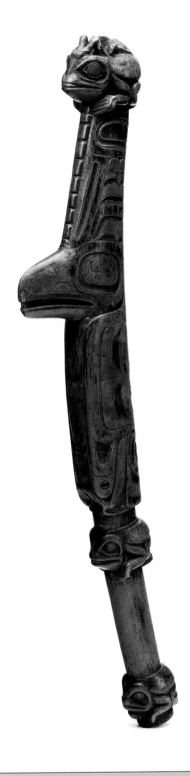

Ha'kalaaw
CEREMONIAL WAR CLUB

British Columbia, Canada
Collected by James G. Swan, accessioned 1876
National Museum of Natural History E020610
Length 64 cm (25.2 in)

Designs carved on this polished wooden club include Raven and three Frogs, a combination of crests associated with Skeena River clans according to David Boxley. Two inlays of abalone shell adorn the wings (not visible in the illustration), and other inlays were once present.

Although recorded by collector James Swan as an "ancient war club" made by the Bella Bella, it was probably a ceremonial weapon used during initiation rituals of the Tsimshian Destroyer society, called Wi'-nanał (meaning "strong breath"). Novices underwent a ritual of possession by the protector spirit of the cult, thus acquiring its *halaayt*. While possessed they destroyed canoes, boxes, and other valuable property using wooden clubs decorated with crest designs. Tsimshian adopted the Destroyer cult and other secret societies from the Bella Bella, which explains the reported provenance of this club, if not its actual origin.[38] David Boxley noted that a genuine war club would have been made of heavy yew, whereas this piece is light and probably carved from cedar. Traces of red and black paint suggest that it was once brightly painted.

Men wearing neck rings. Location and date unknown.

"This is an amazing carving.... These are probably potlatch rings above Raven's head. Below is a human figure between his wings. You see a lot of this kind of design on shamans' things, where they are riding in a canoe, going to the spirit world. Maybe Raven is that canoe."

—David Boxley, 2009

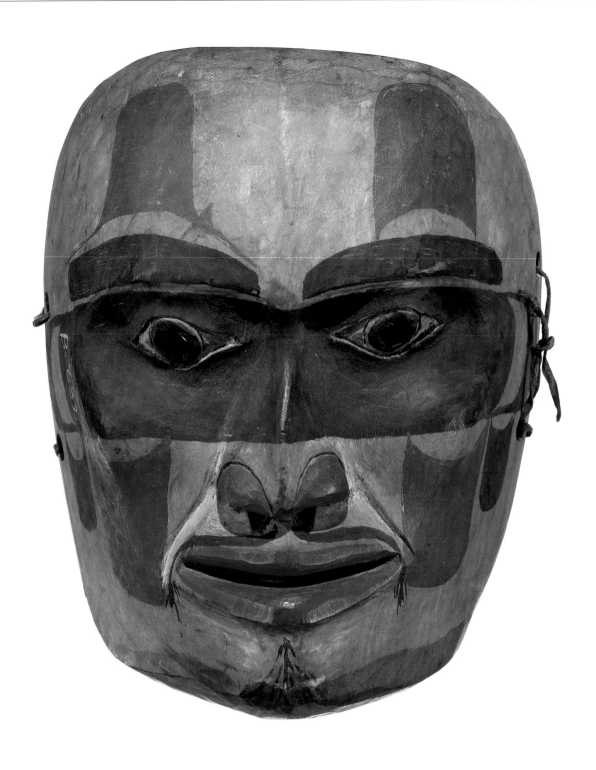

Ameelg

MASK

Probably Skeena River region, British Columbia, Canada
Collected by John G. Brady, donated by Edward H. Harriman 1912
National Museum of Natural History E274242
Length 22.5 cm (8.9 in)

Masks were among the most important objects representing a chief's *halaayt*. Each portrayed a different guardian spirit in bird, animal, or human form. Chiefs wore masks during "throwing dances," in which they caught and threw the spirit into another person. Each mask had a unique name and song and was kept hidden from the uninitiated.[39] Nisga'a artist Norman Tait commented that this example was probably from a Skeena River village and that the black band across the eyes confirmed that it was used for dancing. He thought it was well carved but probably quickly made for a winter ceremony.[40]

Tsimshian mask artists were nobles who worked as members of secret guilds.[41] David Boxley said, "I really believe that 'tribal' styles were established long ago by particular artists who were so good, whose work was so strong, that their apprentices emulated what they did, and it became known as 'the Tsimshian style' or 'the Haida style,' etc."

"If you could call any mask classical Tsimshian, this one has all the features…these cheek-bones, the way the nose is sculpted, the narrow lips, and the way the eyes look down and slightly to the sides. When you dance you're turning from side to side, and that helps you to see where you are going."

—David Boxley, 2009

Masks on display with other regalia. Kitladamixs, British Columbia, 1903.

Haxsgwiikws
WHISTLE

Lower Nass River region, British Columbia, Canada; Collected by George T. Emmons, purchased 1907; National Museum of the American Indian 014171.000
Length 38.5 cm (15.2 in)

The blowing of wooden whistles at night behind the longhouses indicated the arrival of spirits and the beginning of the winter season of secret society initiations. Whistles were made in different sizes and shapes, lending each spirit a unique and often frightening voice. The secret society rituals, led by chiefs and combined with potlatch feasts, were a form of spirit quest. Novices underwent possession in an experience similar to that of shamans.

Celebrants danced in cedar-bark rings, imitating the dress and actions of beings described in the origin story of each society. Bark rings were also hung outside on the houses where ceremonies were in progress, to warn away the uninitiated.[42] This ring consists of several criss-crossing layers of twisted bark cord wrapped around wool; the sash is made of twisted bark cords, each ending in a knot and tassel.

'Yootsihg
CEDAR-BARK
NECK RING

British Columbia, Canada
Collected by George T. Emmons, purchased 1905
National Museum of Natural History E233456
Length 40 cm (15.8 in)

"They put a large grizzly-bear skin on him [the mythical Cannibal], and a large ring of red-cedar bark on his neck and one on his head, and red-cedar bark rings on this hands and on his feet; and at the end of four days, in the morning, they beat a wooden drum… with thundering noise to drive away his supernatural power."

—From "The Cannibal," told by Henry W. Tate, 1903–14[43]

Men dressed for a secret society initiation, with cedar-bark neck rings and whistles (lower left). Gitlakdamixs, British Columbia, date unknown.

IÑUPIAQ

1 Bruce, "Report [Fiscal Year 1892–93]," 106; Dall, *Alaska and Its Resources*, 137–38; Michael, ed., *Lieutenant Zagoskin's Travels*, 116–17; Nelson, *The Eskimo about Bering Strait*, 29, 219–22; Ray, ed., "The Eskimo of St. Michael and Vicinity," 55–58; Thornton, *Among the Eskimos of Wales, Alaska*, 127.

2 Seegana, "Traditional Life on King Island," 19.

3 Murdoch, *Ethnological Results of the Point Barrow Expedition*, 233–35.

4 Ray, "Ethnographic Sketch of the Natives," 40.

5 Murdoch, *Ethnological Results of the Point Barrow Expedition*, 234–35.

6 Ibid., 255–56.

7 Ron Brower Sr., project consultation, Alaska Native Collections: Sharing Knowledge, 2002; Crowell, "The Art of Iñupiaq Whaling," 107.

8 Lowenstein, *Ancient Land*, 150.

9 Kenneth Toovak and Ron Brower Sr., project consultation, Alaska Native Collections: Sharing Knowledge, 2002.

10 Sylvester Ayek, project consultation, Alaska Native Collections: Sharing Knowledge, 2008.

11 Curtis, *The North American Indian*, 115, 140–41; Murdoch, *Ethnological Results of the Point Barrow Expedition*, 274; Rainey, *The Whale Hunters of Tigara*, 259; Spencer, *The North Alaskan Eskimo*, 337–38.

12 Bodenhorn, "I'm Not the Great Hunter, My Wife Is."

13 Curtis, *The North American Indian*, 141; Ostermann and Holtved, eds., *The Alaskan Eskimos*, 26; Spencer, "The North Alaskan Eskimo," 345; Stefánsson, *The Stefánsson-Anderson Arctic Expedition*, 389.

14 Brower, *Fifty Years below Zero*, 48; Rainey, *The Whale Hunters of Tigara*, 257; Spencer, *The North Alaskan Eskimo*, 334; Thornton, *Among the Eskimos of Wales, Alaska*, 166–67.

15 Pulu (Qipuk), Ramoth-Sampson, and Newlin, *Whaling*, 15–16; Rainey, *The Whale Hunters of Tigara*, 270–71; Osterman and Holtved, eds., "The Alaskan Eskimos," 228.

16 Birket-Smith, *The Eskimos*, 121; Bockstoce, *Eskimos of Northwest Alaska*, 65; Fitzhugh and Kaplan, *Inua*, 100; Murdoch, *Ethnological Results of the Point Barrow Expedition*, 260–61; Nelson, *The Eskimo about Bering Strait*, 169–70.

17 Murdoch, *Ethnological Results of the Point Barrow Expedition*, 276.

18 Paul Ongtooguk, project consultation, Alaska Native Collections: Sharing Knowledge, 2009.

19 Murdoch, *Ethnological Results of the Point Barrow Expedition*, 268–71; Ray, "Ethnographic Sketch of the Natives," 40; Rainey, *The Whale Hunters of Tigara*, 255, 264; Spencer, "The North Alaskan Eskimo," 140–43; VanStone, *Point Hope*, 58–60.

20 Sylvester Ayek, project consultation, Alaska Native Collections: Sharing Knowledge, 2008.

21 Murdoch, *Ethnological Results of the Point Barrow Expedition*, 270.

22 Dall, *Alaska and Its Resources*, 143; Fitzhugh and Kaplan, *Inua*, 119; Hough, "The Lamp of the Eskimo," 1033; Michael, ed., *Lieutenant Zagoskin's Travels*, 114; Murdoch, *Ethnological Results of the Point Barrow Expedition*, 161–62; Nelson, *The Eskimo about Bering Strait*, 108; Ray, "The Eskimo of St. Michael and Vicinity," 110; Smith, *Arctic Art*, 13; Thornton, *Among the Eskimos of Wales, Alaska*, 150.

23 Sylvester Ayek, project consultation, Alaska Native Collections: Sharing Knowledge, 2008.

24 Spencer, "The North Alaskan Eskimo," 203–4.

25 Bruce, "Report [Fiscal Year 1892–93]," 110; Cantwell, "Ethnological Notes," 84; Dall, *Alaska and Its Resources*, 21, 22, 141; Kelly, *Ethnographic Memoranda concerning the Arctic Eskimos*, 17; Michael, ed., *Lieutenant Zagoskin's Travels*, 110; Murdoch, *Ethnological Results of the Point Barrow Expedition*, 110–11, 113; Nelson, *The Eskimo about Bering Strait*, 30–35; Ray, "The Eskimo of St. Michael and Vicinity," 35–37; Simpson, "Observations on the Western Eskimo," 241, 244; Thornton, *Among the Eskimos of Wales, Alaska*, 34.

26 Martha Aiken, Jane Brower, Ron Brower Sr., Doreen Simmonds, and Kenneth Toovak, project consultation, Alaska Native Collections: Sharing Knowledge, 2002.

27 Bruce, "Report [Fiscal Year 1892–93]," 110; Dall, *Alaska and Its Resources*, 22, 141; Fitzhugh and Crowell, eds., *Crossroads of Continents*, 214; Michael, ed., *Lieutenant Zagoskin's Travels*, 110; Murdoch, *Ethnological Results of the Point Barrow Expedition*, 110–11, 113, 118–20; Nelson, *The Eskimo about Bering Strait*, 30–35; Ray, "The Eskimo of St. Michael and Vicinity," 35–37; Simpson, "Observations on the Western Eskimo," 244; Thornton, *Among the Eskimos of Wales, Alaska*, 34.

28 Gordon, "Notes on the Western Eskimo," 78; Michael, ed., *Lieutenant Zagoskin's Travels*, 110; Ray, "The Eskimo of St. Michael and Vicinity," 35.

29 Jane Brower, Ron Brower Sr., and Kenneth Toovak, project consultation, Alaska Native Collections: Sharing Knowledge, 2002.

30 Dall, *Alaska and Its Resources*, 22; Michael, ed., *Lieutenant Zagoskin's Travels*, 110; Murdoch, *Ethnological Results of the Point Barrow Expedition*, 129–130; Nelson, *The Eskimo about Bering Strait*, 40; Ray, "The Eskimo of St. Michael and Vicinity," 36–37.

31 Murdoch, *Ethnological Results of the Point Barrow Expedition*, 130; Thornton, *Among the Eskimos of Wales, Alaska*, 28.

32 Bruce, "Report [Fiscal Year 1892–93]," 114; Giddings, "Kobuk River People," 156; Oquilluk, *People of Kauwerak*, 103; Simpson, "Observations on the Western Eskimo," 238; Stoney, *Naval Explorations in Alaska*, 91.

33 Jacob Ahwinona, project consultation, Alaska Native Collections: Sharing Knowledge, 2001.

34 Bodfish, *Kusiq*, 23–24; Curtis, *The North American Indian*, 146–47, 168–77, 213–14; Giddings, "Kobuk River People," 52–60; Kingston, "Returning"; Lantis, *Alaskan Eskimo Ceremonialism*, 67–73; Oquilluk, *People of Kauwerak*, 149–50; Ostermann and Holtved, eds., *The Alaskan Eskimos*, 103–12; Spencer, "The North Alaskan Eskimo," 210–28.

35 Spencer, "The North Alaskan Eskimo," 223.

36 Boas, "The Central Eskimo," 205–8; Garber, *Stories and Legends of the Bering Strait Eskimos*, 29–32.

37 Fitzhugh and Kaplan, *Inua*, 120–22; Nelson, *The Eskimo about Bering Strait*, 287–88.

38 Dall, *Alaska and Its Resources*, 143, 149–50; Fitzhugh and Kaplan, *Inua*, 120–22; Nelson, *The Eskimo about Bering Strait*, 359, 363–65, 379; Ray, "The Eskimo of St. Michael and Vicinity," 87–89.

39 Nelson, *The Eskimo about Bering Strait*, 427–34; Oquilluk, *People of Kauwerak*, 115–32; Rainey, *Eskimo Prehistory*, 274–79; Spencer, "The North Alaskan Eskimo," 299–330.

40 Nelson, *The Eskimo about Bering Strait*, 515.

41 Ron Brower Sr., Jane Brower, and Kenneth Toovak, project consultation, Alaska Native Collections: Sharing Knowledge, 2002.

42 Dall, *Alaska and Its Resources*, 22; Murdoch, *Ethnological Results of the Point Barrow Expedition*, 110, 300; Nelson, *The Eskimo about Bering Strait*, 40; Ray, "The Eskimo of St. Michael and Vicinity," 36, 44, 107; Thornton, *Among the Eskimos of Wales, Alaska*, 17.

43 Dall, *Alaska and Its Resources*, 22; Murdoch, *Ethnological Results of the Point Barrow Expedition*, 111, 174; Nelson, *The Eskimo about Bering Strait*, 30; Ray, "The Eskimo of St. Michael and Vicinity," 37, 39, 108; Simpson, "Observations on the Western Eskimo," 242; Thornton, *Among the Eskimos of Wales, Alaska*, 17.

44 Spencer, "The North Alaskan Eskimo," 348.

45 Murdoch, *Ethnological Results of the Point Barrow Expedition*, 372.

ST. LAWRENCE ISLAND YUPIK

1 Moore, "Social Life of the Eskimo of St. Lawrence Island," 358–59; Oozeva, "Hunting in Gambell Years Ago," 139–41; Silook, *Seevookuk*, 46–47.

2 Oozeva, "Hunting in Gambell Years Ago," 141.

3 Nelson, *The Eskimo about Bering Strait*, 134–35, pl. LI-14.

4 Silook, *Seevookuk*, 51–52.

5 Bogoras, *The Chukchee*, 143–45.

6 Estelle Oozevaseuk, project consultation, Alaska Native Collections: Sharing Knowledge, 2001.

7 Krupnik, Walunga, and Metcalf, eds., *Akuzilleput Igaqullghet*, 147.

8 Giddings, "Kobuk River People," 140; Hughes, "The Eskimos," 7; Moore, "Social Life of the Eskimo of St. Lawrence Island," 341–42; Nelson, *The Eskimo about Bering Strait*, 31; Ray, ed., "The Eskimo of St. Michael and Vicinity," 40; Silook, *Seevookuk*, 20.

9 Aningayou, "Starvation at Southwest Cape," 57.

10 Paige et al., *Subsistence Use of Birds in the Bering Strait Regions*.

11 Estelle Oozevaseuk, project consultation, Alaska Native Collections: Sharing Knowledge, 2001.

12 Silook, *Seevookuk*, 20.

13 Hughes, *An Eskimo Village*, 101–7.

14 Kiyuklook, "Hunting Walrus the Eskimo Way," 183–85; Hughes, *An Eskimo Village*, 101–7; Krupnik, Walunga, and Metcalf, eds. *Akuzilleput Igaqullghet*, 158.

15 Silook, *Seevookuk*, 61.

16 Oozeva, "Hunting in Gambell Years Ago," 137.

17 Nelson, *The Eskimo about Bering Strait*, 208–9.

18 Ibid., 215–16.

19 Branson Tungiyan, project consultation, Alaska Native Collections: Sharing Knowledge, 2001.

20 Collins, *Archeology of St. Lawrence Island*, 134; Rainey, *Eskimo Prehistory*, 502.

21 Silook, *Seevookuk*, 32.

22 Bockstoce, *Eskimos of Northwest Alaska*, 71; Bogoras, *The Chukchee*, 56–59; Fitzhugh and Crowell, eds., *Crossroads of Continents*, 234–8; Fitzhugh and Kaplan, *Inua*, 164–65; Gordon, "Notes on the Western Eskimo," 74; Michael, ed., *Lieutenant Zagoskin's Travels*, 100; Murdoch, *Ethnological Results of the Point Barrow Expedition*, 65; Nelson, *The Eskimo about Bering Strait*, 228–29, 271; Ray, ed., "The Eskimo of St. Michael and Vicinity," 9, 45.

23 Bogoras, *The Chukchee*, 202; Fitzhugh and Crowell, *Crossroads of Continents*, 235; Nelson, *The Eskimo about Bering Strait*, 280.

24 Ray, *Eskimo Art*, 50.

25 Silook, *Seevookuk*, 17.

26 Bogoras, *The Chukchee*, 202; Nelson, *The Eskimo about Bering Strait*, 284–85.

27 Aningayou, "Starvation at Southwest Cape," 57.

28 Bogoras, *The Chukchee*, 226.

29 Estelle Oozevaseuk, project consultation, Alaska Native Collections: Sharing Knowledge, 2001.

30 Geist and Rainey, *Archaeological Excavations at Kukulik*, 30–31, 123; Fair, "Eskimo Dolls," 51; Lee, ed., *Not Just a Pretty Face*, 36.

31 Geist and Rainey, *Archaeological Excavations at Kukulik*, 30–31.

32 Vera Kaneshiro, project translation, Alaska Native Collections: Sharing Knowledge, 2003.

33 Fair, "Eskimo Dolls," 51; Lee, ed., *Not Just a Pretty Face*, 36.

34 Bogoras, *The Chukchee*, 54–55, 161–68; Burch, "Eskimo Warfare in Northwest Alaska"; Burch, "War and Trade"; Jochelson, "The Koryak," 558–62; Nelson, *The Eskimo about Bering Strait*, 327–30;

VanStone, "Protective Hide." Telescoping hide armor was confined to the Chukchi and the Siberian and St. Lawrence Island Yupiget, whereas plate armor was more widely distributed. Designs for northern armor may have all derived from Japanese models, and some actual pieces of Japanese armor were owned by historic Chukchi (Bogoras, *The Chukchee*, 54–55, 161–68; Collins, *Archeology of St. Lawrence Island*, 325–26; VanStone, "Protective Hide"). At least one man on St. Lawrence Island owned a suit of Asian metal plate armor (Geist and Rainey, *Archaeological Excavations at Kukulik*, 134; Geist, "Notes regarding the Famine and Epidemics on St. Lawrence Island," 238).

35 Doty, "The Eskimo on St. Lawrence Island," 187–88; VanStone, "Protective Hide," 16; Silook, *Seevookuk*, 4–6, 10–13.

36 Silook, *Seevookuk*, 11.

37 Ibid. 11.

38 Angela Larson (project consultation, Alaska Native Collections: Sharing Knowledge, 2009) gave the name *kakak*; Elaine Kingeekuk (project consultation, Alaska Native Collections: Sharing Knowledge, 2007) suggested *quultaq*.

39 Turner, *Hair Embroidery in Siberia and North America*.

40 Apassingok, Walunga, and Tennant, eds., *Gambell*, 70, 77; Bogoras, *The Chukchee*, 219–20; Geist and Rainey, *Archaeological Excavations at Kukulik*, 14.

41 Apassingok, Walunga, and Tennant, eds., *Gambell*, 31, 36, 70, 74, 77.

42 Angela Larson, project consultation, Alaska Native Collections: Sharing Knowledge, 2009.

43 Apassingok, Walunga, and Tennant, eds., *Gambell*, 70.

44 Oakes and Riewe, *Spirit of Siberia*, 155–61; Ungott, "How Clothing Was Sewn and Used Long Ago," 95–127.

45 Information about these boots provided by Estelle Oozevaseuk, project consultation, Alaska Native Collections: Sharing Knowledge, 2001.

46 Vera Kaneshiro, project consultation, Alaska Native Collections: Sharing Knowledge, 2002.

47 Ungott, "How Clothing Was Sewn and Used Long Ago," 97.

48 Nelson, *The Eskimo about Bering Strait*, 342–44; Fitzhugh and Kaplan, *Inua*, 153–57; Lee, ed., *Not Just a Pretty Face*.

49 Elaine Kingeekuk, project consultation, Alaska Native Collections: Sharing Knowledge, 2007.

50 Lee, ed., *Not Just a Pretty Face*, 23.

51 Boas, "The Central Eskimo," 567; Mathiassen, "Archaeology of the Central Eskimos," 117–18; Murdoch, *Ethnological Results of the Point Barrow Expedition*, 364–65.

52 Estelle Oozevaseuk, project consultation, Alaska Native Collections: Sharing Knowledge, 2001.

53 Material identifications by Estelle Oozevaseuk (2001) and Elaine Kingeekuk (2007), project consultations, Alaska Native Collections: Sharing Knowledge.

54 Moore, "Social Life of the Eskimo of St. Lawrence Island," 342; Ungott, "How Clothing Was Sewn and Used Long Ago."

55 Blassi, "The Whale Hunt"; Crowell and Oozevaseuk, "The St. Lawrence Island Famine and Epidemic"; Doty, "The Eskimo on St. Lawrence Island," 200; Hughes, "Eskimo Ceremonies"; Hughes, "Saint Lawrence Island Eskimo," 274–75; Silook, *Seevookuk*, 18–20; Victor-Howe, "Songs and Dances of the St. Lawrence Island Eskimos," 180.

56 Bogoras, *The Chukchee*, 247.

57 Hughes, "Eskimo Ceremonies," 71–88; Krupnik, Walunga, and Metcalf, eds., *Akuzilleput Igaqullghet*, 319–22; Victor-Howe, "Songs and Dances of the St. Lawrence Island Eskimos," 180–81.

58 Krupnik, Walunga, and Metcalf, eds., *Akuzilleput Igaqullghet*, 169–170; Silook, *Seevookuk*, 7–10.

59 Moore, "Social Life of the Eskimo of St. Lawrence Island," 365–66.

60 Nelson, *The Eskimo about Bering Strait*, 38–39.

61 Silook, *Seevookuk*, 7.

62 Moore, "Social Life of the Eskimo of St. Lawrence Island," 319–21; Hughes, "Eskimo Ceremonies," 84–86; Rookok, "Memories of My Girlhood," 143–45.

63 Rookok, "Memories of My Girlhood," 145.

64 Bogoras, *The Chukchee*, 271; Silook, *Seevookuk*, 24.

65 Oovi, "How Gambell Was a Long Time Ago," 25.

66 Branson Tungiyan and Estelle Oozevaseuk, project consultation, Alaska Native Collections: Sharing Knowledge, 2001.

YUP'IK

1 Black, *Glory Remembered*, 46–62; Fienup-Riordan, *Ciuliamta Akliut*, 245–51; Fienup-Riordan, *Yuungnaqpiallerput*, 131; Nelson, *The Eskimo about Bering Strait*, 167–69.

2 Chuna McIntyre, project consultation, Alaska Native Collections: Sharing Knowledge, 2007.

3 Lantis, "The Social Culture of the Nunivak Eskimo," 157.

4 Fienup-Riordan, *Ciuliamta Akliut*, 245–47.

5 Fienup-Riordan, "The Bird and the Bladder"; Fienup-Riordan, *Boundaries and Passages*, 128–40.

6 Curtis, *The North American Indian*, 20: 30; Fienup-Riordan, *Boundaries and Passages*, 129; Fienup-Riordan, *Ciuliamta Akliut*, 244–49; Fienup-Riordan, *Yuungnaqpiallerput*, 127–31; Lantis, "The Social Culture of the Nunivak Eskimo," 172.

7 John Phillip Sr., project consultation, Alaska Native Collections: Sharing Knowledge, 2002.

8 Black, *Glory Remembered*, 63; Fienup-Riordan, *Boundaries and Passages*, 129; Fienup-Riordan, *Yup'ik Elders*, 205–7; Michael, ed., *Lieutenant Zagoskin's Travels*, 114; Nelson, *The Eskimo about*

Bering Strait, 167; John Phillip Sr., project consultation, Alaska Native Collections: Sharing Knowledge, 2002.

9 Fienup-Riordan, *The Living Tradition of Yup'ik Masks*; Fienup-Riordan, *Agayuliyararput*, 164–66.

10 Lantis, *Alaskan Eskimo Ceremonialism*, 152; Curtis, *The North American Indian*, 20: 30; Fienup-Riordan, *Boundaries and Passages*, 91.

11 Fienup-Riordan, *Yuungnaqpiallerput*, 127–31.

12 Fienup-Riordan, *Boundaries and Passages*, 129.

13 Curtis, *The North American Indian*, 20: 79–80.

14 Fienup-Riordan, *Yup'ik Elders*, 68–69; Fienup-Riordan, *Yuungnaqpiallerput*, 107; Nelson, *The Eskimo about Bering Strait*, 128–30.

15 Fienup-Riordan, *The Living Tradition of Yup'ik Masks*, 77, 180.

16 Fienup-Riordan, *Ciuliamta Akliut*, 277.

17 Fienup-Riordan, *Yup'ik Elders*, 69–71; Fienup-Riordan, *Yuungnaqpiallerput*, 94–97; Himmelheber, *Eskimo Artists*, 44.

18 Fienup-Riordan, *Yuungnaqpiallerput*, 97.

19 Fienup-Riordan, *Boundaries and Passages*, 94–97.

20 Fienup-Riordan, *Yup'ik Elders*, 71.

21 Beaver et al., eds., *Skin Sewing for Clothing in Akula*, 22; Fienup-Riordan, *The Yup'ik Eskimos*, 11–12; Fienup-Riordan, *Ciuliamta Akliut*, 151–53.

22 Chaussonnet, "Needles and Animals," 212.

23 Fitzhugh and Kaplan, *Inua*, 130; Fienup-Riordan, *The Living Tradition of Yup'ik Masks*, 133.

24 Chaussonnet and Driscoll, "The Bleeding Coat," 110.

25 Beaver et al., eds., *Skin Sewing for Clothing in Akula*, 78.

26 Nelson, *The Eskimo about Bering Strait*, 32–34.

27 Beaver et al., eds., *Skin Sewing for Clothing in Akula*, 4; Nelson, *The Eskimo about Bering Strait*, 32–34; Michael, ed., *Lieutenant Zagoskin's Travels*, 211–12; Varjola, *The Etholén Collection*, 256–57.

28 Michael, ed., *Lieutenant Zagoskin's Travels*, 211–12.

29 Curtis, *The North American Indian*, 20: 69; Lantis, *Alaskan Eskimo Ceremonialism*, 57.

30 Chuna McIntyre, project consultation, Alaska Native Collections: Sharing Knowledge, 2007.

31 Materials identified by Neva Rivers, Joan Hamilton, and John Phillip Sr., project consultation, Alaska Native Collections: Sharing Knowledge, 2002.

32 Beaver et al., eds., *Skin Sewing for Clothing in Akula*, 2; Curtis, *The North American Indian*, 20: 11; Nelson, *The Eskimo about Bering Strait*, 40–42; Ray, ed., "The Eskimo of St. Michael and Vicinity as Related by H. M. W. Edmonds," 36–39; Varjola, *The Etholén Collection*, 260–61.

33 Chaussonnet and Driscoll, "The Bleeding Coat"; another example is the use of animal head skins to make parka hoods (see ibid., 111).

34 Nelson, *The Eskimo about Bering Strait*, 41; additional materials identifications by Neva Rivers, Joan Hamilton, and John Phillip Sr., project consultation, Alaska Native Collections: Sharing Knowledge, 2002.

35 Fienup-Riordan, *Yup'ik Elders*, 135–37; Fitzhugh and Kaplan, *Inua*, 43; Graburn, Lee, and Rousselot, eds., *Catalogue Raisonné of the Alaska Commercial Company Collection*, 209; Krech, *A Victorian Earl in the Arctic*, 118; Michael, ed., *Lieutenant Zagoskin's Travels*, 205; Nelson, *The Eskimo about Bering Strait*, 38–44.

36 Fienup-Riordan, *Boundaries and Passages*, 299–304; Lantis, *Alaskan Eskimo Ceremonialism*, 24; Ray, ed., The Eskimo, 122.

37 Nelson, *The Eskimo about Bering Strait*, 43–44; materials identified by Neva Rivers, Joan Hamilton, and John Phillip Sr., project consultation, Alaska Native Collections: Sharing Knowledge, 2002.

38 Fienup-Riordan, *Ciuliamta Akliut*, 143.

39 Nelson, *The Eskimo about Bering Strait*, 71; Fitzhugh and Kaplan, *Inua*, 190.

40 Curtis, *The North American Indian*, 20: 58–59; Fienup-Riordan, *Ciuliamta Akliut*, 137–139; Fienup-Riordan, *Yuungnaqpiallerput*, 298–302; Krech, *A Victorian Earl in the Arctic*, 119–21; Lantis, "Folk Medicine and Hygiene," 28; Nelson, *The Eskimo about Bering Strait*, 70–72.

41 Curtis, *The North American Indian*, 20: 59; Fienup-Riordan, *Ciuliamta Akliut*, 31; Himmelheber, *Eskimo Artists*, 24–25. Curtis wrote, "These symbols, which are handed down from eldest son to eldest son with the family names, are derived from some great deed done in the past at the time when the family name originated, and they also represent animal, bird, and fish spirit-powers" (59).

42 Fienup-Riordan, *The Yup'ik Eskimos*, 20–21, 36–37; Fienup-Riordan, *Yuungnaqpiallerput*, 37–38; Lantis, "The Social Culture of the Nunivak Eskimo," 160.

43 Fienup-Riordan, The Yup'ik Eskimos, 16; Fienup-Riordan *Yuungnaqpiallerput*, 66–68; Lantis, "The Social Culture of the Nunivak Eskimo," 157.

44 Fienup-Riordan, *The Yup'ik Eskimos*, 468; Fienup-Riordan, *Boundaries and Passages*, 270–75; Himmelheber, *Eskimo Artists*, 15–16, 24, 68–72; Lantis, "The Social Culture of the Nunivak Eskimo," 182–83.

45 Fienup-Riordan, *Boundaries and Passages*, 96–98.

46 Curtis, *The North American Indian*, 20: 41; Fitzhugh and Kaplan, *Inua*, 168, 171; Hoffman, *The Graphic Art of the Eskimos*, 783; Krech, *A Victorian Earl in the Arctic*, 96–97; Nelson, *The Eskimo about Bering Strait*, 85–86; Ray, ed., *The Eskimo*, 54, 110.

47 Fitzhugh and Kaplan, *Inua*, 168, 171–72; Hoffman, *The Graphic Art of the Eskimos*, 783; Nelson, *The Eskimo about Bering Strait*, 85–86; Ray, ed., *The Eskimo*, 54, 110.

48 Fienup-Riordan, *Yup'ik Elders*, 116–19; Fienup-Riordan, *Ciuliamta Akliut*, 99–109; Michael, ed., *Lieutenant Zagoskin's Travels*, 218; Nelson, *The Eskimo about Bering Strait*, 273–75.

49 Fienup-Riordan, *Ciuliamta Akliut*, 99.
50 Fitzhugh and Kaplan, *Inua*, 166; Nelson, *The Eskimo about Bering Strait*, 274.
51 Fienup-Riordan, *The Nelson Island Eskimo*, 217–18; Fienup-Riordan, *Boundaries and Passages*, 162–63; Fienup-Riordan, *Yup'ik Elders*, 254–61.
52 Nelson, *The Eskimo about Bering Strait*, 331, 342–45.
53 Fienup-Riordan, *The Yup'ik Eskimos*, 42; Fienup-Riordan, *Boundaries and Passages*, 126; Fienup-Riordan *Ciuliamta Akliut*, 329.
54 Fienup-Riordan, *The Nelson Island Eskimo*, 217–18.
55 Fienup-Riordan, *The Yup'ik Eskimos*, 17.
56 Fienup-Riordan, *Yup'ik Elders*, 252–54; Himmelheber, *Eskimo Artists*, 28–30; Lantis, "The Social Culture of the Nunivak Eskimo," 214–15; Nelson, *The Eskimo about Bering Strait*, 344–45.
57 Neva Rivers, project consultation, Alaska Native Collections: Sharing Knowledge, 2002.
58 Nelson, *The Eskimo about Bering Strait*, 345–46.
59 Ibid., 373.
60 Fienup-Riordan, *Ciuliamta Akliut*, 321.
61 Fienup-Riordan, *Boundaries and Passages*, 336–38; Fienup-Riordan, *The Living Tradition of Yup'ik Masks*, 137–38; Morrow, "It Is Time for Drumming," 131–35.
62 Fienup-Riordan, *The Living Tradition of Yup'ik Masks*, 135; Lantis, "The Social Culture of the Nunivak Eskimo," 224, 233.
63 Fienup-Riordan, *When Our Bad Season Comes*, 191–202; Fienup-Riordan, *Boundaries and Passages*, 324.
64 Curtis, *The North American Indian*, 20: 67–71; Fienup-Riordan, *Boundaries and Passages*, 324–47; Lantis, "The Social Culture of the Nunivak Eskimo," 188–92; Lantis, *Alaskan Eskimo Ceremonialism*, 67–72; Morrow, "It Is Time for Drumming," 131–35; Nelson, *The Eskimo about Bering Strait*, 361–63; Ostermann and Holtved, eds. "The Alaskan Eskimos," 267–75.
65 Fienup-Riordan, *Boundaries and Passages*, 332–33; Lantis, *Alaskan Eskimo Ceremonialism*, 191.
66 Curtis, *The North American Indian*, 20: 12; Gordon, "Notes on the Western Eskimo," 81; Nelson, *The Eskimo about Bering Strait*, 52–56.
67 Nelson, *The Eskimo about Bering Strait*, 44–50, 53.
68 Fienup-Riordan, *The Living Tradition of Yup'ik Masks*, 133.
69 Lantis, "The Social Culture of the Nunivak Eskimo," 225.
70 Fienup-Riordan, *The Living Tradition of Yup'ik Masks*, 164–66.
71 Ibid., 15–19.
72 Nelson, *The Eskimo about Bering Strait*, 407.
73 Fienup-Riordan, *The Living Tradition of Yup'ik Masks*, 67.
74 Ibid., 85–87.
75 Fienup-Riordan, *Boundaries and Passages*, 62–76; Fienup-Riordan, *The Living Tradition of Yup'ik Masks*, 176; Fienup-Riordan, *Ciuliamta Akliut*, 289–99.
76 Fienup-Riordan, *The Living Tradition of Yup'ik Masks*, 233.
77 Ibid., 77–84; Fienup-Riordan, *Agayuliyararput*, 49–55.
78 Kelek is also called Itruka'ar, Agayuyaraq, and, in historical sources, the Inviting-In Feast or Masquerade.
79 Fienup-Riordan, *Boundaries and Passages*, 304–23; Fienup-Riordan, *The Living Tradition of Yup'ik Masks*, 40–41; Michael, ed., *Lieutenant Zagoskin's Travels*, 228; Morrow, "It Is Time for Drumming," 136–39; Nelson, *The Eskimo about Bering Strait*, 358–59.
80 Fienup-Riordan, *Ciuliamta Akliut*, 275.
81 Fienup-Riordan, *The Living Tradition of Yup'ik Masks*, 66–69.
82 Fienup-Riordan, *Boundaries and Passages*, 307; Nelson, *The Eskimo about Bering Strait*, 430, 494–97.
83 Fienup-Riordan, *The Living Tradition of Yup'ik Masks*, 77.

UNANGA^X

1 Black, *Glory Remembered*; Black, *Aleut Art*, 123–43; Chirikov, "An Extract from the Report of Alekseii I Chirikov" ; Coxe, *The Russian Discoveries between Asia and America*, 151; Jochelson, *History, Ethnology, and Anthropology of the Aleut*, 10; Krenitsyn and Levashev, "An Extract from the Journals," 248; Laughlin, *Aleuts: Survivors*, 57; Liapunova, *Essays on the Ethnography of the Aleuts*, 216–34; Litke, *A Voyage around the World*, 184; Veniaminov, *Notes on the Islands of the Unalashka District*, 269–70.
2 Black, *Glory Remembered*, 36–41, Ivanov, "Aleut Hunting Headgear and Its Ornamentation."
3 Bergsland and Dirks, eds., *Niig^ug^im Hilaqulingis*, 159, 171; Black, *Aleut Art*, 37–39; Crowell, "Alutiiq (Koniag Eskimo) Poison Dart Whaling," 217–42; Langsdorff, *Remarks and Observations on a Voyage around the World*, 2:20; Liapunova, *Essays on the Ethnography of the Aleuts*, 107; Litke, *A Voyage around the World* 169, 219; Merck, *Siberia and Northwestern America*, 71–73; Veniaminov, *Notes on the Islands of the Unalashka District*, 223–24.
4 Veniaminov, *Notes on the Islands of the Unalashka District*, 223–24.
5 Ibid., 267–68.
6 Materials identified by Maria Turnpaugh and Mary Bourdukovsky, project consultation, Alaska Native Collections: Sharing Knowledge, 2003.
7 Hudson, ed., *Unugulux Tunusangin, Oldtime Stories*, 146.
8 Jochelson, *History, Ethnology, and Anthropology of the Aleut*, 20.
9 Veniaminov, *Notes on the Islands of the Unalashka District*, 268.
10 Bergsland and Dirks, eds., *Unangam Ungiikangin kayux Tunusangin*, 111; Black, *Aleut Art*, 152–55; Laughlin, *Aleuts: Survivors*, 56; Liapunova, *Essays on the Ethnography of the Aleuts*, 205–9; Merck, *Siberia and Northwestern America*, 71; Sauer, *An Account of the Geographical and Astronomical Expedition*, 156.

11 Hudson, ed., *Unugulux Tunusangin, Oldtime Stories*, 200.
12 Liapunova, *Essays on the Ethnography of the Aleuts*, 205–9.
13 Black, *Aleut Art*, 152–53; Liapunova, *Essays on the Ethnography of the Aleuts*, 207, 210; Merck, *Siberia and Northwestern America*, 77.
14 Liapunova, *Essays on the Ethnography of the Aleuts*, 210; Merck, *Siberia and Northwestern America*, 77; Sarychev, *Account of a Voyage of Discovery*, 2:8.
15 Beaglehole, ed., "The Journals of Captain James Cook," 393; Langsdorff, *Remarks and Observations on a Voyage around the World*, 2:16; Liapunova, *Essays on the Ethnography of the Aleuts*, 197; Merck, *Siberia and Northwestern America*, 77–79; Sauer, *An Account of the Geographical and Astronomical Expedition*, 156.
16 Beaglehole, ed., "The Journals of Captain James Cook," 1426–27; Liapunova, *Essays on the Ethnography of the Aleuts*, 193–96; Sauer, *An Account of the Geographical and Astronomical Expedition*, 155.
17 Beaglehole, ed., "The Journals of Captain James Cook," 459, 1145; Bergsland and Dirks, eds., *Unangam Ungiikangin kayux Tunusangin*, 425; Cherepanov, "The Account of the Totma Merchant," 210–11; Coxe, *The Russian Discoveries between Asia and America*, 103–5, 152; Jochelson, *History, Ethnology, and Anthropology of the Aleut*, 8, 10; Liapunova, *Essays on the Ethnography of the Aleuts*, 193, 197; Netsvetov, *The Journals of Iakov Netsvetov*, 35–36; Sauer, *An Account of the Geographical and Astronomical Expedition*, 156; Veniaminov, *Notes on the Islands of the Unalashka District*, 266–67, 360; Ziakov, "A Report on the Voyage of Potap K. Zaikov," 265.
18 Laughlin, *Aleuts: Survivors*, 55–56; Liapunova, *Essays on the Ethnography of the Aleuts*, 197.
19 Veniaminov, *Notes on the Islands of the Unalashka District*, 266.
20 Dyson, *Baidarka*; Laughlin, *Aleuts: Survivors*, 34–37; Sauer, *An Account of the Geographical and Astronomical Expedition*, 157; Veniaminov, *Notes on the Islands of the Unalashka District*, 270–75; Zimmerly, *QAJAQ*.
21 Veniaminov, *Notes on the Islands of the Unalashka District*, 271.
22 Laughlin, *Aleuts: Survivors*, 34.
23 Beaglehole, ed., "The Journals of Captain James Cook," 463; Chirikov, "An Extract from the Report of Alekseii I Chirikov," 135; Corney, *Early Voyages in the North Pacific*, 139; Merck, *Siberia and Northwestern America*, 172; Veniaminov, *Notes on the Islands of the Unalashka District*, 272. James Cook wrote in 1778 that Unalaska kayakers using such paddles could "go at a great rate and in a direction as straight as a line can be drawn" (Beaglehole, ed., "The Journals of Captain James Cook," 463).
24 Laughlin, *Aleuts: Survivors*, 37.
25 Veniaminov, *Notes on the Islands of the Unalashka District*, 224.
26 Sauer, *An Account of the Geographical and Astronomical Expedition*, 157.
27 Langsdorff, *Remarks and Observations on a Voyage around the World*, 2: 19; Liapunova, *Essays on the Ethnography of the Aleuts*, 117–21; Veniaminov, *Notes on the Islands of the Unalashka District*, 206, 275.
28 Liapunova, *Essays on the Ethnography of the Aleuts*, 120–21; Veniaminov, *Notes on the Islands of the Unalashka District*, 275.
29 Liapunova, *Essays on the Ethnography of the Aleuts*, 118–20.
30 Corney, *Early Voyages in the North Pacific*, 140; Langsdorff, *Remarks and Observations on a Voyage around the World*, 2: 19; Litke, *A Voyage around the World*, 171–72.
31 Black, *Atka*, 56–57; Hrdlička, *The Aleutian and Commander Islands*, 144; Veniaminov, *Notes on the Islands of the Unalashka District*, 204–10, 248–50.
32 Black, *Russians in Alaska, 1732–1867*; Coxe, *The Russian Discoveries between Asia and America*; Veniaminov, *Notes on the Islands of the Unalashka District*, 250–56.
33 Bergsland and Dirks, eds., *Unangam Ungiikangin kayux Tunusangin*, 403–5; Veniaminov, *Notes on the Islands of the Unalashka District*, 203–5, 371–73.
34 Bergsland and Dirks, eds., *Unangam Ungiikangin kayux Tunusangin*, 441–47.
35 Ibid., 445, 475–77.
36 Hrdlička, *The Aleutian and Commander Islands*, 146–48; Jochelson, *Archeological*, 23; Liapunova, *Essays on the Ethnography of the Aleuts*, 162; Veniaminov, *Notes on the Islands of the Unalashka District*, 264, 372.
37 Jochelson, *Archeological*, 54–55; Veniaminov, *Notes on the Islands of the Unalashka District*, 209–10, 373.
38 Jochelson, *Archeological*, 54–55; Veniaminov, *Notes on the Islands of the Unalashka District*, 210.
39 Hrdlička, *The Aleutian and Commander Islands*, 135–36, 235–43.
40 Quoted in Hrdlička, *The Aleutian and Commander Islands*, 128.
41 Langsdorff, *Remarks and Observations on a Voyage around the World*, 2:16; Merck, *Siberia and Northwestern America*, 77; Sarychev, *Account of a Voyage of Discovery*, 8; Sauer, *An Account of the Geographical and Astronomical Expedition*, 156; Veniaminov, *Notes on the Islands of the Unalashka District*, 267.
42 Langsdorff, *Remarks and Observations on a Voyage around the World*, 2:16.
43 From the story "Luung" (Bergsland and Dirks, eds., *Unangam Ungiikangin kayux Tunusangin*, 467).
44 Jochelson, *Archeological*, 63.
45 Veniaminov, *Notes on the Islands of the Unalashka District*, 285.
46 Merck, *Siberia and Northwestern America*, 76–77.
47 Beaglehole, ed., "The Journals of Captain James Cook," 1146.
48 Varjola, *The Etholén Collection*, 190–93.
49 Hrdlička, *The Aleutian and Commander Islands*, 63, 121.
50 Beaglehole, ed., "The Journals of Captain James Cook," 462, 1146;

Langsdorff, *Remarks and Observations on a Voyage around the World*, 2:21; Sarychev, *Account of a Voyage of Discovery*, 2:8.

51 Black, *Aleut Art*, 161; Liapunova, *Essays on the Ethnography of the Aleuts*, 150, 193; Pinart, *La caverne d'Aknanh*, 17; Veniaminov, *Notes on the Islands of the Unalashka District*, 287.

52 Black, *Aleut Art*; Shapsnikoff and Hudson, "Aleut Basketry."

53 Black, *Aleut Art*, 165; Beaglehole, ed., "The Journals of Captain James Cook," 461; Cherepanov, "The Account of the Totma Merchant," 209; Veniaminov, *Notes on the Islands of the Unalashka District*, 280.

54 Black, *Aleut Art*, 170.

55 Ibid., 167; Liapunova, *Essays on the Ethnography of the Aleuts*, 188; Shapsnikoff and Hudson, "Aleut Basketry," 59–60.

56 Black, *Aleut Art*, 167; Dall, "On the Remains of Later Pre-Historic Man," 12.

57 Shapsnikoff and Hudson, "Aleut Basketry," 44.

58 Hudson, ed., *Unugulux Tunusangin, Oldtime Stories*, 207–8; Liapunova, *Essays on the Ethnography of the Aleuts*, 189–91; Sarychev, *Account of a Voyage of Discovery*, 2:8; Shapsnikoff and Hudson, "Aleut Basketry," 45–46.

59 Black, *Aleut Art*, 161–67; Liapunova, *Essays on the Ethnography of the Aleuts*, 182–88; Mason, "Basket-Work of the North American Aborigines"; Shapsnikoff and Hudson, "Aleut Basketry," 51–56.

60 Black, *Aleut Art*, 162; Hrdlička, *The Aleutian and Commander Islands*, 116; Liapunova, *Essays on the Ethnography of the Aleuts*, 180–93.

61 Coxe, *The Russian Discoveries between Asia and America*, 104.

62 Jochelson, *History, Ethnology, and Anthropology of the Aleut*, 8, 11; Langsdorff, *Remarks and Observations on a Voyage around the World*, 2:13; Merck, *Siberia and Northwestern America*, 81; Sarychev, *Account of a Voyage of Discovery*, 2:8; Veniaminov, *Notes on the Islands of the Unalashka District*, 263.

63 Dall, "On the Remains of Later Pre-Historic Man"; Hrdlička, *The Aleutian and Commander Islands*, 184–94; Jochelson, *Archaeological Investigations in the Aleutian Islands*, 42; Laughlin, *Aleuts: Survivors*, 96, 99.

64 Black, *Aleut Art*, 162.

65 Shapsnikoff and Hudson, "Aleut Basketry," 48.

66 Black, *Aleut Art*, 163; Merck, *Siberia and Northwestern America*, 71, 173.

67 Black, *Aleut Art*, 160; Varjola, *The Etholén Collection*, 182.

68 Coxe, *The Russian Discoveries between Asia and America*, 151; Liapunova, *Essays on the Ethnography of the Aleuts*, 225–33; Merck, *Siberia and Northwestern America*, 69; Sarychev, *Account of a Voyage of Discovery*, 2:62; Varjola, *The Etholén Collection*, 177–81; Veniaminov, *Notes on the Islands of the Unalashka District*, 270.

69 Cherepanov, "The Account of the Totma Merchant," 209; Coxe, *The Russian Discoveries between Asia and America*, 154, 172; Jochelson, *History, Ethnology, and Anthropology of the Aleut*, 12; Krenitsyn and Levashev, "An Extract from the Journals," 247; Langsdorff, *Remarks and Observations on a Voyage around the World*, 2:22; Merck, *Siberia and Northwestern America*, 69–70; Sarychev, *Account of a Voyage of Discovery*, 61–63; Veniaminov, *Notes on the Islands of the Unalashka District*, 198–203, 307, 371; Zaikov, "A Report on the Voyage of Potap K. Zaikov," 265.

70 Hudson, ed., *Unugulux Tunusangin, Oldtime Stories*, 114; Merck, *Siberia and Northwestern America*, 69.

71 Jochelson, *History, Ethnology, and Anthropology of the Aleut*, 12.

72 Coxe, *The Russian Discoveries between Asia and America*, 172.

73 Bergsland and Dirks, eds., *Unangam Ungiikangin kayux Tunusangin*, 463; Laughlin, *Aleuts: Survivors*, 96.

74 Veniaminov, *Notes on the Islands of the Unalashka District*, 207, 219.

75 Hudson, ed., *Unugulux Tunusangin, Oldtime Stories*, 114–15.

76 Krenitsyn and Levashev, "An Extract from the Journals," 247; Merck, *Siberia and Northwestern America*, 69.

77 From the story of Uĝdigdang (Bergsland and Dirks, eds., *Unangam Ungiikangin kayux Tunusangin*, 463).

78 Merck, *Siberia and Northwestern America*, 69.

79 Sarychev, *Account of a Voyage of Discovery*, 62.

80 Veniaminov, *Notes on the Islands of the Unalashka District*, 198–202.

81 Coxe, *The Russian Discoveries between Asia and America*, 154, 172; Jochelson, *History, Ethnology, and Anthropology of the Aleut*, 12; Krenitsyn and Levashev, "An Extract from the Journals," 247; Merck, *Siberia and Northwestern America*, 69–71; Sarychev, *Account of a Voyage of Discovery*, 61–63; Zaikov, "A Report on the Voyage of Potap K. Zaikov," 265.

82 Coxe, *The Russian Discoveries between Asia and America*, 154.

83 Veniaminov, *Notes on the Islands of the Unalashka District*, 202.

84 Black, *Aleut Art*, 89.

85 Ibid., 79–87; Dall, "On the Remains of Later Pre-Historic Man"; Pinart, *La caverne d'Aknanh*.

SUGPIAQ

1 Davydov, *Two Voyages to Russian America*, 153; Sauer, *An Account of a Geographical and Astronomical Expedition*, 199; Shelikhov, *A Voyage to America*, 54.

2 Black, *Glory Remembered*, 30–41; Black, "Deciphering Aleut/Koniag Iconography"; Crowell, Steffian, and Pullar, eds., *Looking Both Ways*, 155–58; Golder, *Tales from Kodiak*, part 2, 16–19, 90–95; Hunt, "The Ethnohistory of Alutiiq Clothing," 126–31; Ivanov, "Aleut Hunting Headgear and Its Ornamentation," 488–89.

3 Black, *Glory Remembered*, 30–31; Varjola, *The Etholén Collection*, 172–75.

4 Smithsonian collector William J. Fisher recorded, "These hats are supposed to have the power of attracting sea otters, and by parting with the hat they also part with all luck in getting the animals." Smithsonian Institution Archives Record Unit 305, accession record 14024, 1884.

5 Sven Haakanson Sr., interview with Laurie Mulchahey, 1987, Archives of the Alutiiq Museum and Archaeological Repository, Kodiak.

6 Golder, "Tales from Kodiak Island," part 2, 18.

7 Beaglehole, ed., "The Journals of Captain James Cook," 346; Billings, "Voyage of Mr. Billings," 207; Davydov, *Two Voyages to Russian America*, 153; Lisiansky, *A Voyage round the World*, 194; Merck, *Siberia and Northwestern America*, 102; Shelikhov, *A Voyage to America*, 54; Langsdorff, *Voyages and Travels*, 63.

8 Birket-Smith, "Early Collections from the Pacific Eskimo," 121–63; Birket-Smith, *The Chugach Eskimo*, 66–67; Beaglehole, ed., "The Journals of Captain James Cook," 1112; Davydov, *Two Voyages to Russian America*, 153.

9 Holm, "Art and Culture Change at the Tlingit-Eskimo Border," 285–93.

10 Crowell, Steffian, and Pullar, eds., *Looking Both Ways*, 157.

11 Lisiansky, *Voyage round the World*, 194; Merck, *Siberia and Northwestern America*, 102.

12 Merck, *Siberia and Northwestern America*, 100–101.

13 Davydov, *Two Voyages to Russian America*, 153.

14 Birket-Smith, *The Chugach Eskimo*, 45–49; Davydov, *Two Voyages to Russian America*, 202–4; Holmberg, *Holmberg's Ethnographic Sketches*, 44–45.

15 Davydov, *Two Voyages to Russian America*, 178; De Laguna, *Chugach Prehistory*, 272; Lisiansky, *Voyage round the World* 211; Merck, *Siberia and Northwestern America*, 105.

16 Helmets carved like seal heads were worn by seal hunters at sea and used for decoy hunting on the shore. With the helmet on his head, a hunter would partly conceal himself behind rocks and imitate seal calls and movements to attract a curious animal to within harpoon range. Black, *Glory Remembered*, 23–24; Crowell, Steffian, and Pullar, eds., *Looking Both Ways*, 160; Gideon, *The Round the World Voyage*, 56; Lisiansky, *Voyage round the World*, 205.

17 Merck, *Siberia and Northwestern America*, 105; Beaglehole, ed., "The Journals of Captain James Cook," 1112–13; Birket-Smith, *The Chugach Eskimo*, 47.

18 Merck, *Siberia and Northwestern America*, 105; Beaglehole, ed., "The Journals of Captain James Cook," 1112–13.

19 Beaglehole, ed., "The Journals of Captain James Cook," 349; Birket-Smith, *The Chugach Eskimo*, 48. Alternatively, a gut spray skirt was utilized (Merck, *Siberia and Northwestern America*, 172).

20 Birket-Smith, *The Chugach Eskimo*, 46–47; Crowell, Steffian, and Pullar, eds., *Looking Both Ways*, 145–48.

21 Kenai Peninsula Borough School District, *Alexandrovsk*, 74.

22 Crowell, Steffian, and Pullar, eds., *Looking Both Ways*, 148–49.

23 Kenai Peninsula Borough School District, *Alexandrovsk*, 75–76. Prince William Sound tradition includes the story "The Man with Running Eyes," whose eponymous character visited killer whales in their village (Birket-Smith, *The Chugach Eskimo*, 149–50).

24 Black, *Glory Remembered*, 30–41; Black, "Deciphering Aleut/Koniag Iconography"; and representation in a rock painting at Sadie Cove in Kachemak Bay (Crowell, Steffian, and Pullar, eds., *Looking Both Ways*, 158; De Laguna, *The Archaeology of Cook Inlet*, pl. 68).

25 Kenai Peninsula Borough School District, *Alexandrovsk*, 75.

26 Birket-Smith, *The Chugach Eskimo*, 33.

27 Ibid., 32.

28 Black, *Aleut Art*, 103–5; Crowell, Steffian, and Pullar, eds., *Looking Both Ways*, 163. A Sugpiaq archaeological example was found at Seldovia, in Cook Inlet (De Laguna, *The Archaeology of Cook Inlet*, pl. 52-9).

29 Birket-Smith, *The Chugach Eskimo*, 33; Crowell, Steffian, and Pullar, eds., *Looking Both Ways*, 163–65.

30 Belief that skin boats were living beings was widespread in Alaska, and in the Aleutians the split kayak prow was specifically said to represent a sea otter's head and arms (Laughlin, "Aleuts," 34). The body of any skin boat, with its skeletal frame and skin covering, is homologous to that of an animal.

31 Larry Matfay, interview with Laurie Mulcahey, 1986, Archives of the Alutiiq Museum and Archaeological Repository, Kodiak.

32 Birket-Smith, "Early Collections from the Pacific Eskimo," 146; Birket-Smith, *The Chugiach Eskimo*, 40; Davydov, *Two Voyages to Russian America*, 232–33; Portlock, *Voyage around the World*, 253.

33 Bobby Stamp interview, 1987, in the archives of the Alutiiq Museum and Archaeological Repository; Davydov, *Two Voyages to Russian America*, 233.

34 Billings, "Voyage of Mr. Billings," 206; Davydov, *Two Voyages to Russian America*, 233.

35 Davydov, *Two Voyages to Russian America*, 233.

36 Beaglehole, ed., "The Journals of Captain James Cook," 349–50; Birket-Smith, *The Chugach Eskimo*, 63–66; Crowell, Steffian, and Pullar, eds., *Looking Both Ways*, 46–49; Davydov, *Two Voyages to Russian America*, 150–52; Gideon, *The Round the World Voyage*, 65–67; Holmberg, *Holmberg's Ethnographic Sketches*, 38–40; Merck, *Siberia and Northwestern America*, 122; Shelikhov, *A Voyage to America*, 53–54; Varjola, *The Etholén Collection*; Zaikov, "Journal of Navigator Potap Zaikov," 1–3.

37 Davydov, *Two Voyages to Russian America*, 152; Gideon, *The Round the World Voyage*, 48, quote from 66; Golovnin, *Around the World on the Kamchatka*, 114; Lisiansky, *A Voyage round the World*, 194; Merck, *Siberia and Northwestern America*, 102.

38 Hunt ("The Ethnohistory of Alutiiq Clothing," 87–101) provides a detailed discussion of this parka and its ethnohistorical context.

39 Kodiak skin-sewer Susan Malutin, examining this parka at the National Museum of Natural History, 1996, consultation for *Looking Both Ways: Heritage and Identity of the Alutiiq People*, Kodiak.

40 Klichka, "A Report on the Voyage of Potap K. Zaikov," 265.

41 Beaglehole, ed., "The Journals of Captain James Cook," 1112; Birket-Smith, *The Chugach Eskimo*, 67–68; Davydov, *Two Voyages to Russian America*, 153; Holmberg, *Holmberg's Ethnographic Sketches*, 41; Merck, *Siberia and Northwestern America*, 102.

42 Davydov, *Two Voyages to Russian America*, 153.

43 Birket-Smith, *The Chugach Eskimo*, 68; Lisiansky, *A Voyage round the World*, 194; Shelikhov, *A Voyage to America*, 53. Meares (quoted in Birket-Smith, *The Chugach Eskimo*, 68) said that he observed that barefoot Prince William Sound residents appeared comfortable in winter with the temperature at minus nine degrees Celsius.

44 Birket-Smith, *The Chugach Eskimo*, 67.

45 Interview with Larry Matfay, 1992, by Joanne Mulcahy, Alutiiq Museum and Archaeological Repository, Kodiak, Alaska.

46 Gideon, *The Round the World Voyage*, 50.

47 Davydov, *Two Voyage to Russian Americas*, 165; Lisiansky, *A Voyage round the World*, 202, 207.

48 Hunt, "The Ethnohistory of Alutiiq Clothing," 142–45; Crowell, Steffian, and Pullar, eds., *Looking Both Ways*, 50. Collector William Fisher described this object as a "hunting bag," but it lacks the necessary shoulder strap and capacity; instead it has all the characteristics of a sewing bag, including a rounded flap and string to wrap around the bag when rolled up.

49 Birket-Smith, *The Chugach Eskimo*, 75–79; Davydov, *Two Voyages to Russian America*, 151; De Laguna, *Chugach Prehistory*, 187, 268; Klichka, "A Report on the Voyage of Potap K. Zaikov," 266; Lisiansky, *A Voyage round the World*, 207.

50 Lucille Antowock Davis, interview at the 1997 elders' planning conference for *Looking Both Ways: Heritage and Identity of the Alutiiq People*, Kodiak.

51 Birket-Smith, "Early Collections from the Pacific Eskimo"; Birket-Smith, *The Chugach Eskimo*, 59–62; Crowell, Steffian, and Pullar, eds., *Looking Both Ways*, 39.

52 Holm, "Art and Culture Change at the Tlingit-Eskimo Border," 284.

53 Davydov, *Two Voyages to Russian America*, 187.

54 Holm, "Art and Culture Change at the Tlingit-Eskimo Border," 282–83; Emmons, *The Tlingit Indians*, 174.

55 Merck, *Siberia and Northwestern America*, 207.

56 Martha Demientieff, interview at the 1997 elders' planning conference for *Looking Both Ways: Heritage and Identity of the Alutiiq People*, Kodiak.

57 Pinart, "Eskimaux et Koloches," 23.

58 Crowell, "Postcontact Koniag Ceremonialism."

59 Birket-Smith, *The Chugach Eskimo*, 68; Crowell, "Postcontact Koniag Ceremonialism," 25–26; Fitzhugh and Crowell, eds., *Crossroads of Continents*, 49; Graburn, Lee, Rousselot, *Catalogue Raisonné of the Alaska Commercial Company Collection*, 361; Hunt, "The Ethnohistory of Alutiiq Clothing," 101–16. Sources listed in Hunt's distributional study include Pinart, "Eskimaux et Koloches"; Jacobsen, *Alaskan Voyage*; Curtis, *The North American Indian*, 10; and unpublished records for museum collections by William Fisher, Charles McKay, Johan Jacobsen, and others.

60 Davydov, *Two Voyages to Russian America*, 110; Gideon, *The Round the World Voyage*, 41–42; Holmberg, *Holmberg's Ethnographic Sketches*, 37–38; Merck, *Siberia and Northwestern America*, 103.

61 Birket-Smith, *The Chugach Eskimo*, 68; De Laguna, *Chugach Prehistory*, 216.

62 Hunt, "The Ethnohistory of Alutiiq Clothing."

63 Gideon, *The Round the World Voyage*, 46.

64 Beaglehole, ed., "The Journals of Captain James Cook," 350; Davydov, *Two Voyages to Russian America*, 110; Merck, *Siberia and Northwestern America*, 103; Portlock, *Voyage around the World*, 248–49; Shelikhov, *A Voyage to America*, 53.

65 Holmberg, *Holmberg's Ethnographic Sketches*, 37.

66 Dixon, "A Voyage round the World," 68.

67 Smithsonian Institution Archives, Record Unit 305, 1881.

68 Mishler, *Black Ducks and Salmon Bellies*, 217.

69 Crowell, Steffian, and Pullar, eds., *Looking Both Ways*, 188–221; Desson, "Masked Rituals of the Kodiak Archipelago."

70 Davydov, *Two Voyages to Russian America*, 107–8; Desson, "Masked Rituals of the Kodiak Archipelago"; Gideon, *The Round the World Voyage*, 44–48; Merck, *Siberia and Northwestern America*, 100–101, 206–7; Pinart, "Eskimaux et Koloches"; Sauer, *An Account of a Geographical and Astronomical Expedition*, 176; Shelikhov, *A Voyage to America*, 55.

71 Birket-Smith, *The Chugach Eskimo*, 120–21.

72 Davydov, *Two Voyages to Russian America*, 108–11; Desson, "Masked Rituals of the Kodiak Archipelago," 132–38; Lisiansky, *A Voyage round the World*, 208.

73 Shelikhov, *A Voyage to America*, 81–82.

74 Desson, "Masked Rituals of the Kodiak Archipelago," 33.

75 Birket-Smith, *The Chugach Eskimo*, 124; Desson, "Masked Rituals of the Kodiak Archipelago," 49–51.

76 Birket-Smith, *The Chugach Eskimo*, 127–29.

77 Desson, "Masked Rituals of the Kodiak Archipelago," 253–55.

78 Crowell, Steffian, and Pullar, eds., *Looking Both Ways*, 215–18; Mishler, *Black Ducks and Salmon Bellies*, 117–19; Vick, *The Cama-i Book*, 125; Partnow, "Alutiiq Ethnicity," 332–36.

79 Koniag, Inc., Alutiiq Museum, and the Château-Musée, *Giinaquq*; Mishler, *Black Ducks and Salmon Bellies*, 219.

80 Ephraim Agnot, interview 1986, Alutiiq Museum and Archaeological Repository, Kodiak, Alaska.

81 Hunt, "The Ethnohistory of Alutiiq Clothing"; Varjola, *The Etholén Collection*, 177–81.

82 Crowell, Steffian, and Pullar, eds., *Looking Both Ways*, 208–11; Birket Smith, *The Chugach Eskimo*, 128–32; Desson, "Masked Rituals of the Kodiak Archipelago," 138–58; Gideon, *The Round the World Voyage*, 59–60; Lisiansky, *A Voyage round the World*, 207–8; Pinart, "Eskimaux et Koloches."

83 Birket-Smith, *The Chugach Eskimo*, 126–32.

84 Sven Hackanson Sr., interview at the 1997 elders' planning conference for "Looking Both Ways: Heritage and Identity of the Alutiiq People."

85 Birket-Smith, "Early Collections from the Pacific Eskimo," 149; Birket-Smith, *The Chugach Eskimo*, 109; Davydov, *Two Voyages to Russian America*, 107–11; Dixon, "A Voyage round the World," 242; Gideon, *The Round the World Voyage*, 43; Lantis, *Alaskan Eskimo Ceremonialism*, 113; Merck, *Siberia and Northwestern America*, 100–101; Langsdorff, *Voyages and Travels*, 64.

86 Collector William J. Fisher identified this object specifically as a "shaman's rattle," but no details of this attribution were recorded.

87 Gideon, *The Round the World Voyage*, 43.

88 Merck, *Siberia and Northwestern America*, 206–7.

ATHABASCAN

1 Duncan, *Some Warmer Tone*, 28; Duncan, *Northern Athapaskan Art*, 139.

2 Hadleigh West, "The Netsi Kutchin," 231–42; McKennan, *The Upper Tanana Indians*, 47; Nelson, *Hunters of the Northern Forest*, 173–75.

3 Duncan and Carney, *A Special Gift*, 80; Hadleigh West, "The Netsi Kutchin," 185; Huntington, *Shadows on the Koyukuk*, 85; Madison and Yarber, *Madeline Solomon*, 77; McKennan, *The Upper Tanana*, 83; McKennan, *The Chandalar Kutchin*, 38; Osgood, *Contributions to the Ethnography of the Kutchin*, 67; Thompson, *From the Land*, 5; Carlo, *Nulato*, 50–53.

4 Steinbright, ed., *From Skins, Trees, Quills, and Beads*, 99–100.

5 Duncan, *Northern Athapaskan Art*, 122.

6 Duncan and Carney, *A Special Gift*, 68–70; Hadleigh West, "The Netsi Kutchin," 295; McKennan, *The Upper Tanana*, 82–83; McKennan, *The Chandalar Kutchin*, 45–46; Simeone and VanStone, *"And He Was Beautiful,"* 22–23.

7 Hadleigh West, "The Netsi Kutchin," 295.

8 Ibid., 155; Huntington, *Shadows on the Koyukuk*, 135; McKennan, *The Upper Tanana*, 57–58; Nelson, *Hunters of the Northern Forest*, 96.

9 McKennan, *The Upper Tanana*, 57–58.

10 Clark, "Koyukuk River Culture," 154–55; McKennan, *The Upper Tanana*, 51–57; McKennan, *The Chandalar Kutchin*, 36; Osgood, *Contributions to the Ethnography of the Kutchin*, 68, 72, 82–83; Osgood, *Ingalik Material Culture*, 201–2.

11 Trimble Gilbert, project consultation, Alaska Native Collections: Sharing Knowledge, 2004; Osgood, *Ingalik Material Culture*, 201.

12 Osgood, *Contributions to the Ethnography of the Kutchin*, 68.

13 Hadleigh West, "The Netsi Kutchin," 141, 150–51; Nelson, *Hunters of the Northern Forest*, 118–25; Osgood, *Contributions to the Ethnography of the Kutchin*, 27; Schmitter, *Upper Yukon Native Customs and Folk-Lore*, 9; VanStone, "Russian Exploration in Interior Alaska," 34.

14 Hadleigh West, "The Netsi Kutchin," 126; Clark, "Koyukuk River Culture," 154–61; McKennan, *The Upper Tanana*, 48; Mishler, ed., *Neerihiinjik*, 241, 553–55; Osgood, *Contributions to the Ethnography of the Kutchin*, 26; Schmitter, *Upper Yukon Native Customs and Folk-Lore*, 8; Whymper, *Travel and Adventure in the Territory of Alaska*, 189.

15 Hadleigh West, "The Netsi Kutchin," 143; Nelson, *Hunters of the Northern Forest*, 79–80.

16 Hadleigh West, "The Netsi Kutchin," 152–53; McKennan, *The Upper Tanana*, 58, 60; McKennan, *The Chandalar Kutchin*, 37, 67–70; Osgood, *Contributions to the Ethnography of the Kutchin*, 88–89; Simeone and VanStone, *"And He Was Beautiful,"* 5.

17 Huntington, *Shadows on the Koyukuk*, 131.

18 Ibid., 52–53; Nelson, *Hunters of the Northern Forest*, 43–54; Whymper, *Travel and Adventure in the Territory of Alaska*, 199–200. Traveling canoes with caribou skin sails were recorded for the Peel River Gwich'in (Osgood, *Contributions to the Ethnography of the Kutchin*, 57–58). This model originally had a canvas sail, but it was too deteriorated for exhibition.

19 Osgood, *Ingalik Material Culture*, 359–71.

20 Clark, "Koyukuk River Culture," 138–40; Nelson, *Hunters of the Northern Forest*, 43–45; Osgood, *Contributions to the Ethnography of the Kutchin*, 57–58.

21 Nelson, *Hunters of the Northern Forest*, 38–45; Osgood, *Contributions to the Ethnography of the Kutchin*, 57–58; McFadyen Clark, "Koyukuk River Culture," 138–40; McKennan, *The Upper Tanana*, 92–93; Michael, ed., *Lieutenant Zagoskin's Travels*, 248; Schmitter, *Upper Yukon Native Customs and Folk-Lore*, 11; Eliza Jones and Judy Woods, project consultation, Alaska Native Collections: Sharing Knowledge, 2004.

22 Huntington, *Shadows on the Koyukuk*, 52–53; Clark, "Koyukuk River Culture," 138–40; Osgood, *Contributions to the Ethnography of the Kutchin*, 61–62; Osgood, *Ingalik Material Culture*, 359–71; Schmitter, *Upper Yukon Native Customs and Folk-Lore*, 11.

23 Hadleigh West, "The Netsi Kutchin," 246–47; Madison and Yarber, *Roger Dayton*, 22; Clark, "Koyukuk River Culture," 62–63; McKennan, *The Upper Tanana*, 49–50, 92–93.

24 McKennan, *The Upper Tanana*, 90.

25 De Laguna and McClellan, "Ahtna," 649; Hadleigh West, "The Netsi Kutchin," 235–36; Clark, "Koyukuk River Culture," 65; McKennan, *The Upper Tanana*, 90; McKennan, *The Chandalar Kutchin*, 41; Michael, ed., *Lieutenant Zagoskin's Travels*, 246; Nelson, *Hunters of the Northern Forest*, 134–41; Osgood, *Contributions to the Ethnography of the Kutchin*, 77–82; Osgood, *Ingalik Material Culture*, 345–49; Steinbright, ed., *From Skins, Trees, Quills, and Beads*, 43–46; Townsend, "Tanaina," 630. Trail shoes with pointed tips appear to be more recent in Alaska, possibly introduced by the Hudson's Bay Company.

26 McKennan, *The Upper Tanana*, 48; McKennan, *The Chandalar Kutchin*, 32; Nelson, *Hunters of the Northern Forest*, 102–3; VanStone, *E. W. Nelson's Notes*, 34.

27 Hadleigh West, "The Netsi Kutchin," 135; McKennan, *The Upper Tanana*, 47.

28 Huntington, *Shadows on the Koyukuk*, 61; Madison and Yarber, *Madeline Solomon*, 65; McKennan, *The Upper Tanana*, 90; Clark, "Koyukuk River Culture," 65; Osgood, *Contributions to the Ethnography of the Kutchin*, 59, 77–82; Osgood, *Ingalik Material Culture*, 345–49; Steinbright, ed., *From Skins, Trees, Quills, and Beads*, 38–46.

29 Madison and Yarber, *Roger Dayton*, 22.

30 Carlo, *Nulato*, 44–45; Clark, "Koyukuk River Culture," 133; McKennan, *The Upper Tanana*, 35; McKennan, *The Chandalar Kutchin*, 30, 39; Osgood, *Contributions to the Ethnography of the Kutchin*, 30, 37–38; Osgood, *Ingalik Material Culture*, 133–36; Simeone and VanStone, *"And He Was Beautiful,"* 21; Steinbright, ed., *From Skins, Trees, Quills, and Beads*, 7–8.

31 Clark, "Koyukuk River Culture," 133; McKennan, *The Upper Tanana*, 33, 41; McKennan, *The Chandalar Kutchin*, 39; Osgood, *Ingalik Material Culture*, 142; Steinbright, ed., *From Skins, Trees, Quills, and Beads*, 13.

32 Carlo, *Nulato*, 44–45; Clark, "Koyukuk River Culture," 133–34; Madison and Yarber, *Madeline Solomon*, 61; Osgood, *Ingalik Material Culture*, 133–36; Simeone and VanStone, *"And He Was Beautiful,"* 21; Steinbright, ed., *From Skins, Trees, Quills, and Beads*, 7–15.

33 Steinbright, ed., *From Skins, Trees, Quills, and Beads*, 14.

34 McFadyen Clark, "Koyukuk River Culture," 137; De Laguna and McClellan, "Ahtna," 649; Duncan and Carney, *A Special Gift*, 58; Clark, "Koyukuk River Culture," 137; McKennan, *The Upper Tanana*, 88–89; McKennan, *The Chandalar Kutchin*, 41; Murray, *Journal of the Yukon*, 86; Osgood, *Contributions to the Ethnography of the Kutchin*, 44; Osgood, *The Ethnography of the Tanaina*, 50; Slobodin, "Kutchin," 520; Whymper, *Travel and Adventure in the Territory of Alaska*, 205–6.

35 McKennan, *The Upper Tanana*, 141; McKennan, *The Chandalar Kutchin*, 41; Osgood, *Contributions to the Ethnography of the Kutchin*, 44. Osgood (*Ingalik Material Culture*, 282) mentions that ashes were also used for this purpose by the Deg Hit'an.

36 Carlo, *Nulato*, 25; Osgood, *Ingalik Mental Culture*, 138.

37 Duncan and Carney, *A Special Gift*, 58–63; Steinbright, ed., *From Skins, Trees, Quills, and Beads*, 101–3.

38 Duncan, *Northern Athapaskan Art*, 97.

39 De Laguna and McClellan, "Ahtna," 649; Duncan, *Northern Athapaskan Art*, 97–101; Duncan and Carney, *A Special Gift*, 58–63; McKennan, *The Upper Tanana*, 88; McKennan, *The Chandalar Kutchin*, 41; Osgood, *Contributions to the Ethnography of the Kutchin*, 40; Osgood, *Ingalik Material Culture*, 282; Simeone and VanStone, "And He Was Beautiful," 25.

40 Steinbright, ed., *From Skins, Trees, Quills, and Beads*, 101.

41 Carlo, *Nulato*, 47–48; Hadleigh West, "The Netsi Kutchin," 288; Madison and Yarber, *Madeline Solomon*, 65; McKennan, *The Upper Tanana*, 78; McKennan, *The Chandalar Kutchin*, 44; Nelson, *Hunters of the Northern Forest*, 141–43; Osgood, *Contributions to the Ethnography of the Kutchin*, 40, 44; Osgood *Ingalik Material Culture*, 253–56, 270; Schmitter, *Upper Yukon Native Customs and Folk-Lore*, 5; Steinbright, ed., *From Skins, Trees, Quills, and Beads*, 78.

42 Carlo, *Nulato*, 48; Osgood, *Ingalik Material Culture*, 253–54.

43 Thompson, *From the Land*, 55.

44 Carlo, *Nulato*, 47; Huntington, *Shadows on the Koyukuk*, 139; McKennan, *The Upper Tanana*, 84; McKennan, *The Chandalar Kutchen*, 39, 44; Osgood, *Contributions to the Ethnography of the Kutchin*, 71; Steinbright, ed., *From Skins, Trees, Quills, and Beads*, 78.

45 Huntington, *Shadows on the Koyukuk*, 140.

46 Hadleigh West, "The Netsi Kutchin," 159–60; McKennan, *The Upper Tanana*, 32; Mishler, ed., *Neerihiinjik*, 617; Nelson, *Hunters of the Northern Forest*, 130–43; Schmitter, *Upper Yukon Native Customs and Folk-Lore*, 9; Simeone, *Rifles, Blankets, and Beads*, 10; VanStone, *E. W. Nelson's Notes*, 34.

47 Kate Duncan, project consultation, Alaska Native Collections: Sharing Knowledge, 2004.

48 Dall, *Alaska and Its Resources*, 82–83; Duncan, *Northern Athapaskan Art*; Jones, "The Kutchin Tribes," 320; McKennan, *The Upper Tanana*, 78–80; Michael, ed., *Lieutenant Zagoskin's Travels*, 244–46; Murray, *Journal of the Yukon*, 84–94; Osgood, *Contributions to the Ethnography of the Kutchin*, 44–45; Richardson, *Arctic Searching Expedition*, 377, 380; Simeone and VanStone, *"And He Was Beautiful,"* 4–5; Whymper, *Travel and Adventure in the Territory of Alaska*, 203.

49 Michael, ed., *Lieutenant Zagoskin's Travels*, 244.

50 VanStone, *Athapaskan Clothing and Related Objects*, 8–10.

51 Project consultation, Alaska Native Collections: Sharing Knowledge, 2009.

52 Thompson, *From the Land*, 25.

53 Mocassin boots: Duncan and Carney, *A Special Gift*, 24: McKennan, *The Upper Tanana*, 79; Simeone and VanStone, *"And He Was Beautiful,"* 7. Mocassin trousers: Osgood, *Contributions to the Ethnography of the Kutchin*, 43; Thompson, *From the Land*, 67; VanStone, *Athapaskan Clothing and Related Objects*, 24.

54 Hadleigh West, "The Netsi Kutchin," 229; Clark, "Koyukuk River Culture," 137; McKennan, *The Upper Tanana*, 68–70; Mishler, ed., *Neerihiinjik*, 409.

55 Emmons, *The Tahltan Indians*, 58–59.

56 McKennan, *The Upper Tanana*, 130.

57 Ibid., 127; Michael, ed., *Lieutenant Zagoskin's Travels*, 246; Osgood, *Contributions to the Ethnography of the Kutchin*, 40–41, 48; Simeone, *Rifles, Blankets, and Beads*, 49.

58 Simeone, *Rifles, Blankets, and Beads*, 50–51; Simeone and VanStone, *"And He Was Beautiful,"* 75.

59 De Laguna and McClellan, "Ahtna," 649; Duncan, *Northern Athapaskan Art*, 144; Duncan and Carney, *A Special Gift*, 46–47; Simeone and VanStone, *"And He Was Beautiful,"* 27.

60 Simeone and VanStone, *"And He Was Beautiful,"* 9.

61 Dall, *Alaska and Its Resources*, 94; Murray, *Journal of the Yukon*, 59; Whymper, *Travel and Adventure in the Territory of Alaska*, 222; Simeone and VanStone, *"And He Was Beautiful,"* 7; Thompson, *From the Land*, 65.

62 Duncan, *Northern Athapaskan Art*, 94–97; Duncan and Carney, *A Special Gift*, 53–55; Thompson, *From the Land*, 51.

63 Mishler, ed., *Neerihiinjik*, 415.

64 Duncan, *Northern Athapaskan Art*, 94–97.

65 Ibid., 56–58.

66 Osgood, *Ingalik Social Culture*, 73–74; Snow, "Ingalik," 608; VanStone, *E. W. Nelson's Notes*, 17–18.

67 Osgood, *Ingalik Social Culture*, 74.

68 Ibid., 73–81.

69 Simeone and VanStone, *"And He Was Beautiful,"* 28.

70 Osgood, *Ingalik Social Culture*, 84, fig. 8.

71 Ibid., 93.

72 Osgood, *Ingalik Material Culture*, 71–73.

73 Osgood, *Ingalik Social Culture*, 96–134; Snow, "Ingalik," 608.

74 Madison and Yarber, *Madeline Solomon*, 26–42; Clark, "Koyukon," 593–94; Huntington, *Shadows on the Koyukuk*, 73.

TLINGIT

1 De Laguna, "Under Mount Saint Elias," 340–41; Emmons, *The Tlingit Indians*, 85–89; Holmberg, *Holmberg's Ethnographic Sketches*, 16; Ismailov, "The Voyage of Izmailov and Bocharov," 93; Lisiansky, *Voyage round the World*, 240; Litke, *A Voyage around the World 1826–1829*, 93.

2 De Laguna, "Under Mount Saint Elias," 335–41; Emmons, *The Tlingit Indians*, 86.

3 The stern image may be Raven, but this crest would not normally appear on the same object with Brown Bear (a Wolf/Eagle crest). A model made for sale might not have followed the normal rules of representation. The figure on the bow represents a bound witch.

4 Emmons, *The Tlingit Indians*, 86; Swanton, *Tlingit Myths and Texts*, 102.

5 Emmons, *The Tlingit Indians*, 94.

6 De Laguna, "Under Mount Saint Elias," 342–43; Dixon, *A Voyage round the World*, 173; Emmons, *The Tlingit Indians*, 89–91; Krause, *The Tlingit Indians*, 118–19. A traditional narrative, "The Youthful Warrior," describes stone adzes and fire being used to shape a spruce canoe from the "biggest tree ever known" (Swanton, *Tlingit Myths and Texts*, 77–78).

7 Identified by George Bennett, project consultation, Alaska Native Collections: Sharing Knowledge, 2008.

8 De Laguna, "Tlingit," 210–11; Emmons, *The Tlingit Indians*, 105–14; Krause, *The Tlingit Indians*, 120–21.

9 Emmons, *The Tlingit Indians*, 104.

10 De Laguna, "Under Mount Saint Elias," 384.

11 Emmons, *The Tlingit Indians*, 374.

12 De Laguna, "Under Mount Saint Elias," 889; Emmons, *The Tlingit Indians*, 388; Swanton, *Tlingit Myths and Texts*, 301–20.

13 De Laguna, "Under Mount Saint Elias," 384.

14 De Laguna, "Tlingit," 212; Emmons, *The Tlingit Indians*, 141; La Pérouse, *The Journal of Jean-François de Galaup de la Pérouse*, 135; Portlock, "Voyage around the World," 291.

15 De Laguna, "Under Mount Saint Elias," 419–20; Emmons, *The Tlingit Indians*, 160; Krause, *The Tlingit Indians*, 141–43.

16 George Bennet thought that the form-line designs on this box looked Haida, and that the piece might have been traded to the Tlingit (project consultation, Alaska Native Collections: Sharing Knowledge, 2008).

17 De Laguna, "Under Mount Saint Elias," 409–10; Emmons, *The Tlingit Indians*, 151, 309.

18 De Laguna, "Under Mount Saint Elias," 873–75; Emmons, "The Basketry of the Tlingit," 229; Swanton, *Tlingit Myths and Texts*, 125–26.

19 De Laguna, "Under Mount Saint Elias," 428; Emmons, "The Basketry of the Tlingit," 230; Emmons, *The Tlingit Indians*, 213.

20 De Laguna, "Under Mount Saint Elias," 393–94, 418; Dixon, *A Voyage round the World*, 175; Emmons, *The Tlingit Indians*, 159–60; Holmberg, *Holmberg's Ethnographic Sketches*, 14–15; Olson,

Through Spanish Eyes, 476–77; Portlock, "Voyage around the World," 293–94; Langsdorff, *Voyages and Travels*, 132.

21 Emmons, "The Basketry of the Tlingit," 234–39.
22 Delores Churchill (Haida), project consultation, Alaska Native Collections: Sharing Knowledge, 2005.
23 According to Delores Churchill, Haida makers weave their baskets upside down, with the result that the pattern appears counter-clockwise on an upright basket; Unangax̂ grass baskets are woven the same way.
24 Emmons, "The Basketry of the Tlingit," 240, 246.
25 Ibid., 276, fig. 359a.
26 Emmons, *The Tlingit Indians*, 174.
27 De Laguna, "Under Mount Saint Elias," 415–16; Emmons, *The Tlingit Indians*, 196–98.
28 De Laguna, "Under Mount Saint Elias," 352.
29 Ibid., 410; De Laguna, "Tlingit," 212; Dixon, *A Voyage round the World*, 175; Emmons, *The Tlingit Indians*, 153–57; Krause, *The Tlingit Indians*, 108, 162.
30 Swanton, *Tlingit Myths and Texts*, 89.
31 Ibid., 342.
32 Krause, *The Tlingit Indians*, 144.
33 Emmons, *The Tlingit Indians*, 155; Jonaitis, *Art of the Northern Tlingit*, 41–42; Krause, *The Tlingit Indians*, 109; Veniaminov, *Notes on the Islands of the Unalashka District*, 406–7.
34 De Laguna, "Tlingit," 220; Emmons, *The Tlingit Indians*, 308; Krause, *The Tlingit Indians*, 156. A similar "smoke feast" was held on the last evening before cremation of a deceased chief (Emmons, *The Tlingit Indians*, 273–74).
35 Swanton, *Tlingit Myths and Texts*, 372.
36 DeLaguna, "Under Mount Saint Elais," 590–91; Emmons, *The Tlingit Indians* 337–46; Holmberg, *Holmberg's Ethnographic Sketches*, 22; Lisiansky, *Voyage round the World*, 149–50; Olson, *Through Spanish Eyes*, 109, 478–89.
37 De Laguna, "Tlingit," 218; Fitzhugh and Crowell, eds., *Crossroads of Continents*, 232–33.
38 Emmons, *The Tlingit Indians*, 344–45.
39 Olson, *Through Spanish Eyes*, 479.
40 Lisiansky, *Voyage round the World*, 150.
41 Jonaitis, *Art of the Northern Tlingit*, 21; Lisiansky, *Voyage round the World*, 150.
42 Swanton, *Tlingit Myths and Texts*, 85.
43 De Laguna, "Under Mount Saint Elias," 580–85; Emmons, *The Tlingit Indians*, 335–37; Krause, *The Tlingit Indians*, 169; Litke, *A Voyage around the World 1826–1829*, 87; Niblack, "The Coast Indians," 340; Olson, *Social Structure and Social Life of the Tlingit*, 69–82.
44 Emmons, *The Tlingit Indians*, 74–78; Moss and Erlandson, "Forts, Refuge Rocks, and Defensive Sites," 1992. An oral narrative of the "First War in the World" (Swanton, *Tlingit Myths and Texts*, 72–79) describes fighting between southern and northern Tlingit communities during which raiders burned enemy forts, killed inhabitants, and took others for slaves. According to the story, "They had no iron in those days, but were armed with mussel-shell knives and spears, and wore round wooden fighting hats."
45 De Laguna et al., *Archaeology of the Yakutat Bay Area*, 88–90; Emmons, *The Tlingit Indians*, 183–89, 340–42; Quimby, "Japanese Wrecks, Iron Tools, and Prehistoric Indians"; Niblack, "The Coast Indians," 283–86.
46 Acheson, "The Thin Edge."
47 De Laguna, "Under Mount Saint Elias," 588; Emmons, *The Tlingit Indians*, 186, 340–42; Holmberg, *Holmberg's Ethnographic Sketches*, 17; Izmailov, "The Voyage of Izmailov and Bocharov," 95; La Pérouse, *The Journal of Jean-François de Galaup de la Pérouse*, 105; Portlock, "Voyage around the World," 260.
48 George Ramos, project consultation, Alaska Native Collections: Sharing Knowledge, 2005. Emmons (*The Tlingit Indians*, 340) says that the wrist strap prevented the dagger from being lost in battle or stripped from a fighter's fallen body. See also Holmberg, *Holmberg's Ethnographic Sketches*, 17.
49 De Laguna, "Under Mount Saint Elias," 590–91; Emmons, *The Tlingit Indians*, 342–44; Hough, "Primitive American Armor"; Krause, *The Tlingit Indians*, 146–48; Lisiansky, *Voyage round the World*, 238; Litke, *A Voyage around the World 1826–1829*, 87; Niblack, "The Coast Indians," 268–70; Olson, *Through Spanish Eyes*, 109, 478–79.
50 De Laguna, "Under Mount Saint Elias," 443–44; Emmons, *The Tlingit Indians*, 34–35, 219–21, 312–14; Jonaitis, *Art of the Northern Tlingit*, 19–21, 98; Krause, *The Tlingit Indians*, 139; Niblack, "The Coast Indians," 266–70.
51 Donald Gregory notes that no definitive features, such as tail, wings, beak, claws, or fins, are present to aid identification of the crest (project consultation, Alaska Native Collections: Sharing Knowledge, 2009).
52 Emmons, "The Basketry of the Tlingit," 239–49.
53 Peter Jack, Clarence Jackson, George Ramos, Rosita Worl, Anna Katzeek, Delores Churchill, and Donald Gregory, project consultation, Alaska Native Collections: Sharing Knowledge, 2005.
54 Emmons, *The Tlingit Indians*, 205.
55 De Laguna, "Under Mount Saint Elias," 690–92; Emmons, *The Tlingit Indians*, 205.
56 De Laguna, "Under Mount Saint Elias," 690–92; De Laguna, "Tlingit," 221–22; Emmons, *The Tlingit Indians*, 377–79; Jonaitis, *Art of the Northern Tlingit*, 27, 57; Krause, *The Tlingit Indians*, 198–99.
57 Swanton, *Tlingit Myths and Texts*, 118–19.
58 Emmons, *The Tlingit Indians*, 342; Niblack, "The Coast Indians," 268–69, pl. 15.

59 Veniaminov, *Notes on the Islands of the Unalashka District*, 397.
60 Emmons, *The Tlingit Indians*, 226. Blue or blue-green may originally have been obtained from a copper oxide mineral, in Tlingit called *naaxeinté* (Anna Katzeek, project consultation, Alaska Native Collections: Sharing Knowledge, 2005). According to Yarrow Vaara, Tlingit language specialist at the Sealaska Heritage Institute, *naaxein* is the word for a Chilkat robe, and *té* is the word for stone. *Naaxeinté* was a paint pigment and may have been used to dye wool for Chilkat weaving; alternatively, it may have been named after the color of the robes and not actually used in the process.
61 Emmons, "The Chilkat Blanket"; Emmons, *The Tlingit Indians*, 224–33; Jonaitis, *Art of the Northern Tlingit*, 21–22; Niblack, "The Coast Indians," 263–65; Samuel, *The Chilkat Dancing Blanket*.
62 Clarence Jackson, Delores Churchill, and Donald Gregory, project consultation, Alaska Native Collections: Sharing Knowledge, 2005. The diving Killer Whale design is a common Chilkat motif (see Boas, "Notes on the Blanket Designs in the Chilkat Blanket," 374).
63 Emmons ("The Chilkat Blanket," pl. 27), who collected this garment, provided the interpretation of its design, which Donald Gregory and Anna Katzeek confirmed (project consultation, Alaska Native Collections: Sharing Knowledge, 2005). Emmons ("The Chilkat Blanket," 348) said that dance tunics of this type are based on the design of hide armor.
64 Emmons, *The Tlingit Indians*, 273, 278–79, 315–19.
65 Ibid., 292–94; Krause, *The Tlingit Indians*, 167.
66 Emmons, *The Tlingit Indians*, 137, 292–94; seal and deer hide were also used.
67 Niblack, "The Coast Indians," pl. 57.
68 Emmons, *The Tlingit Indians*, 383–84.
69 Veniaminov, *Notes on the Islands of the Unalashka* District, 398, 407–8.
70 De Laguna, "Tlingit," 221; Emmons, *The Tlingit Indians*, 368–97; Krause, *The Tlingit Indians*, 194–204; Veniaminov, *Notes on the Islands of the Unalashka District*, 400–411.
71 De Laguna, "Under Mount Saint Elias," 676–78; Emmons, *The Tlingit Indians*, 372–76; Veniaminov, *Notes on the Islands of the Unalashka District*, 401–3.
72 De Laguna, "Under Mount Saint Elias," 455, 698–99; Emmons, *The Tlingit Indians*, 376–82; Jonaitis, *Art of the Northern Tlingit*, 29–30.
73 Peter Jack, Clarence Jackson, George Ramos, Rosita Worl, Anna Katzeek, Delores Churchill, and Donald Gregory, project consultation, Alaska Native Collections: Sharing Knowledge, 2005.

HAIDA

1 Dawson, *To the Charlottes*, 133–34; Holm, *The Box of Daylight*, 79; MacDonald, *Haida Art*, 43.
2 Curtis, "The Haida," 131; Lilliard, ed., *Warriors of the North Pacific*, 158.
3 Swanton, "Contributions to the Ethnology of the Haida," 16–22, 57; Lilliard, ed., *Warriors of the North Pacific*, 159.
4 Murdock, *Rank and Potlatch among the Haida*, 5.
5 Blackman, *During My Time*, 46.
6 Blackman, "Haida," 244; Curtis, "The Haida," 131; Dawson, *To the Charlottes*, 105; Dixon, *A Voyage round the World*, 244; Lilliard, ed., *Warriors of the North Pacific*, 158; Niblack, "The Coast Indians," 276–77; Swanton, "Contributions to the Ethnology of the Haida," 71.
7 Curtis, "The Haida," 186–87; Dawson, *To the Charlottes*, 137; Lilliard, ed., *Warriors of the North Pacific*, 154; Niblack, "The Coast Indians," 288, 300.
8 Holm, *The Box of Daylight*, 90; Lilliard, ed., *Warriors of the North Pacific*, 154–55; Niblack, "The Coast Indians," pl. 28.
9 Swanton, "Contributions to the Ethnology of the Haida," 158–60.
10 Cogo, *Remembering the Past*, 9.
11 Holm, *The Box of Daylight*, 53; Lilliard, ed., Warriors of the North Pacific, 153.
12 Blackman, *During My Time*, 84–86.
13 Blackman, "Haida," 247; Busby, *Spruce Root Basketry of the Haida and Tlingit*, 27–51; MacDonald, *Haida Art*, 127; Niblack, "The Coast Indians," 313–16.
14 MacDonald, *Haida Monumental Art*, 6.
15 Dawson, *To the Charlottes*, 136; Lilliard, ed., *Warriors of the North Pacific*, 153–54; Marchand, *A Voyage around the World*, 282; Niblack, "The Coast Indians," 311–12.
16 Swanton, "Contributions to the Ethnology of the Haida," 29. Young Cedar Woman is mentioned in the "Story of the Food-Giving-Town People" (Swanton, *Haida Texts and Myths*, 78).
17 Reid, "Out of the Silence," 76.
18 Blackman, "Haida," 242–44; Curtis, "The Haida," 128–30; Dawson, *To the Charlottes*, 109–12, 139–40; MacDonald, *Haida Monumental Art*, 19–27; Marchand, *A Voyage around the World*, 268–70; Niblack, "The Coast Indians," 307–9.
19 MacDonald, *Haida Monumental Art*, 142–44.
20 Ibid., 39–57. The model is not entirely faithful to the actual dwelling; for example, no real houses had painted roofs.
21 Swanton, *Haida Texts and Myths*, 153.
22 MacDonald, *Haida Monumental Art*, 79; Swanton, "Contributions to the Ethnology of the Haida," 269, 278, 284.
23 Collector James Swan (NMNH catalog card) recorded only that the chest represents "T'kul"; the modern spelling is "Xyuu," meaning southeast wind (Enrico, *Haida Dictionary*, 1548). Swanton ("Contributions to the Ethnology of the Haida," 15–16) wrote that "Xe-ü'" was the southeast wind, whose siblings included cirrus and other clouds. Niblack wrote that T'kul was the wind spirit who brought cirrus clouds, and he published an image of T'kul drawn

by Johnnie Kit-Elswa (Niblack, "The Coast Indians," 324 and fig. 285), which closely resembles the end panel figure on this chest. Cirrus Clouds was a crest of Gida'nsta's Raven 4 clan (Swanton, "Contributions to the Ethnology of the Haida," 114). As a great chief, Gida'nsta made unusual use of Raven as his personal crest and even assigned it to his wife, although she was not entitled to it by descent (MacDonald, *Haida Monumental Art*, 83).

24 MacDonald, *Haida Monumental Art*, 83.
25 Bringhurst, *A Story as Sharp as a Knife*, 103; Swanton, "Contributions to the Ethnology of the Haida," 22, 109. MacDonald (*Haida Art*, 11) gives the Haida name of this being as Konankada and discusses its widespread representation in Haida art. The Tlingit name was G̲unaakadeit.
26 Swanton, *Haida Texts and Myths*, 26–30.
27 Dawson, *To the Charlottes*, 129, 135–36; Niblack, "The Coast Indians," 318–19; Swanton, "Contributions to the Ethnology of the Haida," 165.
28 Dawson, *To the Charlottes*, 126–27; MacDonald, *Haida Monumental Art*, 27; Swanton, "Contributions to the Ethnology of the Haida," 132.
29 Swanton, *Haida Texts and Myths*, 26–28.
30 The land otter identification was provided by Niblack ("The Coast Indians," pl. 45, fig. 248). Haida shamans, like the Tlingit, acquired a land otter's tongue to gain the animal as one of their helping spirits (Swanton, "Contributions to the Ethnology of the Haida," 40).
31 Niblack, "The Coast Indians," 319–20.
32 Curtis, "The Haida," 118–26, 147; Dawson, *To the Charlottes*, 101–3, 120–25; Murdoch, 7–9; Swan, *The Haidah Indians of Queen Charlotte's Islands*; Swanton, "Contributions to the Ethnology of the Haida," 155–70.
33 Plain sticks were also called "octopus" or "devilfish," referring to the preferred bait for halibut hooks.
34 Curtis, "The Haida," 132–33; Dixon, *A Voyage round the World*, 245; Lilliard, ed., *Warriors of the North Pacific*, 143; MacDonald, *Haida Art*, 93; Marchand, *A Voyage around the World*, 299–300; Niblack, "The Coast Indians," 344–45; Swan, *The Haidah Indians of Queen Charlotte's Islands*, 8; Swanton, "Contributions to the Ethnology of the Haida," 58–59, 147–54.
35 Swanton, *Haida Texts and Myths*, 52–57.
36 Crest identifications by Delores Churchill, project consultation, Alaska Native Collections: Sharing Knowledge, 2005.
37 Curtis, "The Haida," 131; Dawson, *To the Charlottes*, 128–29; Niblack, "The Coast Indians," 335–36.
38 Blackman, *During My Time*, 7; Holm, *The Box of Daylight*, 61–63; MacDonald, *Haida Art*, 19–23; Niblack, "The Coast Indians," 272.
39 Blackman, *During My Time*, 124.
40 Ibid., 124.
41 Dawson, *To the Charlottes*,135; Niblack, "The Coast Indians," 316–19.
42 Swanton, "Contributions to the Ethnology of the Haida," 164.
43 Ibid., 137.
44 Curtis, "The Haida," 140–48; Dawson, *To the Charlottes*, 118–22; Murdock, *Rank and Potlatch among the Haida*, 5–6; Swanton, "Contributions to the Ethnology of the Haida," 156–75.
45 MacDonald, *Haida Art*, 31; Swanton, *Haida Texts and Myths*, 117–18; Swanton, "Contributions to the Ethnology of the Haida," 74.
46 Holm, *The Box of Daylight*, 25–28; Niblack, "The Coast Indians," 324. The identification of this figure as Walala (spelled "Oolalla" in the source) was recorded by collector James G. Swan, presumably from the Haida artist (Niblack, "The Coast Indians," 324).
47 Although shamans more commonly used globular or puffin beak rattles during healing ceremonies, Swanton ("Contributions to the Ethnology of the Haida," fig. 2) illustrates a carving of a shaman dancing with a raven rattle. In the story of "He Who Got Super-natural Power from His Little Finger," a female shaman detects a witch using her bird-shaped rattle (Swanton, *Haida Texts and Myths*, 238–51).
48 Blackman, *During My Time*, 37; Dawson, *To the Charlottes*, 100; Holm, *The Box of Daylight*, 19–24; Lilliard, ed., *Warriors of the North Pacific*, 146; Murdock, *Rank and Potlatch among the Haida*, 5; Niblack, "The Coast Indians," 264–65.
49 MacDonald, *Haida Monumental Art*, 46.
50 Swanton, *Haida Texts and Myths*, 26–31.
51 Swanton, "Contributions to the Ethnology of the Haida," 215. In another Masset story, a hunter accidentally kills a man in a deadfall trap he set for bears. He makes a bow to kill birds from the man's copper ankle ornaments (Swanton, "Contributions to the Ethnology of the Haida," 219).
52 Curtis, "The Haida," 145; Dawson, *To the Charlottes*, 131; Lilliard, ed., *Warriors of the North Pacific*, 155–56; MacDonald, *Haida Art*, 71–91.
53 Blackman *During My Time*, 84.
54 Swanton, "Contributions to the Ethnology of the Haida," 215.

TSIMSHIAN

1 Boas, "Tsimshian Mythology," 50; Niblack, *The Coast Indians*, 298.
2 Boas, "Tsimshian Mythology," 76–77.
3 Ibid., 158–59.
4 Ibid., 399–400; Halpin and Seguin, "Tsimshian Peoples," 269–71.
5 Boas, "Tsimshian Mythology," 449–50; Miller, *Tsimshian Culture*, 65.
6 Boas, "Tsimshian Mythology," 92–94.
7 Ibid., 400–401; Niblack, *The Coast Indians*, 276–98.
8 Boas, "Tsimshian Mythology," 350.
9 Ibid., 402–3; Garfield, Wingert, and Barbeau, "The Tsimshian," 17; Halpin and Seguin, "Tsimshian Peoples," 277; Holm, *The Box of Daylight*, 77.

10 Boas, "Tsimshian Mythology," 57; Niblack, *The Coast Indians*, 316–17.
11 Boas, "Tsimshian Mythology," 85, 538–40.
12 Ibid., 346–50; Holm, *The Box of Daylight*, 74.
13 Halpin and Seguin, "Tsimshian Peoples," 271, 281.
14 Holm, *The Box of Daylight*, 86–87.
15 Garfield, "Tsimshian Clan and Society," 312.
16 Boas, "Tsimshian Mythology," 49, 397; Holm, *The Box of Daylight*, 65–70; Niblack, *The Coast Indians*, 317–19.
17 Boas, "Tsimshian Mythology," 60–62.
18 Ibid., 83–84, 474–76, 558–62; Miller, *Tsimshian Culture*, 106–8.
19 Boas, "Tsimshian Mythology," 62; Miller, *Tsimshian Culture*, 172.
20 Boas, "Tsimshian Mythology," 501.
21 Niblack, *The Coast Indians*, pl. 43.
22 Boas, "Tsimshian Mythology," 122.
23 Ibid., 558; Garfield, Wingert, and Barbeau, "The Tsimshian," 56; Miller, *Tsimshian Culture*, 106–8.
24 Boas, "Tsimshian Mythology," 332.
25 Ibid., 558. Garfield noted that polished bone shamans' charms were characteristically Tsimshian, more so than other northern Northwest Coast peoples (Garfield, Wingert, and Barbeau, "The Tsimshian," 67).
26 Barbeau, *Haida Myths Illustrated in Argillite Carvings*, 269–73.
27 Boas, "Tsimshian Mythology," 563; Guédon, "Tsimshian Shamanic Images"; Halpin and Seguin, "Tsimshian Peoples," 279; Miller, *Tsimshian Culture*, 106–9.
28 Boas, "Tsimshian Mythology," 514–15, 546–47; Garfield, "Tsimshian Clan and Society," 303–11.
29 Boas, "Tsimshian Mythology," 537–42; Halpin and Seguin, "Tsimshian Peoples," 279; Miller, *Tsimshian Culture*, 104; Niblack, *The Coast Indians*, 264–65.
30 See discussion of the Haida raven rattle in this book, for which James Swan recorded that the humanoid figure was Walala, the Cannibal.
31 Holm, *The Box of Daylight*, 25–29; Miller, *Tsimshian Culture*, 37.
32 Boas, "Tsimshian Mythology," 53, 431, 531; Garfield, "Tsimshian Clan and Society," 194–95; Miller, *Tsimshian Culture*, 83; Niblack, *The Coast Indians*, 257–63.
33 Boas, "Tsimshian Mythology," 452, 460; Miller, *Tsimshian Culture*, 68–69, 83.
34 Boas, "Tsimshian Mythology," 73.
35 Ibid., 270–72.
36 Ibid., 500.
37 Niblack, *The Coast Indians*, pl. 19.
38 Boas, "Tsimshian Mythology," 546–47, 551–53; Garfield, "Tsimshian Clan and Society," 293–96.
39 Boas, "Tsimshian Mythology," 514–15, 539–40; Miller, *Tsimshian Culture*, 90–93.
40 Comment by Norman Tait, 10/21/1985, recorded on catalog card.
41 Miller, *Tsimshian Culture*, 92.
42 Boas, "Tsimshian Mythology," 350–54, 546–58; Garfield, "Tsimshian Clan and Society," 293–98.
43 Boas, "Tsimshian Mythology," 353.

COLLABORATIVE CONSERVATION AT THE SMITHSONIAN

Landis Smith, Michele Austin-Dennehy, and Kelly McHugh

OVERVIEW *Landis Smith*

The nearly six hundred extraordinary objects selected for exhibition in Living Our Cultures, Sharing Our Heritage represent all of Alaska's Native cultures and encompass a great diversity of materials, technologies, histories, aesthetics, and conditions. From skin clothing and bent-wood containers to ceremonial regalia and children's toys, from the well-worn to the pristine, each object carries its own story and speaks to the lives of the people who made and used it.

That story often begins a century or more ago with the gathering of raw materials from the Alaskan landscape. It continues with the expert processing of those materials and the fashioning of beautiful objects that were perfectly suited to their purposes and environments. Many pieces were used, cared for, and repaired by their owners; others were made for sale, commissioned by museum collectors, or exchanged in trade. Large numbers of these objects were purchased by Smithsonian naturalists and field agents who traveled to villages, working with Alaska Native guides and translators; others reached the museums through middlemen and artifact dealers. These circumstances affect the condition of the objects as we see them today as well as the quality of associated information about their histories and places of origin.

The story continues in the museum, where over the years the Alaskan materials have been studied, exhibited, published, repaired, and conserved. Some pieces were displayed for decades in glass exhibit cases or on mannequin life-groups intended to replicate Arctic life. Some were nailed to museum walls, exposed to intense light and fading or treated with pesticides. Although good care was intended, museum exhibit techniques, repair procedures, and cramped storage conditions were less than adequate by today's standards, and evidence of these outdated practices may frequently be observed today.

Standards of museum practice have evolved over the years as conservators came to play an increasingly central role in the long-term preservation of collections. Conservators' scientific understanding of the processes of deterioration has led to the establishment of safe environmental conditions and practices for storage and exhibition in museums. Ethnographic conservators emphasize such preventive measures, as well as the stabilization of the object as informed by an understanding of its original cultural context and museum history. Today, as work with collections becomes increasingly collaborative and inclusive of Native people, the story of the museum object takes another turn as contemporary people from indigenous source communities reconnect with the old pieces. The traditional knowledge and contemporary perspectives shared by Native consultants with conservators of the Living Our Cultures project have invariably brought new information to light, challenged old assumptions, and added an extra rigor to every aspect of the work.[1] That engagement has been an essential component of the conservation effort for Living Our Cultures.

Conservators began the project by familiarizing themselves with the characteristic materials and technologies of each Alaskan region. From the icy coastal areas of the north to the wooded interior and forested south, each environment offered specific materials that were used to create

the objects of everyday and ceremonial life. Bone, walrus ivory, the skins and organs of many different animals, trees of various species, grass, sinew, seaweed, bark, and mineral pigments each have unique properties that must be considered when addressing conservation issues.

For background on the history of each object, conservators turned to original field catalogs and collectors' records, nineteenth-century accession ledgers, museum file cards, previous conservation reports, scholarly publications, and old photographs. Exhibition curator Aron Crowell provided extensive input from historical and anthropological sources, and prior discussions with elders, available from the NMNH Arctic Studies Center and on its Web site Alaska Native Collections: Sharing Knowledge, were consulted. Close examination of the objects raised numerous questions about materials identification and Native technologies, leading to collaborations with scientists in the Mammals and Ornithology divisions of NMNH and with colleagues at the NMNH Museum Conservation Institute.

At the time of this writing, consultants from Yup'ik, St. Lawrence Island Yupik, Iñupiaq, Tlingit, and Tsimshian groups have visited in Washington, D.C., with Smithsonian conservators for Living Our Cultures, and the participation of representatives of other cultural groups is anticipated as preparations for the exhibition continue. Worth noting is the experimental use of video conferencing to work with Athabascan advisers in Anchorage. While this method is not a substitute for in-person discussion and hands-on examination of the objects, it does provide a useful alternative when travel to the Smithsonian is not feasible.

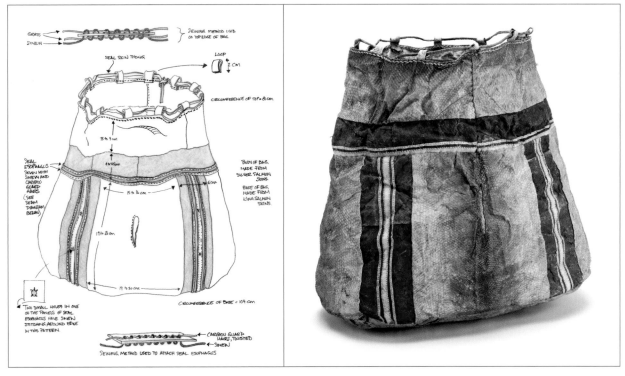

Treatment drawing and notes by conservator Kim Cobb indicating details of a Yup'ik fish skin bag (NMNH E037401), p. 111. The bag is made of silver salmon and king salmon skins, and decorated with strips of bleached and red-dyed sea mammal esophagus.

The experience of looking at objects with Alaska Native consultants makes it clear that no amount of background research, no matter how informative, can substitute for the insights they provide. The conservation stories presented here illustrate a small part of what we have learned. It begins with a better understanding of the materials: why and how they were used and the way they were gathered and processed. We learn about the traditional use and care of objects and how those practices affect their condition. Beyond all of that we gain an understanding of what is most culturally valued about each piece and how conservation decisions and exhibit presentations can best honor those priorities.

These consultations between museum conservators and indigenous advisers can flow both ways. Older objects inspire the work of visiting artists, the telling of stories, and the recounting of memories. Yup'ik artist and scholar Chuna McIntyre traced the pattern of an elaborate nineteenth-century fur parka for future re-creation; for Yup'ik adviser and linguist Vernon Chimegalrea, a pair of boots stirred memories of the way his grandmother had cared for footwear, which explained the unusual wear pattern on the soles. Iñupiaq artist Sylvester Ayek snapped photos of museum objects that will inspire his own work. Yupik skin sewer and doll maker Elaine Kingeekuk, from St. Lawrence Island, was delighted to find a doll made by one of her nineteenth-century predecessors, the tradition behind her art made manifest in its every stitch. Objects and the materials from which they were made are discussed and named in Native languages, demonstrating the inextricable ties between the preservation of museum collections and the preservation of language as well as the traditional knowledge embedded in the objects. We hope and foresee that collaborative conservation and the Living Our Cultures project as a whole will serve Alaska Native communities as they seek to preserve and perpetuate their languages and extraordinary cultural knowledge.

A TALK WITH SYLVESTER AYEK *Michele Austin-Dennehy*

The NMNH conservation laboratory looks today like it normally does, with museum objects spread out on tables and the tools of conservation—computers, fume hoods, microscopes, jars of adhesives and chemicals—all at hand. Museum staff work quietly at their desks. This day is different, however, with its undercurrent of anticipation. Sylvester Ayek will be working with us, looking at Iñupiaq objects for the Living Our Cultures exhibition.

Mr. Ayek, a traditional hunter and artist, arrives and begins with a solitary walk among the Iñupiaq objects laid out in our lab. Afterward, we walk with him as he goes around again, considering each piece. With complete familiarity he picks up harpoons, a seal retriever, and other weapons in his strong hands and begins to talk of his culture.

Together we look at a beautiful, elaborately constructed pair of boots from King Island, Mr. Ayek's home until he was twelve. The boots, collected by Edward W. Nelson in the 1880s, were made for a well-to-do man with two or three wives, according to Mr. Ayek. We wonder at the skill of the sewer, who pieced

RIGHT: Iñupiaq artist Sylvester Ayek examines a pair of embroidered dance boots at the ethnographic conservation laboratory of the National Museum of Natural History, 2008.

OPPOSITE TOP: Traditional walrus skin–covered houses on stilts hug the steep rocky cliffs of King Island in the Bering Sea, 1888.

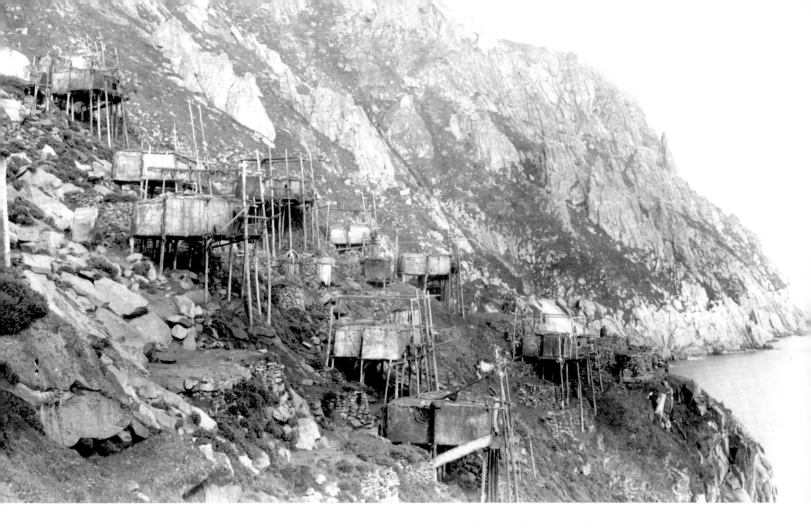

together the caribou fur uppers and beautifully embellished them with fine caribou hair embroidery. Mr. Ayek walks us through the process of making sealskin soles, from preparing the sealskin to finding plant materials used as dyes for coloring the skin. He says that he has not seen this type of elaborate hair embroidery in his lifetime.

What is amazing then is that Nelson wrote about these boots as a "typical" pair from King Island. Were these boots truly common? Were men walking on that rocky, steep island wearing such highly embellished footwear, or were these boots reserved for special events and ceremonies? Mr. Ayek thinks they were strictly for dance ceremonies in the men's houses. However, he points out that an essential component is missing: the ankle straps are gone, and without them the boots would not have stayed securely on a dancer's feet. The question of the missing straps is answered when we looked at a photograph of the boots in Nelson's publication *The Eskimo about Bering Strait*.[2] The straps can be seen in the published image, and it is clear that they were lost later, at some point in the museum history of these objects. When we look at the boots again more closely, we see that the straps were actually cut off, leaving small tabs of skin that remain stitched to the soles; the reasons for this action remain unknown. Input from Mr. Ayek, exhibition curator Aron Crowell, and NMNH curator of northern ethnology Igor Krupnik leads to the decision that the straps will be replaced while the boots reside in Anchorage, in consultation with traditional skin sewers. An experienced King Island artist will be engaged to find the appropriate materials, make the straps, and sew them on.

Mr. Ayek helped us in many ways. He talked about deposits that we might see, such as aged seal oil, which forms a distinct surface or patina on wooden bowls and other objects. He explained how the hunting equipment worked and what parts were missing. He gave general guidance about conservation intervention as we approached our work on the Iñupiaq collections. Mr. Ayek feels that repair and restoration should be minimal, saying that the objects are old and tired and for the most part should simply be left as they are.

Mr. Ayek's thoughtful visit to our lab was also a walk through the cultural landscape of the Iñupiat. His commentaries and stories about his life helped us understand what is important about these artifacts that have traveled so far from home and will now return.

ELAINE KINGEEKUK'S REPAIR OF A SMITHSONIAN CEREMONIAL GUTSKIN PARKA FROM ST. LAWRENCE ISLAND *Kelly McHugh*

A beautiful Yupik ceremonial parka from the NMAI collections will be displayed in the Ceremony and Celebration section of the St. Lawrence Island exhibit case in Anchorage (see p. 92). It represents a long tradition of using the intestines of marine mammals such as the bearded seal, walrus, and sea lion to fabricate waterproof garments for protection against the harsh Arctic climate. Gutskin parkas were traditionally worn over fur or feathered clothing as a barrier to rain and snow. As elders have explained for Living Our Cultures, women's sewing skills were critical for survival. Their ability to sew hide boat covers that would hold up in the rough Bering Sea and north Pacific Ocean and to stitch garments that would protect loved ones on hunting and fishing expeditions meant the difference between life and death. Today, intestine parkas are still made, and knowledge of this organic material and its characteristics is retained by contemporary skin sewers.

In the live mammal, intestine is permeable; however, after death the capillaries close and the membrane becomes impenetrable to water. When gut is wet it is very strong, but when dry the material becomes somewhat fragile, stiff, and prone to tearing. This problem is often encountered with old gutskin garments stored in museum collections. The NMAI parka was collected in 1923 and is still remarkably flexible but was found to have small tears on the hood and lower back. This damage needed to be repaired so that it would not become worse during long-term display in Anchorage or as the result of future study and handling.

Conservation methods for repairing tears in gutskin typically involve the application of an adhesive patch, although these have had varying success. A number of parkas in the Smithsonian collections, however, show strong traditional repairs made by sewing gutskin patches over torn areas with sinew thread, a method that effectively extended the use-life of the garment and protected its wearer. We saw the perfect opportunity to consult an expert skin sewer about undertaking this type of traditional repair on the 1923 NMAI parka. Through the Arctic Studies Center we were extremely fortunate to be connected with St. Lawrence Island Yupik artist Elaine Kingeekuk, originally from St. Lawrence Island. In preliminary discussions, Ms. Kingeekuk stressed the importance of executing the repairs in the traditional way. She felt strongly that adhesive would not have the same longevity and would likely stiffen the gut.

We asked Ms. Kingeekuk if she would be willing to travel to the Smithsonian to execute the repairs on the parka herself. She kindly agreed and came to Washington in November 2006 after a trip home to St. Lawrence Island to gather the materials she would need: whale sinew for thread, winter-bleached walrus intestine, and decorative auklet beaks and feather tufts to replace some that had fallen off the parka. In the NMAI conservation laboratory she discussed these materials and explained every step in the repair process. According to Ms. Kingeekuk, marine

A man and woman from St. Lawrence Island wearing fancy gut parkas made from bleached seal intestine. Illustration by Florence Napaaq Malewotkuk, 1928.

mammal sinew is stronger than that of land animals and is always used for traditional clothing and skin boats on St. Lawrence Island. She brought a large piece with her, and after softening it with water she split it and twisted the strands into various diameters of fine thread. The material's strength and longevity make it ideal for sewing, and in addition it swells when wet, aiding the creation of waterproof seams.

Ms. Kingeekuk used the sinew to sew neat patches of winter-bleached intestine on both the inner and outer surfaces of the tears. Elders she consulted on St. Lawrence Island before coming to NMAI had suggested a two-sided patch because of the age and fragility of the parka. She created a sandwich of new-old-new gutskin that supports the torn areas. Ms. Kingeekuk commented on the difference between working on old gut and new gut and on the fragility of the vintage parka. Despite the challenges, her repairs not only successfully stabilized the torn areas of the garment; they also symbolize living knowledge and an ongoing tradition of care.

Watching Ms. Kingeekuk's deft handling of materials so completely familiar to her was both inspiring and educational. Having the privilege to ask her questions about the working properties of sea mammal intestine and to learn more about the physical and cultural environment from which the garment came was truly invaluable. The experience has informed the treatment of other gutskin objects at NMAI and has prompted a scientific study of sea mammal intestine and the effects of adhesive treatments on it. This type of collaboration facilitates partnerships between museums and source communities, leading to informed and responsible conservation treatments as well as greater equity in the decisions that are required in caring for them.

THE CONTINUING STORY OF THE YUP'IK DANCE FANS *Landis Smith*

When he saw a pair of Yup'ik dance fans that will be included in the Living Our Cultures exhibition, Chuna McIntyre immediately surmised that they had originally been encircled with feathers. Through a conservation lab microscope, we peered together into small holes along the fans'

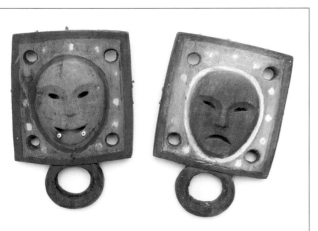

edges. There we saw quill remnants and the wood pegs that once secured them. Mr. McIntyre felt strongly that if the feathers could be replaced the fans would come to life again and be "restored to their former glory"; they would once again "sing."

To make the point, Mr. McIntyre, an accomplished dancer, took the fans in his hands and performed with them, demonstrating how the long plumes that were once attached would accentuate the dramatic, flowing motions of his arms. It was immediately clear how essential new feathers would be to an understanding of the purpose and meaning of these objects.

TOP: Yupik artist Elaine Kingeekuk examines a St. Lawrence Island ceremonial parka before repairing tears with traditional skin patches, 2006.

ABOVE: Chuna McIntyre suggested replacing the lost feathers that once adorned these Yup'ik dance fans (NMNH E217808). The fans are carved with the smiling face of a man and frowning face of a woman; the dots are stars in the night sky; and the four holes represent the cardinal directions.

ALASKA NATIVE COLLECTIONS AT THE SMITHSONIAN

Aron L. Crowell, Landis Smith, and Kelly McHugh

WITH THE 1850 appointment of Spencer F. Baird as assistant secretary of the fledgling Smithsonian Institution, an era of scientific exploration, documentation, and collecting began. Westward expansion, the transfer of Alaska to the United States in 1867, and a federal mandate to document the natural world and indigenous cultures of the continent were inextricably linked to the formation of the Smithsonian's anthropological collections. As William Fitzhugh writes, "Partly by design and partly by circumstance, northwestern North America became the testing ground for Baird's vision of a national program of natural history."[1] Baird worked with naturalists and collectors, including William H. Dall, James G. Swan, George T. Emmons, Albert P. Niblack, Edward W. Nelson, Lucien Turner, William J. Fisher, and others who were attached to various governmental and commercial posts such as the Western Union Telegraph survey, the Army Signal Corps, the U.S. Coast and Geodetic Survey, and the U.S. Navy.

Smithsonian workroom for cataloging Native American collections, 1890

These fieldworkers, with their Native colleagues and contacts, assembled vast holdings of Alaskan material culture as well as systematic documentation—archival field notes, reports, and photographs, in addition to published reports—now held in trust by the National Museum of Natural History. The ethnology catalog at NMNH lists almost ten thousand objects from virtually all of Alaska's peoples. Baird became secretary of the Smithsonian in 1878, ensuring the realization of his vision of one of the most comprehensive and systematic cultural and scientific collections in the world.

The current National Museum of the American Indian has its foundation in New York City's Museum of the American Indian (MAI), established in 1916 by financier and collector George Gustav Heye (1874–1957). Heye's personal collecting activities started during youthful employment as a railroad engineer in Arizona, increasing in pace as his financial means expanded until he had amassed one of the largest collections of Native American materials in the world, more than one million items. He established the Heye Foundation in New York, conducted archaeological research, and worked with major American museums and research institutions, including the Bureau of American Ethnology. The financial crisis of the 1930s curtailed Heye's collecting activities, but he continued to purchase from dealers and to acquire collections assembled by others. The National Museum of the American Indian, which was established in 1989, took over the vast MAI holdings, including some twenty-one thousand ethnological objects from Alaska.[2]

The greater part of Heye's collections, including the Alaska materials, came from dealers who did not provide detailed or accurate information about where the pieces had been obtained. Many Arctic pieces are simply labeled "Eskimo," for example. Exceptions include the large and well-documented collection of Yup'ik masks of the Kuskokwim region acquired from trader Adams H. Twitchell. Work is underway at NMAI to update cultural identifications and to separate archaeological from ethnographic material. Whereas the collection originally served Heye's mission—"The preservation of everything pertaining to our American tribes"—NMAI places its emphasis on partnerships with Native peoples and on their contemporary lives.

NOTES

1 Alaska Native Collections at the Smithsonian Fitzhugh, "Baird's Naturalists," 89.
2 McMullen, "Scope of Collections."

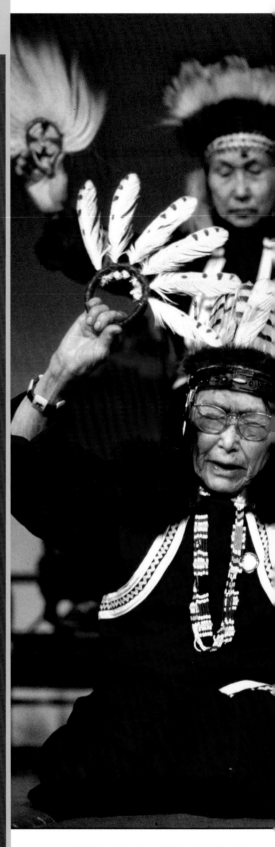

Natalia Smith (kneeling) and Helen Smith of Hooper Bay performing with feathered Yup'ik dance fans at the Camai Dance Festival in Bethel, 1994

Our dilemma as conservators was that in order to make this restoration the original fragments of quill and the wood pegs would need to be removed from the holes; in addition the proper type of new feathers, prepared in a culturally appropriate manner, would have to be used.

A solution has been devised through consultation with NMNH curators, conservators, mount makers, and Mr. McIntyre. The feathers will be restored at the Arctic Studies Center in Anchorage after Living Our Cultures opens there, taking advantage of the hands-on access to objects that the exhibit design affords. The work will be done by an artist who works within the Yup'ik dance tradition and is experienced in making dance fans and in collecting and preparing feathers. The old quill bases and pegs, which are part of the fans and embody important information about their history, will not be removed. Instead new feathers will be inserted into contoured Plexiglas backings fabricated to fit behind each fan as part of the display mount. The backing is predrilled with holes that exactly align with the holes in the fans, so that when the new feathers are inserted into the mount they will appear to be part of the fans. The museum public will see these objects in their original and intended configuration, ready for dancing. To inform the restoration process we have asked NMNH ornithologists to examine the remnant quills and to identity, if possible, what species of bird was used.

Chuna McIntyre aptly summarized the cultural importance of Yup'ik dance regalia and the need to refurbish it for exhibition. He said, "I once asked my late grandmother why we Yup'iks used dance fans and headdresses and everything else to dance. Her answer was simple and poignant. She said, 'Our ancestors are happy to see us so beautiful.'"

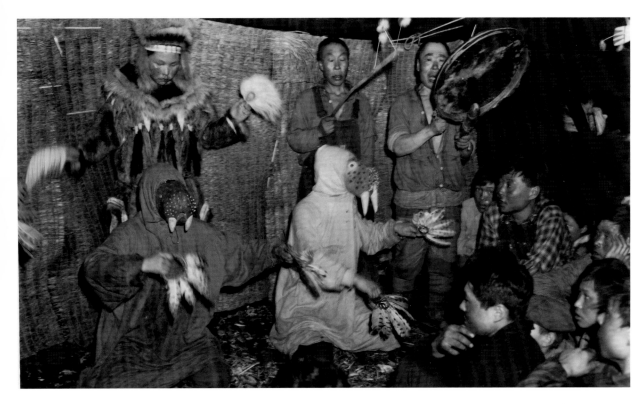

Dancers with masks and fans at the old village of Qissunaq in 1946. The location is near modern Chevak in the Yukon-Kuskokwim Delta.

1 Austin et al., "The Legacy of Anthropology Collections Care"; Clavir, *Preserving What Is Valued*; Johnson et al., "Practical Aspects of Consultation"; Smith, "Collaborative Decisions in Context."
2 Nelson, *The Eskimo about Bering Strait*, pl. XXI-7.

PAUL ASICKSIK JR. is the Iñupiaq cultural program coordinator for the Alaska Native Heritage Center, Anchorage.

DAWN D. BIDDISON is the assistant curator for the Living Our Cultures exhibition and museum specialist with the Arctic Studies Center, National Museum of Natural History, Smithsonian Institution.

KARLA BOOTH is the Alaska Native rural outreach program coordinator for the University of Alaska Anchorage and member of the Lepquinm Gumilgit Gagoadim Tsimshian dancers.

DAVID BOXLEY is a master artist and traditional culture bearer who leads the Tsimshian dance group Git-Hoan (People of the Salmon) Dancers.

DR. JEANE BREINIG is a writer and associate professor of English at the University of Alaska Anchorage.

DELORES CHURCHILL is a Haida elder and renowned textile and basketry artist who works in the Haida, Tlingit, and Tsimshian styles.

DR. ARON L. CROWELL is exhibition curator for the Living Our Cultures exhibition and Alaska director for the Arctic Studies Center, National Museum of Natural History, Smithsonian Institution.

MICHELE AUSTIN-DENNEHY is an ethnographic conservator for the Living Our Cultures exhibition with the National Museum of Natural History, Smithsonian Institution.

CRYSTAL DUSHKIN is a member of the Atka Dancers and an artist, storyteller, and dance instructor.

DR. CLAUDIA S. DYBDAHL is a professor of elementary education at the University of Alaska Anchorage.

DR. SVEN HAAKANSON JR. is the director of the Alutiiq Museum and Archaeological Repository in Kodiak, Alaska.

BEVERLY FAYE HUGO is an Iñupiaq language teacher for the North Slope Borough School District and former facility director for the Iñupiat Heritage Center in Barrow, Alaska.

ELIZA JONES is an elder, educator, and Koyukon Athabascan language expert whose work includes co-authorship of the *Koyukon Athabascan Dictionary*.

PAAPI MERLIN KOONOOKA is a Yupik elder, whaling captain, and educator who serves on the Alaska Eskimo Whaling Commission.

AARON LEGGETT is the Dena'ina cultural historian at the Alaska Native Heritage Center, Anchorage.

KELLY MCHUGH is an ethnographic conservator at the National Museum of the American Indian, Smithsonian Institution.

MARIE MEADE is an elder, Yup'ik language expert, and master teacher with the Department of Alaska Native Studies, University of Alaska Anchorage.

PAUL C. ONGTOOGUK is an assistant professor of secondary education at the University of Alaska Anchorage and former senior research associate with the university's Institute for Social and Economic Research.

ALICE PETRIVELLI is an elder, former chair and president of the Aleut Corporation, and former commissioner of the Alaska Native Science Commission.

DR. GORDON L. PULLAR is assistant professor and director of the Department of Alaska Native and Rural Development in the College of Rural Alaska at the University of Alaska Fairbanks.

ALICE ALUSKAK REARDEN is a Yup'ik language translator for the Calista Elders Council.

LANDIS SMITH is an ethnographic conservator for the Living Our Cultures exhibition with the National Museum of Natural History, Smithsonian Institution.

JONELLA LARSON WHITE is completing her master of arts in museum studies at the Harvard University Extension School.

RICARDO WORL is the tribal services director for the Tlingit-Haida Regional Housing Authority in Anchorage.

DR. ROSITA WORL is president of the Sealaska Heritage Institute and assistant professor of anthropology at the University of Alaska Southeast.

LIVING OUR CULTURES, SHARING OUR HERITAGE: THE FIRST PEOPLES OF ALASKA represents a major Smithsonian commitment to the principles and practice of an engaged, collaborative anthropology. The process of bringing a large and stellar portion of the Smithsonian collections to Alaska for long-term exhibition and community access was initiated in 1994, when the National Museum of Natural History and the Anchorage Museum at Rasmuson Center (AMRC) signed a memorandum of agreement creating the Alaska regional office of the Arctic Studies Center. The National Museum of the American Indian joined in supporting the ASC–Alaska program and eventually signed its own agreement with the Anchorage Museum, in 2008. These unique partnerships yielded research, public programs, and traveling exhibitions, including Looking Both Ways: Heritage and Identity of the Alutiiq People, which received national notice for its groundbreaking diversity of scholarship and community voices. Collaborative programs in cultural studies, archaeology, education, and museum training connected ASC–Alaska with Alaska Native communities and cultural organizations statewide.

In 2001 ASC–Alaska launched the Sharing Knowledge project to survey and document Alaskan collections at NMNH and NMAI. This work, funded by the Rasmuson Foundation, the National Park Service, the Anchorage Museum Foundation, the Smithsonian Institution, and the Museum Loan Network, was preparatory to bringing a significant part of these materials north for exhibition at the Anchorage Museum, where an Arctic Studies Center gallery and research facility were being planned.

Over the next five years, almost forty Alaska Native elders, artists, and cultural advisers traveled with ASC–Alaska staff on a series of research trips to Washington, D.C., where we spent many weeks together in the Suitland, Maryland, collections facilities of both Smithsonian museums. These distinguished contributors are acknowledged individually on page 5, and the insights they shared are represented throughout the book; we offer our profound thanks to them for the rich and informative dialogue—about objects, culture, and history—that poured forth during examination and discussion of more than one thousand objects from all areas of Alaska.

The Washington consultations produced a voluminous project archive composed of audio and video recordings and four thousand pages of annotated transcripts in English, Yup'ik, St. Lawrence Island Yupik, Iñupiaq, Tlingit, Koyukon, Gwich'in, and other languages. The ASC's Dawn Biddison compiled and edited these essential project documents in collaboration with a highly knowledgeable group of Alaska Native linguists, transcribers, and translators. We thank these individuals (also acknowledged by name on page 5), whose generous advice and linguistic review have continued through production of both the catalog manuscript and exhibition texts. Another group of Alaska Native advisers provided essential cultural guidance on conservation treatment, repair, and display of the objects (see the chapter "Collaborative Conservation of Alaska Native Objects at the Smithsonian").

All of these exchanges will become a permanent part of the Smithsonian record, joining an already-rich Alaskan archive of collectors' field reports, historical photographs, accession records, and publications (see National Anthropological Archives, http://www.nmnh.si.edu/naa/). Through the Sharing Knowledge Web site (http://alaska.si.edu), the Washington dialogues as well as new discussions in Anchorage will be available as a public resource for accessing indigenous art, languages, and cultural knowledge.

Rosita Worl, of the Sealaska Heritage Institute, introduced Tlingit and Haida delegates who came to Washington in 2006 with words that could apply to all who represented their communities during the development of Living Our Cultures: "I would like for the record to say that these are our scholars. These are the people that we selected to represent us and who carry the wisdom of our people and our ancestors."

These are the people that we selected to represent us and who carry the wisdom of our people and our ancestors."

Numerous Alaskan organizations generously assisted the Arctic Studies Center with arrangements, logistics, and invitations for the Washington consultations, as well as with later research: the Alaska Native Heritage Center, the Alaska Native Language Center (University of Alaska Fairbanks), the Aleutian-Pribilof Islands Association, the Alutiiq Museum and Archaeological Repository, the Calista Elders Council, the First Alaskans Institute, the Iñupiat Heritage Center, Kawerak, Inc., the Museum of the North (University of Alaska Fairbanks), the Sealaska Heritage Institute, the Tanana Chiefs Conference, the University of Alaska Anchorage, and the Yupiit Piciyarait Cultural Center and Museum.

In Washington the project received the enthusiastic support of NMNH director Cristián Samper and then NMAI director Richard West as well as the full and generous cooperation of the NMNH Department of Anthropology and the assistance of collections staff at both Smithsonian museums. In particular we thank Arctic Studies Center director William W. Fitzhugh; Anthropology Department chair Daniel Rogers; NMNH curator of Arctic ethnology Igor Krupnik; NMNH director of collections and archives Jake Homiak; NMNH collections manager Deborah Hull-Walski; and NMAI collections manager Patricia Nietfeld. Several scholars who specialize in Alaskan anthropology, art, and folklore joined us during the collection consultation visits and contributed their expertise: Ann Fienup-Riordan (Calista Elders Council), Kate Duncan (Arizona State University), and Suzi Jones (Anchorage Museum).

A statewide exhibition advisory panel brought varied expertise and cultural perspectives to conceptualization, development, and review of the exhibition. The panel members were LaRue Barnes (Ilanka Cultural Center), Scott Carrlee (Alaska State Museum), Craig Coray (University of Alaska), Angela Demma (Alaska Native Heritage Center), Barbara Donatelli (Cook Inlet Regional, Inc.), Ann Fienup-Riordan (Calista Elders Council), Sven Haakanson Jr. (Alutiiq Museum), Eleanor Hadden (Alaska Native Heritage Center), Joan Hamilton (Yupiit Piciyarait Cultural Center and Museum), Beverly Faye Hugo (North Slope Borough), John Johnson (Chugach Heritage Foundation), Eliza Jones (elder, teacher, and author), Suzi Jones (Anchorage Museum), Merlin Koonooka (Kawerak, Inc.), Jonella Larson White (Harvard University), Aaron Leggett (Alaska Native Heritage Center), Allison Young McLain (Aleutian-Pribilof Islands Association), Paul C. Ongtooguk (University of Alaska Anchorage), Patricia Partnow (Partnow Consulting), Patricia Petrivelli (Bureau of Indian Affairs), Gordon L. Pullar (University of Alaska Fairbanks), Jonathon Ross (Alaska Native Heritage Center), Monica Shah (Anchorage Museum), Clare Swan (Cook Inlet Tribal Council), and Rosita Worl (Sealaska Heritage Institute). The panel actively engaged in planning and reviewing all phases of the exhibition, from floor plan to exhibit text and media, always attuned to the most important messages—the diversity, resiliency, and creativity of Alaska's First Peoples, their place in history, and the vitality of their cultures today.

ASC–Alaska led the project throughout, taking responsibility for project organization and management, fund-raising, community relations, exhibit curation, and photo research; coordination with collections, exhibit, Web design, photography, film production, and architectural teams; and anthropological, historical, and archival research to build the synthesis of knowledge and perspective presented in this volume. ASC-Alaska director and exhibition curator Aron L. Crowell led and managed the effort with the extremely capable and creative support of assistant curator Dawn D. Biddison. They were aided by interns Amy Chan, Abby Chabitnoy, Ann Fejes, Emmeline Friedman, Saundra Hedrick-Mitrovich, Patricia Janes, Nadia Jackinsky-Horrell, Jonella Larson White, Joshua Peacock, Candice Smith, Alexandra Sprano, Christina Uticone, Bill Walton, Jan Walton, and Kate Worthington.

The massive task of preparing one of the largest object loans ever made by the Smithsonian was undertaken over a nearly three-year period by project conservators, registrars, fellows, and interns.

Their work with the loan objects, which included documentation, archival research, and Alaska Native consultations, sets a new bar for the field of ethnographic conservation. We thank head conservators Marian Kaminitz (NMAI) and Greta Hansen (NMNH); project conservation staff Kelly McHugh (NMAI), Landis Smith (NMNH), Michele Austin-Dennehey (NMNH), Kim Cobb (NMNH); and project loan manager and conservator Valerie Free (NMNH). The registration technicians were Ryan Kenny, Randal Scott, Heather Farley, and Rebecca Withers. NMNH conservation interns included Molly Gleeson, Peter McElhinney, Caitlin Mahoney, Dawn Planas, William Shelley, and Anne Starkweather, assisted by volunteer Patricia Henkel. Funding for NMNH conservation internships was provided by the UCLA/Getty Institute Graduate Program in the Conservation of Ethnographic and Archaeological Materials, the University of London, the NMNH Rose Fund, and George Washington University. A grant from the Andrew W. Mellon Foundation supported Native community consultations during object conservation at NMAI, which was assisted by Mellon fellows Anne Gunnison and Catalina Hernandez. NMAI conservation interns were Kari Kipper and Amber Davis. Technical database support was provided by Elliot Smith Bernstein. Pesticide testing of objects was supported by a 2006 grant from the Smithsonian Collections Care and Preservation Fund.

The design and physical creation of ASC–Alaska's beautiful new facility at the Anchorage Museum and of the Living Our Cultures exhibition now displayed there involved a very large, complex, and successful collaborative process, carried out in parallel with development of the cultural content. In 1999, then-director of the Anchorage Museum Patricia Wolf and the museum's Building Committee began planning for an expansion of eighty thousand square feet that would dedicate one of its levels to a permanent Smithsonian gallery and research space. Alaskan philanthropist Elmer Rasmuson endowed the capital campaign with a substantial gift that was ultimately matched by state and federal monies, support from all twelve Alaska Native regional corporations, and private donations. Project management for the museum expansion was placed in the very capable hands of Sarah Barton (RISE Alaska). The new building, designed by David Chipperfield Architects of London, opened in May 2009, followed by the opening of the Arctic Studies Center exhibition gallery, cultural consultation studio, and research offices in May 2010. James Pepper Henry, who became the new Anchorage Museum director in 2008, gave his enthusiastic and crucial support to the Smithsonian project from the beginning.

To plan the exhibition, the Arctic Studies Center and Anchorage Museum worked with international exhibit firm Ralph Appelbaum Associates of New York. RAA's design, produced under project director Tim Ventimiglia and exhibition designer Jennifer Whitburn, is an aesthetic success that innovatively meets the demanding requirements of a combined exhibit and study collection. We thoroughly enjoyed our work with RAA's Anne Bernard, Caroline Brownell, Diana Greenwold, Jessica Shapiro, John Locascio, and Maggie Jacobstein.

Exhibit fabrication was by Maltbie, Inc., and Click-Netherfield, Ltd., and object mounts were by Benchmark, Ely, Inc., and Robert Fugelstadt. Exhibit media components included the multiscreen orientation film (Donna Lawrence Productions), innovative interactive and Web design (Second Story Interactive), and Listening Space soundscape (Charles Morrow Productions, LLC). Working with such a great team has been a true pleasure.

For this catalog of the exhibition we express our heartfelt thanks to Smithsonian Books director Carolyn Gleason and project editor Christina Wiginton, editor Robin Whitaker, and designer Bill Anton | Service Station. Former Smithsonian Books editor Caroline Newman gave the project early guidance before her deeply regretted passing in late 2008. Smithsonian object photography in this catalog is by Donald Hurlbert (NMNH), Carl Hansen (Smithsonian Photographic Services), Ernest Amoroso (NMAI), and Walter Larrimore (NMAI).

Acheson, Steven. "The Thin Edge: Evidence for Precontact Use and Working of Metal on the Northwest Coast." In *Emerging from the Mist: Studies in Northwest Coast Culture History*, ed. R. G. Matson, Gary Coupland, and Quentin Mackie, 213–29. Vancouver: University of British Columbia Press, 2003.

Ackerman, Robert E. "Prehistory of the Asian Eskimo Zone." In *Arctic*, vol. 5 of *Handbook of North American Indians*, ed. David Damas, 106–18. Washington, DC: Smithsonian Institution, 1984.

Alaska Business Monthly. "Top 49ers: Alaska's Economic Pipelines to the Future." October 2007.

Alaska Native Collections: Sharing Knowledge. Department of Anthropology, National Museum of Natural History, Smithsonian Institution. http://alaska.si.edu.

Alaskool. Jim Crow in Alaska: Articles, Photographs, and More Documenting Some of the History of Racism in Alaska. www.alaskool.org/projects/JimCrow/JimCrow.htm (accessed June 15, 2008).

ANCSA Regional Association Report. Anchorage: Association of ANCSA Regional Corporation Presidents/CEOs, 2006), 37.

Aningayou, Hilda. "Starvation at Southwest Cape." In *Southwest Cape*, vol. 3 of *Sivuqam Nangaghnegha: Siivanllemta Ungipaqellghat (Lore of St. Lawrence Island: Echoes of Our Eskimo Elders)*, ed. Anders Apassingok (Iyaaka), Willis Walunga (Kepelgu), Raymond Oozevaseuk (Awitaq), Jessie Uglowook (Ayuqliq), and Edward Tennant (Tengutkalek), 52–63. Unalakleet, AK: Bering Strait School District, 1987.

Apassingok (Iyaaka), Anders, Willis Walunga (Kepelgu), and Edward Tennant (Tengutkalek), eds. *Gambell.* Vol. 1 of *Sivuqam Nangaghnegha: Siivanllemta Ungipaqellghat (Lore of St. Lawrence Island: Echoes of Our Eskimo Elders)*. Unalakleet, AK: Bering Strait School District, 1985.

Arnold, Robert D. *Alaska Native Land Claims.* Anchorage: Alaska Native Foundation, 1978.

Arutiunov, Sergei A. "The Eskimo Harpoon." In *Gifts from the Ancestors: Ancient Ivories of Bering Strait*, ed. William W. Fitzhugh, Julie Hollowell, and Aron L. Crowell, 52–57. Princeton, NJ: Princeton University Art Museum, 2009.

Austin, Michelle, Natalie Firnhaber, Lisa Goldberg, Greta Hansen, and Catherine Magee. "The Legacy of Anthropology Collections Care at the National Museum of Natural History." *Journal of the American Institute for Conservation* 44, no. 3 (2005): 185–202.

Barbeau, Marius. *Haida Myths Illustrated in Argillite Carvings.* Anthropological Series 32, bulletin no. 127. National Parks Branch, National Museum of Canada. Ottawa: National Museum of Canada, 1953.

Barton, C. Michael, Geoffrey A. Clark, David R. Yesner, and Georges A. Pearson, eds. *The Settlement of the American Continents: A Multidisciplinary Approach to Human Biogeography.* Tucson: University of Arizona Press, 2004.

Beaglehole, John C., ed. "The Journals of Captain James Cook on His Voyages of Discovery." In *The Voyage of the Resolution and Discovery, 1776–1780*, vol. 3, parts 1 and 2. London: Cambridge University Press, 1967.

Beaver, Vivian, Levi Hoover, Lorna Milne, and Patricia Murphy, eds. *Skin Sewing for Clothing in Akula.* Bethel: Lower Kuskokwim School District, 1984.

Berger, Thomas R. *Village Journey. The Report of the Alaska Native Review Commission.* New York: Hill and Wang, 1985.

Bergsland, Knut, and Moses L. Dirks, eds. *Niiǧuǧim Hilaqulingis: Atkan Readings.* Written by Nadesta Golley. Fairbanks: University of Alaska, Rural Education, National Bilingual Development Center, 1981.

———, eds. *Unangam Ungiikangin kayux Tunusangin / Unangam Uniikangis ama Tunuzangis / Aleut Tales and Narratives, Collected 1909–1910 by Waldemar Jochelson.* Fairbanks: University of Alaska, Alaska Native Language Center, 1990.

Billings, Joseph. "Voyage of Mr. Billings from Okhotsk to Kamchatka; His Arrival There; Setting Out for the American Islands: Return to Kamchatka: Second Sea Voyage to Those Islands from the North, Thence to Bering Strait and to Chukotskii Nos, 1789–1790–1791." In *Siberia and Northwestern America, 1788–1792: The Journal of Carl Heinrich Merck, Naturalist with the Russian Scientific Expedition Led by Captains Joseph Billings and Gavriil Sarychev.* Translated by Fritz Jaensch, and edited by Richard A. Pierce, 199–210. Kingston, Ontario: Limestone Press, 1980.

Birket-Smith, Kaj. *The Chugach Eskimo.* Etnografiske Rœkke 6, Copenhagen: Nationalmuseets Skrifter, 1953.

———. "Early Collections from the Pacific Eskimo." In *Ethnological Studies*, vol. 1, 121–63. Etnografiske Rœkke, Nationalmuseets Skrifter. Copenhagen, Denmark: Gyldendal, 1941.

———. *The Eskimos.* Translated by W. E. Calvert. Revised by C. Daryll Forde. London: Methuen, 1959.

Black, Lydia. *Aleut Art: Unangam Aguqaadangin.* Virginia Beach, VA: Donning Company Publishers, 2003.

———. *Atka, an Ethnohistory of the Western Aleutians.* Edited by R. A. Pierce. Kingston, Ontario: Limestone Press, 1984.

———. "Deciphering Aleut/Koniag Iconography." In *Anthropology of the North Pacific Rim*, ed. William W. Fitzhugh and Valérie Chaussonnet, 133–46. Washington, DC: Smithsonian Institution Press, 1994.

———. *Glory Remembered: Wooden Headgear of Alaska Sea Hunters.* Juneau: Alaska State Museums, 1991.

———. *Russians in Alaska, 1732–1867.* Fairbanks: University of Alaska Press, 2004.

Blackman, Margaret B. *During My Time: Florence Davidson, a Haida Woman.* Seattle: University of Washington Press, 1982.

———. "Haida: Traditional Culture." In *Northwest Coast*, vol. 7 of *Handbook of North American Indians*, ed. Wayne Suttles, 240–60. Washington, DC: Smithsonian Institution, 1990.

Blassi, Lincoln. "The Whale Hunt." In *Gambell*, vol. 1 of *Sivuqam Nangaghnegha: Siivanllemta Ungipaqellghat (Lore of St. Lawrence Island: Echoes of our Eskimo Elders)*, ed. Anders Apassingok (Iyaaka), Willis Walunga (Kepelgu), and Edward Tennant (Tengutkalek), 217–23. Unalakleet, AK: Bering Strait School District, 1985.

Boas, Franz. "The Central Eskimo." In *Sixth Annual Report of the Bureau of American Ethnology…, 1884–85*, 409–658. Washington, DC: U.S. Government Printing Office, 1888.

———. "Notes on the Blanket Designs." In "The Chilkat Blanket," by George T. Emmons, in *Memoirs of the American Museum of Natural History*, vol. 3, 351–400. Anthropology series, vol. 4. New York: American Museum of Natural History, 1907.

———. "Tsimshian Mythology, Based on Texts Recorded by Henry W. Tate." In *Thirty-first Annual Report of the Bureau of American Ethnology for the Years 1909–1910*, 29–1037. Washington, DC: U.S. Government Printing Office, 1916.

———. "Tsimshian Texts" (new series). *Publications of the American Ethnological Society*, vol. 3, 65–253. Leiden: E. J. Brill, 1912.

Bockstoce, J. R. *Eskimos of Northwest Alaska in the Early Nineteenth Century: Based on the Beechey and Belcher Collections and Records Compiled during the Voyage of H.M.S. Blossom to Northwest Alaska in 1826 and 1827.* University of Oxford, Pitt Rivers Museum Monograph Series 1. Edited by T. K. Penniman. Oxford: Oxprint Limited, 1977.

Bodenhorn, Barbara. "I'm Not the Great Hunter, My Wife Is." *Études/Inuit/Studies* 14 nos. 1–2 (1990): 55–74.

Bodfish, Waldo, Sr. *Kusiq: An Eskimo Life History from the Arctic Coast of Alaska.* Compiled and edited by William Schneider, in collaboration with Leona Kisautaq Okakok and James Mumigana Nageak. Fairbanks: University of Alaska Press, 1991.

Bogoras, Waldemar. *The Chukchee.* Vol. 7 of *The Jesup North Pacific Expedition*, ed. Franz Boas. New York: A. Stechert, 1904–9.

———. *Chukchee Mythology.* Vol. 8, part 1 of *Memoirs of the American Museum of Natural History.* New York: G. E. Stechert, and Leiden: E. J. Brill, 1910.

Boyd, Robert T. "Demographic History, 1771–1874." In *Northwest Coast*, vol. 7 of *Handbook of North American Indians*, ed. Wayne Suttles, 135–48. Washington, DC: Smithsonian Institution.

Bringhurst, Robert. *A Story as Sharp as a Knife: The Classical Haida Mythtellers and Their World.* Vancouver: Douglas and McIntyre, 1999.

Brower, Charles. *Fifty Years below Zero: A Lifetime of Adventure in the Far North.* 4th ed. New York: Dodd, Mead and Company, 1943.

Bruce, Miner W. "Report [Fiscal Year 1892–93]." In *Sheldon Jackson, Report on Introduction of Domesticated Reindeer into Alaska, 1894*, 96–116. Washington, DC: U.S. Government Printing Office, 1894.

Burch, Ernest S., Jr. "Eskimo Warfare in Northwest Alaska." *Anthropological Papers of the University of Alaska* 16, no. 3 (1974): 1–14.

———. "War and Trade." In *Crossroads of Continents: Cultures of Siberia and Alaska*, ed. William W. Fitzhugh and Aron L. Crowell, 227–40. Washington, DC: Smithsonian Institution Press, 1988.

Busby, Sharon. *Spruce Root Basketry of the Haida and Tlingit.* Seattle: Marquand Books and University of Washington Press, 2003.

Cantwell, John C. "Ethnological Notes." In M. A. Healy, *Report of the Cruise of the Revenue Marine Steamer Corwin in the Arctic Ocean in the Year 1884*, 77–89. Washington, DC: U.S. Government Printing Office, 1889.

Carlo, Poldine. *Nulato: An Indian Life on the Yukon.* Fairbanks: self-published, 1978.

Carlson, Roy L. "Cultural Antecedents." In *Northwest Coast*, vol. 7 of *Handbook of North American Indians*, ed. Wayne Suttles, 60–69. Washington, DC: Smithsonian Institution, 1990.

Case, David S., and David A. Voluck. *Alaska Natives and American Laws.* 2nd ed. Fairbanks: University of Alaska Press, 2002.

Chaussonnet, Valérie. "Needles and Animals: Women's Magic." In *Crossroads of Continents: Cultures of Siberia and Alaska*, ed. William W. Fitzhugh and Aron L. Crowell, 209–26. Washington, DC: Smithsonian Institution Press, 1988.

Chaussonnet, Valérie, and Bernadette Driscoll. "The Bleeding Coat: The Art of North Pacific Ritual Clothing." In *Anthropology of the North Pacific Rim*, ed. William Fitzhugh, 109–31. Washington, DC: Smithsonian Institution Press, 1994.

Cherepanov, Stepan. "The Account of the Totma Merchant, Stepan Cherepanov, concerning His Stay in the Aleutian Islands, 1759–1762." In *Russian Penetration of the North Pacific Ocean 1700–1797*, vol. 2 of *To Siberia and Russian America: Three Centuries of Russian Eastward Expansion, a Documentary Record*, trans. and ed. Basil Dmytryshyn, E. A. P. Crownhart-Vaughan, and Thomas Vaughan, 206–13. Portland: Oregon Historical Society Press, 1988.

Chirikov, Aleksei I. "An Extract from the Report of Aleksei I. Chirikov, Second-in-Command of the Bering Expedition (1735–1741), concerning His Voyage and Discoveries along the Coast of America." In *Russian Penetration of the North Pacific Ocean 1700–1797*, vol. 2 of *To Siberia and Russian America: Three Centuries of Russian Eastward Expansion, a Documentary Record*, trans. and ed. Basil Dmytryshyn, E. A. P. Crownhart-Vaughan, and Thomas Vaughan, 135–38. Portland: Oregon Historical Society Press, 1988.

Clark, Annette McFadyen. "Koyukon." In *Subarctic*, vol. 6 of *Handbook of North American Indians*, ed. June Helm and William C. Sturtevant, 582–601. Washington, DC: Smithsonian Institution, 1981.

——. "Koyukuk River Culture." In *National Museum of Man*, Mercury Series, Ethnology Service Paper 18. Ottawa, Canada: National Museums of Canada, 1974.

Clavir, Miriam. *Preserving What Is Valued: Museums, Conservation, and First Nations*. Vancouver: University of British Columbia Press, 2002.

Cogo, Robert and Nora. *Remembering the Past: Haida History and Culture*. Anchorage: University of Alaska Materials Development Center, Rural Education, 1983.

Collins, Henry. *Archeology of St. Lawrence Island, Alaska*. Washington, DC: U.S. Government Printing Office, 1937.

Corney, Peter. *Early Voyages in the North Pacific, 1813-1818*. Fairfield, WA: Ye Galleon Press, 1965.

Coxe, William. *The Russian Discoveries between Asia and America*. 1780. Reprint, Ann Arbor: University Microfilms, Inc., 1966.

Crowell, Aron L. "The Art of Iñupiaq Whaling: Elders' Interpretations of International Polar Year Ethnological Collections." In *Smithsonian at the Poles: Contributions to International Polar Year Science*, ed. Igor Krupnik, Michale A. Lang, and Scott E. Miller, 99-114. Washington, DC: Smithsonian Institution Scholarly Press, 2008.

——. "Postcontact Koniag Ceremonialism on Kodiak Island and the Alaska Peninsula: Evidence from the Fisher Collection." *Arctic Anthropology* 29, no. 1 (1992): 18-37.

——. "Sea Mammals in Art, Ceremony, and Belief: Knowledge Shared by Yupik and Iñupiaq Elders." In *Gifts from the Ancestors: Ancient Ivories from the Bering Strait*, ed. William W. Fitzhugh, Julie Hollowell, and Aron L. Crowell, 206-25. Princeton, NJ: Princeton University Art Museum, 2009.

Crowell, Aron L., and Estelle Oozevaseuk. "The St. Lawrence Island Famine and Epidemic, 1878-80: A Yupik Narrative in Cultural and Historical Perspective." *Arctic Anthropology* 43, no. 1 (2006): 1-19.

Crowell, Aron L., Amy F. Steffian, and Gordon L. Pullar, eds. *Looking Both Ways: Heritage and Identity of the Alutiiq People*. Fairbanks: University of Alaska Press, 2001.

Curtis, Edward S. "The Haida." In *The North American Indian*, vol. 11, 115-75. 1916. Reprint, New York: Johnson Reprint Company, 1970.

——. *The North American Indian*, vol. 20. Edited by Frederick Webb Hodge. 1930. Reprint, New York: Johnson Reprint Company, 1970.

Dall, William H. *Alaska and Its Resources*. Vol. 1. London: Sampson Low, Son, and Marston, 1870.

——. "On the Remains of Later Pre-Historic Man Obtained from Caves in the Catherina Archipelago, Alaska Territory, and Especially from the Caves of the Aleutian Islands." In *Smithsonian Contributions to Knowledge*, vol. 22, no. 318. Washington, DC: U.S. Government Printing Office, 1878.

Damas, David. Introduction to *Arctic*, vol. 5 of *Handbook of North American Indians*, ed. David Damas, 1-7. Washington, DC: Smithsonian Institution, 1984.

Davydov, Gavriil I *Two Voyages to Russian America, 1802-1807*. Translated by Colin Bearne. Edited by Richard Pierce. Kingston, Ontario: Limestone Press, 1977.

Dawson, George. *To the Charlottes: George Dawson's 1878 Survey of the Queen Charlotte Islands*. Vancouver: University of British Columbia Press, 1993.

De Laguna, Frederica. *The Archaeology of Cook Inlet, Alaska*. 2nd ed. Anchorage: Alaska Historical Society, 1975.

——. *Chugach Prehistory: The Archaeology of Prince William Sound, Alaska*. University of Washington Publications in Anthropology, 13. Seattle: University of Washington Press, 1956.

——. "Tlingit." In *Northwest Coast*. Vol. 7 of *Handbook of American Indians*, ed. Wayne Suttles, 203-28. Washington, DC: Smithsonian Institution, 1990.

——. "Under Mount Saint Elias: The History and Culture of the Yakutat Tlingit," parts 1, 2, and 3. *Smithsonian Contributions to Anthropology*, vol. 7. Washington, DC: Smithsonian Institution Press, 1972.

De Laguna, Frederica, and Catherine McClellan. "Ahtna." In *Subarctic*, vol. 6 of *Handbook of North American Indians*, ed. June Helm, 641-63. Washington, DC: Smithsonian Institution, 1981.

De Laguna, Frederica, Francis A. Riddell, D. F. McGeein, K. S. Lane, J. A. Freed, and C. Osborne. *Archaeology of the Yakutat Bay Area, Alaska*. Smithsonian Institution Bureau of Ethnology Bulletin 192. Washington, DC: U.S. Government Printing Office, 1964.

Deloria, Vine, Jr. "Self-Determination and the Concept of Sovereignty." In *Economic Development in American Indian Reservations*, ed. Roxanne Dunbar Ortiz, 22-28. Albuquerque: University of New Mexico Press, 1979.

Desson, Dominique. "Masked Rituals of the Kodiak Archipelago." PhD diss., University of Alaska Fairbanks, 1995.

Dillehay, Thomas D. *The Settlement of the Americas: A New Prehistory*. New York: Basic Books, 2000.

Dixon, E. James. "Paleo-Indian: Far Northwest." In *Environment, Origins, and Population*, vol. 3 of *Handbook of North American Indians*, ed. Douglas H. Ubelaker, 129-47. Washington, DC: Smithsonian Institution, 2006.

Dixon, George. *A Voyage round the World: But More Particularly to the North West Coast of America*. Amsterdam: N. Israel, and New York: Da Capo Press, 1968.

Doty, William F. "The Eskimo on St. Lawrence Island, Alaska." In *Ninth Annual Report on Introduction of Domestic Reindeer in Alaska... 1899*, 186-223. Washington, DC: U.S. Government Printing Office, 1900.

Drucker, Philip. *The Native Brotherhoods: Modern Intertribal Organizations on the Northwest Coast*. Washington, DC: U.S. Government Printing Office, 1958.

Duflot de Mofras, Eugène. *Exploration du territoire de l'Orégon, des Californies et de la mer Vermeille, exécutée pendant les années 1840, 1841 et 1842*. Paris: A. Bertrand, 1844.

Dumond, Don. *The Eskimos and Aleuts*. London: Thames and Hudson, 1987.

Dumond, Don, and Richard R. Bland. "Holocene Prehistory of the Northernmost North Pacific." *Journal of World Prehistory* 9, no. 4 (1995): 401-51.

Duncan, Kate. *Northern Athapaskan Art: A Beadwork Tradition*. Seattle: University of Washington Press, 1989.

——. *Some Warmer Tone: Alaskan Athabascan Bead Embroidery*. Fairbanks: University of Alaska Museum, 1984.

Duncan, Kate, and Eunice Carney. *A Special Gift: The Kutchin Beadwork Tradition*. Fairbanks: University of Alaska Press, 1997.

Dyson, George. *Baidarka*. Edmonds, WA: Alaska Northwest Publishing Co., 1986.

Emmons, George Thornton. "The Basketry of the Tlingit." In *Memoirs of the American Museum of Natural History*, vol. 3, 229-77. Anthropology series, vol. 2. New York: American Museum of Natural History, 1903.

——. "The Chilkat Blanket." In *Memoirs of the American Museum of Natural History*, vol. 3, 329-400. Anthropology series, vol. 4. New York: American Museum of Natural History, 1907.

——. *The Tahltan Indians*. Philadelphia: University Museum, University of Pennsylvania, 1911.

——. *The Tlingit Indians*. Edited by Frederica De Laguna. Vancouver: Douglas and McIntyre, and New York: American Museum of Natural History, 1991.

Enrico, John. *Haida Dictionary: Skidegate, Masset, and Alaskan Dialects*. Vols. 1 and 2. Fairbanks: Alaska Native Language Center, and Juneau: Sealaska Heritage Center, 2005.

Fair, Susan W. "Eskimo Dolls." In *Eskimo Dolls*, ed. Suzi Jones, 46-71. Anchorage: Alaska State Council on the Arts, 1982.

Fienup-Riordan, Ann. *Agayuliyararput: Kegginaqut, Kangiit-llu: Our Way of Making Prayer: Yup'ik Masks and the Stories They Tell*. Translated by Marie Meade. Anchorage: Anchorage Museum of History and Art, 1996.

——. "The Bird and the Bladder: The Cosmology of Central Yup'ik Seal Hunting." *Études/Inuit/Studies* 14, nos. 1-2 (1990): 23-38.

——. *Boundaries and Passages: Rule and Ritual in Yup'ik Eskimo Oral Tradition*. Norman: University of Oklahoma Press, 1994.

——. *Ciuliamta Akliut Things of Our Ancestors: Yup'ik Elders Explore the Jacobsen Collection at the Ethnologisches Museum Berlin*. Translated by Marie Meade. Seattle: University of Washington Press, 2005.

——. *The Living Tradition of Yup'ik Masks: Agayuliyararput, Our Way of Making Prayer*. Seattle: University of Washington Press, 1996.

——. *The Nelson Island Eskimo: Social Structure and Ritual Distribution*. Anchorage: Alaska Pacific University Press, 1983.

——. *When Our Bad Season Comes: A Cultural Account of Subsistence Harvesting and Harvest Disruption on the Yukon Delta*. Alaska Anthropological Association Monograph Series 1. Anchorage: Alaska Anthropological Association, 1986.

——. *Yup'ik Elders at the Ethnologisches Museum Berlin: Fieldwork Turned on Its Head*. Translated by Marie Meade, Sonja Lührmann, Anja Karlson, and Adelaide Pauls. Seattle: University of Washington Press, 2005.

——. "Yup'ik Warfare and the Myth of the Peaceful Eskimo." In *Eskimo Essays: Yup'ik Lives and How We See Them*, 146-66. New Brunswick, NJ: Rutgers University Press, 1990.

——. *Yuungnaqpiallerput, the Way We Genuinely Live: Masterworks of Yup'ik Science and Survival*. Seattle: University of Washington Press, 2007.

——, ed. *The Yup'ik Eskimos as Described in the Travel Journals and Ethnographic Accounts of John and Edith Kilbuck 1885-1900*. Kingston, Ontario: Limestone Press, 1988.

Fitzhugh, William. "Baird's Naturalists: Smithsonian Collectors in Alaska." In *Crossroads of Continents: Cultures of Siberia and Alaska*, ed. William W. Fitzhugh and Aron L. Crowell, 89-96. Washington, DC: Smithsonian Institution Press, 1988.

Fitzhugh, William W., and Aron L. Crowell, eds. *Crossroads of Contients: Cultures of Siberia and Alaska*. Washington, DC: Smithsonian Institution Press, 1988.

Fitzhugh, William W., and Susan A. Kaplan. *Inua: Spirit World of the Bering Sea Eskimo*. Washington, DC: Smithsonian Institution Press, 1982.

Fortuine, Robert. *Chills and Fever: Health and Disease in the Early History of Alaska*. Fairbanks: University of Alaska Press, 1989.

Garber, Clark McKinley. *Stories and Legends of the Bering Strait Eskimos*. Boston: Christopher Publishing House, 1940.

Garfield, Viola E. "Tsimshian Clan and Society." *University of Washington Publications in Anthropology*, vol. 7, no. 3, 167-340. Seattle: University of Washington, 1939.

Garfield, Viola E., Paul S. Wingert, and Marius Barbeau. "The Tsimshian: Their Arts and Music." *Publications of the American Ethnological Society* 18. New York: J. J. Augustin, 1951.

Geist, Otto W. "Notes regarding the Famine and Epidemics on St. Lawrence Island during the Winter of 1879-80." In *Akuzilleput Igaqullghet: Our Words Put to Paper*, ed. Igor Krupnik, Willis Walunga (Kepelgu) and Vera Metcalf (Qaakaghlleq), 235-38. Washington, DC: Arctic Studies Center, National Museum of Natural History, Smithsonian Institution, 2002.

Geist, Otto W., and Froelich G. Rainey. *Archaeological Excavations at Kukulik, St. Lawrence Island, Alaska: Preliminary Report*. Washington DC: U.S. Government Printing Office, 1936.

Giddings, J. Louis. *Kobuk River People*. Fairbanks: Department of Anthropology and Geography, University of Alaska, 1961.

Gideon, Hieromonk. *The Round the World Voyage of Hieromonk Gideon 1803–1809*. Translated by Lydia T. Black, edited by Richard A. Pierce. Kingston, Ontario: Limestone Press, 1989.

Goddard, Ives, comp. "Native Languages and Language Families of North America," map insert. In *Languages*, vol. 17 of *Handbook of North American Indians*, ed. Ives Goddard. Washington, DC: Smithsonian Institution, 1996.

Golder, Frank A. "Tales from Kodiak Island," parts 1 and 2. *Journal of American Folk-Lore* 16, no. 60, (1903): 16–31, 85–103.

Goldschmidt, Walter R., and Theodore H. Haas. *Haa Aani: Our Land: Tlingit and Haida Land Rights and Use*. Seattle: University of Washington Press, and Juneau: Sealaska Heritage Foundation, 1998.

Golovnin, Vasilii M. *Around the World on the Kamchatka, 1817–1819*. Translated by Ella Lury Wiswell. Honolulu: Hawaiian Historical Society, 1979.

Gordon, George Byron. "Notes on the Western Eskimo." Transactions of the Department of Archaeology, University of Pennsylvania Museum 2, no. 1 (1906): 69–97.

Graburn, Nelson H., Molly Lee, and Jean-Loup Rousselot, eds. *Catalogue Raisonné of the Alaska Commercial Company Collection, Phoebe Apperson Hearst Museum of Anthropology*. Berkeley: University of California Press, 1996.

Greenberg, Joseph H. "The Linguistic Evidence." In *American Beginnings: The Prehistory and Palaeoecology of Beringia*, ed. Frederick Hadleigh West, 525–36. Chicago: University of Chicago Press, 1996.

Greenberg, Joseph H., Christy G. Turner, and Stephen L. Zegura. "The Settlement of the Americas: A Comparison of the Linguistic, Dental, and Genetic Evidence." *Current Anthropology* 27, no. 5 (1986): 477–88.

Guédon, Marie-Françoise, "Tsimshian Shamanic Images." In *The Tsimshian, Images of the Past: Views for the Present*, ed. Margaret Seguin, 174–211. Vancouver: University of British Columbia Press, 1984.

Gunn, Sisvan W. A. *Haida Totems in Wood and Argillite* Vancouver, BC: Whiterocks Publications, 1967.

Hadleigh West, Frederick. "The Netsi Kutchin: An Essay on Human Ecology." PhD diss., Louisiana State University, 1963.

———, ed. *American Beginnings: The Prehistory and Palaeoecology of Beringia*. Chicago: University of Chicago Press, 1996.

Halpin, Marjorie M., and Margaret Seguin. "Tsimshian Peoples: Southern Tsimshian, Coast Tsimshian, Nishga, and Gitskan." In *Northwest Coast*, vol. 7 of *Handbook of North American Indians*, ed. Wayne Suttles, 267–84. Washington, DC: Smithsonian Institution, 1990.

Haycox, Stephen. *Alaska: An American Colony*. Seattle: University of Washington Press, 2002.

Hensley, William L. I. *Fifty Miles from Tomorrow: A Memoir of Alaska and the Real People*. New York: Farrar, Straus and Giroux, 2009.

Himmelheber, Hans. *Eskimo Artists (Fieldwork in Alaska, June 1936 until April 1937)*. Translation of *Eskimokünstler*, 1938. Fairbanks: University of Alaska Press, 1993.

Hoffecker, John F. "Late Pleistocene and Early Holocene Sites in the Nenana River Valley, Central Alaska." *Arctic Anthropology* 38, no. 2 (2001): 139–53.

Hoffecker, John F., W. Roger Powers, and Nancy H. Bigelow. "Dry Creek." In *American Beginnings: The Prehistory and Palaeoecology of Beringia*, ed. Frederick Hadleigh West, 342–52. Chicago: University of Chicago Press, 1996.

Hoffman, Walter J. *The Graphic Art of the Eskimos Based upon the Collection in the National Museum*. 1895. Reprint, Washington, DC: U.S. Government Printing Office, 1897.

Holm, Bill. "Art and Culture Change at the Tlingit-Eskimo Border." In *Crossroads of Continents: Cultures of Siberia and Alaska*, ed. William W. Fitzhugh and Aron L. Crowell, 281–93. Washington, DC: Smithsonian Institution Press, 1988.

———. *The Box of Daylight: Northwest Coast Indian Art*. Seattle: Seattle Art Museum and University of Washington Press, 1983.

Holmberg, Heinrich Johan. *Holmberg's Ethnographic Sketches*. Translated by Fritz Jaensch. Edited by Marvin W. Falk. Fairbanks: University of Alaska Press, 1985.

Holmes, Charles E. "Broken Mammoth." In *American Beginnings: The Prehistory and Palaeoecology of Beringia*, ed. Frederick Hadleigh West, 312–17. Chicago: University of Chicago Press, 1996.

Holmes, Charles E., Richard VanderHoek, and Thomas E. Dilley. "Swan Point." In *American Beginnings: The Prehistory and Palaeoecology of Beringia*, ed. Frederick Hadleigh West, 319–22. Chicago: University of Chicago Press, 1996.

Hoonah Indian Association. *Tlingit Placenames of the Xunaa Káawu*. Map. Hoonah, AK, 2005.

Hough, Walter. "The Lamp of the Eskimo." In *Annual Report of the Board of Regents of the Smithsonian Institution for 1896: Report of the U.S. National Museum*, no. 164, 1027–56. Washington, DC: U.S. Government Printing Office, 1898.

———. "Primitive American Armor." In *U.S. National Museum Annual Report for the Year Ending June 30, 1893*, 625–51. Washington, DC: U.S. National Museum, 1895.

Hrdlička, Aleš. *The Aleutian and Commander Islands and Their Inhabitants*. Philadelphia: Wistar Institute of Anatomy and Biology, 1945.

Hudson, Ray, ed. *Unugulux Tunusangin, Oldtime Stories: Aleut Crafts and Traditions as Taught to Students at the Unalaska City School by Augusta Dushkin, Sophia Pletnikoff, Anfesia Shapsnikoff, Agnes Sovoroff, Sergies Sovoroff, Annie Tcheripanoff, and Bill Stcheripanoff*. Unalaska: Unalaska City School District, 1992.

Hughes, Charles Campbell. "Eskimo Ceremonies." *Anthropological Papers of the University of Alaska* 7, no. 2 (1959): 71–90.

———. "The Eskimos." *Anthropological Papers of the University of Alaska* 12, no. 1 (1964): 1–13.

———. *An Eskimo Village in the Modern World*. Ithaca, NY: Cornell University Press, 1960.

———. "Saint Lawrence Island Eskimo." In *Arctic*, vol. 5 of *Handbook of North American Indians*, ed. David Damas, 262–77. Washington, DC: Smithsonian Institution, 1984.

Hunt, Dolores. C. "The Ethnohistory of Alutiiq Clothing: Comparative Analysis of the Smithsonian's Fisher Collection." MA thesis, San Francisco State University, 2000.

Huntington, Sidney. *Shadows on the Koyukuk: An Alaskan Native's Life along the River*. Anchorage: Alaska Northwest Books, 1993.

Ismailov, Gerasim G. "The Voyage of Izmailov and Bocharov." In *A Voyage to America, 1783–1786*, by Grigorii I. Shelikhov, 83–105. Translated by Marina Ramsay. Edited by Richard A. Pierce. Kingston, Ontario: Limestone Press, 1981.

Ivanov, S. V. "Aleut Hunting Headgear and Its Ornamentation." *Proceedings of the Twenty-third International Congress of Americanists, 1928*, 477–504. New York, 1930.

Ivanov, Viacheslav V. *The Russian Orthodox Church of Alaska and the Aleutian Islands and Its Relation to Native American Traditions: An Attempt at a Multicultural Society 1794–1912*. Washington, DC: Library of Congress, 1997.

Jacobsen, Johan Adrian. *Alaskan Voyage, 1881–1883: An Expedition to the Northwest Coast of America*. Translated by Erna Gunther from the German text of Adrian Woldt. Chicago: University of Chicago Press, 1977.

Jacobson, Steven A. *Yup'ik Eskimo Dictionary*. Fairbanks: University of Alaska Fairbanks, 1984.

Jochelson, Waldemar. *Archaeological Investigations in the Aleutian Islands*. Carnegie Institute of Washington Publication 367. Washington, DC: Carnegie Institute of Washington, 1925.

———. *History, Ethnology, and Anthropology of the Aleut*. Carnegie Institute of Washington Publication 432. Washington, DC: Carnegie Institute of Washington, 1933.

———. *The Koryak*. Vol. 6 of *Publications of the Jesup North Pacific Expedition*, ed. Franz Boas. 1908. Reprint, Leiden: E. J. Brill, and New York: G. E. Stechert, 1975.

Johnson, Andrew (President). Treaty concerning the Cession of the Russian Possessions in North America by His Majesty the Emperor of All the Russias to the United States of America. June 20, 1867. http://avalon.law.yale.edu/19th_century/treatywi.asp (accessed June 15, 2009).

Johnson, Jessica, Susan Heald, Kelly McHugh, Elizabeth Brown, and Marian Kaminitz. "Practical Aspects of Consultation with Communities." *Journal of the American Institute for Conservation* 44, no. 3 (2005): 203–15.

Jonaitis, Aldona. *Art of the Northern Tlingit*. Seattle: University of Washington Press, 1986.

Jones, Strachan. "The Kutchin Tribes." In *Notes on the Tinneh or Chepewyan Indians of British and Russian America: Annual Report of the Smithsonian Institution for the Year 1866*. Washington, DC: Smithsonian Institution, 1872.

Kan, Sergei. *Memory Eternal: Tlingit Culture and Russian Orthodox Christianity through Two Centuries*. Seattle: University of Washington Press, 1999.

Kelly, John W. *Ethnographic Memoranda concerning the Arctic Eskimos in Alaska and Siberia*. Revised and edited by Sheldon Jackson. Washington, DC: U.S. Bureau of Education, 1890.

Kemp, Brian M., et al. "Genetic Analysis of Early Holocene Skeletal Remains from Alaska and Its Implications for the Timing of the Peopling of the Americas." *Journal of Physical Anthropology* 132 (2007): 605–21.

Kenai Peninsula Borough School District. *Alexandrovsk: English Bay in Its Traditional Way*. Anchorage: Alaska Printing Company, 1980.

Kiyuklook, Herbert. "Hunting Walrus the Eskimo Way." In *Savoonga*, vol. 2 of *Sivuqam Nangaghnegha: Siivanllemta Ungipaqellghat (Lore of St. Lawrence Island: Echoes of our Eskimo Elders)*, ed. Anders Apassingok (Iyaaka), Willis Walunga (Kepelgu), Raymond Oozevaseuk (Awitaq), and Edward Tennant (Tengutkalek), 181–85. Unalakleet, AK: Bering Strait School District, 1987.

Klichka, Franz N. "A Report on the Voyage of Potap K. Zaikov to Islands in the North Pacific Ocean between Asia and America, aboard the Merchant Vessel *Sv. Vladimir*, as Described for the Academy of Sciences by Franz Nikolaevich Klichka, Governor of Irkutsk." In *Russian Penetration of the North Pacific Ocean 1700–1797*, vol. 2 of *To Siberia and Russian America, Three Centuries of Russian Eastward Expansion, a Documentary Record*, trans. and ed. Basil Dmytryshyn, E. A. P. Crownhart-Vaughan, and Thomas Vaughan, 259–67. Portland: Oregon Historical Society Press, 1988.

Koniag, Inc., Alutiiq Museum, and the Château-Musée. *Giinaquq: Like a Face*. Kodiak, AK: Alutiiq Museum and Archaeological Repository, 2008.

Krause, Aurel. *The Tlingit Indians: Results of a Trip to the Northwest Coast of America and Bering Straits*. Translated by Erna Gunther. Seattle: University of Washington Press for the American Ethnological Society, 1956.

Krauss, Michael E., and Victor K. Golla. "Northern Athapaskan Languages." In *Subarctic*, vol. 6 of *Handbook of North American Indians*, ed. June Helm, 67–85. Washington, DC: Smithsonian Institution, 1981.

Krenitsyn, Petr Kuzmich, and Mikhail Levashev. "An Extract from the Journals of Captain Petr Kuzmich Krenitsyn and Captain Lieutenant Mikhail Dmitrievich Lavashev Describing Russian Hunting Tech-niques and Natives Encountered in the Aleutian Islands during Their Voyages Commencing in 1764." In *Russian Penetration of the North Pacific Ocean 1700–1797*, vol. 2 of *To Siberia and Russian America: Three Centuries of Russian Eastward Expansion, a Docu-mentary Record*, trans. and ed. Basil Dmytryshyn, E. A. P. Crownhart-Vaughan, and Thomas Vaughan, 245–52. Portland: Oregon Historical Society Press, 1988.

Kroeber, Alfred L. *Cultural and Natural Areas of Native North America*. Berkeley and Los Angeles: University of California Press, 1963.

Krupnik, Igor, Willis Walunga (Kepelgu), and Vera Metcalf (Qaakaghlleq), eds. *Akuzilleput Igaqullghet: Our Words Put to Paper*. Washington, DC: Arctic Studies Center, National Museum of Natural History, Smithsonian Institution, 2002.

Kunz, Michael, Michael Beaver, and Constance Adkins. *The Mesa Site: Paleoindians above the Arctic Circle*. Bureau of Land Management Alaska, Open File Report 86. Anchorage: U.S. Department of the Interior, Alaska State Office, 2003.

Langsdorff, George H. Von. *Remarks and Observations on a Voyage around the World from 1803 to 1807*. 2 vols. Translated by Victoria Joan Moessner. Edited by Richard A. Pierce. Kingston, Ontario: Limestone Press, 1993.

———. *Voyages and Travels in Various Parts of the World during the Years 1803, 1804, 1805, 1806, and 1807*. 2 vols. Amsterdam: N. Israel, and New York: Da Capo Press, 1968.

Lantis, Margaret. *Alaskan Eskimo Ceremonialism*. American Ethnological Society Monograph 11. New York: J. J. Augustin, 1947.

———. "Aleut." In *Arctic*, vol. 5 of *Handbook of North American Indians*, ed. David Damas, 161–84. Washington, DC: Smithsonian Institution, 1984.

———. "Folk Medicine and Hygiene, Lower Kuskokwim and Ninivak-Nelson Island Area." *Anthropological Papers of the University of Alaska* 8, no. 1 (1959): 1–55.

———. "The Social Culture of the Nunivak Eskimo." *Transactions of the American Philosophical Society* 35, pt. 3 (1946): 153–323.

La Pérouse, Jean-François de. *The Journal of Jean-François de Galaup de la Pérouse, 1785–1788*. Vol. 1. Translated by John Dunmore. London: Hakluyt Society, 1994.

Larsen, Helge E., and Froelich Rainey. *Ipiutak and the Arctic Whaling Culture*. Anthropological Papers of the American Museum of Natural History 42. New York, 1947.

Laughlin, William S. "Aleuts: Ecosystem, Holocene History, and Siberian Origin." *Science* 189, no. 4202 (1975): 507–15.

———. *Aleuts: Survivors of the Bering Land Bridge*. New York: Holt, Rinehart, and Winston, 1980.

Lee, Molly C., ed. *Not Just a Pretty Face: Dolls and Figurines in Alaska Native Cultures*. Fairbanks: University of Alaska Museum, 1999.

Liapunova, Rosa. *Essays on the Ethnography of the Aleuts: At the End of the Eighteenth and the First Half of the Nineteenth Century*. Translated by Jerry Shelest. Edited by William B. Workman and Lydia T. Black. Fairbanks: University of Alaska Press, 1996.

Lilliard, Charles, ed. *Warriors of the North Pacific: Missionary Accounts of the Northwest Coast, the Skeena and Stikine Rivers, and the Klondike, 1829–1900*. Victoria, British Columbia: Sono Nis Press, 1984.

Lisiansky, Urey. *A Voyage round the World, in the Years 1803, 1804, 1805, and 1806*. 1848. Reprint, Amsterdam: N. Israel, and New York: Da Capo Press, 1968.

Litke, Frederic. *A Voyage around the World 1826–1829*. Vol. 1 of *To Russian America and Siberia*. Translated from the French by Renée Marshall. Edited by Richard A. Pierce. Kingston, Ontario: Limestone Press, 1987.

Lowenstein, Tom. *Ancient Land: Sacred Whale: The Inuit Hunt and Its Rituals*. New York: Farrar, Straus and Giroux, 1993.

MacDonald, George F. *Haida Monumental Art: Villages of the Queen Charlotte Islands*. Vancouver: University of British Columbia Press, 1983.

———. *Haida Art*. Seattle: University of Washington Press, 1996.

Madison, Curt, and Yvonne Yarber. *Madeline Solomon—Koyukuk*. Yukon-Koyukuk School District. Blaine, WA: Hancock House Publishers, 1981.

———. *Roger Dayton—Koyukuk*. Yukon-Koyukuk School District. Blaine, WA: Hancock House Publishers, 1981.

Marchand, Etienne. *A Voyage around the World Performed during the Years 1790, 1791, and 1792*. Vols. 1 and 2. London: T. N. Longman, 1801.

Marrs, Carl. "ANCSA: An Act of Self-Determination: Harnessing Business Endeavors to Achieve Alaska Native Goals." *Cultural Survival Quarterly* 27, no. 3 (2003): 28–30.

Mason, Otis T. "Basket-Work of the North American Aborigines." In *United States National Museum Report, 1884*, 291–306. Washington, DC: U.S. Government Printing Office, 1885.

Mathiassen, Therkel. "Archaeology of the Central Eskimos: The Thule Culture and Its Position within the Eskimo Culture." In *Report of the Fifth Thule Expedition, 1921–24*, vol. 4, pt. 2, 1–201, trans. W. E. Calvert. Copenhagen: Nordisk, 1927.

Matson, R. G., and Gary Coupland. *The Prehistory of the Northwest Coast*. San Diego: Academic Press, 1995.

McKennan, Robert A. *The Chandalar Kutchin*. Arctic Institute of North America Technical Paper 17. Montreal: Arctic Institute of North America, 1965.

———. *The Upper Tanana Indians*. Yale University Publications in Anthropology, 55. New Haven, CT: Department of Anthropology, Yale University, 1959.

McMullen, Ann, "Scope of Collections, National Museum of the American Indian." Unpublished report. Washington, DC: National Museum of the American Indian, 2007.

Merck, Carl Heinrich. *Siberia and Northwestern America, 1788–1792: The Journal of Carl Heinrich Merck, Naturalist with the Russian Scientific Expedition Led by Captains Joseph Billings and Gavriil Sarychev*. Translated by Fritz Jaensch. Edited by Richard A. Pierce. Kingston, Ontario: Limestone Press, 1980.

Michael, Henry N., ed. *Lieutenant Zagoskin's Travels in Russian America, 1842–1844: The First Ethnographic and Geographic Investigations in the Yukon and Kuskokwim Valleys of Alaska*. Toronto: University of Toronto Press, 1967.

Miller, Jay. *Tsimshian Culture: A Light through the Ages*. Lincoln: University of Nebraska Press, 1997.

Mishler, Craig N. *Black Ducks and Salmon Bellies: An Ethnography of Old Harbor and Ouzinkie, Alaska*. Technical Memorandum 7. Anchorage: Alaska Department of Fish and Game, 2001.

———, ed. *Neerihiinjik: We Traveled from Place to Place: Johnny Sarah Hàa Googwandak, the Gwich'in Stories of Johnny and Sarah Frank*. Fairbanks: Alaska Native Language Center, University of Alaska Fairbanks, 1995.

Mitchell, Donald C. *Sold American: The Story of Alaska Natives and Their Lands 1867–1959*. Fairbanks: University of Alaska Press, 2003.

———. *Take My Land, Take My Life: The Story of Congress's Historic Settlement of Alaska Native Land Claims, 1960–1971*. Fairbanks: University of Alaska Press, 2001.

Moodie, D. Wayne, A. J. W. Catchpole, and Kerry Abel. "Northern Athapaskan Oral Traditions and the White River Volcano." *Ethnohistory* 39, no. 2 (1992): 148–71.

———. "Social Life of the Eskimo of St. Lawrence Island." *American Anthropologist* 25, no. 3 (1923): 339–75.

Morrow, Phyllis. "It Is Time for Drumming: A Summary of Recent Research on Yup'ik Ceremonialism." *Études/Inuit/Studies* 8 (1984): 113–40.

Moss, Madonna, and Jon M. Erlandson. "Forts, Refuge Rocks, and Defensive Sites: The Antiquity of Warfare along the North Pacific Coast of North America." *Arctic Anthropology* 29, no. 2 (1992): 73–90.

Murdoch, John. *Ethnological Results of the Point Barrow Expedition*. Ninth Annual Report of the Bureau of American Ethnology 1887–'88. Washington, DC: U.S. Government Printing Office, 1892.

Murdock, George P. *Rank and Potlatch among the Haida*. Yale University Publications in Anthropology, 13. New Haven, CT: Human Relations Area Files Press, 1936.

Murray, Alexander H. *Journal of the Yukon, 1847–48*. Edited by J. J. Burpee. Ottawa: Publications of the Public Archives of Canada 4, 1910.

Nelson, Edward William. *The Eskimo about Bering Strait*. 1899. Reprint, Washington, DC: Smithsonian Institution Press, 1983.

Nelson, Richard K. *The Athabaskans: People of the Boreal Forest = Ts'ibaa laałta hut'aana*. Edited by Terry P. Dickey and Mary Beth Smetzer. Fairbanks: University of Alaska Museum, 1983.

———. *Hunters of the Northern Forest: Designs for Survival among the Alaska Kutchin*. Chicago: University of Chicago Press, 1973.

Netsvetov, Iakov. *The Journals of Iakov Netsvetov*. Translated by Lydia Black. Kingston, Ontario: Limestone Press, 1980.

Niblack, Albert P. "The Coast Indians of Southern Alaska and Northern British Columbia." In *Annual Report of the Board of Regents of the Smithsonian Institution for the Year Ending June 30, 1888*, 225–386. Washington, DC: U.S. Government Printing Office, 1890.

Notti, Emil. "AFN Position with Respect to the Native Land Claims Issue." June 20, 1969. Incorporated into the U.S. Congress, Senate Hearing records, August 1969, 285.

Oakes, Jill, and Rick Riewe. *Alaska Eskimo Footwear*. Fairbanks: University of Alaska Press, 2007.

———. *Our Boots: An Inuit Women's Art*. London: Thames and Hudson, 1995.

———. *Spirit of Siberia: Traditional Native Life, Clothing, and Footwear*. Washington, DC: Smithsonian Institution Press, 1998.

Oleksa, Michael. *Orthodox Alaska: A Theology of Mission*. Crestwood, NY: St. Vladimir's Seminary Press, 1992.

Olson, Ronald L. *Social Structure and Social Life of the Tlingit in Alaska*. Anthropological Records, 26. Berkeley: University of California Press, 1967.

Olson, Wallace M. *Through Spanish Eyes: Spanish Voyages to Alaska, 1774–1792*. Auke Bay, Alaska: Heritage Research, 2002.

O'Neil, Dan. *The Firecracker Boys: H-Bombs, Inupiat Eskimos, and the Roots of the Environmental Movement*. New York: Basic Books, 2007.

Oovi, Lloyd. "How Gambell Was a Long Time Ago." In *Gambell*, vol. 1 of *Sivuqam Nangaghnegha: Siivanllemta Ungipaqellghat (Lore of St. Lawrence Island: Echoes of our Eskimo Elders)* ed. Anders Apassingok (Iyaaka), Willis Walunga (Kepelgu), and Edward Tennant (Tengutkalek), 11–25. Unalakleet, AK: Bering Strait School District, 1985.

Oozeva, Conrad. "Hunting in Gambell Years Ago." In *Gambell*, vol. 1 of *Sivuqam Nangaghnegha: Siivanllemta Ungipaqellghat (Lore of St. Lawrence Island: Echoes of our Eskimo Elders)*, ed. Anders Apassingok (Iyaaka), Willis Walunga (Kepelgu), and Edward Tennant (Tengutkalek), 129–43. Unalakleet, AK: Bering Strait School District, 1985.

Oquilluk, William A. *People of Kauwerak: Legends of the Northern Eskimo*. With Laurel L. Bland. Anchorage: Alaska Methodist University Press, 1973.

Osgood, Cornelius. *Contributions to the Ethnography of the Kutchin.* Yale University Publications in Anthropology, 14. New Haven, CT: Yale University Press, 1936.

———. *The Ethnography of the Tanaina.* Yale University Publications in Anthropology, 16. New Haven, CT: Yale University Press, 1937.

———. *Ingalik Material Culture.* Yale University Publications in Anthropology, 22. New Haven, CT: Yale University Press, 1940.

———. *Ingalik Mental Culture.* Yale University Publications in Anthropology, 56. New Haven, CT: Yale University Press, 1959.

———. *Ingalik Social Culture.* Yale University Publications in Anthropology, 53. New Haven, CT: Yale University Press, 1958.

Ostermann, Hother, and Erik Holtved, eds. *The Alaskan Eskimos as Described in the Posthumous Notes of Dr. Knud Rasmussen.* Vol. 10, no. 3 of *Report of the Fifth Thule Expedition, 1921–24,* Translated by W. E. Calvert. Copenhagen: Nordisk Forlag, 1952.

Oswalt, Wendell H. *Eskimos and Explorers.* Novato, CA: Chandlar and Sharp, 1979.

———. "A Western Eskimo Ethnobotany." *Anthropological Papers of the University of Alaska* 6, no. 1 (1957): 16–36.

Paige, Amy W., Cheryl L. Scott, David B. Andersen, Susan Georgette, and Robert J. Wolfe. *Subsistence Use of Birds in the Bering Strait Regions, Alaska.* Technical Paper 239. Juneau: Alaska Department of Fish and Game, Division of Subsistence, 1996.

Partnow, Patricia H. "Alutiiq Ethnicity." PhD diss., University of Alaska, Fairbanks, 1993.

Pedersen, Sverre, Michael Coffing, and Jane Thompson. *Subsistence Land Use and Place Names Maps for Kaktovik, Alaska.* Alaska Department of Fish and Game Technical Paper 109. Juneau: Alaska Department of Fish and Game, Division of Subsistence, 1985.

Petroff, Ivan. *Report on the Population, Industries, and Resources of Alaska.* Washington, DC: U.S. Government Printing Office, 1884.

Pinart, Alphonse. "Eskimaux et Koloches: Idées Religieuses des Kaniagmioutes." *Revue d'Anthropologie* 2 (1873): 673–80.

———. *La caverne d'Aknañh, Isle d'Ounga (Archipel Shumagin, Alaska).* Paris: E. Leroux, 1875.

Portlock, Nathaniel. *Voyage around the World; But More Particularly to the North-West Coast of America: Performed in 1785, 1786, 1787, and 1788, in the* King George *and* Queen Charlotte, *Captains Portlock and Dixon.* Amsterdam: N. Israel, and New York: Da Capo Press, 1968.

Prucha, Francis P., ed. *Documents of United States Indian Policy.* 3rd ed. Lincoln: University of Nebraska Press, 2000.

Pulu, Tupou (Qipuk), Ruth (Tatqavin) Ramoth-Sampson, and Angeline (Ipiilik) Newlin. *Whaling: A Way of Life. Aġviġich Iġlauninat Niġinmun.* Anchorage: National Bilingual Materials Development Center, Rural Education, University of Alaska, 1980.

Quimby, George I. "Japanese Wrecks, Iron Tools, and Prehistoric Indians of the Northwest Coast." *Arctic Anthropology* 22, no. 2 (1985): 7–16.

Rainey, Froelich G. *Eskimo Prehistory: The Okvik Site on the Punuk Islands.* Anthropological Papers of the American Museum of Natural History, vol. 37, pt. 4. New York: American Museum of Natural History, 1941.

———. *The Whale Hunters of Tigara.* Anthropological Papers of the American Museum of Natural History, vol. 41, pt. 2. New York: American Museum of Natural History, 1947.

Ramoth-Sampson, Ruth, and Angeline Newlin, comps., Tupou L. Pulu and Ruth Ramoth-Sampson, eds. *Maniilaq.* Anchorage: National Bilingual Materials Development, University of Alaska Anchorage, 1981.

Ray, Dorothy Jean. *Eskimo Art: Tradition and Innovation in North Alaska.* Seattle: University of Washington Press, 1977.

———, ed. "The Eskimo of St. Michael and Vicinity as Related by H. M. W. Edmonds." *Anthropological Papers of the University of Alaska* 13, no. 2. (1966): 1–104.

Ray, Patrick Henry. "Ethnographic Sketch of the Natives." In *Report of the International Polar Expedition to Point Barrow, Alaska, in Response to the Resolution of the U.S. House of Representatives of December 11, 1884,* 37–88. Washington, DC: U.S. Government Printing Office, 1885.

Reid, Bill. "Out of the Silence." In *Solitary Raven: The Selected Writings of Bill Reid,* 71–84. Edited by Robert Bringhurst. Vancouver: Douglas and McIntyre, and Seattle: University of Washington Press, 2000.

Richardson, Sir John. *Arctic Searching Expedition: A Journal of a Boat-voyage through Rupert's Land and the Arctic Sea, in Search of the Discovery of Ships under Command of Sir John Franklin with an Appendix on the Physical Geography of North America.* London: Longman, Brown, Green, and Longmans, 1851.

Rookok, Ruby. "Memories of My Girlhood." In *Savoonga,* vol. 2 of *Sivuqam Nangaghnegha: Siivanllemta Ungipaqellghat (Lore of St. Lawrence Island: Echoes of our Eskimo Elders),* ed. Anders Apassingok (Iyaaka), Willis Walunga (Kepelgu), Raymond Oozevaseuk (Awitaq), and Edward Tennant (Tengutkalek), 131–51. Unalakleet, AK: Bering Strait School District, 1987.

Royal Commission on Indian Affairs for the Province of British Columbia. "At Massett, BC, Sept. 9, 1913, Address of Welcome Read by Chief Councilor Alfred Adams." Reprinted in *Haida Laas: Journal of the Haida Nation* (September 2001): 4–5.

Samuel, Cheryl. *The Chilkat Dancing Blanket.* Seattle: Pacific Search Press, 1982.

Sarychev, Gavrila A. *Account of a Voyage of Discovery to the North-East of Siberia, the Frozen Ocean and the North-East Sea.* 2 vols. 1806. Reprint, Amsterdam: N. Israel, and New York: De Capo Press, 1969.

Sarytschew, Gawrila. *Account of a Voyage of Discovery to the North-East of Siberia, the Frozen Ocean, and the North-East Sea.* Translated from the Russian and embellished with engravings. London: printed for R. Phillips, 1806.

Sauer, Martin. *An Account of a Geographical and Astronomical Expedition to the Northern Parts of Russia...Performed by Commodore Joseph Billings, in the Years 1785 to 1794.* London: T. Cadell and W. Davies, 1802.

Schmitter, Ferdinand. *Upper Yukon Native Customs and Folk-Lore.* Edited by Elva R. Scott. 1906. Reprint. Juneau: Alaska State Historical Commission, 1985.

Secretary of the Treasury. Letter from the Secretary of the Treasury, in relation to the Shelling of an Indian Village in Alaska by the Revenue Steamer *Corwin.* December 21, 1882. http://www.history.navy.mil/library/online/alaska.htm#li (accessed June 15, 2009).

Seegana, Margaret. "Traditional Life on King Island." In *Ugiuvangmiut Quliapyuit King Island Tales: Eskimo History and Legends from Bering Strait,* ed. Lawrence D. Kaplan, 9–29. Fairbanks: Alaska Native Language Center and University of Alaska Press, 1988.

Shapsnikoff, Anfesia T., and Raymond L. Hudson. "Aleut Basketry." *Anthropological Papers of the University of Alaska* 16, no. 2 (1974): 41–69.

Shelikhov, Grigorii I. *A Voyage to America 1783–1786.* Translated by Marina Ramsay. Edited by Richard Pierce. Kingston, Ontario: Limestone Press, 1981.

Silook, Roger S. *Seevookuk: Stories the Old People Told on St. Lawrence Island.* Anchorage: Alaska Publishing Company, 1976.

Simeone, William E. *Rifles, Blankets, and Beads: Identity, History, and the Northern Athapaskan Potlatch.* Norman: University of Oklahoma Press, 1995.

Simeone, William E., and James W. VanStone. *"And He Was Beautiful": Contemporary Athapaskan Material Culture in the Collections of the Field Museum of Natural History* Fieldiana Anthropology, new series no. 10. Chicago: Field Museum of Natural History, 1986.

Simpson, John. "Observations on the Western Eskimo and the Country They Inhabit, from Notes Taken during Two Years at Point Barrow." *Royal Geographic Society, Arctic Geography and Ethnology* (1875): 233–75.

Slobodin, Richard. "Kutchin." In *Subarctic,* vol. 6 of *Handbook of North American Indians,* ed. June Helm and William C. Sturtevant, 514–23. Washington, DC: Smithsonian Institution, 1981.

Smith, J. G. E. *Arctic Art: Eskimo Ivory.* New York: Museum of the American Indian, 1980.

Smith, Landis. "Collaborative Decisions in Context: Loss Compensation in Native American Museum Objects." In *Loss Compensation: Technical and Philosophical Issues,* Objects Specialty Group Postprints, vol. 2, ed. Ellen Pearlstein and Michele D. Marincola. Washington, DC: American Institute for Conservation/Objects Specialty Group, 1994.

Snow, Jeanne H. "Ingalik." In *Subarctic,* vol. 6 of *Handbook of North American Indians,* ed. June Helm and William C. Sturtevant, 602–17. Washington, DC: Smithsonian Institution, 1981.

Spencer, Robert F. *The North Alaskan Eskimo: A Study in Ecology and Society.* Smithsonian Institution, Bureau of American Ethnology Bulletin 171. Washington, DC: Smithsonian Institution Press, 1959.

Stanford, Dennis. "Introduction to Paleo-Indian." In *Environment, Origins, and Population,* vol. 3 of *Handbook of North American Indians,* ed. Douglas H. Ubelaker, 16–22. Washington, DC: Smithsonian Institution, 2006.

Stefánsson, Vilhjámur. *The Stefánsson-Anderson Arctic Expedition of the American Museum: Preliminary Ethnological Report.* Anthro-pological Papers of the American Museum of Natural History, vol. 14, no. 1. New York: American Museum of Natural History, 1919.

Steinbright, Jan, ed. *From Skins, Trees, Quills, and Beads: The Work of Nine Athabascans.* Anchorage: Institute of Alaska Native Arts, 1984.

Stoney, George M. *Naval Explorations in Alaska: An Account of Two Naval Expeditions to Northern Alaska, with Official Maps of the Country Explored.* 2nd ed. Annapolis, MD: United States Naval Institute, 1900.

Swan, James G. *The Haidah Indians of Queen Charlotte's Islands, British Columbia: with a Brief Description of Their Carvings, Tattoo Designs, etc.* Washington, DC: Smithsonian Institution, 1874.

Swanton John R. "Contributions to the Ethnology of the Haida." In *Memoirs of the American Museum of Natural History,* vol. 5-1. New York: G. E. Stechert, and Leiden: E. J. Brill, 1905.

———. *Haida Texts and Myths: Skidegate Dialect.* Smithsonian Institution, Bureau of American Ethnology Bulletin 29. Washington, DC: U.S. Government Printing Office, 1905.

———. *Tlingit Myths and Texts, Recorded by John R. Swanton.* Washington, DC: U.S. Government Printing Office, 1909.

Thompson, Judy. *From the Land: Two Hundred Years of Dene Clothing.* Hull, Quebec: Canadian Museum of Civilization, 1994.

Thompson, Laurence C., and M. Dale Kinkade. "Languages." In *Northwest Coast,* vol. 7 of *Handbook of North American Indians,* ed. Wayne Suttles, 30–51. Washington, DC: Smithsonian Institution, 1990.

Thornton, Harrison Robertson. *Among the Eskimos of Wales, Alaska, 1890–93.* Edited by Neda S. Thornton and William M. Thornton Jr. Baltimore: Johns Hopkins University Press, 1931.

Thornton, Thomas F. "Alaska Native Subsistence: A Matter of Cultural Survival." *Cultural Survival Quarterly* 22, no. 3 (1998): 29–34.

Townsend, Joan B. "Tanaina." In *Subarctic*, vol. 6 of *Handbook of North American Indians*, ed. June Helm and William C. Sturtevant, 623–40. Washington, DC: Smithsonian Institution, 1981.

Turner, Geoffrey. *Hair Embroidery in Siberia and North America*. Occasional Papers on Technology 7, Pitt Rivers Museum. Oxford: Oxford University Press, 1955.

Ungott, Josephine. "How Clothing Was Sewn and Used Years Ago." In *Gambell*, vol. 1 of *Sivuqam Nangaghnegha: Siivanllemta Ungipaqellghat (Lore of St. Lawrence Island: Echoes of our Eskimo Elders)*, ed. Anders Apassingok (Iyaaka), Willis Walunga (Kepelgu), and Edward Tennant (Tengutkalek), 95–126. Unalakleet, AK: Bering Strait School District, 1985.

U.S. Congress. Senate. *Alaska Native Claims Settlement Act*. S 92-581. 92nd Congress, lst sess. Committee on Conference, 1971.

VanStone, James W. *Athapaskan Clothing and Related Objects in the Collections of the Field Museum of Natural History*. Fieldiana Anthropology, new series no. 4. Chicago: Field Museum of Natural History, 1981.

——. *E. W. Nelson's Notes on the Indians of the Yukon and Innoko Rivers, Alaska*. Fieldiana Anthropology, vol. 70. Chicago: Field Museum of Natural History, 1978.

——. *Point Hope: An Eskimo Village in Transition.* Seattle: University of Washington Press, 1962.

——. "Protective Hide Body Armor of the Historic Chukchi and Siberian Eskimos." *Études/Inuit/Studies* 7, no. 2 (1983): 3–23.

——. "Russian Exploration in Interior Alaska: An Extract from the Journal of Andrei Glazunov." *Pacific Northwest Quarterly* 50, no. 2 (1959): 37–47.

Varjola, Pirjo. *The Etholén Collection: The Ethnographic Alaskan Collection of Adolf Etholén and His Contemporaries in the National Museum of Finland*. Helsinki: National Board of Antiquities of Finland, 1990.

Veniaminov, Ivan. *Notes on the Islands of the Unalashka District*. Translated by Lydia T. Black and Richard. H. Geoghegan. Edited by Richard A. Pierce. Kingston, Ontario: Limestone Press, 1984.

Vick, Ann. *The Cama-I Book*. Garden City, NY: Anchor Books, 1983.

Victor-Howe, Anne-Marie. "Songs and Dances of the St. Lawrence Island Eskimos." *Études/Inuit/Studies* 18, nos. 1–2 (1994): 173–82.

Whymper, Frederick. *Travel and Adventure in the Territory of Alaska, Formerly Russian America—Now Ceded to the United States—and in Various Other Parts of the North Pacific*. London: John Murray, 1868.

Wickersham, James, ed. *Alaska Reports: Containing the Decisions of the District Judges of Alaska Territory from January 1, 1906, to January 1, 1910*, vol. 3. *Davis et al. v. Sitka School Board*, January 29, 1908, First Division, Juneau, 481–94. St. Paul, MN: West Publishing, 1938.

Wilkinson, Charles F. *Blood Struggle: The Rise of Modern Indian Nations*. New York: W. W. Norton, 2005.

Wolfe, Robert J., and Charles J. Utermohle. *Wild Food Consumption Rate Estimates for Rural Alaska Populations*. Alaska Department of Fish and Game, Technical Paper 261. Juneau: Alaska Department of Fish and Game, Division of Subsistence, 2000.

Woodbury, Anthony C. "Eskimo and Aleut Languages." In *Arctic*, vol. 5 of *Handbook of North American Indians*, ed. David Damas, 49–63. Washington, DC: Smithsonian Institution, 1984.

Worl, Rosita. "Competition, Confrontation, and Compromise: The Politics of Fish and Game Allocations." *Cultural Survival Quarterly* 22, no. 3 (1998): 77–78.

——. "History of Southeastern Alaska since 1867." In *Northwest Coast*, vol. 7 of *Handbook of North American Indians*, ed. Wayne Suttles, 149–58. Washington, DC: Smithsonian Institution, 1990.

——. "Models of Sovereignty and Survival in Alaska." *Cultural Survival Quarterly* 27, no. 3 (2003): 14–19.

Young, S. Hall. *Hall Young of Alaska, the "Mushing Parson": The Autobiography of S. Hall Young*. Introduction by John A. Marquis. New York: Fleming H. Revell Company, 1927.

Zaikov, Potap. "Journal of Navigator Potap Zaikov, on Ship *Sv. Aleksandr Nevskii* July 27–October 22, 1783." Extract. In *A History of the Russian American Company*, vol. 2, ed. Richard S. Pierce and Alton S. Donnelly, 1–5. Kingston, Ontario: Limestone Press, 1979.

——. "A Report on the Voyage of Potap K. Zaikov to Islands in the North Pacific Ocean between Asia and America, Aboard the Merchant Vessel *Sv. Vladimir*, as Described for the Academy of Sciences by Franz Nikolaevich Kilchka, Governor of Irkutsk." In *Russian Penetration of the North Pacific Ocean 1700–1797*, vol. 2 of *Siberia and Russian America: Three Centuries of Russian Eastward Expansion, a Documentary Record*, trans. and ed. Basil Dmytryshyn, E. A. P. Crownhart-Vaughan, and Thomas Vaughan, 259–67. Portland: Oregon Historical Society Press, 1988.

Zimmerly, David W. *QAJAQ: Kayaks of Siberia and Alaska*. Juneau, Alaska: Division of State Museums, 1986.

ARCHIVAL SOURCES AND IMAGE AGENCIES

Source Abbreviations:
AA = Accent Alaska, AFP = Archives of Foreign Policy, Moscow, AM = Anchorage Museum, AMNH = American Museum of Natural History Library, AP = AP/Wide World Photos, APG = AlaskaPhotoGraphics, AS = AlaskaStock, ASC = Arctic Studies Center, ASL = Alaska State Library, ASM = Alaska State Museum, Juneau, CMC = Canadian Museum of Civilization, Library and Archives, FM = The Field Museum, GA = Glenbow Archives, GSUL = Göttingen State and University Library, KHS = Kodiak Historical Society, LAC = Library and Archives Canada, LC = Library of Congress, NAA = National Anthropological Archives, Smithsonian Institution, NAPAR = National Archives–Pacific Alaska Region, NMAI = National Museum of the American Indian, NUL = Northwestern University Library, RBCM = Royal BC Museum, BC Archives, RSAN = Russian State Archives of the Navy, St. Petersburg, SIA = Smithsonian Institution Archives, SNHP = Sitka National Historic Park, UAA = University of Alaska Anchorage Consortium Library, UAF = Archives, University of Alaska Fairbanks, UAMN = University of Alaska Museum of the North, USGS = U.S. Geological Survey, UWL = University of Washington Libraries, Special Collections

Directionals: B = bottom, C = center, L = left, R = right, T = top

Smithsonian Object Photography
Smithsonian object photography is by Ernest Amoroso (National Museum of the American Indian), Carl Hansen (Smithsonian Photographic Services), Donald Hurlbert (National Museum of Natural History), and Walter Larrimore (National Museum of the American Indian). Accession numbers for these images can be found on the object pages.

FRONT MATTER

Cover
T1 Roy Corral; **T**2 Roy Corral; **T**3 Roy Corral; **T**4 Bill Hess; **T**5 Clark James Mishler; **T**6 William Bacon III, AA; **B**1 Don Pitcher, AS; **B**2 Steve McCutcheon, Steve McCutcheon Collection, AM, B90.14.4.01124; **B**3 Bill Hess; **B**4 Kraig Haver; **B**5 Roy Corral; **B**6 Steve McCutcheon, Steve McCutcheon Collection; AM, B90.14.4.00971

Title Page
pp. 2–3 Luciana Whitaker

Table of Contents
p. 6 Clark James Mishler

Forewords
p. 8 Chris Arend, AS; p. 9 Edward W. Nelson, NAA, GN SI 06370; p. 10 Roy Corral

Introduction
p. 12**T** Clark James Mishler; p. 13**T** Brian and Cherry Alexander; p. 15**L** Randy Brandon, AS; p. 15**C** Chip Porter; p. 15**R** Patrick J. Endres, APG; p. 19 Richard Knecht, ASC; p. 21 Steve McCutcheon, Steve McCutcheon Collection, AM, B90.14.4.00971; p. 23**L** Roy Corral; p. 23**R** Roy Corral; p. 24 Roy Corral

Native Perspectives on Alaska's History
p. 28 Ward Wells, Ward Wells Collection, AM, B83.91.S1867.C101; p. 29**L** Frank Nowell, Perry D. Palmer Photograph Album, UAF, 2004-0120-00019 [cropped]; p. 29**R** From George H. von Langsdorff, *Voyages and Travels in Various Parts of the World during the Years 1803, 1804, 1805, 1806, and 1807,* Alaska Purchase Centennial Collection, ASL, P20-142; p. 31 Kivetoruk Moses, Eskimo Dance Celebrate Big Day, drawing, ca. 1960, AM, Gift of Anchorage Museum Foundation, 2002.002.009, photograph by Chris Arend; p. 32**L** Gertrude Lusk Whaling Album, UAF, 1959-0875-00004 [cropped]; p. 32**R** Winter & Pond Photograph Collection, ASL, P87-1050 [detail]; p. 35 Roy Corral

The First Peoples of Alaska: A Path to Self-Determination
p. 36 LC, LC-USZ62-133506; p. 37 Ordway Photo Shop, Alaska Territorial Governors Collection, ASL, P274-1-2; p. 39 James H. Barker; p. 40 Bill Hess; p. 43 Michael Dinneen, AP, 1082101746

IÑUPIAQ
p. 44**T** Arthur Hansin Eide, Eide Collection, AM, B70.28.200; p. 44**B** Ken Graham, AA; p. 46 Roy Corral; p. 47 Brian Adams; p. 48 Edward S. Curtis, LC, LC-USZ62-111135; p. 49 Keok, Untitled, drawing, ca. 1900, AM, Kathleen Lopp Smith Family Collection, 2004.061.071, photograph by Chris Arend; p. 50 S. R. Bernardi, McBride Collection, AM, B96.9.14;

p. 51 S. R. Bernardi, Wright Collection, AM, B97.19.27; p. 52 Presbytery of the Yukon, UAF, 1995-0244-01421 [cropped]; p. 53 Clowes Collection, UAF, 68-6-45 [cropped]; p. 54 Kivetoruk Moses, Hunter returns to village, drawing, ca. 1960, AM, Gift of Anchorage Museum Foundation, 2002.002.003, photograph by Chris Arend; p. 55 Steve McCutcheon, Steve McCutcheon Collection, AM, B90.14.4.00162; p. 56 Kenneth R. Whitten, AS; p. 57 James H. Barker; p. 58 Luciana Whitaker; p. 59 Chris Arend; p. 60 Courtesy of Charles Deering McCormick Library of Special Collections, NUL, cp20032u; p. 61 Gertrude Lusk Whaling Album, UAF, 1959-0875-00032 [cropped]; p. 62 Lomen Brothers, John Urban Collection, AM, B64.1.395; p. 63 N. S. Jolls, Lomen Collection, UAF, 1966-0054-00114 [cropped]; p. 64 Chris Arend, AS; p. 65**L** Clark James Mishler; p. 65**R** Bill Hess; pp. 66–67 Steve McCutcheon, Steve McCutcheon Collection, AM, B90.14.4.06484; p. 67**T** Lou and Gilbert Adamec Collection, AM, B93.12.39B; p. 68 Father Bernard R. Hubbard, Presbytery of the Yukon, UAF, 88-117-421 [cropped]; p. 69 S.R. Bernardi, McBride Collection, AM, B96.9.6; p. 70 Cochran Collection, AM, B81.164.35; p. 71 Kivetoruk Moses, Untitled, drawing, ca. 1960, AM, Gift of Edith Bullock, 1982.100.007, photograph by Chris Arend.

ST. LAWRENCE ISLAND YUPIK
p. 72**T** Ward Wells, Ward Wells Collection, AM, B83.91.S1867.C49; p. 72**B** Steve McCutcheon, Steve McCutcheon Collection, AM, B90.14.4.01124; p. 73 Roy Corral; p. 74**T** Tom Walker, AA; p. 74**B** Ward Wells, Ward Wells Collection, AM, B83.91.S4393.418; p. 75 Steve McCutcheon, McCutcheon Collection, AM, B90.14.5.AKNative.2.4; p. 76 Dorothea Leighton M. D. Collection, UAF, 1984-0031-00059 [cropped]; p. 77 NAA, INV 1480400; p. 78 Ward Wells, Ward Wells Collection, AM, B83.91.S3017.82; p. 79 Illustration by Florence Napaaq Malewotkuk, UAMN, UA2004-059-001 [cropped]; p. 80 Waldemar Bogoras, Jessup Collection, AMNH, 1375; p. 81 Roy Corral; p. 82 Illustration by Florence Napaaq Malewotkuk, UAMN, UA2004-063-001 [cropped]; p. 83 Illustration by Florence Napaaq Malewotkuk, UAMN, UA2004-043-001 [cropped]; p. 84 LC, LC-USZ62-46891; p. 85 NAA, INV 4122500; p. 86 Illustration by Florence Napaaq Malewotkuk, UAMN, UA2004-061-001 [cropped]; p. 87 Illustration by Florence Napaaq Malewotkuk, UAMN, UA2004-047-001 [cropped]; p. 88 Steve McCutcheon, McCutcheon Collection, AM, B90.14.4.24377; p. 89 Steve McCutcheon, Steve McCutcheon Collection, AM, B90.14.4.06263; p. 90**L** Otto W. Geist, Doris Bordine Collection, AM, B92.33.74; p. 90**R** Brian Adams; p. 91 D'Anne Hamilton; p. 92 NAA, GN SI 04825; p. 93 Illustration by Florence Napaaq Malewotkuk, UAMN, UA2004-045-001 [cropped]; p. 94 Steve McCutcheon, Steve McCutcheon Collection, AM, B83.91.S4393.211; p. 95 Steve McCutcheon, Steve McCutcheon Collection, AM, B90.14.4.15339

YUP'IK
p. 96**T** Edward S. Curtis, LC, LC-USZ62-13912; p. 96**B** Larry McNeil, NMAI, P26512; p. 97 Clark James Mishler; p. 98**T** Clark James Mishler; p. 98**B** Clark James Mishler; p. 99 Roy Corral; p. 100 NAA, GN SI 06383; p. 101 Edward S. Curtis, LC, LC-USZ62-13912; p. 102 ASM, V-A-966; p. 103 Martin Family Collection, AM, B07.5.7.35; p. 104 Kevin G. Smith, AS; p. 105 Kevin G. Smith, AS; p. 106 Clark James Mishler; p. 107 Kevin G. Smith, AS; p. 108 Otto Geist, Doris Bordine Collection, AM, B92.33.21; p. 109 Edward S. Curtis, LC, LC-USZ62-46887; p. 110 Charles O. Farciot, Wickersham State Historic Sites Photograph, ASL, P277-017-009 [detail]; p. 111 Martin Family Collection, AM, B07.5.5.107; p. 112 Hans Himmelheber, Courtesy of Eberhard Fischer and AM, HH Fig. 86 NEG17-18; p. 113 Hans Himmelheber, Courtesy of Eberhard Fischer and AM, HH17-24; p. 114 Christine Heller, Christine Heller Collection, AM, B91.11.116; p. 115 Hans Himmelheber, Courtesy of Eberhard Fischer and AM, HH28; p. 116**T** Ferdinand Drebert, NMAI, L2710; p. 116**B** Elizabeth Wolf, AS; p. 117 James H. Barker; p. 118 Martin Family Collection, AM, B07.5.4.140; p. 119 Edward S. Curtis, LC, LC-USZ62-74130; p. 120 Edward S. Curtis, LC, LC-USZ62-66041; p. 121 Steve McCutcheon, Steve McCutcheon Collection, AM, B90.14.4.06979

UNANGAX̂
p. 122**T** Louis Choris, Oululuk, Principal Settlement on Unalaska Island, lithograph, ca. 1825, AM, Anchorage Municipal Acquisition Fund purchase, 1981.68.7; p. 122**B** Clark James Mishler; p. 123 Clark James Mishler; p. 124 Roy Corral; p. 125 Dan Parrett, AS; p. 126 From Waldemar Jochelson, *History, Ethnology, and Anthropology of the Aleut* [book]; p. 127 Charles Hamlin Collection, UAF, 728-016 [cropped]; p. 128 Crary-Henderson Collection, AM, Gift of Ken Hinchey, B62.1.1239; p. 129 From Gawrila Sarytschew, *Account of a Voyage of Discovery to the North-East of Siberia, the Frozen Ocean, and the North-East Sea,* GSUL,

sarytschew29; p. 130 Charles Hamlin Collection, UAF, 728-027 [cropped]; p. 131 U.S. Navy, San Francisco Call-Bulletin Collection, UAF, 1970-0011-00096 [cropped]; p. 132 Watercolor by Henry Wood Elliot, UAMN, UA482-4B [cropped]; p. 133 U.S. Navy, San Francisco Call-Bulletin Collection, UAF, 1970-0011-00094 [cropped]; p. 134 George A. Dale, Butler/Dale Photograph Collection, ASL, P306-1033; p. 136 Watercolor by Mikhail Levashov, RSAN, F.1331.op.4.d.702; p. 137 Gray & Hereford Photograph Collection, ASL, P185-16 [detail]; p. 138 Watercolor by Mikhail Levashov, RSAN, F.1331.op.4.d.702; p. 139 Charles Hamlin Collection, UAF, 728-024 [cropped]; p. 140 Murie Family Papers, UAF, 1990-0003-00002 [cropped]; p. 141 John Webber, The inside of a house in Oonalashka, print, 1784, AM, Anchorage Municipal Acquisition Fund, 1972.112.003; p. 142L Patrick J. Endres, APG; pp. 142–43 Diana Proemm, AS; p. 144 From Karl F. Gun, *Description ethnographique des peuples de la Russie* [book (LC)]; p. 145 Detail of map by Timofei Shmalev, AFP; p. 146 From Martin Sauer, *An Account of a Geographical and Astronomical Expedition to the Northern Parts of Russia… Performed by Commodore Joseph Billings, in the Years 1785 to 1794* [book]; p. 147L From Alphonse L. Pinart, *La caverne d'Aknañh* [book]; p. 147R From Alphonse L. Pinart, *La caverne d'Aknañh* [book]

SUGPIAQ

p. 148T Merle LaVoy, NAA, NEG 38-108; p. 148B Roy Corral; p. 149L Michael DeYoung, AS; p. 149R Roy Corral; p. 150T Clark James Mishler; p. 150B Sven Haakanson Jr.; p. 151 Clark James Mishler; p. 152 From Ivan Petroff, *Report on the population, industries, and resources of Alaska* [book]; p. 153 From Martin Sauer, *An Account of a Geographical and Astronomical Expedition to the Northern Parts of Russia… Performed by Commodore Joseph Billings, in the Years 1785 to 1794* [book]; p. 154 P.S. Hunt, Crary-Henderson Collection, AM, Gift of Ken Hinchey, B62.1A.375; p. 155 USGS; p. 156 Merle LaVoy, NAA, NEG 38-108; p. 157 Illustration by Henry Wood Elliot, NAA, INV 08594700; p. 158 Engraving from drawing by Luka Voronin, UAF, C0015 Rare Books [cropped]; p. 159 Slifer Collection, KHS, P386-27; p. 160 Kevin G. Smith; p. 161 Courtesy of the Alutiiq Museum; p. 162 Flamen Bell Photograph Collection, ASL, P24-109 [detail]; p. 163 Kenneth Chisolm Photograph Collection, ASL, P105-3; p. 164 Robert F. Griggs, National Geographic Society Katmai Expeditions, UAA, UAA-hmc-0186-volume 6-5210; p. 165 Illustration by Mark Matson, ASC; p. 166L Will Anderson, Courtesy of the Alutiiq Museum; p. 166R Marion Owen, AS; p. 167 Clark James Mishler, AS; p. 168 Illustration by Mark Matson, ASC; p. 169 John N. Cobb, UWL, Cobb 4175; p. 170 Illustration by Mark Matson, ASC; p. 171 KHS, 70-167-17-26N; p. 172 Detail of map by Timofei Shmalev, AFP; p. 173 Illustration by Mark Matson, ASC

ATHABASCAN

p. 174T Edward W. Nelson, NAA, GN SI 06383; p. 174B Roy Corral; p. 175 Patrick J. Endres, AS; p. 176 Clark James Mishler; p. 177T Roy Corral; p. 177B Roy Corral; p. 178 George A. Dale, Butler/Dale Photograph Collection, ASL, P306-0165 [detail]; p. 179 LC, LC-USZ62-133895; p. 180 Albert J. Johnson, Albert Johnson Photograph Collection, UAF, 1989-0166-00408 [cropped]; p. 181 Edward W. Nelson, NAA, GN SI 06341; p. 182 E. A. Hegg, Laurence Tyler Collection, AM, B72.27.60; p. 183 George A. Dale, Butler/Dale Photograph Collection, ASL, P306-0671 [detail]; p. 184 Bill Hess; p. 186 Charles E. Bunnell Collection, UAF, 1958-1026-01543 [cropped]; p. 187 Joseph H. Romig Collection, UAF, 1990-0043-01059 [cropped]; p. 188 AM, B81.19.56; p. 189 Tetlin Photograph Collection, UAF, 1987-0114-00052 [cropped]; p. 190L H. G. Kaiser, Charles E. Bunnell Collecton, UAF, 1973-0066-00081 [cropped]; p. 190R Clark James Mishler; p. 191 Matt Hage; p. 192 Patrick J. Endres, APG; p. 193 Roy Corral; p. 194 From Sir John Richardson, *Arctic Searching Expedition: A Journal of a Boat-voyage through Rupert's Land and the Arctic Sea, in Search of the Discovery Ships under Command of Sir John Franklin* [book]; p. 195 NAA, GN SI 6362; p. 196 Walter and Lillian Phillips Album, UAF, 1985-0072-00105 [cropped]; p. 197 Don Cadzow, Courtesy of Nellie Cadzow Carrol and Kate Duncan; p. 198 Edward W. Nelson, NAA, GN SI 06339; p. 199 Charles E. Bunnell Collection, UAF, 1958-1026-00303 [cropped]

TLINGIT

p. 200T Case & Draper, William Norton Photograph Collection, ASL, P226-010 [detail]; p. 200B Clark James Mishler; p. 201 Clark James Mishler; p. 202 Roy Corral; p. 203L Clark James Mishler, AS; p. 203R Clark James Mishler; p. 204 William A. Kelly Photograph Collection, ASL, P427-40 [detail]; p. 205 John N. Cobb, UWL, NA 2702; p. 206 Vincent Soboleff Photograph Collection, ASL, P1-019 [detail]; p. 207 Case & Draper, William Norton Photograph Collection, ASL, P01-0206

[detail]; p. 208 Don Pitcher, AS; p. 210 Clark James Mishler, AS; p. 211 Bill Hess; p. 212 Winter & Pond Photograph Collection, ASL, P87-0013 [detail]; p. 213 Alaska Purchase Centennial Commission Photograph Collection, ASL, P20-0257; p. 214 Winter & Pond Photograph Collection, ASL, P87-0010 [detail]; p. 215 Redrawn from sketch by Tomás de Suria, UAF, A0414 Rare Books [cropped]; p. 216 Bill Hess; p. 218 Elbridge W. Merrill Photograph Collection, ASL, P57-022 [detail]; p. 219 Merrill Studio, Roy Barron Collection, AM, B80.50.29; p. 220 Winter & Pond, Minnesota Historical Society Collection, AM, B70.73.18; p. 221 Merrill Studio, Roy Barron Collection, AM, B80.50.21; p. 222 Jessup Collection, AMNH, 411184; p. 223 UWL, NA 2920; p. 224 E. W. Merrill, SNHP, SITK 3770; p. 225 Edward de Groff, UWL, NA 2518

HAIDA

p. 226T George M. Dawson, LAC, PA-038148; p. 226B Roy Corral; p. 228 Winter & Pond, UWL, NA 2677; p. 229 Chip Porter, AS; p. 230 Robert Redford, GA, NA-879-12; p. 231 UWL, NA 3061; p. 232 Edward P. Allen, FM, CSA854 [cropped]; p. 233 Winter & Pond Photograph Collection, ASL, P87-0064 [detail]; p. 234 Roy Corral; p. 235 Clark James Mishler; p. 237 C. F. Newcombe, RBCM, AA-00231 [cropped]; p. 238 Richard Maynard, RBCM, AA-00073 [cropped]; p. 239 Julius Sternberg, NAA, GN SI 04315; p. 240 Edward Dossetter, RBCM, D-06324 [cropped]; p. 241 George M. Dawson, LAC, PA-037753; p. 242 Bill Hess; p. 244 Edward S. Curtis, Courtesy of Charles Deering McCormick Library of Special Collections, NUL, ct11068u; p. 245 Winter & Pond Photograph Collection, ASL, P87-0318 [detail]; p. 246 Winter & Pond Photograph Collection, ASL, P87-0318 [detail]; p. 247 Winter & Pond Photograph Collection, ASL, P87-0316 [detail]; p. 248 Edward S. Curtis, RBCM, E-00904 [cropped]; p. 249 Edward Dossetter, RBCM, B-03590 [cropped]

TSIMSHIAN

p. 250T LC, LC-ppmsc-01640; p. 250B Bill Hess; p. 251 Roy Corral; p. 252 Roy Corral; p. 253 Roy Corral; p. 254 Marius Barbeau, RBCM, PN11987 [cropped]; p. 255 Sir Henry S. Wellcome Collection, NAPAR, ARC-297754; p. 256 Mary Randlett Collection, UWL; p. 257 John E. Morgensen, RBCM, AA-00246 [cropped]; p. 258L Bill Hess; p. 258R Roy Corral; p. 259 Roy Corral; pp. 260–61 John E. Thwaites, UWL, UW 21765z; p. 262 RBCM, AA-00108 [cropped]; p. 263 Marius Barbeau, CMC, 62476; p. 264 Marius Barbeau, CMC, 69582; p. 265 Marius Barbeau, CMC, 59800; p. 266 Sir Henry S. Wellcome Collection, NAPAR, WME-V4-P294; p. 268 Bill Hess; p. 269 Bill Hess; p. 270 Marius Barbeau, CMC, 59812; p. 271 Sir Henry S. Wellcome Collection, NAPAR, ARC-297646; p. 272 Sir Henry S. Wellcome Collection, NAPAR, ARC-297646; p. 273 RBCM, AA-00302 [cropped]; p. 274 RBCM AA-00108 [cropped]; p. 275 Marius Barbeau, CMC, 70685

BACK MATTER

Collaborative Conservation of Alaska Native Objects at the Smithsonian

p. 285 Illustration by Kim Cullen Cobb, ASC; p. 286 Kim Cullen Cobb, ASC; p. 287 Mrs. Allen (Agnes Swineford) Shattuck Photograph Collection, ASL, P27-110 [detail]; p. 288 Illustration by Florence Napaaq Malewotkuk, UAMN, UA2004-048-001 [cropped]; p. 289 Kim Cullen Cobb, ASC; p. 290L SIA, NHB-3680; p. 290R James H. Barker; p. 291 Alfred Milotte, ASM, MC NEG 1103